MW01295159

Love and Loss in Hollywood

Special Publications of the Lilly Library
Indiana University Press and the Lilly Library

Love and Loss in Hollywood

Florence Deshon, Max Eastman,
and Charlie Chaplin

Edited by
Cooper C. Graham
and Christoph Irmscher

Indiana University Press

This book is a publication of

INDIANA UNIVERSITY PRESS
Office of Scholarly Publishing
Herman B Wells Library 350
1320 East 10th Street
Bloomington, Indiana 47405 USA
iupress.org

© 2020 by Christoph Irmscher
and Cooper Graham

All rights reserved

No part of this book may be reproduced or
utilized in any form or by any means, electronic
or mechanical, including photocopying
and recording, or by any information
storage and retrieval system, without
permission in writing from the publisher.

The paper used in this publication meets the
minimum requirements of the American
National Standard for Information
Sciences—Permanence of Paper for Printed
Library Materials, ANSI Z39.48–1992.

Manufactured in the United States of America

Cataloging information is available
from the Library of Congress.

ISBN 978-0-253-05292-6 (hard cover)
ISBN 978-0-253-05294-0 (paperback)
ISBN 978-0-253-05293-3 (e-book)

First printing 2020

Cover image Florence Deshon and Max Eastman. Photograph by Margrethe Mather.
From M. Eastman, *Love and Revolution* (1964).

For Philip Danks,
Florence's great-nephew,
with gratitude

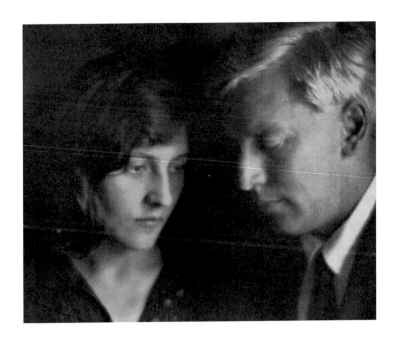

CONTENTS

Abbreviations and Major Works by Max Eastman

Abbreviations

EL = Max Eastman, *Enjoyment of Living*. New York: Harper and Brothers, 1948.

LR = Max Eastman, *Love and Revolution: My Journey through an Epoch*. New York: Random House, 1964.

Major Works by Max Eastman Frequently Cited in the Notes

Enjoyment of Poetry. New York: Scribner's, 1913. Rev. ed. 1921, 1926. Expanded edition (with *Other Essays in Aesthetics*), 1939. One-volume edition (with Anthology for "Enjoyment of Poetry"), 1951.

Child of the Amazons and Other Poems. New York: Mitchell Kennerley, 1913.

Colors of Life: Poems and Songs and Sonnets. New York: Knopf, 1918.

The Sense of Humor. New York: Scribner's, 1922.

Kinds of Love: Poems by Max Eastman. New York: Scribner's, 1931.

Heroes I Have Known: Twelve Who Lived Great Lives. New York: Simon and Schuster, 1942.

Great Companions: Critical Memoirs of Some Famous Friends. New York: Farrar, Straus, and Cudahy, 1959.

ACKNOWLEDGMENTS

There are quite a few institutions and individuals at these institutions without whose help the editors would have been in serious trouble while writing this book. We would like to thank the staff of the Billy Rose Collection of the New York Public Library; Mike Mashon, Zoran Sinobad, and Rosemary Hanes of the Library of Congress, Motion Picture, Broadcasting and Recorded Sound Division; Rachel Bernstein, Jeanie Braun, Louise Hilton, and Faye Thompson of the Margaret Herrick Library, Academy of Motion Picture Arts and Sciences in Los Angeles; Diana Carey and Jennifer Fauxsmith of the Schlesinger Library on History of Women, Harvard University; Ashley Swinnerton of the Film Studies Center at the Museum of Modern Art in New York; and the University of Chicago Stills Collection.

We are indebted to Kevin Brownlow for his invaluable aid in gaining the editors an early entrée into the Chaplin Archives, as well as for providing us with articles, references, and still photos from his own priceless collection, and most of all for his encouraging words. Philip Danks, Florence's great-nephew, was an excellent source of information on the Danks family. Kate Guyonvarch of the Chaplin Archives set us up with multiple photographs, as did Jessica Buxton, author of the outstanding blog Discovering Chaplin. Steven Higgins, former curator of the Film Department of the Museum of Modern Art, read a very early draft and guided us back to the right path. Two readers offered advice for revision; one of them was Charles Maland at the University of Tennessee. His detailed notes immeasurably improved the final version. Croton's village historian, Marc Cheshire, drawing on his unparalleled knowledge of local lore and history, solved several knotty puzzles in the letters; the footnotes document his involvement. Heather Kiernan graciously gave us access to a notebook in her possession, in which Eastman jotted down sundry musings about Florence and Charlie as well as the meaning of life, and, even better, she allowed us to quote from it.

Our work would not have been possible without the unstinting support of Breon Mitchell, literary executor of the Eastman estate, who gave us

access to the invaluable Eastman and Deshon papers at the Lilly Library, Indiana University Bloomington, and graciously permitted us to obtain copies of material from the Eastman estate being held by other institutions.

Thanks are also due to Mary Mallory, who helped us with research in Los Angeles, and the staff of the wonderful Lilly Library, Bloomington, notably its director, Joel Silver; associate director, Erika Dowell; the head of the Lilly's Public Services, Rebecca Baumann; and especially Sarah Mitchell, the Lilly's reading room coordinator, who provided detailed advice on an earlier version of this book. Kudos to the Lilly's retired reference librarian David Frasier—a renowned scholar of early Hollywood—for numerous kindnesses over the years. Dave scanned our manuscript with an eagle eye; meeting with him at his perch at McAllister's to go through our text, line by line, was one of the highlights of the entire process. Our gratitude also to Christoph's students, Casey Hemings, Evan Leake, and Nathan Schmidt, who assisted at various stages in this project's complicated genesis.

Raphael Falco offered incisive comments on a draft of our introduction. Andrea Knutson put us in touch with Emily Spunaugle at Oakland University, who practiced some last-minute librarian wizardry. Naz Pantaloni III at the Herman B Wells Library in Bloomington carefully vetted copyrights for us. And the credit for the book's title goes to Lauren Bernofsky.

This book was partially funded by the Office of the Vice Provost of Indiana University Bloomington through the Grant-in-Aid program. The editors also gratefully acknowledge the generous support of Paul Gutjahr, the associate dean for the arts and humanities in the College of Arts and Sciences, Indiana University Bloomington.

It seems only right to acknowledge that *Love and Loss in Hollywood* wouldn't have seen the light of print if Gary Dunham, director of Indiana University Press, hadn't seen some potential in the project. A round of applause, then, to him and his great staff at the press, including Peggy Solic, who acquired the book; Michelle Mastro, who edited it; and Tony Brewer, David Hurley, Nancy Smith, and Stephen Williams, who made it (and us) look good. Jennifer Crane and her team did a heroic job editing a complex manuscript with many and, as it seemed, constantly moving parts. And Nancy Lightfoot, our marvelously patient production editor, swooped in at the end and rescued us from a sea of troubles. As Charlie Chaplin said, "Imagination means nothing without doing."

Cooper C. Graham and Christoph Irmscher
Baltimore and Bloomington, July 2019

Love and Loss
in Hollywood

The letters collected in this volume tell the story of how three extraordinary people's lives intersected, for a period of a few years, with grave consequences for all of them. One of the three did not survive their relationship; the second kept reliving what had united them for the rest of his long life; and the third worked hard to pretend that nothing had ever happened.

All love triangles begin as a tale of two lovers.

Max Eastman (1883–1969) was a poet, writer, and editor and so many other things that it seems impossible to sum up his life in a few paragraphs. He was brilliant, irresistibly eloquent, and volatile. He completed his dissertation in philosophy at Columbia University (on Plato) but never submitted it. His mentor John Dewey thought so highly of him that he hired Max as a lecturer anyway. Tall, devastatingly handsome, and pervasively charming, Max was loved by men and women all his life. Born as the son of two Congregationalist ministers, the forever unreliable Max was temperamentally unsuited to be a true believer. In 1911, he married Ida Rauh (1877–1970), a Jewish lawyer, sculptor, and birth control activist, and it was under her energetic guidance that he fused the brand of atheism and the pragmatism he had acquired under Dewey's tutelage with an unconventional form of Marxism. His friendship with Trotsky and a prolonged stay in Russia set him on a collision course with developing party orthodoxy in Moscow and at home. Max's energy was prodigious; married three times (though he objected to the idea of marriage in principle), he published countless books: political essays, literary criticism, autobiographies, translations, a novel, and five volumes of poetry. There was no limit to the things that interested him: for a while, in the late 1930s, he even hosted a popular radio quiz show, *Word Game*. Long after the story told in these pages ends, he would become one of the many who swung from a passionate belief in socialism—or what Max called, in his only novel, the possibility of "a sweetly reasonable world"—all the way to the Right, ending up as a roving editor for *Reader's Digest* and an occasional contributor to *National Review*.[1] But at the time our story picks up, he was, at age thirty-three, still the major intellectual figure representing the Left in the United States, and to many, he was a hero.

Florence Deshon (1893–1922) was a twenty-three-year-old actress originally from Tacoma, Washington. Dark-complexioned and slim like Eastman, she had soulful brown eyes, full lips, and a beautiful, heart-shaped face framed by abundant dark brunette hair.[2] A Hollywood executive thought she looked like the Mona Lisa.[3] Despite her lack of formal education, she had broad intellectual interests, identified as a feminist, and became involved in the National Woman's Party. She read voraciously (in her letters she mentions needing reading glasses)[4] and was not afraid of voicing strong opinions: she disliked the poet Sara Teasdale, for example ("too eager to surrender"), but had a soft spot in her heart for the Empress Dowager Cixi, who she was told would not allow any men at her court unless they were poets.[5] When Max met her, she had performed on stage and appeared in movies, dabbled in advertising, and had become a major player in the artistic community of Greenwich Village. Despite her youth, she was sexually experienced and quite aware of her power over men.[6] Max would later describe her characteristic smile as beginning with a flash, as the upper lip opens, and broadening to reveal the teeth, as "the cheeks curve, and the eyes gather light and attract the brows and lashes toward them just infinitesimally," a gesture of such radiant beauty that it becomes the source of light toward which we all strive. For Max, a smile was a "summary of the chief points of personality," the "path along which two selves approach."[7]

Florence's and Max's two selves approached each other on December 15, 1916. "The whole temper and tenor of my living changed" that day, Max recalled in the second volume of his autobiography, *Love and Revolution*. Florence's life also was forever altered. Unbelievably, Max had spied her once before, "a dark-eyed girl of the Leonardo type," walking east on Thirty-fourth Street, holding a painted Japanese parasol over her head, "by far the most beautiful being I had ever seen." They met at a ball in Tammany Hall, New York, a fund-raising event for the socialist magazine *The Masses*, which Max was editing. They danced together while Florence's current beau, the novelist John Fox Jr., author of the bestselling western *The Trail of the Lonesome Pine*, who would celebrate his fifty-fourth birthday the next day, watched from the sidelines. Weeks later—he had in the meantime moved out of the apartment he shared with his wife and his four-year-old son Daniel—Max took Florence out to dinner to Mouquin's on Sixth Avenue. Afterward he drove her, in his beat-up Ford Model T, to his little yellow clapboard house in Croton-on-Hudson, and it was there, later the same night, that "the ideal rapture and the physical achievement of love were so blended as to be indistinguishable."[8]

The letters, telegrams, and photographs the two exchanged between January 1917 and December 1921 offer a richly detailed history of their intense relationship. They tell a story of too much work and too little money: Max was struggling to finish his book *The Sense of Humor* while continuing to edit the major radical magazine of the period, *The Masses*, and then its successor, *The Liberator*, while Florence appeared in theatrical productions and starred in dozens of movies (twenty-four that are known). It is also a story of political turmoil: Max endured two trials brought against him by the government, traveled the country to agitate against the war, and, alongside Florence, fought tooth and claw for the passage of the Nineteenth Amendment. It is useful to remember that, in those years dominated by federal raids and arrests, two prominent public figures with the political convictions of Florence and Max also were in considerable personal danger.[9] Detectives lurked outside Max's Greenwich Village apartment, rifling through his trash to look for incriminating material (Max fed them pages torn from his edition of the *Critique of Pure Reason*), and Max had reason to worry that his well-documented radical views were having an impact on Florence's career.[10] Florence herself narrowly avoided jail when, during a National Woman's Party demonstration, a banner was ripped from her reluctant hands.[11]

For a while at least, things had seemed so promising. In July 1919, Florence accepted an invitation from Samuel Goldwyn to come to Hollywood on what turned out to be a five-year contract:[12] a dream come true for a hardworking actress, her shot at movie stardom. In September, Max, suffering through endless weeks of loneliness, came for an extended, long-anticipated visit. The separation had been hard on both of them, although Florence and Max had kept in touch by frequent, sometimes daily letters and telegrams and "night messages" or "night letters" (messages limited to ten words or telegrams over that limit, sent at night at a reduced rate for delivery the next morning). When Max arrived, he made sure to introduce Florence to his friends, including Charlie Chaplin (1889–1977), a fateful move, as he would realize later, for Charlie changed the Florence-Max dyad to a triad or, put more simply, became the third person in an increasingly complicated, messy relationship scenario.

At age thirty, Charlie was one of the most famous men in the world. Max had met him during a previous lecture and fund-raising tour for *The Liberator*, the magazine he was editing with his sister, the lawyer Crystal Eastman (1881–1928). After Max had returned to New York, Florence, adrift in the rapidly changing landscape of Hollywood, succumbed to Charlie's advances. Max, in turn, his erotic instincts sharpened by

Florence's continuing absence, fell in love with the young German dancer Lisa Duncan (1898–1976). He immediately regretted the pain he had caused Florence, hoping that they could simply pick up where they had left off. Conveniently, Lisa, the most celebrated member of a dance troupe known as the Isadorables, was getting ready to depart for a European tour with Isadora Duncan, her mentor and "adoptive" mother (the arrangement had never been formalized). But the damage to Max's relationship with Florence was done. At the same time, in a twisted way, Max seems to have welcomed Charlie's entrée into his tangled affair with Florence. As the downward spiral of Florence's life continued—from the traumatic termination of her contract with Goldwyn to her abortive pregnancy (with Chaplin as the presumed father of her child) to her apparent suicide in Manhattan at the age of twenty-eight—Max's and Charlie's friendship remained relatively intact.

In a sense, Florence, Max, and Charlie were acting out, albeit unintentionally, an age-old story about sexual desire, one that David Thomson has recently described as central to most movie plots—a fitting coincidence given that what tied Florence, Max, and Charlie together was their shared involvement in the industry.[13] Similar romantic triangles have appeared throughout cultural history, to be sure; what seems worth pointing out here is that such relationships are always as much about those who desire as they are about the person who is being desired.[14]

Consider, for example, René Girard's reading of Shakespeare's *Two Gentlemen of Verona*, which features the troubled love life of the two inseparable well-born friends Valentine and Proteus. Valentine is sent from Verona to study in Milan, where he falls deeply in love with Silvia. Somewhat later, Proteus is also dispatched to Milan to study. He has his own fiancée, Julia, at home, but in Milan, after having heard Valentine wax lyrical about the beauty and perfection of Silvia, he also falls in love with her. Remarkably, he is fully aware of his dubious motivation for desiring his best friend's lover: "Is it my mind, or Valentinus' praise / Her true perfection, or my false transgression, / That makes me reasonless to reason thus?" In Girard's understanding, this is a textbook case of "mimetic desire."[15]

There are obvious parallels between Valentine and Proteus, on the one hand, and Max and Charlie, on the other. Girard's theory would explain

　　　　　　　　　　　　　Love and Loss in Hollywood

why Charlie and Max wrote about their relationship with each other but had very little or only tangled things to say about their feelings for Florence. Charlie, in fact, never discussed Florence except indirectly. And Max's ambivalent attitude, even when it became clear that his much-admired friend was sleeping with his girlfriend, was in complete contrast with his furious behavior when he learned that the English actor Reginald Pole had developed a crush on Florence. "My jealousy is all transferred to Charlie," he told Florence, as if part of his worry were how the new situation would affect his relationship with his friend.[16]

A curious notebook survives, likely kept by Max during the days he and Charlie were competing for Florence's attention.[17] Max's notes sketch out a fascinating portrait of a mercurial, essentially amoral Charlie. A key component is a conversation with the Hollywood director Cecil B. DeMille, perhaps passed on by Charlie himself, in which DeMille warned the entertainer not to "make fun out of the war," to which Charlie responded, "You can make fun of anything." Charlie was not, Max observed, limited by Hollywood and didn't *need* to worry about playing by their rules in order to succeed ("he is *instinctively* careful of money values"). Yet it seems that Max, who was "brave" only "up to the point of danger," was even more bothered by the fact that Charlie was unlimited in other ways, too. For the real theme of Max's notebook wasn't Charlie but a grander, more unrestricted, more fearless view of life, which Charlie just happened to embody. Another name for that view was "unjealous love," according to Max, "the only love that can be enduring and yet promote life." And although it appears that Max had begun his notebook with the intention of writing an essay on Charlie, another, related subject now emerged: "An essay on love should tell how to get rid of jealousy—that is the essential problem." Florence was only a supplemental character in these notes, making clear that the Max-Florence-Charlie triangle had progressed to a point where the primary relationship, in Max's mind, had become the one between him and Charlie. Max's battle with the limitless Charlie was about testing *his* limits and coming up short again and again, with Florence merely serving as the battleground. When Max, during one of the many evenings the trio spent together in Hollywood, challenged Charlie to a contest over who had the greatest lung capacity—an event Florence wanted to write a "funny sketch" about—the two men were comparing more than their lungs.[18]

By 1942, the year Max's "character study" of Chaplin, "Actor of One Role: A Character Study of Charlie Chaplin," appeared, the "unjealous love" theme had vanished: Florence was demoted to two brief references,

"a beautiful actress I loved" and "my actress." Max tried hard to paint Charlie from a detached perspective, as an object of curiosity rather than as a rival and competitor, someone against whom he would measure his own worth. Picking up on his earlier description of Charlie as a grown man who is "in morals a child," he now claimed, acidly, that Charlie had "no unity of character . . . nothing in his head that, when he lays it on the pillow, you can sensibly expect will be there in the morning."[19] Charlie's creation, the Tramp, was a predatory child, a mask for an insecure man whose chameleonic instincts allowed him to use women the way one buys and then immediately discards a cheap fountain pen. Note that this characterization was coming from someone who, having drifted from radical socialism to fervent anticommunism, was himself being accused, exactly around that time, by his own former political allies and friends of exactly the same kind of shape-shifting. Charlie was Max, but with more raw talent and without the religious scruples that kept haunting that son of two preachers.[20] Obviously, despite the analytic, even condescending tone of the piece, Max had not succeeded in getting rid of jealousy—or, for that matter, of love.

In fact, Charlie Chaplin and Max Eastman continued to profess high regard for each other for the rest of their lives and were still visiting each other in the sixties.[21] When Max, as an old man, sat down to write the second installment of his autobiography, he was finally able to confront the role Florence had played in both their lives, devoting several chapters to that subject. But even then, he refused to cast aspersions on his friend, despite the callousness Charlie had shown to Florence when she got sick after "their child" (as Max didn't hesitate to identify it) had died in utero. There had been, he said about Charlie, "no arrogance in his courtship or his love." Rather than blaming him for Florence's decline, he praised him for having brokered her previous triumphs, which had been, he wrote, "mainly due to her companionship with Charlie," a brutal assertion that contradicted his own admiring statements about her acting abilities that he made to Florence herself, including the assurance that there was "no bound or limit to what you can do."[22] Casually minimizing Florence's talent decades after her death, Max thus got the man who had helped cause her misery off the hook. It makes complete sense that David Robinson's exhaustive 1985 biography, *Chaplin: His Life and Art*, authorized by Oona Chaplin, never even mentions Florence.

It is our hope that this book will restore Florence Deshon to the prominent part she played, at least for a while, in the lives of both men, offering a corrective to Max's efforts to diminish her and the steadfast silence

Charlie maintained about her both when he was dating her (there are no surviving letters by Charlie to Florence) and afterward. Beyond strictly biographical interests, Florence's life as we have reconstructed it here—the ambitions she harbored and the tragedies she experienced, as mirrored in the intimacy, rawness, and beauty of her letters—also sheds new light on the history of Hollywood at a time when the industry underwent a massive, consequential transformation. The lives of the stars that survived that transformation have been written about many times; Florence's correspondence offers us the unique perspective of someone who had a shot at greatness and, for professional, personal, and systemic reasons, was not able to take advantage of it. One of the leitmotifs in the correspondence between Max and Florence is the roar of the lions, a kind of metaphor for the pressures of the outside world that for Florence and Max, long before Leo the Lion came to be a symbol of MGM pictures, also included the bosses in charge of the film business. Yet, Max comforted Florence, as long as they were together, "we won't mind the lions roaring and the winds howling" (December 15, 1919). Soothed by such reassurances, Florence would soon discover that she had ignored those lions at her own peril.

———

Florence and Max's love had never been unproblematic, which is evident even in their earliest exchanges. As reflected in the letters collected here, their relationship unfolded against the background of New York bohemian life, the rural charms of Croton, anonymous hotel rooms all over the nation, and the studios, cottages, and apartment houses of Hollywood. Even before Florence moved to Hollywood, she and Max were often apart, with Max spending much time on the road giving speeches, attending meetings, and fund-raising for his magazines, while Florence toured with theater companies. The letters they sent each other were often somber and even desperate, haunted by political events as well as the shadowy presence of other potential lovers. Florence's erotic energies were more than a match for Max's, as became painfully clear to him when she added the brilliant photographer Margrethe Mather (1886–1952) to her portfolio, another friend of Max's to whom he had introduced Florence. At least for a while, Mather lived in Florence's Hollywood apartment at 6220 De Longpre Avenue, taking endless photographs of her, and promptly succeeded in making Max nervous: "Don't love Margaret too much, for I have no other home but where you are," he warned his lover on December 21, 1919.

As a poet, Max was, of course, able to conjure his shifting emotions with precision and in great literary detail. In other words, he knew how to play the poet (fig. i.1). In her part of the correspondence, Florence continued to struggle with syntax and logic. But she wrote with great authenticity about the emotions that she wanted to express. At their best, Florence and Max's letters are luminous, shaped by the frank delight the correspondents take in their complicated lives and by the unembarrassed physical pleasure they derive from being with each other. Both Florence and Max were obsessed, too, with speed and technology, celebrating their rides in the cars they bought and occasionally smashed. Time and again, their Fords, Chevys, and Buicks show up in their letters or the telegrams they sent when regular mail seemed too slow. Florence especially seems to have been a fearless driver; in an unsent letter written after one of their several semibreakups, Max finds himself walking wistfully past the spot in Croton "where you tipped over the automobile" (March 3, 1920). Although younger than Max by more than decade, Florence proved remarkably resistant to her lover's attempts to treat her as little more than a reflection of his own desires. During their relationship, Max was still technically married to the brilliant Ida Rauh, whom he had unceremoniously abandoned when he met Florence. (The divorce would not be formalized before 1922.) When Florence left him behind, even if only temporarily, Max, despite the subject of the book he was writing at the time (*The Sense of Humor*), remained spectacularly unable to view what had happened to him with a degree of irony.

For months at a time, theirs became an exclusively epistolary relationship and one in which Max, the master of the literary allusion, well-placed image, and well-turned phrase, should have had a natural advantage. That this was not so is one of the remarkable features of their correspondence. While Max wallows in his feelings of abandonment and deprivation, reporting how he fell asleep clutching one of Florence's precious letters or how he would open the closet in his house to sniff Florence's lingering scent in the clothes she had left behind, Florence, writing off the cuff, with a gift for original phrases and observations, typically talks more about her new environment, the people she meets, and her glorious plans for the future. And while Max prefers to write his letters in green ink, Florence persists in using a pencil ("I cannot write in pen, it is so slow"),[23] ignoring Max's pleas to avail herself of sturdier writing implements (and, for that matter, to put periods at the ends of her sentences). Ironically, as their correspondence picks up speed, Max finds himself increasingly relying on pencils, too. Florence and Max's letters are, in a sense, drafts, notes toward a supreme

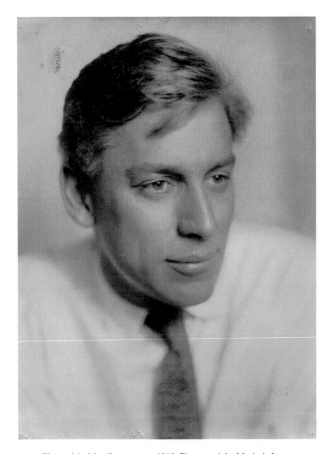

Figure i.1. Max Eastman, ca. 1918. Photograph by Marjorie Jones.
Eastman mss. IV. Courtesy, Lilly Library.

fiction—complete, utter happiness—that had never been attainable to
either of them anyway.

———

Florence and Max's love affair took place during the First World War and
thereafter, against a background of violent reactions to the progressivism
of the previous twenty years. One of the best summations of the hysteria
of the war period is by Max himself in the second volume of his autobiog-
raphy, *Love and Revolution*. It should be remembered that he wrote this in the
early 1960s, long after he had renounced Marxism:

In spite of a ruling by the Attorney General that "the constitutional right of free speech, free assembly, and petition exist in wartime as in peacetime," nearly two thousand men and women were jailed for their opinions during the First World War, their sentences running as high as thirty years. The Espionage Act, signed by Wilson one month after our entrance into the war, although it contained no press censorship clause, was ostensibly designed to protect the nation against foreign agents, established three new crimes which made it dangerous to criticize the war policy and impossible to voice the faintest objections to conscription. A subsequent amendment known as the Sedition Act defined as seditious, and made punishable, all disloyal language and attacks on the government, the army, the navy, or the cause of the United States in the war. Under this act it became a crime to write a "disloyal" letter, or an antiwar article which might reach a training camp, or express antiwar sentiments to an audience which included men of draft age, or where the expression might be heard by shipbuilders or munition makers.[24]

The Espionage and Sedition Acts exacerbated an atmosphere of general political paranoia, and as Max goes on to explain, they changed lives, including his own. Whatever freedom of speech had existed previously suddenly evaporated. And the authorities, the press, and prominent citizens succeeded in deputizing large sections of the population: "The country," wrote Max, "was advised to mob, whip, shoot and kill all dissenters." Decades later, Max's indignation is still palpable as he embarks on a litany of names of those affected, which also included his friend Fred Boyd, who "was beaten up in Rector's restaurant in New York City for not standing up when the national anthem was played."[25]

One might expect some jingoism gone wild in time of war. But this frenzy did not stop after Armistice Day. In some ways, it became worse. "Everywhere in America is depressing," wrote Florence to Max on February 19, 1920. "The frightful ambition to be 100% American is every-where." She wondered if Sigmund Freud would have anything to say about such persistence.

This was also a period marked by intense, often violent labor strikes. During the war, the IWW (Industrial Workers of the World, or "Wobblies"), to which Max's friend Fred Boyd belonged, and other leftist groups were accused of trying to interfere with Allied production in time of war, and hence, at least in the eyes of some, strikes became tantamount

to treason. When the labor unrest was coupled with the socialists' dislike of the war, all leftists came under blanket suspicion.

In 1917, Max's sister Crystal helped found the Civil Liberties Bureau (CLB) to support those who were prosecuted because of their antiwar views. In 1920, now under the sole leadership of Roger Baldwin, the CLB reemerged as the American Civil Liberties Union (ACLU), with a new focus on political activism. A pamphlet put out by the ACLU the year it was founded collects salient statements made by political and civic leaders and newspapers, which highlight the general atmosphere of political paranoia. "As for the Bolshevists," Senator George Chamberlain of Oregon opined, in a comment that may be considered representative of others, "we have a way of dealing with them out West. We string them up and some of them we put aboard a train and send them on their way to Europe." In a public address, Albert P. Langtry, the secretary of state for Massachusetts, chimed in: "If I had my way, I would take them out in the yard every morning and shoot them, and the next day would have a trial to see whether they were guilty."[26]

At least partially responsible for the mood of national gloom and repentance was a major depression in the last half of 1919 as well as 1920, which caught both business and agriculture by surprise. Remarkably, no recession took place immediately after the war had ended, although most experts predicted one; instead, there was a boom and unlimited speculation. This lasted until the surpluses that had been produced by the inflationary war economy were used up, after which the bottom fell out of the market. For this reason, most industries laid off thousands of workers, and the farmers were hurt as badly as they were to be in 1929. This was just about the time that many soldiers returned from the war, only to find out that there was no work to be had. In some cases, their jobs were now being done by African Americans, who had been hired during the wartime labor shortage.[27]

Predictably, racial violence ran to an all-time high, with long simmering tensions exacerbated by the economic downturn. The Klan surged. In 1919, the lynchings were so bad that the period became known as the "Red Summer" (and the term, coined by the writer and NAACP field secretary James Weldon Johnson, was not a reference to politics). When all was over, thirty-eight separate riots had taken place in the United States, in cities that included Charleston, South Carolina; Washington, DC; Knoxville, Tennessee; Longview, Texas; Phillips County, Arkansas; Omaha, Nebraska; and, last but not least, Chicago, Illinois, which greatly worried Florence in July 1919.[28] Seven years earlier, when he heard

about the lynching of a black man in Coatesville, Pennsylvania, the great American essayist John Jay Chapman traveled to the site of the crime, rented a hall, and delivered a speech in front of the only two townspeople who dared to attend. In Coatesville he had looked, he said, into the heart of the United States, "a cold thing, an awful thing."[29] That heart had, it seemed, become even colder now, even more awful.

The 1919 inflation also had an impact on the moving picture industry, in complex ways. In 1914, slightly more than half of the films exhibited in the world were made in the United States; by 1919, 90 percent of the films shown in Europe and all the ones shown in South America came from the United States. For many, Hollywood had become a metaphor for opportunity; Florence was no exception. Her letters from July 1919, written from the train to Los Angeles and after her arrival in Samuel Goldwyn's studio in Culver City, are full of delighted anticipation. However, the industry's very success became the cause of a massive transformation, which would, in due course, affect Florence negatively. Her dreams of stardom crashed when, in February 1920, after little more than a half year, Goldwyn broke his contract with her. Making and selling films had become a big business as large corporations, financed by the big banks, took over and sought to control and homogenize what had formerly been a scattered, decentralized market of multiple producers, distributors, and exhibitors. As Florence observed: "It really costs a lot more to make pictures out here" (to Max, August 6, 1919). By 1921, Adolph Zukor's Paramount not only made the films but also distributed them and collected the admission fees at their own chain of theaters. By 1930, 95 percent of the revenue in the industry went to only eight companies.[30]

The new system created by the well-known megastudios, such as Paramount, MGM, and Warner Brothers, dramatically altered the way movies were being made. The demand for stars—and the likes of Douglas Fairbanks, Charles Chaplin, Norma Talmadge, and Mary Pickford indeed began to rake in salaries ranging into the millions—gave more power to industry executives, putting additional pressure on producers, distributors, and theater owners to cut costs elsewhere. As Lewis Jacobs phrased it, directors, actors, and other movie workers became "mere pawns in production."[31] Films were increasingly completed on an assembly-line basis rather than serving as the carefully crafted expression of an individual director's distinctive vision. By the mid-1920s, the reign of directors like Maurice

Love and Loss in Hollywood

Tourneur, with whom Florence still worked in 1920, was essentially over. The new economic strictures encouraged a cold-blooded approach to filmmaking and much less pretense at creating art. Florence had seen the writing on the wall: "All this talk about a new art being born is untrue," she wrote to Max on January 7, 1920. "It's simply a new business." As she would find out herself, studios were brutal when it came to cutting personnel. For some at least, Hollywood had become, as Florence put it, an "unpleasant place."[32]

If there was one good thing to emerge from the ferment of the period, it might be the ratification of the Nineteenth Amendment on August 18, 1920, which gave women the right to vote, a cause dear to Max's and Florence's hearts. But even this victory was double-edged, because at the time, the women's vote, strongly Christian and pro-temperance, also helped the Eighteenth Amendment, Prohibition, become law. And among the many other problems inherent in Prohibition was the fact that, due to some very astute campaigning by the antialcohol forces, in particular the Anti-Saloon League, the Germans were accused of running the "liquor interests" as part of their alleged campaign to weaken and destroy the United States. The apparently mandatory in-depth investigation run on this subject by the Senate in 1919 was entitled "Brewing and Liquor Interests and German and Bolshevik Propaganda." This kind of heavy-handed, sanctimonious moralizing was typical of the period; enforced morality disguised as legislation for the public good was the inevitable downside of well-intentioned reform efforts.[33]

Along with Prohibition came an increased emphasis on censorship. The League for the Suppression of Vice forced Theodore Dreiser's novel *The Genius* (1915) off the market for alleged obscenity and used the Comstock Act to crack down on any dissemination of information about birth control. Among those arrested was Max Eastman's wife, Ida Rauh, who had publicly distributed birth control pamphlets in Union Square right under the noses of fifty policemen.[34]

The same sanctimonious reaction took place in Hollywood. There is no doubt that some of the excesses of prominent members of the industry during these years helped fuel it. But the cure became worse than the disease, as proven by a series of scandals that rocked Hollywood. Mary Pickford (1892–1979), keen on divorcing her first actor-husband, Owen Moore, got the ball rolling. She traveled to Nevada, where her lawyer

found a loophole in the six-month residency normally mandated for divorces. All that was required of her was to swear that she was a citizen of that state and had resided there for six months. The attorney general of Nevada checked the records, which suggested that she had not lived in Nevada at all, and decided that there had been fraud, collusion, and untruthful testimony in obtaining the divorce. In 1922, the Supreme Court of Nevada eventually sustained her divorce, but the publicity did Pickford no good; nor, arguably, did the news that she had gotten married to fellow star Douglas Fairbanks within three weeks after her Nevada divorce.[35]

A more serious scandal involved the film comedian Roscoe "Fatty" Arbuckle (1887–1933). Although Arbuckle was tried twice for the rape and murder of the actress Virginia Rappe, neither jury found him guilty of wrongdoing. A third trial ended in acquittal, and Arbuckle received a formal apology. Nevertheless, his films were boycotted and his career had effectively ended.[36] It was in this environment of perceived moral decline that Adolph Zukor of Paramount and Marcus Loew of MGM decided to create the Motion Picture Producers and Distributors Association (MPPDA), an office intended to serve as a kind of "buffer between industry and the public" and to help studios navigate through the hundreds of decency laws emerging all across the nation.[37] Self-regulation seemed preferable to government censorship. All the major studios joined. The organization's head, Will H. Hays, a lawyer who had served as postmaster general under President Harding, presided over the implementation of ethical standards that, in 1924, led to a preliminary list of subjects not suitable for motion pictures (including passionate love scenes and the ridiculing of public officials), as well as a longer list of those to be used only with caution. The MPPDA, through the careful vetting of scripts for potential problems and by preventing producers from allowing scenes unacceptable to censorship boards in the United States and elsewhere, saved its member studios untold amounts of money. Thanks to Hays, government interference finally ended; he had convinced everyone that the industry could clean up their own potential messes.[38]

This fever-pitch atmosphere, in which mere allegations could render one liable to harassment and prosecution, also lent a new emphasis to the more interesting kinds of films that were being made. Among the primary targets of Charlie Chaplin's *The Kid* (which was being made while Florence was still with Charlie) are the official authorities, as personified by the doctor and the official of the county orphanage who seize the Kid and take him away from the Tramp "for his own good." Granted that Charlie

Love and Loss in Hollywood

knew about orphanages from personal experience and that the Tramp had his own frequent problems with various authorities and with the police in particular, there is a mood of "us versus them" in the film that seems new and fosters Charlie's emergence as a producer of art with claims to moral relevance.[39] Similarly, the modern story line in D. W. Griffith's 1916 film *Intolerance* was aimed not only at capitalism in its most brutal manifestation but also at the smug representatives of social reform, "the Vestal Virgins of Uplift." There were other scandals, too, involving major producers, which, as we will see, may have touched upon Florence while she worked for Goldwyn Studios.

<center>———</center>

One can hardly imagine a more somber background for Florence and Max's relationship. But these weren't very good years for Charlie Chaplin either. His rise from humble circumstances in London's East End to near-cult status in the United States had become the stuff of legend. In Max's witty summary: "In the History of Great Fame—when that book is written—no chapter will be more astounding than that in which this little modest actor . . . became in three short years known and loved by more men, and more classes and races of men, than anyone."[40] By 1917, Chaplin had arrived at an excellent position to enjoy the fruits of his labor. He had finished his contract with Mutual and Essanay Studios and was beginning work on a series of films for First National, for each of which he was to receive $125,000, the equivalent of $2.5 million in today's money.[41] The new arrangement should have been perfect for him. As it turned out, however, his contract with First National was far from a marriage made in heaven. He was very successful with *A Dog's Life* (April 14, 1918) and *Shoulder Arms* (October 20, 1918). But when he approached J. D. Williams, the company president, about the opportunity to make feature-length films, Williams would not even discuss that prospect. Charlie then hurriedly produced two of the worst films he ever made. The first, *Sunnyside*, released on June 15, 1919, got terrible reviews. The second was *A Day's Pleasure*, released on December 15, 1919, a "makeshift" movie that is at times mean-spirited and, in its portrayal of black trombonists, even racist. *A Day's Pleasure*, opined *Photoplay*, was "certainly not a pleasure."[42]

Another part of the problem was Charlie's messy personal life. Early in 1918, he met Mildred Harris, a sixteen-year old ingenue who was trying to break into movies. Charlie started an affair with her. Mildred was reputed

to be not very bright, but she was certainly smart enough to realize that she had Charlie in a hopeless position. She quickly became demanding, claiming that she was pregnant with his child. Since she was underage, Charlie was not only threatened with scandal but also with a jail cell. Finally, choosing what seemed the least problematic of several bad options, Charlie married her, shortly after shooting ended on *Shoulder Arms*. The wedding took place on October 23, 1918. Mildred's purported pregnancy turned out to be a false alarm, and Charlie felt he had been trapped. He loathed Mildred, and their marriage turned hellish. Unfazed, she became pregnant again and gave birth to a malformed son, Norman Spencer Chaplin, who died three days later, on July 10, 1919. Charlie genuinely mourned the loss of his child, and some commentators believe the inspiration for *The Kid* came from this traumatic experience. Yet Charlie's grief was insufficient to save his marriage, which ended on November 19, 1920.

Arguably, this wasn't the best time for Charlie to be surrounding himself with well-known radicals. In February 1919, he accompanied his friend, the writer and inveterate espouser of leftist causes, Rob Wagner, to the lecture Max was giving, as part of his "Hands Off Russia" tour, at Trinity Auditorium—likely the very same event that caused director Cecil B. DeMille ("a screaming patriot") to show Max the cold shoulder when they met.[43] By the end of the year, various periodicals including *Variety* and *Photoplay* accused Charlie of being a "parlor bolshevist" and presented his friendship with Max as proof. *Variety* went so far as to suggest that Chaplin helped finance *The Liberator*.[44] Charlie, who realized that the Tramp figure he had created, "a pauper condemned to perpetual poverty," was not an unpolitical thing, always insisted that he himself wasn't a socialist[45]—a credible claim considering his shrewd management of his finances; the fact that in 1918, along with Fairbanks, Pickford, and other stars, he had hawked Liberty Bonds and purchased some himself; and the two movies produced in support of a war for which he had himself avoided getting drafted (*The Bond* and *Shoulder Arms*).[46] But the charge of "parlor bolshevism" stuck and, years later, would win Charlie a spot on the list of communist sympathizers compiled by J. Edgar Hoover's Federal Bureau of Investigation.[47]

Whatever the details concerning Charlie's politics, *Photoplay* and *Variety* had correctly established one essential fact—that Max and Charlie had enjoyed an instant bond. After their meeting, Charlie inscribed one of his portraits to Max (fig i.2).[48] A few months after their first meeting, Charlie asked the photographer Marjorie Jones, who had taken a portrait of Max emphasizing his film star looks, dreamy eyes, and sensual lips, if she would

Love and Loss in Hollywood

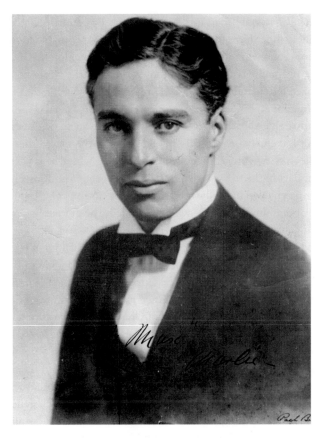

Figure i.2. Pach Brothers Photography Studio. Publicity photograph of Charlie Chaplin, inscribed by Charlie Chaplin to Max Eastman, 1919. Max Eastman Papers. Courtesy, Billy Rose Theatre Division, New York Public Library.

send a copy to him. "He . . . thinks it is beautiful," reported Florence to Max. "He thinks it is such a good picture of you" (September 9, 1919, referring to fig. i.1).

Max and Charlie's friendship flourished when Max returned to Hollywood in September, to spend time with Florence and work on *The Sense of Humor*. Meeting almost nightly at Chaplin's house, Max, Charlie, and Florence would play an extremely complex set of games and charades to the point where these entertainments were taking almost all of Charlie's and Max's creative energy.

Max was not sparing with information about his life, as attested by the two massive volumes of his autobiography, *The Enjoyment of Living* and

Love and Revolution, published in 1948 and 1964. By contrast, Charlie never shared much about himself. *My Autobiography* (1964) is notable more for what it hides than what it reveals. He never mentions Florence. Carlyle Robinson, his publicity director, estimated that Charlie wrote no more than a dozen letters in his life;[49] it is therefore not surprising that there were no notes by him among Florence's papers other than an envelope with this signature that she saved from the days Charlie spent (with or without her) in Salt Lake City (see fig. 3.14 in chap. 3). But there are other reasons for Charlie's relative invisibility even in this book, where he is such an important part of the story: it demonstrates as perhaps nothing else could the power he enjoyed in Hollywood at that time to control the stories that were told about him. If Charlie wanted publicity, he got publicity. But when he wanted privacy, he got that, too.

During his affair with Florence, Charlie presumably did at least some of the things lovers would have done then, such as taking her to the races at Tijuana, dining at various restaurants, and so forth, but with the exception of one brief comment by Grace Kingsley, the movie critic for the *Los Angeles Times* and a confidante of Charlie's, there was preciously little linking Charlie and Florence in any newspaper. Kingsley also wrote several other press items about Florence in the *Times*, most of them highly complimentary, and it is not impossible that Charlie planted them. (As we have seen, Max later believed that she owed some of her career to his influence.)[50] Charlie could be generous, especially when such generosity did not cost him anything. At a time when Charlie was photographed with virtually anyone who showed up on his lot, from Australian soldiers passing through to completely anonymous touring groups to countless unidentified families, there is not a single shot of Florence at his side. There is no mention of her in any of Charlie's writings, although he is usually not shy about listing the other women in his life. The only physical evidence connecting Charlie and Florence, aside from the letters reproduced in this book, is that tattered envelope from the Hotel Utah and a snapshot presumably taken by Florence on the set of *The Kid*, which was also found among her meager papers at the New York Public Library (fig. 3.3). Were it not for Florence and Max's letters (and Max's later comments in his autobiography) and a handful of notices in the papers, there are few indications that Florence and Charlie even inhabited the same universe.

While Charlie might have never mentioned Florence, this book confirms that, at least for some time, both Max's and Charlie's lives revolved around her. Charlie did acknowledge that the playing of charades

Love and Loss in Hollywood

at his house—which we know involved Florence, too—remained one of the most enjoyable experiences of his life; it may have inspired, as Max and others have suggested, the inspiration for the charades scene in *The Pilgrim* (1923), in which Charlie, pretending to be a preacher, pantomimes a sermon about the story of David and Goliath.[51] In any case, the three of them seemed to have developed a Jules and Jim relationship that was, while it lasted, very close.

———

Florence was born as Florence Danks on July 19, 1893, in Tacoma, Washington. Her father, Samuel Danks, is reported to have been Welsh. Her mother, whose name has been given as Florence or Flora or Caroline Spitzer or Spatzer or Spätzer, was Austrian, reputed by various sources to have been either a concert singer, pianist, or an actress. Caroline, as Florence preferred to call her, died on May 9, 1944. Her great-nephew, Philip Danks, has a copy of her death certificate, which lists her name as "Florence Danks" and was signed by her sister, Pauline Boehm.[52] In it, Caroline's father is given as Morris Spitzer (from Austria) and her mother as Regina Stein (also from Austria). Florence was Jewish, a fact she did not advertise.

According to Max, Florence's mother was an overgrown child.[53] Her father, Samuel, a musician, was a cold, unforgiving man, who, in official records, pretended to be from Denmark, ostensibly because back in England he was already married. "Obfuscation seems to have come easily to Samuel," writes Philip Danks, as it did to "many who came to America to make a new life and at the same time to eradicate all traces of the old one."[54] The Danks/Spitzer clan left Washington State for the East Coast when Florence was about ten. Surviving records place them in New Jersey at first, at 17 Baldwin Place in Bloomfield, part of the New York metropolitan area. By 1915, the little makeshift family had fallen apart; census records show Florence's brother Walter and his wife, Olive, continuing to live with Samuel at 31 West 64th Street, while Caroline and her daughter, who had to quit high school, were trying to get by on their own.[55] In Max's unsympathetic summary, "[Samuel] had calmly packed his bag and moved out one day, leaving his beautiful daughter and ineffectual child of a wife to get along in a dingy flat on the poor side of Second Avenue without his company."[56] Samuel earned his living as a music arranger for Leo Feist at 231–235 West 40th Street, while Caroline, who began to refer to herself

as Samuel's "widow," seems to have tried her luck as a music teacher. According to the 1917 New York City directory, mother and daughter were now living at 111 East 34th Street.[57]

Although they may have done little else for Florence, her parents had passed on their artistic ambitions to her. She obtained a tryout with Oscar Hammerstein, which amused Hammerstein but went nowhere. Nevertheless, she soon managed to get a job in a chorus.[58] The name "Deshon" was her own invention, with the accent placed on the last syllable, in the hope it would thus acquire a vaguely Frenchified ring. "At least," wrote Max, "it sounded better than her patronymic, Danks."[59]

From the outset, Florence seems to have been driven by an extremely powerful urge to be a success as an actress. And she knew she had to impress the men she needed to get to that goal. The writer Theodore Dreiser (1871–1945), smitten with her as he was with so many other girls, captured the impression a teenage Florence would have made on men. His portrait, titled "Ernestine," is semifictitious, but it has an immediacy that captures Florence's charismatic appeal:

> The first time I saw Ernestine she was coming down the steps of the Sixth Avenue Elevated Station, at Eighth Street. She was very young, not more than eighteen or nineteen, and sensuously, and so disturbingly, beautiful and magnetic. With her was an aspiring theatrical manager that I knew,—the type that begins with a "little theater." He was showing her the Village, I presume, and his air was that of the impresario. Hers was that of a very young, and not very sophisticated person who condescends to take notice of a domain offered for her inspection. There was a moment's pause while he introduced us, and then they were off. And yet, brief as was the contact, I could not but know that she was exceptional. The litheness and vigor of movement, which half denied a languorousness of temperament, which yet smote one! The health, and gayety, and poetry, and love of beauty![60]

Certainly not all the details in Dreiser's portrait are accurate (for example, the sappy plot of one of Ernestine's films as recounted by Dreiser is quite unlike any of the productions in which Florence would later take part). Yet his description of the almost magical power Ernestine/Florence exerted over the minds (and bodies) of her fellow Villagers rings true.

> She was at this time interpreting something on the legitimate stage, and her true habitat was the white light region between 42nd and

59th Streets. But her flutterings over the surface of the Greenwich Village art sector of New York evoked not a little admiration and enthusiasm. The young artists and playwrights of the Village were, after a fashion, agog. She was quite wonderful, or so they said. One ought to see her. Even the women of the Village admitted, if a little grudgingly, that she had looks and a decided appeal, for men anyhow.[61]

When their paths crossed later in Hollywood, Dreiser told Florence that she was "seeking the moon—and with no small claim."[62] But Florence's quest for the moon had already begun in the Village. From the moment he met her, Max was impressed by her determination, marketing savvy, and ambition: "All I had to do if I wanted a picture of Florence was run through the advertising pages of the magazines. From photographer's model to chorus girl was a short step, and from there to acting a bit part on the stage or in the movies was another—and so on as high as one could go."[63]

Florence certainly enjoyed presenting herself as the epitome of urban sophistication, a representative of everything that was glamorous about New York (fig. i.3). Aside from her many other activities, Florence also seems to have cultivated close relationships with the New York art world, as a model or as a connoisseur of art. In 1916, a bust of her sculptured by Frank Lynn Jenkins, a fairly well known American Renaissance sculptor, was featured in the Reinhardt Galleries in New York in an exhibition of Jenkins's work.[64] In 1918 *Photoplay* accompanied Florence, "unsmocked, unbobbed, and unsandalled," on a leisurely stroll through Greenwich Village, which included visits with the sculptors Jo Davidson and Arthur E. Lorenzani and a photo op in front of the studio of Gertrude Vanderbilt Whitney (who would later found the Whitney Museum of American Art). Her favorite writers, she said, were George Bernard Shaw and H. G. Wells, and she added that she definitely preferred the city to the country. For example, when, having recently ventured into the countryside around New York, she first heard the sound of crickets, Florence said she screamed with terror, a shock from which she only recovered when, upon her return, "the sweet roar of the 'L' touched my ears."[65] Elsewhere Florence mentions modeling for the graphic artists James Montgomery Flagg and Charles Dana Gibson.[66] And she comments that she posed for the photographers Arnold Genthe and Adolph de Meyer (see the "Interlude" section in this edition).[67]

Florence acted in several plays, but her parts were small. In 1913, she was featured in *The Girl and the Pennant: A Base-Ball Comedy in Three Acts,*

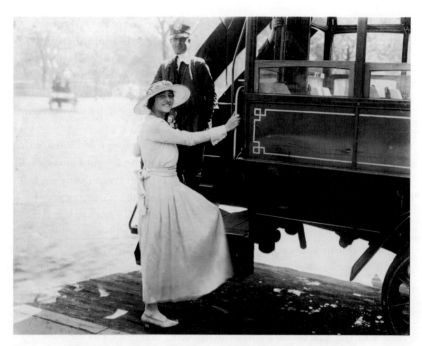

Figure i.3. Florence Deshon boarding a New York City streetcar. From "Greenwich Village as It Ain't," *Photoplay* 15, no. 1 (December 1918).

which is mostly interesting today because it was supposedly cowritten by the great Major League Baseball player Christy Mathewson. Florence was cast as the maid; her lines included such gems as "Yes, sir" and "The gentleman is in the library, sir." The production appeared to be doomed from the start: after only twenty shows, the play ended in early November 1913.[68] In the same year, Florence appeared in the Broadway run of the originally English musical *The Sunshine Girl*, starring Vernon and Irene Castle. She was also in the American version (apparently in a bit part) of Edward Knoblock's play *My Lady's Dress*, starring Mary Boland, which opened at the Playhouse Theater on October 10, 1914.[69] And in March 1915, she surfaced in Chicago, where she was cast in two plays at the same time; she had a part in the second act of William A. Brady's melodrama *Life*, showing at the Auditorium, as well as in the last act of Frank Craven's *Too Many Cooks* at the Princess Theater.[70] When Florence had finished her part in *Life*, she would head over to act in Craven's play.

The stage role for which Florence got the most publicity was as Florence Jones in the David Belasco play, *Seven Chances*, written by Roi Cooper

Love and Loss in Hollywood

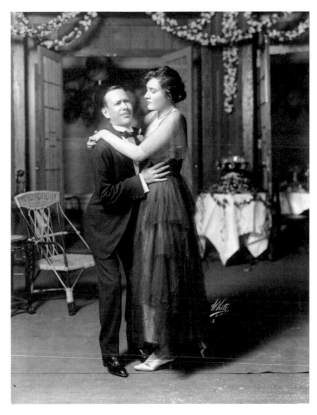

Figure i.4. White Studio (photographer), Frank Craven and
Florence Deshon in *Seven Chances*, 1916. Key sheet, scene 8. Courtesy,
Billy Rose Theatre Division, New York Public Library.

Megrue, which opened on August 8, 1916 (fig. i.4). The play centers on
Jimmy Shannon, a young man (played by Frank Craven) who has abso-
lutely no interest in marriage but learns that his grandfather has suddenly
died and has willed Jimmy his entire estate if he weds before midnight.
That was not a winning plot—Heywood Hale Broun rightly panned the
play in the *New York Tribune*—but *Seven Chances* did well. It is perhaps best
known to modern audiences through Buster Keaton's film adaptation,
released in 1925, featuring a famous and magnificent chase scene in which
Buster is chased down a mountain pursued by a bevy of vengeful rejected
brides and several hundred enormous boulders.

Florence's role was minor, and it may demonstrate one of the problems
that haunted her throughout her career. No waiflike ingenue, she had a

good height and a strong body (five feet seven, with a self-declared weight of 142 pounds) at a time when the more popular actresses tended to be shorter and lighter (Mary Pickford measured all of five feet and weighed less than 100 pounds).[71] Her casting in *Seven Chances*—she played a character named Florence!—may have been the result of her physique. In her one major scene in act two, Jimmie Shannon, having already been rejected by several young ladies, is trying to find out if Florence will marry him. But she wants a "big man" to take care of her:

JIMMIE (Comes over to FLORENCE) Now, I suppose you read about me in the papers this morning, Florence.

FLORENCE Oh, is that what you wanted to talk to me about?

JIMMIE You see, I'll have twelve million dollars.

FLORENCE It's no use, Jimmie. (*JIMMIE sits beside her—she rises and gets to* C.) I know what you're going to say.

JIMMIE You do? I wish I did!

FLORENCE You want me to marry you.

JIMMIE And you will?

FLORENCE No, Jimmie. I want a man who can compel me—a big man—a man of strength—a man who will take me up in his arms and carry me to some far-off cave—(*Pause.*) You couldn't do that.

JIMMIE (*Looking her over*) No, I guess you're right.

FLORENCE You wouldn't even try.

JIMMIE Not unless I went into training.

FLORENCE (*Stamps her foot and goes* R.) You joke about it.

JIMMIE It's no joke to think about carrying you to some far-off cave. (FLORENCE *starts.*) Well, if you must be going, then you must be going. Good-bye, Florence.

FLORENCE Good-bye! (*Exits* R.C.)[72]

––––––

As she was launching her theatrical career, Florence was also starting to break into the movies, although her early roles were somewhat mysterious. Florence claimed she had made films for Kinemacolor and Pathé,[73] but there is no evidence she participated in a Kinemacolor production, and

while the Internet Movie Database gives her a credit for *The Beloved Vagabond* (Pathé Exchange, 1915), the AFI catalog *Feature Films, 1911–1920* does not.[74] According to *Motography*, she made a film before 1916, unfortunately not identified, for Famous Players.[75] It appears that she was given a role because of her close resemblance to a leading actress in the film when it was necessary to show that actress in some sort of flashback at a younger age. Whatever that film was, Florence was sufficiently good in it to be invited to accompany William Fox and his crew to Jamaica. According to contemporary clippings, she was slated to appear in Fox's *Daughter of the Gods*, starring the famous Australian swimmer Annette Kellerman, the first US film ever to cost $1 million to produce.[76] It seems that Florence's role in the film did not involve any acting; rather, she was one of the mermaids, "four score bathing girls, picked from the flower of New York's swimming beauties," who frolicked around Kellerman.[77] (In the movie's most infamous scene, Kellerman apparently was nude, except for her long hair.) Florence did have a proper role, the part of Blanche Walcott, in Fox's *The Ruling Passion*, shot in Jamaica on the same trip. And she did well enough in that film to be recommended for a leading role in *Jaffery*, the film dramatization of William Locke's novel, produced in 1916 by the Frohman Amusement Corporation and distributed by William Randolph Hearst's International Film Services.[78]

Florence's physique, if it was a problem for her in some roles, proved to be a godsend in *Jaffery*, her first major film breakthrough, in which she starred as Liosha. The twisted plot, in both the novel and the film, revolves around Jaffery, a foreign correspondent who has been covering the Balkan Wars in Albania. Liosha, a wild Albanian princess, was married to Jaffery's colleague there, who unfortunately dies of a fever, or as Jaffery says, has "pegged it" (fig. i.5). Liosha's tribal chieftain father and the rest of his family have also been killed (fig. i.6), so Jaffery sees no alternative but to bring Liosha back to England with him. She is wildly in love with him, but he is not aware of it for most of the film, since he has fallen hard for Doria, who happens to be engaged to Jaffery's school chum Adrian. Jaffery, doing the noble thing, suppresses his feelings for Doria. Several plot complications follow, but eventually Jaffery and Liosha do end up together (figs. i.7–i.10). Much of the humor and drama comes from the fiery Liosha's attempts to adapt to English ways, even as she is convinced that the English are crazy. Florence's was a very rich part, and although she was technically not the leading actress, her share in the film was a far more interesting one than that of Eleanor Woodruff playing the sappy Doria.

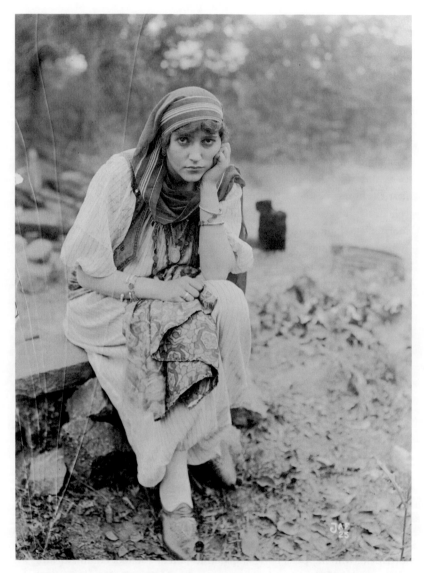

Figure i.5. Film still from *Jaffery* (1917): Liosha in Albanian costume. Max Eastman Papers. Courtesy, Billy Rose Theatre Division, New York Public Library.

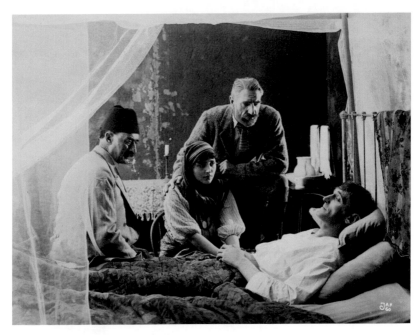

Figure i.6. Film still from *Jaffery* (1917): On Prescott's deathbed. Max Eastman Papers. Courtesy, Billy Rose Theatre Division, New York Public Library.

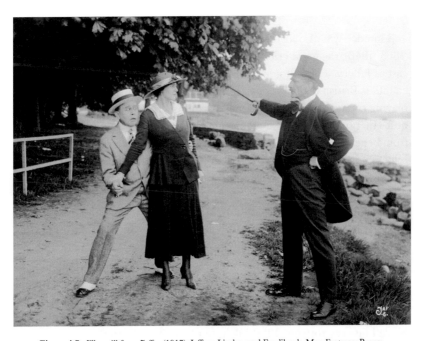

Figure i.7. Film still from *Jaffery* (1917): Jaffery, Liosha, and Fendihook. Max Eastman Papers. Courtesy, Billy Rose Theatre Division, New York Public Library.

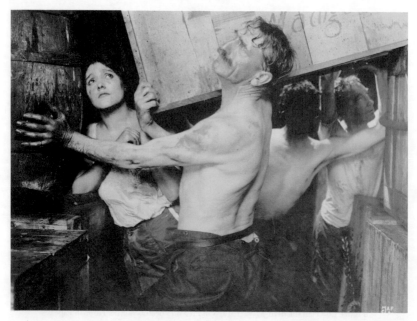

Figure i.8. Film still from *Jaffery* (1917): In the ship's hold. Max Eastman Papers. Courtesy, Billy Rose Theatre Division, New York Public Library.

Florence was also fortunate in costarring with C. Aubrey Smith (1863–1948), the great cricketer and already a stage leading man, who was cast as Jaffery. The epitome of the pukka senior officer, he was to be in countless British and American films over the next thirty years, generally playing correct British types. One look at his cliff-like chin, prominent nose emerging from a bushy moustache, and clear blue eyes peering out from beneath epic eyebrows (fig. i.10) would have convinced even the most reluctant in time of war that here was the absolutely perfect commanding officer. Smith, at six feet four inches, was certainly more than a match physically for Florence.

Jaffery got good reviews, as did Florence. For example, Julian Johnson in *Photoplay* heaped praise on her work: "Consider the slimly beautiful Liosha, when the man [Jaffery] is periled among shifting cargo in a ship's hold. Off goes her civilization along with most of her clothes, and in the murk her white shoulders cut and bruised by flying boxes, she stands once more the devoted barbarian, glorious and thrilling. . . . If I did tatting and fancy work, I would say that Florence Deshon is positively darling as Liosha. Since I tat very rottenly, I'll think it, but I won't say it. In the crooning of

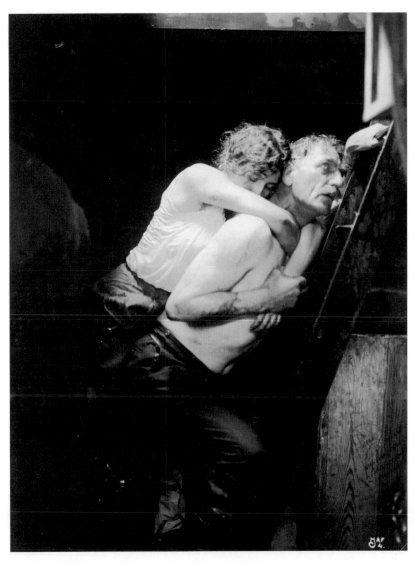

Figure i.9. Film still from *Jaffery* (1917): In the ship's hold. Max Eastman Papers. Billy Rose Theatre Division, New York Public Library.

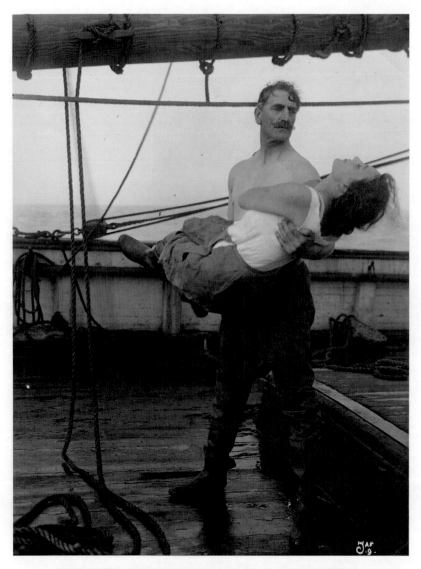

Figure i.10. Film still from *Jaffery* (1917): Jaffery on deck holding Liosha in his arms. Max Eastman Papers. Courtesy, Billy Rose Theatre Division, New York Public Library.

tin-pan alley, this Balkan lady is a dangerous girl."[79] Guy Price of the *Los Angeles Herald* positively glowed about both *Jaffery* and Florence's part in it:

> Among the most remarkable of the scenes are the meeting between Jaffery, Prescott and Liosha in the Balkan mountains; the discovery by Doria of her husband's theft of the manuscript for his great novel; the emotional efforts of Jaffery to control himself at the wedding of Doria to Adrian; the tempest-tossed freighter upon which Jaffery and Liosha took their hairbrained [*sic*] trip; the hold of the ship when the cargo broke loose and Liosha's astonishment at the amazing antics of the unscrupulous Fendihook. A cast of unusual excellence was selected for the film production of "Jaffery." Practically every member is a star.[80]

Granted, the *Los Angeles Evening Herald* was a Hearst newspaper and Hearst had just agreed to distribute the film, so there is some hype involved here. Nevertheless, *Jaffery* was obviously considered to have commercial potential.

While Florence received praise, George Irving, who directed the movie, did not. Jesse Lasky, who had been shopping around for a good director, wrote Cecil B. DeMille that he had watched *Jaffery* with the contracts for Irving already drawn up: "Imagine my disappointment . . . when I found that Irving was not a good director but was really a very poor one. Not alone was he not worth $350 or $400 but we couldn't employ him if he worked for nothing."[81]

The comments on her performance that Florence would have treasured most were those of her costar. C. Aubrey Smith sent her a note from his hotel in New York that is still in her papers at the New York Public Library, along with the stills he mentions. Referring apparently to discarded scenes, in which he felt Florence would have made an impression, he paid her the additional compliment of wishing that her role had been even larger. "Hearty congratulations on the 'hit' you made, and you did make a hit," he wrote to Florence, adding that he hoped "we may work together again."[82]

If *Jaffery* wasn't exactly life changing for Florence, it had given her a seat at the table of actors to be reckoned with. As Max, to whom she must have shown Smith's note, observed, *Jaffery*, "though regarded by the profession as a 'hit,' did not immediately bear fruit in other movie contracts." Florence continued to accept smaller roles in theatrical productions, still waiting for an offer from Fox, Vitagraph, or Samuel Goldwyn. However, as Max added, "it was a tranquil waiting. She had achieved one part of her

ambition—to be among her peers. The more spectacular and flashy part could take its time."[83]

It was during that waiting period, in December 1916, that Florence met Max. Their correspondence began in late January 1917 and quickly grew intense. "Sweetheart, must I be with you every second?" wailed Max on February 17. He could no longer be without her. And soon he wasn't. Within months, Florence and Max were living together in his little house in the communist enclave on Mount Airy Road in Croton.

But Florence was not one to slip easily into the role of the demure domestic partner. When Samuel Goldwyn offered her a contract, she left Croton and Max behind, moving first to Los Angeles and then to Hollywood proper. Max's pride had taken a hit. His letters to Florence, increasing in length as time passes, alternate between wails of loneliness and assertions that he was busy, too. At the same time, his hope that Florence's career might ascend to the next level and offer some financial relief to him is palpable. He needed her to make money, since his own income from occasional publications and editing *The Liberator* was marginal at best. The role of the "kept man" also had a distinct erotic fascination for him, as he admitted: "You were so sweet to telegraph me the money," he wrote to her on August 13, 1919. "I have such a strange—almost passionate—feeling sometimes when you give money to me."

At first, Florence's work did indeed receive a boost. In August, she was cast as the heroine's friend in Goldwyn's *The Cup of Fury*, directed by T. Hayes Hunter after a novel by the writer Rupert Hughes, who was overwhelmed when he met Deshon, "one of the most beautiful girls he had ever seen."[84] Florence's efforts culminated in the first major role of which she was genuinely proud—the part of Marion Allardyce in *The Loves of Letty* (1919), directed by Frank Lloyd and produced by Samuel Goldwyn.

Rendered vulnerable by her attempts to promote herself in Hollywood, Florence, the "most beautiful brunette of the screen," according to *Picture-Play*,[85] proved to be a welcome distraction for Charlie from his own problems. Although he was one of the most successful movie stars in the world, Charlie was a lonely and insecure man, driven by his own demons, scarred from a failed marriage and by the traumatic death of his infant son. It would be too simple to make him the chief culprit in the unraveling of Florence's life. What almost certainly pushed Florence's interest in him to the next level was the unwelcome news that Max had sought a cure for

his own loneliness in inviting the alluring Lisa Duncan out to his Croton residence for passionate nights in the moonlight. Charlie was there when Florence needed him. It was only after their child died in utero (whether as a result of an abortion, we will never know),[86] that Florence fled back to Croton to let Max nurse her back to health.

Charlie, who appears in Florence's letters as both a vain man-child and a needy satyr, has often been faulted for his lack of empathy. But he seems to have genuinely cared about Florence, even giving her and her Ford Model T a cameo part in *A Day's Pleasure*, where Florence appeared in the famous Los Angeles traffic jam, behind the wheel of her own Ford. Caught between two cars, she cried out to the traffic policeman (who was about to end up in a manhole): "Are you going to let them kill me?" She got no sympathy from the copper. As she recalled the scene: "Keep out of the way, can't you, was all he said."[87] Charlie later cut the entire sequence.

And Florence did keep out of the way. Goldwyn had terminated her contract in February 1920. But she couldn't stay with Max either. After her return to Hollywood, she survived by doing some stage acting, though her heart wasn't in it. She had always wanted to be an author—in June 1920, *Picture-Play* identified "writing" as her hobby, a welcome change from the less ambitious leisure pursuits of other stars, such as Fatty Arbuckle ("singing his own lyrics") and Charles Ray ("shooting craps").[88] It seemed only logical that she would try her hand at drafting scripts.[89] Odd roles for Paramount (*Deep Waters*, 1920) and Fox (*Twins of Suffering Creek*, 1920; *The Roof Tree*, 1921) did not lead to a new contract, and by the end of 1921 she was back in New York again, where she avoided having too much to do with Max.

Ultimately, the reasons for Florence's failed Hollywood career have nothing to do with a lack of talent, despite Max's subsequent attempts to create that impression. In the three films that survive—*The Loves of Letty*, Harry Beaumont's *Dollars and Sense* (Goldwyn, 1920), and Reginald Barker's war flick *Dangerous Days* (1920), where she only appears for a few minutes, leaning seductively against a fireplace—she doesn't have leading roles. It is clear, however, that she had charisma and physical appeal, and the positive reviews of her more substantial work, as in *Jaffery*, do indicate that she had definite star potential.

Bookish, analytical, and equipped with a penchant for sarcasm, Florence was likely too smart for her own good. Add to this her mood problems—an inclination toward melancholy and even despair, what Max called her "Black Panther"—and her shocking downfall seems more plausible.[90] Yet it would be too easy also to say she was personally not

well suited for the industry. Florence did recognize the exploitative, life-draining nature of the Hollywood system (castigated more publicly by her new friend Theodore Dreiser). Her letters show her becoming increasingly critical of Hollywood and, in words that uncannily anticipate the dark days of Harvey Weinstein, of the people newly in charge of it: "They do nothing but brag about their power and what they have done for girls, and what they could do for me. It is all terrible and it took me a long time to get it out of my system."[91] She found herself in an impossible situation: while she hated the "commercialism" of the industry, she also desperately wanted to have a career: "I must admit I am anxious to pick up a future myself."[92]

That future never happened. After her final return to New York, Florence was not able to regain her footing. The end came for her ingloriously, on February 4, 1922, after she was found in an apartment she had subleased from her friend Doris Stevens on West 11th Street. A neighbor had discovered her unresponsive, lying on her bed. The gas was turned on. Florence "made a suicide," Claude McKay, a mutual friend, observed. Dispatched by Crystal Eastman to console Max, amid "silly rumors flying across the Village," McKay discovered that there was nothing for him to do except to keep his mouth shut: "What else could I do before such a big trouble."[93] And although newspapers across the nation dutifully repeated the coroner's ruling that Florence's death was accidental, they also invariably reported that there had been a recent, loud quarrel between her and a visitor, insinuating that Max had been the one she had fought with and that he thus bore some responsibility for her death. Inevitably, Charlie's name came up, too, as did rumors that he had proposed to her or even that they had been engaged.[94]

It was the biggest scandal in the Village at the time, the radical writer Joseph Freeman recalled in his autobiography, published sixteen years later. He had worked with Max on *The Liberator*, and although they later had a massive falling out when Max denounced him as Stalin's tool, Freeman was still decent enough to describe what happened only as "the suicide of a beautiful actress, deserted by her lover, a leading bohemian radical." Nevertheless, everyone knew what he was talking about. No one was ever fully responsible for someone else's suicide, Freeman conceded. But he felt that Florence and Max's calamity had shown those Villagers that love was "more complicated than bohemia made it appear."[95]

As if Max didn't already know! In the days after Florence's death, with or without the permission of Florence's overwhelmed mother, he went to her apartment and retrieved his letters as well as other relevant papers, presumably to protect himself from scandal. Ironically, Max's self-serving

gesture is also the reason why Florence Deshon's voice is not lost today, why we have such a complete, unvarnished, almost shockingly honest transcript of the fears, emotions, and hopes of this extraordinarily gifted and extraordinarily complicated woman.

There is no record of what the third person in this story thought of Florence's dismal end. To Max, Charlie would only say, decades later, when pushed, "Florence was a noble girl,"[96] assigning to her a quality that he, having cut her out of his life, his autobiography, and also his art, knew he could not fairly claim for himself.

This edition assembles—except for a few minor notes and undated items—all the letters and telegrams in the Deshon manuscripts (Deshon mss.) at the Lilly Library, Indiana University Bloomington, faithfully transcribed from the originals. Underlining is represented as italics. Obvious spelling errors have been corrected when they are not unique features of the writer's style and have no significance for the context. Florence, for example, has a habit of fragmenting words, writing "to gether" instead of "together," "to day" instead of "today," and "my self" instead of "myself." While we have normalized such idiosyncrasies for the sake of greater readability, we have retained her erratic punctuation and her preference for beginning new sentences in lowercase or leaving space between sentences rather than using a period (a custom occasionally adopted by Max, too). We have also kept Max's preference for the fused "eachother." Florence's periods are frequently hard to distinguish from commas; in reading them as one or the other, we have again striven for readability. Editorial additions, insertions, or deletions are marked by brackets. Genuine misspellings are part of the flair of these documents; if we have retained them, they are usually followed by [*sic*]. Both Florence and Max liked to omit apostrophes in "won't" or "don't" or "haven't," and they weren't loyal fans of the genitive apostrophe either. Like their rendering of "believe" as "beleive" and the confusion of "it's" with "its," these errors or variants are due to haste rather than artistic intention; we have fixed such hiccups throughout in the belief that such modifications will make things easier for the reader. As Florence told Max on March 12, 1919, adding a signature errant comma in the middle of her sentence: "I know that too, should be spelled to."

We have left the misspellings in the telegrams intact, since these contribute to their authenticity. When it could be easily determined, we have also included the time when a telegram was filed. In some cases, when a file time and date was not available, we have noted when a telegram was received.

First in the 1940s and then again in the 1960s, Max reviewed his extensive correspondence with Florence as he was writing the two volumes of his autobiography. He left pencil notes on many of the envelopes; where these shed additional light on the contents of a letter, we have transcribed them.

The letters are arranged chronologically, according to the date they were written or mailed. When the correspondents left their letters undated, we have relied on postmarks instead. Of course, the reader needs to allow for time lags. While some letters arrived the next day (see Max to Florence, July 13, 1919), mail from California would take a while to reach New York. The average journey of a letter across the continent was five days. Regularly scheduled transcontinental mail service began on July 1, 1924, using pilots leaving from both the East and West Coasts; even then the trip took roughly thirty-three hours, though it had become faster, by nearly three days, than rail service.

1. "Words to Keep Us Warm" (1917)

The first year of Max and Florence's correspondence takes the reader from breathless little love notes to extensive, dramatically detailed narratives, especially from Max's pen. Facing outer and inner pressures—the war, financial problems, the fact that Max already had a family—the two lovers shored up their relationship as if it were a shield against a darkening world. Lecturing all around the country, at great risk to himself, Max emerged as one of the leaders of the opposition to American involvement in World War I. Meanwhile, Florence transitioned from minor parts in stage productions to playing better roles in films and winning critical acclaim for her work.

The correspondence begins with a formal notification from Max, written on January 26 on letterhead of the Detroit Athletic Club (perhaps a bit of posturing?), that "dear Florence Deshon" should be waiting for his phone call between 9 and 10 a.m. the next day: "This is a warning!" Their relationship progressed apace, as reflected in a flurry of frequently undated notes arranging dates, planning weekend rides to Max's cottage in Croton, or accompanying flowers sent from Max's apartment at 6 East 8th Street, near Washington Square, to Florence, who continued to live with her mother at 111 East 34th Street, in the Murray Hill neighborhood. As Max insists ("Tell me that you love me"), Florence withdraws ("I worry so").

Max to Florence, 111 East 34th Street, New York City, January 30, 1917

Florence—I want to come to dinner at your house tomorrow—May I? And may I come early? Would you be there by five? Send me a note to 6 East 8 St.

I'm still telling myself what I was going to do today—trying so hard to do it!

<div align="center">Max—</div>

Letter written in pencil on letterhead of The Masses. *Sent "Special Delivery."*

Florence to Max, 6 East 8th Street, New York City, January 31, 1917

I felt so lonely and unhappy. I am so sorry I couldn't be with you. but I hope nothing will interfere with our ride Friday.

Finish all your work, so you will be free.

<div align="center">Florence</div>

I would like to write more, but I am am [*sic*] pig headed too.

Hand-delivered envelope, addressed by Florence to Max.

At some point during those early weeks of their relationship, Florence, according to one undated note, received the key to Max's apartment ("if the outside door is double-locked keep on turning the key hard to the left. It will bring you all the way home").

From the beginning, nothing seems to have been easy between the two lovers. Florence and Max had each come to their relationship with plenty of baggage, Max with a family he had abandoned, Florence with an older lover, the writer John Fox Jr., with whom she had broken up but whose influence lingered.[1] Assertions of love and longing (Max: "There is no hour but the hour when you come back"; "I would give my soul to lie in your arms tonight") alternate with fits of worry and even panic (Florence: "You left me so coldly today"). The correspondence graduates from scattered notes to proper letters when Florence goes on tour with Roi Megrue's Seven Chances *and finds herself in Washington, DC. Max, missing her, throws caution to the wind and promises to join her, although, in a twist that presages later developments, he then finds reasons why he must stay.*

Florence to Max, 6 East 8th Street, New York City, February 11, 1917

WOULD YOU PLEASE BRING MY SKATES WITH YOU I FORGOT THEM I AM STAYING AT THE HOTEL RALEIGH LOVE

FLORENCE.

Western Union telegram, filed 7:04 p.m. The Raleigh Hotel was a historic office building on 12th Street NW and Pennsylvania Avenue in Washington, DC, which was converted into a hotel in 1893.

Florence to Max, 6 East 8th Street, February 12, 1917

This is my last sheet of paper, I have destroyed five others, trying to tell you how awful it is to be so many miles away from you.

Max darling I shall be so glad when I am back in New York with you. I hope the picture won't start right away so that we can have some uninterrupted time together.

We didn't have a matinee today, as it is it is not much of a holiday here.[2] I went to a picture lecture about Hawai [*sic*]. It looks lovely so warm so beautiful. I hope sometime we can go there.

You want me to say I love you? I do dearest I am thinking of you all the time, I want so much to be with you.

<div align="center">Florence</div>

Postmark. Letter written in pencil on Raleigh Hotel stationery.

Max to Florence, Raleigh Hotel, Washington, DC,
February 12, 1917

Florence—dear heart—I have been happy as the sunlight all day thinking of you. I hope you are going to write to me and say the words that keep me warm. I'm not coming tomorrow. I want to come later for you—and for the other purpose to which I seem consecrated I find I can do more here than there.

I will send your skates. And I will come to you soon.

Tell me that you want me.

Tell me what you do.

Postmark. Written in pencil. The note seems to have been included in the same envelope with the following letter.

Max to Florence, Raleigh Hotel, Washington, DC, February 12, 1917

Monday night—

Florence dear, it is almost incredible that I can be so lonely when I go to bed, and feel when I turn back the covers that you belong here with me. I am frightened. I am not going to write any more!

Postmarked February 13. Letter written in pencil.

Max to Florence, Raleigh Hotel, Washington, DC, February 13, 1917

Dearest, yes I wanted you to say you love me—and all the other things you said. I love you. I think and wonder and suffer and laugh. It is beautiful and terrible to love you. Last night I went to sleep by taking the first train this morning to Washington—I couldn't stand it. This morning I have your letter—I have your love—and I can. I have to. I have left *everything* to this week to be done. You can't imagine how much.

Darling, we will go to Hawai [*sic*]—(I can't spell it) We will go everywhere that the sun shines down warm and the people love to be lazy and smile.

Florence dear, send me all the letters next time and I'll choose the best one. But you don't have to write me letters. I'll do the writing if you'll do the talking! The least sentence, if you'll put the warm words in it—is a letter.

But I would love to have you tell me what you do, when you want to. I love to imagine you going around, you are so beautiful, so made to enrich the world where you go.

Postmarked February 13 (marked February 12 by archivist). Letter written in pencil.

Florence to Max, 6 East 8th Street, New York City, February 14, 1917

I go to the theatre in a state of patience, that is wonderful. it is all so uninteresting to me, I cannot wait until the end.

I am telling you what I do, but not what I think. I keep thinking all the time, so many hours have passed and soon I will be with you, close to you, kissing you and talking to you, and feeling happy.

Florence.

Do I tell you that I worry? That all the time I say to myself. It cannot be, you are so lovely that you cannot love me. I worry so.

I cannot write in pen, it is so slow. Max dearest when I awoke this morning it seemed as tho I had been away from you ages and ages, it was terrible to find it was only Tuesday.

I lay thinking of you, and I wanted to telephone you, oh so badly.

I went on to the White House and asked the officer if the peace party had been there, but he did not know.

There are women standing at the gates, with banners asking for their freedom.

It is so cold they stand on boards and straw mats.

I felt sorry for them, but I liked them.[3]

Later I went down to the ice, it is lovely. my skates are not here, but I ran around anyhow with Beverly a dear, little girl in the company.[4]

The lake looked so beautiful I thought how lovely it would be if you were here, we could skate as fast as fast [*sic*] as lightening [*sic*].

Postmark. Letter written in pencil on Raleigh Hotel stationery.

Max to Florence, Raleigh Hotel, Washington, DC, February 17, 1917

Dearest, how long since I saw you. I think I was awake and spinning out the hours all the way here on the train, and I've been as tired as I was busy all day. I've just come home to my bed and its quiet sweet thought of you.

There was no house on tenth street. But anyway I felt a little too *near* them—too near to all the presences that are not yours.[5] I want to go to *away*—a little—to hide myself with you in this wilderness. We can find a place that will be a little away for both of us.

Dear I will come back as soon as I can Sunday morning and telephone you. Be looking through the papers for a house.

My love, I am so tired, I would look once in those starry eyes, and kiss you once, and you would hold me while I sleep—

Postmark.

Max to Florence, Raleigh Hotel, Washington, DC, February 17, 1917

Sweetheart, must I be with you every second? I have hardly slept or eaten since I left you. And yet I am not worried any longer. I just want you. I want you.

Postmarked on verso on envelope. Sent "Special Delivery."

> *Florence's role in* Seven Chances *generated a fair amount of publicity, including a photo shoot with Jean de Strelecki (1882–1947), a Polish-born celebrity photographer who had worked with the Ballets Russes in Paris and had just arrived in the U.S. (fig. 1.1). Note how the indication of Florence's shadow at the right endows her with an aura of mystery. Strelecki's portrait appeared in an advertisement for* Seven Chances *in* The New York Tribune, *December 17, 1916, with the caption: "Florence Deshon as Florence Jones spurns Jimmie because he comes without the slightest impulses of a cave man—and she must have a cave man."*

Florence to Max, 6 East 8th Street, New York City, March 24, 1917

I have been thinking of you all evening. I feel full of you, and I don't feel like going out among people. You make me very happy.

I have been reading about you. I like Arturo Giovannitti so much. He loves you, doesn't he?[6]

The roses are lovely, your note is lovely. I feel rich with happiness.

Florence

Envelope inscribed "Max Eastman 6 East 8th Street," hand delivered.

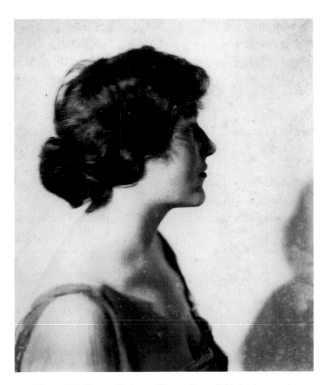

Figure 1.1. Florence Deshon as Florence Jones. Publicity photograph
for *Seven Chances* by Count Jean de Strelecki, December 1916.
Eastman mss. II. Courtesy, Lilly Library.

*On April 1, Max addressed a crowd in Detroit, insisting that one cannot
"destroy German militarism by making war on Germany."[7] Four days
later, responding to President Wilson's demand for a "war to end all wars,"
Congress voted to declare war.*

Florence to Max, Statler Hotel, Detroit, April 1, 1917

I WILL BE SO HAPPY TO SEE YOU TOMORROW NIGHT I MISS
YOU BEST WISHES FOR TONIGHT LOVE

F

Western Union telegram, filed 12:15 p.m. The luxurious Statler Hotel, the first in Detroit to sport private bathrooms, in-room telephones, and running water, was built in 1915. Located at 1539 Washington Boulevard in downtown Detroit, it overlooked Grand Circus Park.

Max to Florence, 111 East 34th Street, New York City, April 12, 1917

Sweetheart I will see you long before you get this, but I have to stop and tell you now how sweet it is to love you.

You are *so beautiful*, so beautiful and strong and kind and full of rebellion.

> I love you—
> Max
> *Yesterday at 2:30*

Postmark. Written in pencil. Max's note on envelope: "So beautiful and strong and kind and full of rebellion."

Florence to Max, 6 East 8th Street, New York City, May 16, 2017

Max dear, I am awfully pleased with the article in Scribner's.[8]

I want to go to Croton so much. I want to spend a day with you so we can do things together.

> Florence

Max to Florence, 111 East 34th Street, New York City, May 25, 1917

My sweet love, I am still waiting for that virtuous feeling you promised would occupy me. Maybe it will come when I start. So far I feel only the utter loveliness of your being—you to whom I give and commit all that I am.

Your love is around me. I am warm. I am not fearful or distrustful. Tonight I dare believe that Nature made her most beautiful miracle for me,

and that time really contained such an hour. It is true—You are thinking of me—you are coming back to me—and when you come you will be all that the impossible beautiful dream of you is. And so my throat is relaxed and my breath flows quietly and I wait for you with joy. I want you to know this, and so I let myself go into the sweet music of saying it.

But, dearest, it was about your "breastie"—that "brickle in your breastie"—I was going to write. I went to see Harry Lorber, and he seemed so sweet and simple and trustworthy I wished you had gone to him. He is like Potash and Perlmutter[9]—you would trust him and be sure of his motives always. Maybe you will want to ask your doctor what he did, and maybe you have your own reluctance about Harry, and if you have, of course no matter. But I have none, I trust him, and feel sure I know him.[10]

I say all this because it is so terrible to be in pain and be wondering about it, and yet not feel perfectly at ease toward your doctor. You may want to try him. I said nothing about us to him, but I guess from the reticence of his questions that he knows.

You might either say I sent you or not.—Dearest, this is only a suggestion in case the pain is still sharp and you are in doubt.

And more yet, it is only a way to tell you again that I love you—and I want to be the one to touch you with the most intimate tenderness always—

<div align="center">Max—</div>

Postmark. Letter written in pencil. Note on envelope: "quoted."

Max to Florence, 111 East 34th Street, New York City, May 31, 1917

My love, how I hope [th]ere is some richness [in] my devotion that may make it worth the price of pain. I have a child's heart and it is hard for you to be a mother. My wild imagining [is] my gift and my distinction. But we will learn of each-other, and grow together towards som[e]thing even more greatly beautiful than these young days of vivid light and shade.

I can understand. You can understand. And my love, and my knowing that I love you, never fails.

I hope [you] are feeling how it folds you in tonight when you go back [to] the little quiet [b]ed of other times.

<div align="center">Max.</div>

Postmark. Max's note on the envelope: "First shadow. (I don't remember what this was about.)" Written entirely in pencil, the letter is fairly damaged, with circular areas cut or ripped out of left margin, hence the conjectures in square brackets.

> *A series of other undated notes sprinkled among these early files of letters confirms that the "Black Panther" inside Florence—Max's term for her periods of despair—was making itself felt even then. Max, selfish, needy, concerned with his own career, was not the man to dispel those moods. "My voice was not cold," explained Florence in a note accompanying flowers from the Greenwich Flower Shop she sent to Max. "I was hungry." And in another note: "I didn't forget you darling." Or: "I felt lonely and unhappy. I am so sorry I couldn't be with you." But Max had a way with words, and one scribbled note of admiration was usually enough to haul his wayward girlfriend back into the tangled web of his affections.*

Max to Florence, 111 East 34th Street, New York City, [July?] 1917

Sweetheart, I am so excited and happy about next year. We will do great things together. I love you tenderly and proudly because you are noble always, and you are so mettlesome, and your intelligence is so keen—ever a swift and careless blade!

I feel near you tonight.

<div style="text-align: right">Max.</div>

Postmark, but stamp partially illegible. Max's note: "quote," "quoted."

> *On July 5, 1917, the US Post Office declared Max's magazine* The Masses *"unmailable under the [Espionage] Act of June 15, 1917," the beginning of legal troubles that would continue through two trials.[11]*
>
> *The more immediate consequence of the government's assault on* The Masses *was that Max went on the road to spread his views, often to overflow audiences, arguing against conscription and for peace. While he was—thanks to his earlier work for the Men's League for Woman Suffrage—an*

experienced and charismatic public speaker, the element of immediate physical danger, increased rather than remedied by the growing police presence at his events, was new.

Max was traveling on behalf and with the financial support of the People's Council of America for Democracy and Peace, which had grown out of the First American Conference for Democracy and Terms of Peace, held in New York, May 1917. From New Ulm, Minnesota, to Parkston, North Dakota, Max saw parts of the United States he had not known actually existed (and which he realized he would not be eager to visit again). Florence and Max's correspondence now turns into a series of missed or nearly missed connections, with Florence unhappily attempting to guess his whereabouts while Max, writing from a series of anonymous hotel rooms or the homes of supporters, was longing to hear from her and be reassured and comforted.

Max to Florence, 111 East 34th Street, New York City, August 13, 1917

Dearest I feel so many miles and so many hours away from you. Art came up yesterday and I drove him over to Bethel and stayed there last night.[12] That makes it seem so long since I saw you, I'd telephone, but I know Caroline would say you were gone off somewhere and that would make me feel worse.

There was a raging storm Thursday—it blew down a glorious big elm tree over by the station road.

I took off my clothes and went out in the yard and *drank* it.

Couldn't blow *me* down!

Dearest, I am going down to look for a letter. If I don't hear from you, I'll meet the train at 12:16 tomorrow.

Love me and don't forget me in all the excitement that is beginning again. You have been so much mine—I don't know what I am going to do now. I love you.

<div align="center">Max.</div>

Postmark. Letter written in pencil on The Masses *stationery.*

Max to Florence, 111 East 34th Street, New York City, August 18, 1917

At Parting
Sweet-languored spirit! Goal of my desire!
Piercing the mist with your sad ray of truth,
Denying me what soothes insurgent youth,
You turn so sadly fron [*sic*] the potent fire
Of Spring's abandon. What my thirsts require
With[h]old, that we may give to all the world
The fruits of souls made sweet with passions furled,
Sweet-throated songs of unfulfilled desire.

Though passion glows sweet in your avid eyes,
Burns in my throat, like fire against the rain,
I turn me, longing, from Youth's paradise
And sing my song so fraught with poignant pain:
Though sweet your bosom, strong the fire of Spring,
Gleam on, and to the world your longing sing.

 Sydney See

I'm so proud of this because everybody recognizes that it is imitative of me, and that makes me think my poetry really has a style!
He is an I.W.W. boy in Butte Montana.[13]

Postmark. The poem typed with title added in ink. Max's note on envelope: "Saturday 12:15 P.M." Max notes down the arrival of Florence's train (which was given as 12:16 in the previous letter).

Max to Florence, [August?] 1917

Dearest, what do you supposed happened—After I bought my ticket, I found there wasn't a single berth—upper, lower, or stateroom left on that train. Just before I got on I happened to think there might be a Lackawanna train,[14] and I went back to information & found out there was, at 2 o'clock. I telephoned & engaged a berth, and went over to Hoboken. I got to bed about half past one. I didn't stop to see you again because I knew you would go right to bed and to sleep and I knew I ought to. I was

dragging my shoes over the ground by the time I reached Hoboken. It took so long a time to sell my ticket back to the New York Central.

It's fun to travel with your expenses paid, you can be so generous to porters. Dear, I was awake most of the night, but happy because I thought of you. I feel fine today, but I doubt if I can do any writing on a train. It is so noisy my brain gets to whirling.

I got out on the platform at Elmira and shook hands with a rather sick-looking friend of my childhood. The rest of the time I've just sat by an open window—they open generously on the railroad—and dreamed, a little about my speech, but more about you-and-me.

My sweet love, these dreams, so wild and yet tender, so quietly excited, are the co[m]rades of every hour. That I could be so happy—

Max.

Undated, no envelope present, but presumably written at the beginning of the lecture tour. The reference to the Lackawanna train suggests that Max traveled from Hoboken, New Jersey, to Buffalo, New York, and from there on to Detroit and Chicago. See the following letters.

Florence to Max Eastman, c/o Mrs. Frederick Holt, 93 Elliot Street, Detroit, Michigan, August 18, 1917

I SENT YOU[R] SUIT TO MILWAUKEE MAX DEAR I MISS YOU LOVE

F

Western Union telegram, filed 5:40 p.m. Name of host misspelled on telegram, which was rerouted to the Statler Hotel in New York City (since Max had not left yet).

Max to Florence, 111 East 34th Street, New York City, August 19, 1917

August 19, Sunday 9 am

My sweetheart, I hope you have my telegram this morning. I feel worried that it may not be delivered.

It is a beautiful sunny Sunday, and I suppose they will have a great meeting. They did at Detroit. I am more than ever sure "the people" (whoever they are) are against the war. The meeting was held inside of a hard shell of policemen—They patted me on the back and mock-arrested me when I left the building, and I noticed they were listening more attentively than anybody else.

Dear, I got an unexpected fee for my speech in Detroit, and I am going to send it to you because you might need it to buy the spotted rosey dress. I wish you would buy a lighter colored hat to go with the pink dress. That one is so lovely that I can't be very convincing, but the *edge* of the extreme beauty of that rose and white soft sweet (candy) linen is dulled by the darker red of your hat.

My dearest, I love you and it is a miracle to love you as I do—

The papers cheer me up this morning—somehow I think the war is ending. Maybe Chicago papers aren't so depressing.

Now I must work on my editorials. I am fine and well—but I don't sleep much. I'm as nervous as a rabbit's nose all night.

Goodbye, my love, for a little while. I think I'll telegraph you again today.

You'll ask your manager about making the bargains for you, won't you? I am sure he could double what you would get—

Max

Written on stationery of the Congress Hotel and Plaza, Chicago.

Florence to Max, c/o Howard Callenden, 2801 Linwood Boulevard, Kansas City, Missouri, August 20, 1917

Dearest. I wanted to send a letter to Milwaukee, but I felt a little unhappy and I did not want to worry you when you are so busy.

Your letter and telegram made me feel so happy, when you are away among so many people I feel you are far from me, forgetting me.

I think you are so sweet, to think of my affairs when you are so busy yourself. I know it would be fine if I could arrange to have my manager talk business for me. I am certainly going to try it.

I was sure the speech would be successful, but I worry about you so much. Yesterday the times [*sic*] quoted from the 'Masses' some of your article about German atrocities and some of Jack's article about freedom.[15]

It did not name the magazine but said it was considered the most dangerous in the country.

Sunday seemed a long day to me away from you. I am going to go to Croton some day this week.

My dearest I love you so much. I think about next winter and how happy we will be in our house. I do not feel I will ever love anyone but you, you are everything in the world I want.

<div align="center">Florence</div>

Postmark. Written entirely in pencil and sent special delivery, with insufficient postage for "Special Delivery." Fee claimed in Kansas City. Inscribed "personal." Note verso on envelope indicates that the letter was returned ("no response").

Florence almost got her first real break when Edgar Selwyn (1875–1944) and Samuel Goldwyn viewed stills from her 1916 movie Jaffery.[16] *Selwyn and his brother Archibald ("Arch" or "Archie," 1877–1959) were the co-owners of an important theatrical production company and play brokerage, which also ventured into the movie business and did very well in the process. In 1916, the Selwyns had merged their company with that of Samuel Goldfish (c. 1879–1974) and the Goldwyn Pictures Corporation was born (as well as "Samuel Goldwyn," Goldfish's new legal name). While Florence's interview did not lead to a job, her name would now have been familiar to Goldwyn. A week later, on August 27, he sent for her again; she was happy to tell him that she had meanwhile found work. Clearly, Goldwyn's curiosity had been awakened.*

Florence to Max, c/o William C. Rempfer, Parkston, South Dakota, August 21, 1917

My Beloved, I felt terrible when I got your wire this morning. Dearest I wired you to Milwaukee. I don't know why you didn't get it. If my not writing would bring you home, I would like that.

I miss you so much, altho I try to keep busy when I realize I am not going to see you I feel very lonely.

I told you that I had an important interview. It was with Goldwyn, but it didn't come to anything as they don't want to pay much money. I told them there was no reason I should work for a small salary so they could pay six useless stars. Mr. Selwyn was very nice, he told me he had been admiring my stills very much.

I took three people to see "Jaffery" this morning and it was a mistake. The picture is very old, and it looked terrible. I looked all right, but my work looked very amateurish. A year certainly makes a difference. I hope they also think that.

Edwin Arden a star I once played with called me up and asked me to come and see him.[17] He told me He [sic] wanted me to play in a one-act play of his. I was very much flattered as he is a fine actor and he was very disappointed when I told him I couldn't, as I didn't want to travel. He made me feel very happy.

I miss you very much, it seems a long time until September, but dearest I think you are wonderful to go on the tour. you must seem like an oasis in the desert, in times like these, to "the people."

A wonderful play has opened in New York, it is called The Deluge.[18] I want you to go with me so I will wait. Please Max dear write all the time and miss me too. You were lovely to send me your check. I will keep it and we will spend it together. I love you, my beloved. Florence.

Postmark. Address misspelled on envelope.

Florence to Max, c/o Carl Braunin, Massachusetts Building, Kansas City, Missouri, August 22, 1917

I SENT A WIRE TO MILWAUKEE I AM SOSORRY [sic] YOU DIDNT GET IT I AM THINKING OF YOU ALL THE TIME I MISS YOU LOVE

F.

Western Union telegram, received 9:51 a.m.

Max to Florence, 111 East 34th Street, New York City, August 22, 1917

O my beloved, how I long for you. I was so lonely and broken-hearted when I found no message in Milwaukee. I had that terrible feeling that you *don't care* for a little while, and then I knew I couldn't stand it, so I just *said* your telegram had gone wrong and went to bed, but I didn't sleep. I could see your sweet contrite silence, the way you put your eyes down and sit still when I am raving because you have hurt my feelings, and I just loved you too sadly and devotedly to sleep.

I see you and talk to you and dream of you all the time. You are the hours and minutes of the day. I wonder what could ever have brought me off here when I look at my body and see that it was made to love you, and my mind to charm you if it can, and make the rich colored laughter gush out of your eyes and lips. I love you utterly, and in all the world there is no richness and color of being and nobleness of beauty like yours.

I was too anxious to write to you, and these two days I have been going away from you. So it will be a long time before you get a letter. But I will send you telegrams.

When I came to St Louis and saw the boy just before the meeting he hadn't got your message. So I thought you were dead, and I remembered your mother would have no way to tell me, and I had to make my speech with that terrible doom in my heart. Then I hurried away to telephone her, and on the way to my hotel I passed the central telegraph office, and went in and asked them and they had just received it. It was as though the blood had been held up in all my veins until it was black, and then suddenly released and sent coursing through them.

These mass meetings are immense, and my speech grows better all the time, but I think very little about them except while I am there. Florence my darling I am in love, and I am a child,[19] and this wonder of happiness and continual anticipation of beauty and play and work together is all I can think of.

Now I must mail this and never write to you this way again, because it is contrary to all the wisdom of how to make a girl love you.

How I wish I could have some news of you, but I know I will now find a letter. It is impossible that one of those rare documents should happen to land in the same place I do at the same time.

I am lying in a cozy compartment with my window wide open going through the green. We will travel this way when we go to Hawaii next winter—it is extravagant but so are we.

Max's note in the margins of the last page states the letter was written "Wednesday AM. 10:30, Aug 23 1917 (On the way to Kansas City)." Yet August 23, 1917, was a Thursday, and the stamp confirms that the letter was indeed posted on August 22 in Mexico, Missouri.

Florence to Max, c/o S. Vickerson Jr., 8 Blenheim Apartments, Fargo, North Dakota, August 22, 1917

I love you dearest I am just waiting for the time we will be together again.
 Write to me and let me know where you are going to be. I hope Eugen[20] will take me to meet you.

Florence.

Postmark.

Florence to Max, Hotel Muehlebach, Kansas City, Missouri, August 23, 1917

I WILL WIRE AGAIN TO PARKSTON I AM SO SORRY YOU ARE
WORRIED I WISH I COULD HELP YOU. YOUR TELEGRAM
MADE ME SO HAPPY, LOVE

F.

Postal Telegraph Cable Company. Night lettergram, filed 1:17 a.m. The Hotel Muehlebach, still a Kansas City fixture, had opened just two years earlier. Florence would stay there three years later en route to Los Angeles (see Max to Florence, October 8, 1920).

Max to Florence, 111 East 34th Street, New York City, August 23, 1917

Dearest, your letter is so sweet and beautiful. It makes me a lot braver
to have it. I find it hard to explain to myself why I am out here when I
might be there with you. I find myself continually playing with the idea
of telegraphing Miss Secor[21] that I'm dying, or that I've joined the army,
or that I can't find South Dakota, and just flying home to you. It seems

so extraordinarily foolish for me to have gone away.—I don't want you to think I'm not doing any good, or not satisfying any of those emotions that drove us to undertake it. I am, and I want you to feel some of the satisfaction too.

In St. Louis there was an opera house—an immense place—loaded full of people, and they got up and yelled and cheered the statements that you most wanted me to make. All the meetings have been wonderful—each one advertised by a newspaper story that secret-service agents would be there to arrest us. The people here say that the secret service man got to laughing so hard at the war he couldn't do it. It would have been a brave man that would have arrested any of us in St. Louis. I never saw such an audience.

Darling, I wonder all the time about you—about the engagements you wouldn't let me know about, and all that you are doing. Did you buy another dress? I love to think of you going around bringing such stimulation and light to everybody. And somehow I am not so tortured as I was. Perhaps I am beginning to believe that you love me! I love you so much and I am so near you every minute in my thoughts I think I would surely know it if you didn't love me anymore.

At any rate, I must think so, for it is as your lover that I live and that my heart beats, and that I open my eyes to the light in the morning.

<div style="text-align:center">Max.</div>

Postmark. Letter written in pencil.

Florence to Max, c/o William C. Rempfer, Parkston, South Dakota, August 24, 1917

I could never tire of reading your letter I will write to fargo [*sic*] and tell you all about my new engagement love

<div style="text-align:center">F</div>

Typed Western Union telegram, filed 6:10 p.m.

Florence to Max, c/o F. H. Retzlaff, New Ulm, Minnesota, August 24, 1917

My dearest your letter was lovely. I am so happy when you tell me you love me. Do not think my beloved there are ways and means of making me love you, it's just your beautiful self I love and everything about you.

I signed a contract for a new picture beginning on Wednesday, the part is excellent and everything looks fine. I could only get $150, but I do not feel discouraged.[22]

Goldwyn sent for me again today. I was so pleased to tell them I had an engagement they will want me all the more next time, and perhaps will not let me go just because of a few dollars.

I have had an awfully exciting week and I feel very tired.

I think of you all the time darling, I love to. I feel close to you and not strange as I used to when I was away from you.

I look at your list of speeches and it seems to me you will soon reach the end of them, tell me where to reach you after New Ulm.

I love you my dearest

<div align="center">Florence</div>

Postmark. Sent "Special Delivery" and marked "Personal" by Florence. Max's note on the envelope: "her love."

Max to Florence, 111 East 34th Street, New York City, August 25, 1917

Saturday, Aug 25, 9: A.M. 1917

My darling, if you were with me—it is such a beautiful morning, and I wouldn't care where we were going. I am just pulling out of Sioux City Iowa ("whatever that is!") bound north north west. I spent from 11:35 AM to 10:30 P.M. yesterday getting to Sioux City Iowa, and after all that trouble it seems rather foolish to leave, but I have to spend the day hunting for Parkston, South Dakota. Nobody that I have seen has ever heard of it.

I am feeling so well this morning. I don't drink coffee anymore. At least I am going to reserve it for special celebrations or joyful festivals when poison seems appropriate.

Dearest, you never saw such weather—clear shining windy cool days—ever since I left St. Louis. I played tennis in Kansas City.

I've had a funny time with myself—You know how nervous I was at night a week or so before I left. Well, it got worse and worse Every night, I would go to bed dragging my dead bones in weariness, and then the minute I hit the pillow, brain and spinal column would begin to dance. I went automobile riding with some friends in K.C. out in the country to dinner and when we got home I was so tired I didn't go back to the hotel but stayed with them. They gave me a room with a bed like a slab of cold rocks. You know what that means to me when I think I'm nervous. I just wept on that marble-hearted bed for two hours and a half, and then I heard the horn of a trolley car in the distance (this was about 4 miles out of Kansas City) I slid into my clothes, and downstairs and out the front doors. It was just midnight. The dog took after me barking, but I beat him to the gate in my stocking feet, slid on my shoes in the grass and went after that trolley-car a half mile in the dark along a road similar to Trine's road on a winter night.[23] I just barely made it, and it was the last car to Kansas City. I arrived in my hotel—a perfect haven of home and mother it had become by that time—at 1:30. When I called up my host in the morning at nine I found out that they were all still going around on tip-toe congratulating themselves that I had slept so long,—they knew I hadn't been sleeping—and he had climbed a tree in the night to catch a rooster so it wouldn't wake me up crowing at dawn!

Well—I decided if I was going to have nervous prostration I ought to know it, so I looked over the list of nerve doctors in the classified telephone directory, called up a man who runs a mad house, and went to see him. He gave me a complete going over, told me I was both sane and sound, and my blood-pressure excellent (My heart had stopped beating several times in the night, I thought) He performed a minor operation on my pocket-book, and dismissed me with the remark that if I would go to bed intending to rest, instead of to sleep I would both rest and sleep, but if I went to bed intending to sleep I would neither. I went away feeling fine and lay down to sleep last night like a lamb.

Dearest, I long to know the news of you, what you are doing and what is happening to you, but I suppose it is impossible to write when you don't know whether your letters will soon find me. It makes me so jealous and angry to think there will be interesting things happening that you'll never remember to tell me.

Do you know, I've been thinking after all it would be better to have those doors in the bath-room the way he proposed, because we would be

able to get from one room to the other if anybody came to the door. It would seem a little more together-like too, wouldn't it? If you think so too, you might call him up about it.

I wonder if you've been up to Croton. I feel so bad about the suburbanites my thoughts don't wander about the little house so happily as they used to. I know that I am going to do something drastic about that before long.[24]

Isn't it strange that a person of Mike's intellect and charm should enjoy associating with his inferiors? He could have such fun with gifted and witty people—I can't understand it.[25]

Dearest, don't you think we can get a few days to go away on a trip when I come home? I want to go to the mountains or the ocean. Let's go up to a Vermont Lake in the car. We'll stop at Williamstown.

My beloved, never be unhappy because I am away among strangers. I am never away from you. If I am alone, we are together in a million dreams of adventure and happy laughter and love and ambition that fill my imagination. If I am not alone I am only tolerant of people, and always resentful against them because they are not you. I love you and I see you beside me in every joy, and in the lonely night I touch you and caress you with my hands in all the parts of your beautiful body, and I cling close to you with passion and fill you with my love. You cannot be unhappy or lonely if you love me. I am never away—

Max.

Written entirely in pencil on letterhead from The Masses. *Envelope from the Hotel Martin, Sioux City, Iowa ("absolutely fire proof"). Built in 1912, it is now an apartment complex.*

Max to Florence, 111 East 34th Street, New York City, August 26, 1917

My sweetheart, I was so glad to see your little letter and telegram in Parkston. I was laughing and talking like a baby over them in my forlorn little hotel room. You have a new engagement—and you expect me to wait three days to hear about it. Well—I know it is not over $150 or you would have told me in the telegram. But that is all right if you only like it. We only have to earn our livings [*sic*] and enjoy our work—and for all the rest of joy and the fruition of life we have eachother. I love you so much that I live in a

new world—I am so much sweeter and more courageous and happier than I ever was—and the world answers me.

Darling I've missed my train here—at Aberdeen S.D[.]—and I have to go 100 miles by automobile. I have just sat around a garage for an hour discussing whether it is worth 20 or 25 dollars to me. We came to no conclusion and I sauntered out as if I didn't care, but I've got to go, so I suppose they will get their price.

It will be fun—the fields are full of sun-flowers, and the air is fresh and soft. I will be making up things that I would say to you, and dreaming of what we will do.

Florence, I think that Jaffery looked that way to you because you have thought about it so much, but they will know—if they know anything—that you were untrained. You know it made a hit, and so it can't be anything but good from their standpoint. I wish I could talk to you and "advise" you about it all. But I guess it's kind of fun to steer it all yourself and then tell me about it.

Dearest, this is just a talky letter on a very sleepy morning. These towns are so flat, dull and characterless, like a row of boxes, they dull my consciousness. Perception seems hardly worth while.

The meeting in Parkston was just like comic opera—they moved a little band-stand on wheels out into the public square, laid some planks down on boxes for seats, and the people flocked around in all kinds of costumes, like a chorus. The village band played. There were more men and women at the meeting than the entire population—new women & children—of the village. Some of them came 300 miles. You said I must seem like an oasis. I felt like one and tried to behave as oases do—but it was pretty hot and I was terribly sleepy.

The people here are almost all of them against the war.

Darling I must stop talking now and go over to my automobile—goodbye sweet heart—until tomorrow. I will write again in the morning.

Date added by Max in pencil. Written entirely in pencil, on letterhead of the St. Charles Hotel, Parkston, South Dakota (but crossed out and replaced by Max's note: "Aberdeen S.D. 12:15 P.M."), and on an envelope from the Hotel Martin, Sioux City, Iowa.

Florence to Max, c/o S. Vickerson Jr., 8 Blenheim Apartments, Fargo, North Dakota, August 28, 1917

I DIDN'T HAVE ANY ADDRESS FOR THE LAST TWO DAYS THATS WHY I DIDN'T WRITE I WENT TO CROTON ON SUNDAY I TOOK CAROLINE SHE WANTED TO GO I HOPE YOU DON'T MIND EVERYBODY WAS AWAY I SAW CRYSTALL [sic] AND RUTH[26] I WROTE TO NEWULM I MISS YOU LOVE

F

Western Union telegram, filed 11:16 p.m.

Florence to Max, Gardner Hotel, Fargo, North Dakota, August 28, 1917

AM SORRY YOU ARE WORRIED WIRE YOU THIS MORNING EVERYTHING ALL RIGHT LOVE

F

Western Union telegram, sent 7:16 p.m. The 150-room Gardner Hotel, which opened in 1909, was designed by the Hancock Brothers and was named after Frank C. Gardner, the head of a group of Fargo investors. It was located at 26 Roberts Street—on the southwest corner of Roberts Street and First Avenue N. The Gardner's motto—ironic given what was to befall Max there—was "Cleanliness Courtesy Comfort."

Max to Florence, 111 East 34th Street, New York City, August 28, 1917

O Florence I am in despair because I have no word from you but this little hurried letter written on the 22nd. You said you would write me about your engagement to Fargo, and my heart has been occupied with expectation of that letter, and here there is nothing, and I telegraphed you begging for a night letter last night, and I sent you a night letter too, but no answer.

I know why you have not written me a long letter. I know how you are being rushed from one thing to another by the people that admire and eat you with their eyes.[27] And you have no time to tell me even the most important news.

But I don't know why you won't answer my telegrams. I am suffering terribly. I have been refused every hall in this town, and now they have advertised a military drill on the block where I was to speak outdoors. The proprietor of the hotel I am in said he would hang me if I tried to speak in front of his hotel, and I am laughingly informed that the rifles will be loaded in the drill tonight. That is the way they talk out in this country— they think it is humor. And it is if a man's heart is happy—I can stand it—but when you desert me too, then I am sick.

This is the most difficult thing I ever did in my life, and I do want your help. You don't know how lonely it is to be alone and all the press and the power and the prestige against you.

You would save me this terrible suffering of worry and jealousy and lonely despair with a simple little word.

Letter written in pencil verso on ruled letterhead of the Gardner Hotel. Max's note on envelope: "love's misery."

Max to Florence, 111 East 34th Street, New York City, August 28, 1917

Darling I sent you a terrible letter this morning before your telegram came. I was suffering so. Now I take it back. I am eating up every word of your telegram. I love you, I love you, and when I think you have forsaken me I don't know what to do. I have been jealous since I came to Fargo. I don't know why. Is someone making love to you? I remember all the times when you didn't seem to care that you had an appointment with me. I remember all those times. Darling, forgive me, and don't let my letter make you unhappy. I am so lonesome and my heart and body are sick for you—

Postmark. Written entirely in pencil on Gardner Hotel stationery. On the envelope, the picture of the hotel is crossed out and Max adds again: "lov's [sic] misery."

Florence to Max, General Delivery, Minneapolis, Minnesota, August 29, 1917

Max dear,

I really cannot write today & feel to[o] unhappy.

I am glad you are over your nervousness.

I hope everything will go all right at Minneapolis. Everybody in other countries is crying for a leader. In America I think you are the leader.

I cannot write any more today.

I went to the theatre with Ruth last night.

she is a very sweet little girl

<div align="center">Florence</div>

Postmark. Written entirely in pencil. On the envelope, Florence adds: "Personal."

> *Max ran into serious trouble in Fargo, North Dakota, where his antiwar views were greeted with an organized response by soldiers and rabble-rousers, sent to disrupt his event. In fact, he came close to being lynched. In an article for the* Bismarck Tribune *remarkably sympathetic to Max, the reporter wrote that a band of citizens and members of Company B, Fargo's National Guard, surrounded the Gardner Hotel where Max was staying, and "some of the members of the crowd, mostly civilians, suggested personal violence, even going so far as to threaten a 'necktie party.' Others suggested that Eastman should be made to 'kiss the flag.'"[28] Max, who escaped hidden on the floor of an automobile while this crowd was waiting for him, was lucky indeed to get out of town unscathed.*

Max to Florence, August 29, 1917

Sweetheart my love, I have thought each hour since I reached here Wednesday morning I would take the next train home to you, and so I've been unable to write.

But your darling note today in which you say I am the "leader" makes it impossible, at the same time to[o] makes me a thousand times more longing, to go. If I am even in any degree that, I cannot desert this distracted enterprise now.

I will come the second that I can, for my heart thirsts for your loveliness, my mind for your speech, my body for the tenderness of your body—nothing, nothing but to drink you into my being forever will slake the longing that possesses me—My beloved. I have been nearer to the hideous death than I ever thought so gentle a person could go. I left Fargo

by a back road in the dark in the bottom of an automobile with a revolver in my hand, and a company of soldiers surrounded my hotel where my bags were and waited until after midnight to lynch me. I cannot believe it when I write it down, but such is the hour we have come to.

I told you that they had planned a parade on the same corner where I was booked to speak, and the rumor too that their rifles would be loaded for me in that parade. They were there, and the police commissioner refused me permission to speak on any other corner, and the whole money and power of the town was behind them. Reason enough, God knows, for me to quit. But my determination to make sure I'm a man, or whatever is that obscure power that drives me on to act as though I were not afraid when I am had full possession of me. I insisted on having the meeting, and sent two boys out in an automobile to announce through the streets that I would speak in a certain small building that was found near the outskirts of the town. The crowd went over there in a body—200 people inside the building and hundreds outside, filling the blocks, waiting to see what would happen, [*Max continues in pencil*] for the soldiers came too. I walked very quietly down the aisle smiling and began to talk. I think I had talked for five minutes when a gang of six soldiers burst through the crowd at the door almost knocking the people down. There was some commotion, and I paused and told them to come down in front, there were seats on the platform. Cold-eyed, coarse, professional fighters—low in the brow, big in the torso—I knew them, I feared them, and I hated them. They were non-plussed a little at my politeness and quietness and their public position. I told them I wanted to go back a few sentences so they could get the thread of my argument. I addressed them directly, turning my back half way to the audience. They tried to sit down sprawling aggressively as if to say "we are not sitting here listening". But they were—for three minutes. Then I gradually turned toward the audience, and they got back their courage and began to yell. It had no bearing on my remarks. I had said nothing. They simply came there to do it, and I saw that. I asked for a vote of the audience as to who wanted to hear me speak, and I counted eleven who didn't. The rest rose when I asked them if they did. But that was the last word I had. More soldiers poured in and the yelling was continual. I had no power, and the audience sat still as a rock, not a friendly move (I learned afterwards that more were friends there, a few at least, but they knew I would be shot at the first sign of resistance.) A soldier started turning out the lights. A woman said "For God['s] sake don't do that, there are women and children here!" and turned it on again. There were fifteen soldiers behind me by this time, drawing nearer to me and getting bolder as the noise prevented

me from holding any attention with my voice. "All the ladies will please leave the building!" one of them shouted. I was not afraid then so much as I was possessed by the idea that I must not show that I was afraid before all those people. I looked at these soldiers and looked around a little as though I were making up my mind to do something—I wasn't, but it made them watch. Then I caught sight of a fellow I had met—one of the organizers of the non partisan league (the farmers movement there). He was a great big fellow—an old red rebel. I stepped down and put my hand on his shoulder as though he were the best friend I had, and asked him what he would advise me to do. He said I had better give it up. Then behind him I saw Townley—the head of the non-partisan league—a fearless wise big leader out here.[29] I asked him, and he said if I had been you I would have started in complimenting them and gone on and made a speech about something else. I said "I can't do that." He looked up at them, and said very quickly "Come around here behind me". I did, and I noticed that there were two other men with those two. So it looked a little as if I had "my crowd" there—though it was nothing compared to a whole company of soldiers, for that was what was on the platform now. And their officers were in the room. Still it gave me a moment to think and a little comfort inside—for I was now fairly and still rather calmly convinced that I would never get away from that building without being man-handled if not lynched. "This is not all, either", was one of the remarks after I stopped speaking. I thought of you and wondered quickly—but the concentration of one's mind upon expedients is terrific at such a time.

A little woman from out in a village thirty miles away who loves The Masses, and had driven thirty miles to hear me, stepped up to the platform some time during these proceedings and stood beside me. she was the only person in the audience who moved. She told me afterward she thought that being a woman she might delay things, although a man would only have precipitated them. She did delay things, too. I don't know but she saved my life, for she started arguing with the soldiers—a little amusedly—interesting them. In the midst of it, while another woman, my hostess, commanded their attention and ordered them to respect the chairs as they were private property (it was all a little foolish and hysterical you see) this first woman came down and begged me to leave the building. Well—I needed that to overcome this absurd inhibition that was keeping me from acting as though I were afraid. They started singing the Star Spangled Banner, and yelled "Get up!" at us. *I got up*. I saw Townley wave his hat at the end of a stanza, and I waved mine, but I was moving toward

my hostess who sat in the direction of a side door. I said: "I'm going. I want you with me."

I had to go up two steps and then through a crowd in a little wing of the hall. One of the soldiers saw me and shouted "Mr. Eastman retires, now everybody leave the hall in an orderly fashion!" For some reason—I don't know what—I walked straight back to the edge of those two steps as though I were not retiring from the building at all. Then this blessed woman started arguing with them again, and they [were] singing, and thinking I was still in the room. I made my way with *extreme leisure* through the crowd—some of them soldiers too and jeering me, but only quietly for they were the quieter sort, others, not soldiers, shaking my hand and saying they were very sorry and they had come a long way to hear me. At the door there was nothing said aloud, so the crowd outside did not know me, and I slipped away and up a black street [*sic*] with my hostess, who had beckoned to her big Swede nephew to follow. We got to her house and sank into chairs—she and I at least—pretty well exhausted. A few of her relatives came in, I went out in the kitchen and got a drink, but she kept frightening me to death by pulling down shades and acting as though the house was a fort. The reaction was coming too. I was beginning to feel the fear that I had repressed. But I sat trying to talk laughingly with the company, until the telephone rang. She answered, and it was Townley in a telephone booth. He said that if I was there she had better hide me, because the soldiers were out after me. She said "What do you mean? How far would they go?" He said. "Yes I mean that—they will go that far". She came and told me, and asked me if she hadn't better take me in her automobile down to the next station to take a train. I said "yes you had." I remember how quickly and decisively I said it, for I was frightened then—the strain was over, and I was unprepared for a new one. Her husband got me a loaded revolver, and a hat and raincoat (our hat[30] was still on that platform) I made a rather sad attempt to say a laughing goodbye to the guests, and while her husband went out front to get the car and bring it round the block, we slipped out the back-door, through the neighbors['] yard, and hid behind a bush until he came. I lay on the floor of the car until we were out of town, and we went twenty miles in the dark to arrive at a station ten miles down the tracks. It was cold, and my fear was physical now—I was sick, chilly, I wanted to be alone, it was hard to talk naturally, I felt weak, but I loved that six-shooter as I never loved any inanimate thing before! I don't think I showed it very badly unless hiding on the floor of the car was bad, and that was her suggestion. Strange how self-conscious I am—how

possessed with the idea that nobody must see me as I am! For I was—on that ride—*sick with fright*, or the effects of fright.

The woman who had come up to the platform saw them formed in groups around my hotel, stopping everybody who entered, guarding all the doors, and heard them promising themselves a "necktie party" when I arrived. So there is the horrible truth.

The young fellow who arranged the meeting escaped too and is in hiding, and I haven't been able to get my host or hostess on the telephone, so I guess they found it comfortable to take a short vacation too.

The attorney general of North Dakota, (a boy to whom I gave a mark of 100% in Logic at Columbia!)[31] telephoned me here from Bismarck that the Governor would invite the People's Council to Dakota and he would go down to Fargo and give me complete protection. He said he would call out the "home guard" if necessary—it was "Company B of the Home Guard" that spent the night around my hotel! When the whole story became known of course it seemed absurd to try to go there.

Dearest, this is a long story—but it seared so deep into me, with sickness of realization of the tragic state of our world, that I could not talk of anything else until I told you.

My beloved, can you even shadow in your imagination the longing to come home to your arms? I thought I had to, and I thought I could, but there were these people here waiting for my advice, and there was another speech to make. So again—to prove that I am a man—but I am not, I am a baby and I yearn for your breast. O my beautiful and my beloved I want to lie down in your arms. That is all I want.

No envelope present. Dated by Max, who adds after the date: "I suppose." Written partly in ink, partly in pencil, partly recto, partly verso on stationery of the Hotel Dyckman ("refrigerated Artesian drinking water in every room") in Minneapolis, Minnesota.

Florence to Max, Hotel Dyckman, Minneapolis, Minnesota, August 30, 1917

I SENT YOU TWO TELEGRAMS TO FARGO AND A LETTER TO NEWULM I THINK IT IS TERRIBLE THAT YOU DID NOT RECEIVE THEM AM WORKING VERY HARD EVERYBODY IN THE COMPANY IS DELIGHTFUL I WAS SO DISAPPOINTED

WHEN I GOT YOUR TELEGRAM SAYING YOU WERE NOT COMING I AM LONGING TO SEE YOU LOVE I FINISHED MY PYSCHOLOGY [*sic*]

F.

Western Union telegram, received August 31, 12:16 a.m.

The company mentioned in Florence's telegram was the cast of The Auction Block, *a film based on Rex Beach's novel with the same title, produced by the Rex Beach Film Company, with a script and intertitles by Beach and distributed by Samuel Goldwyn. As Florence recalled in her interview with* Picture-Play, *Beach thought she was so good in* Jaffery *that he wanted her for his picture.*[32] *Production had begun in February or early March of 1917 and continued for six months.*[33] *In August, the film was going through a "final polishing process."* [34] *Florence had a good role in the film, which also brought her to the attention of Goldwyn and established her ties with Goldwyn's Eminent Authors series. So Florence could have done far worse than ending up in a Rex Beach film.*

No letters from September have survived, an indication that Florence and Max had more time for each other. But Max's break from dangerous travel assignments didn't last long. The war in Europe was not going well. Amid mounting casualties, the British were trying to break through German lines at Ypres, while the Russian army was retreating. In October, Max was back on the road, resuming his antiwar lecturing. Florence was so worried about him that she recommended he carry a weapon.

But Florence was working again, too. Sometime in October, she made the film The Judgment House, *directed by J. Stuart Blackton, for Paramount, although she was evidently not under contract. The film also starred Violet Heming, Wilfred Lucas, Conway Tearle, Paul Doucet, and Lucille Hammill. Set against the background of the Boer War, the film features Florence in the role of the exotic dancer Al'Mah, who becomes a Red Cross nurse. Fatally struck by a bullet, she reveals that, out of jealousy, she has murdered her lover, the private secretary Adrian Fellowes (played by Paul Doucet).*[35]

Florence to Max, c/o Miss Viva Flaherty, Secretary of the People's Forum of Grand Rapids, Grand Rapids, Michigan, October 28, 1917

CRYSTAL AND RUTH AND I HAD A LOVELY DAY IN THE COUNTRY I MISSED YOU AND THOUGHT OF YOU ALL THE TIME I AM SENDING A LETTER TO ROCKFORD LOVE

F

Western Union telegram, filed 7:32 p.m. "Returned to Delivery."

Florence to Max, c/o Mrs. John R. Gray, Room 1507 Stevens Building, 17 North State Street, Chicago, October 29, 1917

Dearest, I was so disappointed when I came back home on Sunday and didn't find any word from you. but then I knew it was because you knew I had been away in the country. We've succeeded in getting a very good driver to take us to Croton. We had lots of fun. the weather was so beautiful. All day long we played tennis Crystal is so pleased that she hasn't any blood pressure and played beautifully. I beat Sally 6-4 in a game of singles, and I played at the net in a game of doubles and made two points.

I haven't been called to the Studios, but they have started my publicity in the Sunday papers.

Your talk with Pepe has done a lot of good.[36] He has been very solicitous. but I don't think the house will be quite ready on the first. It will be ready enough to move furniture in but the hot water and heat will be lacking.

We'll have lots of fun picking out curtains and arranging the rooms. I am so impatient to begin. Dearest I feel often ashamed of the way I behaved, you must forgive me. I was really very unhappy. I am afraid I will never feel very close to Crystal and Ruth. they are enough to each other and I feel unnatural when I am too much with them. You must not let this upset you because it is nothing serious. I want to tell you how I feel just as I always want to know how you are feeling.

Write to me often, beloved. I shall be so lonely without you.

Florence

Postmark. Letter in pencil. Max's notes on envelope: "About moving in on the first—the house on Washington Pl.," "F.'s reaction to Ruth and Crystal," "I feel often ashamed of the way I behaved." Originally sent to Annie F. Thompson, Rockford Women's Club, Rockford, Illinois, and then forwarded.

Florence to Max, c/o Mrs. Y. T. Hendrie, Pontiac, Michigan, October 30, 1917

Dearest. I did miss you in the little house and out of the little house and everywhere I have been. I think of the sweet happy times we have together all the time, and always I promise myself never to spoil them with my bad disposition. Your last page of your letter did not explain everything to me, but I guessed you had an inspiration about the magazine. I should love you to have a weekly dearest. I seem to sway from one idea to another, but that is not always true. I was always a little wary of Piersons [*sic*] and the Masses but everyone spoke of how wonderful it would be and that seemed true enough to me but Frank Harris[37] was always an unstaple [*sic*] quantity in my mind. and so I was really glad when you all began to consider things without him. I want you to have absolute control, as it is only your powers I am not doubtful of. I have not been to the studio yet, I am sorry.

I wore my green coat and hat today. it is raining. I wish you could see me in it, I thought how lovely it would be if I was going over to see you in your room. you would smile so happily and kiss me I look so nice.

Dearest I am worried about you. I love you Florence

Postmark. Written in pencil. Max's note: "about Frank Harris and my continuing with Pearson's magazine."

Florence to Max, c/o Mrs. Y. Y. Hendrie, Pontiac, Michigan, October 30, 1917

Beloved, I just hinted to you in my last letter that I am worried about you. I did not like to say much because I don't want to bother you, but I have been talking to Crystal and she thinks you ought to be very careful, and carry a revolver and go with a lot of people. Of course you are on a very different tour from your last one. but for me please dearest be very careful.

It will be long before I will agree to have you go away again.

Florence.

Postmark. Written in pencil. Max's note on envelope: "warning that I am danger—"

Florence to Max, c/o Sheldon Auditorium, 3658 Worthington Avenue, St. Louis, Missouri, November 5, 1917

Max beloved, I wish I had received your letter before I left home, we never discussed the things you wrote about, and I feel I have so much to say. Always I have wanted you to write to me when an impulse is so strong as this is in you, nothing should be allowed to interfere. Anything you try to do, you can do and do well. that is why it is hard to stop doing them and concentrate on me, at least that seems to be so to one. It is hard for me to write to you dearest because I do not feel very confident of myself. I don't really know how you feel about lots of things, so it is hard to decide. but I could never feel guilty if I advised you to write and use all your gifts to the utmost.

I will join you as soon as it is possible for you to have me. I feel a little worried about the news in the papers about you and the Masses.[38] Forgive this careless letter, and write to me immediately. I love you dearest and don't want to be any longer away from you.

<div align="center">Florence.</div>

Postmark. Written in pencil on letterhead of the Brevoort Hotel, "Coin de la 5me Avenue et de la 8me Rue." Forwarded to 23 West 14th Street, New York City. Notes on envelope, in unidentified handwriting: "Masses," "Max," and "D."

Florence to Max, Sheldon Auditorium, 3648 Washington Avenue, St. Louis, Missouri, November 5, 1917

I am worried so telegraph me am sending long letter to Chicago love

<div align="center">F</div>

Typed Postal Telegraph Company telegram, filed at 1:23 p.m., was addressed to "Max Eastlman" [sic].

Max to Florence, 19 West 9th Street, New York City, November 7, 1917

Wednesday, November 8 p.m.

My sweetheart and darling I am so lonely for you tonight. You said you had sent me a "long letter to Chicago", but you haven't.

I am going down to see "17" tonight. I have a lovely ticket in the front row.[39]

All the rest of the time I've spent trying to meet people with money. I've only raised a promise of 500 so far.

Dearest I wonder what you think of my letter about Toledo. I am so lonely now I hope you don't agree with me.[40] But I don't know—I feel *poor*—a little worried about money. Isn't it funny? I don't know why.

Darling, if you are really worried I want you to come to Toledo at any cost.

I felt somehow after that Cleveland meeting that the worry was all off.

I do wish I had a letter from you. I'm terribly disappointed and a little worried. I think of you and I am with you all the time.

I went to our cafeteria today—44 cents. I was too lonesome to do better. Darling I love you and I want to be with you always and in everything.

[*Note added to first page:*] Hillquit[41] did wonderfully well, and isn't it Glory to God glad I am about suffrage! O you don't know how happy I am about that—almost more than if Hillquit had won.

Postmark. Written on stationery of the Congress Hotel and Annex.

Florence to Max, Congress Hotel and Annex, Chicago, November 7, 1917

Dearest I just received your sweet letter from Chicago, and I suppose you have just received my worried incoherent one. I feel much better since I find you unworried. You are right about the hundred. let's spend it on the house. I went to the studio today and they gave me my first play. I read it. it is very good for a beginning[42] I guess the pickets in Washington must be very happy. I think the victory is due to them. they put Suffrage back on the map after a long silence.[43] Dearest I have not been able to read. my eyes are paining me almost more than I can stand. My new glasses are a joke. it serves me right for going to another old fool. I am going to wait until you come home before I do anything more about a new doctor.

If your speech in Cleveland is in the afternoon, you can take the same train I took and you will be here early Tuesday morning. I don't have to work until Thursday or Friday. so we can have a lot of time together

Florence

Dearest. Shall I get tickets for a play for Tuesday.

Postmark. Letter written with very thick, blunt pencil.

Florence to Max, Congress Hotel and Annex, Chicago, November 9, 1917

Perhaps by this time you have the letter I sent to the Hotel I am [so] sorry my letter seemed business like I don't feel that way I Miss [*sic*] you and am thinking of you all the time Love.

F.

Typewritten postal telegram, filed 10:36 p.m., with correction in pencil.

> *On December 2, 1917, Rex Beach's* The Auction Block *was released. Florence seemed to have very little to say about the film one way or the other.*
> *The film, produced by the Rex Beach Company, is considered lost today. Whether Beach's opus (not to be confused with its 1926 MGM remake, directed by Hobart Henley and starring Charles Ray and Eleanor Boardman, also lost) was any good is indeed arguable, but one cannot deny that Beach knew how to keep a plot moving along. The document cuts required by the Chicago Board of Censors, along with surviving film stills and Beach's 1914 novel,*[44] *allow us to reconstruct the film in which Florence was cast in a significant role.*
> *The* Auction Block *covered subjects, including drug addiction, that would be absolutely forbidden after the establishment of the Production Code Administration in 1934. As the discussion below indicates, they were barely acceptable even in 1917. True, there is a happy ending, and the heroine is purer than snow. In this regard,* The Auction Block *harps on the*

working-class themes that, as Steven Ross has demonstrated, enjoyed consid-erable popularity in American filmmaking before the consolidation of the big studios. However, since the main working-class character (played by Florence) is shown to be motivated not by social justice but personal revenge, The Auction Block *ultimately belongs more in Ross's category of "conservative films," in which rank-and-file workers are painted as selfish and greedy.*[45]

There is an important qualification that needs to be made, however. Although the film's conclusion proves that the rich, when pressed, can get their act together, they are portrayed with a fair amount of cynicism, too. Beach's book and film radiate cynicism about the world that is reflected in the title, which is not only a reference to the heroine's situation but a metaphor for New York and society itself. One imagines that Florence, given her documented political convictions, had a hard time identifying with her role. Since she wasn't open about her origins, it would have been not much of a consolation to her that the character she was to play was supposed to be Jewish. The not-so-latent antisemitism that had gone into the conception of her role would have added additional stress to her task.

The main heroine of The Auction Block *is the young and beautiful Lorelei Knight, played by Rubye de Remer. Her family is despicable. Her father, an upstate politician who has taken a bribe or two, has been sacked by his political bosses. His wife is money mad. The Knights, aided by Lorelei's villainous brother Tom, decide to move to New York, where the family can essentially sell Lorelei to the highest bidder, hence the title* The Auction Block. *They manage to get Lorelei into one of the slimy Roman Bergman's musical revues as a showgirl and try to marry her off to a millionaire.*

While performing for Bergman's revue, Lorelei becomes acquainted with Lilas Lynn, played by Florence, whose role is almost Shakespearean in its intensity, if not in poetry. Lilas is the daughter of a Pittsburgh steelworker who was killed when a converter full of tons of molten steel was dropped on him and twelve other workers—deaths that could have been avoided except for the deliberately dangerous and negligent actions of their foreman Jarvis Hammon, who was determined to get the award for having the fastest crew in his mill and took risks to earn the prize. Hammon later becomes a millionaire and an unscrupulous and brutal member of the Steel Trust. (The director

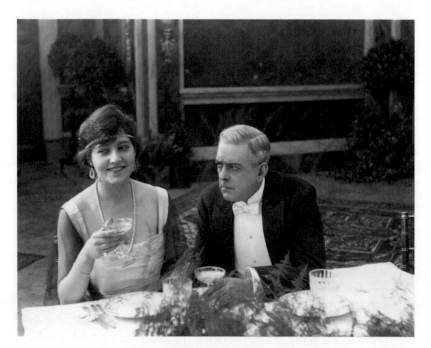

Figure 1.2. Film still from *The Auction Block*, 1917. Florence Deshon (Lilas Lynn) and Walter Hitchcock (Jarvis Hammon). Courtesy, Museum of Modern Art Stills Collection.

even went to the trouble of shooting this sequence in Pittsburgh.) Lilas, whose family has been destroyed, swears eternal vengeance and, after being reduced to prostitution and working her way up the ladder in show business, follows Hammon to New York and becomes his mistress, so she can all the better destroy him, ruin his business, and wreck his family. In figure 1.2, a still from the film, Lilas seems to be making Hammon's life a hell already. To accomplish her goal, Lilas and Max Melcher, a racketeer, work out a complicated blackmail scheme in which they lure Hammon out to a roadhouse in Long Island, where they take compromising pictures of him and Lilas.

Meanwhile, Lorelei has found a perfect suitor, Bob Wharton, played by Tom Powers. He is a millionaire, handsome and affable. Unfortunately, he is also a falling-down drunk, and Lorelei spurns him, much to her family's disgust. However, through no fault of her own, she gets involved in Lilas Lynn's blackmail scheme, through the collusion of her own horrible family and Max Melcher. Lorelei's reputation is sufficiently damaged that she has no choice but to marry Wharton. Much to her surprise, as well as Bob's, he

Love and Loss in Hollywood

manages to pull himself together, find a job, and get reasonably sober. It begins to look as if they can make a go of it.

In the meantime, though, Lilas Lynn has accomplished her goal of destroying Hammon. His wife divorces him; his family disowns him; his business associates spurn him. He angrily confronts and threatens Lilas, who verbally disembowels him. Enraged, he attacks her physically, and she shoots him dead. The shooting is hushed up, to protect the innocent bystanders at the scene as well as Hammon's business interests.

Lilas then leaves town for a while but manages to get hooked on cocaine. Sick and desperate, she decides to return and blackmail Lorelei. She again enlists the aid of Melcher and Lorelei's villainous brother in this scheme. But before she can do so, she overdoses and dies. Lorelei has made a benevolent millionaire friend, and with his help, as well as that of others in high places, the racketeers are disbanded.

Although The Auction Block *is lost, one gathers that it was as lurid as the book. Rex Beach and the director Larry Trimble added extra scenes that were not in the book, and the Chicago Board of Censors required many cuts to them. In reel 1, Beach and Trimble inserted a scene of an encounter between Lilas and Melcher, which emphasized that the relationship between them was carnal as well as simply commercial. Of course, it had to go. There was a cut of a long gambling scene, as well as of two intertitles "Since you want to go on the stage, Melcher will want to see more of you" and "True to Mercher's [sic] prediction, he did want to see more of Lilas." Also removed were all indications of the young woman posing, including a scene in which she is shown undressing behind screens; her handing Melcher a kimono and his handing it back to her; a view of a nude painting in the background; and the incident of a maid opening a secret panel admitting a man to a speakeasy.*

In reel 2, two views of a nude painting were cut, as was the entire incident of a second young woman posing before a man. The censors also did not like the allusion to Hammon's setting up Lilas as his mistress. And the intertitle "Animated by revenge, Lilas permitted Hammon to install her in the Elegancia Apartments" and the shot of a man putting his hand suggestively on a woman's bare shoulder had to be discarded.

In reel 3, two views of a man kissing a woman on the neck and the intertitle "Take him to Clover roadhouse," where Hammon was to be set up for a badger game, were deleted.

In reel 4, five intertitles had to be taken out: "The little flashlight will cost you $20,000," referring to the flash pictures taken of Hammon and Lilas at the roadhouse to blackmail him; "Melcher accepted a check keeping the plate

*as security"; "In the apartments below Lilas rejoices in Hammon's absence";
"Here is hoping he stays away a month"; and, in an apparent reference to
setting up Bob Wharton to marry Lorelei, "Fill him up with booze and we
will take him to New Jersey to get married"; as well as a closeup of a roulette
wheel (an indication of gambling).*

*In reel 5, three intertitles were scrapped: "Hammon returns unexpectedly,"
"Who has been here with her," and "You can't buy me off with a string of
pearls." The shooting of Hammon was also cut. The censors were particu-
larly upset by the material suggesting that Lorelei would not have sex with her
husband until he stopped drinking, and they demanded the slashing of three
intertitles in reel 6: "When you redeem yourself I'll be a real wife to you,"
"Tell him he better pay again or his baby will be born in jail," and "As the
months roll by, Bob still lives apart from his wife." The board also asked for
cuts to reel 7, including a passionate and violent love scene and a sequence
involving a policeman striking a black man over the head. It also demanded
that a long gambling scene be removed from reel 8.[46]*

*The film did well, and the critics were by and large respectful, but clearly
there was an awful lot of plot that Rex Beach, who wrote the script as well as
the intertitles, and the director had thrown into a seventy-minute film. Making
it somewhat more interesting for contemporary audiences, the novel was in
part a roman à clef, and so was the film. (For example, Roman Bergman,
the impresario who hires Lorelei and Lilas as showgirls, was based on the
Broadway impresario Florenz Ziegfeld.)*

As in Jaffery, *in a plummy supporting role, Florence seems to have
outshone her leading lady. Rubye de Remer was considered beautiful, though
she could not act to save her life. Dorothy Day, writing for the* Des Moines
Tribune, *found the film far inferior to the novel but threw a bouquet to
Florence: "Florence Deshon as Lilas Lynn carries away the feminine honors
of the picture in her portrayal of this difficult role."[47]* Day, née Dorothy
Gottlieb, not to be confused with the suffragist who wrote for* The Masses
and The Liberator, *was an important reviewer in the Midwest and was no
flack. She could be extremely direct about her likes and dislikes.[48]*

Joseph L. Kelley of the Motion Picture News *did not hold back with
praise either: "Florence Deshon is rightly entitled to second honors, and if we
sit in judgment with the purely dramatic as the decisive quality, Miss Deshon
is entitled to first honors. She reaches the high spots in dramatic action, is
emotional not to excess, and idealizes the author's creation of Lilas Lynn.
Miss Deshon acts under the handicap of being always in the disfavor of her
audience because she portrays the villainess. Lilas Lynn has reason to seek*

revenge and this fact should excuse her action. In the heavy character role Miss Deshon gives an excellent performance and one that will stand as par excellence."[49]

On December 29, 1917, to cap what had turned out to be a banner year for Florence, the Brooklyn-based Vitagraph Studio officially announced that it had signed a contract with Florence.[50] *She would make a total of eight films during 1917–1918.*

Vitagraph, run by Albert E. Smith, had been one of the major film studios on the East Coast, but it lost much of its prestige and power during the war years. Smith's former partner, J. Stuart Blackton, quit the firm in 1917. Smith ran studios on both the West and East Coasts; his mainstays in Brooklyn were Corinne Griffith, Alice Joyce, Harry Morey, and, somewhat later, Gladys Leslie and Alice Calhoun.[51]

Florence remained in Brooklyn. In the immediate postwar period, Vitagraph did have some success with its Corinne Griffith and Alice Joyce films, and Florence had roles in several of these. She had little or nothing to say about any of them, and none of the films seem to have survived.

2. "A Lovely Place to Work?" (1918/1919)

> Since they were able to spend more time with each other, Florence and Max
> did not exchange many letters in 1918. Outside events—World War I, the
> ongoing revolutionary efforts in Russia, the Sedition Act of 1918—as well as
> the pressures of their work might also have taken precedence over the sharing
> of private sentiments. In March, Max's new magazine, The Liberator,
> coedited with his sister Crystal, began publication. In October, Alfred Knopf
> published Max's second volume of poetry, Colors of Life, with an exuberant
> dedication to Florence ("To One Who Loves Them / And Whose Beauty
> Crowned Their Dreams"). The slim volume, published in a handsome
> powder-blue dust jacket, contained several poems about her, among them
> "To an Actress" and "Those You Dined With," which portrayed Florence
> as the preferred object of desire for multiple men. Max was jealous of all his
> competitors, real or imagined, and he was not shy about letting others know
> that he was.
>
> As Florence worked hard to establish herself as a major film actress, Max
> welcomed her to his house at 70 Mount Airy Road in Croton-on-Hudson and
> introduced her to his radical friends, who celebrated her "natural beauty" and
> appreciated her political views. As Doris Stevens recalled later, she "easily
> became the center of the gatherings" in Croton.[1]

Florence to Max, January 14, 1918

You sent me such a nice note, dearest and the medicine made me almost
well.

Florence.

Written on a business card of the Greenwich Flower Shop.

> In January, Florence, Harry Morey, and a Vitagraph crew headed to Georgia
> to film The Desired Woman. *Florence's first work for Vitagraph,* The
> Other Man, *directed by Paul Scardon, was released the first week of*

February 1918. The New York Dramatic Mirror *commented: "Florence Deshon was a splendid selection for the woman who caused his downfall. This is Miss Deshon's first appearance as a Vitagraph star, and her clever work in 'The Other Man' gives promise of making her a popular luminary."*[2]

Florence to Max, February 24, 1918

I love you so much today sweetheart. Florence.

Small greeting card, in envelope inscribed "Max Eastman."

In the early months of 1918, Dorothy Day (the celebrated suffragist and leftist social activist, not the film reviewer from Des Moines) had been working at both The Masses *and* The Liberator. *She told William D. Miller in 1978 that part of her duties was to collect the mail addressed to Max that came to the magazines and deliver it to Max's home on Washington Square. She never liked the job, as Miller reports: "Eastman had an Olympian manner about him, and Florence Deshon was always hovering about to inspect the mail for signs of foreign female intrusion." If Max and Florence's relationship was based on free love, it must have had its limits even then.*[3]

The war raging in Europe added its own pressures. Max had announced early on that it would be a very bad idea to draft him: "I do not recognize the right of a government to draft me to a war whose purposes I do not believe in," he had written in The Masses.[4] *Whatever private feelings Florence had about World War I, she was trying to be more circumspect. She knew that film people were supposed to support the war. In the spring of 1918, Florence contributed to a Catholic campaign for war relief. It was probably in the same spirit that Charlie participated in the 1918 Liberty bond drive, accompanied in part by Mary Pickford and Douglas Fairbanks.*[5]

Max did reap what he sowed. Charged with seeking to "unlawfully and willfully . . . obstruct the recruiting and enlistment of the United States" military, he and his partners in crime (Floyd Dell, John Reed, Josephine Bell, H. J. Glintenkamp, Art Young, and Merrill Rogers) stood trial on April 15, 1918.[6] *It ended with a hung jury, thanks in part to one allegedly socialist juror, celebrated by Max in his sonnet "To the Twelfth Juror": "I knew that in twelve chances I had one."*[7] *Of course, Florence was caught up in Max's*

notoriety, too, a worry that would continue to haunt her career, leading to discussions in the correspondence as to whether it was smart for them to be seen together.

Florence to Max, 1918?

You look so worried dearest, my heart aches for you.

Please forgive me but the trial is a strain to me also and I miss you so much.

I love you—

<div align="center">F.</div>

Written in blunt pencil on a scrap of thin paper.

In May 1918, Vitagraph released no fewer than sixteen new movies, "the largest of any single production company in the history of the industry," according to Motography.[8] *Among those films was* The Golden Goal *(fig. 2.1), directed by the Australian-born filmmaker Paul Scardon, which starred Florence as Beatrice Walton, alongside the prolific Vitagraph actor Harry T. Morey as the rough-hewn lumberjack John Doran. One imagines that the film, if not exactly her part in it, would have been a bit more to Florence's liking than the role she was given in* The Auction Block. *After missing his ride back up the river where he works felling trees, John is hired by Beatrice, who wants him to run her father's estate. Beatrice falls in love with John but eventually has to let him go because of his lack of education. In a valiant attempt to win back her love, John asks a willing stenographer to educate him. Newly literate, he rises to become the president of the Lumber Workmen's Union. When Beatrice's father tries to persuade him to launch a strike and thus force a lumber company he wants to buy into bankruptcy, the lumberjack's conscience gets the better of him, and he decides to marry the stenographer, his true love. Beatrice, a.k.a. Florence Deshon, comes away empty-handed.*

Scardon's film was more friendly to the working class than Beach's The Auction Block, *even though his final message, too, was a conservative one: accept your own station in life. The way out of the "dregs" of society,*

according to the preview, is a clean conscience, not the desire for wealth that isn't properly yours.[9] *The film is now considered lost.*[10]

Figure 2.1. Lantern slide preview for *The Golden Goal* (1917).Collection of Cooper C. Graham.

Florence to Max, Hotel Bellevue, Washington, DC, May 15, 1918

AM THINKING OF YOU ALL THE TIME LOVE

F.

Western Union telegram, filed 10:15 p.m.

After the first Masses *trial had ended without a verdict, Max and his "coconspirators" found themselves back in court in September 1918. The charge against Max focused on his professed admiration of conscientious objectors, as he had expressed it in editorials.*

In his speech to the jury, published separately by The Liberator, *the magazine Max and his sister Crystal had created to carry on the legacy of* The Masses, *Max called socialism "either the most beautiful and courageous mistake that hundreds of millions of mankind ever made" or "the truth that will lead us out of misery, anxiety, and poverty, and war, and strife and hatred between classes, into a free and happy world." On October 15, the trial ended. And once again, with only four jurors voting for conviction and eight against, the jury was unable to reach a verdict.[11]*

Florence to Max, 126 Washington Square, New York City, December 15, 1918

Beloved, I miss you so much, I'm so sorry I went away
love

<div align="right">Florence.</div>

Sent in envelope of the National Woman's Party, Lafayette Square, Washington, DC.

More signs of trouble surface in the letters and in a series of undated notes that have survived. A major blow-up left its traces in a note Max wrote to Florence in December 1918. Desperate for social affirmation, Florence had felt slighted by Max's elderly African American cook, Geneva, who she believed had served her later than the others during dinner (LR, 81–82). Max refused to take Florence's side, arguing that her anger directed at his unfortunate cook was in reality an attack on him.[12]

Max to Florence, around December 15, 1918

Florence, my dearest, I think you must misunderstand me completely, or you couldn't be angry at me because of the request I made, or my sadness that you refused to grant it.

I do not deny that Geneva spoke in a bad and maddening way to you.

I do not take her part against you.

I did not intimate that you have done anything wrong or owe her anything.

I do not ask you to take her back into any relations with you.

I only ask you to recognize that you have never expressed your feeling to her, nor given her a chance to explain or apologize, and to give it when she asks. I only want you to be generous to one who is subordinate and so much less fortunate and happy of life and who asks something of you.

Surely you cannot be angry at me for asking this. Surely you cannot be angry at my sadness in your intolerant refusal. My sadness is the sadness of one who knows that he has lost the power to appeal to you. You used to love my gentleness and aspire to it a little, as I love and aspire to your impetuous strength. You used to be moved when I showed you my ideals, as I am moved by yours, and we grew together. You are growing away from me now, resenting me, and so easily pushing me out on the edge of your world.

I am bewildered that I should be the object of your anger, and I am sad and lonely in your absence beyond any thought.

Likely hand delivered. Unstamped envelope marked by Max "around Dec. 15 1918" addressed to Florence Deshon, 19 West 9 Street. Max also noted on the envelope: "Beginning of our parting—& no date."

Perhaps it was in response to this letter that Florence sent an undated note, written in characteristically faint pencil: "Dearest, I am ashamed of the way I have been acting, please forgive me. I feel unhappy, and unable to rise above it, so I thought I would go away for a few days." Inevitably, the lovers reconciled again, lapsing into their favorite fiction, that of two children playing with each other. For Christmas that year, Florence sent Max a small card (accompanying perhaps a bouquet of flowers) that featured two Santa-like kids hugging each other, "A Merry Christmas Sweetheart." Letters from Max's friends in Croton show that they embraced "the great Deshon" as the

new "Mrs. Eastman," basking in her successes on the screen. Walter Fuller, Crystal Eastman's second husband, reported to his wife about collective trips undertaken to Ossining to see Florence in her new releases. Florence immersed herself in the life of the "Mount Airy Soviet,"[13] as Max's neighbor Jack Reed had dubbed the radical community along steep Mount Airy Road in Croton, where Max, Crystal, and Jack lived and residents would walk around incompletely dressed, play tennis late at night, and engage in other unconventional living arrangements that shocked the local women who were brought in to cook their meals or clean up after them.

When things got too crowded for them, Florence and Max escaped to Nantucket, returning a "deep brown color," as Fuller also shared with Crystal. Florence, he added, was a "dear thing" yet terribly gossipy (a feature certainly not suppressed in the letters collected here).[14]

A raw autodidact competing with a sophisticated former Columbia PhD student, Florence eagerly embraced also the intellectual opportunities that life with Max afforded her. On one occasion, she compiled a list of complicated words such as entelechy, tropisms, *and* utility—*a result of Max's tutoring, no doubt. The full list, saved among Max's papers at the Lilly Library, begins with a word John Dewey's former master student must have considered essential (*pragmatic*) and includes terms that reflect Max's other-than-academic interests (*comic, libido*).*

An especially touching document is a somewhat chaotic catalog, also preserved, of the birthdays of famous writers that includes Max's birthday (January 4), positioned, in Florence's list, right between John Milton (December 9) and Charles Baudelaire (which Florence lists as April 21, though it was in fact April 9).

Florence's new intellectual experiences generated two poems. The first expresses one of her favorite dreams—flying high and looking down, in every sense of the phrase, on the world below,[15] while the other prefigures what would happen later, when Florence left Max and the Crotonites behind and sailed forth to Hollywood, alone.

The Scare-crow
I laugh, Caw, Caw,
When I fly in the sky,
And look down on the fields
And see what men think
They look like.

Susan B. Anthony.

I think of tug boats on the river
Steaming, strong and self reliant
Alongside the great white ship,
Coaxing, encouraging
Until the beautiful timid maiden
Feels her strength,
And goes sailing
All over the strong seas, alone.

In early 1919, Max departed for a "Hands Off Russia!" speaking tour that was also intended to garner new subscribers for The Liberator. *He was accompanied by Isaac McBride, a "bellicose" IWW agitator, "brilliant and handsome and defiantly dressed in a black string tie," whose function it was to get people in the audience to open their wallets for* The Liberator *after Max was done (LR, 147–48). This adventure put him at great personal risk and took him to, among other places, Cleveland, Chicago, Denver, Spokane, Seattle, and Los Angeles. Florence followed his progress anxiously in her letters even as she continued to work on her own career.*

Florence to Max, c/o Paul Linwood, PO Box 770, Butte, Montana, February 11, 1919

I sent letter to Tacoma am thinking of you all the time I miss you so much had three exciting offers today will tell you about them in letter all my love is for you.

<div align="center">F.</div>

Night lettergram (heavily damaged) of the Postal-Telegraph Cable Company, filed 3:05 a.m.

Among Max and Florence's most important friends in Croton were the writer and former managing editor of The Masses, *Floyd Dell (1887–1969), and his wife, B. Marie. As reported in the following letter, Floyd had married Berta Marie Gage (who went by "B. Marie Gage," since she disliked the*

name Berta) on February 8, 1919, in Peekskill. Later that spring, the couple purchased a house right across the road from Max's, at 75 Mount Airy Street in Croton; they left their Greenwich Village apartment and moved to Croton permanently in 1921. Much of Dell's copious literary output—novels, collections of short stories, poems, essays, and plays—originated in this magical little house in Croton with its distinctive orange curtains, "the walls lined from floor to ceiling with books," as the radical writer Joseph Freeman, who was on the staff of The Liberator and later became the editor of New Masses, fondly remembered it. "Here ideas flowed without reserve, false shame, class or racial prejudice."[16] B. Marie Gage was Dell's second wife; a husky California girl, she towered over the slight, 120-pound Dell, who had proposed to her after only three meetings. Against all predictions, their marriage lasted fifty years, until Floyd's death in 1969.[17]

Figure 2.2 is an unusual portrait of Florence and B. Marie taking a bath, perhaps cut into this shape by Max himself so that it would fit into a wallet or a frame. Uniquely, it shows Florence in an unguarded moment, not made up and not posing for a professional photographer.

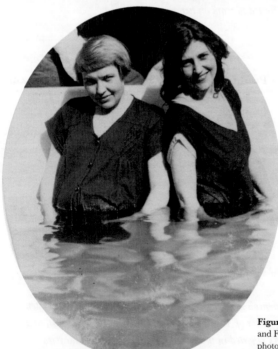

Figure 2.2. B. Marie Gage Dell and Florence Deshon. Unknown photographer. Eastman mss. II. Courtesy, Lilly Library.

Florence to Max, c/o F. J. Cassidy, Room 215, Liberty Building, Seattle, Washington, February 13, 1919

Dearest. Did you think I had deserted you? I had such a hard time getting your addresses. I went to the country last weekend with Gregory and Francis.[18] They were lovely they did all the work, and on Sunday Floyd came up the hill with his wife. Perhaps you know he has married Mary Gage, the girl I told you about. She likes me a lot, so I will try to get over my first impression of her.

She wants you to tell Upton Sinclair and Kate Crane how lovely Floyd really is because she feels they don't approve of him.[19]

I have been very busy. I was sent for by the manager of the play you remember. I told you about it before you left. Well I had two moving picture companies on the string so I didn't know what to do, but I didn't feel like going in that play so I gave it up.

One of the picture offers is still pending the other didn't want to pay my salary. I hope you get back before I sail. you know I am rather worried about going it seems to me there is going to be another war Beloved I suppose you have been so busy and excited you haven't had time to miss me. The weather is still lovely here. I imagine it is lovelier where you are. I am glad you are not worried anymore, it makes me feel better and I am glad you like Ike.[20] I think he's a lovely fellow

The boy who took your pictures came one day and took away the one I liked. I wasn't here I wouldn't have given it to him but I can close my eyes and see you and you look very sweet.

Be careful of yourself Beloved and know that I am thinking of you with love all the time

<div align="right">Florence.</div>

Postmark. Sent "special delivery."

The two promising movie offers fell through, a great disappointment to Florence (LR, 148). Florence had other worries, too. With not much of a career in the balance, she talked herself into signing up for a stint in Europe, during which she would—under the auspices of the Overseas Theatre League, an organization of the YMCA formed after the armistice—perform "entertainment work" for the troops stationed abroad. On February 28, she applied for a passport, listing Samuel Danks ("from Liverpool") as her father and

stating her intention to be away for three months. Typed across the bottom of
the form was the sentence: "I have never had a passport." Florence's applica-
tion was accompanied by affidavits from her mother ("Caroline Danks") and
from the YMCA, certifying that Florence had been appointed a "Secretary"
of the YMCA's National Work Council "for service with the troops of the
American Expeditionary Force in France." The duration of her appointment
would be one year.[21]

Whether Florence's main motivation had been a thirst for new adventures,
dismay over Max's frequent absences, or an attempt (for the sake of her career)
to burnish her somewhat tattered patriotic credentials, she almost immediately
regretted her decision to join the league.

Florence to Max, c/o People's House, 1256 Market Street, San Francisco, California, February 17, 1919

Dearest, I have written you three letters and torn them all up They were
so sad. All my bright hopes of last week are crushed. without any expla-
nation my picture offers fell through and of course I sacrificed the play
because of them.

My trip to France worries me also I have to sail March 3rd and they
are very indefinite about when I return. I should hate to be tied up over
there against my will and of course Caroline is very worried about money
while I am gone. Altogether you can see how sad I am about so many
things

I went to Croton on Sunday and drove the car to New York at night.
Wasn't that wonderful? I left it up town as I was worried a little about the
lights. I will take it back soon, and you needn't worry about it. I am very
very careful.

The country. [*sic*] looked beautiful. It is still warm. I read the text of the
Legue [*sic*] of Nations[22] it has much more back bone than I ever expected.
How do you feel about it. I feel so happy dear the way all the worry about
your trip has blown away.

I am so glad you arrived just in time to hear and see everything that is
going on out West. Beloved I missed you so much on Sunday I played the
Victrola, all the melodies we love. I have heard some new ones I want to
get for you.

I have been reading Plato's Dialogues again I don't know why but
they remind me of you.[23]

You do seem very far away. I am afraid to write a love letter to you. you seem so full of business Reassure me and I shall tell you how much I love you, my beloved

Somebody took your pouty picture away I only have the one in the bad light which isn't much like your sweet self.

Postmark. Letter written in pencil. Max's note on envelope: "All my bright hopes of last week are crushed."

Florence to Max, c/o J. H. Ryckman, 1921 Higgins Building, Los Angeles, California, February 21, 1919

My beloved. Your telegram made me so happy. I miss you so much. I miss your advice too. You would be impressed if you knew how undecided I am I think it is because I will have to sail away without seeing you, without kissing you. It will be so long that you will forget me. I am so glad sweetheart that you are well and strong I have been all through the part of the country you are traveling through, I know how beautiful it is in the early spring. But the sun still shines warmly here. It is beautiful I have been in our house in the country the last few days. Last night a white moon woke me up to loneliness I was so frightened You were not near to tell me you would take care of me. I longed so to lie close to you I could scarcely bear it.

Did I tell you Ben Hampton wrote me a lovely letter.[24] Also I heard from that company in Cleveland They said my pictures came too late for the present picture. But they were glad to hear from me because they are going to do a lot of producing.[25]

Do not thank "Cor Gentile"[26] that I have only written you a few letters I have written lots and lots but they have not been sent. I drive the car all over[27] I am a fine driver. I drove up from New York with little Francis and she wasn't a bit afraid. I brought your blue curtains up here, but they are not becoming. I shall have them cleaned and use them in your little room in New York. Caroline isn't worried about my going as much as she was at first. That relieves me. I am sorry that Mac is sick.[28] What happened to him? Good night beloved I am thinking of you all the time I love you.

This is what I call a staccatic letter.

Postmark. Letter written in pencil, on crossed-out letterhead of the "Editorial Department, New York Medical Journal, incorporating the Philadelphia Journal and the Medical News, Sixty-six West Broadway, New York." Why Florence would have had such stationery in her possession is a mystery.

Florence to Max, Clift Hotel, San Francisco, February 25, 1919

TRIED TO TELEGRAPH YOU AS SOON AS I HEARD FROM
YOU PHONE WAS SHUT OFF FORD WOULDN'T GO AM UP
HERE WITH DUDLEY AND DORRIS [*sic*] FOR A FEW DAYS
LETTER FOR YOU IN LOSANGELES [*sic*] WILL WRITE YOU
LONG LETTER TODAY AM THINKING OF YOU ALL THE TIME
LOVE

<div align="center">F</div>

Western Union telegram, filed 12:17 p.m.

Max met Charlie Chaplin for the first time on February 26, 1919, the day Max gave his "Hands Off Russia!" speech at the Trinity Auditorium in Los Angeles. A photograph taken on that occasion (fig. 2.3), included in Max's Great Companions *(1959), captures the instant rapport the two men enjoyed: Max seems perfectly at ease, laughing heartily with his eyes closed, while Chaplin, ever the consummate professional, remains conscious of the camera, even as he leaves his hand resting on his new friend's shoulder. The* Los Angeles Times *covered the speech in its own inimitable fashion:*

Call for Police at Eastman's Meeting

If Max Eastman, Socialist editor and defender of the I.W.W. and Bolsheviki, had made during the war the address he made at Trinity Auditorium last night he would probably have spent a considerable space in jail for violating the Espionage Act. As it was a number of indignant auditors left to ask the police by telephone to stop the meeting. As the police were unable to act, the complainants announced their intention of laying the matter before Special Agent Keep, of the Department of Justice, this morning.

Max Eastman, who is a sort of parlor socialist, warmly espoused the cause of Bolshevism and declared that it should be substituted for our existing form of government. He denounced the administration at Washington for enforcing the

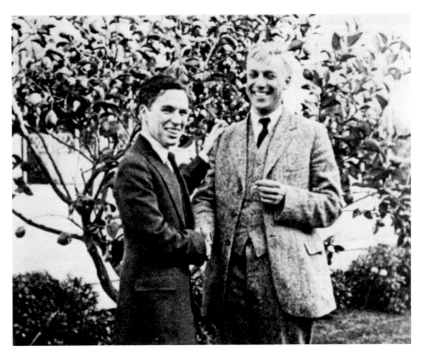

Figure 2.3. Charlie Chaplin and Max Eastman in 1919. Unknown photographer. From Max Eastman, *Great Companions: Critical Memoirs of Some Famous Friends* (1959).

Espionage Act, thereby shutting up Eastman et al, and demanded the immediate release of Eugene V. Debs, Tom Mooney and the I.W.W. conspirators convicted in several States.

In conclusion he demanded, with Hearst, that the American Army be withdrawn from Russian soil, and denounced that the allied army of occupation was "an army of capitalism."[29]

Max and Charlie hit it off. In fact, so taken with Charlie was Max that he devoted a whole chapter of his book Heroes I Have Known *to his relationship with him, recalling the first time they laid eyes on each other:*

My meetings were the first opportunity the radicals had had for a long two years to make their voices heard, and they came out in mobs. The police came too. There were forty of them lined up like great blue smooth-feathered birds of prey around the inside wall of the Philharmonic Auditorium where I spoke in Los Angeles. My friend Bob Wagner came up afterwards, while I was shaking hands with people, and whispered:

"Charlie Chaplin is in the wings and would like to meet you."

If he had said "Julius Caesar," I would not have been more astonished or delighted. To crown my delight, Charlie's first words when we shook hands were in genuine admiration of what he termed my eloquence.

"You have what I consider the essence of all art," he said, "even of mine, if I may call myself an artist—restraint."

"Well, did you see those policemen?" I said.[30]

Max was surprised by Charlie's modesty, a quality in short supply in Hollywood, which he was pleased to see Charlie had also found in him. (A bit of wishful thinking on Max's part). Having started out on a "note of . . . mutual taste," the two new friends spent the rest of the day together and had their picture taken:

We had supper together that night, and the next day I went out to the little row of English-village houses on La Brea Avenue that formed the street in front of his studio. It was the only studio in Hollywood that did not look like a freight yard. We swam together in his marble pool, and talked again all afternoon, and had our "movie" taken, eating raw lemons like apples off a tree. I was, as almost everyone is, quite as captivated by the real Chaplin as by the Chaplin on the screen.[31]

A photograph taken before or after Max's talk (fig. 2.4) shows him flanked by a cigarette-smoking Charlie on the left and Isaac McBride on the right. Rob Wagner is on the far right, next to an unidentified gentleman. McBride came on after Max was finished, "browbeating" the listeners into donating money for The Liberator. Max liked McBride personally but hated his exaggerated sales pitches, figuring that if he had done the fund-raising himself, he would have made twice as much money (LR, 148). One of McBride's specialties at these events was taunting the police in the audience, "so that [they] can hear better," by which he no doubt added some additional frisson to the not inconsiderable danger of these appearances.[32]

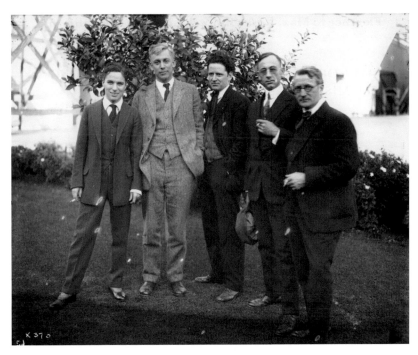

Figure 2.4. Charles Chaplin, Max Eastman, Isaac McBride, unidentified male, and Rob Wagner, Los Angeles, February 1919. Unknown photographer. Courtesy of Roy-Export Company.

Florence to Max, Rosslyn Hotel, Los Angeles, California, February 27, 1919

TRIP NOT DECIDED YET WIILL LET YOU KNOW DEFINITELY TOMORROW

F.

Western Union telegram. The Rosslyn Hotel and Annex, built, respectively, in 1914 and 1923, was at one time the largest hotel on the Pacific Coast, with 1,100 rooms and 800 baths.

Florence to Max, Rosslyn Hotel, Los Angeles, California, February 28, 1919

AM NOT GOING TO FRANCE WILL WRITE YOU A LONG LETTER MISS YOU VERY MUCH LOVE

<div align="center">F.</div>

Western Union telegram, filed at 9:43 a.m.

Max to Florence, 19 West 9th Street, New York City, March 4, 1919

My sweetheart, I am thinking what fun we will have in the coming of spring when I come home. I am so homesick to see you. All you tell me about Croton and your driving the Ford sounds as far and alluring as the poems of Li Po. And it always "accelerates my pulse" to know that you've been in the little house because there I feel sure that you loved me.

Sweetheart, it came over me last night in my berth that it may have been on account of me that your picture offers came to nothing. You told me so little in your letter. I can hardly think that is possible, and yet I suppose it is. Cecil De Mille[33] was rather nasty to me when he met me— but it was on account of the report in the papers out here. (I came very near getting into trouble in L.A.). He is a screaming patriot—also an ugly fat fool. But Griffith was very nice. He said "I take my hat off to you. You're a braver man than I am"—this after telling me about his exploits on the battle-field, and admitting that he didn't believe in his war-picture at all, and that war is equally "atrocious" on both sides. He seemed to have a real liking for me—which as usual in such cases I pretended to reciprocate. I urged him to do a picture of the history of the class struggle, and I'm going to send him the Communist Manifesto and that book we've talked about reading "The Ancient Lowly."[34]

I tell all this to try to argue myself out of the terrible feeling that I have been an injury to your career!

Darling, how I long to throw my arms around you, and kiss you and tell you that I will take care of you. We will be happy together no matter what comes.

I hope you will get my addresses on the way home from Margaret,[35] so that I may have some word to carry me along. It will be so hard when I am on the way to have to come so slowly. It begins at Dinner on the 13th—but I am going to telegraph you an address before that.

My love, how I hope your decision not to go to France has meant happiness to you as it has to me. Let's go to some safer place together this summer. Let's take a grand lazy trip.

Be careful of your sweet beautiful body, my darling. Be careful in the Ford. And dare me all you can, I love you.

<div align="center">Max.</div>

Postmark. Written on stationery of the Lark, *the overnight passenger train of the Southern Pacific Company between San Francisco and Los Angeles. Max's notes: "Meeting with D. W. Griffith, Mar 4, 1919" and "Put this with the chapter on Hollywood—."*

If Max was fighting the good fight in Los Angeles, Florence in New York had embarked on a similar effort. On March 4, Woodrow Wilson, on his way to France, gave a speech at the Metropolitan Opera House. The National Woman's Party (NWP) organized a demonstration in support of women's suffrage. The police seemed to be keeping the demonstrators in hand, but then a crowd of soldiers and sailors joined in the fray. They started grabbing the banners the women were holding and used them as clubs. It is unclear to what extent the army and navy were acting under orders or on their own, but things got serious. They damaged the eye of one suffragist and roughed up several others. Six women, including Alice Paul and Doris Stevens, were arrested. The New-York Tribune *reported that the soldiers seized and destroyed all the suffragist banners. The last banner in the demonstration—bearing the inscription "President Wilson, what will you do for the suffragists?"—was ripped from the hands of Florence. She did not get arrested. The Mooney agitators—supporters of the imprisoned labor leader Tom Mooney—formed part of the same demonstration; two months later, Max dismissed contemptuously Doris's suggestion that they had fared better at the hands of the police than the suffragists (Max to Florence, May 11, 1919).[36] Florence did not even write Max about her confrontation with the authorities, a remarkable contrast to Max's blow-by-blow description of the events in Fargo of 1917.*

Florence to Max, c/o Sidney Wood, Smartsville, Yuba County, California, March 7, 1919[37]

Max dear. what will you think of me. I have run away from you. Your letters pain me, and I see your face before me, sad and pained because you do not miss me. Do not be sad.

<div align="center">Florence.</div>

Postmark. Addressed first to Max, c/o Sidney Ward, Smartville, Yuba county, California, then rerouted to "General Delivery, Chicago."

Florence to Max, c/o William Dietrich, 1386 Perry Street, Denver, Colorado, March 13, 1919

SENT YOU LETTER TO MARSVILLE] WE ALL FEEL SAD ABOUT DEBS I HOPE YOU HAVE THE OPPORTUNITY OF SEEING HIM AGAIN[38]

<div align="center">F.</div>

Western Union telegram, filed 1:40 p.m.

Florence had become progressively tired of Max's long absences, and in her growing loneliness she remembered an earlier incident in which Max had castigated her for something minor—a letter that he thought Florence wanted to read even as he was hoping to keep it private. The letter she now sent almost too neatly reveals what ultimately became one of the reasons their relationship crumbled. As Max recoiled from perceived intrusions into his intimate life, Florence berated him and simultaneously apologized for her behavior. That she would direct letters to Chicago as well as St. Louis indicates that she often didn't know where he was, which must have added to her depressed state.

Florence to Max, c/o Lenetta M. Cooper, 1505 Lakeview Building, Chicago, Illinois, March 15, 1919

Max dear I have turned away from you because you no longer mean happiness to me. My heart is hurt so deeply I only want to run away.

I went to your house in the evening and tried to warm myself, but your house has become like other houses, it did not warm me. I went to your room in New York, but I could not stay there. Sometimes when I am walking on the street I almost fall when I think of that terrible night you leapt at me suspicious that I would read your letter. How could you even feel that way towards me.

Please forgive me for the cruel way I acted. I am so ashamed of it. You are too lovely and sweet too light and sunny for anyone to treat so horribly as I did. Please please try to forgive that. I didn't seem to know what to do. I guess I am not grown up.

I wrote you a short letter to Smarsville] telling you this. When you receive it you need not fear it.

I admire you so much. You are wonderful and courageous to go across the country speaking at a time like this

Your tender letters from Smarsville could not pass into my mind. it is too full of the truth which you tried so hard to tell me before you left.

<div align="right">Florence</div>

Postmark. Written entirely in pencil.

Florence to Max, c/o William Brandt, 940 Chouteau, [St. Louis], March 15, 1919

PLEASE FORGIVE TELEGRAM AM SORRY LETTER IN
CHICAGO

<div align="center">F</div>

Western Union telegram, filed 11:53 a.m.

Florence to Max, c/o Lenetta M. Cooper, 1505 Lakeview Building, Chicago, Illinois, March 16, 1919

I DO NOT WANT YOU TO OPEN THE LETTER I SENT YOU
PLEASE BRING IT BACK TO ME

<div align="center">F.</div>

Western Union night letter.

Florence to Max, c/o Lenetta M. Cooper, 1505 Lakeview Building, Chicago, Illinois, March 17, 1919

I HOPE YOU ARE LEAVING FOR HOME TODAY I MISS YOU
LOVE

<div align="center">F.</div>

Postal night letter, filed 2:46 p.m.

In May 1919, Florence was hired by Selwyn & Co. to go on tour with the cast of Among the Girls, *the musical version of* Seven Chances, *cowritten by Roi Cooper Megrue and Henry Blossom. The show had opened in New Haven on May 8, a fact not forgotten by Max. The musical seems to have been cursed from the beginning. Henry Blossom died while writing it; it became a bone of contention between David Belasco, the original producer of* Seven Chances, *and the Selwyn brothers, who were producing the musical; and clearly there were problems with the lead, the Scottish-born actor Percival ("Percy") Knight, as Florence shared in amusing detail. Alcohol or tuberculosis, or both, finally got the better of Percy, who died in 1923 in Montreux, Switzerland, at the age of forty-eight.*[39]

Max to Florence, Hotel Taft, New Haven, Connecticut, May 9, 1919

DEVOTED LOVE AND PRIDE AND CONFIDENCE

M

Postal telegram, filed 1:43 p.m. Addressed to "Florence Deshom"].

Florence to Max, Croton-on-Hudson, New York, May 9, 1919

Dearest,

I am thinking about you all the time, loving you and missing you so much.

Thank you for your sweet telegram.

My sweet love.

Florence.

Postmark.

Max to Florence, c/o Poli's Theatre, Washington, DC, May 11, 1919[40]

Darling, my beloved, I worked all day from 9 to 6 in my barn yesterday, only pausing to send you my love in a telegram. When I came out of the barn I was *staggering*. I staggered up to Dudley's after dinner and got into a fight with Doris—terrible. She certainly is just as Dutch as he is Irish! She started in running down the Mooney agitators in that priggish tone that all Alice Paulites take to all other pathetic attempts of human nature to do anything.[41] It made me mad, and in the course of a three hours battle some of my intellectual ammunition trains having got lost, I filled a breach with a few sketchy pictures of the noble consecration with which *she* has been sticking to her job the last year. Of course she dissolved like a dew-drop, and we all sat staring into the fire very uncomfortable. But I was *not sorry*. Priggishness I cannot stand.

Today I had to come down here with what I've written, and I've been writing again in the office and in my room. Tomorrow and Monday my

book again—Tuesday we make up the magazine, maybe Wednesday—then toward the end of the week the deep dive for a masterpiece![42]

You must write to me, Sweetheart, all about the play, and how it goes, and how your part goes. I think of you all the time as I go about our little house, and I open the drawer to see that your things are still there. I never feel so near to you here, I am going back as soon as I take some things over to Floyd. I love you.

Caroline showed me two lovely dramatic pictures of you that I never saw before. I went over for my umbrella. She was going to show me Sam,[43] but she couldn't find him.

My dearest, think of me and love me, and tell me that you do—write to Croton—

<div align="right">Max.</div>

Postmark. Letter written in pencil.

Florence to Max, Croton-on-Hudson, New York, May 12, 1919

Dearest. The play went very well, but Percy Knight can't touch Frank Craven when it comes to a finished performance. I am very disappointed in him.[44] I can never tell how my scenes with him will go, he is just as liable to kill them as not, and not through mean[n]ess, but just inability. I realize more and more every day that nobody can arrive anywhere no matter how great their natural talent if they don't work seriously. After the play Percy gets drunk with some of the Chorus girls and so it goes. Roi told me the other night he was going to rehearse on the train all day and give Percy a good talking to. But he was not able to be with us today on account of his uncle's death, and he won't get back until Wednesday. Now darling don't feel discouraged because I don't.

My scenes go beautifully now, only I am anxious to have them even better because I know they can be with a little mutual work.

Tonight is the most beautiful spring night I long so much for you. I would love to be out riding through the soft air with you.

I am stopping at this hotel. Dearest would you care to meet me for a few minutes at the railway station next Sunday when I pass through, nobody need see you, but me. If you care to, I'll find out what time the train arrives and let you know. My love to you beloved.

I know that too, should be spelled to.

Postmark. Written on letterhead and envelope of the Hotel Powhatan, DC.

Max to Florence, Among the Girls Company, Poli's Theatre, Washington, DC, [May?] 1919

Darling, that was such a sweet note, and it made me so happy. I am thinking about you and waiting for Sunday when you will stop here, won't you? I sit at my desk *all day*.

Last night I went to bed at nine.

Tonight Eugen is taking me to dinner and the theatre.

Sweetheart, your voice was so beautiful over the phone and I was so sorry I couldn't tell you all I had to tell because Mike and Sallie were in the room.

I am so glad and proud about the play. Do you want me to see it? Dearest, write me more about it. I'll have a new chapter to show you Sunday. Thank you for the sweet note, dear, with your love.

I miss you. Goodnight, sweetheart—Max.

We are going to see Dear Brutus[45]

No postmark extant. Letter dated by archivist.

Max to Florence, Among the Girls Company, Poli's Theatre, Washington, DC, May 13, 1919

My darling I am so lonely for you tonight and full of fear that you are not thinking about me with love. I wish you were here. I wish I could afford to telephone. Max.

Postmark. Written in pencil on Copley-Plaza Boston letterhead. Return address on envelope crossed out.

Florence to Max, Croton-on-Hudson, New York, May 15, 1919

Dearest. I telephoned you twice but without success.

I am thinking of you all the time with love, darling and I miss. [*sic*] you so much.

I am hoping to be able to leave here Saturday night and spend Sunday until 3 o'clock with you, if you care to, Florence. Write to me often I am so lonely

Letter written in pencil on Hotel Powhatan stationery.

Max to Florence, Hotel Powhatan, Washington, DC, May 15, 1919

My beloved, how happy I am that I am going to see you Sunday. I'm going to a Left Wing meeting Saturday night, so I will stay in town over night—unless it should be late Sunday that you come. I did hope you could spend the day with me, and I still think you can if you plan it, but I want any minute that I can have. I was so lonely last night that I slept all night with your letter in my hand. You will be sure to get word to me, so I won't miss you.

The birds are singing their joy into the air. The sun is shining. I wanted to write to you and about you today, but the Liberator has just called up— an emergency—I have to go to town. I am going to drive in anyway, and I will be thinking of the—(telephone from my sweet-voiced child of love)— times we ride together through the soft wind and feel so happy—Max.

I can't find either of the books here—maybe they're at your house?

Postmarked May 15 (dated by archivist to May 16). Postscript in pencil. Sent in Liberator *envelope.*

Florence's amusing account of her arrival in Boston reveals her talents as a writer—what a memorable image she paints of herself as the dominatrix of the Boston underworld, where tough lions are being made into meek lambs by a mere wave of her wand! As his responses show, Max's literary imagination was tickled by Florence's flights of fancy. But her letters also draw a stark picture of the hardships experienced by actors on tour: the unrelenting pressures of work, the cheap (or unavailable) hotel rooms, the inevitable concerns about personal safety.

To be sure, Boston was a rough environment in 1919. In May, the waters of the harbor would have still been brown from the Great Molasses Flood that had taken place earlier that year, when a huge tank owned by United States Industrial Alcohol burst, killing 21 and injuring 150. The prospect of reuniting with Max on her free days promised relief from Florence's acting routine. Did they choose Pittsfield because it would have taken Max about the same amount of time to get there from New York as Florence would have needed from Boston? In the end, it was Florence who embarked on the long, hot trip back to New York and, presumably, Croton, to spend time with Max, who, as usual, would have offered a million excuses as to why he could not

travel, being unable to free himself of his many responsibilities, including the need to keep working on his constantly evolving work in progress, the book that would become The Sense of Humor.

Florence had also hoped that she would be offered a modeling gig in New York—by Coca-Cola, no less. The Coca-Cola advertisements never material- ized, one in a series of setbacks that would reinforce Florence's later suspicion that she was being targeted.

Florence to Max, Croton-on-Hudson, New York, May 21, 1919

Beloved. Boston certainly has proven to be the city of adventure. When I arrived here Monday morning I couldn't find my companions at the Hotel they said they would be at, so I started off to another one. Every room in every hotel was taken as a convention is going on here, two or three conventions I should think. At last I met another member of the company wandering forlornly about and together we engaged a room until 11 o'clock as it was engaged from this hour for someone else. but at the rehearsal I met my friends and I am staying with them for a few days in this uncom- fortable hotel. Don't write to me here, address my Park Square Theatre as I am moving.

Boston is charming in the day time, but at night it is another story. I walk home with a thick stick held threateningly in my right hand. The men here ought to be all shot at sunrise, they are so tough But they all shy away when they see the stick and by the time we land home our anger has turned to fit[s] of laughing to see them all react the same way.

The play got beautiful notices, and we are doing very good business.

I'll write again about Pittsfield as I haven't had a minute to find out about it.

I had a lovely day with you Sunday I have been happy thinking about it. I so hope the weather will be beautiful again this week, so we can see each other again.

Write to me often dearest as I am so lonely to hear from you.

You were lovely and beautiful dearest when I saw you I shall always think of you that way.

<div align="center">Florence.</div>

P.S. A train leaves here Sunday morning at 10 o'clock for Pittsfield arriving at 2 o'clock. That is [the] only train there is. The fare is $10 round trip or more.

P.S. Dearest, I don't think I will meet you in Pittsfield this week. I think I will have a chance to come to New York for nothing next week as those Coca Cola people are still after me. I have suggested to them that I will come to New York and I expect them to send for me. I wouldn't have to pose for them until about 10 o'clock Monday morning and we would have a day and a night together. What do you think about it.

Postmark. Written in pencil (except for the second "P.S.") on letterhead of the Commonwealth Hotel, Bowdoin Street, Beacon Hill, Boston.

The Eighteenth Amendment, banning the manufacture, sales, and transportation of liquor, was ratified on January 16, 1919. However, it did not go into effect until January 16, 1920. In May, the Association Opposed to National Prohibition and other "wet" groups including the American Legion, representing thirsty veterans of the recent war, staged a number of rallies in a last-minute effort to prevent the Volstead Act (which enabled the enforcement of Prohibition) from ever being implemented, and there was a major rally in New York on May 24.[46] It is not entirely clear whose side Florence was on, but she does not seem like a dry and certainly would not have wanted to be associated with the Baptists. A few months later, newly arrived in Hollywood, she noted that Prohibition had ended the good times for "the people out here" and concluded: "they are rather hard up for fun now" (to Max, July 19, 1919).

Florence to Max, Croton-on-Hudson, New York, May 22, 1919

Dearest. Your letter was so beautiful that I read it over and over.

I felt sorry that I had sent you a letter telling you that I wouldn't meet you Sunday. I felt like telephoning you that I would, because I can meet you this Sunday if you would rather. I thought later it would be a change for you to come to Pittsfield instead of my coming to New York so let me know.

The play is going very well, and it looks as tho we might be here seven or eight weeks. I like Boston so much. I moved to this hotel now, still I like you to write to the theatre if you don't mind.

I keep thinking of you working on your book. if we do meet this Sunday bring me anything new you have written This is all the paper I have so I have to begin at the beginning. Don't forget to send me things to read especially the Liberator. I am anxious to see the German answer[47] we have to wait another week for it. I suppose Mr. Wilson still regards himself as a great man.

I think the news about prohibition looks promising despite the Baptists objecting to it. Give my love to my dear friends and don't forget to explain to Sally and Mike that Crystal did not say I was bad in the picture.[48]

Beloved I hope you are thinking of me as happily and with lots of love as I am thinking of you. I miss you all the time my beloved.

<div align="center">Florence.</div>

Postmark. Written entirely in pencil on stationery of the Georgian Hotel, Boston. Once she had filled all pages with letterhead, Florence proceeded to use the verso of the sheets but in no discernible order.

Max to Florence, Among the Girls Company, Park Square Theatre, Boston, May 22, 1919

Dearest, I suppose you were right about this Sunday. I have just overdrawn my bank account the second time, and I have paid none of last month[']s bills, so I suppose we will have to admit that for the time being we are poor. I hope you have written to me again, though I miss you and long for you so much, and your letter was so long coming.

You make Boston sound very funny. It sounds more like Florence in the days of Cellini. I hope you will never forget to bring the big stick with you.

I saw "The Jest" last night with no great pleasure.[49] Such a great quantity of *acting*, of throaty spasms and wretching [*sic*] up of the interior emotions into the face, with no moment of peace for the eyes and ears, should require a more significant and more reasonable plot. It tired me. I wish I had seen a good play.

That is all I have done but write, and go to bed, and think of ways that I might say how wonderful you are. I think that Θυμος, the Greek word of

praise is the word for you—I feel in your letter that you don't love me quite as much as I do you, so I hope you will write again soon.[50]

Did you get my two letters addressed to the company?—"Theatre, Boston, Mass" This is my last sheet of paper! Goodnight my darling—Max

Postmark. Max crossed out "The Copley Plaza Boston" return address on the envelope.

Florence to Max, Croton-on-Hudson, New York, May 23, 1919

Dearest. I called you up to tell you how much I love you and think about you all the time, then I became self conscious and thought the operator was listening.

I have moved to a hotel close to the theatre so I don't have to carry a stick anymore. Please darling don't forget to send me the New Republic with Arturo's review of your poetry.[51]

I am going out to buy you a present today. I wish I had lots of money there are so many things I want to send to you. I think it would be more fun to go to Wood's Hole [*sic*] when it is warmer.

I have your beautiful picture with me all the time, but I do miss your lovely smile I can understand how much you wanted that picture Don't forget me dearest and next Sunday we'll have another beautiful day together.

<div align="right">Florence.</div>

Postmark. Written entirely in pencil on stationery provided by the Georgian Hotel.

Max to Florence, Among the Girls Company, Park Square Theatre, Boston, May 23, 1919

My dearest love, I felt so lonely after your voice died away in the telephone. How sad that we can't be together in the sunshine of this day. I do love you so happily and long for you so sadly, so beautiful and wonderful you are.

I thought after you telephoned that maybe you can never know again how much I love you.

It is 4 o'clock and I am going in to get some liberty bonds that I secured over the telephone to get George Andreytchine out of prison[52]—then

maybe I will go to a Left Wing City Committee meeting. Things are getting so hot that it is very exciting.[53] But home early because I must feel energetic in the morning, so I can finish the first draft of my next chapter. Maybe I'll almost read you two more chapters when you come.—No, the Liberator will step in there, I'm afraid. But I've had a great week.

I'll send you the new magazine and I'll send you Sidney Lanier tonight.

My beautiful love, write to me, and save your money so we can be together. I think of you and I see you all the time.

Postmark. Written in pencil verso on Liberator *letterhead. Envelope from the Copley Plaza Hotel, with return address crossed out.*

Max to Florence, Among the Girls Company, Park Square Theatre, Boston, May 25, 1919

Darling I wrote you a mad letter[54] last night and now in the daylight I realize that I should never have mailed it. If it should come to you when you are feeling cool toward me I would die of shame, and so I don't know what to do. I hope you will open this one first and maybe you will prepare to think of the other one just as something that escaped into the daylight and send it back where it belongs—

Max

Max's letter includes a clipping from The Continent, *April 24, 1919, which refers to him as deserving "honorable mention" when it comes to English verse, likely because of his book* Enjoyment of Poetry *(1913). However, the review is in fact of another book, Harvard professor John Livingston Lowes's* Convention and Revolt in Poetry, *published by Houghton Mifflin, which the reviewer considers "the best" of recent treatises about poetry.*

Florence to Max, Croton-on-Hudson, New York, May 26, 1919

Dearest. What a terrible day this is. I am so lonely for you. I think the news about Russia is so sad, at least the Times was this morning.[55] There is a silly review comparing Lincoln and Shakespeare, and also a very funny review about the Critic in Literature.[56] Did you see Doris' picture and the article by Alice Paul, that was in the Times too.[57] You know when I read a New York paper I always feel as tho I was there.

Percy continues worse in his part. I have a terrible feeling that we will not be here as long as we expected. He goes up in his lines all the time, and is so nervous. Roi thinks he is worried about his wife, you know she is going to have a baby very soon, but I think the part is too big for him. Mrs. Mc Grue [*sic*] Roi's mother talks about Dudley a lot, she likes him, and she admires Doris.

Beloved. I wanted to buy you a present I have promised you some cups and saucers but there is nothing beautiful enough here so I ended by buying you a chinese yellow one, like the one we broke. I am sending you $30, five I owe you on my ticket.

Beloved, your letters make me so happy. please write me often even if it is only a line.

I thought I wouldn't try to buy material for curtains alone, I would rather be with you.

I would rather be with you all the time my love

Florence.

Sent registered mail. Letter written in pencil on stationery of the Georgian Hotel.

Max to Florence, Among the Girls Company, Park Square Theatre, May 26, 1919

My dearest love, how I have missed you today. Your sweet image has been in my heart continually—and your voice of laughter on the court. Darling, how I love to hear you talk. You must remember every little thing to tell me in that vivid way next Sunday.

O I am so glad you love me—my body just seemed to surge full of happiness when I got your little special delivery letter yesterday. They telephoned to me and I went down for it.

Today was our first day on the court, though we played a half a game in the rain at twilight yesterday. Today I stopped work at three and we played some doubles and singles—Mike and Dudley and I and some of Mike's liberal friends. He had quite a throng of "folks" around today, and about five hundred children. It was good to play and my "members" feel limbered up and better reconciled to their membership—but it only made the absence of your beauty and bright laughter more poignant. I can't get along very well without you, darling.

Doris has been pretty mad at me, but she's getting over it. Her brother is here tonight—tall, high-round-headed, very sharp-nosed, with Doris's awkwardness of pose. What a strange inexplicable thing family resemblance is. I should think they would be either exact duplicates or else entirely different.[58]

Last night I had Floyd and Marie to dinner, Jack & Louise[59] came in after dinner, Mike and Sallie too, and three of their liberals. Much smoke and ashes and lively unimportant talking, but there is no gay pleasure in those things without you. I can hardly drag up the interest to invite them.

Louise seems nice. Maybe she has gotten tired of her importance. I have a kind of fondness for her—perhaps by contrast with the louder and more waxy and flaxen importance of Miss Marie. Don't you think Floyd is in for a terrible disillusionment? She's a nice sensible kind girl, of course, but so doughy a vacancy of brain and countenance, and so callow an enthusiasm about herself and the surface of anything that happens to come before her.—This is all gossip which should have been spoken after the party if you had been here, and then forgotten. I was very bad to write it in a letter.

Max then continues his letter with an openly pornographic fantasy, written in the flirtatious, heavy-breathing mode he occasionally used in his dealings with Florence. It would be wrong to assume that Florence was not responsive to such musings. "You write so vividly," she responded (May 27). To the end of her life, she seems to have carried with her a sexually explicit poem, "Sweet Lovely Night," that Max had addressed to her.[60]

But I want to talk to you so much—to see your bright eyes and exchange vivid warm thoughts with you. I love you. I want you. Darling if you were here now—the yellow lights are shining just in the dark edge of twilight, and we would soon pull the curtains and lock the door, and all the sweet

quiet little house would be ours, and I would stand before you and kiss you and put my hands in your hair, and then I would try to unfasten your dress and you would help me, and your clothes would slip down, and you would laugh and put your arms around me, and I would take my clothes off too, and then I would fix the bed for you, and we would slip in there together, shivering a little at the cold sheets but warm in the touch of eachother. My lips would cling to your lips quivering, beloved; until your thighs throbbed under me, and all the warm color and wonder of your beautiful life thirsted to receive me, and every nerve and muscle of my being stood full of the fierce will to thrust in to the deeps of you. And then for madness I would leave your kiss and creep down to bury my lips and sensitive tongue in the hot salt flame of the flesh of your body, and you would find my body too, and those sweet delicate lips of your love would burn against the very intimate essence of myself, until we could bear no longer any separation, and with your eyes closed and your lip curved intensely and your white thighs open, you would lie one second til I seized and clung to you all over, and my hot muscle plunged up through you to the inmost thirsting nerve, and we were lost, lost, lost in madness of eachother's life.

Postmark. Written on Copley Plaza Hotel stationery, with return address crossed out on envelope.

Florence to Max, Croton-on-Hudson, New York, May 27, 1919

Beloved, your letter frig[h]tened me so much this morning. You said you had written a mad letter, and I misunderstood. I thought you meant you were angry.

I couldn't imagine what had angered you.

Dearest I loved your letter I read it over and over I can almost feel your sweet body close to mine you write so vividly. I would love to come to New York this weekend, but if you rather come to Pittsfield I would like that too, but not quite as much. The boats to Martha's Vineyard are not running yet. I think the two clippings you sent me are fine. I loved the one about Colors of Life, didn't you? Isn't Lowes the man who wrote the book on r[h]ythm.[61] You say Floyd is in for a (dissilution [*sic*])? I cannot understand him at all. You would think an artist would suffer with Marie around. but he evidently doesn't

We are busy rehearsing new things all the time, and my heart stops at the thought that rehearsals may keep me here this weekend. I should die. I must see you I must touch you dearest and hear you, if I am to live.

Thank you so much for the book I wanted to read it.

P.S. Darling I loved both clippings. but I am always happy when your poetry is praised.

My beautiful love. always my mind is full of your beauty of the wonder of you. There is no one else as lovely as you in the world. I am amazed at you when I see other men They are so pleased with their small accomplishments and expect the whole world to come to them, while you beloved are ever yearning for new accomplishments greater than the last, and never satisfied to the point of standing still. You are so generous in your appreciation,

<div align="right">My sweet love.</div>

Postmark. Letter written in pencil. Letterhead and envelope of the Georgian Hotel.

Florence to Max, Croton-on-Hudson, New York, May 28, 1919

Dearest. I am thinking about you with love and admiration all the time. Florence.

Postmark. Letter written in pencil on stationery of the Georgian Hotel.

Max to Florence, Among the Girls Company, Park Square Theatre, Boston, May 29, 1919

My sweet love, how I miss you today. All the little conveniences—the hot water and everything—seem so futile when you are not here. I have been digging in the garden a little and now I must go down and get some meat. I want to put this in the Post Office before it closes, because my letter yesterday didn't go out until this morning and I'm afraid you won't get it until tomorrow. I walked down with it.

How I wish we could sit at the little red table together tonight. I miss you—

<div align="right">Max.</div>

Postmark. Written verso on letterhead (first sheet only) of the Antaeus Trading Company in New York City. Mailed with next letter in Copley Plaza envelope, with return address crossed out.

Max to Florence, Among the Girls Company,
Park Square Theatre, Boston, May 29, 1919

My dearest, all my heart and mind are full of you. I love you with wonder and admiration. You are so beautiful to all passion and yet you are so noble and Greek, and your mind shines like a pure light.

Yesterday was such a day. We were beautiful gods, weren't we?

<div align="center">Max—</div>

Postmark. Mailed together with previous letter.

Max to Florence, Among the Girls Company,
Park Square Theatre, Boston, May 31, 1919

My sweetheart, your warm loving letters have made me so happy. It is wonderful that I should receive such words from you. And day after tomorrow I shall receive you—all of you into my arms. O my beloved I am waiting for that.

You will telegraph in time if they rehearse and you can't get excused so I can come to Boston. But come here to our house, my darling, if you can.

Max to Florence, Among the Girls Company, Park Square
Theatre, Boston, Massachusetts, June 4, 1919

My sweetheart, I'm sending this special delivery in the hope you will get it tomorrow night. It is already too late for it to go out tonight.

I worked in town until 9 o'clock Monday, and today I worked at my desk until 5:30. Then Hutch Hapgood[62] came to see me, and I lost my last chance to send you my love tonight. I've been thinking of you with the sweetest happy thoughts, my love, and I am longing for next week when I will not be alone any longer.

Didn't we have a lovely day Sunday—and we will have so many of them!

I am not so happy this week because I am working on the magazine, and my heart is not there. It will not go back ever as it usually does. I guess I've become an author for good.

Goodnight, sweetheart. This is not a letter but just a word out of my thoughts of you—

Max.

Postmark, sent "Special Delivery." Copley Plaza Hotel envelope. Stamp illegible, but special delivery fee shown to be paid on June 4. Later note by Max: "My attitude to The Liberator 1919."

Florence to Max, Croton-on-Hudson, New York, June 4, 1919

Dearest. I just finished the "Soul of Ann Rutledge"[63] it is a very sweet book and she draws a lovely picture of Lincoln in it.

Sidney Lanier arrived and I read The Revenge of Hammish [*sic*][64] I have read it before in a book I had at school. I haven't had time to read anything else so I can't tell you what I think of him.

The trip back from New York was long and hot. I was coal black when I arrived, and I had to go to the theatre for a short rehearsal.

It has turned very hot here, almost as hot as those days last summer.

Dearest I was so happy Sunday. we had such a beautiful day together My heart is full of you and I am longing so for the end of the week when I will see you again.

Florence

Stationery of the Georgian Hotel in Boston. Letter written in pencil.

Florence to Max, Croton-on-Hudson, New York, June 5, 1919

Dearest, this is the only piece of paper I have, so I am writing small. I was thinking that until you rent your apartment I would rather you didn't get another place. I can stay with Caroline any time I want to. I feel like being in the country for a little while I am so tired of the hot city. You know I missed the whole beautiful Spring. I cannot tell you beloved how lonely I am for you. I want to play in the sunshine with you. I have read in the

papers about Dudley's case. He is a strange man to me, how can he want to handle a case like that?[65] I suppose Doris is happy about the Amendment.[66] I'll see your beautiful self Sunday on the minute of 3:36.

<div align="center">Florence.</div>

Postmark on stationery of the Georgian Hotel. Letter and envelope written in pencil.

Max to Florence, Among the Girls Company, Park Square Theatre, Boston, Massachusetts, June 6, 1919

Darling, I am using my last Copley-Plaza envelope to send you this letter. I'm writing it on the train to New York with my finished editorials, I'm all tired out.

Your little note came today. It was sweet but your voice was sweeter. I will be at the Manhattan at 3:36 Sunday.

Here are some clippings[67]—the little one to show you what good company I keep in your absence. Bring home the big one as I want to keep it.

Dearest love, I am tired. I wish I could lay my head against your shoulders.

Until Sunday—beloved.

<div align="center">Max.</div>

Postmark on Copley Plaza envelope, with return address crossed out. Written entirely in pencil.

In June 1919, Samuel Goldwyn hired Florence Deshon for his studio and along with a formal contract included this handwritten note:

> Dear Miss Deshaunt
> You are to start for our studio not later than August first, 1919, and you are to begin work not later than August 8, 1919.
> Samuel Goldwyn[68]

The letter features an early example of Goldwyn's chronic inability to get other people's names right. The timing, coming soon after Among the Girls *closed in Boston, suggests that the Selwyn brothers, who had produced*

*the play, might have wanted to do something for Florence. "Everyone who knew Florence felt certain that this was the beginning of a quick rise to fame. . . . On July 9 she boarded the train that was to carry her to glory, and I redoubled my efforts, which were perennial, to organize the magazine [*The Liberator*] in such a way that it would run without too much attention from me"(*LR, 159).*

Samuel Goldwyn has been called many things, but he must be given credit for one thing: he always strived for excellence. And despite his lack of education, he understood and believed in the necessity of good writing in the production of good films. His problem was that, in 1919, he did not have the sophistication or the expertise to make this belief bear fruit.

In some ways, circumstances dictated his emphasis on story. For one thing, Goldwyn had no big stars. This was probably in part because he could not afford the likes of Chaplin, Fairbanks, or Pickford. But in not trying to find alternative faces that the public liked, he made a big mistake, because, starting with Florence Lawrence, the "Biograph Girl," back in 1909, the audiences had continually demonstrated that they wanted stars. Goldwyn went in the opposite direction. He decided that if he had excellent writing in his films, he was assured of first-rate productions. This was not necessarily a bad idea, and when Goldwyn replicated that strategy in the sound period with writers like Lillian Hellman and Robert E. Sherwood, he produced some of Hollywood's greatest films. But in 1919, his original approach just did not work. He started the "Eminent Authors" series, hiring such famous writers as Rex Beach, Mary Roberts Rinehart, Rupert Hughes and others, and several installments of the "Eminent Authors" series featured Florence. But aside from Rex Beach and Rupert Hughes, many of Goldwyn's "eminent" authors knew little about film writing: hired at exorbitant salaries, they produced laughable screenplays, which were then doctored into at least usable scripts by a hack writer on the studio payroll.[69]

Nevertheless, Rex Beach admired Goldwyn and felt that Sam was about the only Hollywood producer who gave writers a fair shake:

> I had heard stories about Samuel Goldwyn; how tempestuous he could be, how ruthless were his methods and how hard it was to get along with him. Enmities inside the industry were open and bitter in those days, rivalry was merciless and competitors spoke nothing except evil of each other. There was but one honest man in the business and he was the one to whom you were then speaking: the others had their fingerprints on file at headquarters, removed their brass knuckles only to eat and carried a length of lead pipe in each sleeve. Mr. Goldwyn was a wolf in Schanz's clothing, he was harder to handle than an electric eel and it was more dangerous to fool with him than with a pocketful of loose razor blades. In view

of these reports I feared that he and I would never link arms and sing "Sweet Adeline."

Luckily, Beach turned out to be wrong:

That human cocklebur, that porcupine of pictures proved to be about the fairest, squarest, most agreeable business associate I ever had, and I took a great liking to him. I admired him, too, for he was amazingly quick in his thinking, he was daring, resourceful and enthusiastic: nothing was too big for him to tackle. No bulldog could have been more tenacious and although he took some cruel business beatings I never heard him admit that he was hurt. One or the other of us must have been easy to get along with for we never had an argument. There was no friction whatever. It was a state of affairs the credit for which I suspect was due more to him than to me.

Who would have expected Goldwyn to be a champion of writers?

He revealed other characteristics at complete variance with his popular reputation. Even at the time I write of, the industry was clamoring for better pictures and undertook to get them by hiking the salaries of stars or directors and building bigger sets: Sam clamored for better stories. He was the first mogul in the business to recognize the importance of writers and to offer them real encouragement. He treated them, so far as I know, with the same generosity, fairness and consideration that he afforded me and although he was denied the early advantages in education and training by which many of his contemporaries profited, none of them is responsible for more fine, artistic, worth-while productions than he.[70]

There have been various explanations for Goldwyn's offer to Florence. The most common is that Charlie himself asked Goldwyn to hire her. Charlie and Goldwyn were friends, at least at that time, and in fact, Charlie had met Mildred Harris, his first wife, at one of Goldwyn's dinner parties.[71] In addition, both Chaplin and Goldwyn were independent producers and thus in the same boat. Goldwyn was already distributing his films through United Artists, and Charlie, a founder of United Artists, planned to distribute his films through them once he had finished his obligations to First National. That said, Charlie did not meet Florence until after she arrived in Hollywood in July, although Charlie had already met and befriended Max.

But it is also possible that the Selwyn brothers recommended Florence to Goldwyn. As already noted, Florence had featured in The Girl and the Pennant *and* Among the Girls, *the musical version of* Seven Chances, *which died in Boston, all of them Selwyn works. Or it may be that Goldwyn was impressed by Florence's performance in* The Auction Block, *which he had distributed, and decided not to lose her.*

Florence left New York and Max in July 1919. After spending a few weeks in Los Angeles, she moved to Hollywood, first into an apartment at 1824 Highland Avenue and, by the end of the year, into the apartment in which she lived for the majority of her time in Hollywood, 6220 De Longpre Avenue, right around the corner from Sunset Boulevard. The Los Angeles City Directory *listed her as a "photoplayer."*[72]

Los Angeles made her unhappy, and the presence of her mother, who had come along, added to Florence's misery. But, a worshipper of the sun like Max, she enjoyed living in Hollywood, which to her seemed like a summer resort filled not with tourists but interesting, hardworking people. And she loved her dressing room in Culver City, with its sun-yellow walls, green floor, cream-colored furniture, and multicolored curtains—a promise of the wonderful career that seemed to be waiting for her.

In September 1919, Max arrived for his first visit and introduced her to Charlie Chaplin.

Florence to Max, Croton-on-Hudson, New York, July 9, 1919

Dearest. I tried to rush through to the last train, to see you once again and throw you a kiss, but it was a diner, and I couldn't. I felt so sad, it seems I am going so far away. I am so afraid you will get lonely and fall in love with somebody else.

There are four actors on the train that I know slightly they are going to Los Angeles to play in a picture. I haven't spoken to them yet. I don't feel like it.

Dearest I forgot the make up I bought could you mail it out to the Goldwyn Studio, I will need it as soon as I arrive, don't be afraid to send it. I am not going to change my make up. but I will feel better if I have it in case I have to make up a little lighter on account of being so tanned.

Beloved think of me, I am thinking of you, loving you and missing you so much. Only the trip to China is keeping me up.[73] Florence.

Postmark.

Floyd Dell had given Florence a book to read for the trip to Los Angeles, a lurid new novel titled Peter Middleton, *by Henry K. Marks, the story of a man who, temperamentally weak though not really evil, during a single night of indiscretion, contracts syphilis and, years later, ruins not only his life but also that of his new wife.*

It is also possible that he had recommended another, weightier book that Florence carried in her luggage, Robert Burton's Anatomy of Melancholy *(1621), not exactly light reading for a train ride. A few years later, Floyd would coedit an edition of* Anatomy *for Farrar & Rinehart (1927). In his introduction, he described Burton as a precursor to Freud and argued that a modern equivalent of the book's title would be* An Analysis of Morbid Psychology. *The reason why the book would have seemed appealing to Florence is clear from Dell's summary: "Here, drawn from history, poetry and legend, is a pageant of all the mad lovers of the world. Erotic psychology is set forth in its wealth of familiar symptoms—leanness, waking, sighing, fear, sorrow, suspicion, wantonness, strange actions, gestures, looks, speeches, locking up, outrages, severe laws, prodigious trials, despair, madness, frenzy, murder, suicide—and illustrated with a thousand anecdotes."[74] In other words, a book right up Florence's alley.*

Florence to Max, Croton-on-Hudson, New York, July 10, 1919

Dearest. This is all the paper I can find. I have just boarded the train for Los Angeles and I thought perhaps I could get a letter off to you before we start. The trip was very comfortable from New York and from here we have a compartment and it promises to be fine. I am steeped in melancholy. I am so lonely for you. apart from all your charm dearest you are so beautiful to look at and to touch. I hope there will be a letter in California for me. I finished reading Peter Middleton the book Floyd sent me. It made me so sad. I cannot bear to read stories about diseases, it frightens me. Writers take such pleasure in hiding it for 289 pages and then suddenly springing it on you with a sort of There ever you might have it. you never can tell. I'll never read another.

I bought the Anatomy of Melancholy, did you ever read it. It looks interesting. I have always been curious about it, ever since I read Keats['s] biography.

There certainly ought to be some kind of a revolt in Chicago. What a horrid city. It seems very far indeed from anything beautiful or happy.

Give my love to George and Sally and Mike and Doris and Dudley. also remember me to Marie and Floyd. Good night beloved. I love you.

[*Added at the bottom of the sheet:*] It isn't very nice writing, but that's because I was in a great hurry.

Postmarked in Chicago. Written on Western Union paper.

Max to Florence, c/o Goldwyn Studios, Culver City, California, July 10, 1919

My darling, my beloved, it seems incredible that you have gone so far away. I could not go back to the house after I left you. I rode around the country crying like a child—it seemed I couldn't bear to see the empty house. And when I did come how terrible it was—nothing, nothing of my darling's presence and all her beautiful ways of laughter—only the most heart-breaking memories of your motions thronging upon me. George came over to ask me to go up to Jack Reed's, and I could only shake my head. He put his arm around me with sweet affection and told me I would see you soon, and then I went up in the meadow above the big houses and wallowed around for a long time in that strange misty wind, and felt that you were thinking of me, and that our hearts were together and nature was friendly to our love. I realized that I am glad I love you so greatly and I can suffer so much, and so I smiled a little with the waving trees and came home to my lonely bed.

It was more terrible to wake up. I was lost when I woke up, and in the bathroom I could hardly see the use of going through all those motions. The thing I cannot stand is to look into that bare closet where our clothes were always so intimate and friendly together. How I wish I had asked you to leave a few more things—that little shimmy-shirt[75] is so frail.—Dearest, I have come to my desk and I am trying to find the thing that will sustain me. It is here, I suppose, but I can't find it. I am just all full of tears and longing.

<div align="center">Max</div>

Postmark. Marked "Personal" on envelope. Later note by Max: "First letter to Hollywood."

Florence to Max, Croton-on-Hudson, New York, July 11, 1919

Somewhere in America.

Darling. I read a good deal in Florence Wilkerson [*sic*] book yesterday.[76] I like her choice of poetry a good deal better than other anthologies I have read. but her opinions about poetry are not very original or interesting to me. they are just nice In her love poems she thinks Sara Teasdale ranks the highest. But to me her love poems are unhappily feminine, too eager to surrender they seem to me. I would almost suspect Sara Teasdale had never had a love affair.[77] Her face is unattractive to me. Nothing strong or noble or alone about it. Florence Wilkerson quotes from your Enjoyment of Poetry she praises you very highly. I think she is with you on your attitude on free verse.

Today it is very hot but it is still comfortable. So far there is nobody I feel like talking to I had a little chat with my actor friends, but it was pretty hard work they are so conceited. They are a handsome bunch of men, but that lets them out. I have three grand new words but I don't know what any of them mean. I'll take a chance with one. Here goes

The manifesto issued by the French working class seems like a *Feminarchy* to you—but I do not feel that way about it.

Be sure dearest to send all the make up I left in the car. I wrote you about it. I hope you got the letter, because I cannot get any make up out here.

I hope you are busy working, because I want you to come to see me as soon as your book is finished.

I am reading your article "The New Internation[al"] of course it is out of my class.[78] But I shall try to understand it.

<div align="right">Florence</div>

I miss you so much.

Letter postmarked in Dodge City, Kansas.

Max to Florence, c/o Goldwyn Studios, Culver City, California, July 13, 1919

My darling, I am so lonesome. O I am so lonesome. Somehow it seems sad and terrible and not right that you should be way off there and all our summer cut off.

I was so busy Thursday and Friday and yesterday—day and night that I kept my sadness a little at bay. Floyd and I made up the magazine in the big room Thursday until 3 A.M. Friday we worked at the printers until 12:30 A.M. and again in the morning. I slept on Eugen's couch up on 59th St. Then I brought them all up here in the car, Floyd, Eugen and George, about 4 in the afternoon. Eugen is attending a "House party" at Dudley's—two flat and sweet ladies and a gentleman. I asked Doris who they were, and she whispered "I never saw them before, and I hope to God I will never see them again." Dudley certainly gathers the noisy and shallow dames.

Beloved I was so desolate when I came back to the vacancy of the little house, and I didn't find your letter for a long time because it had been pushed under the kitchen door. Then when I found it and you said you were "steeped in melancholy" I didn't know whether to feel better or worse. But I did feel better, because I wanted you to be as sad as I was. And it is always so sweet to me when you tell me I am good to look at. I know you had been talking to other men, and you liked me better.

Sweetheart I hope you will try to tell me in your letters what you have been doing. You always tell me so much when we meet, and so I participate in your life, but now it will be too long to remember and you must try to make your letters more like a story as I do mine.

Your letter from Albany came *the next morning*. I had already set the things out to mail for you, and they went that afternoon. The hat I took to Peggy Hoyt's Friday morning.[79]

Now I must try to find my book again for that is the only way I can bear the loneliness. My beloved, how I want you here. How I love you.

<div align="center">Max.</div>

Please date your letters the day of the week and month—so I can imagine better.

Postmark.

Upon their arrival in Los Angeles, Florence and Caroline checked into the Hotel Alexandria at 501 South Spring Street, the most luxurious establishment in town and—thanks to its ornate lobby—the site of countless film shoots in the decades to come. It was in the dining room of the Alexandria that Charlie was introduced to Jackie Coogan, his four-year-old sidekick in The Kid, *Charlie's most successful film, which he began shooting in August of that year.*[80]

Florence to Max, Croton-on-Hudson, New York, July 14, 1919

Dearest. I wanted to wire you as soon as I arrived, but I thought perhaps you had gone on your sailing trip, and so you wouldn't get it. I arrived last night and I went to this hotel as it was the only one I knew about. I am only going to stay here until I find a bungalow. Our studio is in Culver City and that is too far away from Hollywood where I really want to live now that I am here. I think perhaps I will find a place on the outskirts of the city.

I do not seem to get over my depression and I think Caroline makes me feel that way. and then of course I feel so lonely for you. It seems so many days since I have kissed you. it is sad to wake up in the morning and not feel you are near.

I met Mr. Sherrill[81] in the lobby this morning and he lent me his car to go out to the Studio, which is beautiful. Everybody was charming to me, I liked them all. I have a lovely little dressing room. It['s] like a little cottage.

The stenographer there is a girl I met at the "Masses" Ball, the night I met you. I couldn't remember her but I was glad to see her. I haven't felt a bit well since I left New York, but I guess that will pass as soon as I get to work.

I hope you have sent my make up as I expect to start work this week

I read some of my friend John Milton last night and I felt happier for a little while. I like Joan of Arc. I think Mark Twain loved her, she reminds me of Lenin whenever she speaks, she is so truthful[82]

Write to the studio just now as I may leave here any day.

I am going to save all my money and work very hard to get a raise before the year is over I know I can do it. I [am] really planning all the time for the time you will come out here. I read all the papers but there is very little news of the East in them so you must send me clippings

It is hard to be so far away from you, but dearest we will both work hard and have a lovely time when you come to see me.

All my love is for you my beloved. Florence

Postmark. On Hotel Alexandria stationery.

Max to Florence, c/o Goldwyn Studios, Culver City, California, July 14, 1919

Darling, I am too lonely and too sad. I don't know what I shall do. I think I shall have to go away from this house until I can come to you. Everywhere is your absence, everywhere the thought of your coming. When the telephone rings my heart jumps thinking it must be you, and then it sinks again

Your lovely letter came, telling me what you think about Marguerite Wilkinson's book. It is just what I think about her, and it is very lovely writing—especially what you said about Sara Teasdale's face.

If you will write me letters like that—what you think—and then also what you *do*—I will be able to stand it better. I think you are in Los Angeles now, and perhaps you have found your house. You must surely tell me everything.

Yesterday after some tennis in the morning we undertook to go sailing—Eugen, George, Jack and I—but there was no wind. We loafed on the boat and went swimming, but I was blue. I don't like to sail without wind or fish when they don't bite. In those two respects I am not romantic.

Eugen couldn't go on the cruise now, and I didn't want to go with Jack alone. He depresses me too much. So I told him I was immersed in my book (I wish I were!)

The truth is I dreaded it a little with Jack along anyway, and was glad we couldn't go. Eugen & George and I are going for a little cruise Friday, I hope.—You won't misunderstand: I'm fond of Jack but his impersonality, his conversational remoteness has a terribly depressing effect on me.

Eugen wants to give Art 50 a week for a few months, since Good Morning is gone under (He, by the way, is the one who put up most of the money for Art) so he is going to give it to me, and I'm going to ask Art to go to Washington for the Liberator.[83]

I borrowed 200 from Eugen and I'm not paying any bills that I don't have to, so don't be worried about me, but save your money just the same, darling. And don't be experimental about your beautiful, beautiful gipsy

color on the screen.[84] It is the color of passion and wonder, and it is the color of you.

I have moved my precious bed into the barn, in place of the Kipps bed,[85] and I sleep there. I sleep *here*, for this is where I am now, in the after supper light, and where I have been all day, not doing much but tinkering with my thoughts, noting and philosophating (that is my new word). I still wait for the inspiration.

My darling, how I miss you—
Monday Eve, July 14

Postmarked July 15.

Max to Florence, c/o Goldwyn Studios, Culver City, California, July 15, 1919

I'm so sorry, darling, this must have slipped out of your package. I just found it in the bottom of the car—

Postmarked July 15, dated July 16. On Liberator *letterhead. Letter in pencil.*

Florence to Max, Croton-on-Hudson, New York, July 16, 1919

Please write to the studio.

My dearest. I was so glad to get your letter. It was like touching you. Darling I envy you so, you can bring yourself right to me in a letter, you write so well. I start work tomorrow in a play by Pinero called "Letty". Pauline Fredricks [*sic*] is the star but I have a lovely part. I play the part of a shop girl in England, her best friend. I still feel very lonely, so I am going to stay on at this hotel a little longer. I went looking for a bungalow yesterday in Hollywood. I saw one that made me cry. it was as lovely as our little house, just three rooms and a kitchen, but I couldn't live in it with Caroline. She feels she would rather be in the city, because she likes to go to the movies. I finished Joan of Arc. it seems as tho the French wouldn't be able to forgive England she has treated their two greatest idols so cruelly. Joan and Napoleon.

I am always thinking of the time you come to see me. We can hire a Ford out here for very little money so we can ride to all the beautiful places near here.

I have closed my eyes and brought your sweet face near me and kissed you.

On Hotel Alexandria stationery.

The Loves of Letty *(1919), based on a play by the English actor and playwright Arthur Pinero, was Florence's first Goldwyn film. Directed by Frank Lloyd (fig. 2.7), the movie starred Pauline Frederick (1883–1938), a seasoned stage actress who had made her film debut in 1915. (Her best-known role would be the part of Joan Crawford's mother in* This Modern Age, *1931). Florence liked her part, and Frank Lloyd was, she told Max, "lovely." She had been cast as Letty's best friend, Marion Allardyce (figs. 2.5, 2.6), a down-to-earth London shop girl. Unfortunately, Frederick barely talked to her, out of jealousy, as Florence suspected. Although they didn't look much like each other, Frederick's facial expressions made her appear as if she were Florence's sister, a resemblance Florence did not find encouraging. "I don't feel a bit happy here" (Florence to Max, July 16, 1919). If Frederick did not like Florence, she had the ability to make real trouble for Florence at the studio. Evidently, she was a prima donna whose ridiculous demands drove Goldwyn crazy.*[86]

Miraculously, one copy of The Loves of Letty *has survived, although it is in rather poor shape.*[87] *Titled* Tentations, *the version held at the Academy Film Archives in Hollywood is the French release, and the intertitles are in French, too.* Tentations *has a complicated plot, made even more incomprehensible by the French adaptation. But one thing is clear: Frederick would have had little reason to be jealous of Florence, since the film is almost entirely focused on her character.*

Frederick's Letty finds herself entangled in multiple relationships: with a married man, separated from his wife, whom she thinks she loves; with her rich, frog-like boss, whom she doesn't love but who wants to propose to her; and with a man she doesn't yet know she loves. Her desire for Sir Neville Lechmere, whose ominous name already suggests that he's trouble, induces Letty to invest in her wardrobe rather than her meals, with the result that she faints from sheer hunger. Marion Allardyce, the character played by Florence, rushes over to revive her. As it happens, Marion is both Letty's friend and

"A Lovely Place to Work?" (1918/1919)

127

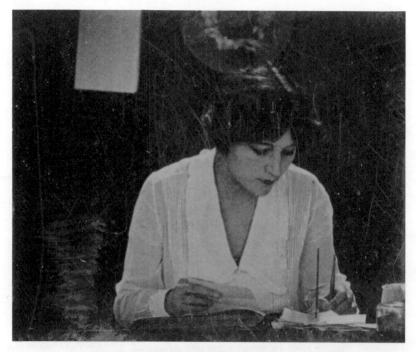

Figure 2.5. Film still from *The Loves of Letty*, 1919. Florence Deshon as Marion Allardyce. Deshon mss. Courtesy, Lilly Library.

Facing, **Figure 2.6.** Film still from *The Loves of Letty*, 1919. Florence Deshon as Marion Allardyce. Deshon mss. Courtesy, Lilly Library.

roommate, in a rather lively boardinghouse community. An independent woman, she has no need for a lover and knows how to provide for herself. In fact, in her first extensive appearance in the film, she can be seen cooking a rather tasty-looking dinner for herself.

Frederick clearly dominates the screen, though Florence is frequently at her side, engaging in the usual eye rolling, head shaking, and hand holding that one would expect from a silent movie star. But she clearly identifies with her part. Marion's concern for her friend is evident and entirely believable—she worries when Letty agrees to marry her boss, and she is equally concerned when, after a disastrous dinner intended to celebrate the engagement, Letty does take off with her married would-be lover. In despair, Marion announces that this will destroy her relationship. Fortunately, she doesn't really mean that. In fact, Marion precipitates the film's happy ending. She tells Mr. Perry, the man who is genuinely in love with her friend, that Letty has run

Love and Loss in Hollywood

away with the sinister Lechmere. This prompts Perry to look for Letty, whom he finds on the street, in a state of collapse. He takes her in, and the last scene is set at the country estate of Mr. Perry's mother. Turns out that Mr. Perry wasn't so poor after all.

Throughout the movie, Florence looks stylish and graceful, if slightly somber and pale, her heart-shaped face emphasized by the hat she wears for the failed engagement party. Tall and slim, she towers over the shorter Frederick. Her dark eyes burn themselves into the viewer's mind; ultimately, they make her character more mysterious and inscrutable than Frederick's rather transparent Letty.

Not surprisingly, The Loves of Letty *came to occupy a special place in Florence's portfolio: "There is never a moment I look strange like I sometimes did in Vitagraph pictures," she said, remembering the studio she worked for before she met Max. "I always look like myself"(Florence to Max, September 4, 1919).*

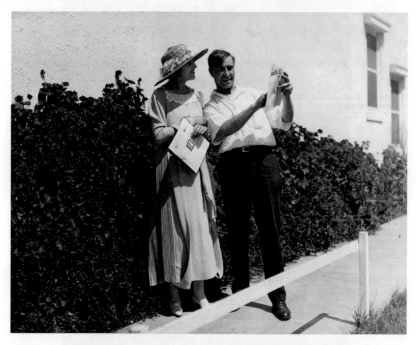

Figure 2.7. Frank Lloyd, director of *The Loves of Letty*, reading *The Skeleton*, the Goldwyn Studio newssheet, to Florence Deshon at the Culver City studio, Culver City, California, ca. 1919. Courtesy, Kevin Brownlow.

Love and Loss in Hollywood

Max to Florence, c/o Goldwyn Studios, Culver City, California, July 16, 1919

My darling—I am just homesick for you. It is terrible to be left behind. I just sent you a telegram. I hope you have my letter. I know you are so excited you are not thinking about me.

I am in the library now. This afternoon I am going out to Betty Hare's with Maurice Sterne.[88] Last night I had dinner with Art and arranged to send him to Washington.

Sally wants me to go down to Martha's Vineyard, but I think I'd be terribly lonesome with those people.

Darling, how I wish we were going there. My sweet love, I am so very lonely—

Max.

Originally dated by Max "Wednesday, July 16," with the 6 crossed out and replaced with a 9. But the postmark indicates July 16, which was indeed a Wednesday. Written in pencil on ruled paper.

Max to Florence, c/o Goldwyn Studios, Culver City, California, July 18, 1919

Thursday night—

My sweetheart,

I have no letter from you tonight and I am very sad and lonesome. Everybody says "Why, hasn't she telegraphed to let you know she has arrived?" Well, I wouldn't expect you to unless you felt like it, but I did want a letter. I'm afraid you forgot me after you went over the mountains.

I came home from Betty Hare[']s this evening. Anna[89] wasn't here, George is away too. I'm very lonely.

Isn't this a sweet letter from the boy who gave me those Hungarian poems "*with* a revolutionary affection"?[90]

Max

Although the postmark identifies the letter as sent on July 18, 1919 (a Friday), Max's own note ("Thursday night") reveals it was written on July 17. Written in pencil.

Florence to Max, Croton-on-Hudson, New York,
July 19, 1919

Saturday night, July 9, 1919

Dearest. I tried to telephone you tonight, as I wanted to hear your voice. but the lines to New York were busy and I knew it was getting too late. I can speak to you after 8:30 for about $7.00 but of course that is 11.30 in New York. I worked again today out at our beautiful studio. I have a lovely part in this picture and a lovely director. Miss Fredericks is a little jealous of me, and doesn't speak to me very much. It is very curious our resemblance to each other. She looks nothing like me really, yet there is a very similar expression which makes her look as tho she might be my sister. I don't like Los Angeles. I don't feel a bit happy here. I only wish you could come out right away and be with me. I wish it were possible for you to finish your book out here.

Everything is very expensive out here, except food. which reminds me of Ben Hampton. I am going to see him soon.

I read the N.Y. Times about five day[s] late, so I saw the article about you and Bob Minor.[91] I must say his actions are very puzzling. at one time to denounce the Bolchivists [*sic*] and at another to risk his life for them. The people out here had so much fun before prohibition but I think they are rather hard up for fun now, as everything seems very quiet. The beach is beautiful but I haven't been in swimming yet. I want to fly over to Catilina [*sic*] Island[92] with you when you come. I hope you won't have been up before.

I think about you all the time. I am longing so much for the time we will be together.

I feel terrible sometimes, I feel you will fall in love with someone else and not come and see me. I shall save all my money until you come and then we will play and have such fun.

I am reading the Anatomy of Melancholy, or at least those portions written in English I like it. He mentions a book by "Anthony Zara Pap Epis. his Anatomy of Wit." did you ever hear of that.[93]

Beloved you never told me whether you went sailing with Eugene. It is strange to contrast the papers. The Eastern or New York papers are full of the Red Terror, while there is never a word about it in the papers out here.

I am writing to you dearest as I talk to you in the evenings in our little house.

I am telling you about everything. Do you expect to be called before the Lusk Committee.[94] It scarcely seems possible they will really have that investigation.

Caroline wants to know if her barrell [sic] arrived. and I received my make up. Thank you.

Darling, do not forget me. How I wish you were here. I am not a bit happy when I realize how far away you are. Oh come to me soon my beloved.

Postmarked July 20. On Hotel Alexandria stationery. Note Florence's effort to date the letter, after Max had admonished her to do so. She fills the recto of the pages, then uses the verso going backward, a confusing method.

Florence to Max, Croton-on-Hudson, New York, July 20, 1919

Darling. I wanted to ask you what you think about Marie[95] writing me some letters to some of her friends out here. I get awfully tired of talking to professionals, they don't talk about the things I care about anyhow.

Darling. Each day I wish that you were coming tomorrow. The mornings are so sad, when I wake up so far away from you. Florence.

Postmark. On Hotel Alexandria stationery.

Max to Florence, c/o Goldwyn Studios, Culver City, California, July 20, 1919

My darling, nothing can tell you how the flowers and your little message brought warmth and color and all the wonderful happiness of love back into the deserted house. I have carried them with me everywhere. For some reason I felt that you had stopped loving me and that you weren't thinking about me anymore. The card with the beautiful Indian, who George says looks like me, came the same morning.[96] I hope he looks like me. At least I am trying to look like him, and for that purpose I've pinned him up beside the mirror on the bath-room wall. If I had that mouth I'd be a great Indian.

George's Indian looks like him too. Sallie was very pleased to have your card. I've asked George to stay with me while Sallie & Mike are gone.

Eugen is here today, and I've asked Sallie & Mike & George to dinner. It rains—rains—rains—and the mist is so thick the raindrops fall slowly through it. And so it has been for days. I never saw anything like it outside of the tropics and I never saw the tropics.

I send you a clipping to show that Villard[97] and I are having some fun. He called me up the morning this came out with a tone of voice like a mischievous school-boy.

I'm afraid the general strike in Europe is not going to happen, but other things look hopeful. We must reconcile our hearts to all fluctuations—years and years of them. I believe Koltchak[98] is about licked, and if he is—then the Allied betting on him was a good thing. So we can hardly tell when to be glad and when to be sorry. Always to be resolute—that is all.

I love you, my darling.

I love you all the time

<div align="right">Max.</div>

Postmark. Written in pencil.

Florence to Max, Croton-on-Hudson, New York, July 21, 1919

Darling. I am so wretchedly unhappy. Why I brought Caroline with me, I don't know. she is driving me mad. She interferes with everything I do, until I am almost insane. Then when I make the least effort to save myself she gets furiously angry at me, and curses me and my selfishness terribly. I know I have been unkind to her, but there is no test or sense to your feelings as to be away with someone you don't really care for. She comes to the studio, so that even there I have no time to myself. She says she is going back to New York as soon as you come out here, but I don't believe her. It[']s true I brought her here, she says she didn't want to come, but now I know it was a terrible mistake. Dearest I hope you understand and do not think too harshly of me. I feel so sad.

Your letter made me so happy. I like you to tell me all you are doing and thinking. I am sorry the book is not going so well, because my happiness depends on your finishing it soon and coming to me.

I have put on a lighter make up than the one you are used to but they say you have to working in this sunlight, even the men use it. I worked again today. I must say I like the studio and I am going to move to a lovely little dressing room some day this week, a better one than I have now.

There is one thing you can cheer yourself up about. I certainly won't buy any clothes out here. there is nothing attractive, I wear my green sweater with a white shirt, mostly all the time. Everybody admires it, it looks so pretty in the sunlight.

What do you think of my taking a flying trip to New York. I will lose the salary while I am gone, but it almost seems to me as tho I must do it. I have such an unsettled feeling. It would be cheaper if you did it darling, because then I could draw my salary every week. Tell me what you think about it.

Oh my beloved, my heart longs so for you. you are so lovely, it is hard to be so far away. I want to be with you.

<div align="center">Florence.</div>

Postmark. On Hotel Alexandria letterhead and envelope.

Florence to Max, Croton-on-Hudson, New York, July 22, 1919

At the Studio. Tuesday afternoon.

Beloved. The brightest spot in my day is your letter. I almost wish you could write every day. it makes me so happy. I haven't felt a bit well since I arrived here, and I think it's because I left New York so hurriedly. I play with [the] idea of a flying trip, it cheers me up. I bought a biography of Milton, it isn't so good as the author is so stingy in his praise. I think dearest the reason I feel so fond of Milton is that he reminds me of you. I do not mean his struggle between passion and puritism [*sic*]. I think you have been more victorious in that than he was. But he cared so much for perfection. And then too he cared so much for the truth. I like to read his poetry. I like it more every time.

Weren't you shocked at the race riots? Down in Washington Doris and Sally and I were playing with the (Weegee?) board[99] and it said that when the blacks came back, they would burn the senate, we were all surprised and I believe a little scared. I'm sure Doris and Sally will remember it. I have seen the Liberator in a couple of book stores out here. What news do you have from Crystal, when is she coming home.

I think of you all the time beloved and I miss you, sometimes it seems impossible to stand it. I telegraphed you some flowers last week, did you

get them? Dearest I am very happy in my work down here, the sun shines so beautiffully [*sic*] still it is never hot, always there is a breeze, it is really an ideal summer resort. Perhaps by this time dearest you are caring about your book again. I think it is lots of fun we are both so busy and beloved we won't be apart long. we'll see each other soon, very soon. I am perfectly free to come and go any time I choose, now that I know that I feel ever so much better. I haven't seen myself on the screen yet, but I expect to tomorrow. I'll tell you all about it.

Louis Sherwin is a scenario writer out here, Do you know him.[100]

Everything about this company is so high class. I feel I have a much better chance than I have ever had before.

Darling do not forget me. Do not get tired of wanting to see me. I'll come to New York if you do. Florence

Dated by Florence. Written entirely in pencil on Hotel Alexandria stationery.

In April 1919, Crystal Eastman had moved to England with her British husband, Walter Fuller, and their two-year-old son, Jeffrey. In practical terms, this meant that Max was left to his own devices when it came to The Liberator. *Crystal was desperately unhappy in England, where the seasons seemed identical and people were undemonstrative,[101] although she did manage to slip away to attend the Second International Congress of Women in Zurich, Switzerland (May 12–17). While she had plans to travel to Russia, she probably was easily convinced when Max, eager to join Florence in Hollywood, urged her to return home to take charge of* The Liberator *in his absence. On October 20, 1919, Crystal, Walter, and Jeffrey were back in the United States.*

Max to Florence, c/o Goldwyn Studios, Culver City, California, July 22, 1919

I WORRY CONTINUALLY ABOUT YOUR CHANGING THE
MAKE UP YOU USED IN JAFFERY AND AUCTION BLOCK
YOUR COLOR WAS EVERYTHING IN THOSE PICTURES
THEIR SUCCESS HAS BROUGHT YOU THIS OPPORTUNITY
WHY TAMPER WITH ONE OF THE CHIEF ELEMENTS OF

THIS SUCCESS YOU ARE LESS TANNED NOW THAN YOU
WERE THEN IT SEEMS IMPRACTICABLE TO THE POINT
OF FOLLY TO EXPERIMENT WITH SOMETHING THAT
WAS ABSOLUTELY PERFECT TO ALL EYES JUST BECAUSE
YOU SAW A PICTURE OF A TOTALLY DIFFERENT TYPE
IN A MAGAZINE I KNOW YOU ARE SUBJECT TO VERY
UNREASONABLE AND COMPELLING WHIMS ABOUT
YOURSELF AND I HAVE TO WARN YOU AGAINST THIS ONE
FORGIVE ME LOVE

M.

Western Union night letter.

Max to Florence, c/o Goldwyn Studios, Culver City, California, July 23, 1919

I THINK YOU WILL NEVER BE HAPPY IN THAT TOWN WHY
NOT CAROLINE HIRE ROOM NEAR BROADWAY GO IN
ALL THE TIME ITS NO FURTHER THAN BRONX SHE HAS
NOTHING ELSE TO DO YOU HAVE YOUR WORK AND CARE
YOU MUST BE SELFISH AND DOMINATING I MISS YOU
TERRIBLY LOVE

M

Western Union night letter.

Florence to Max, Croton-on-Hudson, New York, July 24, 1919

Beloved. When I read your letters and realize how lonely we both are, I
am impatient that anything keeps me from you. I will never like it out here,
that much is certain, never, never. I haven't felt well since I arrived and I
don't seem to get any better I am happy enough at the studio, but I don't
feel happy in the evenings. If I had this contract in the East and could see
you my dearest I would be so happy. for it is certainly the nicest studio,
and the nicest people I have ever worked with. I saw some more films run
off today, and I realized I have been working too fast. I must move slower.
Pauline Fredericks is a fine screen artist, I am anxious for you to see her.
She bores me, but she is a great favorite, and is considered a very fine

actress. She isn't a bit nice to me, I think she thinks I imitate her. I look so much like her. The vice president asked me if I always wore my hair the way I fix it. I told him yes. then he said well it looks so much like Miss Frederick[102]

They are starting a big picture and I have been introduced to the director for the leading part. and the leading man wants me also, but I don't know the verdict yet. I want so much to do it. Dearest it seems from the paper as the things are really happening in England. I think it is wonderful.[103] Caroline saw a beautiful large apartment, seven rooms for $85, she likes it, but it is too large for her to do all the work, anyway I want a smaller place, one we can have together when you come here for Caroline is going East then. Oh my darling if only you were here. Dearest I won't be able to send you any money until the end of next week. I haven't any left over, as I have only received a week[']s salary. Oh my beloved, I love and miss you do not forget me.

<div align="center">Florence.</div>

I like the little Hungarian boy[']s greeting[104]

Postmark. Written on Hotel Alexandria letterhead and envelope.

Florence to Max, Croton-on-Hudson, New York, July 25, 1919

Friday 7 A.M.

My beloved, I feel so sad this morning. I dreamt last night that you didn't love me, when I came to see you, you were too tired to see me, and I cried, in my sleep. Dearest I am longing for you so. Florence.

Date provided by Florence. Written on Hotel Alexandria stationery.

Florence to Max, Croton-on-Hudson, New York, July 25, 1919

Dearest. I sent you the handsome Indian because I thought he looked like you. isn't he beautiful?[105] I see the New York papers mostly every day, so I had already seen the news about you and Villiard [sic].[106] The general strike may not come off in France, but it looks exciting enough in England. The New York papers are childish with their red terror, there is scarcely

a word about it in the papers here. They have a paper here called the Record. it seems to be like the Call, it carries labor news. the other papers never do.[107]

It is not very interesting here away from the studios. Sometimes I am afraid to have you come and see me. I am afraid you will find it dull. To me the ever lasting calmness is tiring. I feel tired mostly all the time. I feel sick too—.

I think Caroline is going East very soon. I am going to try to live with a girl I know in Hollywood. I think I will like it better There is one thing dear, I know you will be glad to hear. At this studio they think of me as a lovely sweet girl, and only want to cast me in sympathetic parts. I made a big fight to get the lead in "The Perch of the Devil" but Miss Atherton, the author said, you certainly have the beauty, but she said my character never had a smile like that, she was a calculating woman.[108] you could never look like that. I laughed, it is so different from Vitagraph. still I was disappointed. it is such a big wonderful part. But they told me, I was too young also. they want me to play young girls only. Another big story is coming along, and the heroine is lovely now I am hoping I will get that. I miss you so in the evenings I would like to tell you everything that happens, and I miss your advice. Dearest it seems as tho all my beauty had come back. I don't worry how I photograph. I don't have to in this picture, the camera man is fine. It is all very exciting but I am lonely for you my beautiful love. You must come to me soon. I love you and think of you with admiration: all the time.

<div align="center">Florence</div>

Give my love to George

Max to Florence, c/o Goldwyn Studios, Culver City, California, July 25, 1919

My darling, this is just a word of love to you before I go over to the library. George & I just drove in through the most beautiful clear air and sunshine.

Frank Walsh[109] was up at Dudley's last night and we lost 12 dollars to him on those fast horses. I never go anywhere that I don't think what fun it would be if you were there. I love you with all my heart—

<div align="center">Max.</div>

My darling, I've been so worried about you lately I telegraphed instead of writing, but your telegram this morning set me all at rest. I felt suddenly that everything is going to go well.

I think your telling me that you were not very well and that you were depressed awoke all the troubles and anxieties I could think of.

Of course you found it depressing to be alone with Caroline so long, and then it is always terrible the first [time] coming into a new place to live.

I know you are surrounded with courtiers by this time, and I have something much more appropriate to worry about.

I never heard anything praised as Betty Hare praised your beauty. She seemed to think you could hardly be of this earth.

I spend all these days in the library. I am writing here now. But in one or two days more I am going back to my barn and write the thing. I'm getting tired of it.

I went over to Selwyn's theater this morning & saw what they call the Bolshivik [*sic*] scene in Eugene Walter's play. It's a good scene, and he gave me the script to read. I imagine his play is a little better than his idea of it, but I don't know. I met Selwyn too & Holbrook Blyn.[110]

Selwyn seems nicer than his brother. I don't think any of them know what the play's about! Eugene Walter seems to be a very good director.

Isn't it fine that you have a good part.

Pauline Frederick is "an old sweetheart of Dudley's" as you can hear Doris say in her indifferent tone, as though they were not worth counting. Dudley said he would write to her & tell her to give you lots of room on the screen.

I happened to read the ms. of Dudley's speech at one of those committee of 48 meetings.[111] It was really a fun and brilliant speech. I was surprised at his gift.

I am coming to see you soon. Already I have three fine excuses to have my fare out there paid by The Liberator.

I think George & Eugene & I will go on a sail this Saturday—maybe to Martha's Vineyard.

How I hope you took the little house in Hollywood. I know you will have a hard time satisfying Caroline, but she will be about the same if she is satisfied as she will if she isn't. I don't see how you can live and prosper in your work if you try to arrange your life to suit her. I felt this so strongly when I read your letter that I would have sent you a terribly emphatic telegram if I hadn't just sent you one about something else. I was afraid I had "used up my influence". Caroline can just as well spend her time on

the street-car as on the street, you know, and it would be a good thing if she went away a lot.

Darling, I feel that you need me—you need a comfort expert—and I hope you won't be too finally settled when I come out. Maybe together we could arrange it better.

It is true about Lenin & Joan of Arc. His soul is as purely committed to the dictates of practical intelligence as hers was to those of God. He is as sure and as courageous and calm.

Darling would you like to have me send the New York Times or Tribune? I guess the Tribune would be better coming so late. And the Nation?

I was going to wait until I have your own address. I am sending The Liberator & your diamond pin which you left at April[']s.[112]

Goodbye my beloved. This is no letter, but for the sweet love and anticipation it brings.

<div align="center">Max.</div>

Your letter was so beautiful.

Postmark. Letterhead of the Hotel Manhattan, New York.

Florence to Max, Croton-on-Hudson, New York, July 26, 1919

At the Studio Saturday July 26, 1919

Beloved. I didn't get any letter today, so that means I won't have any word from you until Monday. I haven't been very busy the last few days, as Pauline Fredericks has been home, sick. There's a little piece of film, don't you think I look nice?

I am thinking of moving to Hollywood. I like it over there the best of any place I have seen. It is very wonderful out here, for Summer, it[']s never as hot as New York.

Dearest I will surely send you some money next week. So far I have only received one week[']s salary. They hold back a half week, I don't know why. Have you any idea when you will be coming out to see me. You will surely come soon won't you beloved.

I am glad George is staying with you a little while, he is so sweet. Eugene seems to be in love with you. in every letter you say "Eugene is

here". I haven't been driving very much. I am waiting for you. I love you so much sweetheart. Florence.

Dated by Florence. Includes film stills from The Loves of Letty. *See figures 2.5 and 2.6.*

Max to Florence, c/o Goldwyn Studios, Culver City, California, July 29, 1919

My beautiful, I love you and I want to be near you. I hope you will find a little place not in the city—at least not too close in—where we can be happy together. I want to learn to read more poetry with you, and live a little more deeply. And we will hire a Ford and go to all the beautiful places around there. When I get this chapter done I won't have to go back to the library anymore, and then I will come to you. I will have to fix it some way with The Liberator. I will have a type written draft of all my chapters, and the rest will be joyful work that I can do anywhere.

I'm on the train back from Long Beach after a lonely swim and dinner ($3.75!)

You are the only person I can be close to.

Postmark. Written in pencil. On letterhead and envelope of the Hotel Nassau, Long Beach, Long Island.

Max to Florence, c/o Goldwyn Studios, Culver City, California, July 29, 1919

I FEEL AS YOU DO I AM COMING SOON LOVE

M

Western Union telegram. Addressed to "Florence De Shon [sic].*"*

Max also introduced Florence to the photographer Margrethe Mather (1886–1952), a move he came to regret later almost as much as he afterward rued having introduced Florence to Charlie. Originally from Salt Lake City,

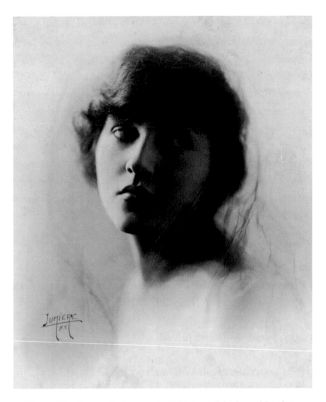

Figure 2.8. Florence Deshon, ca. 1919. Photograph by Samuel Lumiere.
Eastman mss. II. Courtesy, Lilly Library.

a *"slim, quietly magnetic girl, snub-nosed, grey-eyed, with this-way and that-way floating ash-blond hair"* (LR, *172*). *Mather preferred women, yet she was also in a relationship with the photographer Edward Weston (1886–1958). Like Florence, she had changed her name. Born Emma Caroline Youngren, the daughter of Danish converts to Mormonism, she had adopted the last name of a man for whom her aunt worked as a housekeeper. And like Florence, she was in the shadow of a man with a powerful personality.*

As both Max's and Florence's letters insinuate, Mather—often called "Margaret" or "Margarethe" in this correspondence—fell in love with Florence. If more evidence is needed, her portraits of Florence easily deliver it. They dwell lovingly on her face or her boyish figure and creatively use lighting and placement to establish a photographic equivalent for the complexity of her character.

> *As would have been natural for an actress bent on becoming a star, Florence was obsessed with how she looked in her portraits. Max recommended Mather when yet another set of portraits, taken by Samuel Lumiere (1878–1971), failed to please. In the Lumiere photograph reproduced here (fig. 2.8), Florence is little more than a disembodied head floating in white space. Lumiere emphasizes her oval face to such an extent that it seems almost a little freakish. There is little of Florence's radiant charisma here, which Mather would soon capture so brilliantly (figs. 3.17, 4.2). Lumiere was a Russian-born Broadway photographer who claimed to be related to the French inventors of the autochrome color process in photography. Lumiere's specialty in an increasingly crowded market was shooting vaudeville performers and movie stars associated with New York film studios, such as World Films and Vitagraph.*[113]

Max to Florence, c/o Goldwyn Studios, Culver City, California, July 29, 1919

In the Library Tuesday noon—July 29

Darling—I've written Rob Wagner and Joe O'Carrol [*sic*], and B. Marie has telegraphed Mrs. Gartz to go to see you.[114] I know how lonely you must be for a free word with somebody.

After three visits to Lumiere I managed to see proofs of your pictures. In many of them you would have been perfect if you hadn't felt so mad and sad about the dress. As it is I'm not satisfied with any of them, and I don't think Goldwyn took the best either. Can't you get the camera man out there—or somebody—to take some others? You might go to my friend Margarethe Mather, 715 West 4th St.[115] Indeed I wish you would go, and get the plate of the laughing picture of me which she endlessly postpones sending.

I see it isn't your diamond pin, either, that April had, but I'm sending it.

Here's a little letter from the Hungarian that I forgot to send.

And here's a note I wrote on the train last night and didn't finish.

I am a good deal worried about our life. I'm terribly afraid it will destroy your career for me to come out there. Do you think we can keep it at all secret as we do here?

No, you mustn't be the one to take the flying trip, dearest. You must let me. We are about 600 dollars in debt, and the only way we will ever get out is to sit still and pay it. Then we can begin to feel free again.

Love and Loss in Hollywood

I still have spells of terrible resentment that you have gone way off there at such cost in happiness and without getting the money that would have set you free. I feel so deprived of the *fun* that it would have been.

I am going to try and sell my chapters to a magazine before I go

I don't know what to say to you about Caroline. You ask me not to think you harsh, but you know what I think is almost opposite to that. You may be harsh about details and [*sic*] at times, but you let her dominate you. You fear her anger, and so it conquers you. For instance you say "she comes to the studio too" as though you were an inferior to be imposed on. It is *intolerable* that she should come there interfering in the tranquillity of your work, which is the one thing all-important, and you know very well it is the *weakness* of your submitting to it—not any harshness—that hurts me. You are not harsh. You are kind and generous as a summer day. But if you get into your pictures on the screen any of the mood that is in these photographs, you will break my heart. You will break my admiration, for I haven't any tolerance toward weakness and the kind of impracticalness that is a failure to see clearly what is important and what isn't.

You are afflicted in your attitude towards Caroline with something that never troubles your clear mind in other matters. Let me put this before you clearly once more. You give her a munificent living—she is a grown up person—the world is accessible to her—and you are *not responsible for her happiness*. You owe her no duty or consideration whatever. She does nothing for you. You don't have to be with her for a single minute that you don't want to, and for my sake and the sake of those that love you and are ambitious for you, you ought not to. You cannot succeed on the screen unless you are carefree and happy.

I'm afraid I'm scolding you a little this morning! Your letter worried me.

Darling, if you don't feel well, we must face the possibility that it is the divine misfortune again, and if it is, I don't want you to do anything without consulting me. Will you write to me about this?

Yes, the race riots are terrible, and more is coming.[116] There was truth in that old editorial "Advertising Democracy."[117] It was a dangerous thing to do. I can see absolutely no end of the race-riots except either the slaughter of hundreds of thousands of negroes, or a success on their part in compelling the respect of the whites by force and organization.

It is sweet the way you speak of me in connection with your beloved Milton. I wish I knew just what you mean when you say I have been more victorious than he was in the struggle between passion and puritanism. I feel that I am not victorious in life. Life conquers me.

Darling I hope you will think about the question of my coming out there in relation to your career, and have that all in mind when you decide where to live. Maybe Mrs. Gartz could help you find a place to live.

Beloved, I am very lonely. I woke up so lonely for you this morning.

Max

I[t] takes a whole week, doesn't it, for letters to go?

Written in pencil, on ruled paper, ripped from a pad. No envelope present. Date completed by archivist.

Max's talk of "divine misfortune" in his July 29 letter and his subsequent anxious inquiries about Florence's health strongly suggest that he was worried Florence might be pregnant. The "again" he added hints that this would not have been the first time, and Max's plea to consult him appears to support the theory, offered without evidence by Charlie's biographer Joyce Milton, that Florence had undergone a previous abortion before the disastrous ending of her pregnancy in 1921.[118]

Attached to Max's letter was a clipping from Gale's Magazine, *a radical periodical published in Mexico by the socialist and pacifist Linn A. E. Gale (1892–1940), who had, along with his wife, fled the United States to avoid the draft. (He was later deported back and court-martialed).[119] Gale's glowing review of* Colors of Life *would have allayed one of Max's major fears, namely, that his poetry, conventional in tone and form, undermined the revolutionary cause:*

> *Max Eastman has the soul of a poet and an artist and the heart of a crusader and a revolutionist. . . . He loves life but he knows there can be no life of true value and beauty, while injustice reigns and the profit system lasts. So he has subordinated in his active career, his poetical longings while he fights the battle of the rising proletariat. After the battle, when the age-old struggle is won, he may perhaps revel freely and gladly again in the glories of literature, that alluring art of translating beatiful [sic] ideas into equally beautiful words. . . . "Colors of Life" is a collection of these outbursts of a soul that soars with the gods even while it battles with men and what are worse than men—corporations.*

Max also included, with a pencil note that said, "Destroy it," a flattering letter by a Hungarian admirer, who was thanking Max profusely for having taken an interest in his work (Géza Válfi to Max, July 14, 1919).

Love and Loss in Hollywood

Max to Florence, c/o Goldwyn Studios, Culver City, California, July 30, 1919

My darling, I woke up with such sweet thoughts of you this morning. The sun was streaming in through the leaves.

I feel that I gave you a wrong impression of George, or of my attitude to him. He is untactful in a funny impetuous way, but he is so sweet and strong that you only smile at that. It is very good for me, I think, to have him here.

I am on the train—the 8:16 (I wrote that number in the dark of the tunnel below Ossining). Mr. Larkin is sitting opposite me, but I haven't spoken to him yet. Later I will borrow his paper.[120] I saw Marie Howe as I ran to the train and waved to her.

I am reading a ponderous German book which is the last long book I have to read. I am relieved to find that it isn't my theory—I was always half afraid that it was. But just what theory it is, is another question only to be determined by long and patient dredging and steam-drilling among nouns, adjectives, prepositions, verbs, particles, adverbs, prefixes, suffixes, and just ordinary fixes mixed up and melted together like the primeval lava.[121]

It cost me $50 to mend the Ford, and I'm not sure I'm done yet.

When we went to Tumble Inn Sunday to dinner George said, "My, I would like to have been here that night when you had Florence here to make it so beautiful. You know I feel when I look at her as if we had Venus or some goddess sitting at the table with us."[122]

I love you, darling, and I am hurrying to come to you.

Please answer all my questions of yesterday—Max.

Postmark. Written entirely in pencil. Max's handwriting reflects the motions of the train.

Max to Florence, c/o Goldwyn Studios, Culver City, California, July 31, 1919

Darling, I guess my suggestion was wrong about not living in the city. I guess that is the only place where it would be possible for us to be together. I'm very much troubled about what it may do to your career, and I think we'll have to find some pretty elaborate way to camouflage our living together.

I have an aunt out there who might take Caroline's place when she goes! That would be funny.

I am just going down on the train as I was yesterday morning. I think I can almost find out what that German book is about today. I read it steadily for six hours yesterday.

The French books I can read quite fluently—about half as fast as I read English.

I'm very much worried about your health, and you must tell me if you feel any better, and if you don't you must go to a doctor. Remember to answer what I said in the letter I wrote in the library.

There's a tiny notice that one of the cities in Bulgaria has established a soviet, and George says it is the chief rail-road center in Bulgaria.[123]

I guess Bela Kun[124] is a very strong man. Isn't it marvelous how they arrive in time? And yet I'm afraid there is none in Germany.

I suppose some boy is growing up here who will be the great leader. Maybe it is Karl Hoessler in Fort Leavenworth.[125]

Darling, how I wish we were going to Long Beach today—

I saw a notice in the paper that all the southern California movie companies are going to move back to New York because they like interior lighting better!

Samuel Untermyer[126] went in and scared the Attorney General to death. He tried to get a postponement, Untermyer insisted on immediate trial, he said he wasn't prepared, and the judge dismissed the case! It was the "motion to revoke the charter" of the Rand School.[127] I think that will cramp their style a little when it comes to indicting us. I hope so. I don't want to be tried again for a while.

Darling, I think George would like it if you wrote him a little note. He is very fond of you.

Sweetheart, this is no letter but it contains all my love—

Max

Postmark. Written entirely in pencil.

The next letter is one of the longest Max sent to Florence in Hollywood, and one of the most carefully composed. As Florence was striking out on her own, Max clearly wanted to remind her of his masculine prowess, portraying himself as taking charge of a difficult traffic situation (he knew he could count

on Florence taking an interest in anything related to cars) or of bad weather
on the Tappan Zee. In both cases, at least in his own biased assessment,
he had saved lives. The strategy worked: as Florence's response shows, she
immediately telephoned him, reporting her acute disappointment when he
wasn't home. On another front, his urgent letter was successful, too: with his
car all in pieces, through no fault of his own, Max clearly needed money, and
Florence promised to send some cash soon.

Max to Florence, c/o Goldwyn Studios, Culver City, California, July [?], 1919

Darling, do you know what a tragic thing has happened. I was sitting on the porch yesterday talking to Claude McKay[128] about his poems, and George was mowing the grass, and right while I was sitting there and without a word to me he went and got a butcher knife in the kitchen and cut all the lower branches off all of my beloved pine trees that were to be a hedge, and now they stand there all trimmed up like long-legged chickens, and the sweetness of seclusion and the beauty and all that I have watched and waited for those four years since I planted them is gone. And it is gone for good. Those branches will never grow again. I can only call a person who would do a thing like that a damned fool. I can't find any tolerance of it. I go to bed mad, and I wake up mad. And I want to go away. I want to come out there, and get a little place and start all over again. My love for this place was all concentrated in that little corner, and it is too deeply wounded. I can't think about it anymore, and I am surprised to realize how much I did think about it. It is all gone. It is all destroyed. I have behaved very well so far. I didn't say anything when I saw it. I was just too stunned to express anything, but I knew I would kill him if I didn't at least tell him how I felt, so I did later in the day just explain to him that I am the kind of a person who has definite tastes and wishes about things, and that he ought not to try to do kindnesses for people without first finding out what they want. The tears came in his eyes, and he said he would restore them, he would go and get me some new trees in the woods. I said "No for god's sake, don't do that! It's all right, I'll just forget it." But I can't. I guess there is something in me that I get mad at people when I live too close to them anyway; and his kind of blundering extravagant expense of energy in kindness, that was and really ought to be attractive and charming, now seems repelling.

He is a strange being—full of kindness and yet almost entirely without sympathy. He doesn't know what the other person feels, and he has no organ with which to find out. I'm not surprised that his girl left him. It's too bad, because it seemed as though I almost could love George, and we were both so fond of him. (In saying "it's too bad" I mostly meant it's too bad I have this interior revolt against intimacy that makes me give such a strong color to people's faults when I come too close to them. I meant my own failing more than his.)

It has been an eventful two days. Friday I smashed the Ford all to pieces. I did it deliberately. It was one of the strangest things that ever happened. I started from the Grand Central with Floyd and George, and we went up to Harlem and picked up Claude McKay. We started up town and I found I was on the wrong side of the hollow under Highbridge, and I had to turn around and go back. It was late, and I was driving a little fast down a practically empty street. I was talking—just as I always so loftily tell you not to—and suddenly there appeared a little boy, just about the size of Dan when I left him, running from clear across the street diagonally in the direction we were going, with his head down and his arms pumping just as one would do who was absolutely determined to get in front of the car. It was so strange that I heard Floyd say, "Why look at this!" in a voice of incredulous surprise as well as alarm. The whole order of sane things was reversed. He was running toward death in the same haste that one would run away from it. I knew there was no hope in my brakes, for the car would slide far enough to knock him down and kill him. I simply swung straight up onto the curb and into a tree with an unspeakable crash, and the boy struck the side of the mud guard and was knocked over, frightened almost to death, and got his shoulder and elbow scraped on the pavement. I picked him up and carried him home, and I think he was even more frightened by my kindness, for there were about a thousand other kids in the flat and his mother seemed only mildly interested in what I had to tell her. Then I had to go and find a garage, and get a truck to drag the tin remnants of our long suffering Ford along the street. I was so glad I hadn't hurt the child that I had no other emotion about it, and I guess none of us had. I could see his little legs and body running for me when I lay down to bed. It was a terrible moment. I guess I could never have slept if I had hurt him. It will make me more careful, although I do think I have been careful about children to an almost absurd degree.

Then yesterday we went sailing—Claude Eugen George and I—and when we got right out in the middle of Tappan Zee a perfect hurricane of thunder lightning wind and hail stones swept down on us—a storm that

broke trees down in the woods. Dudley stood in the middle of his house in the corner—Doris told us afterwards—frightened for himself and saying Aves for us. It was the most marvellous storm I was ever out in. By the grace of God I was at the helm, for Eugen knows very little about sailing, and I managed to keep her right side up, and get George into a life belt. The rest of us could swim, and I felt no fear and all. I was wildly happy with the excitement. Nothing can equal it, you know. The boat rolling half over, the sail creaking and booming, dipping in the water and flying into the sky, sheets of water from the sky and great waves crashing over the boat drenching and pounding us, the river so full of white caps that it looked like foam under the black wind, and great cracks of light[n]ing rending the sky with terrific thunder no further off than the top of the mast. Doris said she was running around the house frantically saying "They're drowned, they're drowned." She knew we had just started and would be out there in the middle of the wide water. Well—that was fine. I needed it. I have no fear of the water. I wish there were more things I have no fear of. George and Claude really expected to die, I guess. They think I am very brave because I kept saying "Isn't this glorious?" and they said my voice giving orders sounded so "sonorous and steady" in the storm that it comforted them—you know how people praise you when they think you have come up to the degree of their admiration.

The fact is, though, that as soon as I got that life-belt on George, who cannot swim, I felt nothing but pure joy and elation. And that too only because I *knew* there was no danger of death. If we had been way out at sea, I would have been sick with fear. However I enjoy being a hero, so I don't make a great deal of that.

Darling, I am not happy without you, and I am thinking all the time of the day when I will come out there. I wish you could have a lovely little house somewhere, so that I wouldn't feel that I am going to Los Angeles. I hate that town. But I am coming just as soon as I can. I am still in the Library. Do you think I should go away before the first of September when we make up the October Liberator? Of course, I can't desert the ship for any very long time until Crystal comes back, and I don't know when she is coming—whether I had better go out there and then come back and go again for the winter. I think it will take me a good deal of August to get through with the library. Could you tell me how much it costs to go across and back?

Do you suppose I could arrange a good place to work in, so it wouldn't take me ages to get down to it after I get there? I'm simply obsessed by the desire to finish this. That's why I wish you could be living in a nice place.

Sweetheart, I hope you'll like this letter. It has made me so much happier to write it. I felt as you did that I just had to have a long talk with you. I loved your letter.

Did you send me a cup and a bowl? If you did I am quite sure they didn't send the cup you selected. The bowl is sweet, and I drink out of the cup anyway because it came from Los Angeles, although it is so small that I have to fill it twice, and I fill it three times to make sure.

I hardly expect to be called before the Lusk committee.

I am going to ask Marie to write to Mrs. Gartz about you. She will show you a lot of people I'm sure, but I'm afraid you'll be disappointed there too. It is too bad that it is such a terrible town. I never saw a person there that I wanted to see again but Charlie.[129]

I'm trying to think how to write to Rob Wagner about you. I wonder if Mrs. Wagner is jealous.[130] I should think she would be. I think I'll ask him to call on you anyway. Joe O'Carroll wouldn't be very interesting, I'm afraid. He's a kind of anti-social person, but he's a rebel and it might be a relief to talk to him.

I don't believe we will hear much more about the Red Terror. Lenin is winning overwhelming victories on all fronts. I fear the absence of revolution in the other countries will compel a great deal of compromise in Russia, though; I'm disappointed in France and Italy and England. Still this is only the mood of a moment. There will be no rest in the world for years.

Beloved, your desire to have me is no more than my desire to come. It is a desire that grows more compelling every day, and I hardly know what to do. Please answer all my questions.

Goodbye my darling.

<div align="right">Max</div>

Postmark illegible.

Florence to Max, Croton-on-Hudson, New York, August 1, 1919

At the hotel.

Dearest. I am heartbroken about the trees. How could George do such a thing? I was frightened when I read about the storm. you know I am so afraid of the water. The Ford, all broken to pieces again. I think it is all

tired out. How lucky no one was hurt. I am going to move to Hollywood next week, either to a bungalow, or else an apartment. The apartments are two large rooms. you could visit me if you liked it, otherwise you can get any kind of a place you want out here by the month. Caroline is going East whenever you come out. It costs an extravagant person $250 round trip, including meals and sleepers. that is over the Santa Fe, which is the shortest. I wish you could come soon. I am so lonely for your beautiful presence.

I telephoned you twice, but you were not home I thought you had fallen in love with someone in New York, and didn't go to the little cottage anymore.

I am very busy. I go to the studio every morning at eight o'clock, and I usually work until half past four. I hate Los Angeles myself. I haven't felt well once since I arrived here I know it will be better in Hollywood. it is so nice there. I didn't like any of the proofs.[131] I am looking much better then [*sic*] that now. I look mad, don't I. My clothes are so pretty. I hope I wear them soon. they are keeping their promise about clothes all right I didn't have to buy a thing for this picture.

Naomi Childers another girl out here, thinks she is getting a wonderful salary and is so pleased with herself.[132] I asked what she got. she gets $300 for 40 weeks in the year, and has to furnish all her clothes. Everybody thinks mine is a very good contract. Most of the others have 40 week contracts, that means between pictures, they don't draw any salary. Surely tomorrow dearest, I shall send you some money. I sent you a cup and bowl. I guess they weren't very nice, but I just wanted to send you something. Lets act like rich people. dearest if you want to see me just jump on a train and come, it would be such fun, we'll go flying and to the painted desert.[133] Each time you come out we'll go on a little trip. Maybe when I finish this picture I'll take a flying trip East myself. I love to play with the idea anyway. Beloved, I love your letters. You write so beautifully. I read them over and over. I like you to tell me everything you do. I follow you in my mind.

Do not get angry at people just because you are near them. Don't play with them so much go away a little more, and you won't get so tired of them.

There is lots of talk out here, warning people against the I.W.W. A man made a speech to the employees at the studios the other day. He talked about 45 minutes, the men kept drifting away. there was very little enthusiasm for him. He talked a lot about mothers and wives, and one of

the electricians told me that thirty years ago, he ran away with his mother and sister, and he had just asked him for his mother's address. She was still with him. They were married and living in Los Angeles. He ran away from Edinburgh, Scotland. Wasn't that remarkable he should see him way out west.

Dearest, I miss you so much at times, my ambitions seem to dwindle, and I feel I only want to go home to my lovely sunlit cottage and you.

My sweet love, come to me soon.

Postmark. Letterhead and envelope of Hotel Alexandria.

Perhaps to alleviate Florence's concerns about Max's mutilated trees and to corroborate Max's exciting stories about survival on the mean streets of New York and the waters of the Tappan Zee, Max's wild friend George Andreytchine sent her a note, too (see Max to Florence, May 23, 1919). He made a point of assuring Florence how much she was missed: "When you left, dearest Florence, we all felt an emptiness in our hearts & souls—but none so deeply as Max. I came to invite him to dinner with Jack Reed at his place and found your mate with tear-stained face & all aquiver with emotion. Then I cried on my way up the hill when Max refused to come—Love is so cruel—it steals away like a cold snake—at least it did with me." But George, who had been unhappy in love, too, knew whom to blame: "I could not help but curse the capitalist system which alone is responsible for my & Max's sufferings. If I was not anguished & you didn't have to go to distant California to earn your living—Max & I would be happy now."

The only way to cope with such despair was to have adventures: "We had an awful accident a few days ago & smashed the car at 153 st. Max saved the life of a little boy & we nearly paid a high price for it. The next day we went sailing & a hurricane overtook us & we nearly drowned ourselves & the boat. Max, being our sailor—saved us but we had a thrilling time! It was beautiful storm & so terrible like love."

Before he closed his letter with "Communist Greetings," George promised to send Florence a book, Mark Twain's last, unfinished novel, The Mysterious Stranger, *published in 1916.*[134]

Florence to Max, Croton-on-Hudson, New York, August 3, 1919

Sunday. Aug. 3, 1919
1824 Highland Ave.
Hollywood, Cal.

Beloved. I moved over to Hollywood today. I have the prettiest little apartment with a sleeping porch. It is so pretty over here. I feel happier already. I am not going to San Francisco, we are going to finish the picture here. it will be finished this week. I have worked nearly every day since we started. I hope you will see the picture. I hope you will like me in it. The wardrobe woman from New York called on me the other day. She said Mr. Goldwyn told her I was to have first choice of everything she had, and besides she was to make me anything I wanted. I was pleased and surprised, you know I never expect them to keep their promises.

Mr. Goldwyn must certainly think of me as very extravagant she bought about twelve dresses for a thousand dollars.

It is amazing here the way the sun shines every day. a little tiresome too.

Dearest, the papers here for weeks have been announcing Bela Kun's overthrow, and still are. Do you know if it is true? The cost of food has gone down a little in Los Angeles the last week. It always was cheaper than the East, but car fare here is terrible, it costs 65¢ round trip in the street car to any one of the beaches. you know how near they are to the city. A dollar is the lowest taxi rate, it would cost that to go a block. I hope in your next letter you will tell me something definite about your trip West.

You know how I am always talking about writing a book. I feel as tho I will do it out here I think this is a wonderful place to write. I know you'll like it. Dearest I like you to write to the studio because I get your letter about the middle of the morning. The mail doesn't come until 9:30. But you can send magazines and telegrams to my house. The telegrams at the studio come over the telephone so everybody can read them.

Do not neglect me sweetheart. Do not forget me. All my love to you.

Dated by Florence, who proudly notes her new address. Written entirely in pencil, on Hotel Alexandria letterhead and envelope.

Max to Florence, c/o Goldwyn Studios, Culver City, California, August 4, 1919

O my darling, you are so beautiful in these little pictures![135] They are so beautiful they make me tremble with joy. I love you my darling—

<div align="center">Max</div>

Postmark. Written in thick pencil.

Florence to Max, Croton-on-Hudson, New York, August 4, 1919

Dearest, your sweet letter made me so happy. I feel you are coming to me soon. Beloved we will be so happy. I love you so much, we will see all the lovely places near here and we will go flying we will make it a poetic journey.

Postmark. Written entirely in pencil on Hotel Alexandria letterhead.

Florence to Max, Croton-on-Hudson, New York, August 4, 1919

At the Studio

Beloved. How I envy you a day at Long Beach, how happy we have been there. Dearest I put $50 in the bank on Saturday, and then when I moved into my apartment I found I had to pay 2 months['] rent in advance and so after I paid my hotel bill, I just had enough to pull me through the week. Beloved forgive me. I meant to send you $50 every week. but I'll surely start next week. If you come out here, we can keep the fact that we are together a secret. But otherwise we can go every place together it won't hurt me a bit. Mr. Goldwyn didn't mean anything but that I just keep my personal affairs secret.

I can find a cottage for you in Pasadena perhaps, but I surely can find one for us, that much I know.

Darling I don't think you want to come and see me. I think you are falling in love with a blond actress. You are always finding reasons for not coming. I am sorry to learn we are so much in debt, but I shan't spend a

cent until it is paid. I plan to send you $50 a week, and to save $75 myself, then in case you run short I'll have it to send you. I liked the series about you in the English magazine. It makes me so happy dearest when you are called the most distinguished poet in America.[136] I liked what Linn said about you too. The series in Gales was lovely. Linn makes Mexico seem very attractive.[137] Darling don't seem unhappy about the money maybe I can get more in a little while. I am surprised to find how small the salaries are out here a girl I know has been out here three years and has no contract, and she told me it was a struggle to get $150 and she has to buy her own clothes. The company car takes me back and forth from Hollywood, otherwise I couldn't live there.

Darling I am beginning to feel better, they say the water doesn't agree with you at first, so I am drinking Spring water.

Everything is all right with Caroline now she has the apartment to take care of. She never comes to the studio. Beloved I wake up in the night missing you so much, it makes me cry.

Darling we could pay our debt just the same if you were out here. don't say you are going to stay home until it is all paid. I should feel too terrible. Can't you make the Liberator pay your fare, you remember you said you would raise money for them. I know you are going to make a lot of money from your book.

Dearest I have this letter all mixed up it was because I had no blotter. Darling it will not hurt my career the least bit if you come out here. They like me very much at the studio, it is a lovely place to work.

You did scold me didn't you sweetheart. You sound so mad at me I'm afraid you don't like me. What do you mean life conquers you. I don't understand you. I mean Milton conquered all his beautiful feelings about life. Darling let me tell you when I see you. I can tell you better. I bought the August Liberator in Hollywood. The cover is beautiful.[138] Dearest be sure to give me plenty of warning when you are coming I want to ask you to bring me some things. I will tell you about the magazine in another letter this is all the paper I have my beloved.

Dated by Max. Written on Hotel Alexandria letterhead and envelope. As Florence herself points out, she used the sheets erratically, writing on them first recto and then verso in no discernible order and numbering them later, hence the hilarious page "3½."

Florence to Max, Croton-on-Hudson, New York, August 5, 1919

At home Tuesday Aug. 5, 1919

Beloved. I want to tell you about the magazine. I think it is the finest number I have ever read. Your editorial on Wilson is wonderful, so brilliant and witty. I think Arthur Ransome[']s and Crystal's article[s] are great. Ransome['s] description of Lenin reminds me of your poem about him, "His whole faith is in the elemental forces that move people, his faith in himself is merely his belief that he justly estimates the direction of these forces.["][139]

I thought there was so much lovely poetry in the magazine, also I think the cover is beautiful.[140]

The publicity department took a lot of pictures of me the other day, they are all lovely. I am going to try and get some to send to you my beloved.

I feel happy because I know you will soon be with me.

Written entirely in pencil on Hotel Alexandria letterhead and envelope.

Max to Florence, c/o Goldwyn Studios, Culver City, California, August 5, 1919

Tuesday P.M. August 5

Beloved, I am taking the 6:13 down to New York to go with George to the opening of Eugene Walter's play. I guess Eugen will go with us. Yes, he comes up every Saturday, and this week he came Friday. He is very sweet and very lonely. I guess we are really about the only friends he has.

George has been very funny in his desparate [*sic*] search for a sweetheart—with Doris wanting to make love to him, and Dudley very jealous—and other girls failing him for one cause or another. He is so naïve and frank—something like a little child and something like a big stallion—that we get a great deal of amusement out of him.

My darling I love the little house so much. I was alone there today, and I realized that I love it for you. I was in the bath-room and it came over me so vividly the wonderful magnetic joy and beauty of your presence.

I hope you are going to write me soon about how we are to live when I come out there. It makes me much happier to think you are going to be in

Hollywood, but I am very much troubled about how we shall arrange to be together.

I talked to Margaret Lane about my going the other day.[141] She is taking a vacation now, and Floyd next, and she thinks I ought to stay until we get out the October number—that is early in September. It just about fits into the possibilities of getting independent of the library, so I can just take my book out there and finish it. Does it seem longer than you expected?

Darling, nothing can tell you how happy those pictures made me, and all that you tell me makes me very happy about your work. I haven't thought about the salary for a long time. If they will only believe in your loveliness and give it a chance, there is no doubt anywhere, and now I believe they will.

I asked Marie to telegraph Mrs. Gartz—she said yes, and I sent the telegram for her. . . . I also sent one to Pauline Frederick which Dudley wrote. Maybe it is too late, and maybe it wouldn't do any good anyway. Marie is also writing to Paul Jordan Smith—I remember him as a sort of smoothly eccentric good-looking person, I believe he wrote a feminist book. I don't think he is very original, but I was told he had a charming place, and I kind of felt like going out there. He would be one you could talk to and yet also look at.[142]

Have you met Charlie?

Darling, I hope you won't fall in love with anybody. I feel kind of frightened when I speak of him. I want you to love me. You never speak of any boys to me in your letters, and yet I know they are flocking around you with passionate adoration. My darling, don't stop thinking about me—Sweetheart I love you and I want you in my arms—

Max

Dated by Max. Written in pencil.

Florence to Max, Croton-on-Hudson, New York, August 6, 1919

Aug. 6, 1919 At home.

Beloved. When you come here, I will find a cottage for you outside of the city limits or else in Pasedena [*sic*].

Caroline will stay on in my apartment and the studio can call me there, and it will be just like it was in New York. You cannot hurt my career, that much I know. If I am at all successful out here, I will be able to do anything I please. There is no one in the Studio that looks like me, and they seem to be paying a bit of attention to me. I saw Mr. Goldwyn for a few minutes & I expect to see him again before he goes

Dearest, do not worry about my career I am telling you the truth when I tell you that. Everything out here seems so different, and you can keep to yourself all you like, no one need ever know what the other fellow is doing.

I believe in you and in everything you do and say I am with you heart and soul.

I won't allow anyone or anything to take me from the happy and beautiful life we live together.

Darling I feel very successful out here. I feel that in no time I will be able to ask for more money. Let us be happy, we will both work hard and know that we are going to take a lovely trip to China when I finish my first year here.[143] All studios are slowly moving back East. It really costs a lot more to make pictures out here. I am only hoping it will take place soon.

I am so much in love with you my dearest. I long so for you. I am only waiting for the day I will drive to the station to meet you.

On Hotel Alexandria letterhead and envelope. Max's later note on envelope: "special."

Florence to Max, Croton-on-Hudson, New York, August 7, 1919

Beloved. Your little note telling me that you loved me, made me so happy. Darling this is all the paper I have. I don't have to go to the studios until later, as we are going to take night stuff. I cannot tell you how hard it is for me to be way out here away from you, and from all that makes me happy. I am so stingy I never spend a penny, my whole idea is to save money, so we can have a good time when my year is up. Also I think if I am patient and work hard, I may find myself working in New York at a large salary that one idea keeps up my courage. I feel soon the studios will all have big places in the East, because everybody from office boy to star kicks about being here.

Darling would you go to Peggy Hoyt and see about my hat, also look around the house and see if you see my fur scarf. I can't find it.

Tell George I will drop him a line next week.

I haven't any paper this week. Do you think my letters are too long. I feel I have so much to say to you.

I am always thinking of the time we will be together again. I will be so happy

<div align="center">Florence.</div>

Postmarked August 8. Written in ink on two envelopes cut open to form sheets of papers. Words written where the envelopes are stuck together were identified by the Lilly Library's conservator.

Max to Florence, c/o Goldwyn Studios, Culver City, California, August 8, 1919

Friday

Darling, I was going to write to you all the way down from Harmon this morning, but Fred Howe & Sen[a]tor Thompson got around me and talked to me all the time. Sen[a]tor Thompson is the man who exposed Whitman's offer of $50,000 and the governorship if he would support the bill to raise street-car fares.[144] You remember. I paid his seat in the pullman, & when he offered to pay me back the 27 cents I said "No—some day I may want you to put through a street-car franchise for me." He said, "Well any time you or Fred Howe want to put anything thro' my committee you can—but Whitman can't."

I'm sending you Untermyer's letter to me—also a nice letter from Geo. Bellows.[145] I was trying to get him to do a revolutionary cartoon. Also an I.W.W. paper with an editorial by Justus Ebert, who is their best editorial writer.[146] He seems to like me, but I don't know just exactly why. There is something awfully bookish & self-important about all the manifestoes of the Left Wing. They aren't the Labor movement but think they are. I'm not either and I know it. I guess that's the difference. It is nice to be spoken of this way by those who *are on the job.*

I've had Bellowes [*sic*] pictures framed, and the picture that Sterne gave me, and the little green goat picture. They all look beautiful in the little house—the Bellowes one near the phonograph, the little goat over the couch.

I have a kind of amorous pleasure in fixing the little house, because it is the thing most identified with you. I feel very romantic and *subdued* when I go up there after being away for a little while.

I promised Mike I'd go down there for a couple of days, but this is getting short for me to do my chapter, and I don't believe I could work down there. I want to go, though, and see it.

I guess it is the resurrection to Sallie. They are staying til September. I wrote you about that, didn't I?

I have your little picture in my watch, and another in my pocket mounted on white paper so I can see it clearly. You are lovelier than anything else in the world.

<div style="text-align: center">Max.</div>

I've written this in the waiting room of the Grand Central—at 12:30—before going down to make up the magazine.

Grand cables from Crystal. British labor is moving. Love—

Dated and written entirely in pencil by Max.

Max to Florence, c/o Goldwyn Studios, Culver City, California, August 9, 1919

Darling—if you want to see some wonderful visions and hear music like the wind among the stars, read Shelley's "The Witch of Atlas".[147] I never read it before, and I received all over again the joy of discovering his miraculous imagination and warm tender heart.

Another thing that was new to me is the "Letter To Maria Gisborne."[148] It is more human and talky than any of his prose letters.

I feel like writing poetry again, and O I want to finish my book, but I am on the train again going in the finish pasting up the magazine. It is the last time, I firmly believe, and tomorrow I shall go to work on my chapter—my erudite chapter. You'll see me slinging Plato Aristotle Kant Hegel Bergson Voltaire Schopenhauer and many more pompous professors around my head and through my legs and up over, twirling and tossing them like a juggler.

What do you think of the actors' strike! It really seems to me the world is in motion when striking gets as respectable as that. I confess to a secret counter-revolutionary hope that it won't hit the movies, though!

Crystal has been a great thing. She's got a cable message to the
American Railroad workers from the *President* of the British R.R. workers'
union advocating industrial unionism and direct action—to be published
in the Liberator! Isn't that wonderful? It gives a kind of weight and
standing to the magazine—internationally—that will greatly increase its
safety, I think.[149]

Sweetheart, whenever I read poetry it makes me so much in love with
you. As soon as Crystal comes home I am going to drop everything and go
and live for poetry with you. We will go to the Painted Desert!

Max

Postmark. Written entirely in pencil on Liberator *letterhead.*

*Between August 7, 1919, and September 6, 1919, hundreds of actors in New
York and Chicago walked out of theaters and picketed the ones that remained
open. Their target was the Producing Manager's Association, and they were
protesting against working conditions Florence knew intimately: endless hours
of rehearsal time, at no extra pay; expenses for travel and costume that had
to be paid out of pocket; the constant threat of getting fired on the spot if one
had provoked a manager's disapproval. The Actors' Equity Association, or
AEA, had become part of the American Federation of Labor only a few weeks
earlier, and one of the most heartening aspects of the strike was the support
actors gained from other workers in the industry, such as stagehands and
musicians. News from the front lines of the protest was eagerly soaked up by
Florence, who chided Max when he appeared to break the strike by attending
a play (granted, it was a "socialist" one). The strikers were successful beyond
their wildest expectations: theater managers caved to the demands of the AEA,
which saw a more than fourfold increase in membership.[150] In his coverage of
the strike for* The Liberator, *Max praised it as a "very complete picture" of
the Bolshevik uprising, a social revolution in miniature and living proof that
change is possible.[151]*

Max to Florence, c/o Goldwyn Studios, Culver City, California, August 11, 1919

Aug. 14 [*sic*] Monday Morning on the train

Darling, I'm going down for my last day on the old magazine. I worked on my book yesterday and it made me very much happier. Eugen was there. He & George and I are getting to be quite a close corporation.

I love George. He is a very very wonderful person. And I am fond of Eugen too. We have pretty good times together, and it is good for me to be a little more human than I am when I'm alone.

I'm so proud and pleased with Ethel Barrymore. Did you see the letter she wrote to the Actors' Equity? I think I'll go up on Broadway tonight and see it.[152]

It is very sad about Hungary, but I think Bela Kun acted wisely in resigning,[153] and if all those little nationalities get to scrapping there in hope of the proletarian view triumphing throughout central Europe, certainly there is no sign of the world's quieting down, is there? [154]

I'm writing this way 'cause I have only a little book to write on.

Sweetheart, I think I will be able to finish this chapter very fast. It's easier to write about other people's opinions.

I'm so glad you've gone to Hollywood. I feel much happier about you, and now I am just writing until I can come. I hope you will say something about how we shall live when I come, for I cannot bear to feel that I am a danger to your career.

What you tell me about the wonderful woman, & the announcement of your 5 year contract, all makes me so happy, and I am very confident. O I wish I were just a private citizen! I am going to try very hard to be one when I come out there.

One other thing—have you found any way of staying awake?

I think that would be a wonderful place to work, if I could find some way of staying awake.

You were sweet to send me the money by telegraph. I know it must have cost you a lot getting adjusted out there and I wasn't expecting it very soon. I'm getting pretty fond of my little cup, although I didn't think it was pretty at first.

I wish they would release your picture before I go out there. It would be so sweet to go to see you here.

Darling, this isn't much of a letter, but I had a lot of things that I wanted to say.

I woke up with such a longing for you this morning. I look forward so much to the winter in California. Crystal will be back there and the magazine will be off my mind entirely. Then I'm going to be a poet—a poet and your lover, and *nothing else*! My sweet love—

Max dates the letter to August 14, but "Monday" was August 11, hence the archivist's correction. Written entirely in pencil.

Max to Florence, c/o Goldwyn Studios, Culver City, California, August 12, 1919

Darling, I laughed and laughed I was so happy to have your sweet letter last night. I found three of them when I came home at one o'clock after a night at the printers. I think I laughed at the way you wandered around from one page to another until you got entirely lost and you seemed so sweet and near to me in all that you said.[155]

I am crazy to come out there now that you have moved to Hollywood. You don't know how different it seems, and your recognition and success makes me more happy than anything could tell you.

Give my love to Caroline and tell her the barrel is safe in our attic. I looked to see if there was anything I wanted in it, but there wasn't.

Darling, I can't write any more now, because I have to work. Dearest devoted love to you. I am coming soon! Max

Postmark. Written entirely in pencil on letterhead of The Masses.

Florence to Max, Croton-on-Hudson, New York, August 12, 1919

At home. Aug. 12, 1919

Beloved. I wish you were here with me. I feel a little jealous, you are always going to see the Challenge[156] Are you in love with somebody in it.

You shouldn't go to the theatre during the strike. I had dinner with Thompson Buchanan the other night. you know him don't you.[157] I like Louis Sherwin the best of anybody I have met here so far. An awfully English actor asked me to marry him rather suddenly. I have given him the cold shoulder ever since[158]

George told me in his letter that you missed me and loved me. but I want you to tell me. I am so lonely for you—

Max was not the only Croton resident who missed Florence. In August, Sally Senter Whitney, a sculptor who had given up her artistic ambitions to marry the painter and cartoonist Boardman Robinson, sent Max an ecstatic letter from Chilmark on Martha's Vineyard that sounded as if Max could have written it: "Always the breeze varying in mood from the sun-kissed sighing caress to the mad thrashing creature of the sea—The hot white sanded beach with the ocean, which in our present mood seems a gay shouting playmate—." She then expressed her longing for Florence and Max to join them: "Perhaps you too are playing with it and will come, sailing gull-like into a near harbor. . . . We miss your beautiful Florence. She is warmer and more humanly lovely than all of you up there on Croton's green hill-side" (Sally Senter Whitney to Max Eastman, August 13, 1919, Deshon mss.). Max forwarded the letter to Florence. She appreciated the compliment but also worried that Sally's letter, sweet and poetic as it was, had been written to take Max away from her: "Is she in love with you?" (Florence to Max, August 18, 1919).

If Max used his letters to manipulate her, Florence was, as the following letters show, not above trying a similar approach (e.g., by emphasizing her melancholy and frail health). But whatever concerns Max might have had about Florence's condition, he certainly appreciated the money she was now sending. Being a sort of "kept man" had, it seems, a strange kind of erotic frisson for Max.

Max to Florence, c/o Goldwyn Studios, Culver City, California, August 13, 1919

Darling—I'm just sending you a few clippings before I go to bed. I'm so filled with longing for you—my heart, my mind, my eyes, my body long for you—and they have all day—I can't seem to write the letters I've been writing, I just want to come to you and lay myself in your arms, so close to you, so warm, so tranquil.

Darling, I had a little letter from Ruth. She & Amos had good reason for what they did. It was not as we thought. I think she would like if you'd write to her at Milford, Pike County Pa. You probably saw that they were married. Doris too thinks you should write to her, & told me to give you her love & tell you you were a "poor friend" to write to Sally & not to her.

You were so sweet to telegraph me the money. I have such a strange—almost passionate—feeling sometimes when you give money to me.

Sweetheart, send me the pictures. Your letters are everything. I wait for them. I love them.

<div align="center">Max</div>

Written on letterhead of the Hotel St. Regis, New York. Max's note at the top of the first sheet: "I'm not at the St. Regis—this came in a letter—I'm at home at our desk—at 10 o'clock P.M. Wednesday Aug. 13." For more on one of the enclosed clippings, see Florence to Max, August 18, 1919.

Max to Florence, c/o Goldwyn Studios, Culver City, California, August 13, 1919

My Darling how I long for you tonight. I am too lonely to write. Only I long for you. I long for you. I want to be in your arms until I die—

<div align="center">Max.</div>

Postmark. Written in pencil on a ruled piece of paper. The envelope, also written in pencil, shows Florence trying out the word "character" on the back flap, as "character" and "characther"—a feminist joke?

Florence to Max, Croton-on-Hudson, New York, August 15, 1919

Hollywood

Dearest, I have not written to you because I have felt so sick

I feel as tho I was standing on a precipice and any day I will fall over the edge into the oblivion of a terrible illness

You were sweet to telegraph Mrs. Wagner. I saw her this afternoon. I liked looking at her, and I would have enjoyed her but she had three movie mad girls there and I felt so badly. I could scarcely stand them. I saw Margaret Mathers [*sic*] also this week, she gave me a lovely print of you. She said Charlie had asked for one, he admired you so much.[159]

I cannot write any more, except that I have been reading Keats and Shelley every day. They make me so happy

Good night, sweetheart, I lie down at night with you in my arms, but my thoughts are so black and moody that you steal away, and I am left alone in the darkness. Florence.

Postmarked August 16.

Max to Florence, c/o Goldwyn Studios, Culver City, California, August 16, 1919

Darling, the pictures are so beautiful, so sunny and happy. What an *exquisite* dress that is! It makes me long for your sweet body so.

Dearest, I've found your fur and I'm sending it to you. Hasn't Peggy Hoyt sent the hat? I'll go in and see about it.

O darling, don't make your letters any shorter. Tell me *everything*. You can't tell me enough.

<div align="right">Max—</div>

Postmark.

Florence to Max, Croton-on-Hudson, New York, August 17, 1919

Hollywood

Dearest, Your letter made me so happy. I am glad you are having such a nice time and that you love George again. You must not like him more than me. If we like perhaps he will be able to visit us this winter. I had hoped you were going to finish your book out here, and that we would read it together before it went to the printer. Will Crystal be home soon. That will be fine to have the magazine off your mind.

We have finished the first picture. Mr. Goldwyn saw it, he said it is the finest picture he has seen in a long time.[160] I don't think I count for very much in the picture. I just seem rather sweet in it. But everybody else likes me very much. Did I tell you I start work in "The Cup of Fury" by Ruppert [*sic*] Hughes.[161] he likes me very much and told me I was one of the most beautiful girls he had ever seen on the screen. You alway[s] worry dear about how we will be together. You shouldn't I can fix it easily. I will get a cottage for you, but I will keep my apartment for myself. Someone told me the reason Rex Beach[162] didn't engage me for his picture was because he thought I didn't know how to dress. he never forgot that awful dress I wore in The Auction Block and not on account of you.

I am going to see Mr. Goldwyn next week and have a little talk with him. Do you know that Ford's new car has a self starter, dim lights and batteries just like any other car, would you rather have that in a chevolet [*sic*]. The difference in price is about $150. The Chevrolet cost the most,

but you said you thought you would like to have one let me know as
soon as possible as you have to order them way in advance. Dearest I feel
sometimes we are just writing business letters to each other you never make
much love to me and then I am afraid you are feeling cold to me and so I
don't make much love to you.

Of course I realize we wouldn't be able to stand it if our letters were just
letters of longing and love, still I am lonely for you to say you miss me to say
you are thinking of me.

You have no idea how sad I am. I never feel well[163] one moment of the
day or night. You can imagine how hopeless it makes me feel to be in a
strange place where there are no good doctors because all the people here
are Christian Scientists

They made a mistake in my check this week, so I have to wait until
Monday to send you some money. I will send it postal order this time as you
say you are not in such a hurry for it. Give my love to Eugene and George

Dearest I have torn up so many letters because I felt it was cruel and
selfish of me to complain Then I would start another but sooner or later
a little sadness would creep into it. Forgive me this time I will not write
again unless I can promise you a brighter letter.

From Keats to his sister[164]

I am so glad you got on so well with Mons Le Cure. a good deal
depends on a cock'd hat and powder, not gun powder lord love us, but lady
meal, violet smooth, dainty scented, lily white feather soft, wigsby-dressing
coat collar-spoiling whisker-reaching, pig-tail-loving, swans-down-puffing,
parson-sweetening powder

The whole letter is in such a charming playful mood. of course you can't
read it because it is your book I read it in.

When you come out, you must bring some of our favorite books, we will
read them together. I still feel I am going to finish the book on Science I
liked so much.

3000 miles is such a foolish distance between lovers, but I cannot laugh
at it, it seems more like years than miles.

Florence

Written entirely in pencil.

Florence to Max, Croton-on-Hudson, New York, August 18, 1919

At the studio.

Beloved. Your letters when you tell me you love me and miss me, make me so happy. I long for you too sweetheart. I am always thinking of the time we will be together. I started work yesterday with a new director, he is a charming man, but he has so many funny characteristics,[165] (here I was called back to work and I was busy until late afternoon, when I returned to my room and a lovely letter from you was there with clippings and other letters enclosed.) Dearest I will write Ruth but I am so curious when you say she had good reason to go away.

(I'm home now)

Are you allowed to tell me. I am curious. I guess Doris has my letter by now. I thought Sally's letter was so sweet and poetic how nice she seems, she's not a bit tongue tied in a letter. What a sweet poem that girl wrote you; Is she in love with you? I hope you're not in love with her. I have not had time to read the article about Voltaire, only one sentence caught my eye, and made me so angry. He said Madam de Chalet [*sic*][166] died, just in time, and he accounted the time Voltaire spent with her, as wasted. He ought to let Voltaire speak for himself. he says she was the most remarkable woman of all centuries, her brain was wonderful Altho she had trans- lated a book of Newton, still she could chat in the most charming young manner He says he carried her off, and that she gave up everything to spend her time with him while he studied and read dull books. I don't know Lytton Strachey but I don't like him. Keats the other day in writing to his brother told him his exact position, how his feet were placed, what he could see when he raised his eyes from his book, and what he was thinking as he read, he adds it is such things as these I would like to know of Shakespeare and Newton.[167] I feel it is such things as that I would like to know of all great men I admire how they lived when they worked, not the florid acts which biographies think add a little glamour to a man. Claude McKay's letter is lovely. I always feel I ought to send your letters back to you to read again especially when they are so beautiful.

I think dearest you would be a great man under any form of Government.

Beloved I long for you. to see your beautiful body walking around, to touch you and kiss you.

I long so for you.

Is it true you are coming to me soon, or are we just writing letters about it. Can't you ever settle on a date dearest I cannot think of it There is no time for my mind to look forward to.

In pencil, except for the envelope. First page written verso on Goldwyn Pictures Corporation letterhead. The motto at the bottom of the sheet: "It's a Goldwyn Year."

From the clipping of "Voltaire" by Lytton Strachey that Max had enclosed in his letter of August 13: "At times one fancies him as a puppet on wires, a creature raving in a mechanical frenzy—and then one remembers that lucid, piercing intellect, that overwhelming passion for reason and liberty. The contradiction is strange; but the world is full of strange contradictions; and, on the whole, it is more interesting, and also wiser, to face them than to hush them up." The essay had appeared in the New Republic, *August 6, 1919, and was later included in Strachey's* Characters and Commentaries *(1933). As this letter shows, Florence, while acutely aware of the differences in educational background, was eager throughout their relationship to establish herself as Max's intellectual equal, as someone who would also be comfortable to push back against Max's solemnities. Florence's newfound confidence would, on occasion, lead to some raised eyebrows among Max's literary peers.*

Max to Florence, c/o Goldwyn Studios, Culver City, California, August 18, 1919

My sweetheart, O how I have missed you and wanted you over this Sunday! It seems terribly wrong that we should be separated when we make eachother so happy. I find I am thinking all the time about two things— the first is September when I will go to you for at least a month and a half, and the next is December or January when Crystal comes home, and I will go out there to stay.

I want to live out there with you. I think it will be fine to go away from New York for awhile. And to be in the sun! I can't imagine getting tired of it.

I have a kind of feeling you will be back in New York again after a year.

It is raining, and I'm on the train going down for a day in the library (we just left Ossining.) Tonight Eugen and George and I are going to the actors' performance at the Lexington theatre. The spirit of that strike

seems to be about the most wonderful thing New York ever saw. Dudley says they just simply adore Frank Bacon (is his name Frank?)[168]—and Ethel Barrymore.[169] You know how late and how great Bacon's success was, & he is a joint producer as well as author of his play—so that royalties and profits are the biggest part of his income from it. He came to a meeting after he walked out, and people went around Broadway with signs reading "Lightning has struck!" and they got him up to make a speech. Dudley says he is just exactly the same in real life as he is on the stage. He said "Well, I says to mother, 'Mother,' I says 'I guess the boys are going to strike', and Mother says 'Well Frank, where do you stand?', 'Well, mother,' I says 'I guess I'll have to stand with the boys and girls'. 'That's right, Frank', Mother says, 'We began with an oil stove, and we can go back to the oil stove if we have to.[']"[170]

There is something about it that appeals strongly to my emotions. I read the paper every morning with tears in my eyes.

Belasco got out some perfectly terrible sentimental statement. It disappointed me. In the course of it, he said if the A.E.A. won he would leave the stage, and Marie Dressler sent him a message saying that if the Managers won she would leave the stage, and it wouldn't make any difference to the stage in either case because they were both old enough to retire!

But probably you see all this in the papers. Dudley has offered to write about it for me, and I'm rather in a quandary, because Dudley offended the I.W.W. so much in that murder trial that I'm afraid his name would hurt in one way—and that is more important—while it would help in another.[171]

I'm going to have Art & Frank Walts[172] both draw pictures, and George is gathering information—and seeking a sweetheart—among the chorus girls!

Darling, Anna washed the lavendar [sic] curtains and dipped them in tinted [water] Saturday, and I was so sad that you couldn't see how sweet they look.

O I saw Pauline Frederick Friday—just for fifteen minutes before my train left. Beloved, I don't wonder she is jealous of you! She is so lacking in charm and loveliness and freshness—just the things that you bring so abundantly. It must have been very hard for her. Did you see any change after I sent Dudley's telegram?

I keep going deeper and deeper into the history of theories of humor. It has never been written before, and I think it will make my book very interesting to psychologists even if my own theory isn't true. I wish I weren't the editor of a magazine and never had been!

Floyd is on his vacation now—until Labor Day—so even my half month's leisure is qualified this time. But I'm taking lots of notes so even if I don't finish my history here, I can do it out there without the books. It is

great fun—I love to do it. But I would love it so much more if I could come home to your heart in the evening, and wake up to see your sweet beautiful smile in the morning. I am always sad and lonely when I wake up.—I love you, darling—

<p style="text-align:center">Max.</p>

Postmark. Written entirely in pencil, including envelope.

Max to Florence, c/o Goldwyn Studios, Culver City, California, August 19, 1919

Wednesday, Aug. 19, Croton

My darling, if you were here right now we would go down to the river for a swim before dinner, and then we would have such a lovely dinner and happy anticipation of the evening and of the night. My love, I thought I was brave when you went away. I cried a great deal but I continually thought in my brain that it might be well for us to be separated a while. But I don't think so any longer. I miss you awfully and all over and all the time.

I read your sweet humorous letter to Doris. You don't write me humorous letters like that, but I think I know why, so it's all right. I felt better about the Englishman when I heard of his big hands and feet. But I guess he is just a blind for Louis Sherwin. Are you falling in love with him? Yes, I have had somewhat to do with him, which left me with a feeling that he is a little strange in some way, though he seems intelligent and nice.

I hope you will tell me if you are not falling in love with him.

How I wish that picture would bring you to New York now! We would go out to Nantucket for Sunday.

Beloved, unless it does I am coming to you in less than a month now, and if it does, maybe we can go back together!

It is 5:30 and I've just stopped working. A yellow jacket stung my hand in the middle of the night last night out in the barn, and if you saw my fat hand you would hate me. Everybody agrees to that.

I have had a fine day's work today, and I begin to see the light. I *know all about this subject* even if my own theory isn't true. Nobody ever knew more.

I was so lonely and longing last night I would have telephoned you if I could—I want you so much—

Postmarked August 21, 1919. Letter written in pencil.

Max to Florence, c/o Goldwyn Studios, Culver City, California, August 20, 1919

Darling, if I could only lie down in your arms tonight, I am so lonely and the time is so far. You tell me about a man asking you to marry him, and that makes me feel jealous and frightened. Darling don't fall in love with anybody. And don't go off in strange desert places with people alone, will you. Sometimes I think of things you've told me about narrow escapes you've had, and I shudder at your ruthlessness.

No, sweetheart, I only went to the challenge once[173]— & one morning for a few minutes to a rehearsal. It was two nights before the strike: I would as soon cut off my hand as scab on that strike. You don't know how it appeals to our hearts.

I'm sending you a program of the opening night at the Lexington. Eugen took George and me as his guests.

Your letter to George was so sweet and humorous. He liked getting it from you.

Darling I love you, I love you. O if I could lie down to sleep in your arms tonight.

<div align="center">Max.</div>

I don't get along without you. I'm not a success. My editorials are so bad I don't want you to see the magazine, and my other writing is slow and hard to do. I don't think I'll ever come back to N.Y. after I get out there— until you do.

Postmark.

Florence to Max, Croton-on-Hudson, New York, August 21, 1919

Good night, my sweet love. how I wish I was going to lie close to you tonight to feel your soft cheek against my lips, for I would kiss you so sweetly and hold you softly in my arms all night.

<div align="center">Florence.</div>

Postmark. Letter written in pencil.

Max to Florence, Goldwyn Studios, Culver City, California, August 22, 1919

WOULD YOU TELEPHONE ME TONIGHT IF NOT TELEGRAPH
I CAN NOT REST BECAUSE YOU HAVE GONE AWAY NOW AND
YOU DONT EXPLAIN ABOUT YOUR HEALTH I WOULD TAKE
TRAIN TONIGHT BUT BY WAITING I CAN STAY SO LONG
PLEASE HELP ME I HAVE NO OTHER HOPE OR INTEREST
LOVE

M

Western Union telegram, filed 3:00 p.m.

Max to Florence, c/o Goldwyn Studios, Culver City, California, August 22, 1919

Darling, nothing can tell you the degree of my longing for the sound of
your voice. I am lost in the woods of life. If I could just hear your voice—

Max.

Postmark. Letter written in pencil.

Max to Florence, c/o Goldwyn Studios, Culver City, California, August 23, 1919

Your long letter and your telegram came today, my sweetheart, and so
I feel better again. I was so sad and troubled last night, and I waited to
see if you could telephone me, but I half thought it would be impossible
from Hollywood. I know I shall still be worried when night comes, both
because nothing can make me sure you have not gone away from me, and
because you refuse to explain to me about your health. I cannot believe
it is anything unnatural—if I did, I should be worried to death. And if it
is natural—then I am worried too, because I think you always need my
advice.

Darling I think you ought in kindness to tell me, and in wisdom to ask
my advice.

I guess I bored you with my long letters telling you everything I was doing! There was such a dry time there when I was reading all day in the library, and then I went from there to the old magazine. I didn't seem to have any strong emotions. I just wanted to talk to you all the time. Lately I have been so lonely I just wander around the house disconsolate, the time and space between us a great cold wall.

Another thing, sweetheart—a thousand times I am impelled to send you a telegram but I actually haven't had the money in my possession. You know, I had drawn my salary up to the 16th of August, and perfectly overwhelming bills were coming in, and I felt that I shouldn't borrow any more. So I just lived without any money at all the way you do when it's gone.

You are reading Shelley too? We will take him with us, and Keats, and all our beautiful companions, when we go away to lie down together by the sea. And the wind and the sea and that great eternal murmur in the silence will fill our moody hearts with rest.

O my love, I can see the warm colors in the secret curves of your body like light on the brown sand. You fill me with fire and passion across all these miles and hours. How can I be distant from you? My beloved, take me back into your arms again, and my body to yours when you lie down. All my love is for you. I wait for you thirsting. I am sure I have told you in my letters lately, for I have missed you so much that I could not write about little facts anymore. O my beloved sweet child I wish you could find some way to tell me you are not turning from me, and make me sure. You found such poetry to express your sadness. Be my sweetheart and be happy in your sadness till I come.

<div align="center">Max.</div>

Postmark. Written entirely in pencil.

Max to Florence, 1824 Highland Avenue, Hollywood, California, August 25, 1919

YOUR LETTER AND TELEGRAM MADE ME HAPPIER BUT I MISS YOU SO TERRIBLY AM LEAVING THE SECOND MAGAZINE IS DONE SEPTEMBER TENTH SURELY PLEASE BE INTELLIGENT WITHOUT ANY EMOTION ABOUT YOUR

HEALTH I WANT A CHEVROLET I THINK[174] AND DREAM ABOUT YOU ALL THE TIME

<div align="center">M</div>

Western Union night letter.

Max to Florence, c/o Goldwyn Studios, Culver City, California, August 26, 1919

My sweet and darling child, I don't want you to wait until you feel cheerful before you write to me. I want you to tell me how you feel. I am walking on quicksand when I don't know that you are writing me your real thoughts—

Darling, the indefiniteness about the very day I will come is only that inevitable question about delays in the magazine. I am undertaking a great deal of writing for it, besides all the gathering of material, so I will be held there until all that writing is in print. I want to make a kind of final burst that will last them for a while, and I want to leave Floyd re[con]ciled to doing it all the next month. But I have packed up my books, sweetheart, and I shall be ready to fly the moment that task is done.

O my darling I am so weary of the hours that keep me from you. I am so hungry for the life of your body in the night, and the days are dark because your laughter is gone. I often stand still and think how sweet it would seem if you were just coming along the little path from Sally's house. I lie in my bed and feel the curves of your sweet body fitted so close to mine. Darling, keep your love vivid and happy till I come.

Will you find me a little cottage, then, in a quiet place? It would be so sweet if we could go there when I come. I live [*sic*] you, darling, and I miss you deeply and all the time—

<div align="center">Max.</div>

Postmark. Max's note inserted at the top of the letter: "I'm sending you a telegram about the date & about the Chevrolet." Written entirely in pencil on letterhead (verso) and envelope from Hotel Manhattan, Madison Avenue and 42nd Street.

Florence to Max, Croton-on-Hudson, New York, August 27, 1919

Hollywood. Aug, 27:1919

Dearest. I am so happy tonight. I had not been to the studio for a couple of days, and when I went today, there were two lovely letters from you, and the programs of the Equity. Your letters were so sweet to me my love, I feel as tho we will soon be together. You wrote so intimately on the program that you brought it all before me, and I felt as tho I had been there. I had to show the program to the other people who were just hungry for news. It made them all so happy and proud.

They had painted my dressing room, in beautiful sun yellow. The boss painter had sent away and gotten me just what I wanted. It looks beautiful. I painted my floor green, or rather they did, and I have curtains that would make you jealous, they are the most beautiful blue, and there is yellow, and black, rose and white in them. The furniture is cream color, and I have a rose covered couch. I wish you could see it, but there is a big sign on the steps, saying, no men allowed upstairs, so I shall just paint it for you, and you will have to imagine it. I like the director I have now, he is careful, and the camera man is a genius, he is a Russian, and a cripple, but he is so sweet and gentle everybody loves him.[175]

I don't like Louis Sherwin a bit sweetheart, he is a smarty without any foundation, and you know it gets tiresome traveling on thin air. Dearest, you say I haven't written humorous letters to you. I have been telling you all my troubles haven't I sweetheart. well they are all over, so I shall smile in my letters to you once again. The car strike here has lasted two weeks here, and now you know the train strike has started. it looks as tho we were facing a crisis I feel very serious about it, but very hopeful.

Darling wire me if you would care to live in an apartment in case I couldn't find you a cottage. I will try to get the cottage tho, because they are so pretty. You spend too much time thinking we should be separated. I shall run away from you some day and never come back if your [sic] always thinking it is best for us to be apart whenever we are together. I do not think such things of you I really enjoy being with you once in a while.

Some friends of Marie's H. B. Smith have written me a nice letter and I will see them the first chance I have.[176]

I have so much to tell you, but I shall write you another letter.

Tell George I got the book. It is a beautiful book, I'll write and thank him.[177]

Good night my sweet love. I shall lie close to you all night in my sleep.

P.S. I received my fur, thank you. Peggy Hoyt's new address is 16 E. 55.

Max to Florence, c/o Goldwyn Studios, Culver City, California, August 28, 1919

Darling I've just been to a meeting of the Actor's Fidelity League at which George Cohan was elected president. I never saw such a scream of a meeting in my life. O how I would love to tell you it all—but I mustn't for then I could never write it again.[178] George Cohan, Louis Mann, Warfield, Willie Collier, Blynn [*sic*], Julia Arthur, Mrs. Fiske, Lenore Ulrich, Alan Dinehart, Howard Kyle, Janet Beecher— & Marjorie Wood sitting up at a long table, with Louis Mann in the chair—and *nothing to do*, and nothing to decide—except what to do with Cohan's gift of $100,000. And all urgently conscious of the necessity of registering sincerity and enthusiasm.[179]

Marjorie Wood looking earnest and "moved," you know, with that utterly empty head showing in every gesture.

And at the end they found Frank Bacon there, & urged him to speak. They were so excited to find him. He demurred, and at last got up & made a quiet little sad talk, and said he was "with the Equity absolutely, and I will stay with them sink or swim!"

But I mustn't write any more about it now. My darling how you would have laughed and laughed with me at that meeting. O sweetheart I will have so much to tell you. I will talk to you until you beg for a chance to speak.

This afternoon I had a talk with Marie Dressler at her house, yesterday with Harry Mountford.[180] He's the real thing. Friday I'm going to an Equity meeting.

I had kind of a funny time with Louise yesterday at the station; she called me a snob, & then wrote me a letter apologizing.

She has a French sweetheart, whom she brings up here & actually drives Jack out of his house.[181] Jack has been up about two days since they got back.

Sweetheart I feel like gossipping [*sic*] again. But I'm very tired & it's the late train, so I guess I'll rest my eyes—

Goodnight my beloved. Soon we'll be together, and our hearts will be warm and happy—

<div style="text-align:center">Max.</div>

Postmark. Letter written in pencil on ruled paper; envelope in pencil.

Max to Florence, c/o Goldwyn Studios, Culver City, California, August 28, 1919

My darling, I can't write to you because I feel you don't like my letters. I have so much to tell you, and I just can't help pouring it all out. But I will save it all, and tell you soon.

My work is exciting because I'm doing the actor's [*sic*] strike, but every minute my mind returns to the hour when I will fly to you. I miss you so. I so long to talk to you endlessly about everything—

My sweet love, I just tore up a long letter to you.

<div align="right">Max.</div>

You can destroy the enclosed letters

Postmark. Florence seems to have destroyed the enclosures. Letter and envelope in pencil.

At the end of August, as the floodgates of Max's emotions were open, Florence took an envelope Max had addressed to her, ripped it, flattened it out, and, besides other scribbles, wrote "Goldwyn" and "Florence Deshon" all over the front, fantasizing about her future successes (fig. 2.9).

Max to Florence, c/o Goldwyn Studios, Culver City, California, August 30, 1919

O my beloved, your words have made me so happy. They were like infinite wine to my thirst I slept all night with your little note folded in my hand. I didn't realize how much I had needed it.

My dearest, I wish you could feel my thoughts in my berth last night, as I lay awake dreaming and remembering. In two weeks I will be on this train again with all of our joy in my heart. Today I am just going to the convention for two or three days, and then back.[182]

Be careful of your sweet life my beloved. Be careful for me. I have been a good deal worried and thought I was pretty stupid about interpreting your letters. I could have found the name of a good doctor in Los Angeles for you, and I hope you will tel[e]graph me if you still want one.

Figure 2.9. Envelope addressed by Max to Florence, August 29, 1919, with scribbles by Florence. Deshon mss. Courtesy, Lilly Library.

Darling, I love you. I long for you—You are the only thing in my heart—

<div style="text-align: center">Max.</div>

Postmark. Written entirely in pencil.

> *Note the reference to the "one man I like" in Florence's next letter. Max would have noted it, too, though Florence was never abashed about the fact that, as an equal-opportunity connoisseur of human beauty, she would let her roving eyes linger on other men—and women, too. (In that context, recall her attraction to Rob Wagner's wife, Florence Welch, August 15, 1919.)*

Florence to Max, Croton-on-Hudson, New York,
August 31, 1919

Hollywood, Aug 31, 1919

Darling I wanted to speak you so much last night to tell you how much I love and want you all the time. I could only send a little stiff telegram and pray you could read between the lines.

How sad darling you should be walking around without any money. I have sent you so little. I had to stay home a few days this last week and rest I was so sick and tired, so my check was small, as they took it out of my salary. Wire me if you need any money. I have some in the bank, I can draw it and send it to you. Dearest my illness was such a crazy combination of things.

I was homesick for my little house on the hill. I was longing for you. Then the water here made me sick, and I thought Caroline would drive me mad. I am ashamed to talk about it, but I cannot live so close to a person I do not love without suffering terribly. All the time I complained I was sick and should eat simple food, she ignored me and prepared all kinds of highly seasoned food and she would never get more than enough milk than she needed for herself, and I didn't like her a bit. I have asked her to go home, but you know her.

It is well settled at night, and all unsettled the next morning. Forgive me my beloved for such a dull account but it just poured itself out before I could stop it.

I have taken you back into my arms beloved I slept all night with your body close to mine it made my heart beat fast and I curved my lips in my sleep the way you say I do sometimes, and I sighed for you to be really there so I could feel your sweet touch. I did not want to open my eyes this morning I did not want you to go away. I think about the time we will be together.

I think you will like it here. The nights are so lovely and still, and in a little while the hills will be green and the air will be sweet with flowers.

Would you like to bring one of the lamps do you think, and would you like to bring the beautiful blue curtains. I am just suggesting that if you care to do it. We can have lots of pretty things without them. I shall order a chevrolet [*sic*] so you will have it when you get here, you will have to learn to run it, and I'll learn too. Dearest I am so excited at all wonderful trips we can make as you can [go] anywhere in a car. Mrs Gartz called on me and I may see her today.

I am going swimming with Mrs. Wagner some day next week I think they are so kind to help me forget my loneliness. I have met one man I might like but he is always with a girl I know so I imagine they like each other. They remind me a little of Doris and Dudley only of course they are not half as charming. The man is more like Doris, and the girl is like Dudley. Give my regards to the people on the hil[l] and tell Marie and Floyd I owe them a letter and I shall pay my debt. My dearest all my love is for you, tell me you love me in your letters I am hungry for your love.

<div align="center">Florence.</div>

I loved all your busy letters too dearest.

Letter written in pencil. The envelope carries a note in Max's handwriting: "Special."

Max to Florence, c/o Goldwyn Studios, Culver City, California, August [?], 1919

My sweetheart, tears came in my eyes when I read in your letter that you cried in your sleep.
 I am not tired, darling, and I love you all the time. I could not love anybody else even if I tried

<div align="center">Max</div>

Postmark partially illegible.

Max to Florence, c/o Goldwyn Studios, Culver City, California, September 2, 1919

My beloved, in all the terrible rush and tiredness, your sweet love and very happy longing are never absent from me—

<div align="center">Max</div>

Written on letterhead and envelope of Hotel Sherman, Chicago. The Sherman was Chicago's premier night spot during the Jazz Age.

**Florence to Max, c/o Hotel Sherman, Chicago,
September 2, 1919**

THINKING OF YOU ALL THE TIME AND MISS YOU LOVE

F.

Western Union telegram, filed 5:34 p.m.

**Max to Florence, c/o Goldwyn Studios, Culver City, California,
September 3, 1919**

My sweetheart, I just saw a girl with cheek bones shaped like yours, but she wasn't shaped like you anywhere else.

My beloved, I feel so excited and happy when I think of our meeting.

Crystal said in a letter that there is nobody in England as beautiful as you are.

I am having lots of fun at these conventions. I wander around among all three of them, and laugh at them so much that they all feel friendly toward me.

Beloved, I will be in your arms so soon. I can't think of anything else—

Max

Postmark. Letterhead and envelope of Hotel Sherman.

**Florence to Max, Croton-on-Hudson, New York,
September 4, 1919**

Hollywood, Sept. 4, 1919

Beloved, Did you know William Gropper works for Goldwyn,[183] and Charles Schwab put up the money for Helen Keller's picture "Deliverence" [*sic*] which has made a great hit.[184] everybody is impressed with her wonderful spirit and character. I love you to gossip to me in your letters I like you to make love to me too. I guess I like it best when you tell me you love me.

You know I would love a little racer, but I thought perhaps you would think it was too extravagent [*sic*]. I may wait until you get here before I decide. I am feeling so well, I shall be able to write you smiling letters once again.

I am always thinking of the time we will be together, I am going out to look for a little cottage for you on a hill if I can find it. Darling I saw the finished production of "Letty" last night. everybody Complimented [*sic*] me, there is never a moment I look strange like I sometimes did in Vitagraph pictures. I always look like myself. I am so happy you are writing about the actors strike what a wonderful vivid article you will write with such fine material. Aren't they sweet with the precious new born independence. I think they are so brave.

Los Angeles is all tied up with strikes. There are lots of scabs here, it is amazing but strikers tell me they are one lungers[185] who have no spirit and my heart aches for them. Even with all the scabs they [*sic*] car service is ruined no cars run after 7 o'clock and very few during the day.

Everything is very high here. There is no doubt we are approaching a crisis. Dearest I spent a lovely day with Rob Wagner and his wife.

What a lot we shall have to tell each other. I wish you could see me tomorrow I wear that beautiful coral colored evening gown I love it. I am going to ask Mr. Goldwyn to give it to me, darling.

Postmarked September 5. Written in pencil. At the top of the first page, Florence inserted the note: "I have the lovely smiling picture of you."

Max to Florence, c/o Goldwyn Studios, Culver City, California, September 5, 1919

Darling, do you remember how we lay close in eachother's arms on the top shelf in our little stateroom those days when we travelled together? I went to sleep with that memory last night.

My beloved—

<div align="right">Max.</div>

Friday morning—In the train

Postmark. Written entirely in pencil.

Florence to Max, Croton-on-Hudson, New York, September 6, 1919

Beloved. In two weeks you will be on the train coming to me. I hope darling it is because you want to come, and not because I have urged you so much.

I have so much to ask you, so much to tell you. I am curious to hear what happened in Chicago.

The girl who photographed you sent Charlie Chaplin one of your pictures he had asked her for it. He said he thinks it is beautiful, he thinks it is such a good picture of you.[186]

How the days will fly. you will be here in no time. oh dearest I shall be so happy. Florence

Dearest. I cannot tell you how passionately I long for you. you know that I am too shy to write. I must have you close to me, so I can whisper in your ear.

Written entirely in pencil on Goldwyn Pictures Corporation letterhead (verso) and envelope.

Florence to Max, Croton-on-Hudson, New York, September 7, 1919

My sweet love, how I long for you and dream of you.

Postmark. Written entirely in pencil.

Max to Florence, c/o Goldwyn Studios, Culver City, California, September 7, 1919

My dearest, it was so sweet to find your warm happy letters here, and your telegram telling me you are all well. I knew as I came up the hill that they were all I came for.

My beloved, I'm afraid it will be almost or quite a week later than I said before I can start. We have delayed the magazine that long in order to get this story in—and my story of the Actor's Strike [*sic*], which is still unwritten. I am applying every moment to it, to do it well, but I am impetuous in my heart. Nothing could delay me but the fact that I can stay

longer with you. I love you and I want you. My flesh wants you, and my spirit, all day and all night—

<div align="center">Max</div>

Postmark.

Max to Florence, c/o Goldwyn Studios, Culver City, California, September 9, 1919

My beloved, you will think my letters are getting awfully short—it is because I spend every minute on these stories and getting out the magazine. I am so tired and nervous when I drop into bed, but then I throw them all away and dream of the days of sweet freedom we are going to have.

O my dearest, I am so eager to come. I love you so much I miss you so much.

Never mind about Caroline—Don't take her seriously. Maybe we can get her off to New York while I am there.

Never mind about anything Sweetheart—we will be together so soon!

<div align="center">Max</div>

Postmark. Written entirely in pencil.

Florence to Max, Croton-on-Hudson, New York, September 10, 1919

Beloved, I smiled when I read your little letter about the top shelf we slept on together, how happy we were, we both loved to be moving.

All this week a beautiful moon has silenced all the mountains and torn my spirit with such longing I am almost sick.

Darling I hope there will be no more delays. What a wonderful number the next one should be such a lot of varied articles. I am so glad the strike was won so soon. George Cohan seems to realize now what a terrible mistake he has made.

I am only thinking of the time I will hold all your loveliness close to me. To kiss your sweet eyes and lips. O come soon my beloved. come soon.

Written in pencil, on thin yellow paper. Envelope, also inscribed in pencil, from Goldwyn Pictures Corporation. Max's note on envelope: "Special."

Max to Florence, c/o Goldwyn Studios, Culver City, California, September 12, 1919

Darling I don't know what you will think, but I have felt so sad at the postponement of my going, and all the things that have piled up to be done before I go. I can't describe them all, but you know the magazine has grown to be an enormous thing, and Crystal's away, and Floyd is coming into another irresponsible phase (I think he's getting sick of Marie) We have postponed the magazine almost two weeks already, and that two weeks will come out of my time with you. And more yet, for I have to go to Washington for a day.

Well, darling, I was getting just hopelessly sad and dismayed, and lying awake at night, and last night I happened to think that if I would just add two weeks and a day or two more to my delay I could get all my duties done, and get the *next number* all ready, leaving it in Floyd's hands to make up, and then it will be the number after that that I will ship, and I will be able to go away with a free mind and come to you for the long time that we planned. I will devote myself all to getting ready between now and the first, and I will be able to leave by the 3rd or 4th of October, perhaps sooner.

Darling, I was relieved when I thought of this. I can't explain fully how many reasons there are why I can't go away with a free and unworried mind now, and I can then. Fundamentally it is because I worked on my book too long in August. Now I will spend the whole of this month preparing the magazine in advance. But also it is because September is always the month of things to be done.

Beloved, my darling, I only fear you will misunderstand and think I have anything in my heart but the longing to go to you. You won't, will you? Dearest, your happier loving letters are sunlight and air to my life. I press them close to me. I love them. I love you. You don't know how I love you.

<div align="center">Max.</div>

I think I will send you a telegram that I cannot come until the first of October, if I can think of a way to express it, so you won't be puzzled and wondering until this comes. Don't take Caroline *seriously* at all, darling, if you can help it.

Postmark. Written on the French version of the Brevoort Hotel letterhead. Envelope also from the Brevoort.

Max to Florence, 1824 Highland Avenue, Hollywood, California, September 15, 1919

FLORENCE DESHON 1824 HIGHLAND AVE HOLLYWOOD
 YOUR LETTERS MAKE ME SO HAPPY BUT I AM
DISCOURAGED BECAUSE I CANNOT COME FOR DAYS I
AM AFRAID YOU WILL MISUNDERSTAND WILL WRITTEN
[*sic*] LONG LETTER ABSOLUTELY IMPOSSIBLE TO LEAVE
MAGAZINE UNTIL OCTOBER FIRST DO NOT MIND MY
TELEGRAM ABOUT MONEY IF DIFFICULT LOVE

M

Western Union telegram, filed 2:28 p.m.

Florence to Max, Croton-on-Hudson, New York, September 15, 1919

Los Angeles Calif 15/19

Your telegram made me so sad Caroline is going home Wednesday so I could not spare the money this week will surely send it next week I feel it is all over & I really understand it

F.

Handwritten Western Union telegram. No time stamp.

Max to Florence, c/o Goldwyn Studios, Culver City, California, September 15, 1919

My beloved one, it is the end of summer. Today, there was a little bronze in all the leafy places, a great bold wind, and the autumn roses come again to your pink bush. They are so lonely and sad for you, and for the summer that is gone. I am sending you a little petal to remind you. We would go out over the fields back of the hill today if you were here, feeling the cool air against our faces, drinking the sweet colors, and I would watch your sweet gracious steps, the motions of your body through the grass and under the

trees, the truly beautiful thing in my life equal to them, and I would be so proud and happy in my passion.

Darling, it will be soon. I have telegraphed you today that I had to stay two weeks longer, because I am afraid you will stop writing to me. And yet I am afraid you will misunderstand, and so I hated to send the telegram. It is hard to explain all the necessities that hold me even in a letter, but if I tell you I will be working hard all day every minute of these two weeks preparing everything for my absence until December, you will understand.

Sweetheart, your letters bring such sweet breaths of passion and of tenderness. I tremble when I open them. How wonderful that you love me and let me lie in your arms at night.

<div align="right">Max.</div>

Postmark.

Max's constant postponements, in the name of yet-to-be-completed work on the forthcoming issue of The Liberator, *dampened the lovers' excitement over the reunion. But the anger over the delays was mostly Max's, a preemptive gesture not justified by Florence's mostly tolerant responses. Her forbearance might not be unrelated to the date with a film director she mentions, casually, in her September 19 letter to Max.*

Max to Florence, 1824 Highland Avenue, Hollywood, California, September 16, 1919

YOU NEVER WOULD TAKE MY DUTIES SERIOUSLY STRIKE STORY JUST FINISHED MAGAZINE TWO WEEKS LATE FLOYD SICK EVERYTHING IN CONFUSION FINANCIAL AND LITERARY MY LEAVING AT THIS MOMENT WOULD BE END OF MY CAREER THINK YOU OUGHT TO BELIEVE MY WORDS I HAVE NO COURAGE TO TELL YOU THE TRUTH I COULD NOT WRITE SUCH LIES I AM COMING THE MOMENT I CAN AND ONLY LIVING UNTIL THAT MOMENT LOVE

<div align="center">M</div>

Western Union Telegram, filed 10:45 a.m.

Florence to Max, Croton-on-Hudson, New York, September 18, 1919

My sweet love. I saw a lovely picture of you at Mrs Gartz the other night. It made my heart faint with longing.

Florence

Postmark. Written with blunt pencil, also on envelope, provided by the Hotel Hollywood. Marked "special" by Max on envelope.

Max to Florence, 1824 Highland Avenue, Hollywood, California, September 18, 1919

O my darling, if you knew how passionately I love you and long for you— how tormented and worried and mad I am at everything that holds me—at everything that touches me. There is nobody but you. I only love you—I only want you. I am doing everything in my power to get away—but *I don't want to come* only for a few worried days. I want to live with you. My sweetheart you *know* there is nobody alive; there is nothing else but you.

Dearest I can't write to you any more since your telegram I feel that you do not believe my words. But I am coming to you. I am working day and night to come and you will know when you see me that I am truthful. My beloved.

Max

I will come just the first day I can—

Postmark. Written entirely in pencil on coarse brown paper and a Liberator *envelope.*

Max to Florence, 1824 Highland Avenue, Hollywood, California, September 19, 1919

HAVE CABLED CRYSTAL COME HOME AM COMING NEXT WEEK YOU WOULD LAUGH AT YOUR DOUBTS IF YOU SAW ME LOVE

M.

Western Union telegram, filed 2:05 p.m.

As she was waiting for Max to clear his schedule so that he could visit her, Florence made it plain that she wasn't spending all her time working. With "a director I know" she went swimming. If the detail about her getting hurt was meant to arouse Max's pity, he was likely more disturbed by the fact that her unnamed swimming buddy subsequently took such good care of her. Since, in the same letter, Florence also mentions that she was reading Max's poems to Allan Dwan (1885–1981), one of the pioneers of early film, it is at least possible that Dwan was her new best friend. Also known as "Capability Dwan," the prolific Canadian-born director was the kind of "man you would turn to in a crisis" (as Florence clearly did).[187] At the time, Dwan was in the process of getting divorced from Pauline Bush; he seems to have genuinely cared about Florence, too, and remained her confidant—see Florence to Max, March [15?] and 22, 1920.

Florence to Max, Croton-on-Hudson, New York, September 19, 1919

Dearest, I sent you $50 a few weeks ago, did you get it, you didn't say. I had dinner with Mrs. Gartz. Chase Herendeen was there with the boy she has married. Poor Child. I didn't like her. she has all the conceit and confidence of a homely girl, who thinks she is beautiful. She said to me very imperiously "Tell Max I want him to come out. I want to see him, you know he is an old suitor of mine.["] I must say I looked surprised. "Oh yes[,"] she answered ["]We often went swimming together. it was thrilling" [188]

Cranie Gartz is the most beautiful boy. he looks like George,[189] only he is really more lovely looking he has such dark wonderful eyes. Mrs. Gartz annoys her children she loves them so intensely. I was swimming with a director I know, and went skipping along the beach. I hit my toe against a rock, and fell on my side, at first my side hurt the most but after a while my toe hurt so much, he sent for the doctor, he put a splint on it and bandaged it. it[']s all right now. I seem to be going through an infantile stage, don't I sweetheart always falling down and hurting myself that[']s because you are not here to take care of me.

Mr. Goldwyn invited me to dinner he wanted me to meet some big picture people. he treats me beautifully. The men thought I looked lovely.

One man said I looked like Mona Lisa. he meant the other picture, we like so much.

Mr. Goldwyn was so pleased. he wants to get these men behind him. Godsol and Price I don't know if you know them. Abrams the head of Charlie's company and a lot of others They were all so homely but so polite and respectful I almost laughed at them.

Did I tell you beloved how pleased I was with the sale of your poems. Mr. Dwan a director out here likes them. I read him some. he wants me to get him a copy.

I hope there will be no more delays. but you know Max I do think of your career. I don't want you to take this trip if it is going to interfere with your work in any way. I love you darling and want you all the time, your beauty and loveliness haunt me.

When I wake in the morning, I am so sad. in my dreams you are often close to me, and in the morning I know you are far away.

Florence

Postmark. Written in pencil and mailed in Hotel Hollywood envelope. Max's note on envelope "F Summer 1919."

Florence was laughing at dangerous men.

Hiram Abrams (1878–1926) had a background very similar to many others who rose to power and influence in the movie business. The son of a Jewish immigrant, he began selling newspapers at the age of sixteen, left school at an early age, and started managing theaters by 1909; he was also marketing films and became a distributor.

Abrams got to know W. W. Hodkinson of Paramount Pictures. Hodkinson put Abrams on the board of directors of Paramount Pictures in 1914. When Hodkinson denied Paramount producers Adolph Zukor and Jesse L. Lasky more of the profits, Zukor thought up a way to get rid of him.

Zukor and Lasky sold Hodkinson more of their film rights, and using that money, they purchased Paramount stock to gain a majority of it, which they did in 1916. Then, joined by Abrams and others, they used this majority to vote Hodkinson out. Abrams took over as president of Paramount Pictures in 1917.

Then a sex scandal came to light, which also involved Abrams. While in Boston, he organized a party for Fatty Arbuckle, Zukor, Lasky, and several

others. At the end of the evening—or rather, morning—the check totaled
$1,050. Some of the girls present that night had decided to talk, and funds
($100,000, to be precise) were raised to avert criminal charges.[190]

It is likely this escapade cost Abrams his job, as Zukor fired him soon
afterward. Abrams's wild party was one of the episodes that led to the renewed
outcry for Hollywood to get its house in order. Abrams more than landed on
his feet, however, becoming managing director of United Artists in February
1919. Goldwyn pictures were being distributed through United Artists since
Goldwyn had for the most part avoided investing in theaters. So Florence was
substantially right in describing Abrams as the head of "Charlie's Company."
Oscar A. Price was the future head of United Artists.

As for Frank Joseph Godsol (1873–1934), Goldwyn got Godsol "behind
him" all right, bringing him on board as "Chairman of the Executive
Committee" of the Goldwyn Pictures Corporation around August 1, 1919,
which was somewhat similar to deliberately swallowing a tapeworm.

For Godsol did his best to destroy Goldwyn. A corporate raider par excel-
lence, flamboyant, darkly handsome, oozing confidence from every pore, Godsol
owned some theaters and had handled a number of theater deals, dating back
to 1912, with Lee and Jacob Shubert, owners of the largest theater empire of
the time. He had a shady reputation even before he became a stockholder in the
Goldwyn Studio. He had apparently cheated the French government by selling
it defective horses in World War I and so was under investigation by the
French Council of War. He also touted a brand of pearls without mentioning
to investors that the pearls were artificial. And what he was to do to Goldwyn
was very similar to what Hiram Abrams did to W. W. Hodkinson.[191]

When credit was plentiful in 1918, profits from pictures such as Birth
of a Nation *convinced businessmen who had originally considered film a*
risky investment to pour their money into the industry. Goldwyn needed funds
as well as theaters, so he brought on Godsol as a stockholder. Godsol in turn
persuaded Chase Manhattan Bank, Dupont, and others to invest and buy up
large shares of stock. This gave Goldwyn seven million dollars in cash, which
he spent buying literary properties, actors and actresses (such as Florence),
and even theaters. Godsol was also in a position to bring along the Shuberts,
with the numerous plays they owned, as well as A. H. Woods, who possessed
theaters that Goldwyn coveted. Because of the added income and other assets
from these new investors, Goldwyn increased his capital stock to one million
shares. But he forgot two valuable lessons he should have already learned.
First, never in his life could he get along with partners—any partners. And
second, the new investors, who owed their allegiance to Godsol as much as to

Goldwyn, were now in a position to use their shares of stock to oust Goldwyn from the presidency of his own company. And in 1919, Goldwyn was making some bad investments.

Max to Florence, 1824 Highland Avenue, Hollywood, California, September 20, 1919

Saturday.

My darling, last night we sent the last pages of the dummy dozen to the printer. Today—and tonight I guess –I will spend at the printers seeing it through. Then I will have to make preparations for pictures and so forth in the next number, write an ocean of letters, arrange about the furniture, pack my bag—and that's all.

You see it is the 20th today, and we should have been where we were or are on the 6th. It is the first time it has ever happened on The Liberator.

I called Crystal to come home, and I am trusting that she will be here in time for the December number, so I won't have to leave Margaret[192] alone over two numbers—But if she doesn't—well, I've told Margaret I'll come back if I absolutely have to, but I think I can do all that is necessary by mail from there.

I want to stay with you. I don't want to come back.

My sweetheart, I could hardly tell you the dear passionate thoughts of our meeting that fill me when I lie down to sleep and when my eyes open in the morning. The color and motion of your being fill me, and my heart beats faster, and my muscles are all quivering that it is not a mere picture in my imagination, but that I am really coming to you and your body will be palpable and throbbing in my arms. O how I love you—Max—

Your little telegram made me feel happy again. When I feel that you don't believe me and I am cut off from understanding and communion with you, everything seems disjointed and fitful and impossible, and I think that nothing can ever get it straight. Then your letter or your telegram comes and a warm light seems to dawn and everything flows tranquilly and smoothly again.

My darling, I would die like a *starved* man if I thought you were withholding any love from me, or not waiting for me with all the doors unfolded and open.

Written entirely in pencil and sent in Liberator *envelope. Max's note on envelope:* "*The complete love in this letter—.*"

Max to Florence, 1824 Highland Avenue, Hollywood, California, September 24, 1919

STARTING THURSDAY AFTERNOON ARRIVE MONDAY AFTERNOON TRIED MY BEST FOR SUNDAY I WOULD BE UTTERLY JOYFUL IF I KNOW WHAT [*sic*] YOU STILL WANT ME YOUR LETTERS HAVE STOPPED AND I AM FILLED WITH DREAD ALL THE TIME PLEASE TELEGRAPH ME AT MY OFFICE BEFORE I START LOVE

M

Western Union telegram, filed 1:10 p.m.

Max to Florence, 1824 Highland Avenue, Hollywood, California, September 26, 1919

LEAVING CHICAGO HAPPY AS A WILD BIRD LOVE

M

Western Union telegram, filed 10:00 p.m.

Max to Florence, 1824 Highland Avenue, Hollywood, California, September 27, 1919

KANSAS INTERMINABLE BUT ONLY TWO NIGHTS MORE HAPPY LOVE

M.

Western Union night message, sent from La Junta, Colorado.

Max to Florence, 1824 Highland Avenue, Hollywood, California, September 28, 1919

ON TIME ARRIVING FIVE THIRTY TOMORROW WILL COME STRAIGHT TO YOUR HOUSE LOVE

M

Western Union telegram, filed 1:15 p.m. in Albuquerque, New Mexico. With Max's note: "N.B. date."

The gap in their correspondence from late September to early December is easily explained: at long last, Max was with Florence in Hollywood. If they both had wanted to keep their relationship secret, they didn't do a very good job of it. They went out in public and attended parties together. It was at one such gathering that Howard Sheridan Bickers (1883–1975), a Brit who had written a screenplay for the mercifully forgotten Universal picture Her Body in Bond *(1918) and otherwise earned his living as a journalist in Los Angeles, chatted with both of them. Other notorious "parlor Bolshevists" were in attendance. What the merrymakers didn't know: "Sergeant Major Sheridan Bickers," as federal investigators referred to him, was an informant. After the party, the duplicitous sergeant major dashed to the Los Angeles field office to report that Florence had "the same views as Eastman."[193] Agents there seemed mildly interested: "This office has files on most of the parties mentioned."[194]*

Meanwhile, Max worked to introduce Florence to his favorite parlor Bolshevist, Charlie Chaplin, although (or precisely because) his friend was still reeling from the loss of his infant son:

> *I took Florence one day to Charlie Chaplin's studio to pay a call, remembering his cordial welcome of the previous winter and surmising that her beauty and the lovely tones of her voice would not make another welcome less cordial. He was in one of his troubled phases, having recently buried the little malformed child that blue-eyed, empty-headed Mildred Harris bore him. Having been married to her long enough to feel lonesome, he greeted us as though we were intimate friends he had been longing to see. We soon* were *intimate friends—as intimate as one can be with Charlie, who carries a remoteness with him however close he comes. We formed almost a nightly habit of coming together, Charlie and Margarethe [Mather] and some friends from the movie colony, to play charades and other*

dramatic games. I remember those nights' entertainments as the gayest and most enjoyable social experiences of my life.[195]

These games became very important to both Charlie and Max. Note the intensity with which these two hypercompetitive men played them:

The harvest days of our friendship were in 1920 and '21, when I went to Hollywood to be far from The Liberator—*and near a beautiful actress I loved [Florence, of course]—writing a book on* The Sense of Humor. *Charlie was devoted to my actress too, and our friendship became a three-cornered one in which a lot of unusual emotions were given a place in the sun. As I look back upon those winters, Charlie and I seem to have been together almost every evening, playing charades and the speechmaking game and the drama game. We had to give up charades finally, because we found our whole energy going into all-night sessions of it, and neither of us doing a stroke of work in the daytime.*

I must explain that these charades of ours were not little impromptu guessing games; they were elaborately worked out dramas and scenic spectacles, in the preparation of which all human experience and the entire contents of Charlie's house would be levied on. His dining room opened through a wide archway into the library, and it had two exits at the opposite corners, one into the kitchen and one that went upstairs. There was a curtain in the archway that could be drawn, and thus the whole living part of the house would be converted into a theater. Without disturbing the guests, you could sneak up those back stairs and ransack their wardrobes, if any of them had had the hardihood to come for the night. Charlie and I would always choose the sides, and we would choose them the day before, inviting to dinner those whom we each wanted on our team. We got so expert at this game that we thought a charade was no good if it didn't have continuity—the first syllable being the first act of a play, the next the second act, etc.[196]

The "speechmaking game" was Max's literary addition to the charades, and it is notable how that, too, quickly became an occasion for male competitiveness. If Max's innovation, when Charlie first tried it out, made him look effeminate, like an "embarrassed schoolgirl," giggling and at a loss for words, Charlie soon seized control and introduced improvements to Max's design. Max's game had forced him to act a part rather than choosing to play the roles with which he was familiar; he remedied the situation by becoming a director of the game, not just an actor in it.

The sheer obsessiveness with which both men pursued their parlor games suggests that these entertainments were a displaced way of transcending the complex situation in which they found themselves, competing for the favors of the same woman. Of course, some of the competitiveness also came from the fact that Charlie, who had received no schooling beyond the age of thirteen, enjoyed sparring with the Columbia-educated, rhetorically gifted Max. The

parlor games allowed him to show that he was equal to, if not better than, folks who had been given more opportunities in life:

> It is not easy to get people into a mood at once energetic enough and relaxed enough to enter into such exploits, and that is where the speechmaking game came in. It was a creation of mine; a revenge I took for my long years of suffering before audiences who wouldn't give me any help.
>
> We played it this way: one end of the room would be cleared of people, and regarded as a platform. Everyone would write the subject of a speech on a slip of paper, fold it tight, and drop it into a hat. We always had to warn them to write a serious subject, not a funny one—the fun would come afterwards. And we had to make everyone in the room honestly agree to play: if anyone hung back, they all would. Then the host or ringmaster—whoever was engineering the game—would take out his watch, and pass the hat to the first person on the left of the platform. He—or she—had to draw a folded paper from the hat, mount the platform, face the audience, unfold and read it aloud, and make a speech one minute long on the subject read. If he could not think of a word to say, he had to stand there facing the audience just the same, until the minute was up.
>
> It is one way to finding out how long a minute is. And it is an unfailing means of limbering people up to the point of playing charades. After they have suffered through one of those lonely minutes, they are ready for anything that is done in company.
>
> Charlie improved on my speechmaking game by passing two hats, in one of which a subject was dropped, in the other a description of a character. Then we had to make a speech *on* the subject and *in* the character. This soon involved costumes and became almost as formidable as charades. I vividly remember Charlie as a "Toothless Old Veteran" discoursing on the "The Benefits of Birth Control." He rises before my mind's eye, too, completely costumed and made up as Carrie Nation,[197] delivering, hatchet in hand, a lecture on "Some Doubts as to the Origin of Species." It was in one of our games that he first preached the sermon on David and Goliath that forms a hilarious climax in The Pilgrim. When I saw it my mind traveled back to the evening I first introduced him to the speechmaking game, and he stood up there valiantly for one minute—fussed and embarrassed as a schoolgirl, giggling and saying absolutely nothing. He was trying to be himself. A soon as he caught on to the trick of acting a part he adored it.
>
> Charlie devised what we called the drama game, to take the place of those charades after they got so elaborate that neither The Kid nor The Sense of Humor was getting any attention at all. For this game we would drop into the hat titles suitable for one-act plays. We would divide the company into couples, and each couple would draw a subject. After consultation, and a raid on the wardrobes upstairs, they would put on a one-act play corresponding to that title, making up the dialogue as they went along. Of all the "parlor games" I ever played, that is the best fun.[198]

Charlie continued to entertain friends and guests with such parlor games when he was back in New York. In My Trip Abroad, describing a gathering he attended at Max's house in New York in 1921, he wrote that the charades he played with Max were a sort of therapy for him: "What a night it was for me! I got out of myself. My emotions went the gamut of tears to laughter without artificiality. It was what I had left Los Angeles for, and that night Charlie Chaplin seemed very far away, and I felt or wanted to feel myself just a simple soul among other souls."[199] The actress Rosalinde Fuller, Crystal Eastman's sister-in-law, left a vivid description of the get-together that suggests that the Tramp was not too far away that evening. The final charade was supposed to illustrate the word champagne, and the participants embarked on the simulation of a wild orgy: "I lay on the sofa, voluptuous and wanton, while the others danced drunkenly round me. Suddenly Charlie, with a quick, clean pirouette, emptied his pockets over me, scattering nickels and cents with wild abandon." Imagine Fuller's surprise when, the charade ended, she saw Charlie, "the richest man in the room," on his hands and knees busily gathering the coins and putting them back in his pocket.[200]

Max and Charlie revived their game playing in the 1940s, when Charlie was staying at the Waldorf Astoria after the premiere of The Great Dictator. Along with Edmund Wilson and Mary McCarthy, they engaged in a variety of personality tests, administered by the economist Charles Reitell. Max was pleased to reveal that Charlie and he had numerous traits in common, among them a high degree of emotional instability (Max's score was slightly higher).[201]

After a tearful parting from Florence in December 1919, Max accidentally took her car keys, leaving her stranded, an act that, in retrospect, must have seemed symbolic to him. Arriving in San Francisco, he compulsively embarked on torrid affairs with the poet Genevieve Taggard, who would later become one of his sworn enemies, and another admirer (not mentioned in his letters to Florence) named Vera Zaliasnik.[202]

 Love and Loss in Hollywood

Max to Florence, 6220 De Longpre Avenue, Hollywood, California, December 5, 1919

Darling, I don't know how to write to you. I want to tell you that I have seen four female poets since I reached this town and they have left me cold! There is no further seeking for one who has seen your loveliness and grace.

I want to tell you how impossible it is for me to go about like a book-agent soliciting funds from strangers. I have fallen down on it again here. I cannot do it. I am going up to see Sidney Wood one night tomorrow, then to Denver where there is a definite man to see, then Chicago the same, and then home to clarify and determine the future. I cannot stand this. I am deeply unhappy all the time.

Then I want to tell you about Joe. I am still feeding him dollars but rather enjoying his company. I have an affection for him. I'm trying to get Sid on the telephone to see if I can get him a job up there.[203]

Then I want to ask you to write to me at the Congress Hotel Chicago, so I won't be so terribly cut off from you so long, and then write to me at home too, so I will not have to wait for a letter after I get there.

All these things and many more I want to say, but yet I know it will be very hard for me to write until I have a letter from you, and feel sure of your warmness and your love.

My arms will be around you when I lie down tonight.

Max.

Postmark. Written on stationery of the Clift Hotel in San Francisco.

Max to Florence, 6220 De Longpre Avenue, Hollywood, California, December 13, 1919

My darling—I'm so sorry. How terrible it must have been for you to find you had no car. I can't tell you how mad at myself I feel, I'm afraid it was a terrible shock for you.

I'm still on the train, and sending this back the first opportunity.

Could you write me a little letter to the Clift Hotel?

My sweetheart, forgive me. I was so absorbed in you and I am so lonely.

You are the loveliest being on the world—that was what I thought when I went to sleep—

Max

Postmark. Sent "Special Delivery." Written entirely in pencil, including the address. Note on envelope: "I went off with the car key."

Max to Florence, Culver City, California, December 13, 1919

MAILED KEY SPECIAL DELIVERY TERRIBLY SORRY ADDRESS CLIFT HOTEL LOVE

<div align="center">M</div>

Western Union telegram, filed 10:28 a.m.

Florence to Max, Clift Hotel, San Francisco, California, December 15, 1919

Darling as soon as you left me, I knew you had the key. I rushed to the gate man he let me through, the first section was just pulling out. I felt so lost. The station master sent a porter through the train, but you were not on the second section. The station master was very nice and at last we found a man who said he knew all about electricity. I didn't like the way he attacked the job, anyhow. I felt blue and lonely & wanted to go home to our house and be a little near you. He fumbled and fumbled, and took out more screws and springs than you can possibly imagine. Then when they were strewn in great disorder all about the floor of the car, he said he didn't have the right tools to fix it. I was mad but I controlled myself, and hired a taxi met Margaret, then I drove to a garage, gave them an order to tow the car to their place, then I had a brilliant idea. I went over to Clark, the man that sold us the Ford and asked him if he had a key. You know how funny he is how slow and stingy, but I got a key out of him. I thought I was so smart, but the key didn't fit as all Ford keys are slightly different. I hadn't any money and I gave bad checks right and left and at last I took a Taxi home. How I missed you. I hoped you were missing me too. Margaret is so lovely, she was just as patient through the thing, tho she was very tired and hungry. I started today on the picture with Madge Kennedy. Mr. Beaumont is a lovely director, but I am not very interested, everybody in the picture is bored with it. There isn't any enthusiasm anywhere, but that might have been the day. it was rather cloudy. Dearest I stole a Liberator from the package. It looks beautiful. The cover is wonderful.

Beloved it was so sweet to have you with me. I only hope you get so cold and lonely that you rush right back. I shall hold you in my arms close to me and keep you warm, and we won't mind the lions roaring and the winds howling.

Good night my dearest

I long for you.

Florence.

Postmark. Envelope from the Stratford Inn, Del Mar, Southern California.

How amusing that, after Max had "stolen" her key, Florence would pilfer one of Max's magazines (maybe from a packet he had left for her to distribute) and then tell him about it, her cheekiness cushioned by flattery. While she might have found her new movie, Harry Beaumont's Dollars and Sense *(Goldwyn, 1920), tedious, it is in fact a charming, tightly structured work, with a simple but effective plot line: Florence's partner, Madge Kennedy (1891–1987), playing the part of Hazel Farron, a down-on-her-luck actress, falls for a baker with socialist leanings. To pay for his debts, she has to enter into a relationship with a disagreeable rich man, who, to her surprise, turns out to be magnanimous and unselfish and sponsors her marriage to the righteous baker.*

Presumably, Florence, given her leftist leanings, disapproved of the transparent political message underlying the film—that the rich aren't that bad after all and that, in a pickle, help will come from them rather than from the workers' own efforts. But that did not keep her from delivering a lovely performance as Madge's more free-spirited, seductive friend Daisy. Alas, her appearance was limited to the first ten minutes of the film. A copy of Dollars and Sense *has survived at the Library of Congress.*

Beaumont, incidentally, went on to enjoy a successful career as a director, with films such as Beau Brummel *(1924), starring John Barrymore and Mary Astor,* Our Dancing Daughters *(1928), starring Joan Crawford, and MGM's first sound musical,* The Broadway Melody, *which won the Best Picture Academy Award in 1929. Florence's costar Madge Kennedy, after initially retiring from acting in the late 1920s, returned over two decades later to a busy career in the movies, on stage, as well as on television, including a recurring role as Aunt Martha in* Leave It to Beaver *(1957–1963).*

Max to Florence, 6220 De Longpre Avenue, Hollywood, California, December 20, 1919

Darling,

I'm afraid my letters will strike a low tone because I am travelling away from you. Did you ever notice how a railroad whistle or a bicycle bell gets lower as it recedes after passing you? That is because the moving away of the source makes the sound-waves arrive less frequently. And so of my letters. (I offer this as the most complicated simile ever put down on paper.)

It is crisp and snowy this morning, and I feel the exhilaration that often comes after a sleepless night. I feel like fooling—and how I miss you then.

I went to bed in a berth that creaked and groaned with every motion of the train last night, and after pouring a cup of water all over its joints, I gave up and moved into another, beneath which there was a great fat man who creaked and groaned whether the train moved or not, and I would like to have poured a cup of water all over him.

("I would have liked to pour" would be better English.)

I picked up $300 in six hours of Denver, and got a telegram from Crystal capitulating to my rebellion and telling me to come home for Christmas.

I feel so happy because I am resolute and without any doubting about the future. Already I am doing some writing every day. I've done the review of Floyd's book, and made poetry of two of Moon Quan's translations. I wonder what you will think of them. Isn't it strange that I should have felt such an identity with the word's [*sic*] of Wang Wei, when I knew so little about them, and they seem all of them to be just what I want to feel?[204]

Be sure to tell me all about what happens at the studio—and everywhere else.

Be near me in the midst of this wild, lonely plain,

Max.

Envelope marked "clever." The poems were included as pencil drafts.

A Farm-House by the Wai River

The resting sun shines on the highlands only;
The sheep return along the pauper street;
The old man peering for his youthful shepherd

Leans on his staff beside the brown-thatched door;
The cocks are young, the rice-blades very green,
The silk-worms lie in many mulberry leaves.
The farmers now are bringing home their plows;
They meet together and they talk as friends.
In envy of this idle quietude
I pensively write the Sick Mi* song.

* "Song of a Recluse"

Passing the Heng Tze Temple

I did not know it was the Heng Tze Temple,
Miles up in the cloudy-headed hills,
The agéd trees—no treaded path comes here,
From what deep mountain heart resounds a bell?
It is but water sobbing on the perilous rock.
The sun's declining color chills the pines,
And a thin twilight fills the winding gorge.
The demon-greed of power is silenced here.

Date added by archivist. Max's note on envelope: "clever."

Max to Florence, 6220 De Longpre Avenue, Hollywood, California, December 21, 1919

Darling, I wish I could tell you what a flood of vitality and joy came into me with your beautiful voice over the telephone. I was so weary and despairing, and then at once I was all smiles and energy.

O my sweetheart, don't let anything ever make you grow sad. Your laughter attracts me as nothing else ever in the world will, your playful and sweet laughter.

I wanted to come back to you from San Francisco with all my heart. I had had enough of ego-adventure already.

Joe started for Bakersfield today.[205] He cost me 50 dollars, and I thought I was a fool not to send him there in the first place. I had to have my over-coat changed—and it cost me $110! Do you think it was wrong for me to pay so much? My own small town instincts were horrified at the idea but I

held resolutely to the thought of you, and how you always buy the best with money that you don't have, and how I must try to be worthy to associate with you. It was the only decent coat there was.

How glad I am that you have Margaret with you. "She seems to me like a god. . . ."[206]

I'm sorry I couldn't have my meddling hand in the letter to Mr. Goldwyn. We would have had such a funny time writing it.

I love San Francisco. It is a romantic city, one of the cities with poetic quality like New York and New Orleans. But I always expect the people to be more lively and vivid than they are. Perhaps there is some group there that has a poignant time living, but it is not the "reds".

Bob Minor had gone to New York, and his girl was away somewhere getting ready to follow him.[207] Lydia Gibson and her husband had me up there to dinner, and I've just decided to enjoy the luxury of saying that I don't like either of them. I hate to face it in her case, because her poetry is so beautiful, and it makes me wonder if I would have liked some of the poets I love best! At any rate she's "out" as you say.[208]

Genevieve Taggart [sic][209] is a sweet girl. Her hands show that she has worked all her life, and her mouth shows that she has suffered. It is not beautiful, but her eyes and nose and forehead with the strange high arched eyebrows are the very reincarnation of Walt Whitman! I declare you could dress her up in a beard and take a picture of Walt Whitman. She made me very happy by showing me a volume of my poems almost all worn out, and the passages marked that I know are the best. It was wonderful to find that my poems were to a stranger who read them just the same thing they are to me.

Do you remember what you said when I recited "The Lonely Bather" to you.[210] She said almost the same thing, and she spoke so calmly and matter-of-factly about the reasons why they are "so much better than any of the other things that are being written", that I had to ask her to say it over again to make sure.

So for once I encouraged a poet who was generous enough to encourage back.

C.E.S. Wood[211] showered me with copies of The Poet in the Desert for distribution, standing on the verandah as I went down the steep walk. He has drunk all my praise, adopted most of my laborious criticisms, asked and received reviews and advertisements in The Liberator, and never said a word to me in his life about anything I have written. He has humor, though, and an excellent cellar of wine. He told me that Hugo and Livia boasted of a Chinese kakemono[212] that they had bought in San Francisco

for twenty dollars, at the same time that they were asking for another two hundred![213] Some artistic temperaments those kids.

Darling, you wrote me such a sweet funny letter. I hope you won't dislike Hollywood, because I love it very much. I was happy there, and I want to come back. I am so lonely tonight to be going the other way—and especially as I don't see where the money is, to bring me back. To think we have not a cent of that thousand dollars left.

Never mind, I guess you will help me come back, and when I get there I am not going to spend a cent except for *L o g e S e a t s* in the California and Kinema.[214] There I will pass my leisure time.

Give my love to Charlie, and try to keep my memory green—or at least not too red—among the child-millionaires of Hollywood.

Try not to be afraid when the lions roar. I will be back before they ever catch you. And don't love Margaret too much, for I have no other home but where you are—

Max.

Date added by archivist. Max's note on envelope: "I have no home but where you are"; *"G. Taggard, C.E.S. Wood, Hugo Gellert."*

Max to Florence, 6220 Longpre Avenue, Hollywood, California, December 23, 1919

My dearest bright-colored being, it is so sombre, so cold, so wet, so dirty-snowy, and I have such a bad cold! I *believe in* California.

But my duties are done and I am on to the twentieth century[215] to New York. I hate almost to say it, you will envy me so. still if you take my advice you will postpone longing to be here very hard until spring. It was a very tolerant geographer who called this zone temperate. I haven't slept a wink for two nights, the change is so stimulating to me.

Dearest your letter, if you wrote one, hadn't arrived at the Congress hotel, so I am waiting for one in New York. You don't know how I am longing for the words that will make me see you and share in what you are doing.

I am very resolute about what the new year is going to be for me, and very sure it is going to be gay and free and full of the things we love for both of us. I shall be adamant to all untoward influences. You may count on that. The victory of Soviet Russia has taken all the compelling anguish

out of the temptation to sacrifice my creative life to the revolution. The whole scene is changed. It is well with the practical world, and I can live in the world of my thoughts.

Be happy too, my love, and write to me so I will *know all about everything*—

<div align="right">Max.</div>

Postmark. Letter in pencil, address on envelope typed.

Max to Florence, 6220 De Longpre Avenue, Hollywood, California, December 24, 1919

I AM INFINITELY LONELY FOR YOU AND THOUGH ALL THE CHILDREN OF LAUGHTER ARE GATHERING FOR XMAS ON THE HILL I AM THINKING OF YOU ALL THE TIME [IT] IS YOUR PLACE AND IT IS NO PLACE WITHOUT YOU YOUR LOVE

<div align="right">M.</div>

Western Union night letter.

Florence to Max, 34 Union Square, New York City, December 24, 1919

Dearest I haven't heard from you in ages. I suppose you are home by this time. The Wagners had a fire the other night, and I think it did a lot of damage. I haven't called up to ask about it. as she told me she was going away for the holidays. Charlie's picture is playing here this week. everybody is very disappointed in it.[216] They think it is very cheap. I mean by everybody, the people who care about him. The audiences seem to like it well enough. Elmer says he is devoting all his time to the "Kid" and is very happy about it.[217] I met Paul Jordan Smith in Parker's bookstore[218] and I had Variety with me. "This is my favorite sheet" I said to him. He said I [*sic*][219] got the funniest telegram from them a little while ago. "Our interest was purely a news interest." he said he puzzled over it and called up most of his friends. I think he said it was addressed to Helen Rickman, Judge Rickman[']s daughter, who just returned from New York.[220] The Smiths asked me down to their house for Christmas dinner, but Margaret and I

are going to the lunch. Darling have you forgotten me? I think of you all the time and miss you so much.

The car is always running out of gas. I guess she misses you too.

Reginald Pole called on me last Sunday and read Shakespeare to me in a voice trembling with emotion. I must say I agree with you about reading poetry. I like your way best. I think I am going to play in a play with him.[221] I hope so anyhow. It would be lots of fun. I read some notices of Letty. They all spoke nicely of me, nothing extraordinary, but very good considering the insignificance of my part. I have been on an orange juice diet for three days, as I ate some shrimp salad which knocked me out. I think you would like me. I look nice and thin.

Darling the sun has been shining its brightest and warmest for about three weeks. I think of you when I am riding along. I feel you would love it now. Tell me all about New York, if you write to me, but I feel you have given me the air. Write and tell me you haven't my dearest. I have given you all the room there is in my heart and mind.

Florence.

Despite Florence's assertions of love for Max, she may have begun her affair with Charlie right around then. Her abortive pregnancy the following year supports that timing, as does the fact that from now on references to Charlie proliferate in her letters.

Granted, especially later in his life, Charlie's fame and wealth made him a target for spurious paternity claims. Consider the paternity suit brought against him by Joan Barry in 1944, retried in 1945, which ended with a ruling against Charlie, even though blood tests appeared to exonerate him.[222] But with Florence the situation was different. Although she, too, was the subject of much innuendo about her alleged promiscuity, Max, who knew both Florence and Charlie best, also knew that Charlie had fathered Florence's baby, as he revealed in 1964, in Love and Revolution, *the second volume of his autobiography (*LR, *207). Chaplin, who maintained a steadfast silence in all matters concerning Florence, never refuted Max's version.*

The gifts that the famously frugal Charlie had bought for Florence (and, as she hastened to tell Max, also for Margrethe Mather and an unnamed girl at the office) would have helped clarify his intentions. Being courted by a man who was earning a lot more money than the president of the United States[223] would have flattered Florence, of course. Yet there is reason to assume

that Charlie was as genuine in his affection for Florence as she was when she welcomed him into her life. Charlie's taste for adventure stirred emotions in Florence that Max, with his constant yammering about his workload at The Liberator *and the slow progress of his interminable manuscript on humor, had ceased to evoke.*

But workaholic Max wasn't as oblivious as Florence might have thought. As his letter of December 21 shows, he knew something was afoot: "try to keep my memory green."

Crystal Eastman and Others to Florence Deshon, 6220 De Longpre Avenue, Hollywood, California, December 25, 1919

WE ARE HAVING A JOLLY CROTON CHRISTMAS BUT IT NEEDS YOU TO MAKE IT COMPLETE LOVE FROM EVERBODY ON THE HILL
CRYSTAL
WALTER DUDLEY DORIS MAX EUGENE MARGARET DAN[224] FRED AND MARIE

Western Union holiday telegram, filed 10:10 a.m.

Florence to Max, no address, December 26, 1919

Dearest I had an unexpectedly lovely Christmas. Christmas morning I received your sweet letter and telegram.[225] I hadn't heard from you in ages and I thought perhaps you didn't think of me anymore. Charlie had dinner with me Christmas Eve, and gave me a lovely box of hand made handkerchiefs. He told Elmer he got more kick out of the presents he bought for me and Margaret and our little girl in the office, wasn't that nice.

If you see "The Day's Pleasure", you will recognize me in the Los Angeles Jam. When Charlie goes around the corner at 7th Street and B'way, it looks very famaliar [*sic*]. I was caught between the cars, and I cried to the traffic cop [*Florence switches to ink*] Are you going to let them kill me. but very little sympathy did I get from that Gentleman. Keep out of the way can't you, was all he said. I guess it's because I drive a Ford.[226]

Mrs. Gartz sent me a Christmas card. Frayne[227] gave me a lovely book of poems, and Mr. McGehee had me down to dinner and gave me a lovely

piece of Japanese pottery. He has a sweet little house near the water. and lots of beautiful things. You would like it very much.[228]

Dearest I have some errands for you to do one is to go and see about my pin, now I like my pin and I don't want you to think that this is a good chance to get rid of it. Thank all my friends on the hill for the telegram which brought them all very clearly to my mind[']s eye and made me very homesick. Margaret is still here, but I feel every day that she will fly. she is very unsettled. All the time since you have been gone the sun has been shining like a summer day in Nantucket. it has been beautiful.

Did you get the working man's wallet I sent you and did you like it. Caroline sent me a nice present and so did Walter,[229] but nothing made my heart beat so fast with happiness as your sweet letter telling me your thoughts of me. I feel very close to you beloved and all my thoughts of you are happy thoughts.

Darling I shall send you a check next week to cover the expense of the pin. I am glad you have a nice new coat. I wish I could have bought it for you. Never mind I shall return in the summer laden with gold, all of which we shall spend on the house and a little for Nantucket. I have a beautiful idea about the barn. I want to make a nice room downstairs and a sleeping porch upstairs. Dearest don't have the kitchen painted without telling me. will you. I got two records for a Christmas present. One a piano record by Chopin and Emma Cahn singing the other which I can't pronounce.

Good bye my sweet love. Do not forget me. I shall keep your memory green.

Florence.

Dated by archivist; no envelope present. Written partly in pencil, partly in ink.

After his return from Hollywood, Max had joined his friend Eugen Boissevain in renting an apartment at 11 St. Luke's Place in the lower West Village west of 7th Avenue: an arrangement based on the premise that both men would be "consciously and frankly selfish" (LR, 179). Max said he honored his part of the bargain, while Eugen broke it by giving him $1,000 to help him finish his Sense of Humor. Since he couldn't live with Florence, Max had settled for domestic companionship with a man. Their new living situation was enhanced by the constant presence of two or three detectives lingering outside, whose task it was to rummage through their garbage and

Max to Florence, 6220 De Longpre Avenue, Hollywood, California, December 29, 1919

11 St Luke[']s Place
Monday Dec 29.

Darling, your sweet present came today, and I laughed out loud because I was so happy and excited over it. I think I was even more excited because it was a message from you, and made me feel I am still dear to you.

I have been here five days and no word from you. I thought all the time at Croton there would be a letter or a telegram when I got back here, and then Sunday night (last night) when there was none here, I thought it would be at the office. I asked the boy to bring down my mail early this morning, and at first I saw there was no letter from you, and then I saw the box.

It is a sweet present—perfect to my use—and I smiled when I saw that you had insisted on getting it at a jeweler's. But the little silver corners are so chaste and restrained I like them very much.

Tuesday morning: Do you know who interrupted me there? It was Louise Bryant, come in to see Eugen about sending some telegram to Jack. Eugen thinks she is pretty!

I was too tired and sleepy to finish my letter after she had gone, and I'm sorry because I was going to tell you all about the Christmas party at Croton. We divided into 3 troupes and went into separate rooms and each troupe gave a one-act play. It was quite a large party—Fred & Marie, Floyd and the moon-calf,[231] Crystal, Walter, Eugene, Jan, Margaret and Dan,[232] Dudley, Doris and one or two people staying with her. The plays were wonderful. You wouldn't believe they could be so good. I'll tell you all about it some day.

I must go to work now, for there are so many many things to do. I can't have my freedom for 3 more weeks because Crystal had arranged this speaking trip to raise money, before she got my letter and of course she has to go.

Love and Loss in Hollywood

Dearest, I am longing to see you. I am very lonely for a letter. I can't write to you when I don't get letters because I become convinced that you don't like me. I haven't written you for almost a week, and last night I dreamed you sailed away on a ship while I was trying to get the car ready, and when I ran down to the wharf I could just barely see you sitting there with your chin in your hand and your big hat on, looking sadly and beautifully back at me. I threw myself down on the wharf in despair, crying, and then I saw you seemed to be pointing down the shore, and I realized that the ship made one more stop before it sailed away, and I hoped you meant that you would get off then. I started running in that direction, mad with doubt, and then I woke up.

I find it very hard to feel settled here, or feel that I belong here. Jan and Eugen both live here, but Jan is so sweet and quiet that I like it better than if Eugen and I were alone. It is a nice house, but not too quiet in front (where alone it is warm) and Eugen has too much junk.[233]

Two detectives were in here yesterday trying to nose around. I suppose a couple of hundred dollars of the people's money will be spent "locating" me, when anybody could find out where I am by coming up and asking me. How absurd and how frantic they are!

I didn't have a very happy time at Croton. I didn't like to be in our little house with so many people. I feel that my emotions are driven out.

O how I would love to spend the spring there with you! Do you suppose if I got acquainted with Goldwyn I could persuade him to bring you out for a while?

I had already been to see about your pin when Caroline telephoned. I didn't have enough money—$45.25—so I have to go again today to get it.

Dearest, you don't like to write to me, but I need a letter from you.

Postmark. Written entirely in pencil. Max's note: "Big party at Dudley's."

Max to Florence, 6220 De Longpre Avenue, Hollywood, California, December 30, 1919

PLEASE SEND NIGHTLETTER ELEVEN ST LUKES PLACE I MISS YOU SO TERRIBLY LOVE

M

Western Union telegram, filed 4:17 p.m.

**Florence to Max, 11 St. Luke's Place, New York City,
December 30, 1919**

FORGIVE ME FOR NOT SENDING YOU A XMAS TELEGRAM
BUT I THOUGHT YOU WOULD RECEIVE MY LETTER AND
GIFT I MISS YOU SO MUCH EVERYTHING ABOUT THE
HOUSE REMINDS OF YOU AND I THINK OF YOU ALL THE
TIME ALL MY LOVE IS FOR YOU

<div align="center">F</div>

Postal night lettergram, filed 12:18 a.m.

3. "Talking Together in the Ford" (1920)

Max began the new year with repeated protestations of love, but the truth is that things were changing between him and Florence. As Florence increasingly redirected her erotic energies toward Charlie, Max focused his attentions on the German-born dancer Lisa Duncan, a member of Isadora Duncan's Isadorables. News of this affair, along with other disastrous events, was to have a profound effect on Florence, her career, and her relationship with Max. The year also brought the inglorious end of her dreams of fame in Hollywood, a fall made more dramatic for Florence because of Max's desertion. Florence soldiered on, continuing to appear in movies, working for Maurice Tourneur, First National, and Fox, but the lack of a safety net, personal as well as financial, had thrown her into an existential void, even as she kept reaffirming, in her letters to Max, her commitment to her work and career. Her "disastrous pregnancy" (LR, 217) brought her back to Croton (followed by Charlie). In October, Florence, her health restored and certain that she didn't want to share her life with Charlie either, defiantly returned to Hollywood to the little that was left of her former life.

Max to Florence, 6220 De Longpre Avenue, Hollywood, California, January 2, 1920

Dearest, I love you.

I love you with a song in my heart this morning.

I hope you are thinking of me—

<div align="right">Max.</div>

Postmark. Written in pencil.

Florence to Max, 11 St. Luke's Place, New York City, January 2, 1920

Beloved, I wanted to send you a poem about all the love I have for you but I am shy. If I sent you lots of sweet roses every day in the bud and you

watched them grow lov[e]lier as they opened and bloomed so has my love grown for you.

<div align="center">Florence.</div>

Postmark. Written in pencil. Max's note on envelope: "Special"; "The poem letter."

Max to Florence, 6220 De Longpre Avenue, Hollywood, California, January 4, 1920

Sweetheart your two telegrams and two letters have made me much happier. I was afraid I had lost my place in your heart. I always find myself laughing and singing after I get a letter telling me that you are still thinking of me.

I thought last night that there was none of my hopes or ambitious dreams that is worth what it is to be down beside you *one night* in that sweet quiet bed in the cool room. How happy we were! And what a wonderful place. It makes me very jealous to hear of the sunshine, for it has been dismal here, and now though the sun has come out it is very cold.

I am terribly afflicted in these days with the fact that nothing ever gets done. One day after another passes in details and plans of the preliminary arrangements for beginning to anticipate the necessary conditions for doing something. Here is this house with all our junk in it, and no cook, and no proper arrangement of heat or light, no bookshelves—dirty, dishevelled, half-cold. I go out after carpenters, plumbers, electricians. They promise to come, and they don't come. It is a month's labor.

Then there is the Liberator—all dependent on me, as I told you, and Floyd becoming more and more of an unconscious obstructionist in the effort to make it really good. Crystal has gone on her speaking tour. Then there is still money to be raised, and I am working on that. I think January 20th is about the nearest date I can hope to get free.

I think the last number is very bad,[1] and that gives me a terrible feeling that it really is my choice and judgment that has made the Liberator what it is—but I don't care. It will have to be something else. I do so wish I could talk to you about it all. I feel so sad when I see the Manuscript of my book lying untouched all this time. Really it is almost unendurable.

The one good thing is that I do not seem to be in for an indictment. Either they haven't got a plausible case against me, or they have decided to leave Americans alone. At any rate I feel rather confident for the time being.

I am so glad Charlie is still coming to the house, and that he gave you a Christmas present. I am going to send a copy of Enjoyment of Poetry to him, along with a present I am sending you. You must remind him that there is a summary at the beginning of the book and *that's all he has to read*! I really hate to give people my book because they always imagine that I will examine them later to see if they've read it. Tell him I won't.

I am also sending a review of Waldo Frank's book by Francis Hackett which expressed what I *didn't* like about the book exceedingly well, though not what I did like at all.[2]

I have your pin in my "workingman's wallet", and will send it to you tomorrow.

Darling, I won't do anything to the little house without you. I have a fire going up there and the water turned on, but I think it is foolish. It isn't foolish to use it much in winter. The truth is it is too small for two people, unless the two are you and I. No others in the world.

The phonograph is broken. I believe George had a whole family up there for a time—until Anna rebelled. George is so irresponsible, a mere fluid stream of emotions, that you get very mad at him in his absence. At present nobody knows where he is at all.

Eugen & Jan are both very sweet. I enjoy them. But my "feeling tone" toward my environment here is of distressing confusion. I feel as if I were always postponing my emotional and mental life—postponing, postponing until things get cleared up. I am not sure I could ever feel otherwise in this house.

Do you suppose if I got acquainted with Goldwyn I could persuade him to bring you back here for the spring? It seems like a dream of paradise—that we two should go up to the little house when the warm days are coming and fix it all up again together. But I suppose we can only wish for that—until summer when you will come home "laden with gold"! (You couldn't get from 42nd St down to the Brevoort[3] without spending it all.)

Everybody talks about you. Everybody loves you. My heart is full of you all the time—

Max.

Postmark. Written in pencil. Max's note: "George Andreychine [sic]. Liberator troubles!"

On November 7, 1919, and again on January 2, 1920, in an attempt to rid the United States of "moral perverts," federal agents carried out the so-called

Palmer raids. Under the direction of US attorney general A. Mitchell Palmer, the agents raided pool halls, restaurants, and private homes in thirty-five American cities and, without warrants, arrested thousands of alleged radicals over the course of several weeks. Florence's confidence that the jails could not hold those arrested turned out to be misplaced: many were locked up for weeks or months without access to legal counsel, sometimes in deserted army encampments. Among the federal agents who participated in the Palmer raids was a young J. Edgar Hoover, who had been put in charge of the newly created General Intelligence Division.[4]

Florence to Max, 11 St. Luke's Place, New York City, January 4, 1920

NEWS IN PAPER WORRIES ME SO LONELY FOR YOU LOVE[5]

F.

Western Union night message.

Florence to Max, 11 St. Luke's Place, New York City, January 6, 1920

SO SORRY YOU HAVEN'T RECEIVED MY LETTERS WROTE TO CHICAGO ALSO OFFICE THINK OF YOU ALL THE TIME AND FEEL SO LONELY WHEN I DONT HEAR FROM YOU WILL WRITE TODAY WANT SO MUCH TO RETURN IN THE SPRING LONG FOR MY LITTLE HOUSE ON THE HILL AND YOU LOVE

F.

Western Union night letter.

Florence to Max, 11 St. Luke's Place, New York City, January 7, 1920

Beloved, when I did not hear from you for so long I felt indeed deserted. Your dream was just turned about. I felt you were going far away from me.

Love and Loss in Hollywood

The news of the raids frightened me very much. Everybody was scared at the efficiency of the whole thing. But I felt they would have to build lots of new jails to hold all the people they arrested. Mrs. Gartz has been very nice to me, she has asked me several times to spend a weekend with her, so far I haven't done it. but I think I will some day.

Darling I understand why all these movie people are so restless and discontented. There is absolutely no poetry or beauty in their lives. Charlie Ray was telling a friend of mine he had a three months['] vacation coming to him, but he didn't know whether he would take it as he hadn't any idea what to do.[6] They are all the same. There is no artistic reward only material. I must say that as far as I am concerned, all this talk about a new art being born is untrue, it[']s simply a new business. Its name gives it away. Moving pictures. that[']s all they are and the only art is that of photography.

Mr. Goldwyn will be here soon. I am anxious to see him. I didn't write to him as he was expected here sooner. Margaret: a strange girl, you wouldn't like her if you knew her. I don't mean like, I mean you couldn't be in love with her. I think she would remind you of Ida. She never accomplishes anything and has excuse after excuse. I like her so much and wish I could help her, but it's no use, she is very stubborn. Dearest I miss you so much. It is just before supper and how I wish you were going to eat with me. I miss your beauty and I long for your presence. I am so sorry I am not working in the East, so we could be together. I am going to dramatic school did I tell you about it. I hope to play in a Shakespearian play.[7] How I would like to have been at the Christmas party. Sally sent me a cute little Christmas purse for Christmas. I was just in a Chinese mood. I had their beautiful New Year[']s lilies all around the house in dark brown jugs I bought in Chinatown it smelled lovely and looked lovely. I have changed the two front rooms quite a little. They are much prettier. Darling my letter seems dry as this sun burned count[r]y I am living in. All the fountains of my being are stopped.

Beloved, I am sending you a check for the pin, you keep it for me. Did I tell you my purse was stolen with my little watch and all my keys and my glasses. I cannot begin to tell you how much fun I have with the Ford. It is quite life like in its behavior. Do not desert me dearest. I need you. I long for you. we will be happy.

Florence

Postmark.

Florence's comment that Max did not really "know" Margrethe the way she did (even though it was Max who had introduced her to Mather) hints at the degree to which, in less than a year, she had become comfortable with people Max used to think of as his friends. She had not reached the same comfort level in her professional life, however. In fact, Florence now increasingly began to voice her dissatisfaction with the roles in which she was cast by the Goldwyn Studio and expressed her dislike of the medium of film in particular. In a way, this shouldn't have surprised anyone, considering her standard parts in Goldwyn films. Florence was generally cast as either the villainess from whose clutches the hero was lucky to escape or given the rather insipid role of the heroine's Best Pal. And to the extent that Florence was a believer in progressive, socialist ideas, the films in which she was cast must have been extremely painful to her personally.

A good example is The Cup of Fury, *released in January 1920 as one of the Goldwyn Eminent Authors Production films directed by T. Hayes Hunter. It was based on a novel by Rupert Hughes (1872–1956), who also wrote the screenplay with Anthony Paul Kelly. Hughes was a respected author, screenwriter, and critic, although no one ever cited him as a great writer. He was evidently not without wit or charm. One reads without much surprise that Hughes, uncle of the millionaire Howard Hughes, was in some ways extremely conservative. He served on George Creel's Committee on Public Information during World War I and in later years accused Hollywood screenwriters of communism.[8] Even so,* The Cup of Fury, *released more than a year after World War I ended, is remarkable for showing how the dominant ideology continued to insinuate the relation between union activity, Bolshevism, and treason. And the filmmakers must have had the Seattle General Strike of 1919 in mind.*

The Seattle General Strike was a job action in the city of Seattle, Washington, which lasted from February 6 to February 11. Several labor unions took part in the strike, an attempt to gain higher wages after two years of World War I wage controls. Many other local unions, including members of the American Federation of Labor (AFL) and the Industrial Workers of the World (IWW), joined the walkout. Although the strike was nonviolent and lasted less than a week, government officials, the press, and much of the public viewed it as a radical attempt to subvert US institutions, and it was attacked as the work of Bolsheviks and other radical groups. This was perhaps the first demonstration of the red scare that was to sweep the United States in 1919 and 1920.

Hughes's novel was published in May 1919. Florence mentions in her correspondence with Max that she started work on the film in August 1919, a

scant six months after the Seattle strike. It is hard to believe that the book and the film were not produced at least in part in reaction to the worker's actions in Seattle, which were of course supported by Max and his associates.[9]

The Cup of Fury is considered lost, but a complete copyright synopsis of the film is still at the Library of Congress.[10] *In addition, there are several stills from the film at the Museum of Modern Art, and of course Rupert Hughes's novel—not to be confused with Upton Sinclair's 1956 novel with the same title—is still available. The plot device that Hughes uses to get the ball rolling is a doozy. The heroine, Marie-Louise, a.k.a. "Mamise" (Helene Chadwick), is the foster child of Lord and Lady Webling, who are German-born but live in London. In a series of vertigo-inducing coincidences, it turns out that Mamise is not really their rich and socially prominent daughter but was formerly an American vaudeville performer from the Midwest who, having escaped a miserable orphaned family existence, ended up in a comedy novelty band called The Musical Mokes, in which she played various musical instruments, including the xylophone and trombone. Somehow, the band is invited to play at the Winter Garden in Berlin, where Lord and Lady Webling, in mourning for their deceased daughter, happen to see her. She reminds them of their lost daughter so much that they adopt her and take her back to London with them to raise as their daughter.*

Mamise is fortunate in not only possessing unique musical gifts but also being adept at mimicking English accents as well as the ways of the British gentry and is soon able to pass as a member of the British upper middle class, if not the nobility. One guesses that Rupert Hughes had managed to see Pygmalion *in New York.*

But beneath her crusty newly minted British exterior, Mamise is a true blue American, terribly upset about the sinking of the Lusitania *(in the film, the ship is renamed the* Tuscania, *for some reason). This causes problems when she finds out that her adopted parents, Lord and Lady Webling, are German spies. The Weblings commit suicide to avoid charges of treason, brought against them by the British Secret Service. Mamise is implicated in the espionage as well, since she had innocently run a few errands for Lord Webling, which turned out to be message drops for a German espionage ring. She is advised by the Secret Service to get out of Britain and to return to the United States, which she does.*

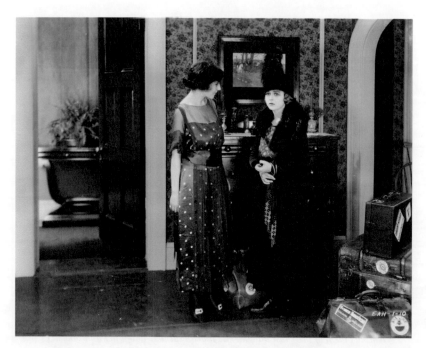

Figure 3.1. Still from *The Cup of Fury*, 1919. Florence *left* and Helene Chadwick *right*.
Courtesy, Museum of Modern Art, Film Stills Archive.

*Once there she makes a few new friends, among them Polly Widdicombe,
played by Florence Deshon (fig. 3.1), "one of the best-dressed women in the
world." This was a part tailor-made for Florence: while Polly is permanently
upbeat ("Laughter rippled all through her life"), she is also "tremendously
smart."*[11]

*However, also recently arrived in the United States is the insufferable Lady
Clifton-Wyatt (played by Clarissa Selwynne), who was present in London
when Mamise was implicated in the German spy scandal and who now
broadcasts Mamise's supposed guilt to everyone, including Polly (see the scene
captured in fig. 3.2). Thus, Mamise is met with suspicion wherever she goes.*[12]
*Fortunately, Mamise encounters Davidge, an American shipbuilder
(played by Rockliffe Fellowes[13]), whom she had previously met in London,*

Love and Loss in Hollywood

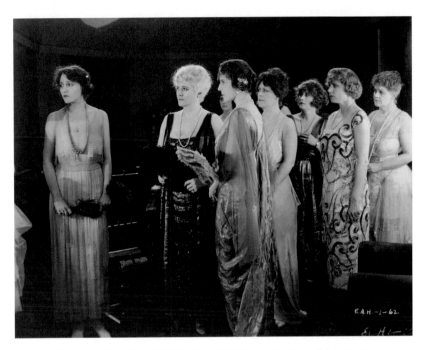

Figure 3.2. Film still from *The Cup of Fury*, 1919. Florence *left*, Clarissa Selwynne *center*. Courtesy, Museum of Modern Art, Film Stills Archive.

and induces him to give her a job in the shipyards as her contribution to the war effort, in the hope that such a move would quiet the suspicions about her patriotism. While she is at work in the plant, the plot substantially thickens. Mamise had a sister Abbie back in the Midwest before she escaped her miserable family. Having discovered that Mamise is back in the United States, Abbie reenters her life. Abbie is married to a factory worker named Jake, the worst sort of IWW, Bolshevik-loving type. Mamise finds Jake despicable but nevertheless secures a job for him at Davidge's plant. To complicate matters even more, Mamise is approached by Nicky Easton, a German spy, also a former acquaintance from London, who attempts to enlist her in a plot to sabotage the operations at Davidge's plant. She turns him down, but then Jake the Bolshevik teams up with the despicable Nicky to achieve that devious goal. Mamise, with Davidge's help, foils Nicky's scheme and is cleared of all suspicions when the next vessel launched is named for her. At dockside, Davidge announces their engagement.

It is not so remarkable that Hughes treats the Germans in his novel as fiends incarnate some six months after the armistice, but what is striking is

his treatment of the working-class Jake. The following description is from the novel, not the film, but the synopsis suggests that the film treated Jake similarly:

> *Jake Nuddle did not look so dangerous as he was. He was like an old toma-to-can that an anarchist has filled with dynamite and provided with a trigger for the destruction of whosoever disturbs it. Explosives are useful in place. But Jake was the sort that blow up regardless of the occasion.*
>
> *His dynamite was discontent. He hated everybody who was richer or better paid, better clothed, better spoken of than he was. Yet he had nothing in him of that constructive envy which is called emulation and leads to progress, to days of toil, nights of thought. His idea of equality was not to climb to the peak, but to drag the climbers down. Prating always of the sufferings of the poor, he did nothing to soothe them or remove them. His only contribution to the improvement of wages was to call a strike and get none at all. His contribution to the war against oppressive capital was to denounce all successful men as brutes and tyrants, lumping the benefactors with the malefactors.*
>
> *Men of his type made up the blood-spillers of the French Revolution, and the packs of the earlier Jacquerie, the thugs who burned châteaux and shops, and butchered women as well as men, growling their ominous refrain:*
>
> *"Noo sum zum cum eel zaw"* ("Nous sommes hommes comme ils sont.")[14]
>
> *The Jake Nuddles are hating personified. They formed secret armies of enemies now inside the nation and threatened her success in the war. The thing that prevented their triumph was that their blunders were greater than their malice, their folly more certain than their villainy. As soon as America entered the lists against Germany, the Jake Nuddles would begin doing their stupid best to prevent enlistment, to persuade destruction, to stop war-production, to wreck factories and trains, to ruin sawmills and burn crops. In the name of freedom they would betray its most earnest defenders, compel the battle-line to face both ways. They were more subtle than the snaky spies of Germany, and more venomous.*[15]

When it came to portraying his villains, Rupert Hughes certainly did not have a light touch. Shortly thereafter, Jake, speaking of Mamise, sums her up thus: "Dammer and her aristocratic ways! Daughter of a Sir and a Lady, eh? Just wait till we get through with them Sirs and Ladies. We'll mow 'em down. You'll see. Robbin' us poor toilers that does all the work! We'll put an end to their peerages and their deer-parks. What Germany leaves of these birds we'll finish up. And then we'll take this rotten United States, the rottenest tyranny of all. Gawdammit! You just wait!"[16]

Sophisticated The Cup of Fury *was not, but it was certainly timely. The trade journals had already made it clear which way the wind was blowing politically. And things would only get worse. On January 11, 1920, Secretary of the Interior Franklin K. Lane would introduce what he called*

his Americanization plan. At an assembly of two hundred of the leaders of the motion picture industry at the Waldorf-Astoria Hotel in New York, "Secretary Lane, in an eloquent address, outlined the proposed plan of using the screen as the most effective mode of combating Bolshevism."[17] Samuel Goldwyn was an enthusiastic supporter of the plan and proposed forming a committee of the most prominent authors (could he have had the Eminent Authors in mind?) to start the process of Americanizing appropriate films and periodicals.

The New Republic *panned Hughes's novel, complaining about his "querulous arguing" and claiming that he was "haunted by an obsession." But it got a respectful review from the* New York Times.[18] *And when* Photoplay *criticized the film, lambasting the many plot twists and melodramatic ending, the author of the article did not blame Hughes ("he is a skilled writer"), even though he perhaps should have done so, especially since the scenario follows the plot in the novel extremely closely.*[19]

The political situation also had a direct influence on Charlie Chaplin's activities. In February 1920, a report in Photoplay *suggested that Charlie was finding it prudent to trim his ideological sails. The rumor that he was backing* The Liberator *had made some urgent back-pedaling necessary, including the assertion that "he cherished absolutely no socialist or bolshevist tendencies."*[20]

With this kind of propaganda holding sway also in the world of American movies, the enthusiasm for lynch mobs in the period becomes more understandable, if not forgivable. Florence, considering her and Max's beliefs, must have found it incredibly difficult to crank out such mush while Max and his friends were risking federal prison and angry mobs to defend what a film like The Cup of Fury *had been made to attack. No wonder that she started to criticize Hollywood, too, and that she was spending more and more time with her friend Margrethe Mather and similarly inclined Hollywood intellectuals and artists.*

Max to Florence, 6220 De Longpre Avenue, Hollywood, California, January 7, 1920

I WAS SO GLAD OF YOUR TELEGRAM I AM SO TIRED AND LONG TO REST MY HEAD AND HEART WHERE THERE IS PEACE IT IS TEN OCLOCK I AM WALKING UP AND DOWN FIFTH AVENUE ALL ALONE THINKING OF THE HAPPY TIMES WE HAVE HAD MY DEAREST LOVE TO YOU

M.

Western Union night letter. The telegram was returned for correct address (De Longpre was misspelled "De Lengpre").

Florence to Max, 11 St. Luke's Place, New York City, January 9, 1920

Dearest. I was lying in bed dreaming of your loveliness this morning when the bell rang and it was a sweet telegram from you. I was so happy. Then later your letter came. Darling I was longing to hear from you, so it made me so happy. Don't like Jan better than me. Do you know that is all I can do to stay here. I feel like giving up my contract and going home. I am homesick. I am lonely for you and I keep playing with the idea that I will leave here in the Spring. Last night I had dinner with Mr. Godsol and Mr. Abrams. you remember those men I told you about.

They do nothing but brag about their power and what they have done for girls, and what they could do for me. It[']s all terrible and it took me a long time to get it out of my system. Louis[e] Glaum a very homely but lovely girl was there and we went in the dressing room together. She said to me. You are very foolish to go out with these people, a kike will never do anything for a girl for nothing and none of these men will do you any good. I told her I thought it was diplomacy to go out with them, but she said never do it again.

I felt terrible all night I really couldn't sleep. The only thing I gained from the evening was Mr. Abrams said it pays to advertise and every girl should have a press agent.

I am going to have some pictures taken tomorrow. I wonder if you could go to Baron De Meyer and get me some copies of that large head he did for me ask him if he could make a dozen shiny prints for me.[21] If it costs too

much just get six. I think I will go and see Mrs. Gartz this weekend. If you should ever feel like returning to this unpleasant place. I wouldn't hesitate to ask her to pay your fare.

Darling I would like to take a trip in July. I wish one could go to Europe. You think about it and see what lovely spot of the globe we can afford to visit. Do not forget me dearest. You are ever in my thoughts. I love you dearest I love you.

<div align="right">Florence.</div>

P.S. I shall send you a poem and not an epistle next time. a sweet kiss to you beloved.

Postmark.

Florence's vindictive bathroom interlocutor was Louise Glaum (1888–1970), who was in the process of developing quite a reputation for her roles as femme fatale, in movies with titles such as Sex *(1920) or* Greater than Love *(1921). At the time of Florence's letter, she was working for J. Parker Read productions, a subsidiary of Thomas H. Ince's studio, so this was not strictly a Goldwyn party. Her antisemitism aside, she had a point. It is clear that Godsol and Abrams (who had already gotten caught in a badger game in Boston) wanted to party. Although Abrams gave Florence some good advice about hiring a press agent, Louise Glaum and Florence were playing with a very rough, take-no-prisoners crowd. If Florence needed further reason to dislike "this unpleasant place," as she had termed Hollywood (January 9, 1920), people like Godsol and Abrams gladly provided it.*

Max to Florence, 6220 De Longpre Avenue, Hollywood, California, January 10, 1920

O my beloved, I want you so much tonight.

Postmark. Penciled, unsigned note, mailed in envelope addressed in pencil.

Max to Florence, 6220 De Longpre Avenue, Hollywood, California, January 10, 1920

My darling, your little shy poem-letter crept in so close to my tired heart. O you are so sweet and wonderful!

I am going to write you a long letter in a day or two

The pressure and anxiety of editorials and pictures and business will be over, and I have so much to tell you. I shall return to myself.

x

I keep your little letter on my bureau where I can reach it from my bed. My bed is so little and I am so lonely—

Postmarked and dated later, in Max's handwriting.

Florence to Max, 11 St. Luke's Place, New York City, January 11, 1920

Dearest. My only desire is to return in the Spring, but I am afraid unless I am sent there to do a picture I had better finish the year here and save all my money. I know how terrible it must be for you to be in so unsettled a state and have so much to do.

The days pass so quickly here that I feel very little is accomplished. Never mind if the Liberator seems very different without you. I was thinking that the ideas are what count[s] and surely the same idea will be behind the magazine.

A Russian professor from San Francisco is here lecturing on painting he had slides of Boris Anisfeld's paintings which I wanted Margarethe to see—we met him later and he was surprisingly conservative.[22] Very much afraid that the Revolution: would kill all artists or artistic efforts. He took me very seriously and Margarethe and Frayne[23] were so pleased, because they said I made him change his mind. We all went to a Greek Coffee house, and there the Greeks were all dancing and singing so simply and beautifully. I said surely you think that these people can be taught about Art better than that [*continues in pencil*] dry crowd at your lecture this evening. Well I have had a funny experience with Mr. Pole. Evidently he is in love with me, but I was unsuspicious until the other evening. He has been calling me up about his play and coming out here and staying very late, talking of everything but the play. The other night

Love and Loss in Hollywood

he stayed so late I was so tired that I told him I must go to bed. "It is about half an hour before my train leaves so if you don't mind I'll just sit here and read rather than stand on a cold street corner." Well I minded but I didn't say anything. I was so tired that I went to sleep as soon as I lay down. I woke up a little later and there was Mr. Pole sitting on my bed. I was furious, but I said very quietly. You will surely miss the last car, I don't like the way you are acting. He went away, but he returned the next morning before I was up. He is strange. I told him I was going to the theatre, he was there when I came out and drove home with me, but I didn't ask him in.

He has been here this morning and left a little present and a note for me. I am very angry and when I see him I shall tell him so. He talks of your poetry all the time and thinks you have the making of a great poet. Dearest I have just read over what I have said, perhaps you will be very angry, but don't misunderstand. he is not the least bit fresh or anything like that. I am going to send you $100 every now and then, which you must save for the summer. In the summer let[']s have the kitchen painted and get new curtains and a rug. If your phonograph is so broken it can't be fixed, I'll bring mine back with me.

The apartment here is lovely I miss you so much, sometimes I hate to open my eyes when I know they are not going to fill themselves with your beloved image.

I have breakfast before the fire in the morning, and when I have dinner home I do the same. I am getting a scrap book, so you can see all my clippings.

My whole being longs to take a trip away from commercialism. then I must admit I am anxious to pick up a future myself.

Charlie is always very sweet to me. Elmer says he likes me a lot. I met Edna Purviance.[24] I get the same feeling about her that you had so violently the first time you saw her. I have only a few lines to tell you you are ever in my thoughts sometimes happily sometimes with a sad longing, but you are always there.

P.S. Beloved I was going to mail you a check this time, but I thought I would wait and find out if you were in need of it. otherwise I'll keep it in the bank out here.

Another kiss to you sweetheart and another tiny kiss on your sweet lips and eyes.

Postmark. Notes on envelope, in Max's handwriting: "Special." "Charlie is always very sweet to me"; "about a check"; "I guess she owed me some money"; "There is a little evasiveness." Florence switches to pencil halfway through the letter.

Max to Florence, 6220 De Longpre Avenue, Hollywood, California, January 13, 1920

Darling, I do so wish that I had a long letter from you. I think about you more and more all the time. Sunday I rode up to the country with Eugen in his new car. It was late at night and I was still all the way dreaming in recollection of the nights we have driven there, our hearts so wildly happy; I felt your sweet lips so close to me. I lay beside you in the little narrow bed in the dark weather. I breathed the fragrance and knew the warm places of your body. O my love, how I longed for you! And that night—it was Saturday night—I built my fire and slept alone in the barn, because there I could have you all to myself. How beautiful you are. How luminous and tender in the dark, how warm against my flesh.

In the morning it was sad because you were not there. The little house is very shabby and discouraged.

It is really sad-hearted and will never smile brightly again until you come.

<div align="right">Max.</div>

Written in pencil; date added by Max in red pencil.

Max to Florence, 6220 De Longpre Avenue, Hollywood, California, January 14, 1920

YOUR LONG LETTER MADE ME SO HAPPY DO NOT LET
THE FOUNTAINS DRY UP I DEPEND ON THEM REMEMBER
WHEN YOU SEE G[25] COST OF LIVING MORE THAN DOUBLED
YOUR SALARY MUCH LESS THAN YOU THOUGHT DOES NOT
ENABLE YOU COME HOME MAKE HIM BRING YOU I AM SO
LONELY LOVE

<div align="center">M.</div>

Western Union night letter.

Florence to Max, 11 St. Luke's Place, New York City, January 15, 1920

Beloved, I received your sweet telegram and letter this morning also my pin, for a moment or two I thought perhaps the box contained a little shirt, which I need so much. Did I tell you about the Chinese professor from San Francisco, he is taking a party of people to China in June and the cost is $2000 for three months. I met him and had a long talk with him about going as usual I am anxious to go some place, but it is too expensive and altho he is very sweet I don't believe it will be very interesting. He told us about a wonderful dowager Empress that became bored, so she pushed her son off the throne, and ascended it herself. She conquered other countries and was a great Empress, no man could apply for a position in the Court unless he qualified as a poet. She was so vain of her power that she had special Chinese characters for her name which nobody else in the world was allowed to use. Moon-huan who is very child like in some ways, doesn't like her because she had many love affairs.[26]

I had to give up the idea of playing in the Shakespearian production: as Reggie Pole was simply using it as a blind to drop in my house at all times of the day and night and compare me in a shy voice to every know[n] Greek Goddess and Italian Madon[n]a.

Margarethe is still getting around to printing your pictures, and from what I know of her it would be best for you never to expect them and some day they will drop from the sky to your waiting hands.

The people here are so kind to me. Mr. Weston is going to give me a lovely portfolio and some exceedingly fine prints and Mr. McGehee is giving me three presents, a Japanese book with a lovely tapestry binding and a Japanese print and a Weston picture of himself in Japanese costume.[27] I judge people's kindness like a child by what they give me it seems. Margarethe has given me a lovely old Chinese fan. I seem to be growing again I realize why I have not developed the way I promised to a few years ago because of my living with Caroline. I enjoy the hours alone in my pretty house playing theatre before the mirror or pretending I am a writer and scribbling seriously for hours. I shall beat you to your biography. Now that I have not your sympathetic ear to pour out long tales of myself I pour them out on poor brown paper, and as they take form before my eyes I sympathize with them, and advize [*sic*] myself.

Goldwyn isn't here yet, but I expect him next week.

Darling I feel sorry for you with so much hard work to do, it must be terrible to raise money with all the new laws being printed every day.

The Japanese boy, I cannot say or spell his name tried to get the Liberator but it was impossible.[28] He is waiting for his book from you. I have seventy million things to do, so I cannot talk to you any longer. I would rather kiss you and hold you in my arms. Dearest I am shy about making love to you I feel perhaps you do not feel close to me and do not want to be drawn close by my love words.

Florence.

The letter mentions, and is in fact written on, Florence's favorite coarse brown paper. Max's note on envelope: "Special."

Reginald ("Reggie") Pole had entered the crowded stage of Florence's admirers just a few weeks earlier, promising her a part in a play (see Florence to Max, December 24, 1919). Indeed, Pole was getting ready to perform the lead in Shakespeare's Othello *at the Los Angeles Trinity Auditorium, in a production he also directed. Performances were on February 20 and 21, 1920; Florence was not a member of the cast.[29] Margrethe Mather took a photograph of Pole as Othello, looking both maniacal and handsome, his glowing eyes distracted by something that seems to be happening to his right.[30]*

Now mostly remembered as the father of Rupert Pole, the "duplicate husband" of the writer Anaïs Nin, Reginald Pole had developed quite a reputation not only for his theatrical exploits but also for his eccentric habits, which included sleeping till noon in darkened hotel rooms, traveling with an entire pharmacy at his disposal, and aimlessly roaming the streets at night. Suffering from chronic asthma, Pole had come to Southern California from Tahiti, hoping the climate would improve his health. Tall and slim like Florence, he had a "marvelously sensitive face." He was liked by audiences and left his mark in the role of Christ in Christine Wetherill Stevenson's Pilgrimage Play, *performed in the Hollywood Hills, and as Myshkin in a theatrical adaptation of Dostoevsky's* The Idiot.[31] *Pole was married to the actress Helen Taggart; his stalking of Florence does not seem particularly Christlike under any definition of the term.*

Surprisingly, while Max was bothered by the mere notion of Florence spending time with Pole, he panicked when she intimated she wanted to quit Hollywood. As little as Florence was making in Hollywood, he was not looking forward to having to support her again.

Max to Florence, 6220 De Longpre Avenue, Hollywood, California, January 15, 1920

Darling, it made me so happy to get a nice long letter from you. I miss them terribly. I wish you would tell me a little more about your work, and events in the studio. I am pinning my hopes on your persuading Goldwyn to bring you east at least for one part. I think you can do that if you concentrate on it. I rather doubt if you can do anything else, though I'll be glad if you make a great try. Get him very friendly with you first.

But if you tell him your salary is so small you simply can't afford a vacation to New York, and you can't stand it out there without, you may get him to make a definite promise.

I cling to the hope that you will be able to come soon, and then we could go back together.

But, sweetheart don't let "the fountains of your spirit dry up". Don't lose the habit of laughing. Your laughter is the one perfect jewel of all my riches in life. Please, please be playful and happy with your friends. Remember that you are doing something difficult towards an end that you really want, and it won't last so long.

This may sound like a sermon but it is a good one. I've decided to be happy and childlike and undistressed, whatever comes, and whether I get anything important done or not, *the rest of my life*!

Today is the first day I've touched hands to my book, and that may account for this noble-sounding resolve.

Darling I had already sent you the pin, and yesterday I sent you a buckle made out of Chinese letters. "Good luck" it says. Eugen brought it from the East, and he asked me to give it to you. You can thank him through me—assuming you shouldn't feel like writing him a letter.

I saw Caroline yesterday. She looks very fine and handsome. It did her good to work. She realizes that you aren't going to live together anymore—although she can't keep it in her thoughts continually. She just wavers back and forth between the reality and her wish-fulfillment. She had built up a conviction that we were about to be married, and I want to completely demolish that. I was really embarrassed when she said "Have you got something to tell me?" She is such a child. But she is very well and young looking, dearest, and you don't need to worry about her. Just write her letters that tell her about your work and play a little. I'll take her to a movie soon.

Now I must go to work. If I write to you oftener would you write me more letters? Be happy, sweetheart—Max

Postmark. Date added in red by Max.

Max to Florence, 6220 De Longpre Avenue, Hollywood, California, January 17, 1920

Darling, your letter made me very unhappy at first. I hate to have you talk of striking your colors and coming back to the vague shifting hopes again. You would not be happy. I think you should bend all your mind and your effort to *making Goldwyn bring you home,* or at least coming home *with a better contract* with somebody else. When that is your dream, then the dream nourishes your activities, and helps you to do all the little details—picture-taking, pure work, making friends—all the things that tend in that direction But when you dream of giving up—then you nourish your habits of procrastination and of letting the details slide. I want you to be resolute and courageous about it, darling, and I think it would be fatal for you to disappear into the nebulum again. You have to be with somebody and stay until people know who you are and where you are.

I don't like to have you call Hollywood an unpleasant place, either, because I like it. I wish you would make friends with Mrs. Gartz, so that she would pay my fare out there, for I shall be wanting it paid before long if you don't succeed in getting Goldwyn to bring you here. It is hard for me too. I feel strangely unbelonging to anything here.

Today I finished the magazine, and Crystal comes back this week, so now I shall to go work on my book. I think it may go very fast, for I live very quietly and have few distractions. You will think it is strange, I've only been twice to Broadway—one to see Grock, the famous French clown.[32] (You should take Charlie to see him, if he comes there—he really has quality, genius). The other time I went to see Civilian Clothes—a pretty shallow and poor show.[33]

I have been working terribly hard on the magazine, I shall play a little more now, as I shall be doing work that I cannot continue so long at a time.

I am really well. I never minded a New York winter, and a cold one, so little. It seems I stored up a lot of health in Hollywood, even if you didn't get the benefit of it!

It is evening, and I am sitting all alone by the fire. What amazes me is the *few* friends I have—the few people that I ever go to see, nobody telephones me, and I telephone nobody.

I wonder if you are saving any money. Caroline told me she saved just about all you sent her while she was working, and she says she's going to work again. If the Liberator could pay up my back salary I could pay all my debts—just. But that would include my overcoat and a new suit. Dearest, I wish you would take this advice—don't borrow any money and

don't charge anything. The freedom of mind that has come to me with being out of debt is indescribable—I certainly lack the true revolutionary unconcern about such things. I do hope you will have a little more than enough to cover your cheques in the bank, instead of a little less than enough when I come back.

I want to warn you, dear, also not to think it is necessary for you to help Margaret. Just don't let such an issue ever come up. You owe it to yourself to *have* and keep what you earn, and she can count upon somebody that is rich and to whom she gives his returns.

My sweet child, I'm afraid you'll think this is a scolding and complaining letter. No it is just one of our practical conversations. I still feel sure it is within that contract you have made that you can get the things you want, and that your will and ingenuity ought to be busy there.

Is Margaret still with you?

Is Clarissa still weeping? Betty still laughing? [34] Tateishi still at the rink? [35] There are lots of things you should tell me.

Yes—I realized that about Margaret. I'm sure I shall never see my laughing pictures.

Good night, sweetheart. I am quite a hardy pioneer—I sleep on the little bed that used to be scorned as a mere couch in my study at 126. [36] The important thing about it is that you have slept on it too.

The big Acre—which I never liked—I've sold to Walter for $80, exactly what it cost.

One last bit of gossip—Allan [sic] Norton is going with Louise Bryant [37]—and then to bed.

Goodnight, my own

beloved—Max.

Postmark. Letter written in pencil.

Max to Florence, 6220 De Longpre Avenue, Hollywood, California, January 17, 1920

Darling, I was shaking from hand to foot when I finished reading your letter about Reginald Pole. I was standing in the middle of the street. My heart almost stopped beating until I read to the end. I was so jealous. Then I was exultant—exultant as though I had won a victory, exultant to be on the edge of danger. O I love excitement—I love the excitement of love.

I am happy because of your letter, sweetheart.

I think it is partly because I love you to be loved. It makes me passionate. It makes me throb with the adventure of your life as well as mine.

Can you understand this, sweetheart, and yet know that if you loved him—unless you were going away from me—I should not want you to tell me? Perhaps it is a weak and timid way for one whose religion is reality to live. I don't know. It lets me love you and yet love your liberty. How often do you have filled me when I thirsted for emotion! How richly you have poured colors into my life!

<div align="right">Max.</div>

Postmark. Max's notes on envelope: "Jealous of Reginald Pole!"; "Later."

Max to Florence, 6220 De Longpre Avenue, Hollywood, California, January 19, 1920

Monday evening by the fire.

My beloved, I've been up to Croton again on Sunday, and I missed you and thought about you so continually I thought you must feel a warm stream of love flowing to you.

I didn't read your letter again—perhaps fearing the pain would have grown and the pleasure diminished—until tonight. And I am afraid it has a little. I shudder at his coming into our bed room and sitting there when you were sleeping.—Darling I feel about those rooms just as you feel about the house at Croton. If anybody ever entered these I would know that I was not to come again.

Beloved, do you mind my saying that? I feel very strong and strange emotions about what you told me—and they are a little bit unexpected in this quality.—I guess perhaps he kissed you in your sleep.

I am so glad you said what you did about the Liberator. It made an enormous difference at a most critical time. It is very hard for me to resist the influences that surround me here, the influence of the magazine itself—its being there, and being mine—especially as the last number which I had nothing to do with seemed so poor.

Crystal is a great problem to me—she seems to lack the old vigor and self-confidence and yet to thirst for recognition and egoistic success more restlessly than ever. It was a great mistake, her coming on the Liberator with me. It puts her in a position of fixed and public inferiority—no matter

what we may do with our names, because the writing is what people care about. And she simply can't stand that. I see it quite clearly now and sympathize with it, but there is nothing in the world to do about it. I don't know quite what she could do now that she has been on the Liberator—certainly nothing in her former line. Restless, insatiable girl—self-assertive yet utterly dependent on others. I don't know what to do for her, and it makes me very sad.[38]

I hope you will be careful about Reginald Pole. I have a kind of frightened feeling that he might be queer and do something a little crazy. Please remember that your serene unconsciousness drives people mad, and try to feel a little responsible for his feelings, and not just leave it all cold and unspoken. People must be allowed to talk it out, and feel that you are not without compassion.

I feel pretty wild now, because I don't know what may have happened since you wrote to me, and I haven't any other letter. I hope you don't love him.

I want you, darling. I want you in my arms. O I hope you think of me when you lie down to sleep. I hope you can feel me as I feel you, so intimately perfect to my touch—

<div align="center">Max</div>

Postmarked January 20. Date provided by archivist (January 19, 1920, was indeed a Monday). Written in pencil. Max's notes on envelope: "re Crystal"; "important."

Florence to Max, 11 St. Luke's Place, New York City, January 19, 1920

My beloved. My body aches to feel the sweet weight of you, my fingers to touch you. I am lonely for you my beloved.

Florence.

Postmark.

Max to Florence, 6220 De Longpre Avenue, Hollywood, California, January 21, 1920

My sweet love, you never wrote me so lovely a letter before—so sweetly written, so full of the vivid ways of your speech. It made me love you wildly

in my heart. O it makes me so happy when you sound poised and free and growing. I admire you so much. Sometimes I just lie and name over your miracle qualities.

It is true as gold about your living with Caroline; I realized it so fully when I tried to talk with her. It is a little sad, but it is true, and not sadder than most other things are for somebody.

I am very happy because I see you in all the glories of my admiring dream, moving with poised limbs untrammeled, independent, equal to all the world. I love you so. I love you.

<div align="right">Max</div>

Postmark. Written in pencil.

Florence to Max, 11 St. Luke's Place, New York City, January 22, 1920

Beloved. Just quickly I must tell you I love you and think of you all the time. Mrs. Gartz is very fond of me. She loves you, and told me she was going to write you again soon. She tries to put her sister to help you but most of her money is being used as bail.[39]

I must rush darling I am convinced there are no longer 60 minutes to the hour, time flys [*sic*] so fast.

<div align="right">All my love to you my beautiful one. Florence</div>

Postmark. Written in pencil.

Charlie began planning The Kid *shortly after the death of his own child, Norman Spencer Chaplin, on July 10, 1919. Norman ("Little Mouse") had birth defects and lived only for three days, a great blow to Charlie, who cried when the baby died. Yet when Charlie a short time later met the four-year-old Jackie Coogan, the son of a music hall performer, everything fell into place again. By the time shooting had ended, Charlie's estranged wife Mildred Harris had initiated divorce proceedings.*

The Kid *was to be Charlie's first full-length film, and he was determined to make it perfect. During the nine months he spent working on the movie, taking a break only to shoot* A Day's Pleasure, *he filmed*

more than fifty times the length of the finished picture. Shooting ended on
July 30, 1920. Still considered by some to be Charlie's finest achievement
as a director,[40] *The Kid opened in January 1921, to ecstatic reviews. "A*
landmark in his personal and professional development," The Kid heralded
the emergence of a new Chaplin, a nobler figure than the girl-obsessed Tramp
of his earlier movies, capable of commitment and empathy.[41] *When Florence*
saw an early version of The Kid nearly a year before the release, she instantly
realized that Charlie was a genius. While Max whined about not having
enough time to work on The Sense of Humor, *in Charlie she had found*
a man who, amid a sea of troubles, had both the vision and the strength and
perseverance to finish what he began.

Not coincidentally, Charlie became the hidden star of Max's slow-moving
manuscript, too. His art, revealing the simple, original, pure truth underneath
the crazy, complicated things we do every day, was the essence of humor, Max
wrote. "You think this is it, don't you?" Charlie would say to us. "Well it
isn't, but this *is, see?" And then we laugh. Baffled by what his "relentlessly*
playful hand" uncovers, "our deepest wish drinks deep."[42]

Florence to Max, 11 St. Luke's Place, New York City, January 23, 1920

Beloved. Charlie came to dinner last night and I gave him your book. He
was so happy to get it. I saw his picture "The Kid" in the projection room.
It is wonderful wonderful. I cried and laughed and smiled and was so
worried some of the terrible policemen in the picture would get him. It was
the most exciting thing I ever saw. I introduced him to an English actress
that is visiting here. She loved him and made him so happy because she is
an artist and a very generous one, she praised him so. She told him she was
returning to England in April and was going right to Barrie and tell him to
write a play for Charlie.[43]

Charlie is all excited about buying a yacht. He said let[']s you and me
and Max and Elmer go off together. I said let[']s take pictures in all the
countries we travel and he is crazy about your acting in them. Well we had
a wonderful time. Anyhow as soon as he finishes this picture he asked me
if I wouldn't take a trip in his car. We all had the wanderlust very strongly
and were flying all over the world at a great rate.

Beloved I will write you a long letter tonight as I have to rush away
now. Margaret is not much with me. I like it better alone. It was a little

depressing her never accomplishing anything and her relation with Joe is annoying[44] she answers every letter religiously and at great length. I feel that is one reason nobody helps her.

I fear in each letter I receive that you will describe somebody you have fallen in love with.

<div align="center">Florence</div>

P.S. I love you dearest.[45]

Postmark. Written entirely in pencil.

Among Max's papers at the New York Public Library is a snapshot taken on the set of The Kid *(fig. 3.3). Max left a note on it, verso, in his trademark green ink: "Woman in the background is Florence," but the person in question is clearly Edna Purviance, who was discovered by Chaplin and starred in more than thirty of his movies, while also being romantically involved with him. Max, reviewing his papers as he was writing his autobiography, must have been confused about Florence's participation. Florence was a professional and would never have interrupted a scene in progress; it is possible, though, that she took that photograph.*

In Chaplin's film, Purviance plays the Woman, a mother who has given up her boy (the Kid), who is then taken in and raised, in haphazard but loving fashion, by Chaplin's character, the Tramp. Figure 3.3 appears to come from a rehearsal of the sequence in which the Woman, who happens to be passing by but doesn't recognize her child, seeks to end a fight between the Tramp and a neighborhood bully, played by Charles Reisner (who had previously appeared alongside Chaplin in A Dog's Life*). The Bully is pummeling the much smaller (but more flexible) Tramp in retaliation for the Kid having previously beaten up the Bully's little brother—an ironic, very funny reversal of the tussle between those boys, since the Kid, a fierce fighter, was much smaller than the Bully's brother.*

Purviance's character interrupts the two men and, quoting scripture, seeks to convince each of them to turn the other cheek—a losing proposition, as it turns out, partly because the Bully takes the Woman's suggestion literally and the Tramp goes on to strike his adversary so hard, not on the proverbial but the actual other cheek (and with his fist, too!), that the fighting continues. Figure 3.4 is a frame enlargement from a moment in the scene as it appears in the finished movie.

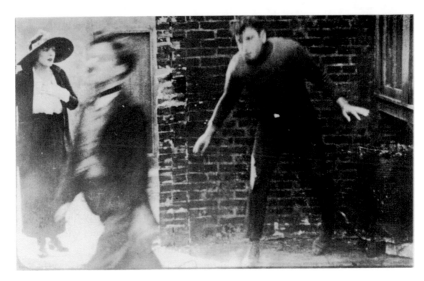

Figure 3.3. Charlie Chaplin, Edna Purviance, and Charles Reisner in *The Kid* (1921). Photograph taken from set by Florence Deshon (?). Max Eastman Papers. Courtesy, Billy Rose Theatre Division, New York Public Library.

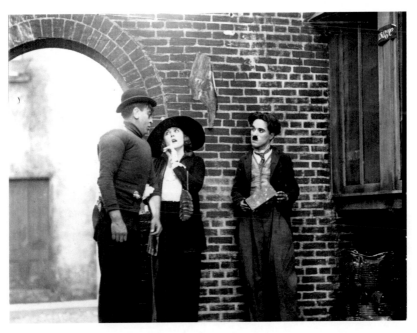

Figure 3.4. Charlie Chaplin, Edna Purviance, and Charles Reisner. Frame enlargement from Chaplin's *The Kid* (1921). © Roy Export SAS.

Max to Florence, 6220 De Longpre Avenue, Hollywood, California, January 26, 1920

Darling, you spoke about sending me a cheque, and then said you had changed your mind now I think you ought to send it. I think it was your *unconscious deciding to spend it,* and not *you deciding to keep it in your own bank,* that made you change.

I think you should send me $200 when you get this. I'll put it in a special account, where it will help me to feel above the line of destitution, and yet I won't use it.

Please send it to me, dearest, I do need it—I need it for you.—And another *very important* thing, I need some pictures of you. I only have these two reproachful ones that Margaret took. They are very sweet while I'm with you, but when I'm away they're altogether too sad.[46]

Do you remember one very vivid one that the man at the Beach Shops was developing for me? I want that one—and some laughing happy pictures. Please send me a lot of pictures. Dearest, I need them when you are away so long.

I don't believe Margarethe's pictures are much good for publicity purposes. Some of them are, but she is more interested in line than in personality, and movie fans are not!

Your letter was so sweet. You told me so much, and so generously gave your sweet self to me. I hope you won't think I've been little and mean in my answers.

I went up to Baron De Meyer's, but they have not saved the negatives of your pictures. I'm awfully sorry. I have some, but only of the full-length ones that I guess you don't want.

A sweet passionate kiss to you my beloved

Max

Dated by archivist. Max provides January 23, 1920, on envelope and adds: "About the money—she didn't send—a bit of a lecture."

Interlude: Deshon Portraits by Adolph de Meyer

The "full-length" photographs Max picked up for Florence from de Meyer's studio on January 26 are likely the four unattributed prints of Florence Deshon found among Max's papers (all from Eastman mss. V, Lilly Library). After Florence had rejected them, Max must have decided to keep them in case she changed her mind or, more simply, so that he would have something to look at.

The photographer's name does not appear anywhere, but the similarities to de Meyer's Model Wearing Chéruit Afternoon Dress, *which appeared in the November 1918 issue of* Vogue, *are too strong to be coincidences. For example, the doorframe in figure 3.8 is identical to one used in de Meyer's* Model, *and the Japanese screen also points in the same direction.*[47]

Adolph de Meyer (1868–1946), the son of a German Jewish father and Scottish mother, was a mysterious figure. His name appears in exhibition catalogs in many different forms, including "von Meyer" or "Meyer-Watson." In 1912, he left London for New York City. He had already made a name for himself as a photographer of the dancer Nijinsky and the Ballets Russes. Several of his photographs appeared in Alfred Stieglitz's Camera Work. *In 1914, Condé Nast hired him as* Vogue's *first official fashion photographer. When* Harper's Bazaar *recruited de Meyer to work for them, he returned to Paris, a dream that ended roughly when the Nazis invaded the city. In 1939, de Meyer was back in the United States. Having changed his name yet again—he was now "Gayne Adolphus Demeyer, writer"—he died in 1946 in Hollywood, alone and forgotten.*[48]

De Meyer was obsessively evasive about the facts of his life, creating an aura of mystery around his person and his work. Many of his prints have disappeared, which makes the discovery of these photographs—and they are exquisite and lovely, no matter what Florence thought of them!—particularly exciting.

Dubbed "the Debussy of the camera" (a phrase coined by the British photographer Cecil Beaton), de Meyer never quite shed his pictorialist beginnings, using soft focus to surround his sitters with a sense of magic. Yet what is so startling about these four Deshon portraits is precisely their unabashedly nonromantic, cool immediacy, which transcends the pictorialist goal of turning a photograph into an example of high art. De Meyer's Florence portraits combine aesthetic appeal with a tantalizing mundaneness. They place the viewer right on the scene, as if Florence, after visiting us in our own apartment, were getting ready to leave and had just opened the door, slightly bending forward, a move that casually highlights her tallness (fig. 3.5)—or

as if she, at the end of such a visit, were now waiting for someone to pick her up, scanning the hallway for that person's arrival (fig. 3.6).

De Meyer's photographs of Florence are both poetic and entirely accessible, taken from real life. In that, they are quite unlike his self-consciously elegant, stylized, commercial portraits for Vogue *or* Vanity Fair. *For the latter, he also photographed Charlie in January 1921, the month* The Kid *was released: a polished, somewhat dreamy image that presents Charlie how he wanted to be seen when he wasn't on camera—pensive, well groomed, an intellectual. His head, heavy with thought, rests on his right hand, while the books before him gesture at the education he had in fact never received.*[49]

The Florence images are different. Anne Ehrenkranz has faulted de Meyer for striving to suppress the physicality especially of his female sitters, whom he inevitably turns into befeathered ice maidens incapable of feeling emotions, an impulse she attributes to de Meyer's own conflicted sexuality.[50] *By contrast, Florence's portraits seem far less contrived, less invested in producing elegance at any cost. Ironically, this might have been one important reason why Florence, who was so adamant that she be perceived as a star, rejected them.*

Figure 3.7 even seems a little awkward, but only until the viewer has figured out the implied correspondence between Florence and the barely visible, framed portrait of a woman propped up against the wall to the left—does it show Florence, too? Playing on the contrast between art and life, picture and person, de Meyer brilliantly suggests that his portrait (as opposed to the framed one) captures Florence as she really is, a point underscored by the mocking sideward turn of Florence's head, away from that framed picture and from the confinement it represents. Smiling, looking directly at us (a pose de Meyer normally avoids), her left hand casually stuck in her pocket, the fingers of her right hand resting lightly on the shiny top of the small dresser, Florence seems fully alive, an effect to which the contrasting background of the empty apartment behind her also contributes. The fact that the framed portrait does not hang on the wall gives Florence's environment a kind of makeshift quality, suggesting that the one permanent, living thing in this world is she, not her surroundings. The simple trick of having Florence lift her right foot ever so gently in figures 3.6 and 3.8 further animates her presence in the series, making these images so much more than static representations of an actress's beauty.

Figure 3.8 is perhaps the most effective of the four: it shows Florence leaning against a lacquered Japanese screen, with her face enticingly turned toward us, welcoming us into her world. De Meyer, influenced by his extensive travels in Japan, liked to include decorative elements such as screens and fans in his compositions, but they were more than props to him.[51] *Take a*

look at the visual echoes between the exotic figures on the screen and, next to it, Florence, who all of a sudden seems as if she had herself just stepped out from the world of the screen, an exotic, well-dressed miracle made flesh, graceful as the heron depicted beside her right shoulder.

Even though Florence is fully clothed in these shots, de Meyer's photographs are also quite erotic in an understated, subliminal way. He was a master of directional lighting, allowing it to tell stories about his sitters rather than fixing them in place. Consider, in figure 3.5, the way the light rests on Florence's finely shaped right hand as it grasps the door. Thrown into bold relief by the limp fur fox stole hanging from her right arm and the gloves dangling disorderly from her other hand, that right hand becomes, as Florence herself was in real life, a wonder of beauty, grace, and determination.

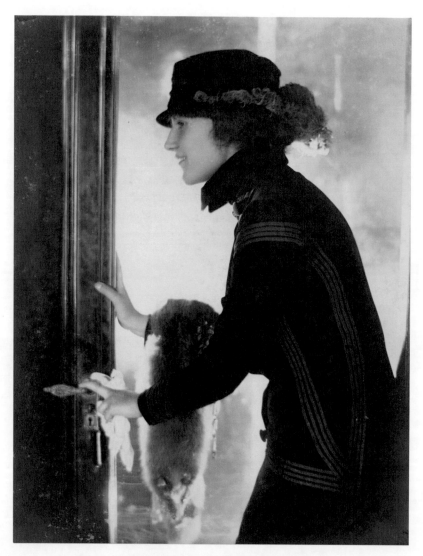

Figure 3.5. Florence Deshon, ca. 1920. Photograph by Adolph de Meyer.
Eastman mss. V. Courtesy, Lilly Library.

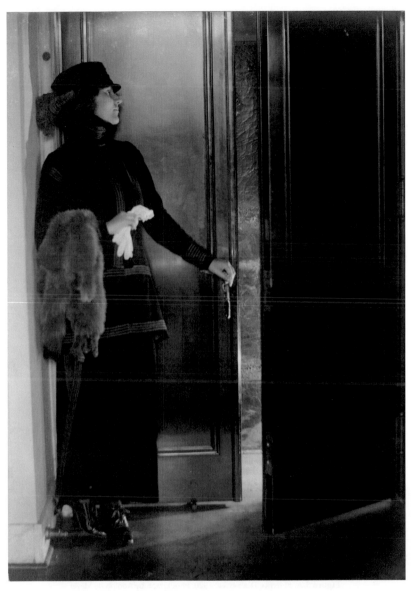

Figure 3.6. Florence Deshon, ca. 1920. Photograph by Adolph de Meyer.
Eastman mss. V. Courtesy, Lilly Library.

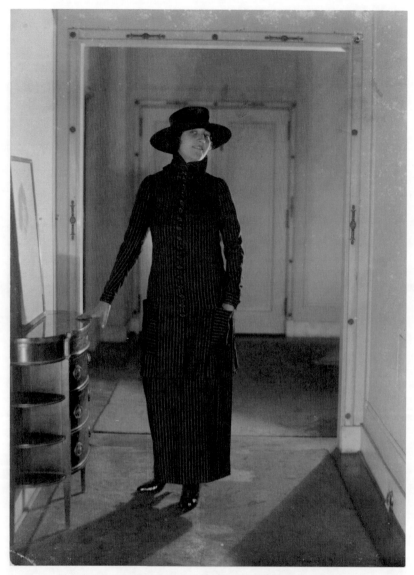

Figure 3.7. Florence Deshon, ca. 1920. Photograph by Adolph de Meyer.
Eastman mss. V. Courtesy, Lilly Library.

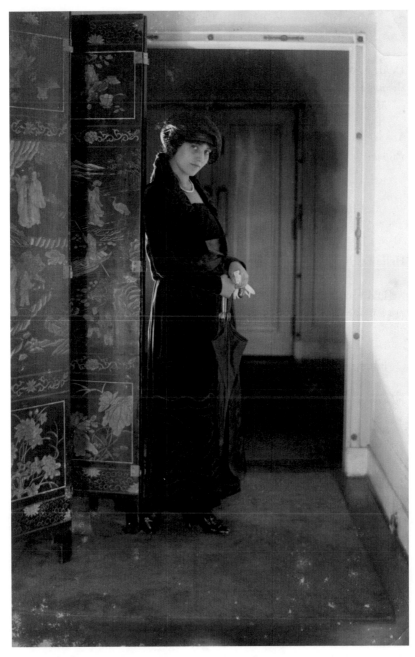

Figure 3.8. Florence Deshon, ca. 1920. Photograph by Adolph de Meyer. Eastman mss. V. Courtesy, Lilly Library.

Max to Florence, 6220 De Longpre Avenue, Hollywood, California, January 26, 1920

Dearest, your little letter kindled the fires in my body that burned all through the night for you, and they are burning today.

My beautiful love—

<div align="right">Max.</div>

Postmark.

Florence to Max, 11 St. Luke's Place, New York City, January 30, 1920

Hello Darling,

Did you like the pictures I sent you. I didn't like them very much, and I am looking for some others for you my beloved.

<div align="right">Florence.</div>

I miss you so much. I long for you all the time

Postmark.

Florence to Max, 11 St. Luke's Place, New York City, early February 1920

Dearest, I am so sorry I wrote you that letter about Reginald. The whole thing has blown over, you know I could not admire a man so stupid as he is. He pours out his long silly memory lessons without a single idea of his own, that is bad but not as bad as the fact that he doesn't recognize an idea when it is presented to him. He told me rather hesitently [*sic*] that he loved me and couldn't help admiring my beauty and intelligence but I said well I don't admire yours, if [*sic*] fact you haven't any to me.[52]

Dearest, don't think I was mean, but he is really a very small nature. he showed it to me in many ways. He got angry at me and was rather disagreeable, but we parted friendly enough. He asked me to telephone him the next day. I didn't do it. Then he got his wife to phone me and ask me to dinner at W. A. Clark's[53] one of the rich men here. I went and had a lovely

time, there were a lot of charming people there. Mrs. Pole wasn't there and Reggie asked me why I hadn't phoned him. I cannot tell you how angry he made me. I was very rude to him and since then he has been rather afraid of me and lets me alone. Dearest I am so sorry I even wrote you about it, it[']s just because you are my sweet confident [*sic*] my dearest to whom I want to tell everything. I saw in the N.Y. paper that Ida was playing at the Garrick. I am so glad that she is having such success I know she is just the person to play in Tolstoi [*sic*]. I suppose beloved you will go to see her, and fall madly in love with her.[54]

The studio has been rather idle since New Year[']s. Nobody is working, but we will be going full blast in a few more days. I cannot tell you my plans about returning in the Spring today I haven't seen Goldwyn yet. Beloved will you be angry at me if I send you $50 when you asked for $200. I have set a new schedule for myself I don't want to break away from it. In fact I have just started it. Also dearest at the New Year old bills as far back as 1916 found me and of course I have to pay them. Darling don't fall in love with Ida I am so jealous.

Charlie came to dinner I guess I told you didn't I.

I think of the little house all the time I long for you all the time.

Beloved I will send you a small check every week. Thank you for the books and the R. Rolland letters.[55]

P. J. Smith[56] was jealous of them. Good night sweet love. when you lie down take me in your arms I am so lonely for you my beloved. Florence.

Envelope present, but no postmark. Letter written in pencil. Max's note on envelope: "About the money, answering my letter of Jan. 26 Early February Then 1920."

Max to Florence, 6220 De Longpre Avenue, Hollywood, California, February 2, 1920

My beloved one, I am going to send you a telegram tonight because I feel so far away from you and so lonely. It is only because I have not written to you and I know you are not getting any letters from me. I am not loving anybody else, and I have hoped each day that I would get another of your sweet letters.

They have stopped coming, and I'm afraid you didn't like the way I talked when you told me about Reginald Pole.

Darling, you say you are coming in the spring, but you don't say how, and you had just said you were going to stay til summer. Have you seen

Goldwyn? Has anything happened? You don't tell me about any pictures. I watch the papers for "The Cup of Fury" or "Dangerous Days", but I don't see them. And I can't find "A Day's Pleasure" either, to see you on the street. Darling, you won't let them come out without telling me, will you? It would mean so much happiness to me to see you moving and living before me even for a moment.

O I hope you can come in the spring. It will so happy and beautiful for us in the little house, making it laugh.

I'm sending you a little picture of it taken by our cook—a half-breed Filipino boy—the sweetest boy. He is in the other picture. The third is the scene from our front window in New York.

Dearest, I was just going to write you and tell you I thought you would get more out of a real school of dancing than any dramatic school. Isn't that strange?

It would be wonderful to go off on an international trip with Charlie and Elmer. It seems hardly probable—we all dream so much and do so little.

'Sweet is the world to the dreamer and lover of dreams.'[57] But *I* am ready!

You have written me such sweet letters (on this fancy brown paper) and I have answered so little—just this week—I don't know why. It was just one thing coming up after another.

I love you, and I am frightened about Charlie. Do you think he's as nice as I am? I am frightened in two ways when I feel jealous of him—for you and for me.

It was all about the "short wrinkles of grief" that he felt resentful toward you that night.[58] I can see it so plainly now. Of course he would be extremely sensitive about any suggestion of a limitation of his expressive ability. I guess we were both a little tactless as well as scientific about those wrinkles.

You never said a word about *your* books that I sent you. Did you like them? I spilled ink on one of them, but I thought you would like it just the same

Darling, you said you could write better in pencil, but I don't think so. I love you just a little bit more when you put periods at the end of your sentences, and begin the new ones with capitals. And you do that when you write with ink.

Mrs. Gartz's sister is a bad woman. She told me she would give me "something but not as much as that" when I asked her to match Mrs.

Gartz's pledge, and then when Crystal wrote for it she said she didn't promise me anything.

However, I suppose the conversation didn't mean as much to her as it did to me. So it goes.

My beautiful one, I have written you a long letter, but I haven't told you how I long to hold you, and kiss your sweet warm lips and eyes, and lie down with your young vivid body throbbing in my arms. O my love, you are so far, so far away!

Written on letterhead of 137 Front Street. Max mailed the snapshots of his cook, posing likely with Max's Ford T, and the view from his New York City apartment at St. Luke's place in a separate envelope. The picture of the house in Croton is no longer present.

Max to Florence, 6220 De Longpre Avenue, Hollywood, California, February 5, 1920

My darling, your pictures are so beautiful and they fill me with happy excitement. I am having two of them framed, the big one and the smiling one. It is your own beloved smile, with your sweet lip so broad and full—I laughed with delight when I saw it

The other standing one I don't like. He has not draped the vest pin[59] gracefully and that troubles me too much though your expression is very dramatic.

I still hope I may have that vivid one we were looking at in the Beach shops. You ordered me a whole set right there.—If you could have seen me when I got them, you would send me pictures more often.

I hope you weren't cruel to Reginald Pole. It sounds terrible the way you write it, but I suppose it wasn't so bad. People can't be told that they are stupid, you know. There is nothing in life for him but thinking how intellectual he is.

My jealousy is all transferred to Charlie.

You say: "Darling don't fall in love with Ida, I am so jealous. Charlie came to dinner—I guess I told you, didn't I?"

And I understand the underlying associations of ideas!

I haven't been to see Ida yet. I saw Florence Rauh at Art Young's dinner the other night, and she turned her back on me.[60] I have nothing but horror—horror of that family.

Poor Dan—it is a terrible grief in my heart that I can do nothing for him. But I am helpless.[61]

Here is an autograph of Romain Rolland for Paul Jordan, if he wants it.

Geoffrey has had the measles,[62] Crystal is in bed with a terrible cough—I've had to drop everything again, and make the magazine. (Floyd is on vacation.)

However, my arrangement with Crystal is quite definite, and this can't last. I've got typewritten copies of *all* my chapter on "Theories of Humor."

Sweet love to you, my beautiful one—Max

Postmarked "February 6." Date marked as "Feb. 5" on envelope in Max's handwriting. On verso of Clift Hotel stationery, San Francisco.

Max to Florence, 6220 De Longpre Avenue, Hollywood, California, February 10, 1920

My beloved, I am just sending you my sweetest thoughts this moment before I go to the printers. Your dear eyes and smiling lips greeted me this morning when I woke up—for I have had the two pictures framed, one in silver and one in gold.

Crystal herself has the measles now—so you can imagine what has become of my hopes—for the time. I wish I could talk to you.

I can't say anything that will make you know the joy I have in these pictures. They have changed my room as though they were sunshine—

Max.

Postmark. Written in pencil.

Florence to Max, 11 St. Luke's Place, New York City, February 10, 1920

6220 DeLong Pre.
Hollywood
Feb 10, 1920
A correct letter to
Mr. Max Eastman—poet
From Florence Deshon actress

to make him love her a bit more

Will Mr. Eastman kindly acknowledge checks when he receives same.

Will he please state what he is doing whether he is a poet, a writer of books or edits a magazine.

Will he please not care too much about Eugen Bossevain [*sic*].

And find time to write a little oftener to his friend

<div align="right">Florence Deshon</div>

P.S. Will write more later.

Green sealing wax used on envelope.

Florence to Max, 11 St. Luke's Place, New York City, February 12, 1920

Dearest, I felt lonely when I didn't hear from you in so long. I made up my mind that it was fatal to call a place home and long for it which was not my own. For when I did not hear from you I felt the doors of the sweet house which I love so much were closed to me and I felt very sad. Did I tell you I met Max Linder. I spent the day at Charlie's studio, and he had a lot of callers that day, among them Max Linder.[63] He is smaller than Charlie and very good looking and well dressed. He is a very sweet little fellow and Charlie was quite jealous of him for a few minutes. Then we went into his dressing room. he pulled off his cap and roughed his hair and you know he always looks charming that way, so he caught a fleeting vision of himself in the glass and all was well in the world again. He is very bad about his work. he takes scenes over and over again, not because he is striving for perfection, but because something in him can't go forward. Do you think he could be (analized?) [*sic*]. Mary Wilshire seems such a fool, but Chase Herendeen liked her. Chase and her husband are broke, she is living at the Studio Club as a free guest and he is living with his mother.[64]

I had an awful scare the other night. You know I am living alone here. Margaret comes out once in a while, but I like it alone so much. I read the newspapers in bed and I read that awful case of that young girl that was beaten to death by some unknown man.[65] You will think I am sick, when I tell you how frightened I became. There is something the matter with the front door lock, sometimes it locks and sometimes it doesn't. Well I was sure it wasn't locked and I spent a very unhappy few hours. I am better in the sun light I know I shall be all right tonight. Of course every day

the papers seem full of threats at you. it worries me altho you have been untouched so far. I am sorry Crystal's ill and Geoffrey too. Dearest I am so glad you have all the typewritten chapters of your book, but I am so sad that you cannot read them to me

I have heard some lovely things about your poetry from so many people. Reginald likes you as poet better than anything else you can do. I have read some lovely poetry lately I have a book of Swinburne which is new to me.[66] Do not think my interests are so far away as this letter seems I will have to write you another right away. but your telegram and long silence have confused me. Florence

Postmark. Max's notes on envelope: "['] Your telegram & long silence have confused me.['] But I wrote her Jan. 27 and Feb. 2—full of passionate love. It is the Jan. 26 letter about the money I was going to save for her that caused all this—" Note in upper left corner: "She dreads it's all over." Sealed with Florence's characteristic green sealing wax.

Florence was now spending more time with Charlie, as Max had feared. But that also meant that Charlie's flaws and quirks were becoming more obvious to Florence. When she was back in Croton in August 1920, she shared some of her concerns with Doris Stevens: "one of the first stories [Florence] told me was about the penuriousness of Charlie. He would never pay his chauffeur in advance. He could not bring himself to pay until the week was up and then he would pay him the following day. More likely is, he could not bring himself to pay his chauffeur and would let the chauffeur's pay run for a week after it was due so that a second week was also due. Then on the following day after the end of the 2nd week, he would pay the first week's bill."[67] Max's lingering worry that Florence was slipping away from him, because of men like Reginald Pole or, more likely, Charlie Chaplin, manifested itself in increasingly incoherent missives, followed by other panicky messages—such as a completely garbled "night letter" of February 14, not included here—in which he asked her to ignore or tear up what he had just sent. Reviewing the correspondence decades later, Max couldn't even remember what specifically had caused the friction in their relationship or what he was apologizing for.

Love and Loss in Hollywood

Max to Florence, 6220 De Longpre Avenue, Hollywood, California, February 13, 1920

My beloved, I think of you all the time today, and your sweet bright pictures reproach me very bitterly for the way I behaved—even more bitterly than they reproached you for betraying them on the screen.

I shall telegraph you again tonight, for I am so unhappy at feeling separated from you by any sharp feelings.

My beloved, my bright colored, my beautiful girl, write me those sweet words again that tell me you long for me and love me with passion.

I love you and I lie down with you to my sleep.

Your pictures have made home, have made happiness and rest, of the little room where I had felt so transient and so comfortless.

My dearest, forgive me—Max.

Dated by archivist to February 13, which was, indeed a Friday, as noted on sheet by Max, who also adds a puzzled note: "Asking forgiveness (for what?)." Postmarked February 14.

Max to Florence, 6220 De Longpre Avenue, Hollywood, California, February 13, 1920

I feel so lonely because I have driven you away with my telegrams Please come back and forgive me I have no letters either only your pictures they are all my home love

<div align="center">M</div>

Postal night lettergram, filed 13:20 a.m.

Max to Florence, 6220 De Longpre Avenue, Hollywood, California, February 14, 1920

O my beloved, I am so lonesome tonight. Darling I want you with me.

I went to see a play since I wrote to you earlier in the evening. It was "For the defense" by Elmer Rice. I went all alone. It's a wonderfully clever, well-written, well-acted melodrama, full of humor and legitimate excitement—never a hitch or a clumsiness of construction anywhere. He is the one to write a movie for you—a mystery movie. And he's out there working

for Goldwyn. And he must be of the same general spirit as us for he is the Elmer Reizenstein who wrote that charming play for the Liberator about the Czar shovelling snow. Do you remember? (He changed his name)[68]

I hope you'll meet him.

I started out to see Tolstoy's play with Ida in it, but when I got to that station I just went by. Repulsion was stronger than curiosity.

Tonight, darling, I feel like throwing it all up and getting on a train with my book again and coming out there. Poor Crystal—she is very sick and Walter almost distracted. The Liberator has gone to press, and Margaret[69] promises me two weeks for my book, but of course I won't get it. There'll be troubles again.

When Crystal gets well and takes it, I want to *go away.* I almost hope you'll be there yet, so I can come to you.

But more I wish we would be in our little house together—O this very night—lying so tranquil-tenderly, warm to eachother in the sweet darkness.

Either there or here—soon, soon, my dear heart, my lover and my beloved—

Postmark. Max's notes: "re Ida Rauh"; "Magazine Troubles again"; "Also re Elmer Rice."

Florence to Max, 11 St. Luke's Place, New York City, February 14, 1920

Beloved, I was so sorry you had turned away from me, for all last week you were so happily in my thoughts. I bought a green cape the color you love, the same as my rain coat, and I could only think how much you would love me if you could see me in it. Dearest in truth "My deep spirit is unvisited" in this shallow place.[70] Sometimes I am too tired to even speak. it is so difficult to be ever talking of something that does not interest you. Did I tell you they liked me in my last two pictures at the studio. A new director has arrived besides Paul Scardon who is very friendly to me. He is a Dutchman I dined with him and his beautiful English wife. He said he cannot understand the studios not using me more as I am the best looking person on the lot. He will certainly work with me as soon as he starts working.[71] I am going to meet Jasha Heifitz [*sic*] when he comes here, but it is too funny to meet artists no matter how different they are they just love to talk about the pictures, at least that has been my experience so far. all but you, beloved.[72]

Love and Loss in Hollywood

P.S. How I long to see you, dearest, we have been apart so long. would you care to make a flying trip out here again.

<div align="center">Florence.</div>

Postmark. Sent to St. Luke's Place and then forwarded to Max's Croton-on-Hudson address.

Florence to Max, 11. St. Luke's Place, New York City, February 15, 1920

TELEGRAMS A THING OF THE PAST LOVE

<div align="center">F</div>

Western Union night message.

On February 17, the Goldwyn Studio broke its contract with Florence, a seismic shock to her system, even though that development should not have been entirely unexpected. Various reasons have been given for this. Charlie had lost interest in her; Clifford Robertson, the casting director at Goldwyn, did not like her because of her politics; the other women at the studio did not like her; and so forth. All these explanations are possibly true to some extent. But the underlying cause might have been an economic one, especially since Goldwyn fired not only Florence but Naomi Childers and Barbara Castleton as well and had already sent Betty Compson and Clarissa Selwynne packing.

In fact, the Goldwyn Studio was in deep trouble in the last part of 1920. This was not entirely Goldwyn's fault. The inflation and recession of 1918–1920, already mentioned, caught him at the worst possible moment. The 1918 business boom caused Goldwyn to go on a spending spree. In 1919 and 1920, even though the Goldwyn Studio had barely broken even in 1918 and lost $100,000 in 1920, Goldwyn compulsively spent huge amounts of money, in what seems like the action of an amateur gambler. He had a valid additional incentive to do this. In 1918, for the first time, conservative banks and corporations were willing to buy stock in films, and late in 1919, Goldwyn had the likes of Chase National Bank and the DuPont corporation as shareholders in his studio, with an enormous amount of cash to invest.[73] It

was about then that Goldwyn hired Florence, just at the start of what would turn out to be a sea of troubles for him.

Goldwyn might have considered that adding new shareholders (among them also Frank Joseph Godsol), armed with voting stock, carried risks, especially the likelihood that not all of them would always be so enthusiastic about the way he ran things. Nevertheless, he continued to buy. He invested in a huge number of literary properties, mostly plays, many of which got made, for better or worse. In February 1920, he acquired a controlling interest in Bray Studios, Inc., so he was now also in the short feature and animation business. Although he had never been keen on owning theaters, he had, in addition, bought an interest in the Ascher Circuit in Chicago, so he was now involved in film distribution as well as production. This was very much in fashion. Said the Moving Picture World, *"The trend of the times is toward combination and centralization. Like it some of us may not, but it is a condition, not a theory."[74] In addition to his other commitments, Goldwyn invested in intellectual properties that would not pay off in the near future, such as a series of short fiction films by Booth Tarkington featuring a juvenile named Edgar, based on Tarkington's novel* Penrod and Sam *(1916). At least five were made and distributed.*

Predictably, when the crash came in 1920, Goldwyn was hit hard. Benjamin B. Hampton wrote that, following the inflation of the war and the immediate postwar period, all businesses had to face the consequences as deflation and recession hit the industry.[75] With the economy overheating to meet the needs of war production and encouraged by the resulting boom, too many goods and services were produced, and wages and prices skyrocketed. When the inevitable readjustment came, the subsequent industrial slump wrecked many industries. Among those hit hardest was the film business. The theaters weathered the storm, but the production and distribution branches struggled. While the companies that were, in Douglas Gomery's terms, "vertically integrated" (meaning they had taken control of the making, the distribution, and the exhibition of films in theaters)[76] continued to thrive, many of the smaller companies were forced to close down.

Too many new films were made as well, which forced producers to lower their prices if they wanted to find theaters willing to show their films. Paramount, Vitagraph, and Fox, companies that already owned chains of first-run theaters, were in an advantageous position. But producers such as Hodkinson, Goldwyn, and Selznick, who did not have large chains at their disposal and who were producing standard "programmers" instead of elaborate large specials like United Artists, DeMille, and Paramount, ended up in an impossible financial position. Drastic cuts were inevitable.[77]

In 1922, Goldwyn left the company he had founded; two years later, what had been Goldwyn Pictures became part of Metro-Goldwyn-Mayer, one of the megastudios that would, through shifting social, cultural, and economic conditions, control the market.

Interestingly, during the same month in which Florence's Hollywood career collapsed, Chaplin and his partners Douglas Fairbanks, Mary Pickford, and D. W. Griffith drew up the contracts for the independent production company they called United Artists, a revolutionary system that made these stars their own employers and put them in a position to receive directly the profits from their drawing power at the box office.[78] Once again, Charlie, who had made a lot of money with The Kid, *had proved to be the exception to the rule. Florence, although she continued to see Charlie, did not benefit from Charlie's new venture.*

In "Ernestine," the semifictional short story based on Florence's life, Theodore Dreiser painted a vivid portrait of the recession. As he saw it, Ernestine's downfall was certainly connected to the general economic situation that had affected Goldwyn's studio. But the underlying reasons why she (or Florence) was let go were, he felt, ultimately more complicated and had more to do with her personally:

> About that time there came the first and most serious slump in the motion picture industry. For one or another of the various reasons assigned at the time—over-production, importation of foreign films, extravagance on the part of those engaged in production, the determination of Wall Street to force a reduction of expenses and smaller salaries on all principals, a falling off of attendance at movie theaters—productions all but ceased for something over a year. Such salaries as were paid were cut to one-half or less. Perhaps as many as forty thousand workers of all sorts and descriptions were most disastrously affected for more than a year. Literally scores of directors, who posed as dictators and masters and had built for themselves imposing homes and strutted about with the air of princes, were compelled to close or dispose of these either permanently or temporarily. Stars, staresses, and starettes, of much or little repute, to say nothing of actors and actresses of the second lead, "heavies," "vamps," assistant leads, ingénues, camera men, assistant directors, scenarists, and so on, were compelled to abandon, for the time being anyhow, their almost luxurious fields of employment, and wait, making the best of a dreary period during which their incomes ceased. . . . By the beginning of the second year nearly all had returned to the east, hoping to sustain themselves in some way until better times should come again. Indeed, a year and a half had passed before there was even a shadow of change in this very depressed field.[79]

Dreiser gives several reasons for Goldwyn's getting rid of Ernestine/ Florence. Her exotic looks were a problem as was her physique, which made her more than a match for some of her male costars. In addition, while Florence's alleged failure to stand up for the national anthem may not have

been publicized, she would have talked about leftist causes around the studio enough to get noticed. Her complaint that the other women at the studio and Clifford Robertson disliked her was probably well founded.

Dreiser's analysis of Ernestine's failure to find permanent employment in Hollywood purports to be based on inside information from the industry. But even if all he offers is speculation, his assessment of early Hollywood's preference of body over brain is stingingly accurate:

> *A competent interpreter of such rôles as were assigned to her, still she was placed second to one and another movie queen or king of probably no greater acting ability than herself. Why? By more than one casting director I was told that while she was a competent actress, still her coloring, which was dark, and her height, about five feet seven inches, were not in the mode just at the moment. Besides, she was looked upon as rather serious, more so than most of the stars then shining, and directors desired and required types which were all that youth and beauty meant but without much brains. They liked to provide the "thought." "They say that when they think too much, or even a little, they lose that girlish something whi ch is very much in demand at this time," one casting director explained. I am convinced that he spoke the truth. The annual movie output of that period should attest the soundness of his observation, I think.*[80]

Florence to Max, 11 St. Luke's Place, New York City, February 17, 1920

ROBERTSON OFFERS TWENTY FIVE HUNDRED FOR ME TO BREAK CONTRACT HAVE SEEN GOLDWIN [*sic*] AND HAMPTON BOTH VERY SORRY BUT SAYS HIS POSITION WOULD BE VERY DIFFICULT TO FILL SO THEY MUST STAND BEHIND HIM HE IS MOST POWERFUL MAN IN THE STUDIO AND SIMPLY WILL NOT SEE ME IN ANY PART OF NONSEQUENCE [*sic*] I FEEL ABSOLUTELY HELPLESS AM HOLDING OUT FOR FIVE THOUSAND WHICH THEY OWE ME IF I WILL NOT TAKE LESS THEY WILL KEEP ME HERE UNTIL JANUARY AND I DO NOT KNOW WHIHER [*sic*] THEY WILL USE ME OR NOT ROBERTSON HAS SUCCEEDED IN BREAKING EVERY CONTRACT THAT GOLDWIN HAS MADE PLEASE ADVISE ME WHAT TO DO I DO NOT FEEL BAD ABOUT IT SO PLEASE DONT YOU LOVE ANSWER IMMEDIATELY AM WAITING FOR YOURR [*sic*] ANSWER[81]

Western Union telegram, filed 11:28 a.m.

Max to Florence, 6220 De Longpre Avenue, Hollywood, California, February 17, 1920

I DONT FEEL BAD I LOVE CHANGE ONLY PLEASE BE PRACTICAL THIS TIME SIT TIGHT THEY MUST GIVE YOU AMPLE TIME ON SALARY TO CONSULT ATTORNEY IN NEWYORK [*sic*] YOU HAVE THE UPPER HAND WILL NEED EVERY CENT BE PEACEFUL AND DONT MOVE UNTIL WE TELEGRAPH SEEING DUDLEY TOMORROW DEAREST LOVE

M

Postal telegram, filed 11:30 p.m.

Dudley Malone to Florence, 6220 De Longpre Avenue, Hollywood, California, February 18, 1920

IF GODSOL IS STILL THERE GO SEE HIM AND TELL HIM THE REPEATED PROMISES THAT GOLDWIN [*sic*] AND OTHERS HAVE MADE YOU STOP OF COURSE IF THEY WANT TO BREAK YOUR CONTRACT IT WOULD BE UNPLEASANT FOR YOU TO REMAIN BUT STICK OUT FOR FOUR THOUSAND DOLLARS AND EXPENSES BACK AND IN NO EVENT TAKE LESS THAN THREE THOUSAND FIVE HUNDRED DOLLARS AND EXPENSES BACK STOP YOU HAVE FULFILLED YOUR PART OF THE CONTRACT LEFT YOUR HOME GONE WEST AT GREAT INCONVENIENCE AND LOST ADMIRABLE OPPORTUNITY FOR OTHER EMPLOYMENT AND EVEN IF YOU LEAVE NOW THEY OUGHT TO PAY YOU MORE THAN HALF THE CONTRACT WHICH THEY ARE LEGALLY OBLIGATED TO FULFILL STOP BE WISE AND SHREWD AND NOT IN A HURRY AND KEEP THIS MATTER CONFIDENTIALLY

Western Union night letter, mistakenly addressed to "Miss Florence Beshon" [sic]. Identified in pencil by archivist as sent by Dudley Malone.

Max to Florence, 6220 De Longpre Avenue, Hollywood, California, February 18, 1920

DUDLEY TELEGRAPHED THE ADVICE I THINK IT GOOD IF
YOU CAN REALLY PURPOSE [sic] TO STAY ON IN CASE THEY
REFUSE YOU WILL BE IN MENTAL CONDITION TO MAKE
THEM ACCEPT THAT ABOUT NEXT JANUARY IS PURE BLUFF
QUITE OBVIOUSLY DO NOT HURRY EVERY WEEK ADDS
TWO HUNDRED HAVE YOU LOOKED AROUND THERE FOR
ANYTHING ELSE I THINK IF YOU COULD GET SOMEBODY
OUT THERE TO USE YOU IN ONE GOOD PICTURE BEFORE
YOU CAME BACK KEEP ME INFORMED I AM VERY MUCH
EXCITED AND THINKING ABOUT YOU ALL THE TIME
ADDRESS CROTON FOR A WEEK LOVE

M.

Western Union night letter.

Florence to Max, undated

Your letters have turned colder. The last drop of warmth you had in your
heart for me was frozen by your great disappointment. But think of me. It
is my disappointment, not one I can sympathize with in another, but my
own which is with me all the time. I who began the race for success so well
equipped, now stand completely stripped with no vision before my eyes but
one of mediocrity. I cannot face it. I cannot give up all my bright hopes. I
would die first. Utter despair fills my heart. It is myself I have to live with
always it was myself I wanted to love, how can I care about this dark girl,
she is no longer lovely to me, no longer beautiful. Do not think I mean I did
not love you dearest. That is not so, but I cannot be happy with you unless
I am happy about myself. You understand that don't you. I am not coming
back to the little house on the hill. I have given up that dream completely. I
cannot go back.

You do not have to answer this letter, you do not need to write me at all.
It makes no difference.

Florence.

You were ever the brightest vision in my dreams.

In a note on the verso of the second sheet Max identifies this letter as "the 'humble letter' written when Goldwyn broke his contract with her." Since the letter is not dated, placement remains uncertain, but given Florence's comment in the next letter, it makes more sense here than where it appears in the Lilly file (the archivist assigned it an "October 1920" date). See also the chronology given in LR, 186, where Max unconvincingly claims that this letter was never mailed and that he only read it "long after." His letter of November 5, 1920, included in this volume, shows that he did receive it.

Florence to Max, Croton-on-Hudson, New York, February 19, 1920

Am so sorry letter worried you. please forgive me for sending it. am taking good care of myself and will be all right in a little while please don't worry & don't take a train now if it means you can only stay a little while I want you to stay a long time when you come am thinking of you and miss you all the time love

<div align="center">F.</div>

Handwritten Western Union telegram.

In September 1919, an angry, out-of-control white mob in Omaha, Nebraska, lynched Will Brown, an African American man, for a rape that he did not commit and nearly killed the town's elected mayor, who courageously intervened to defend Brown's right to a trial only to find himself strung up on a lamppost. The shocking incident, as well as other disheartening examples of white, male aggressiveness in the nation, triggered one of the most sarcastic pieces of writing Max ever produced: "Examples of 'Americanism.'" Declared Max: "[Americans'] most conspicuous national characteristic, at the present time at least, is a contempt for personal liberty." Max's essay was included in the February 1920 issue of The Liberator, *which had become Florence's bedside reading. As the following letter affirms, she was a receptive audience. In offering her own condemnation of the insane desire to be "100% American," she might have remembered the fact that her unreliable musician father was British and her unpredictable mother a Jewish pianist from Austria.*[82]

Florence to Max, 11 St. Luke's Place, New York City, February 19, 1920

Dearest. I hope you will be able to come out here again. The way you said you wanted too, stepping off at all the places that might be interesting. I will look up Elmer Rice at the studio and tell you what I think of him.

Dearest you have no idea how beautiful my house has become. I have had so many lovely presents. Mr. McGehee gave me a Japanese print, an old piece of Japanese pottery and a marvelous book all bound in red and gold tapestry and fitted in a green silk case. Margaret has given me some old fans and Mr. Weston has given me some prints. Even your friend Mr. Parker the book store man[83] has made me a gift of a book about China by C. Lowe Dickenson [*sic*] who wrote the Greek View of Life.[84]

Charlie speaks ever of going away, but it all depends on this picture and at the rate he is working, he will never finish it. I know I am naughty, but I became tired of Charlie's troubles. He stays in that frightful situation at his home, and his powerlessness to move wears me out. I did not go with him to meet Heifietz [*sic*] as there were too many people there. I would rather not meet him alone with Dagmar.[85] You are the God of his accompanist.[86] he talks of you all the time. Heifietz laughingly says he himself is rich enough to be a socialist. Darling I was writing small trying to get all my news on one piece of paper. I don't know how Wilson even achieved a reputation as a writer. I think his letters to Lansing are awful.[87] Beloved you are ever in my thoughts. I long for you all the time. I would be so happy if you could ever come out to see me. I am sending you a small check towards your fare. I am full of longing to travel. I feel that everywhere in America is depressing. The frightful ambition to be 100% American is everywhere. I wonder if Freud would see anything significant in their persistence about the 100 it looks like a love of figures to me. Dearest I thought your essay on Americanism as fine as the one on Patriotism.[88]

Beloved come to me soon. I long for you. Florence.

Postmark. Forwarded to Max's address in Croton-on-Hudson. Max's note on envelope: "a small check toward my fare—Heifetz + others."

Florence to Max, 11 St. Luke's Place, New York, February 20, 1920

Beloved. You have been such a help to me through this crisis. I don't know what I should have done without you. Cliff was suddenly called to account for his large expenses in casting the pictures. You know he will pay his friends anything they ask and I feel sure they give him a commission. Well there I was as an expense as I haven't worked much and he said because they hadn't any parts that suited me. So he took it on his own to get rid of me. They were certainly unprepared for my conduct. He made his offer of $2500, then after I had wired you he called me up and told me he could only afford $1000 and if I didn't accept that he would use me as an extra. I told him I could not reply to such an offer I would have to have some time. I haven't been near them they have called and called and called and I kept putting them off. I had made up my mind to one thing I would do no more business with Cliff. So this morning Lehr[89] called me up and asked me please to come over and see him. I looked lovely in my beautiful green cape and a lovely rose colored hat I have. Lehr was simply helpless, he made no fight at all, just accepted the fact that I wouldn't break my contract for less than $4000. Of course I was armed with your telegram and Dudley's. I didn't tell him I had any advice, but I guess he knew it.

Lehr is leaving and Cliff becomes the head of the Studio. Do you think I should stay on no matter how meanly he acts, and save all my money. Betty and Clarissa have been out of work nine weeks, it makes me think it best to stick it out.

Dearest, write to me oftener it will be so long until I see you. Beloved have no feelings about this matter this is not a legitimate business. Mr. Goldwyn tried to break Naomi's contract also Miss Castleton.[90] He finds it too expensive I guess.

I am so lonely for you my beautiful love. There is no one so lovely as you. My thoughts are ever in my little house on the hill. Dearest. have the kitchen painted if you like, put the same colors as now with yellow cupboards.

<div align="center">My beloved.</div>

<div align="center">Florence.</div>

Postmark. Forwarded to Max's address in Croton-on-Hudson. Max's note on envelope: "About the breaking of her contract."

Max to Florence, 6220 De Longpre Avenue, Hollywood, California, February 20, 1920

My sweetheart, how terrible that I shouldn't have been with you when that happened. I know it must have hurt you, or at least worried you and made you unhappy. It seems as though I've never been there for you when you most needed me.

But don't mind, darling. You are that much more free. And it is the only way in the world you'll ever get any money in the bank!

You can surely find work at about the same salary, and then just think how rich you will be!

I feel as though I've given you all the advice I can by telegraph. I hope it was not bad advice.

I'm at Croton working on my book—for at least a week. Doris is working on hers too, and I'm boarding there and helping her a little.[91]

In one month here I could finish my book.

My sweetheart, be happy, and remember all life is change and adventure and that is all there is to it.

Dearest love to you.

<div align="right">Max.</div>

Dated in pencil on envelope of Liberator *stationery, likely in Max's hand. Letter written in pencil on ruled paper. Address on envelope also in pencil.*

Max to Florence, 6220 De Longpre Avenue, Hollywood, California, February 24, 1920

Darling, I'm going sadly down from my brief days in Croton to see about The Liberator. It is so sweet to be there and so sweet to have a few days for my own thoughts. But Crystal has been terribly sick—measles, acute bronchitis, a slight pneumonia, influenza—in that order. She is getting well, but of course it means another full month of burial for me.

Nevertheless my book has come to the point where I'm happy in it. I know I can make it a good book.

Our little home is too stained and tumbled to tell you about. It sighs for you.

Darling, I still wonder what settlement you reached, or what decision about your contract. Your telegram explained so little. Do you suppose

Godsol had not yet seen Mr. Lehr when Robertson made the proposal to you? Maybe he put his oar in just after the ship started down stream.

Anyway, if it has come to "spending the day" at Charlie's studio I guess you are going to stay a while.

My sweetest thoughts are with you.

<div align="center">Max.</div>

Postmark. Written entirely in pencil, including address on Liberator *envelope.*

Florence to Max, 11 St. Luke's Place, New York City, February 25, 1920

Dearest I am here for a few days with a picture will write you as soon as I return.

<div align="right">love. Florence</div>

Postmark. Written in pencil on color postcard showing "Miramar Beach near Santa Barbara."

> *Florence was in Santa Barbara because she had been cast in Maurice Tourneur's* Deep Waters. *Figure 3.9 features her receiving "swimming lessons" from Captain Tom Sheffield. The British-born Thomas William Sheffield was a popular coach for Hollywood stars and the inventor of the "rescue can," the lifesaving device carried by lifeguards to this day. Tourneur had previously used Sheffield for* Treasure Island *(1920).*[92]
>
> *Released on October 20, 1920,* Deep Waters *also starred Rudolph Christians, Barbara Bedford, John Gilbert, Jack McDonald, Henry Woodward, and George Nichols. Tourneur had used Santa Barbara and Balboa Island for location shooting; in this case, the beach had to double as a New England village. The film's source was the play* Caleb West, Master Diver *(1898), by Francis Hopkinson Smith, which centered on jealousy among deep sea divers who have been commissioned to build a lighthouse. Florence played Kate, who is married to the wealthy Morgan Leroy. Henry Sanford, who oversees the lighthouse construction, falls for Kate, while another member of Caleb's diving crew named Bill Lacey lusts after his boss's young wife. At the end, they all reconcile. The waters weren't that deep after all.*

Clearly, this wasn't a winner of a plot, and no one should have been surprised when the movie, now lost, got tepid reviews after its release.[93]

Maybe it was the bad example of Deep Waters *that inspired Florence to try her hand at script writing, too. She sought guidance from Mabel Normand (1892–1930), one of the industry's first female screenwriters and producers. A likely candidate for a film scenario drafted by Florence is among Max's papers. Titled "Brother Going Away to School," it features a complicated unfinished story set during revolutionary times, perhaps in Russia, involving a brother placed under arrest, a prince in disguise, and a band of rebels trying to free the captive brother (Eastman mss. II, Lilly Library).*

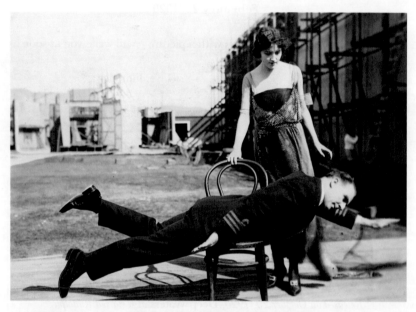

Figure 3.9. Florence Deshon receiving "swimming lessons" from Captain Tom Sheffield. Courtesy of Margaret Herrick Library, Academy of Motion Picture Arts and Sciences.

Florence to Max, 11 St. Luke's Place, New York City, February 26, 1920

Dearest. I have been away to Santa Barbara so I could not answer your telegram. I don't know if you will be able to believe me when I tell you Cliff is a regular Iago. I went around the studio asking all the directors

Love and Loss in Hollywood

questions. They would tell me that every time they asked for me, Cliff would praise me to the skies but say I was busy. If I had not [*sic*] known this I would not have been so determined to stay at all costs.[94]

He cares neither for the good of the Goldwyn Co. nor for the good of any player, only himself.

My idea is to go to the studio every day, and learn everything I can about the industry. I am working on a scenario for Mabel Normand now, and she is very excited about it, and I am going to ask a new director there to let me help him as much as possible. I love the industry and there is no reason I shouldn't succeed in some branch of it. Thank Dudley a hundred times. Your advice was fine and I took it, didn't I. What is Doris writing? You must be so happy working on your book in your little house. I am very very lonely for you sometimes I feel we will never be together again. love. Florence.

Postmark. Max's note on envelope: "'I am very very lonely for you sometimes, I feel we will never be together again.' About the broken contract again."

Max to Florence, 6220 De Longpre Avenue, Hollywood, California, February 28, 1920

My darling, I got two sweet letters from you this morning, and I am hurrying to put this in the mail to tell you how I love you and long for you. I still find it impossible to believe we will not be here together again in the spring.

I am still making a rather unsuccessful attempt to live in the little house and eat up at Doris's.

This is not much of a letter, because it is before breakfast, and I want the postman to take it. I will write you a better one after breakfast.

Thank you for the cheque you sent me, dearest. I want to come, but there is only one fact in my horizon: *Crystal will not be well for at least a month.*

Dearest love for you until after breakfast when I will write again!

Max

Postmark. Written in pencil, including address on envelope, which carries a note by Max: "Thanking her for the check."

Max to Florence, 6220 De Longpre Avenue, Hollywood, California, March 2, 1920

My sweetheart, I keep planning to write you a long long letter, and then something always interferes. I am giving up now, and going to write a short one just before I go to work.

I am back again to my little room where I wake up with your pictures. I must say they are the most precious and beloved things in all my world.

O I would love to come out there again! But you see I was going to live on you if I came! (I couldn't go away on my salary again so soon). And now I feel that it would be impossible to spend your money.

Anyway, Crystal will not be up and out for another month, and all the magazine is on my hands—Floyd too vacationing until April first. And it would take "quite some time" still in the library before I could go away with my book. I have moods in which I think the minute she takes the magazine I must buckle down where I am and just finish it—then to wander free—a poet and a lover coming to you.

My love—this is neither the long letter nor the short one. But it brings you all my love—

<div align="center">Max</div>

Tell me how you liked Santa Barbara—

Postmark. Written in pencil. Max's note on envelope: "Crystal's illness—and the book—I can't come."

Max to Florence, 6220 De Longpre Avenue, Hollywood, California, March 3, 1920

Darling, I don't need to tell you how much this review of my poems meant to me.[95] It was an event in my life.

Stirling Bowen is himself a lovely lyric poet, as you may remember. I half begin to dream that I believe people are going to deign to consider my poems before I get through.

Oh how sad I am to be tangled up in this magazine! Crystal is barely walking around the room, and even when she is well she seems to me to have lost all her zeal for action, her responsibility and concentration. I can't understand what has happened to her, but I am afraid I can never leave the Liberator in her hands. I don't think she wants to do it. It isn't sufficiently *hers*, and can never be.

I'll make her take it for 6 months anyway, and in the meantime seek a solution. She knows she owes me that. How I wish I could talk and talk to you about it.

I want to say a lot about your problem too, but I believe I'll wait now until Dudley sees Godsol. It may throw some light on the possibilities that are left.

I have put off my work as long as I dare! Goodbye, my sweet love, for a few hours—

Max.

Postmarked. Date penciled in later by Max. Envelope 137 Front Street stationery (partially crossed out).

Max to Florence, 6220 De Longpre Avenue, Hollywood, California, March 7, 1920

10:00 AM

Dearest, have you stopped writing to me altogether? Have I behaved so bad? Or are your lovely thoughts and sweet warm glances all going to someone else? You ask for my practical advice now—you are very sweet about that—but I didn't want you to give up all poetic interest in my existence at the same time!

Your last letter is dated two weeks ago at Los Angeles. If I did not have your telegram in which you say you still love me, and if I were not credulous because I want to be, I should feel very poor for the want of these rich yellow envelopes.

You didn't tell me about Heifetz.

You didn't tell me about Santa Barbara.

You didn't tell me about Nazimova.[96] Did you meet her?

Who is Max Linder?

Dearest, here is another piece of advice. In whatever negotiations you do undertake—with anybody—I would let your press agent (for some reason I have forgotten his name completely) act for you. It is impossible to do justice by yourself; your very interest in the proceedings puts you at a disadvantage, and you can't conceal it.

I believe it would pay you abundantly to give him a very liberal commission if he could agree to do it. Please answer me about this—if you ever write to me again.

I've been hunting everywhere for the April Picture Play, but it isn't out yet.[97]

Aren't you going to send me some new pictures?

Dearest if you still love me I will come out there again before long. (I am saving both your presents to bring [with] me.) But I have decided to go up to Croton on the first of April, when Crystal and Floyd (or at least surely Floyd) come back to the Liberator, and work all day every day on my book until it is really in shape. I can't possibly have that free and light-hearted wandering to you, until this thing which has become a burden, it has been so long shifted about and postponed, is off. I think I can finish it very rapidly, and I will be coming to you just when the swimming begins to be good. But I simply can't spend more and more time on the cars, or getting resettled, gathering up books again and carrying them across the country—I can't feel that life is joyful and romantic—if I do that after all the wasting and postponing of these four months. I've just got to sit down where the books are and where the library is, and finish it so it can be published next fall.

Here is my nice letter from Scribner's. I told them perhaps my career as a traitor had been so brilliant that Mr. Scribner might not think I was a good business proposition anymore.

Darling, I hope you understand how inevitable it is that I should stay here and finish that job. I don't know whether you will or not. It would be done now if Crystal had not gone down.

She promises now to make me free until *next January*, leaving the plans thereafter undefined for us both. In the meantime I shall be planning how to make myself most free after that, and I will be able to talk with you about it.

My darling, I am so glad I was a help to you in your crisis with Cliff Robertson, and wiped off a little of the stain of my bad conduct just before it.

(I thought you weren't paying *any attention* to my advice and became angry, and acting on some hastily gotten up theory that I ought to give complete expression to such emotions, I sent you that long telegram without thought or further feeling.)

Darling I have just paid Harry[98] the last of our debts. I want to tell you this as a kind of apology for not sending you a lovely present, as I want to.

Please, please write to me, my beloved—Max.

Postmark. Written in pencil. Dated also by Max, who notes on envelope, "The book pressing me—my bad behavior."

Love and Loss in Hollywood

**Florence to Max, 11 St. Luke's Place, New York City,
March 6, 1920**

HAVE HAD THREE OFFERS AT TWICE MY SALARY THIS
WEEK WILL ASK YOUR ADVICE BEFORE I MAKE A MOVE AS
I AM STILL UNDER CONTRACT SEE APRIL PICTURE PLAY
STORY ABOUT ME THINK OF YOU ALL THE TIME AND MISS
YOU SO MUCH ALL MY LOVE

<div align="center">F.</div>

Postal night lettergram, filed 8:15 p.m.

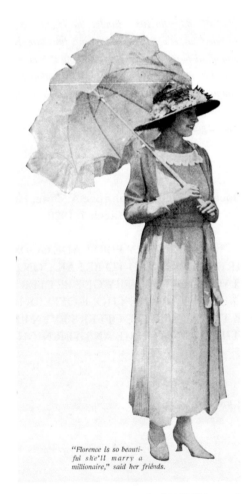

"Florence is so beauti-
ful she'll marry a
millionaire," said her friends.

Figure 3.10. Florence in *Picture Play* 12, no. 2 (April 1920). Unknown photographer.

"Talking Together in the Ford" (1920)

It seems a terrible irony that the Picture-Play *puff piece about Florence appeared just as her career was about to tank. The author, Gordon Brooke, pulled all the stops in representing her as the embodiment of exotic beauty, but one equipped with a brain: "Had Carmen lived in the hills of Hollywood instead of Hispania; had she attended lectures and theaters instead of bull-fights; had she read Plato and Balzac and Conrad instead of aces, deuces, and tea-grounds; had she lived in this picture-romance of today instead of Spanish lore of yesterday, she, Carmen the Free, might have been Florence Deshon." The photographs accompanying the article show Florence with a parasol (fig. 3.10) or seated next to a pretty garden pond, adding a contemplative Eastern element to the portrait, which is enhanced by the references to Florence's exquisitely appointed apartment—the silken shades, the Japanese paper over the mantelpiece, the velvet carpeting, the olive-leaf gray furniture. Florence herself added to the aura of all-purpose foreignness by telling Brooke, inaccurately, that her mother had been a "Hungarian gypsy." The ending of the article, in light of what had just happened to her, lifts this hyperbolic portrait of Florence to the level of unintended tragedy: "I am going to be a star," she told Brooke, "if Goldwyn doesn't give the chance, I shall find it—elsewhere."*

Max to Florence, 6220 De Longpre Avenue, Hollywood, California, March 7, 1920

SHALL WE HAVE DUDLEY TRY PERSUADE GODSOL GIVE
YOU TWO THREE THOUSAND TO BREAK CONTRACT OR
TELLING HIM YOUR OFFERS TRY GET BETTER CONTRACT
WITH THEM NEXT YEAR ARE THOSE OFFERS JUST ONE
PICTURE ARE THEY DEFINITE OFFERS EVEN BETTER NEWS
WHAT YOU STILL THINK OF ME ANSWER NIGHTLETTER
LOVE

M

Postal telegram, filed 4:50 p.m.

Max to Florence, 6220 De Longpre Avenue, Hollywood, California, March 8, 1920

Sweetheart. I am so happy at the news you sent me today. I have been singing ever since I got up. How good you must feel.

I wish I could know whom the offers are from. I think Dudley might be able to get something out of Godsol if he knew just what.

I'm going out to buy the magazine right off.

I have happier news too. Crystal is getting well and makes fine promises—I'll tell you about them. I must go to the office now—as soon as I get your magazine.

Here's me sitting by my fire. Ain't I nice?[99]

Max.

Postmark.

Florence to Max, 11 St. Luke's Place, New York City, March 9, 1920

Beloved. You will be jealous when I tell you of my adventure today. I have been flying. It was a lovely sunless day, and I thought. I would like to fly, so I drove over to the aviation field[100] and said to the man, I would like to fly. He put a coat and hat and goggles on me and in ten minutes I was in the air. We kept going higher and higher, but the pilot promised to turn the corners slowly, and to start down as soon as I wished. I loved it loved it. I was sorry that I had to fly over a town I should have loved just looking down on broad green fields I didn't like the house tops I should think birds would hate the city. It looks so unmemorable and so hard too I stayed up fifteen minutes I was sorry to come down. Let us write each other conversations as tho we were talking together in the Ford. I feel sad a little because in your letters you seem to feel that you must come out here again. I wouldn't have you come for anything unless it just appealed to you as an adventure.

How we jump from black despair to brightest hope. I am all excited again and happy. The offers I had were for only one picture, but they were all leading parts and $400 was the salary. I might be borrowed from Goldwyn they are asking $300 for me and I would get my salary from them and the rest. Nothing more has happened, but I have been offered

a contract as soon as I finish with Goldwyn. I will tell you more about it when it is settled. Do not forget me sweetheart

<div align="center">Florence</div>

Postmark. Faded pencil on paper.

Max to Florence, 6220 De Longpre Avenue, Hollywood, California, March 9, 1920

Darling, I have been so close to you all night that my body was hot with your dear presence when I awoke. Did you know how close together we lay? My sweet love—

<div align="center">Max.</div>

The letter likely was written earlier than the postmark indicated; envelope taken from 137 Front Street stationery.

Florence to Max, 11 St. Luke's Place, New York City, [March 15], 1920

Beloved. I am so happy you must let me write in pencil I have a ticket to New York 1,200 in the savings bank and a little little [*sic*] in the Checking account and a five weeks quarter from Maurice Tourneur at $350. a week. I begin work in a lovely part with him.[101]

March 22nd. Allan Dwan told me that I had stayed at Goldwyn just long enough, a little longer and I would be ruined. But dearest I am so happy about your news. The notice of your poems was beautiful, it is what I am always hearing about you out here.[102] I think your note from Scribners wonderful. How everybody admires you. I do too the most of everybody because I know you the most and you are lovely.

Darling the book mustn't be a burden. Go to your little house in April and if I sign up for a good picture I shall steal a month and come to see you.

I haven't met Nazimova, she hasn't met anybody. Max Linder is a great French comedian, he was famous long ago. he is just the opposite of Charlie. He is a little dandy. Think of me beloved and know that your

beautiful pictures are everywhere in my house and you are always in my thoughts.

I want to send you a lovely present. What shall it be?[103]

Postmarked March 16. Last sentence added in top margin on first sheet. The letter was likely written earlier than the postmark indicates, since it contains information also conveyed in the March 15 telegram, in which Florence, her contract and pride broken, also breaks up with Max.

Florence to Max, 11 St. Luke's Place, New York City, March 15, 1920

HAD TURNED AWAY FROM YOU BECAUSE OF GOSSIP ABOUT YOU WHICH HURT MY HEART HAVE BROKEN MY CONTRACT FOR ONE THOUSAND DOLLARS AND TICKET HOME STARTING MONDAY WITH TOUNEUR [*sic*] AT THREE HUNDRED FIFTY IN BIG PART FOR[GI]VE ME NOT ASKING YOUR ADVICE BUT I THOUGHT YOU [were too] DISAPPOINTED IN ME TO CARE (AM FREE AS WINDY [morning])[104] LOVE

F

Western Union telegram, filed 2:16 p.m. Significantly damaged. Reconstructed parts in square brackets (those penciled in by Max in lower case).

News traveled fast in the acting world, even across the continent. Having just promised Max a "lovely present," Florence must have heard later that same morning (her telegram to Max was sent at 2:16 p.m.) that Max had attached himself to the lovely dancer Lisa Duncan. Perhaps a helpful soul from Croton had called her; perhaps she had received a note in the mail. For some reason, Florence knew instantly that this wasn't just "gossip." She had not hidden Charlie's visits from Max. But Max had kept her entirely in the dark about Lisa, and that hurt Florence beyond measure. Her worst fears had been confirmed. She had been betrayed by Goldwyn and now by Max as well.

Originally, Florence had vowed not to go down without a fight, even though she must have felt like David pelting the Goliath Goldwyn with

mere pebbles. Max and Dudley Malone, who enjoyed multiple contacts to Hollywood executives going back to his time in political office, had advised her to hold out for as much as $4,000 plus expenses in severance pay. But Max's betrayal so demoralized Florence that she settled for a much smaller sum than Clifford Robertson had offered her ($2,500; see Florence to Max, February 17, 1920). Florence's statement that she rather than Goldwyn had broken her contract was little more than a desperate attempt to save face, as Max (who was familiar with the chronology of events) would have realized, too. She was, her spur-of-the-moment decision suggests, done listening to Max and his pals. In a sense, she had already devalued herself by even bartering with Goldwyn's lackeys. Florence Deshon the future star deserved better.

Max to Florence, 6220 De Longpre Avenue, Hollywood, California, March 16, 1920

IT IS NOT TRUE THE OPPOSITE WAS TRUE I CANNOT FORGET YOU PLEASE GORGIVE [*sic*] INEVITIBLE [*sic*] RUMORS I WOULD TELL YOU IF SUCH A THING WERE TRUE YOU KNOW THAT DONT YOU I CAN HARDLY BELIEVE YOUR WONDERFUL STORY OF HIGH FINANCE I AM AS LONELY AS A CLOWN [cloud] LOVE

M

Western Union telegram, filed 12:43 p.m. "LONELY AS A CLOWN"—a wonderful Freudian slip, though likely just an error that occurred in transmission. Corrected to "cloud" by either Max or Florence, restoring the allusion to William Wordsworth's poem "I Wandered Lonely as a Cloud," also known as "Daffodils" (1807).

Max to Florence, 6220 De Longpre Avenue, Hollywood, California, March 21, 1920

I MISS YOUR LETTERS TERRIBLY YOU HAVE ALL MY THOUGHTS

M

Postal telegram, filed 4:16 p.m.

Max to Florence, 6220 De Longpre Avenue, Hollywood, California, March [22?], 1920

Dear, it is harder to write you a letter after that shock than it was to send you a telegram in the midst of it. I do not know what the rumor was. I do not even feel sure to what "woman" it refers! So gay and playful have I become.

But I will tell you who has swayed my emotions more than anybody else but you ever did. It is Lisa Duncan. There are all those beautiful girls around her. I love them all. I love to play with them. And when in the midst of that happy playing I saw Lisa dance in Carnegie Hall I was entranced away beyond any thought by the perfection of her being. I was in love. I knew I could not write to you without telling you that. And before I could try to think—only the next day—your letter came. I felt you slipping away from me. I felt that I was losing your passionate friendship. And yet what I was gaining was not friendship. It was pure love. That is, it was pain and ecstasy and quivering restless madness.

All that day I was beaten sand under a tempest of emotions. I knew that the rumor you had heard was false—I felt that you thought your shrine in the country had been violated—it has not. So I telegraphed that I could not forget you. And then I went and told Lisa that I could not forget you.

And that was the end—or at least it was the beginning of some rest and temperation into my mad feelings, and in hers of that tender and infinite furling up which only girls and spring flowers understand.

Now I feel that I have lost you both, and gained nothing—not even my own soul, for I do not know where it is. But I have returned to my work, the only emerging rock in this sea of feelings where I am so rudderless and unresolute a passenger.—I miss your letters. Your portraits in Picture Play are rich and gypsy-warm and beautiful as the world's desire—

Max.

Written in pencil. The date seems to have been added later by Max: "circa Mar 22, 1920" (the note is repeated on the last page verso). But the reference to the "rumor" places it right after Florence's March 15 telegram.

Lisa Duncan (1898–1976) was one of Isadora Duncan's Isadorables, the adopted German-born daughters of the famous, and famously idiosyncratic,

Figure 3.11. Lisa Duncan. Unknown photographer.
Eastman mss. Courtesy, Lilly Library.

dancer Isadora Duncan. Max had been "passionately desirous" of Isadora's
"half-naked" girls in their Greek tunics (EL, 562) from the moment he
first laid eyes on them. (He was still living with Ida Rauh at the time.) He
elected to have a passionate affair with the best dancer of the lot, the beautiful,
entirely liberated, golden-haired "Lisa" (Elisabeth Milker, fig. 3.11), inviting
her to his house in Croton, where they spent the nights together and once, in
a fit of "decorative fervor," painted part of his living room red (LR, 205).
Their relationship continued through letters when Lisa left for an extended
European tour with Isadora in June 1920. Yet her absence was enough of an
incentive for mercurial Max to try and patch up things with Florence again.

Ross Wetzsteon has perhaps offered the best description of Max's oppor-
tunistic behavior as a lover: "Disenchantment with ideologies took months,
years, of reflection, but disenchantment with women . . . took place in a
monstrous moment."[105] Lisa went on to have a career of her own as a dancer
and dance instructor in Paris. In 1962, when Lisa had retired from dancing
and was living in poverty in her native, now communist Dresden, Max sought
her out again, and she responded: "Your memory is very precious to me,"
revealing that she had been reading Max's poem "To Lisa in Summer" to
herself over the last decades "in moments of doubts or disappointments."[106]

Figure 3.12. Lisa Duncan in Croton, 1920. Photograph by Max Eastman.
Eastman mss. Courtesy, Lilly Library.

> *Even though Florence was embarked on an affair of her own, Max's obfuscations about his interest in Lisa angered her. And she had good reasons to suspect that he was less than truthful about his feelings. For example, while he assured her that their "shrine"—the shared house in Croton—had not been "violated," the surviving evidence (passionate letters from Lisa recalling nights of ecstasy, photographs of Lisa in Croton, the red paint in the living room) proves that he was lying (fig. 3.12). Florence must have known that Lisa was more than some random chorus girl. Contemporary reviews regularly singled her out as the best and most athletically accomplished member of the Isadorables. Long-legged, doe-eyed, and equipped with abundant, curly hair, muscular yet still enticingly fragile-looking, Lisa had become an audience favorite in the United States, celebrated for her "airy leaps" and her sophisticated interpretations of Chopin. If Charlie had become Max's rival in Florence's heart, Lisa's charisma, spontaneity, and artistic achievements threatened to permanently displace Florence in the shifting panorama of Max's affections.[107]*

Max to Florence, 6220 De Longpre Avenue, Hollywood, California, March 23, 1920

HAPPY [TO] HAVE YOUR LETTER DIDNT SEND LETTER
LAST WEEK SENT IT SUNDAY HAVE WRITTEN TWICE SINCE
TOO WONDERFUL YOUR ENGAGEMENT WITH TOURNEUR
DEAREST LOVE

<div align="center">M</div>

Western Union, night message.

Max to Florence, 6220 De Longpre Avenue, Hollywood, California, March 27, 1920

My darling, couldn't you tell me a definite date pretty soon when you are coming? Everything calls for you here, every object, every ray and shadow and motion of the wind—we want you. We are lonely and we want you to come home.

<div align="center">Max</div>

Postmark. Date also penciled on envelope by Max.

Florence to Max, 11 St. Luke's Place, New York City, March 29, 1920

Shall I tell you my emotions when I read your letter. I was sad for you. then I was angry I thought, if he does not know whether he would like to know about me if I was in love, I will write him such a letter. then again it all seemed so simple. If you are in love with Liza [*sic*] there is no reason in the world that I should come between you. I cannot prevent you from falling in love. if it is not so lovely a girl as Liza [*sic*] it would be someone else.

I feel practical about the emotion of love. You have lived a pure love life for a long time that emotion is used to flowing out, because you are a giver even if you do not think you are. Suddenly removing the object of love is not going to stop the flow of emotions. I do not care if you are in love with Liza [*sic*] I feel like one who has walked and trotted and run a long way, and now I can rest. It is almost two years since you stopped loving me, and my first instinct was to go away but it seemed wanton and we liked each other still there was really no change in the basis of our relationship, now there is. Perhaps I am writing you too quickly after reading your letters. also I think I am such a bad writer that half my thoughts are not finishing their way to you.

I have given up the house in the country it is yours please make it your own again.

Please do not think that I am presuming to know more about you than you know yourself on that.

I think that because you are sweet and for other reasons perhaps you think you want my letters and my friendship and that you want me to come and see you. I don't think it is what you want and I am concerned with what I want.

I am not turning away. Truly with my hand on my heart my feelings and emotions for you have never been kinder.

Florence.

Postmark. Written in pencil. Letter carries note in Max's handwriting: "Envelope marked Mar 2, 1920."

Max to Florence, 6220 De Longpre Avenue, Hollywood, California, April 3, 1920

I HAVE BEEN IN THE COUNTRY ALL ALONE THE WHOLE
WEEK THINKING OF YOU ALL THE TIME AND WAITING FOR
A LETTER I AM SO SORRY I WROTE YO[u] THAT FOOLISH
LETTER I AM DISMAYED AT YOUR SILENCE WITH ALL MY
LOVE SADLY

<div align="center">M.</div>

Western Union night letter.

Max to Florence, 6220 De Longpre Avenue, Hollywood, California, April 5, 1920

YOUR LETTER CAME THIS MORNING AND ALTHOUGH IT
LEAVES ME SO MUCH ALONE I AM MORE AT REST BECAUSE
OF THE BEAUTIFUL WORDS IN IT I HAVE MAILED YOU AN
ANSWER TOO LOVE

<div align="center">M.</div>

Western Union night message.

Max to Florence, 6220 De Longpre Avenue, Hollywood, California, April 9, 1920

O Darling, I am so lonesome. I long for a sweet letter from you—any
letter—any word of friendship and warm counsel. I have no friends. I am
lost in the world. You are the only person in all the world that is dear to me.
I just can't bear to think that somebody will come and make love to you,
and you will fall in love and be gone from me forever.

You don't know how continually I live in the thought that I am going
to you as soon as my book is done. I just can't give it up whatever you say. I
don't care what the "basis of our relation" is. I want to be with you and talk
to you and have you be my friend and sit beside me in the Ford.

Be my friend. Talk to me. Tell me about yourself. It is all I ask. How can
any words I have written make it impossible? Don't you want my advice
anymore?

O my child—I know how it is. You think you are in a position like I do [*sic*]. Well how shall I prove you are in the very opposite position? I *longed* to have her[108] fall in love with somebody. If you tell me you are in love with somebody I will be devastated, I will think my life is cut off. I always shudder when I tell myself you will. I think myself on the train to go to you and prevent it immediately.

Don't you see? It is not so. I know I was a poor lover, and you must think I am very inadequate to your glorious beauty even as a friend, but such as I am—you are my friend. You never go out of me. You are my only friend, the only person and the only thing I always come back to in my thoughts as though to myself.

What shall I do then if you will not be my friend? Give me your counsel. What shall I do?

I am very very lonely and tired of my wandering. I have only one home in the world, where I am at rest even if it is but for a moment that I am ever at rest—it is in your presence when we talk together about things and people, when we cook breakfast or dinner and eat together and laugh and play. It is the only time.

If it would not utterly disrupt and destroy my plans and hopes for my book to leave the library, I would get on a train today and just come whether you want me or not to beg you to be my friend. But you care about my book too and you wouldn't want me to do that, won't you write to me then? Just a single, little letter about what you are doing. Just talk to me as though you were riding along beside me in the Ford.

I believe I am going to compel you to be my friend by telling you so much of the naked truth that there will never be any queer reactions or distressing moods in me anymore—you will find me so sweet when the truth has made me free—but I can't do that all at once. And meanwhile I am so lonesome. I am so thirsty, and so worried that you are altogether lost. Won't you send me some single friendly understanding word? Please remember if I ever did anything for you, and do this for me now.

<div style="text-align:center">Max.</div>

Postmark. Written in pencil.

Max to Florence, 6220 De Longpre Avenue, Hollywood, California, April 15, 1920

Croton—April 15th

Dearest, I dreamed last night that I was seeking you, I had a date with you at a restaurant, and you didn't come, and I grew very wild and jealous, and went to Caroline and she said you had gone to ___ some place, a name like Monte Carlo, with a man. I asked her if you liked him very much and she said yes, you were with him all the time, and you lay down beside him when he was only wrapped up in a curtain! That sounds funny. but I woke up in a mad passion of jealousy and forlorn love. It was my first night in our bed at Croton for almost a week, as I have been working in the library in the day and playing in New York in the evenings.

O how I miss your sweet letters. I have been reading one over—just the last dear note of love you wrote me. "I am so happy you must let me write in pencil," you began.[109] Now you are still happy, but because you have killed me in your heart and thrown out my dead and useless image. I know your pride and ferocity. Why should I fool myself? "He will never be in a position to hurt me again"—that is what you say. But I do fool myself. I tell myself that you realize that I who love it above all ideals, have never really experienced liberty. I was bound by my bringing-up all through my youth, and then I was bound falsely and outrageously by my relation to Ida, and then just twenty-five days after I escaped from her, love conquered me, putting down in pain and cruelty the terrible rebellion in my soul. I didn't want to die without tasting of youth's foolish and wayward and inconsiderate freedom. And so that rebel still lived in my heart, it seems, gathering his forces in the dark, and he knew how to poison love even if he couldn't conquer him in open battle.

I have tasted a lot of youth's freedom, and at least realized what a great deal of sorrow it brings with its beauty.

———

It is terribly just that I cannot have your letters, but you cannot take away from me the pure memory and presence of you in this house and in my study and the little acre of ground where our trees are planted. It is mine.

———

I thought I could relieve my heart and get happy for my work by writing to you, but I grow more oppressed and worried with every word. I would like to cry this morning. I can't find what I want in the world. I can't find anything that endures. I can't make absolute choices. I never made but one, and that was you, and if I can't come back to that there's nothing in the world will ever stand for me, and I shall simply flow to my grave in a lazy and meaningless stream of emotions.

I wonder if you are as cold as your silence seems. It seems to despise me. It is very hard to write to you when I do not know. I thought I could be very frank and intimate—and what is more important, interesting—to you, even without any response, but I guess I am not confident enough for that. Seven beautiful girls—at least all beautiful but one—have offered me their love since I left you in December, and I doubt if even your own record of devastation is very much greater than that, but yet if I go away for twelve hours by myself my heart is void and lonely and only knows its one sad thought, that our love is broken and lost.

I talk about it glibly, but I can't understand it. I don't know what is the truth underlying my dream and these words and the sobs that are pouring upward now in my heart—

<div align="right">Max.</div>

Postmarked April 20, 1920. The letter looks as if Florence had tried to burn it but then changed her mind.

Max to Florence, 6220 De Longpre Avenue, Hollywood, California, April 16, 1920

Dearest, I went to see your precious Elsie Ferguson[110] in the flesh the other night. I got a seat in the front balcony but I could not see her face very clearly, so I went down to the box office and told them I didn't think it was fair as that was all there was to the show. They agreed, and gave me a whole box, so I sat there in the front all by myself and did my best to admire. Her face is amazingly beautiful, and her body is not unbeautiful either, but she wields it with such labored awkwardness, and speaks with so much ingrained and thoroughly learned affectation, that I was not happy. I could not *like* her a bit. In all her ways I could feel that rather small priggish interior expressing itself, and that is not beauty.

A couple of weeks ago I went to the Hippodrome to hear Galli-Curci,[111] and then too I was disappointed. The songs she sang were so silly and

characterless, and she was dressed in such hideous taste, and the whole thing was so flat and well-lighted and unimpassioned. She did sing "I Puritani" at the end, but with a piano, and somehow she did not sail up above the music strongly as she does in our phonograph. I suppose the place is too big. She didn't carry me anywhere at any time, and I was terribly disappointed. I wish I had gone to hear her in an opera.

Night before last I went to McBride's and bought a ticket to see Ina Claire in The Gold-diggers.[112] She is a great success and I've tried before to get one, but as I came out I met Floyd & Greenberg[113] on their way to the opening of Gorki's Night Lodging, one of Arthur Hopkins['s] experiments in real drama. I rushed over to 45th St and sold my ticket to the Gold Diggers the second I came in the door, and then rushed back and got a seat in the second row at Night Lodging. It was truly wonderful—an incredible conglomerate Russian picture of true life, starting nowhere and arriving nowhere either, I think. Wonderfully staged, wonderfully acted. That and Eugene O'Neill's "Beyond the Horizon" are the best plays I've seen—both tragic and terrible.[114]

You will be surprised to know I've never yet been inside "The Capitol." That and Theda Bara are still waiting for me.[115]

Rose Rolando[116] tells me that you are to play the real leading part in Tourneur's picture. It makes me think your love for me was almost a voodoo to you, and all my picture advice a burden. If I could have had my choice for you, I think it would have been just that—to play the lead in one of his pictures.

Do you know I left the Ford in the barn last fall with the water in it, and of course it was all blown to pieces by freezing. I guess I can hardly get more than $250 for it. I don't know whether to sell it and put away the money, or turn it in and start buying a new one on the installment plan. If you were coming to see me, I would buy a new one, but as I fear you are not I think I would rather have the money so I can go out there and talk to you.

I was thinking that I said in my last letter "I don't care what the basis of our relationship is". That was only an impetuous way of saying I want your friendship anyway—My life is a good deal more "sublimated" somehow than it used to be. It did not mean that "I don't care", or that there is any body toward which I can feel that devouring passion I feel toward yours.

I didn't intend to write this way. I was just going to talk to you about the theatre, but I don't want to forget that, because if you don't answer my letters, I may never know whether I have said something that you didn't like.

I feel that I am terrible novice in life, but somehow that I am growing wiser and more strong—not foolisher and less contained as you probably think.

<div align="center">Max—</div>

Postmark. Written in pencil, including address.

Florence to Max, 11 St. Luke's Place, New York City, April 26, 1920

Dearest. I am not like you I cannot write long letters about my feelings I must just depend on your wonderful understanding if I don't explain but just tell you I am in love.

Your letter about Lysa [*sic*] set me free until then you were first in my thoughts, you and happy times in Croton. Then I realized I had had those things, but I would never have them again. I too love love. I am not one to be content with just a friendship in my life. I long to feel love to express it,

I cannot write any more about it. forgive me.

<div align="center">Florence</div>

Postmark. Forwarded to Max's address in Croton.

> When Max received Florence's letter, he panicked. But first he went to their favorite millinery shop in Manhattan and picked out a nice hat for Florence, apparently still unaware that the times when he could play Pygmalion to Florence's Galatea had passed.

Max to Florence, 6220 De Longpre Avenue, Hollywood, California, April 29, 1920

Dearest, I had such fun yesterday. I spent the whole afternoon, almost, up at Peggy Hoyt's, choosing a hat for you. They were all so sweet to me, and so enthusiastic about getting one you would like. Miss Sophia loves you so much, she told me she dreamed about you only two nights before, that you

came in the store and she had such fun showing you everything they had. She said "You know I think she is the most beautiful girl that ever comes in this shop. I saw her in the Loves of Letty and I was so excited my friends didn't know what was the matter with me."

She had just been waiting on Billie Burke,[117] so I guess she has experience enough of pretty girls. I felt very friendly to her, but I could only see in her my memories of you. I felt very romantic and happy to be there again with all my pride in your beauty that adorns everything they make.

You needn't thank me for my present. It gave me the one rapturously happy time I have had in so long—

<div align="right">Max—</div>

Postmark.

Max to Florence, 6220 De Longpre Avenue, Hollywood, California, May 3, 1920

YOUR LETTER IS UNENDURABLY BRIEF AND I AM COMING TO HEAR IT ALL FROM YOUR LIPS BEFORE I CAN BELIEVE ANY OF IT NO WORDS CAN TELL MY FEELINGS I WAS PACKING MY THINGS FOR HOLLYWOOD WHEN YOUR LETTER CAME I WILL TELEGRAPH FROM THE TRAIN LOVE

<div align="center">MAX</div>

Western Union telegram, filed 10:10 p.m.

Florence to Max, 11 St. Luke's Place, New York City, May 3–4, 1920

IF THIS TELEGRAM REACHES YOU I WISH YOU COULD PLEASE DELAY YOUR TRIP UNTIL LETTER I AM WRITING REACHES YOU PLEASE DO THIS FOR MY SAKE MY WHOLE FUTURE DEPENDS ON IT PLEASE FORGIVE BRIEF LETTER LOVE

<div align="center">F</div>

Western Union night letter.

Shocked by Florence's retaliatory rejection, Max embarked on a series of monologic, self-pitying green-inked letters, vacillating between regret and vituperation, in which he also tried to imagine who Florence's new lover could be. (Strangely, Charlie's name did not come up.) Most of these he wisely chose not to mail. But he kept the drafts, just in case.

Max to Florence, May 3, 1920, not mailed

(Written Monday, May 3 1920
but not mailed.)

I have lost you, and I have lost everything on which my being rested and toward which my thoughts were turned. I was in the act of gathering up the last pages of the last writing to put in my suit-case and go to you. The pain of your silence had grown steadily and unendurably. I had kept your house and barn and meadow like a temple for you. I had kept my heart. Only last night I made a scene of embarrassment because I did not want my guests of the day to stay here overnight with all their emotions.

You did not write to me of your feelings. Ah but why? Why couldn't you tell me of what was befalling me.[118]

Well, you did not care. I had hurt you and lost you. You wanted to go away. And you were gone.

Oh forgive me. It is just, but it is an unendurable pain. And you are so brief, so utterly and incredibly brief. All your feeling dead as it was toward John.[119]

I had not turned from you. I was going to you, and all my friends knew it, and I thought you would feel and believe it.

But how just it is! At last I am the one to be spurned. And like all the others, I cannot bear it.

Today is Monday and it was just this past week that I have gone around with pain in my heart, lain awake at night suffering about you—inexplicably—counting my money—planning to get free—and seeing that I would finish everything up this week—that I would take the train *next Monday!* Surely my heart has known every second that your letter was on its way.

And I was congratulating myself in my very pain because I know now that I am grown up and have so much deeper feelings and more constant than I had believed!

Florence dearest, I know with what folly I write this letter to you whose feeling and whose imagination are all elsewhere. I do not need to be reminded of John. But I have written it instantly because I cannot any other way live through these coming moments. I have no friend in the world, nobody that I even talk to. Perhaps when you see my words, if you are alone you will have a little moment of kindness and give them a thought. At least you will never show them to your lover, never tell him what I said.

I am all alone in the little barn—Dudley just came by and handed me your letter, saying "I didn't want to interrupt you, but I know you would like this." I look out of my window at the little lilac bush—it has just got its leaves, pale green in the sun. There is no one but Annie in the house. There will never be. The tears are flowing out of my eyes. The end is come. I have failed, and failure was written in my blood from the beginning. I could not act a clear part. I could not bear to be an individual—I wanted to be the universe. That is why I have failed.

Florence I want to ask you to do one thing, and that is what I was going to do first when I came there—if you haven't done it already tear up or burn up all the letters I wrote you after the one in which I acknowledged your last one—after the one in which I quoted that poem "Peace peace I give to you".[120] It will only take you a minute, if you haven't been throwing them away; If you have, then you have been wiser than I who wrote them. But please be sure for my sake they don't exist any longer.

———

I have had my lunch now, and Annie asked if the food was bad and what was the matter with my eyes. I told her I had had bad news, and she looked as though she would hardly believe it. I had just told her that I wasn't going to California after all. It is just as incredible to me too.

I can't believe it. I have to break the heart of a whole hillside—and they will all condemn *me* and they are right.

My beloved, I have chosen to let you see all my emotions instead of writing you just a little note of admiration. You will not make the mistake of thinking I want sympathy or any answers. I only want the one last little bit I can have—that you should see me and be with me here as I am just in this moment. Then you are gone. Incredible that you are gone.

You will have a little present from me to make you beautiful for your love. I am glad of that, and I hope he will not dislike them. You can tell him that he is like a god to me.

You see I cling to the writing of this letter for it seems to be the last bit of a thing in the world that I have any interest in. How do you suppose I knew that your letter was coming? I said to Eugen yesterday: "What I cannot understand is, that after all this winter of nervously missing Florence and dreaming about her, I should suddenly just this last week be seized with an actual pain in my breast, and sleeplessness, and a perfectly uncontrollable determination to go to her." I got a kind of wan phantom of pleasure by telling myself that it proves at last that there *is* a deeper thing in me than any of these totally changeful emotions that seem sometimes to occupy all that is visible of my spirit. It proves too late that I loved you beneath them all. I loved you.

———

I have walked all around the road by the wild lake, where you tipped over the automobile, trying to think the incredible, to endure the unendurable. It is growing dark now, for it was noon when your letter came, and now I shall lock up the house and the little barn and go away, for it is you here, and I am getting dizzy and I am afraid of the night.

Do not think I am weak, sweetheart. I am jealous and proud of your freedom and as sure of the nobility and pure beauty of what you do as ever. I know your lover is noble and beautiful. And I have the strength to play my part. I only grant myself this letter, because your own was brief, so relentlessly brief. I ask you to be with me when you read it—give me the imagination of your heart only for a moment—O my beloved—and then you are gone.

Incredible that you
are gone.

Dated by Max in top margin of first sheet.

Max to Florence, 6220 De Longpre Avenue, Hollywood, California, May 4, 1920

I AM WAITING FOR YOUR LETTER DO NOT FEAR THAT I WILL NOT PLAY MY PART BUT ONLY FOR ONCE BE GENEROUS OF WORDS FOR TO KNOW AND UNDERSTAND IS ALL I HAVE LEFT LOVE

NO SIG

Western Union telegram, filed 10:15 a.m.

Florence to Max, 11 St. Luke's Place, New York City, May 5, 1920

THERE WAS NO ANGER IN YOUR TELEGRAM HAVE
DESTROYED LETTER AFTER LETTER TRYING TO WRITE
TO YOU DONT QUITE KNOW WHAT YOU WANT TO KNOW
WOULD YOU LIKE TO WRITE ME A LETTER THEN I COULD
ANSWER IT AM WORKING VERY HARD CANNOT SUCCEED
UNLESS I DEVOTE ALL MY TIME TO MY WORK THAT IS WHY
I DIDNT WANT YOU TO COME TO CALIFORNIA LOVE

F.

Western Union night letter.

Max to Florence, May 7, 1920, not mailed

Darling, it was sweet of you to try so hard to write to me, and I recognize
the impossibility of it. If you should ever want me again, or just feel like
hearing from me or speaking to me—don't think it means explanations,
or problems, or letters that are hard to write. You can break a silence of
ten years by asking me to go over to Lord and Taylor's[121] and buy you a
little shimmy-shirt—or just writing to tell me what your salary is—nothing
could be sweeter to me than that.

The questions I need to ask so that I can live my own life are simple,
and I will fix them so that you can answer either yes or no. First I will ask
them in full, and then I will ask them in a shorter way on a separate page,
and you can write in the answers and send it to me.

Is your love all-possessing, and am I practically dead to you as John was?

I could so well understand your turning away from me after the mad
letter I wrote you, turning altogether into the world of your ambition. And
in whatever world you live, in that world you will love. I know that. And
the fact that you have loved someone else does not alter the warmth and
color of your image in my heart. I know that whatever you have done is
touched with beauty and is sacred. I might someday hold you, and your
ambitions, and your impulsive pride, and your love for him too, all in a
very tenderly strong embrace, and you would feel as you were sinking
tranquilly to sleep in my arms again that you had come home into a dearer
world after all.

On the other hand I know how drastic your heart is, how creating and destroying. I do not need to be reminded of John. If I am to you somewhat as he was, I want you to tell me so, relentlessly.

The second question is perhaps not very different. If I should write you a little letter once in a while, would you open it with pleasure and with interest, or would you dread it or be indifferent to it? It would not be a "long letter about my feelings".[122] Just a word or two about things I would write; and maybe I would not write at all for I would be afraid.

Florence dear, are you angry or disgusted at me because of the letters I have written to you since the one about Lisa? Is there a little contempt in your silence and brevity and the statement that you "are not like me, you cannot write long letters about your feelings"? Is your love turned into something tinctured with hate? That is my question.

I want to ask you to destroy all those letters—if you have not been wise enough to do that as they came—and I wish I could think that they have not been crude and tactless and like handfuls of gravel cast in among the jewels of your experience. There is something ghastly to me in the thought that you have not felt the idealism, and the desire to grow, and to grow in relation to you, that was the motive and true color of them. But if that is so, if there is any hate in the ceasing of your love, I want to know the truth.

That is all I have to ask, sweetheart. I have poured out all my feelings to you with terrible tears since your letter came, but I can never send any words like that when I know they will not come flowing deep into your waiting heart. I can only tell you that I *need* the true answers to my questions, and I hope you will write them without mercy and just in the simple matter-of-fact way I have asked.

A letter from you—a word of feeling—would be precious above all gifts, but these inflexible answers are what I must live by.

With dearest love and all-yielding faith in your ambition—

<div align="center">Max.</div>

Max to Florence, Hollywood, May 10, 1920, not mailed

My beloved, it is so incredible to me that you would behave this way, toss me off like a dead dog after all our sweet deep confiding love and admiration of eachother. Surely you would speak to me. Surely you would tell me of your feelings. Surely you would say goodbye to your lover. I cannot comprehend it. I cannot believe it. It is not you.

You will not let me come and talk to you. You will not write to me. What can I do? I walk the streets. It is unbearable. I think about you day and night. I love you. I love you too much. That is the trouble. That is why I rebel and break away. Your beauty and completeness fill me full of you, and I lose myself. I want to stop loving you in order to recapture myself. I have to. That is why I tell you that I don't love you. But there is nobody else. Everybody knows there is nobody else. Perhaps you have misunderstood my smiling remarks about girls—I was only trying to feel the liberty of my candor toward you, to talk easily. I am not living any different kind of life from what I always did. I am working hard and living all alone—except when Eugen comes.

Perhaps you think I am in love. Perhaps you didn't believe me when I said I told Lisa I couldn't forget you. But it was true. You hold me like a magnet, and yet you will not speak to me, you will not move, you will not accept any responsibility—not even for a tender word of parting if you are going away forever.

I am writing all this—not because I am incapable of realizing that you might leave me, that you may have surrendered your being wholly to another love. I do realize that possibility, and I am proud enough and strong enough to meet it and play my part. But I cannot understand or believe in that event that you would treat me like this. Surely you would speak to me from your heart.

I don't want to know who he is. I don't want to know any facts that you don't feel like telling me. I want to know what your feeling is toward me—nothing else. How could you pretend that you have to ask me what I want to know?

This is the fourth letter I have written to you. I can't send them. I don't know what to do. It is not fair for you to leave me in utter darkness about your feelings and then compel me to write the letter. You know my feelings. You know how your letter will be received. It is easy for you to write. For me it is impossible—

<div align="right">Max.</div>

Dated on the last page by Max.

Max to Florence, May 11 [1920], not mailed[123]

If you feel like suspending our love and its problems of feeling, while you give all your emotion and energy to being yourself, I can understand that. If you don't want to have me there, or come to see me here, now, but might want it again later—if that is the conflict which makes it impossible for you to write, I can understand that. I can enter into that idea with sympathy, and join you in that plan, for it is of the very nature of my own conflict.

But if it is not yourself, if it is not success and egoistic adventure, but a better love you are seeking—or have found—that is another thing. I cannot understand your inability to tell me in plain words.

If you cannot write to me about your feelings, it is because there is some conflict in them. Then tell me what the conflict is. Tell me both sides. Surely dearest if I have nothing else, you know that I have sympathetic understanding. The least candid words you write will tell me what has happened.

Are you in love with him, and yet finding it hard to forget me? Are you afraid of my coming to California because my presence will interfere with your abandon? Is it he that decrees my staying away? Is it he that suggested those words "I am not one to be satisfied with a mere friendship in my life"? It sounds like him.

Why can't you tell me the truth?

Your letter and your telegram are directly contradictory. What am I to think? *What am I to do in my heart?*

Don't you realize that at a distance of two thousand miles, you cannot act upon those petty superficial motives through which I could penetrate in an hour or two if I were there? You cannot just be a mule colt in such a crisis of life. You have got to speak nobly and generously and without pride of a childish kind from the depth of your heart. You would do so if life were at stake, and yet how much more important it is that I should hear from you than that I should continue to live.

How sad it is that you do not want to speak to me. How pitiful and ignoble an ending of our wonderful love and friendship. O my love tell me what is in your heart. I will send you then these letters. I will not trouble you then anymore.

Dated in pencil by Max on the last page.

Max to Florence, 6220 DeLongpre Avenue, Hollywood, California, May 13, 1920

My dearest, I wrote this letter to you a week ago when your telegram came. It was the first one I wrote. It is an attempt to be brave and generous and not let you feel any burden of me. But it is not sincere. I want to speak to your soul. I want you to speak to mine. I cannot endure that our beautiful strong intelligent love and admiration of eachother should end, or even should subside, in this inadequate and ignoble fashion.

I do not mean it is not sincere in asking the questions that I really want answered. They are the questions. But it is not sincere in that it does not humbly beg you to answer fully, deeply, without pride or any of those feelings we always said should not be allowed to determine our relations. Speak the truth that your beautiful mind always sees and holds so dearly.

I think about you all day and all night. You need have no fear (as I have) that your words will come to one preoccupied with something or someone else. I am thirsting for them. My whole action and passion of life is in suspense for the meaning and trend of these days and hours.

I want to consider your ambition to the last degree, and if you think you might reach a point where we could have a talk together *after a while*—tell me. I will come out there any time for a few hours of conversation with you. And if I knew that was coming, I could extend the state of suspense I am in. I do not want to make any "immediate demands". I really feel that you must think of me and my emotions as a bother.

But I cannot pretend away the depth of my attachment to you. It will not let me live in any direction until there is a clear current of understanding between us.

I was coming to you. You will not let me. Speak to me then, darling, if you possibly can. And if there is a conflict when you sit down to write, the way to do it is to tell me there is conflict and express both sides.

With troubled and sad love—

Max.

Letter written in pencil and dated by Max, on letter and envelope.

Despite the drama with Max, Florence's career sputtered on, at least for now. In the Fox western The Twins of Suffering Creek, *directed by Scott R. Dunlap and released in June 1920, she was cast as Jess Jones, a*

dissatisfied rancher's wife who leaves her husband to join the ruthless bandit
Jim Pemberton and is retrieved later by the saloonkeeper Bill Lark, played by
William Russell (1884–1929). She also costarred with Russell, a prolific
actor and director who appeared in more than two hundred silent films, in
The Roof Tree, *another Fox production, released in December 1921.*
Florence was also excited about her next project, Curtain, *for First National,*
directed by James Young and featuring one of the top-earning actresses in
Hollywood, Katherine MacDonald (1891–1956). However, Florence's
role proved to be more of the same. Cast as Lila Grant, a seductive actress,
she wrecks the marriage of her former colleague Nancy Bradshaw, played
by MacDonald. Yet in the end, Lila doesn't get Nancy's husband and finds
herself alone and without a career. Given her new assignments, the possibility
of a "long talk" with Max, sitting in Florence's favorite meadow in Croton
(fig. 3.13), seemed to be receding into the distant future.

Florence to Max, May 20, 1920, likely mailed
with the following two letters

It is too bad that I haven't any paper, but I have been so busy Did you
know as soon as I am finished with Tourneur I started a picture for Fox,
playing the lead opposite Bill Russell. We went to San Francisco on
location and I bought myself a beautiful suit and hat. I always think of you
when I buy anything, because you always liked to see me look pretty. I fell
in Frisco and hurt myself a lot I hit my spine and I have been dizzy ever
since. We worked on the bay and always in sight of some prison or other. I
kept thinking of Debs all the time.[124] When I finish with Bill Russell I am
going to play in a picture with Katherine McDonald after that if I have a
little time I want to come to New York, then we can have a long talk in the
beautiful meadow on the hill.

The letter written in ink would be torn up only your questions are on
the side. My feelings are conflicting, the little devil in me keeps saying hurt
him, hurt him. he hurt you and then again I know you did not mean to
hurt me. it is life that hurts.

No envelope present. Written in very faint pencil, with date given by Florence (Max
added the year later).

Figure 3.13. "Then we can have a long talk in the beautiful meadow."
Florence in Croton. Photograph by Max Eastman.
Eastman mss. II. Courtesy, Lilly Library.

Florence to Max, May 23, 1920

When I said "I am not like you I cannot describe my feelings," I meant it
childishly I am shy about describing my feelings for anyone else to you.
 Just as I think of things I will write them down, just as tho we were
talking. Your letters had nothing to do with my change of feeling They

Love and Loss in Hollywood

were a relieve [*sic*] they released me from a situation which contained only sorrow. I think even if I was very much in love with you, I would turn away from it now. I have come to the point in my life where I cannot love myself unless I am successful in my work.

I really have so much to say to you for I am anxious that you do not get the wrong impression of me. I am vain of my image in your heart so as I think of things I will write them to you.

Florence

No envelope present. Date added in Max's handwriting.

> *Max's relentless flood of green-inked letters culminated in an extraordinary questionnaire he submitted to Florence, hoping that her answers would help him determine the nature of their future relationship. Florence obliged him and enclosed the completed questionnaire in her May 23 mailing to Max. He had composed his questions in his preferred green ink. For her answers, Florence, rather uncharacteristically, chose not pencil but black ink, perhaps to emphasize her resolve.*

Max and Florence, May 23, 1920, Sent to Max Eastman, Croton-on-Hudson

(to be returned to me with your answers.)

1. [*Max*] Am I in anything like the same position that John was?
 [*Florence*] no. I think of you a lot. I was not in love with John as I was with you.
2. [*Max*] Would you feel *indifferent*, or *disturbed unpleasantly*, if you saw a letter from me in your box?
 [*Florence*] I like to hear from you
3. [*Max*] Do you feel anger, disgust, contempt, resentment, or any of the manner of hate, toward me in the slightest degree?
 [*Florence*] no. my heart is friendly to you. I am not angry
4. [*Max*] Have you destroyed the letters I asked you to?
 [*Florence*] I never wanted to see any of them again.

[*Florence*] You think I am punishing you, for your attempts to be happy and free. You shouldn't it is not true. I always said an ideal relationship was one which wandered away perhaps and after came back happier to their love. When your letter came, I was not shocked. I was hurt that you should describe your love for someone else and talk of me in a resentful manner. You had had only twenty four days of freedom then you met me. I was used to the fact that you did not [love] me, but [*text begins to fade out*] I hoped you would know my love was and

Postmarked March 24. Words smudged and faded; bottom of the sheet torn off.

Included in Max and Florence's correspondence from those early months of 1920 were two checks signed by Florence on January 27 and February 20, 1920, drawn on Citizens Trust and Savings Bank, Los Angeles, California. Both were for fifty dollars. On an enclosed envelope marked May 24, 1920, Max noted: "Checks I never cashed—repaying a loan." The checks reinforce the theory, mentioned in the introduction, that Max originally needed Florence to work in Hollywood, hoping that she would thus repay him for his support when they lived together—an obligation that had lost its relevance for him as Florence was drifting away from him.

Max to Florence, 6220 De Longpre Avenue, Hollywood, California, [May?] 1920

It was so sweet to have a friendly-warm letter from you. That is all I want to say. I tried to answer some of the parts of it. But I have committed so many follies with my pen—I cannot write anymore about my feelings, either. I will wait for the day when we will have a long talk in the beautiful meadow on the hill, and I will show you all my thoughts.

You were sweet to write to me as you did.

I hope you went to see a good doctor about the injury you received. It is so foolish to leave those things all to chance and nature. Our doctor at the Beach Shops could tell you who is a good scientist, and I don't believe any of the movie people can.

I am so happy about all the things I hear of your success. When I think of all the things you have to tell me that I just ought to be told, I hardly

know what to do. Everybody asks about you. Everybody misses you. I wish you could tell me a little more about the pictures, and you never told me which hat you liked best. I wish I could have a little piece of film of you with one of them on.

I went to the Capitol the other day.[125] It has "divans", but they don't seem to compare with the ones in Los Angeles.

You thought just what I always do in San Francisco Bay—beautiful, free, romantic, and lovely-colored place—and those terrible dungeons of torture. Some of the bravest and biggest-hearted of us all are right in those prisons. Two or three of them I know.[126]

I am getting you ready another present for your book-shop.

Things are going very hard with the Liberator, but there is an exciting hope for it six or eight months away if we can keep it alive.

I saw Waldo Frank in the library today, and he expressed a great affection for Charlie.[127] He was very happy when I told him I would try to bring them together some time.

Is Elmer still on the job? Is there no hope of Charlie's picture ever being done?

Does your press-agent make your contacts for you? O I could read volumes of news from you! I could ask volumes of questions. But most of all I want to know that you are well again. Won't you tell me that?

And if you would just say to the devil in you that wants to hurt me that she succeeded—abundantly—perhaps she would let you send me another sweet letter about all the things you are thinking and doing—

Max—

No envelope present. Tentative date supplied by archivist.

On June 9, 1920, the following note by Grace Kingsley appeared in the Los Angeles Times: *"What are Charlie Chaplin and Florence Deshon talking about so clubbily in café corners these days? Miss Deshon's feminist theories?"*[128]

Actually, there was very little newspaper gossip about Florence and Charlie Chaplin in 1920, suggesting that Charlie was anxious to keep their affair under wraps. That said, Kingsley, chief film writer for the Times, appears to have been Charlie's favorite reporter and interviewer. She got an interview with Charlie on the site of his new studio on January 20, 1918,

as well as many other opportunities for interviews with him, and she even was allowed on the set while he was shooting one of his films. As we will see, Florence was also very much on Kingsley's mind during the summer of 1920.

Max to Florence, 6220 De Longpre Avenue, Hollywood, California, June 12, 1920

YOUR LETTER MAKES ALL THE DAYS SWEETEST I HOPE YOU HAVE SEEN A SCIENTIFIC PHYSICIAN ABOUT THAT INJURY OUR DOCTOR PARKER[129] COULD RECOMMEND ONE PLEASE DONT BE CASUAL ABOUT IT I WAIT FOR THAT DAY IN THE MEADOW LOVE

<div align="center">M.</div>

Western Union night letter.

Max to Florence, 6220 De Longpre Avenue, Hollywood, California, June 16, 1920

Dearest, The reason I cannot write to you, or send you the letters I've written, is that I am mortified beyond expression. I cannot write to you without trying to explain away my terrible letters that you never wanted to see again—my crass and insane conduct—and I cannot explain anything because I have lost confidence. I do not feel that you can possibly read anything more without thinking it is more of the same thing.

I weigh and appreciate every word and syllable of your sweet kind letters to me. The more lovely and poised and all like you they are, the more impossible for me to answer in my humiliation.

I will try to say something for myself when we can talk together in the meadow.

With love and infinite gratitude for your sweet quiet letters—

<div align="center">Max.</div>

Postmark. Written entirely in pencil.

Max to Florence, 6220 De Longpre Avenue, Hollywood, California, June 27, 1920

Florence dear, I found among some old things those verses of Sappho that I always wanted to put in your book. Maybe you can paste them right in in this envelope.[130]

I am sending you today my other little present that I have been preparing for you.

I wish I knew how you are. If you write me a line please above all things be sure to tell me that.

Others tell me that you are coming east.

I wish I knew when.

With my love—

<div align="right">Max.</div>

Postmark.

Max to Florence, 6220 De Longpre Avenue, Hollywood, California, June 30, 1920

Florence dear, you will surely let me know when you are coming, won't you?

I think of you so continually, and I have a fear that you may not want to talk to me after all.

It is terrible for one so vain as I am to have his letters rejected and thrown away—no matter how completely they deserved it—and to have no chance to explain, to merge this ugliness at least in the general color of my character.

It is too beautiful and sad under this still sky today.

<div align="right">Max.</div>

Croton June 30

Postmarked July 1, 1920.

Max to Florence, 6220 De Longpre Avenue, Hollywood, California, [July?] 1920

Florence dear, I wish I could talk to you today. Here is one of the letters I wrote long ago. It seemed affected then. It doesn't now. But I shall not be myself to you, nor at peace to myself, until we talk.

I wish it could bring me another letter from you.

I am so lonesome today—

<div align="right">Max—</div>

Stamp partially illegible. Written on the verso of letterhead of The Liberator.

Max to Florence, 6220 De Longpre Avenue, Hollywood, California, July 3, 1920

YOU WILL SURELY LET ME KNOW WHEN YOU ARE COMING WONT YOU SO I WILL NOT MISS YOU I AM SENDING YOU A LITTLE PRESENT TODAY LOVE

<div align="center">M.</div>

Western Union night letter.

Max to Florence, 6220 De Longpre Avenue, Hollywood, California, July 6, 1920

I HAD DECIDED YOU WERE COMING AND THAT I WOULD TELL YOU HOW NICE I AM AND PERSUADE YOU TO TAKE A TRIP TO MARTHAS VINEYARD AND NANTICKET [*sic*] WITH ME BEFORE THE SUMMER[']S GONE SUCH ARE MAY DAY DREAMS

<div align="center">M.</div>

Western Union night letter.

Grace Kingsley, in her Los Angeles Times *column Flashes, continued to lavish praise on Florence. This was most likely due to Charlie's influence. On July 9, 1920, for example, she wrote:*

> *Smart Florence Deshon.*
> *It does seem as if anybody as pretty as Florence Deshon really doesn't need so many brains as she possesses. Her latest achievement is the writing of a play which is to be tried out at the Hollywood Theater some time this fall. The tentative title is "Always Tell a Lie."*[131]

Most of Kingsley's columns stress how clever Florence was. On July 2, Kingsley mentioned that given a choice between going to Tijuana and attending the Democratic Convention in San Francisco, Florence opted for the convention, which to Kingsley was a sign of her superior intelligence. Kingsley also shared, on May 27, that Florence had begun work on a series of film scenarios dealing with famous women, starting with the Empress Josephine, a project that, like her play, seems to have gone nowhere.

On July 10, Wid's Daily *noted that "Florence Deshon, having completed work on 'Curtain' at the Katherine McDonald Studio, has left for San Francisco on a vacation."*[132] *In reality, though, Florence and Margrethe had traveled to San Francisco to attend the Democratic National Convention, which met in the Civic Auditorium from June 28 to July 6, 1920. It resulted in the nomination of the governor of Ohio, James M. Cox, for president and FDR for vice president. Their platform did include women's suffrage. It is an indication of the seriousness of her political interests that Florence, who was a National Woman's Party (NWP) stalwart, tried to meet with Abby Scott Baker, who chaired the NWP from 1919 to 1921. (It was on Baker's watch that the Nineteenth Amendment was passed.) Note Florence's biting comment on the chilling effect that the climate of political repression under Wilson had on the state of the American republic: "Mr. Wilson certainly knocked the love of liberty out of the American people."*

Florence to Max, Croton-on-Hudson, New York, July 8, 1920

Max dear, you have been in my thoughts constantly the last sixty hours. I have taken your pictures out of the dark drawer I had thrust them in and looked relentlessly at all your beauty. I have read some of your letters again too, but I cannot bring myself to write freely to you. I am self conscience

[*sic*] all the time in my feelings to you. You told me if there was a conflict to write both sides of it.[133] Once in a letter you said you were a little afraid of my liking Charlie what did you mean?[134]

He is finishing his picture this week then he is going to New York to sell it. He is afraid of it because it is quite serious, but he has no reason to be. it is a very wonderful picture.

Elmer is still with him, though he is going through a terrible reaction against him, but of course Charlie would keep him there forever rather than go through the agony of telling him. Elmer's personality has changed a lot. He had all his teeth pulled out and his false teeth are so noticable [*sic*].

Margaret and I went to the convention. I only succeeded in speaking to Mrs. A. S. Baker over the phone she was so busy I didn't see her. I was disappointed she would have been like a breath from home. I often get very homesick. It looks to me as though the third party has a wonderful chance. There was quite a joke in San Francisco everybody that arrived, would ask "do you think I came in time to be nominated". Cox and Harding I have to laugh whenever I see their helpless expression of patriotism as they grasp their wifes [*sic*] arms in the sunday [*sic*] supplement while they yield to no man in the love of their country. Mr. Wilson has certainly knocked the love of liberty out of the American people they seem content and pleased if they are still allowed a few liberties. I had hoped to get away for a few weeks, but now it looks impossible. Do not be angry at me or sad. I know it is just the distance between us that keeps me so cool towards you, once we have had a little time together to untangle our emotions towards each other and the world, it will be easy for me to be friendly again.

I read large advertisements of property in Harmon. If there is any property for sale near you that you think I would like [you to] tell me about it.

You said in a letter it was hard for one so vain as you to have his letters ignored.[135] I do not ignore your letters there is nothing in my attitude to make you sad or mortified. If I had been able to come East I wouldn't have cared to go to Nantucket. I should have wanted to stay in Croton.

I have torn up a lot of letters this one will have to go to you. Its unmagical quality saddens me more than it can you.

<div align="center">Florence.</div>

I hope the abundance of capitals and periods will make you forgive the pencil.

Postmark. Written in pencil. Envelope sealed with elaborate bronze-colored seal.

Biographers have speculated that Charlie was worried about having contracted
venereal disease or inherited his mother's syphilis. Louise Brooks would later
tell the story of how Charlie would treat his private parts with iodine before
sex to protect himself against infection. It is impossible to know what Max
had heard about Charlie's intimate habits in 1920, but some such concern
was likely behind his dark, underhanded warning in this letter to Florence
that Charlie was a person who had been "sick in those ways."[136]

Max to Florence, 6220 De Longpre Avenue, Hollywood, California, July 15, 1920

Sweet Florence, how grateful and happy you have made me. I only need to
know that you too felt confident we would understand and be friends again
if we could talk. For I know that I am still growing—in spite of appear-
ances to the contrary!—and I only felt incapable of proving it to you at
such a distance. Less than an hour before your letter came I was sitting on
the couch in the blue room half-dressed, and I looked at my new rug and
thought of you, and I said "There is no one—I can't write to Florence—I
have made a fool of myself and I can't stand not to be admired." So you
can imagine what a sweet back-flowing of my feelings to that silver pool
that holds your image, came when I read your letter.

And it is such a lovely and delightful letter, and yet very stately with its
fine periods and capitals. You need not worry or ever fear that your letters
are not "magical."

Indeed they are a little too magical when you put in dark hints like
this one about Charlie. Did you ask that question because you wanted the
answer? I said that I was afraid in two ways of your loving him—one for
myself; that was jealousy—the other for you; that was the question that
seemed to exist about his health. Only a very elaborate series of tests can
prove that a person who has ever been sick in those ways is completely well.

Are you going to make me know in my imagination about your love?
That indeed would be your cruel revenge.[137]

There are those two acres at $1500 each the other side of Dudley's.
Terrible price, but the most wonderful sites there are, for they reach—I
think—way down to the road (next to Floyd's) and command the whole
Hudson river and the heaven above it. Eugen is planning to buy them as

soon as he can get together the price, but that is merely a plan, and there they are.

I suppose you could buy one of them, and build a little house on the other side towards Dudley's yard—if you are as rich as your casual inquiry sounds!

I hope Charlie will not fail to let me know when he comes to New York. I am in Croton all the time, and the number is still 162.

I had a glorious cruise on the Sound last Saturday and Sunday, and tomorrow I am going out in a sail-boat to see the yacht races. I am brown all over, and very good looking and very young—everybody tells me—but most of the days I sit in my little study and work on my book, and most of the nights I lie on the tiny couch by the lamp and read German and French. It is pleasant to be so unexcited for a while, and my book is developing into a "great work of science", but it is the quietest Croton!

Ruth, by the way, has come up to Fred Howe's house while Amos goes to the children—Ruth and her coming baby. It makes her very fat all over, as well as placidly contented, it seems to me, and I foolishly resent it. She has a great interest in arranging to play bridge. I guess we succeeded in getting her to be Mrs. Pinchot!

Doris I am inwardly enraged against, and outwardly distressed by as always. Dudley is very amusing and great fun on the tennis court whenever some queer collection strolls in to play. The weeds are a foot high inside the tapes—Mike being away since July first, and having being half-sick before that. Two elderly people named "Tough" have taken his house, and I don't dare speak to them for fear that I will stutter or laugh.—Mike and Sallie have a Ford—closed car!—and they have fixed their barn into an adorable studio-cottage which is occupied for the season by Marie's friend, Paula Jacobi.[138] They plan to live up here all next winter, and Mike to[o] works there.

Marie Gage is waxier and more voluble than ever, and Floyd more devoted.

Louise Bryant practically never appears, but Johnnie Mosher[139] lives in one of her small sheds, and some other Bohemian odds and ends come up occasionally over Sunday.

I had Annie for two paradisal months of spring, thanks to an arrangement with Eugen, but I can't afford it any longer, so I am getting my own breakfast and lunch, and *washing the dishes immediately after each,* hoping each week that he will bring her up over Sunday and she will clean the house (I go down to the Drowsy Saint for dinner).[140]

Love and Loss in Hollywood

Crystal is here three or four days a week, and Walter over Sunday. They are still "troubled", and Crystal's life seems very, very sad to me, but I believe she is getting a little more indifferent of Walter.[141]

The Lanes are away for a month, and several little short Jewish girls from the office are in their house.[142]

You would come like Artemis from rainbow heavens into this dull scene, and I am so sorry it is not to be. But I remind myself that movie people always change their minds every week, and there are a good many weeks, and somewhere some time anyway we will talk together under a friendly sun.

<div align="center">Max</div>

Date in pencil on envelope added later, likely by Max. Stamp partially illegible.

Fox released Twins of Suffering Creek *in June 1920. Again, Grace Kingsley gave Florence a rave review: "Standing out like a cameo among the supporting characters is Florence Deshon's portrayal of the wife, torn between contending emotions, her love for her children, her infatuation for the gambler, her real affection for the husband she is leaving, and her hate of drab ranch life. Miss Deshon's impersonation has subtlety as well as dramatic vigor, and shows an unerring sense of drama. I do not know why she is not a star. Not only has she beauty and distinction, but a tremendous fund of emotionalism never at fault in its manifestations."[143] Yet by then Florence was already ill, suffering from complications related to her abortive pregnancy.*

Florence to Max, Croton-on-Hudson, New York, August 7, 1920

Max dear. I have been sick in bed for a month, that is why I haven't written.

I was taken sick in San Francisco, but at first I didn't pay much attention to it, but I became so bad that I was worried. At last I went to doctor that our friend Parker recommended.[144] he sent me to bed with a nurse[145] to take care of me. Don't tell Caroline because she would feel jealous.

This doctor admits I am not recovering very rapidly and he advises me to go home as soon as it is cooler.

Charlie has left Los Angeles as Mildred was trying to attach his picture.[146] He has just gone out of the state, but I think it is quite possible that he will go to New York to see Mildred he says he will make up with her before he will give her all the money she is demanding

It was such a sad picture you drew of yourself washing the dishes after each meal. I can scarcely believe it. I bet your meals consist of raw celery I wanted to send you a present, but there are so few beautiful things in this city. I cannot even find an orange tie.

I feel very sad and forlorn today

<div align="right">Florence.</div>

Postmark. Max's note: "I have been sick in bed for a month."

Florence to Max, Croton-on-Hudson, New York, August 9, 1920

Max dear. I am making my plans to come to New York at the end of this month. I want to leave about the 23rd and spend about three weeks there.

I am writing this in bed so perhaps it will be hard to read.

Are you going to be in New York about that time? You say in your letter that you can't imagine seeing me. would you be glad to see me.

Could you let me know your plans in time before I leave.

<div align="right">Florence.</div>

I could get off the train at Harmon and you could meet me in your orange sweater.

Postmark.

Max to Florence, 6220 De Longpre Avenue, Hollywood, California, August 13, 1920

Wont you please come straight to Croton where you can get well in the little house with all you [*sic*] admiring friends around you it is a lovely cool summer the house is waiting I know you need to come here again where you feel happy and have more fun and I want with all my heart to be your nurse please telegraph me immediately that you will come and also tell me

about your condition are you still in bed you must not ANSWER no to this
telegram you must come love

<div align="center">MAD..[sic]</div>

Western Union Telegram night letter, two pages. Received August 14, 1920. Later that day, Max transferred an unspecified amount of money to her, also via Western Union. Florence saved the notification.

Max to Florence, 6220 De Longpre Avenue, Hollywood, California, August 16, 1920

YOUR SECOND LETTER[147] CAME WITH ITS LOVELY AND
JOYFUL NEWS PLEASE HAVE YOUR TRUNK PUT OFF AT
HARMON TOO I WILL MEET YOU IN ALL THERE IS LEFT OF
MY SWEATER LOVE

<div align="center">MAX.</div>

Western Union night letter.

Crystal Eastman to Florence, 6220 DeLongpre Avenue, Hollywood, California, August 17, 1920

WIRE YOUR ARRIVAL WILL EXPECT YOU THURSDAY OR
FRIDAY LOVE

<div align="center">C.</div>

Western Union telegram, duplicate of telegram filed in Croton-upon-Hudson, telephoned at 11:40 a.m. from Salt Lake City, Utah.

As noted in Florence's letter of August 7, the attempts of Mildred's attorneys to attach the negative of The Kid *were coming to a climax. Rollie Totheroh, Charlie's cameraman, was awakened at three o'clock one morning by Alf Reeves, who told him that they had to get out of town. Totheroh, in turn, got hold of his assistant, Jack Wilson, and the studio carpenter, and together they worked to pack the negative—it amounted to some 400,000 feet—in twelve*

crates. Inside the crates, the film was in 200-foot rolls, enclosed for safety in coffee tins. At the Santa Fe railroad depot, they were met by Charlie and his valet, who had the tickets.

On August 7, the conspirators arrived in Salt Lake City and put up at the Hotel Utah, where Charlie registered as Charles Spencer, and they turned a bedroom into an improvised cutting room. Handling the highly flammable nitrate film in a public place of this sort was against all regulations, but somehow they managed to keep their operations and the vast quantities of film secret. When the editing was completed, they risked a trial preview in a local cinema. Charlie was greatly reassured by the enthusiasm of the audience. With the cut negative, they took the train to New York and found a vacant studio in New Jersey to complete the editing and laboratory work. To evade awkward inquiries, they put up a notice outside the place that said, "Blue Moon Film Company."[148]

Joyce Milton and Kenneth S. Lynn state, without offering proof, that Florence was in Utah with Charlie. In fact, there is some evidence that this might be true, even if it is ambiguous. In her August 9 letter, Florence, although she was evidently so ill that she had to write Max while lying in bed, said that she wouldn't be coming before the end of the month, which would indicate that she had plans until then (such as joining Charlie in Salt Lake City). More interesting is a telegram sent by Crystal Eastman on the morning of August 17 to Florence in Salt Lake City, Utah, because she had been told that Florence had traveled there. (The train from Los Angeles would have taken only a few hours.) However, the copy of the telegram in the Deshon mss. at the Lilly Library suggests that Florence wasn't in Salt Lake City when it was received and that the message was then relayed by telephone to her home address in Hollywood. Two possibilities present themselves: that Florence never left Hollywood or (more likely, since Crystal clearly assumed she was there) that she did leave for Salt Lake—say on August 14 or 15—but felt so sick that she decided to go back home to Hollywood on August 16. Max evidently knew where she was, because he sent a night letter on August 16, to be received in the early morning of August 17, to her Hollywood address. But he had probably omitted to update his sister.[149]

*Thus, several things seem to point in the direction of Florence having spent at least some time with Charlie in Salt Lake City before she left for New York, arriving in Croton on August 20 (*LR, 205*).*

Whether or not she was in Salt Lake City between August 14 and 16, she did not wait till the end of the month (as originally planned) to come stay with Max, likely because she was so ill by then that she realized she would need the help Max had offered sooner rather than later.

The final piece of the puzzle might be an envelope from the Hotel Utah with Charlie's handwriting on it (fig. 3.14), which is now among the Max Eastman Papers at the New York Public Library. It may have been a souvenir saved by Florence when she was with him.[150] The envelope itself offers a window into Charlie's character: not much a of a letter writer and always concerned about appearances, he likely wanted to practice his closing ("Am Sincerely Yours, Charlie Chaplin") and then added scribbles ("Kammmm" etc.) as well as, on the right, a mostly illegible address, as if to warm up his pen.

Florence was adamant that the public not know anything about the nature of her troubles—another indication of Charlie's involvement, which had rendered the whole matter of her pregnancy extremely sensitive (and potentially newsworthy). On September 1, Wid's Year Book offered what would have been her preferred explanation: that Florence was in New York "to spend a vacation with her family."[151]

Figure 3.14. Envelope from Hotel Utah, Max Eastman Papers.
Billy Rose Theatre Division, New York Public Library.

Florence spent several weeks with Max, who relished taking care of her after the unconventional but competent Dr. Lorber diagnosed Florence's abortive pregnancy and removed the dead fetus from her body. Charlie's subsequent arrival in New York complicated the situation not inconsiderably, but his

awkward hovering on the periphery did not prevent the temporary rekindling of Florence and Max's passion for each other. Florence did go and see Charlie in New York, and Charlie even ventured out to Croton, staying at the Tumble Inn, where Florence would meet him to go on long walks.

And thus the three continued, as if nothing of great importance had happened, their "triangular attachment" (in Max's later, decorous phrase). It helped matters that Max was now certain that Florence had no intention of marrying Charlie: "I was still first in her thoughts, and she couldn't act on any other motive" (LR, 207). Unsurprisingly, the problems that had driven them apart had remained.

Florence to Max, Croton-on-Hudson, New York, October 8, 1920

Beloved. It was lovely to talk to you over the phone. I was so worried that perhaps you would be in New York. What I tried to say was that I would not regard you as a problem and if you did not make a problem of me we would both be free to do our work. Do you understand what I am trying to say. I met a girl here that likes you and admires you so much I gave her your book of poems.[152] I always love to give that book to people I like. I think it is such a pretty book it always makes me happy to see it.

Darling this letter is like a primer it is because the pen is so bad and the desk is too high. Send me the sweet message I missed on the train how sad I was on that trip how happy I would have been to have had some word from you my beloved.

<div align="right">Florence.</div>

Postmark. Sent from Chicago, on letterhead of the Congress Hotel and Annex.

En route to Los Angeles, Florence stopped in Kansas City, where her former acting partner Percival (Percy) Knight was starring in Apple Blossoms *at the Grand Theatre. The show, with music by the violinist Fritz Kreisler and Victor Jacobi, included dancing by Fred and Adele Astaire, who were, as the* Kansas City Independent *mentioned, "recalled repeatedly."*[153]

Max to Florence, c/o Mrs. Percival Knight, Hotel Muehlebach, Kansas City, Missouri, October 8, 1920

EVERYBODY SAYS YOU HAVE GROWN MORE BEAUTIFUL AND LOVELY BE HAPPY AND MAKE THE WORLD YOU[R] OWN WITH DEEP LOVE, M.

Western Union night letter.

> *Publicity coverage of Florence and Charlie is remarkably rare in 1920, though they were seen together a few times. With his divorce pending, Charlie was taking no unnecessary risks. Specifically, Charlie is supposed to have dined with Florence at the Hotel Alexandria, from where Florence, a year ago, had staged her first forays into the industry.*[154]

Florence to Max, Croton-on-Hudson, New York, October 10, 1920

When I first knew you I used to say I love Max because I am myself with him. I love him. I think for a time I suffered from hurting you because you did not allow me to be myself. I am myself again All morning I have thought of you with love and yearning with sadness too a dark shadow is ever present but I will wait until my life is more normal before I face it. I am not going to add here as I have been doing lately what you will think or do I will leave that to you and I will believe you.

I must tell you first that one part of my statement made at Mühlebach is untrue. I cannot marry Charlie. I was tired from a long unhappiness and I thought of marriage as a haven, as a place of peace. I know it is not so, through all my unhappiness in New York I know how childishly I longed for a mother that was all. I have to tell you this because I cannot have you think of me as a person who is going to marry. I have never wanted to and I do not now and you must think of me as I am, not practical, incabable [*sic*] of doing the thing that is good for me, because I know it is not good for me and with real ambition burning fitfully in my heart for personal achievement.

Dearest this pencil which writes so dark and thick is the one you gave me but you did not give my ink pencil, send it to me, will you?

It is Sunday and I think I am in Kansas. I do not arrive in Los Angeles until Tuesday late in the afternoon. I have not read my book that you gave me I have been reading a silly story by Mary Austin called 26 Jayne Street which a man in Chicago gave me telling me that one of the characters was supposed to be you.[155] if so I cannot imagine how anybody discovered it. it bears so little resemblance to you.

I shall talk to you to morrow again.

When I said I was myself again and that I thought of you with love and yearning I did not want you to think that I have lulled myself into a false idea of your attitude towards me. I wanted you to know that I am not angry at you and that I could once more think of you without getting angry.

I love you dearest

Florence.

Postmark. Written entirely in pencil. Envelope of the Congress Hotel and Annex in Chicago. According to Florence's note added on verso of penultimate page: "I wrote all this on Sunday I meant to keep it until Monday."

Florence to Max, Croton-on-Hudson, New York, October 11, 1920

Max dear. Do you remember Mr. Scripps said he would not give anything for the magazine but would be glad to do something for you as an artist[156] Isn't it possible to write him and ask him to help you.

Florence

Oct. 11, 1920 New Mexico

Written entirely in pencil. Envelope from the Congress Hotel and Annex in Chicago.

Florence to Max, October 11, 1920

The last beautiful Indian. For you

Florence.

Postmark on Fred Harvey postcard.

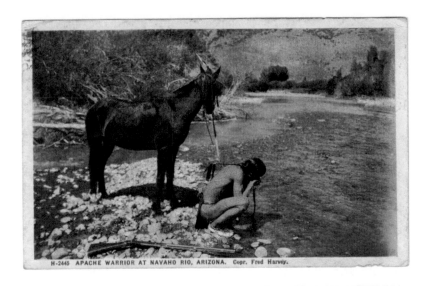

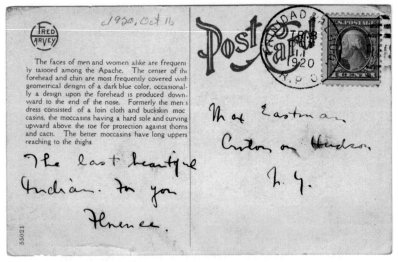

The faces of men and women alike are frequently tatooed among the Apache. The center of the forehead and chin are most frequently covered with geometrical designs of a dark blue color, occasionally a design upon the forehead is produced downward to the end of the nose. Formerly the men's dress consisted of a loin cloth and buckskin moccasins, the moccasins having a hard sole and curving upward above the toe for protection against thorns and cacti. The better moccasins have long uppers reaching to the thighs.

1920, Oct 11

The last beautiful Indian. For you Florence.

Max Eastman, Croton on Hudson, N.Y.

H-2445 APACHE WARRIOR AT NAVAHO RIO, ARIZONA. Copr. Fred Harvey.

Figures 3.15 and 3.16. The Last Beautiful Indian. Postcard, front and verso, from Florence to Max, October 11, 1920. Deshon mss. Courtesy, Lilly Library.

Florence liked to think of Max as her "handsome Indian," a label Max gladly accepted. A postcard she sent him (fig. 3.15, 3.16) clarifies what she had in mind. Allegedly featuring an Apache Indian at Navaho Rio in Arizona, the card came from a series of similar images produced by the firm of Fred Harvey, in Detroit, Michigan, a leader in mass market postcard production

capitalizing on the public's romantic interest in Native Americans. Harvey (1835–1901), an entrepreneur and owner of restaurant chains, had organized fake "Indian Detours" for tourists, in which he had actors mimic a certain lifestyle in the desert. His promotional postcards were part of the enterprise, which continued after his death. Florence's fantasy has sexual overtones, but it also reflects her sense that Max, in his fight against the American political establishment, was a kind of warrior, too, even without the tattoos and buckskin moccasins mentioned in Harvey's text. She liked to imagine their relationship as insulated against the pressures of the outside world. Her disappointment that that wasn't the case became a precipitating factor in the eventual catastrophe. Sending Max that beautiful Indian after he returned from Croton was an attempt to hold on to something that she already knew was a fiction, a cliché like one of Harvey's postcards or the myth of the "last Indian" itself.

Max to Florence, 6220 DeLongpre Avenue, Hollywood, California, October 14, 1920

YOUR ACTING IN THE FOX PICTURE[157] IS SIMPLY ABOVE CRITICISM VIVID EMOTIONAL AND YET EXQUISITE A GREAT BIG MAN NEXT TO ME WAS WEEPING OVER YOU AND SO WAS I AS YOU CAN IMAGINE WITH LOVE AND LONGING

<div align="center">M.</div>

Western Union night letter.

Florence to Max, Croton-on-Hudson, New York, October 15, 1920

Max dear. Please do not be angry with me, but I have wondered at myself for leaving that letter with you. The one I wrote when my Goldwyn contract was broken. I want it, I want to destroy it. Please send it to me.

<div align="center">Florence.</div>

Max's note on envelope: "Asking for the humble letter back" (see Florence to Max undated, before November 19, 1920).

Florence to Max, Croton-on-Hudson, New York, October 16, 1920

I had a terrible dream about you. It frightened me. please wire me if you are all right and your feelings friendly to me. Love,

<div align="center">F.</div>

Handwritten Western Union telegram.

Max to Florence, 6220 De Longpre Avenue, Hollywood, California, October 16, 1920

I AM JUST STARTING FOR LONG ISLAND I HAVE NOT WRITTEN TO YOU YET BECAUSE I HAVE BEEN TOO SAD TO WRITE BUT NOW I WILL YOUR SECOND LETTER MADE ME HAPPIER THAN YOUR FIRST ALTHOUGH THEY WERE BOTH SO SWEET AND KIND WITH DEEPEST LOVE

<div align="center">M.</div>

Western Union night letter.

Max to Florence, 6220 De Longpre Avenue, Hollywood, California, October 19, 1920

Darling, I'm sending you a little piece of cloth hat Miss Moran[158] said was the only thing she could get for the hat with the chiffon. It seemed to me it was too hard a blue, and though she seemed to think I might order it, I didn't. What shall I do? She says they went ahead and made the black dress, so if you want to order that, you can—but you don't have to take it. Why don't you leave that money there, and let me go up some time later and buy you a hat? Or would you like the little blue one—or the big black one?

My present to you is the jade-green one with fringes all over it. I am so sorry I didn't see the black one with a green feather—she didn't seem to have it there—or else she couldn't find it and didn't want to say so.

They were all very sweet to me—she and Tappé and "Anna"[159]—but that was because I left my new overcoat on.

I have just come back from Betty Hare's. I didn't get any chance to talk to her alone, but she spoke of it and said we would soon have a talk about those things. I judge that she feels poor, though, from something else she said, and my visit made me very blue and discouraged—although I had the pleasure of watching Herbert Croly at tennis![160]—Her house is the most beautiful big house I have ever seen, and the most full of beautiful things.

Darling, I didn't half tell you in my telegram how much I admired your acting in the Fox picture. You were every moment an artist—and at some moments, in spite of the sorrow and weariness, O so beautiful! There is no bound or limit to what you can do. I was so proud of the big fat man crying next me!

And I must tell you the almost incredible coincidence. I called up the Fox Exchange one afternoon just when I happened to get through work at the office, and asked them if the picture was playing "anywhere in New York or Brooklyn or the Bronx any day this week." They looked it up, and said "It's playing today at the Village Theatre—8th Ave & 16th St." Well, I put on my coat and hat and walked over there and bought a ticket, and went in—I saw some lions on the screen—I found a seat and, as I bent down to put my hat under it, the lions disappeared, and at the very moment when I settled into my seat and raised my eyes to the screen, the curtains drew back and there was the title "The Twins of Suffering Creek." Just think of the things that had to combine to make a thing happen like that!

O but I was proud of your acting in that part! Now I am watching for Tourneur's picture. Are you sure it will be at the Strand?[161]

I saw Caroline, and I told her I was too sentimental about the peacock robe to give it to her—I wanted to keep it in my closet—and she was very sweet about it. She was packing up to leave her flat and go to Baltimore. I sent her some almond soap from Bigelowe's.[162]

I know this is no answer to your sweet, sweet letters from the train. It is just talking to you "as if we were at breakfast together". Ah that we were, and laughing happily as of old, tender and ecstatic children—but the hot hot passion of our dark-haired bodies beneath.

You talk to me, too, as if we were at breakfast together, for I long to know what has happened to you there—everything and anything.

I have made a grand calculation based on my returned cheques from the bank, and I think you owe me just a hundred dollars.—But here is Mike telling me it is time to eat lunch & go to town. (I am eating with Julia,[163] by special arrangement with Doris, and paying her wages—)

Max.

Love and Loss in Hollywood

Over. Maybe you will think what I said in the next to the last page sounds as though we were gorillas—but I guess you will know what I felt—with dearest love—

<div align="center">M.</div>

Postmark. The postscript is in pencil. Max's notes on envelope: "The visit to Betty Hare—Herbert Croly—The Fox picture."

Max to Florence, 6220 De Longpre Avenue, Hollywood, California, October 20, 1920

I JUST FOUND YOUR MESSAGE I HOPE MY OTHER TELEGRAM CAME IN TIME TO ANSWER YOU MY SADDEST THOUGHTS ARE FRIENDLY I HAVE JUST WRITTEN YOU A NICE LONG LETTER AND I WISH YOU WOULD WRITE ME ALL ABOUT WHAT HAPPENS THERE AS IF YOU WERE MY CHILD LOVE

<div align="center">M.</div>

Western Union telegram, sent 2:17 p.m.

Max to Florence, 6220 De Longpre Avenue, Hollywood, California, October 21, 1920

Oh my love, my darling, I can't bear it. I am heart broken. I cry all day and all night long. I have nothing and nobody, no friend but death to come to me. I don't know what to do. I only know that I cannot bear what I have come to.

Written in Max's characteristic green ink and smudged, as if tears had stained the page. Postmark and also dated on first page, likely by Max.

Florence to Max, 11 St. Luke's Place, New York City, October 23, 1920

COULD YOU PLEASE BORROW A HUNDRED DOLLARS FOR
ME FOR A MONTH I WISH YOU WOULD WIRE IT TO ME AS I
NEED IT IMMEDIATELY LOVE

F

Western Union telegram, filed 8:23 a.m.

Max to Florence, 6220 De Longpre Avenue, Hollywood, California, October 25, 1920

YOUR REQUEST MADE ME HAPPY BECAUSE I FELT YOU
WERE FRIENDLY AGAIN I HAVE BEEN IN THE DARKEST PAIN
OF MY LIFE AND YOU MUST FORGIVE MY CRYING OUT TO
YOU LIKE A BABY IN TWO LETTERS WRITE ME SOME SIMPLE
WORD ABOUT YOURSELF AS OFTEN AS YOU CAN LOVE

M.

*Western Union night letter. Florence copied the text of that telegram verbatim on a
separate sheet of paper.*

Florence to Max Eastman, 11 St. Luke's Place, New York City, October 26, 1920

THANK YOU SO MUCH FOR TELEGRAM AND DRAFT I WILL
RETURN THE MONEY VERY SOON I AM YOUR FRIEND AND
I BELIEVE IN YOU DO NOT BE SAD WRITE ME WHAT YOU
HAVE BEEN THINKING MARGARET TOOK SOME LOVELY
PICTURES OF ME I WILL SEND YOU A SET LOVE

F.

Western Union night letter.

In 1919, the cash-strapped Theodore Dreiser had followed his new lover (and second cousin) Helen Patges Richardson (1894–1955), an aspiring movie actress, to Hollywood. They rented a bungalow on 1515 Detroit Street, near Sunset Boulevard and a fifteen-minute walk from Florence's house. Richardson's career didn't flourish. Dreiser tried his hand at script writing for Jesse Lasky's Famous Players Studio and made some progress on The Bulwark, *a novel about a Quaker family, published posthumously in 1946. Yet the Hollywood setting turned out not to be entirely conducive to work on a Quaker-themed book, and Dreiser redirected his energies to the book that became his only best-seller,* An American Tragedy *(1925), drafting the first twenty-two chapters.*

Hollywood did not impress Dreiser. In a four-part exposé, published in the monthly magazine Shadowland *and titled "Hollywood: Its Morals and Manners," he blasted the industry as an exploitative system treating hundreds, if not thousands, of young women as sexual prey, a charge he reiterated in an interview given to the* Los Angeles Times, *shortly before Richardson and he moved back east.*[164] *His scorn for Hollywood morals might explain the tone of the following letter, in which he seems to reject Florence's offer to introduce him to someone who wanted to meet him. Florence saved it along with Max's letter, an indication perhaps of how important Dreiser (and his views on Hollywood) had become to her.*

Theodore Dreiser to Florence, 6220 De Longpre Avenue, Hollywood, California, October 29, 1920

P.O. Box 181
Los Angeles

Florence Deshon:

Your letter reaches me too late to accept even though a previous engagement did not interfere. But saying so much I owe it to myself to add that I am but faintly interested by perfect homes occupied by people who are interested in celebrities. My offenses in connection with them, alas, are many and I regret that this may be counted another. Yet I recall you with pleasure and something more,—a sense of someone seeking the moon— and with no small claim. If it were you, singly and frankly seeking to know, and not merely to introduce—

But again I fear I verge on offense—and my desire is not to—

Theodore Dreiser

Dreiser's letter was sent special delivery. He had originally dated it 1930, then replaced the 3 with a 2.

Max to Florence, 6220 De Longpre Avenue, Hollywood, California, November 3, 1920

WOULD YOU PLEASE SEND A LONG NIGHTLETTER TELLING SOME NEWS ABOUT YOURSELF SEND IT COLLECT AND MAKE IT A COUPLE OF HUNDRED WORDS WHAT DID YOU DO TODAY YOUR OTHER TELEGRAM MADE SUCH A DIFFERENCE FOR SO LONG HAVE WRITTEN YOU A NICE LETTER ADDRESS NEW YORK WITH LOVE

M.

Western Union, sent 11:56 a.m.

Florence to Max, 11 St. Luke's Place, New York City, November 3, 1920

EVERYTHING IS VERY QUIET SO THERE ISNT VERY MUCH TO TELL YOU MARGARET TOOK SOME PICTURES OF ME TODAY AM GOING TO POSE FOR HER AGAIN FRIDAY THEN SHE WILL SELECT THE BEST ONES AND SEND THEM TO YOU LOVE

F.

Western Union night letter.

Perhaps the best-known Mather photograph of Florence shows her head tilted, eyes turned away to the side, darkness encroaching upon her (fig. 3.17). Mather only rarely gets so close to a sitter's face; here, the effect is extraordinary. The light models Florence's body as if in a painting (like de Meyer, Mather started

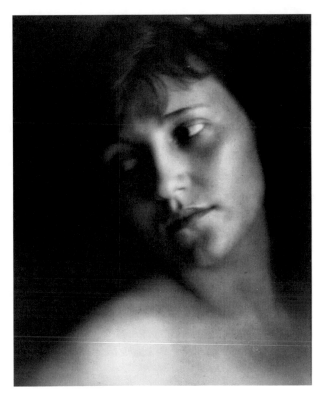

Figure 3.17. Florence Deshon, 1921. Photograph by Margrethe Mather. Eastman mss. II. Courtesy, Lilly Library.

out as a photographer in the pictorialist tradition), highlighting her cheekbones, chin, and right shoulder, thus creating a contrast between the drama of her luminous skin and the blackness that seems to engulf her, with Florence's hair serving as a kind of transitional element. While some strands trail down her forehead—note the stray lock of hair traveling down to her eyebrow—the rest of her hair is already part of the dark background to which Florence, in Mather's view, will soon belong, too. Mather's portrait hints that Florence's problems were external as well as internal ones.[165] Max thought that Mather was "more interested in line than in personality" (to Florence, January 26, 1920), a reference perhaps to the stylized environments in which she placed her sitters, making them seem part of their carefully crafted surroundings rather than independent agents, but this portrait shows that Mather was capable of conveying profound and moving insights into a person's character and situation in life.

Max to Florence, 6220 De Longpre Avenue, Hollywood, California, November 5, 1920

I will send back the humble letter if you ask it again, but if you knew what I suffer, your pride would be appeased.

You do not need to write in such a way as tells me that you do not love me anymore. You do not admire me anymore. In every breath I breathe I feel that sustenance withdrawn. I go through the activities of my ambition, now grown so petty, weakly and without life. My heart is in a perpetual swoon.

Though I would not seem to manage my side of our love, nevertheless your ceasing to love me has broken my heart. Your emotions are mine—I too have ceased to love myself, to believe in myself. My will is broken. My youth is gone.

You said you would believe me. I beg you to believe this and be merciful. Be merciful to me for I was once your lover and now I am nothing.

<div align="right">Max—</div>

Written in pencil. Appears to have been dated later by Max, at the top of the first sheet and on envelope. His note: "Sending back the humble letter" (see Florence to Max, undated, before November 19, 1920).

Max to Florence, 6220 De Longpre Avenue, Hollywood, California, November 5, 1920

Dearest Florence, I wish I had written you some nice letter instead of those baby-cries of madness, for then I might hope not utterly in vain for a letter from you. I long so for a word of news. I miss the privilege of entering into your life, and you deprive me of it so suddenly and so completely.

"I will talk to you again tomorrow" you said in your sweet warm letter that you wrote with my pencil. But that tomorrow never came.

Did your visit with Dorothy Knight[166] raise up the proud child again, and eclipse all those gentle feelings that made you talk?

You were sweet to think of that suggestion about Mr. Scripps, but what he did was to offer—or half offer—me a job (which I could not take.)

I got a letter from Eugen that made me want to join him in Europe, and I wrote to Mrs. Gartz asking her for a thousand dollars to make it possible—partly a gift to the Liberator, because I would write articles. But the idea of going off on such an adventure revived an interest in my own life, which is growing—under careful nursing—to the proportions that

health demands, and I have decided not to go. I was frightened then, but now I have decided to learn to balance upon myself, to achieve a poise in solitude which will put me beyond such dangers. I am not going to be a baby again, and no person and no thing shall ever be my mother!

So you can think of me as a kind of Doric column—or cold water pipe—standing up all alone, and surrendering only to the Master Plumber when he comes.

That is you can, *if* you can, after what you have seen of my infantile possibilities.

I hope you will understand.

Betty Hare says she is as poor as I am, and I can't see anything further to do, but tie Crystal fast to the Liberator and use her as doggedly as she could use me. It is the best chance I have at present to make a living and have time to write. Maybe I can do something with Eugen, too, if business prospers. At any rate I shall have no principles and no mercy, and if you can think of anything better or more unscrupulous, tell me.

My book about Humor will not be very good—except from a scientific standpoint. I am sorry anybody expects much of it. I have never had any real inspiration to do it: I should have been writing poetry all that time. But don't despair of me—I shall write other things.

I miscalculated by $200 the amount you owe me. It was $300, and adding the $100 you borrowed, that makes $400. I have to tell you because if I didn't it would deprive me of my chief pleasure in life which is to contemplate my two beloved overcoats and repeat "You didn't cost me a cent!" I wore them *both* from Croton in Jan's automobile yesterday—to the admiration of the hill-side.

With dearest love Max.—
Did you like Floyd's book?[167]

I forgot to thank you for the picture. It is a beautiful picture, but still no picture of your beauty.[168] I begin to think Margaret doesn't know what you *are*.

Remember you promised me *a set* of the pictures she took recently—if ever a set is done!

I mean that Margaret doesn't take pictures of the *life* that shines in you.

Max.

Written in ink and pencil on the back of sheets of stationery from the Commodore Hotel in New York City, with the exception of one sheet of letterhead from The Liberator.

> *On November 13, 1920, a divorce was granted to Charlie Chaplin and Mildred Harris, with a substantial portion of her settlement going to the attorneys, the main beneficiaries of eight months of constant and, in Mildred's case, public bickering. In one celebrated incident, Charlie snuck out of the New York Ritz wearing his sister-in-law's dress, hat, and veil so that he could avoid the reporters who had congregated in the lobby.*[169] *Charlie was now officially free, but ironically Florence, who increasingly believed that her problems resided in herself and not in her partners, was no longer interested in marrying him.*

Theodore Dreiser to Florence, 6220 De Longpre Avenue, Hollywood, California, November 23, 1920

Dear Florence Deshon:

I like your letter. It[']s graceful and tactful and I hope not as Punitive as it sounds—just at the end—or might—if I didn't give you credit for stature very much above a little quarrel. You must realize, I know, that I was really trying to make myself clear to you—not to be unduly lofty

I am a good deal misunderstood, even though you might not think it. But you must decide of course if at any time you would walk or drive—let me know. A 24 hour notice is best. And you wouldn't be *"seeking a kindness"* of me. (I like that last. Now, really.)

<div align="right">Theodore Dreiser.</div>

Max's note on envelope: "From Dreiser."

> *It appears that Florence took Dreiser up on his offer and invited him to her bungalow in Los Angeles. Dreiser's diary entry for November 29, 1920, suffused with Dreiser's trademark ill humor, sheds some additional light on her tempestuous relationship with Max and the role money, or the lack thereof, played in it. Among the many interesting details is Florence's claim, uncon- firmed by other sources, that she was the driving force behind getting Max to*

dedicate Colors of Life *to her instead of Lenin. Dreiser being Dreiser, he was convinced that Florence wanted to have an affair with him, too:*

> *Monday, November 29, 1920. Los Angeles*
>
> *I dislike the thought of this day some, because of my agreement to visit and talk with Florence Deshon. . . . Walk to DeLongpre and down. Find her expecting me. The usual summery moving picture actress get up. We begin talking at once of L. A. Max Eastman (her former lover) at New York. Tells me of her life with Eastman. His literary and artistic temperament. His poems. How he made money. Got sixty per from the Liberator, then borrowed for the Socialist cause occasionally. Could always get money from the rich, sometimes as much as ten thousand [sic]. She made as high as three hundred per, and helped him. How they quarreled and why. Too strong for each other. She calls him a slick gin gink. Says that his work was always important and had to be put first, hers never. The visit of Norman B. Angell, and the hit she made. The visit of Thorsten Veblin [sic]and the second hit she made, on account of her beauty I presume. She then throws it up to them that they have been trying to keep her intellectually in the shade, that they have been ashamed of her intellectual poverty before their high brow friends when as a matter of fact their high brow friends are more interested in her than than [sic] they are in the Eastmans. Crystal Eastman drops out of the fight. The book of poems. How she kept it from being dedicated to Lenin. The poems in it to her—some of them very beautiful. How she left Eastman. His distress. Visits her but cannot make her reform. Becomes the mistress of Charlie Chaplin. Tells me of his peculiarities. Likes him but cannot love him. Really craves, as I can see, another literary celebrity. Is angling for me as her letters show. We go to lunch at the* Come-On-Inn, *a Gower Street Movie restaurant. The movie queens in there. F.Ds vanity. After lunch we return to her place and talk until four. Her life with Chaplin. The character of Mildred Harris Chaplin. How she got him. Became his mistress, then got with child, then made him marry her. Her mother aided her in this. Previously they had tried to ensnare D. W. Griffiths [sic], and after him Maurice Touneur [sic]. Neither of these would fall for her. Is very small, very babydollish, with blue eyes and light hair. Threatened to shoot Chaplin and had him frightened, so much that he ran away. Paid her 200,999 to quit.*
>
> *I leave at four admiring the apartment, but little more. Wants me to meet Chaplin and Mme. Nazimova. I do not promise.*[170]

More than forty years later, in the second volume of his autobiography, Max also commented patronizingly on these examples of Florence's alleged success with the economist Thorstein Veblen (1857–1929) and the British writer/politician Norman Angell (1872–1967):

> *Florence never hesitated to dash into an argument or exchange earnest opinions with learned authorities upon the most complicated subjects. One of the eminent men in those days . . . was Norman Angell, author of* The Great Illusion, *a book*

*which first proved with icy logic that modern war, aside from being barbarous, is
bad business, and that victory in modern war is a disaster. He came up to see me in
Croton, and we dined—quite a group of us—on my little roofless porch under the
Osage orange tree. He is a small man, smaller than Florence, and of a palish color,
with pale hair and eyes, although the clarity of those eyes is beautiful to see, and
his brow also is impressively beautiful. But Florence, never having read his book,
seemed a little like a down-swooping bird of bright plumage when she undertook
to abolish one of his statements with a few hasty remarks. They were not foolish
remarks exactly, but her innocence of the depth of her subject, and of his learning,
was a little embarrassing—except to Sir Norman himself, who seemed delighted to
defend himself from so lovely and irrelevant an attack.*

Max also remembers the excruciating dinner with Thorstein Veblen,
who looked like a "Lapland papoose" and maintained a stony silence until
Florence leaned over and whispered confidentially: "This meat is a little too
well done for my taste—what do you think?" Veblen turned in his chair,
"gave her one look of very masculine appreciation, and launched into a
two-sided conversation on his tastes and hers, his distastes and hers, which
covered pretty near the whole range of life's experience, and lasted through the
rest of the dinner"(LR, 66–67).

It is interesting to see how Dreiser and, with some delay, Max worked to
outdo each other in a joint effort to diminish Florence intellectually. (There is
also some delicious irony in the fact that Max, as he was writing the passage
quoted above, was married to Dreiser's former lover, Yvette Szekely.)

Of course, not everything Dreiser said about Florence was driven by the
desire to humiliate her. His sketch "Ernestine," for example, a veiled portrait
of Florence, is full of sharp and poignant observations about her career in
Hollywood, her friendship with "a film comedian of some standing and
considerable intelligence" (Chaplin), her dealings with the Hollywood intelli-
gentsia, and her suicide. But Dreiser again resorts to insinuation, proposing
that Ernestine slept around in Hollywood in furtherance of her career. She
became, he claims, involved with an important producer not unlike the great
Goldwyn himself: "He's a grandee of sorts in the movie world out there, you
know. He recently built himself a gorgeous residence in a place called Beverly
Hills, which is just west of Hollywood. He's married, you know, and has a
child."

Goldwyn was not married at the time, but adding that detail underlines
Ernestine's naïveté. "But those things never last," a friend of the narrator
pontificates. "A fellow like that meets too many beautiful aspirants all the
time. And as things are now, it isn't very hard to launch one or two of them
now and then. If she makes good, very well. If she doesn't, in the course of

time, she has to fall in behind those who do."[171] *Goldwyn's biographers A. Scott Berg and Arthur Marx agree that Goldwyn was a womanizer and slept with a lot of his starlets. Given the authenticity of Dreiser's voice, it is not unthinkable that Goldwyn at least made some kind of pass at Florence (and that she had told Dreiser about it).*[172]

Figure 3.18. Florence to Max, November 20, 1920. Deshon mss. Courtesy, Lilly Library.

On November 30, 1920, Florence sent a shock of her very fine, brunette hair in an envelope from the Friday Morning Club, Los Angeles, California, to Max at 11 St. Luke's Place (fig. 3.18). This was not a Victorian memento of her love for him but an assertion of her independence from him. If he wasn't her beautiful Indian any longer, she wasn't going to be his "miracle child" either. Max had always tried to control her appearance, down to the makeup that he thought she should use. Now she had bobbed her hair, and she no longer cared what Max thought of it. Even Florence's choice of envelope might not have been accidental: founded in Los Angeles in April 1891, by Caroline Seymour Severance, the first president of the New England Women's Club in Boston, the Friday Morning Club had been at the forefront of the struggle for women's suffrage.

When, at the beginning of the new year, Florence tried to find out from their mutual friend Doris Stevens if Max was sad about her radical haircut, her friend responded cryptically: "I do not know whether his sadness was general or specific. I think both." Doris's letter also suggests that one of the reasons for Florence's haircutting was her attempt to look younger: "I was tempted to cut mine when I got your letter, for if you are already beginning to reduce the years, I certainly should lose no time in doing so." Doris, who was vacationing in France, seized the chance also to include some derogatory comments about Charlie Chaplin, whose Hula Hula Dance *she had just seen in Paris: "It was terribly punk—not in the least funny." Charlie was not nearly as attractive as "the most beautiful slim negro boy" she had seen dancing with a white girl on stage at one of the Paris theaters. That boy had looked "like a lissome brown panther."*[173] Hula Hula Dance *was a rerelease of* His Prehistoric Past *(1914), an early Chaplin Keystone film, so clearly did not represent Charlie at his best or most recent.*

If Doris had intended to cheer Florence up—and to tell her that there was a life of pleasure beyond her fraught relationships with Max and Charlie— her friend was not a receptive audience. Florence still missed Max, or at least missed what she thought he should have been able to give her. She rounded off the year with a sonnet addressed to Max, in which she signaled her hope for a new beginning. If they could only turn back to the summer of their love and forget what autumn had brought them! They were still, she thought, a "golden pair," all grace and sweetness.

Florence to Max, 11 St. Luke's Place, New York City, December 26, 1920

Forget forever those wild Autumn days
When I returned and stared with mad surprise
At my dreams all ended, my heart amazed
No hope of a new Spring met my sad eyes.
Love hurt only passion raised his dark head
Darting a thin sharp tongue of hate and pain
Kissing and scorching like a flame burned dead,
The world turned black. Life itself seemed insane.

All night closely entwined in love they lay
In sleep graceful and sweet a golden pair
'Even the moon reluctant to steal away
Tears her light gently from the lovers there.
Forget forever those wild Autumn ways
Turn back softly to lovely Summer days.

Postmark. The sonnet is neatly typed. Max's note on the sheet: "her sonnet." In envelope postmarked December 26, with Max's later note: "Her sonnet."

4. "I Object to the Slander of the Ladies" (1921)

In February 1921, Max came for an ill-fated second and final visit to Hollywood, during which he also hoped to complete his long-delayed book on humor. The miracle was that he was in fact able to do some of that, writing in the mornings and then reading fresh sections of his work in progress to Florence. Yet the inevitable happened. Tempers flared when the future of their relationship came up and, more specifically, the question of whether Florence should move back to New York. A final row, in which Florence declared that Max stifled her, led to Max's departure in June. Back in Croton, Max redoubled his efforts to finish The Sense of Humor, *while Florence, who was now writing actively as well, valiantly tried to shift their exchanges to a more intellectual level, commenting on Max's ongoing manuscript as well as books related to his topic. But renewed, muted assertions of tenderness could not obscure the deep-seated resentment they felt toward each other over the failure of their relationship.*

The unavoidable final breakup was initiated by Florence, who did return to New York in the fall, although not to live with Max. One of the most touching entries in the correspondence came toward the end of the year, when Florence acknowledged her happiness over Max's dedication of The Sense of Humor *to her. Nothing had made her happier, she said, than seeing her name in Max's book. Given the impact she had on the book's final form, she could have also called it* her *book, which she had in fact done once already (to Max, June 8, 1921).*

As it happened, the finished version of The Sense of Humor *was as much a tribute to Florence as it was to Charlie. Writing about the dream sequence in* The Kid, *Max celebrated Charlie as the epitome of the "humorous poet." What is more laughable, he asked, than the moment in which the Tramp, transformed into an angel, discovers his new wings, reaches back, and pulls out a few feathers, a reminder that they aren't real? Dreams are just that, dreams, and the desire to fly, to go higher and higher, so powerfully felt by Florence (to Max, March 9, 1920), only brings us more firmly back down to the ground. "We must either humorously laugh, or give up the hope of remaining alive in this perception."[1] As it turned out, Florence had given up precisely that hope.*

The year's correspondence begins with a flurry of telegrams sent from Max's apartment at 11 St. Luke's Place, New York City, to 6220 De Longpre Avenue in Hollywood.

**Max to Florence, 6220 De Longpre Avenue, Hollywood,
California, January 1, 1921**

YOUR TELEGRAM MADE ME HAPPY I HOPE YOU GET [*sic*] MY
ROSES I WAS AFRAID THEY WOULD GET LOST BETWEEN
HERE AND CALIFORNIA PLEASE DO NOT FORGET ME IN
THE NEW YEAR LOVE

M

Postal telegram, filed 3:35 p.m.

**Florence to Max, 11 St. Luke's Place, New York City,
January 1, 1921**

WHAT A SHAME I NEVER RECEIVED THE ROSES THEY
WOULD HAVE MADE ME SO HAPPY I HOPE YOU RECEIVED
MY PICTURES AND POEM[2] I SHALL NOT FORGET YOU LOVE

F.

Western Union night letter, received January 2, 1:53 a.m.

**Max to Florence, 6220 De Longpre Avenue, Hollywood,
California, January 3, 1921**

MY MIRACLE CHILD YOUR WONDERFUL WORDS ARE
HEALING AND NOURISHING MY HEART THEIR BEAUTY AND
POWER IS THRILLING TO MY MIND I AM SO HAPPY AND
EXCITED LOVE

N. [*sic*]

Western Union telegram, filed 11:45 a.m.

Max to Florence, 6220 De Longpre Avenue, Hollywood, California, January 8, 1921

THE PICTURES HAVE COME THEY ARE PERFECT AND THEY ARE YOU I HAVE NEVER POSSESSED ANYTHING THAT I LOVED SO MUCH

M.

Western Union night message.

Max to Florence, 6220 De Longpre Avenue, Hollywood, California, January 13, 1921

I AM SENDING YOU ANOTHER PRESENT IN PLACE OF THE LOST ROSES I HAVE BEEN SICK AND I WISH I COULD FEEL THAT YOU WERE THINKING OF ME MY THOUGHTS ARE IN HOLLYWOOD ALL THE TIME LOVE

M.

Western Union telegram, filed 10:45 a.m.

Florence to Max, 11. St. Luke's Place, New York City, January 13, 1921

I AM SO SORRY YOU HAVE BEEN ILL YOU WILL LET ME KNOW HOW YOU ARE AS I SHALL BE WORRIED ABOUT YOU I SENT YOU A FUNNY LITTLE PRESENT ONE I HAD PROMISED YOU PLEASE TAKE CARE OF YOURSELF LOVE

F.

Western Union night letter.

Max to Florence, 6220 De Longpre Avenue, Hollywood, California, January 15, 1921

I AM ALL W[E]LL AGAIN THANK YOU FOR THE PRETTY
FUNNY PRESENT I AM STILL TRYING TO BELIEVE IN AND
THANK YOU FOR YOUR DEAR TELEGRAM WHICH MADE ME
HAPPY LOVE

<div align="center">M.</div>

Western Union night letter, with pencil correction.

Max to Florence, 6220 De Longpre Avenue, Hollywood, California, January 20, 1921

IN MY HEART I AM ON MY WAY TO HOLLYWOOD ALL THE
TIME I WISH I KNEW WHETHER YOU WOULD LIKE TO
HAVE ME COME TO SEE YOU PLEASE TELL ME THE TRUTH I
WOULD NOT COME UNLESS YOU WANTED ME IN THE SAME
WHOLEHEARTED WAY THAT I WANT TO COME BUT I CAN
NOT REMAIN IN DOUBT ANY LONGER LOVE

<div align="center">M.</div>

Western Union night letter, with correction in pencil separating fused words.

Florence to Max, 11 St. Luke's Place, New York City, January 21, 1921

WITH ALL MY HEART I WOULD LOVE YOU TO COME

<div align="center">F.</div>

Western Union night message.

**Max to Florence, 6220 De Longpre Avenue, Hollywood,
California, January 24, 1921**

I AM SO HAPPY I AM STARTING IN ABOUT A WEEK I WISH
YOU COULD FIND ME A LOVELY ROOM OR A HOUSE TO
WORK IN I WOULD PAY A GOOD DEAL FOR IT IF I DONT LIKE
YOUR HAIR I AM GOING RIGHT ON TO JAPAN LOVE

M.

Western Union night letter, delivered January 25, 1921, 7:00 a.m.

**Max to Florence, 6220 De Longpre Avenue, Hollywood,
California, January 26, 1921**

PLEASE TELEGRAPH STRAIGHT MESSAGE WHETHER YOU
ARE FEELING RICH OR POOR BECAUSE I HAVE A CHANCE
TO RENT MY HOUSE FOR FIFTY DOLLARS A MONTH FOR
THREE MONTHS I AM HOPING TO SAIL FOR HOLLYWOOD
TUESDAY WITH LOVE

M.

Western Union night letter.

**Max to Florence, 6220 De Longpre Avenue, Hollywood,
California, January 27, 1921**

AM SO HAPPY BECAUSE I AM COMING TO HOLLYWOOD
LOVE

M.

Western Union telegram, filed 1:24 p.m.

Florence to Max, 11 St. Luke's Place, New York City, January 27, 1921

MUST I PAY THE PRICE SAMSON PAID[3] IF YOU COULD LET
ME KNOW DEFINITELY WHEN YOU ARE LEAVING IT WOULD
MAKE IT EASIER FOR ME TO FIND A PLACE FOR YOU I WISH
YOU COULD BRING THE LAMP WITH THE BLUE SHADE LOVE

F

Western Union telegram, filed 10:10 a.m.

Max to Florence, 6220 De Longpre Avenue, Hollywood, California, January 31, 1921

AFTER ALL I HAVE GOT TO STAY ANOTHER TWO WEEKS
TO ARRANGE THE DESTINY OF THE MAGAZINE I AM SO
SORRY I LONG TO COME IF YOU SHOULD FIND ME A VERY
BEAUTIFUL ROOM PLEASE TAKE IT FOR ME JUST THE SAME
HAP[P]Y LOVE

M.

Western Union night letter, with correction in pencil.

Max to Florence, 6220 De Longpre Avenue, Hollywood, California, February 4, 1921

CRYSTAL HAS LEFT THE MAGAZINE FOR GOOD AND FLOYD
FOR FOUR MONTHS[4] I CANNOT BEAR TO QUIT COLD SO I
AM REORGAINZING [*sic*] IT IN A NEW WAY I STILL INTEND TO
COME OUT TO HOLLYWOOD INSIDE OF TWO WEEKS FROM
TODAY PLEASE KEEP ON WAITING FOR ME LOVE

M

Postal night lettergram, filed 7:20 p.m.

Max to Florence, 6220 De Longpre Avenue, Hollywood, California, February 10, 1921

I WAS SO HAPPY LAST NIGHT I COULD NOT GO TO SLEEP
DO HOPE YOU CAN FIND ME A WARM LIGHT QUIET HAPPY
BEAUTIFUL ROOM TO LIVE IN WITH MY BOOKS IN ALL DAY
PAY ALMOST ANYTHING FOR IT I AM SO GLAD YOU WANT
ME AND I AM COMING LOVE

<div align="center">M.</div>

Western Union night letter.

Max to Florence, 6220 De Longpre Avenue, Hollywood, California, February 18, 1921

ARRIVE MONDAY MORNING EIGHT TWENTY SANTAFE DO
NOT GET UP TO MEET ME I WILL COME TO BREAKFAST AT
YOUR HOUSE BUT IF YOU ARE WORKING PLEASE LEAVE
A NOTE AND A KEY WITH THE PEOPLE DOWNSTAIRS SO I
WONT FEEL TOO LONELY HAPPY LOVE

<div align="center">M.</div>

Western Union night letter, filed at 2:48 p.m., delivered February 19, 7:35 a.m.

At first, things were going well. Florence was still living in her old apartment on De Longpre Avenue, from where Max departed during the day to work on The Sense of Humor *in a room Florence had found for him. In the evenings, they would sometimes join Charlie for charades—once Max challenged him to a contest over who had the greatest lung capacity—but otherwise, preoccupied with his new paramour May Collins (fig. 4.1), Charlie seems to have kept his distance. He even helped Max purchase a new Buick, for the long drives in the country that Max and Florence had been planning. Florence and Max breakfasted together and, during walks, marveled at the lions, tigers, and alligators in the nearby Griffith Park Zoo (which had opened in 1912). When Max finished a section or a chapter of his manuscript, he would read the pages to Florence.*

But such tranquility couldn't last. When Florence wondered if they would be able to transfer their new form of living together to New York or Croton, Max, constitutionally unable to commit, balked and refused to give a straight answer, angering Florence, whose outburst led him to become angry in turn. The "Black Panther" had been reawakened. At one point, Max spat in Florence's face. A hurried note and two self-pitying letters by Max reflect the immediate fallout from these squabbles. As they had done before, they hastily, imperfectly made up again. Two weeks of relative calm followed, but the demons had only been temporarily quieted.

It was around that time that Florence gave up her DeLongpre Avenue apartment, a symbol of the good times they had spent together in Hollywood (but also of Charlie's casual incursion into their lives), and moved into a new place at 1743 Cherokee (now North Cherokee) Avenue, off Hollywood Boulevard. At the end of June 1921, Max fled Hollywood, dejectedly embarking on the five-day railroad trek back home. What a mess he had made of things.[5]

Max to Florence, undated

Darling—I'm terribly worried—please, please leave me word if you come back & go again. I love you. Forgive me. Don't kill me today. Please, please—M.

Dated February 1921 by archivist, though likely written later. In envelope, bearing additional contemporary notes by Max: "Florence." And: "I'll come right back after I talk to Mrs. G." (Gartz?), as well as his later notes: "In Hollywood" and "Important."

Max to Florence, 1743 Cherokee Avenue, Hollywood, California, [May 1921]

My dearest, I know that you really wanted me to go, even though you had to say it in anger. I know how impossible it is for you to endure my staying. And so with my tears and my bed-clothes and all my weak foolish troubles, I have gone. You will put me out of all the tender deep peace of your heart, but I cling to the hope that some day when that is completely accomplished, you will let me play again in the doorways.

You are the only beautiful and divine thing I have touched in my life— my love for you was my only great moment of being. Though you may

think so, I will not forget you, or cease to love you, and care everything about what you do and become.

I see how true it is that I deprive you of life without really giving myself. And I deprive myself of life without really attaining you. And as I cannot change it by any means at my command, I know that I must go away. That knowledge is all there is to my "attitude about your coming to New York". My going away alone, and leaving you here for the time, makes it possible to accomplish a thing that I am too weak to accomplish any other way. Surely you will know, when you repent, that it is not any matter of selfish conscience that made me stay and stay. You know that my book had nothing whatever to do with it, don't you? I have been engrossed in every motion with the problem of my relation to you. I simply had not the strength to go away and let you live—I love you too much—and yet I did have the strength to let circumstances carry me away.

There was another thing too, that seemed to urge and justify my staying longer. My reading to you and getting your subtly understanding help had come to be a kind of part of the creation of my book, and I really felt as though I were doing it for you and with you, and I felt that my dedication would be so real and would set a kind of seal upon our friendship and lovingness that would endure after our hearts were torn apart. I felt that my book was becoming yours. Well, it is yours anyway.

It is because the question whether I am in your house or you in mine, is so superficial—a mere matter of appearances—that I cried out about pride as I did this morning. It meant nothing. I should have been proud too, and angry, and all the other things, if you had happened to be the first one to fall away. I still think we are not so different.

And you have given me so generous and sweet a vision these last weeks of yourself as you used to be—it has restored all the faith and beauty to my dreaming memory of our love. Nothing can ever take it from me now. Nothing but death can ever take from me what I possess of you, the golden certainty, the poetry of your perfect being. No one will ever realize it as well as I do—even stricken and divided as I am.

I shall go up and put this in your box now, and then—an ocean of blackness will encompass me. I can hardly hold myself up as I walk along the street. I keep telling myself that you will lend me a friendly hand now that you have put me out, and not leave me entirely alone in this dreadfulness to stagger away to a train. I cannot go at least until I see Mrs. Gartz and Charlie. Did you want me to go entirely from your sight?

O God, how I hope you may want to see me.

Max

Written on folded sheets of ring binder paper. Not dated or mailed. Dated at top of first sheet by Max himself, in pencil: "In Hollywood 1921." Accompanied by torn envelope, inscribed by Max to Florence. Hand delivered.

Max to Florence, 1743 Cherokee Avenue, Hollywood, California, May/June 1921

My darling, I know there is nothing left I can do for you but take my terrible self out of the way of your beautiful brave life. I am trying in tears and agony to pick up my things.

It is true that I was selfish last night, but it is so much worse than that— It is a neurotic insane thing. I am all right in the morning, but more than half of those nights and evenings I am struggling madly all the time within my mind.

I will not afflict you with it any longer.

If I could only make you believe in the grief and remorse I suffer because I have brought this on you gratuitously again. I have made myself a terrible incubus. If I had any thought or feeling towards any other person or even towards adventuring in general, I would not be able to hold up my head. I have nowhere that I want to go. I have nothing that I want to do.

I am sure when you think it all over you will not call it a "crime" for me to come.

If I could live through one day of our love again I would go to the end of the world.

It was my moment of life.

You cannot quite understand or believe that I blossomed so late and bore no fruit. But you can understand enough to forgive this terrible thing that I have done to you. Forgive me, for your life is before you, and mine is gone.

I want to do whatever is least unbearable to you. I will go away without seeing you again if you send me word, or I will stay until my visit is over and people will not wonder why I went. If I set a date for my going I think it would quiet the demon in me that fights against you, and I would be myself again for you to remember.

We could buy a car and spend all my money, for I have nothing to do now but go back to work.

This is a funny ending for such a letter.

It comes from the unspeakable longing in my heart—

Max.

Added later by Max: "Late May or June 1921 in Hollywood." No envelope present, likely hand delivered.

> *Mixed in with Max's feelings of guilt toward Florence was his concern that, by introducing Charlie to Florence, he had also complicated things for Charlie, whose feelings for Florence had become deeper than Max had anticipated. Florence, practically minded as always, responded that Charlie was already distracting himself with May Collins, short-lived as this romance would likely turn out to be.*

Max to Florence, 1743 Cherokee Avenue, Hollywood, California, June 7, 1921

I too am lonely and sad, dear heart, as I lie down on my little shelf tonight. The train is swaying down the mountain side, and the high air and my heart's longing make me a little sick and wild. When I reflect how solely it is the thought of my book that keeps me strong, I realize how very hard this loneliness is for you, because your work is in suspense, and because it depends as yet so terribly upon others.

You will do your work. You will succeed. It will come surprisingly to you. For you have all the gifts in richness, and the time is certainly near when that thing will be done. But what patience it means, and what impatience.

I was so glad—and so relieved—by what you told me about Charlie. Your warm tenderness meant so much to me that night, that I could not care about his attitude at all. But afterwards it began gradually to come over me, and I felt terribly bad about it. Now I am inclined to think I was wholly mistaken, and that his feelings at being asked to "take a little care of you" were deeper and more complicated than I thought.

I shall write to him just the same and I'll ask him never to tell you what I said.

You sounded a little doubtful about the pictures of me, but if there is a truly beautiful one of us two, then I don't care. I would rather have that than anything else there is.

I am too dizzy to write any more now. I will save this and mail it at Ogden, for I think it will go faster down across the desert.

Goodbye, sweet gipsy. Be happy in your beauty which is the greatest in the world.

<div align="center">Max.</div>

On letterhead of the Clift Hotel, San Francisco. Posted June 8 in Ogden, Utah.

Max to Florence, 1743 Cherokee Avenue, Hollywood, California, June 8, 1921

I AM THINKING SO TENDERLY OF YOU SLEEP SWEETLY TONIGHT MY BEAUTIFUL GIPSY FRIEND

<div align="center">M.</div>

Western Union night message, filed in Ogden, Utah.

Florence to Max, 11 St. Luke's Place, New York City, June 8, 1921

Dearest. When you called me from San Francisco I was embarrassed and couldn't say the things I wanted to. Mrs. King[6] stood right there and was trying to talk to me at the same time. I was very angry with her and told her so. Her idea is to console me with an endless stream of words meaning absolutely nothing. I dined with the Edesons Monday night and Bob and Mary admitted they were angry at us but wouldn't go into details.[7] I think perhaps we offended Bob that night he dined here.

I saw Margarethe and she promised to send you all the proofs. I love the one of us together. Perhaps you won't as I look as sweet as a little lamb and you might not consider that a very true portrait of me.

I wrote to Vanity Fair and also to Nazimova. She called me up immediately and seemed so cheerful and happy. Her voice sounded beautiful on the phone I am going to have lunch with her. I hope she won't disillusion me. Please don't feel worried about Charlie I don't think there is much harm done. May is over here all the time I suspect her of liking Charlie a great deal more than she admits. She acted in that nervous, cross way with me and I scolded her, then she told me that we had hurt her feelings by going out in public with Claire Windsor.[8] When she left me she promised to behave herself and act decently if she can [with][9] Charlie that night but

he never turned up, so I don't know how long her good resolution will last. Dearest I miss you so when I wake up in the morning. My larder is bare, no cream, no eggs and milk, no cereals to remind me that you are there. When I came home the other evening a sample of Shredded wheat was in the letter box it looked so cute. I felt sad because you would have liked it so, and you were not there to have it.

I am writing a funny sketch of that evening at Charlie's house when you contested who had the greatest lung capacity. also an article about the screen. I was very pleased with the title I had chosen, "The Dictatorship of Mediocrity" but after thinking about it, it sounds too harsh and I have decided upon the simple and more Grecian title of "The Way Out."[10] Dear, think of me sweetly. I could not bear it if your thoughts of my naughtiness made you think angrily and coldly of me. I feel sad because you didn't read me all of your book. I mean my book. A kiss to your sweet temples. Florence

Postmark and dated by Max on first sheet. Written in pencil. Max's note on the envelope: "her 'naughtiness.'"

May Collins (1903–1955; fig. 4.1) was a fresh-faced, seventeen-year-old aspiring actress from New York, who had her sights on Charlie and was said to be engaged to him. Cal York in Photoplay Magazine *reported: "I saw [Chaplin and Collins] dining together the other evening at the Maison Marcell in Los Angeles with Florence Deshon and a gray-haired man [presumably Max] and it certainly had all the earmarks of a happy evening for Charlie and his pretty partner. They danced as devotedly and smilingly as a couple of high school kids." This could be simple press agent hype, but it sounds as if Charlie was still playing both ends against the middle, as was his custom.[11]*

Max to Florence, 1743 Cherokee Avenue, Hollywood, California, June 10, 1921

Dearest, I guess you thought my telegram from Omaha sounded like a Christian Science practitioner encouraging a patient, but I didn't mean it so, and I won't make any charge for it.

Love and Loss in Hollywood

Figure 4.1. *From left to right*: Charlie Chaplin, May Collins, and Samuel Goldwyn. Associated Press, created May 13, 1921. Courtesy, AP Images 21051314.

I wish I had a letter from you. There is very little for me to tell. I haven't been very well, and after eating very little all the way, today I am going back to the "something six times a day" regime, which seems to be about the only final wisdom I have arrived at in life.

It has been cool every day until now—east of Chicago. I read Einstein thro' once with much interest and little comprehension and now I'm beginning again with less interest but more comprehension.[12]

And by reading enough literary piquots[13] to get me mad I managed to drag out a few editorials. My heart is altogether in my book. I care less and less about journalism. I wonder how it will be when the book is done. Do you suppose I would ever care so steadily and strongly about poems? Not so confidently anyway.

I wish I could know where you are now, and what you are doing. I am so glad you will have the car for a few days anyway. Think of our luck to lose 400 dollars on that car! Didn't it look grand and fine when it was all polished up? O it just breaks my heart that I can't give it to you.

Give my love to Marie and Margaret.[14] One of the chief things in New York will be the coming of that picture of us.[15] I hope it is on its way. And I

hope I will have a letter. I want to get a letter from you. I have a feeling that Dora[16] is angry because I succeeded in getting away as a friend, and that makes it hard for me to write!

with love

Max.

Postmark. Written on paper supplied by the New York Central Lines: "En route."

Max to Florence, 1743 Cherokee Avenue, Hollywood, California, June 10, 1921

I AM READING EINSTEIN BUT THINKING OF YOU DO NOT BE LONELY OR DISCOURAGED EVERYTHING YOU WANT UNTIMATELY COME [*sic*] TO YOU BEAUTY AND BEAUTIFUL MIND LOVE

M.

Western Union night letter.

Max to Florence, 1743 Cherokee Avenue, Hollywood, California, June 14, 1921

Dearest,

You didn't write me the letter that you promised. It is Tuesday and there is no word from you. I wish I could have news.

I went straight to the office Saturday morning. Nobody was there but Mylius,[17] and Claude in his queer way was very slow and indifferent about coming down when I telephoned him. But there was lots of work to do, and I eat up work like the-ant-thou-sluggard now.[18]

In the evening I came out to Croton, and Sallie asked me to dinner. Crystal was away at Vassar, and there is no boarding house. Their friends "Patsy" (Pitkin) and Dorothy Kenyon (female lawyer in crimson bloomers) were there, and the two noisy children.[19] But we had some gin and got cheered up.

Mike has no job and they are staying here for the summer.

Sunday I ate with them again, and for supper we went down to Nikko.[20]

Floyd and Marie went went [*sic*] the same day I arrived. They expect to go on as far as Los Angeles before they come back.

Yesterday I finished the proofs of the new edition of my book, took them to Scribner, and arranged for two months more on the new book. I worked in the office again until ten in the evening.

Crystal arrived at seven, and I had dinner with her and Walter at "Jack's."[21] She came home early from her reunion in order to see "Irene" before it is taken off—which sounds more like old times.[22] She looks very much better, and is—Walter tells me—entirely different under the thyroid treatment. Everybody agrees, however, that she must do nothing, and she starts with Ruth for Vineyard Haven tomorrow.

When she suggested to Ruth that they might invite me to visit them for a week or two, Ruth demurred. She tho't "Amos might not like it." So that is Ruth—sold into bondage.

When I sell myself I will have the money passed over the counter, I am at least sure of that.

I am sending you $20 today, and I shall make every effort to find $85 by the time your rent is due. I can't bear to think of your leaving that sweet house. And I will "talk about my feelings" in a poem soon, I think. With grateful love—Max.

Postmark; date also added on envelope. Written on stiff cardstock; Max's note in the left margin, first page: "Paper supplied by Rupert Hughes!" For more on Hughes, see the comment after Florence to Max, January 7, 1920. The envelope also contains a dried flower, perhaps as a reminder of Florence's favorite meadow in Croton.

Max to Florence, 1743 Cherokee Avenue, Hollywood, California, June 16, 1921

COULDNT YOU PLEASE SEND ME A TELEGRAM TO CROTON
I AM SO UTTERLY LONELY UP THERE AND SAD WITH
NO LETTER FROM YOU AND NO PICTURES NO SHRED OF
CONNECTION WITH ALL I WAS SO DEEPLY CARING FOR
PLEASE SPEAK TO ME LOVE

M.

Western Union night letter. Max's urgency is reflected in the sticker pasted to the telegram. "A reply is requested by the sender of this message. May we rush it for you?"

Florence was now alone. Her glittering dreams of a Hollywood career had faded. An even younger woman, pliable and predictable where Florence had been moody and complicated, had replaced her in the tangle of Charlie's affections, while her relationship with Max was over—partly, as she well knew, because of her own intransigence, partly because of Max's constitutional selfishness. Max had easily slipped back into his old life and resumed his compulsive philandering. And he readily embraced, even as he continued to complain about it, the important work waiting for him back in New York. All that Florence could do now was to pick up the pieces of her shattered career.

In some corner of his overactive mind, Charlie must have realized the share he had in Florence's downfall, which is probably why he asked his trusted valet, Thomas Michael Harrington (1881–1959), to step in. Harrington, who took care of Charlie's expenses and wardrobes for a decade, was an "exceptionally thrifty man who rarely paid retail for anything," according to one of Charlie's biographers.[23] He didn't disappoint and proposed a deal that he knew would make car-crazy Florence happy and Charlie look good while also saving him some money and inoculating him against future demands. Better still, the deal implicated Max, forcing him to assume responsibility for the current situation, too.

In the following telegram, Harrington offers to take possession of the Buick that Charlie had helped procure when Max came to Hollywood, provided that all Harrington had to do was pay off the money (the $400) Max still owed to Buick—a simple transfer of ownership, in other words, not a costly purchase. The expense would have been modest for an entertainer as flush as Charlie. In 1921, the cheapest available Buick was a four-cylinder, four-passenger coupe, which sold new for $395, the equivalent of about $5,800 today.[24] Florence did have to wait for her car till July 1, but when it came, it was a thing of beauty, with a new top and a new spare tire.

The correspondence between Florence and Max sputtered on, out of habit and need rather than an overflow of powerful feeling. Their letters were still laced with some of the old banter and familiar protestations of love that ultimately did little to hide the undercurrent of pain that now would no longer go away (see Max's half-hearted apology extended on June 20). Max kept reiterating how "beautiful" Florence was, as if she were a distant object of veneration, an artifact that would only grow more valuable with time, rather than his former partner. As far as he was concerned, he was making good progress on his book, and that was what mattered! He was still sending her new chapters, and Florence, clear-headed, smart, and unencumbered by the fancy intellectual baggage of his New York friends, continued to be a good and

impartial critic. She was not afraid to suggest to him, at least once, that his time might be better spent working "towards Liberty" again, as he was doing when they first met. But Max the courageous risk taker had, at least for now, given way to Max the woolly would-be academic and Important Poet. He rejected Florence's suggestion: "My poetry might grow" (to Florence, July 19, 1921).

Tom Harrington to Max, Croton-on-Hudson, New York, June 17, 1921

DEAR MAX LEARNED THAT FLORENCE TURNED CAR IN TO BUICK LOOKED IT OVER AND IT NEEDS REPAIRS TO PUT IN SHAPE THEY HAVE CUT THIS MODEL THREE HUNDRED SINCE YOUR PURCHASE WOULD LIKE TO TAKE CAR OVER AND ASSUME ALL UNPAID BALANCE BUT COULD ONLY DO THIS IF YOU WILL ALLOW ME TO HAVE CAR WITHOUT ANY PAYMENT TO YOU OK WITH BUICK PEOPLE WIRE COLLECT AND ALSO AUTHORIZE BUICK TO MAKE TRANSFER IF AGREEABLE REGARDS

TOM HARRINGTON

Western Union night letter. Max's note: "Charlie's valet & care-taker, almost mother—"

Florence to Max, Croton-on-Hudson, New York, June 17, 1921

I SENT A LETTER TO STLUKE PLACE TO BE THERE WHEN YOU ARRIVED I AM SORRY YOU DIDN'T GET IT I MISS YOU SO MUCH LOVE

F.

Western Union night message, sent collect. (Florence was broke.)

Florence to Max, Croton-on-Hudson, New York,
June 17, 1921

Dearest, I sent you a letter to St. Lukes Place. I wrote it and mailed it so it would be there before you. I hope you have it Margarethe is really working hard and I know she will send you a picture soon.

Charlie is not angry at you in any way nor is he angry at me. Poor boy he can't stand M.[25]—and it is very hard to get her to realize it. She comes over here all the time and I feel so unkind in my innermost thoughts, but I know altho she hasn't much sensitiveness, she is suffering.

I was thinking dear, about your book, how much you love the subject you were writing about, and it seems to me the only other things you care about with anywhere near that degree are psychology, and the truth about the class struggle. Do you ever think you would care to work again on towards Liberty. This is no answer to your doubting whether writing poetry would really be fulfilling your greatest desire. I think you have such a wonderful clear mind that it will always demand some highly intellectual outlet. This is just a little letter, please send me a letter full of news about you and lots of nice things about me. Florence

I was also thinking dearest that you ought to write that article of Charlie's character while everything about him is still fresh in your mind[26] You might not be able to use it right away but it would certainly be valuable in the future. Charlie has had the grippe and has really been very sick. The weather is lovely once again, and the hills are green because of all the mist we have had lately. I only wish you were here. I would be so sweet to you in the morning. I would wear my beautiful green kimono and bring you your breakfast then we would have a lovely talk and you would go away to your study to write your book which you love. I have not seen much of Marie and Fred but they both called me up. They miss you so much. Do you miss me dear? Do you think tenderly of me? There is no Dora[27] I'm all Florence.

P.S. You must send me a little love in your letter, for I am a lonely little girl and very sad.

Postmarked in Los Angeles. Date also penciled in by Max. Written on letterhead from the Samarkand hotel, Santa Barbara, California.

Max to Florence, 1743 Cherokee Avenue, Hollywood, California, June 18, 1921

Darling and beautiful little girl, it makes me so happy to have your two letters, and know you are still thinking tenderly of me, and that Dora is dead—or *inactive*. (It is the word they use of volcanos!). After your first letter came to Croton I was happy for three days, and then suddenly it came over me that you had written it only the day after I left, and you hadn't said a word since, and so I got terribly gloomy again. For even your telegram said so little—only just as much as I asked you.

(I wish, dear, you would send me a telegram collect any time you are near the office and haven't any money, but feel like telling me something. That would be the one luxury I could afford.)

So the letters just brought me the one assurance I was longing for. A tender word from you lasts me just about four days, and then I get to fearing you don't like me again.

My beautiful-bodied gypsey, when you tell me you would get my breakfast in the green kimono, and be sweet to me, and send me away happy to my work after we had a nice talk, it brings tears to my eyes.

You are the loveliest and most gracefully beautiful being in the world.

You must not be sad, dearest friend of my heart and mind. You will have your season of discouragement. It will not last too long. Sometimes I think it might make you even more beautiful, if you were compelled for a little while to turn away from pride, and find yourself more akin to the mortals who do not have your divine beauty and power. You would see better what life is—your life is not what it is to you—to one endowed like you.

You see, I have renounced talking about my feelings, so I have to talk about yours! You brought it on yourself.

I am so happy in your assurance about Charlie. And I am glad he is having a hard time about May—it makes him seem a little more responsible, than as if he just threw her off as I feared he would.

I wish you would tell me how Nazimova talked.

You asked me to tell you all sorts of little news, but you didn't tell it to me. And I can't tell you how I long for it. I have no pictures of what you are doing.

Did you go to Santa Barbara?

Won't you try writing me a nice gossippy [*sic*] letter about yourself and your friends—just like I wrote you?

Peter came to see me for three or four hours yesterday—in a beautiful six cylinder Paige car. We went over to the pool and talked over old times. He always makes me sad.[28]

How few people that you don't feel sad about if you think about them!

He left me a cocktail or two, and I invited Claude up to dinner to drink them. That is about all that has happened. Croton is really desolate—Dudley's place all grown up to long grass, no sounds from there, no motion—Jack's little house silent, utterly silent, even on Sundays[29]—strangers in Floyd's house and Crystal's—quiet people whom you never see—Jane Burr all alone and working very hard in the house up the road that she bought (something appealingly kind and straight-out about her, in spite of everything—and she is *not* going to turn that house into an inn).[30] Sally and Mike never stroll over—I am too ungracious to Sally, I suppose—nobody comes to the tennis-court.

I don't love Croton anymore. I think it died for everybody when you went away. I really do.

I'm going to ask Claude up again over Sunday—and Art Young, though I doubt if he'll come.

Eugen is in San Francisco, and says he's coming back about the 15th.

I saw Betty Hare one afternoon. She not only stood for the boss, but took him into her house when he was hiding and took care of him several days. She certainly is game! G. is safe, by the way—in Russia now.[31]

There, dear. I've told you *everything*. Now won't you please tell me everything too?

Ah I do miss you. I do think tenderly of you—never otherwise. And in your beautiful green kimono I clasp you in my arms and kiss you—

Max—

Postmark.

Max to Florence, 1743 Cherokee Avenue, Hollywood, California, June 20, 1921

Croton—
Monday—June 20

My sweet, sweet child, I have no words of adoring gratitude for your letter. I was so dark and sad and growing a little bitter in my sadness. It

seemed so cruel that you should not say a word—even if it was only for my sake. But since it came I have been happy.

When you speak of your mighty and terrible anger as "being naughty",[32] then this would all straighten itself out, and I think of you without shadows, with infinite tenderness.

You are so sweet. You are so adorable in your letters—so humorous and alive to everything.

Dear, you must send me the article, and I hope you will tell me about Nazimova. When you spend money to send me a telegram of rescue, you must use all the fifty words to tell me news, and make it a hundred if you can.[33]

I wrote you a little letter in my sorrow. I said: "I hope you can wholly forgive and a little forget my terrible ways—the pain I brought you—as I can forgive and forget your anger at me. I understand you now, and you are beautiful. You have given me back the knowledge of your beauty—of one beauty, perhaps I should say, for I am not quite sure what it is you have given me back, some privilege of faith in my dream."—But I decided I was talking about my feelings too much, and that I had better do that only in poems.

The same day your telegram came, I got one from Tom about the car. You can imagine how joyous I was to know you are to have it. All my anxiety was not in vain! And I felt *so very much* happier, and tender as I used to feel, toward Charlie.

How I wish I were going to spend the week-end with *you*, and tell you a million things, and hear all the things that have happened to you. Mine would be dull, though—I have done nothing but work. Absolutely nothing. The Liberator was sinking down into an abyss when I got here. Claude is a wonderful under-editor—by far the best I have had—but he does not know how to make the Liberator. I just had to sail in and save it from reading like the Nation. Of course I was fretting every second, and as soon as that was done I flew to my barn, and I have worked morning, afternoon, and evening, weekday and Sunday, on my book.

In a day or two I'll send you the unfinished sections of the last chapter of Part I. Part II I am doing all over—a fourth time, as I did Part I— making it rapid and vigorous even if it is learned! But of course it is a much simpler task. I believe I shall be done in July.

Claude read part I last night, and he says it will "make a sensation". But I did not need that. I have never lost confidence in my book since the morning you told me it was good. I have thought of your words a thousand times when it seemed impossible to write.

Claude and Gropper[34] were up here over Sunday. Claude brought your letter, and I was so happy they thought I was very nice.

Mike is lovely as ever. Sally I can't stand—it is growing terrible. She has lost the excuse of "children" for nor doing any work last winter and now she is blaming Mike. She says "he admitted that he was jealous of any achievement on her part"! Poor Mike—I bet he was racking his brains for some complimentary way to explain a fit of uncontrollable boredom! Anyway they had no celestial time living in that one room up here all last winter— which proves at last that they are both human—and Sallie is announcing to all that she is going to have her own studio in New York this year.[35]

It pleases me—in some thoroughly unneighborly way—to see a little trouble there!

Did you get the $20.00 I sent you by telegram?[36] And $20.00 in a letter?

I am enclosing $100 in this letter, because I keep thinking of Mrs. King turning hard like drying cement from the morning of the 28th If you should happen to have any money and not have to use it, please send it back to me, because I had to borrow money on a note, and not the way we borrow from Mrs. Gartz, to get it.

I like "The Dictatorship of Mediocrity"—but for your signed article I guess the other is best.

No pictures yet! O I want to *see* them!

I think of you sweetly continually—

Max.

Dated by Max at the top of the first sheet and on the envelope, in what appears to Florence's handwriting, as "June 20." Dated in Deshon mss. as June 20, 1920.

As she began to set her sights on a possible new career as a writer, Florence became even more involved in Max's work, reading not just his manuscript and commenting on individual passages but also studying other works on the subject. Always an avid reader, she now picked up more specialized titles, such as the literary critic Van Wyck Brooks's brand-new The Ordeal of Mark Twain *(1920), which was unfamiliar even to Max. For Brooks, Twain had fallen short of true greatness because he had never been able to free himself of the shackles of domestic life, represented largely by women, that is, his mother and his wife, Olivia Langdon Clemens, a thesis that angered Florence the feminist. It speaks to the quality of Florence's mind that, rather*

than tossing Brooks's misogynistic book aside, she continued to give it a fair
hearing. She challenged his argument that Twain's turn from satire to humor
had to be understood as a decline; at the same time, she was interested enough
in the examples of humor he had provided to pass one of them on to Max.

No wonder that Florence also felt comfortable enough to object to the
cumbersome title Max had chosen for his book—"What and Why Is
Humor?"—as too ponderous and difficult to remember. Her former lover's
miffed rejoinder—others had liked it! you once did, too!—only shows that
Florence had become what Charlie had always wanted to be: Max's intellectual
equal. And as if he had become aware of the ramifications, Max invoked their
triangle again—why don't we ask Charlie what he thinks? (July 19, 1921).

Florence to Max, Croton-on-Hudson, New York, June 21, 1921

Dearest. You were so sweet to send me that money. I have gone on a very strict diet so I don't need much for food. Marg.[37] lost 10 pounds in three days. she didn't even drink a glass of water she got a good look at herself one day and she couldn't stand it any longer.

I finished "The Ordeal of Mark Twain" and I object to the slander of the ladies. Mark hadn't much character as a man and I feel it is unfair to blame anyone for that but himself. He knew it and it made him sad. Then again I can't understand why Van Wyck Brooks mourned because Mark became a humorist instead of a Satirist. it's not clear to me. The sourest flavor in literature is satire and it requires less of the artist than any other creative writing. Also they are tiresome. nobody reads Voltaire very much and children read Swift, again satire is local and very short lived. There is some poetical humor on page 213 at least I think it is the kind of humor you illustrated in the story of the old irishman [*sic*] drinking out of his saucer You might like it better.[38]

I miss you so much dearest. I wish you were here so we could go places together. I told Mrs. Gartz we thought she should take us to Europe and she smiled in her childish way but I guess she didn't take me very seriously. Amos is really mean I always thought so, but Ruth is getting what she wants despite him so I wouldn't call it sold into bondage. Give my love to all my dear friends and my tender love to you dearest.

P.S. Send me a copy of the new edition of Enjoyment of Poetry?[39]

Postmark. Written in pencil. Max's note on envelope: "About satire and Mark Twain. ('The Ordeal of M.T.')." Postscript added at the top of the first sheet.

Max to Florence, 1743 Cherokee Avenue, Hollywood, California, June 24, 1921

Dear, I have just time to get this on the train west. I have just heard that you sent me a telegram and I'm going down to get it instead of having it read to me. I almost died last night of thirst for any word or motion from you.

 Whatever the telegram says it will relieve that unbearable void—

<div align="center">Max</div>

Postmark. Written in pencil, with penciled note in Max's handwriting added on envelope: "About June 24—" The year (1921) supplied in different handwriting.

Max to Florence, 1743 Cherokee Avenue, Hollywood, California, June 26, 1921

YOUR LETTERS WERE LIGHT IN LON[E]LINESS I COULD SEE YOU SO BEAUTIFUL TALKING WISELY AND SWEETLY ABOUT MY BOOK DID YOU GET MY LONG LETTER WITH HUNDRED DOLLARS ANOTHER MAILED YESTERDAY ANOTHER TOMORROW WITH QUESTIONS AND ADVICE PLEASE WIRE ME ABOUT YOURSELF PLEASE SEND LONG NIGHTLETTER COLLECT DEAR LOVE

<div align="center">M</div>

Western Union telegram, filed 1:30 p.m.

Max to Florence, 1743 Cherokee Avenue, Hollywood, California, June 27, 1921

Monday.

My dearest child, I have just finished those last sections of my book, going over some that I had read to you, and my heart goes all to you in gratitude for what you did. My book came to life as a really beautiful thing—however beautiful it is—when I began to bring it to you those mornings in Hollywood. My whole feeling of it changed and grew beautiful.

As soon as they are typed now, I will send you these last four "laws."[40] And you will tell me if there is anything you don't like, or anything obscure in them.

I was going to write you a long letter today, but I did this instead, and now I must go to town. I will write tomorrow.

Dearest love. Max.

Postmark. Date added in pencil on first page.

Florence to Max, Croton-on-Hudson, New York, June 28, 1921

Dearest. I sent you a sweet telegram Saturday and it came back today it had been sent to the wrong address.

Charles hasn't given me the car yet. I am thinking up some magic words to drag it from him.

Dear I'll send you a letter tomorrow or the next day and then I'll send you the little article.

I have never heard any word from Vanity Fair. I guess they lost my article.

You wrote me such a sweet letter. I felt so sad that you had to send me that $100. You must not send me any more money. I only hope I will be able to send you some.

Good night dearest

Florence.

Postmark. Letter written in pencil on letterhead of the Samarkand hotel, Santa Barbara. Max's note on envelope: "Charlie gave her a car."

Florence to Max, Croton-on-Hudson, New York, July 1, 1921

YOUR SWEET LETTER MADE ME SO HAPPY I[']M GOING
TO GET THE CAR TOMORROW IT HAS A NEW TOP AND AN
EXTRA TIRE WITH COVER AND THE INSURANCE IS ALL
PAID FOR I[']M GOING TO PLAY IN MARY[']S COMPANY[41]
UNTIL THE SITUATION GETS BETTER WITH DEEP LOVE

F

Western Union collect night letter.

Florence preferred to view her new theatrical work as little more than a stopgap ("until the situation gets better"). However, contemporary reviews show that she was quite successful on the stage and that audiences liked her. In March 1921, she had appeared as a member of an experimental theater group, The Mummers' Workshop, at Morgan Place in Hollywood, in a poetic "playlet" on Chinese themes written by Ida Mallory Remsen called The Lotus Flower. *The reviewer for the* Los Angeles Herald *appreciated the play and especially Florence: "Florence Deshon pleased in the role of Tin Tu." The* Los Angeles Times *agreed: "Florence Deshon showed real artistic skill in the playing of the rompish Tin Tu."[42]*

The "company" she had joined was the Wilkes Stock Company. They cast Florence in Charles William Bell and Mark Swan's Broadway success Parlor, Bedroom, and Bath *(later made into a movie by Buster Keaton), which ran at the Majestic in Los Angeles. Mary Newcomb, Robert Edeson's wife (see Florence to Max, June 8, 1921), played the lead, but the* Herald *insisted that Mary's "fast pace for fun making" was "capably followed" by the rest of the cast, including Florence.[43]*

All of which goes to show that, in the absence of glamorous movie contracts, a workaday stage career would have been a possible, if not altogether attractive, option for Florence. But even with her dreams of Hollywood stardom in tatters, she clearly wasn't too keen on resuming the kind of hand-to-mouth existence she had led before Goldwyn asked her to come join him in Hollywood.

Florence to Max, Croton-on-Hudson, New York, July 2, 1921

Dearest, I told you in my telegram that I was going to play down in the theatre with Mary. They asked me if I wouldn't like to join them and as long as I had nothing else definite at the time I accepted.

I do not think it is good for me not to earn my own living. I have two or three picture offers and any moment they might be settled. then I shall have to go on in the play I am rehearsing with as I open a week from this Sunday. but I haven't signed any contract, so I can leave if I have to.

Did I tell you Mrs. Gartz, came to take me to lunch and brought two terrible women, two silly sentimental unintelligent sycophants. I couldn't eat. There[']s no doubt you are right about my being so violent about small matters.

I am glad Claude admired your book so much. I wish you would discuss the title with someone whose artistic judgement you admire. Sometimes I think the title is difficult to remember. The arrangement of the words "What" being the first word is strange and then after all it is not a question you have to remember but a question and answer. If nobody else has even remarked about it why please don't pay any attention to what I say.

I see the Merideth's [*sic*] a lot.[44] Everybody misses you and asks about you.

Darling I really finished my little article that I told you about but it isn't typewritten yet next letter I'll send it to you. Croton seems very sad and lonely from your letters. Don't my neighbors ever mention me? Doesn't Jane Burr keep up the Inn she used to have? Does Sally live in her big house again. Did you see the Steiglitz [*sic*] exhibition of photographs?[45] Florence.

P.S. I thought I'd written you about Nazimova.

She was lovely. she looked beautiful and seemed very happy. she said she was sorry you were gone as now she felt well again she would like to see more of you. I told her she had been naughty to you and she was very worried, and tried to reassure me that it was not so. She really was nervous and upset at the time, as they were trying to break her contract. She has a beautiful Rolls Royce. But even though she is better she is still so restless. She's been untrue to herself, and her spirit is lashing her with its contempt all the time.

P.S. Send me the Liberator please?

Postmark. Letter written in pencil on letterhead of the Samarkand hotel, Santa Barbara. Postscript added at top of first sheet.

**Florence to Max, Croton-on-Hudson, New York,
July 9, 1921**

Dearest, I thought the chapter was lovely, especially the last paragraph. also the last paragraph of chapter VI. It was all so clear and beautifully written. If Scribners allows you two months will it be published in the fall just the same? I told you I was going to play in Mary's company. everything is in such bad condition. I thought it would be foolish to refuse it. I open this Sunday. I miss you soo [*sic*], no one to go see the alligators and tigers with, no one to ride in my beautiful Buick.

<div align="right">Good night dearest.</div>

<div align="right">Florence.</div>

Postmark. Max's note on envelope: "Her last letter before the crash."

Excited by Florence's news about her return to the stage, Max sent her a chatty letter that would have seemed entirely casual if not for the added spice of viciousness. Perhaps he also wanted to tell Florence that, although he had spent a day in the company of several desirable women, he had instead been thinking about her?

The letter is undated, but the reference to "the fight" (likely the bout between the world heavyweight champion Jack Dempsey and the world light-heavyweight champion Georges Carpentier) places it in the days after July 2, a Saturday. Max had chosen that day to leave Croton, which had become so dreary without Florence, and hang out with a truly extraordinary cast of characters. The group included the writer Anita Loos (1889–1981), who, after providing scripts to the Biograph and Lubin Studios, had written for Norma and Constance Talmadge. (Loos is now mostly remembered as the author of the comic novel Gentlemen Prefer Blondes, 1925.) *Norma Talmadge (1894–1957) was one of the most glamorous stars of the silent film era, a big box-office draw, who had founded her own corporation, thanks also to her wealthy husband Joseph M. Schenck, with whom she shared a palatial estate at Bayside, Long Island, where they often threw parties. Perhaps Max had been invited to one of those or, missing his Hollywood days, had asked himself over and was gladly received, since all the real men, as Max points out, had gone to Jersey City to watch Dempsey, a.k.a. "the Manassa Mauler," pummel Georges Carpentier into oblivion.*

Norma's sister Constance (1898–1973) also stopped by that afternoon, too briefly for Max's taste. She had married John Pialoglou, the "man without life or looks," a Greek importer of tobacco products, in December 1920; the marriage would fail by June 1922. And finally, there was Mae Marsh (1894–1968), the "freckled mick," forever notorious for her grass-skirted appearance in D. W. Griffith's Man's Genesis *(1912), a role Mary Pickford had refused. Looking back later on her willingness to play that part, Marsh acknowledged that she was a "lamebrain,"[46] an assessment Max's description ("simple—sincere") seems intended to confirm. Mae Marsh had married Goldwyn's publicity agent Louis Lee Arms in 1918, and as Max suggests, she pretty much gave up her film career for motherhood, after a series of unsuccessful films that she made for Goldwyn. Her brother Oliver Marsh was an excellent film cameraman who worked on several of the Talmadge sisters' films, which may explain Mae Marsh's presence at Bayside.*

Max didn't have a good time, and he let Florence know about it. Amid his litany of hollow-point insults, Max's harshness toward Anita Loos is especially remarkable. He had, after all, featured her on the cover of The Liberator *in April 1918. He also completely disregarded and diminished Mae Marsh's contributions to D. W. Griffith's* Birth of a Nation *(1915) and* Intolerance *(1916), where her simplicity and innate vulnerability resulted in transcendent performances.*

Perhaps in denigrating these women, Max was trying to suggest that Florence was more beautiful and more talented than all of them put together. Or maybe he was trying to help her envision herself as something other than an actress, since she was evidently so much more interesting than these air-headed women? Well, whatever he had intended, it was in vain, as Florence's response would soon make abundantly clear.

Max to Florence, 1743 Cherokee Avenue, Hollywood, California, [July?] 1921

Dearest, I was so happy when I came home yesterday to find your sweet little note and a telegram telling me the news.[47]

It is strange there is no person in the world about whom I starve for the mere facts, if I don't hear them, except you. I feel that I have to know what is happening to you, even if it is something that carries you away from me. It is nevertheless part of myself.

I am glad you are going into the stock-company. I like to think you are using your voice and your color. I have had a feeling lately that you ought to go back on the stage. So few, few girls in the world—even the beautiful ones are completely beautiful as you are.

You don't know the wondering admiration I've been sending you these last three days. I spent the entire day Saturday with Norma Talmadge and Mae Marsh down at Bayside[48]—and two other girls—and Anita Loos—all the men having gone to the fight.[49] I kept thinking to myself—well there are probably several million males in the United States who would sell their birth-right to be where you are now—but it didn't do any good. I was bored to death. There was no spark of life, as of life's real beauty, in the crowd. I was terribly disappointed in Mae Marsh. She is very sweet— simple—sincere. She's all right, but all that wistful charm is simply not there. She is a nice little freckled mick,[50] the kind that you'd do anything in the world to keep if you had the good luck to get her as a hired girl. She talks like a hired girl, and has dishwashing hands, I think. And she is so crazy about her baby that you know there's no more talking about any other subject. I hate to see people in that condition—about anything.

Norma Talmadge has, I think, a little more charm. She has a vein of humor—or semi-humorous remark-making—very much diluted in the process of inheritance from her mother who is a wonderfully humorous character. She is worth going to near and look at. Constance is much more beautiful than Norma. She really is very lovely looking, and I had a feeling I would like her better than the others, but she only came and went. She is married to a man without life or looks, whom they all dislike.

They are all so damned lifeless and unresponsive to the value of things.

Anita Loos is terrible-voiced and much the same way—though she has an ambition to be intellectual and acquainted with literature. She does read a little, but what she gets out of it I could never find out. I think is a rather unreal ambition.

Now in fairness I ought to add that I'm sure they were all equally bored with me, and almost although not quite as glad as I was when I got away.

I will never do it again. I just called up Anita Loos in desparation [*sic*] at the dullness of Croton.

Eugen is coming Sunday. I've a faint hope he will feel like taking a place by the sea somewhere, and will let me come and stay with him. I have such a longing for the salt water.

But I have no friends—nobody in the world that I love to be with as I love to be with you. I find myself almost wishing that we had never fallen in love, so that I might be one of those lucky men who have been able just

to go and drink and refresh their souls with your happy companionship—
your generous laughing irresponsible sprit of life, so beautiful, so sensitive,
so free.

Of all miracle gifts that might be imagined, I would choose to spend
next Saturday and Sunday by the sea-shore with you as my playmate—

<div align="center">Max.</div>

*No date recognizable in postmark. Max's note: "My last letter" (which it was, at least
in the sense that this was the last letter by him Florence actually read).*

Max to Florence, 1743 Cherokee Avenue, Hollywood, California, July 9, 1921

DEAREST LOVE AND GOOD LUCK TO YOU I CANNOT TELL
YOU HOW HAPPY YOUR TELEGRAM AND SWEET LETTERS
HAVE MADE ME PLEASE TELL ME ALL ABOUT THE PLAY
I HAVE WRITTEN YOU ANOTHER LONG LONG LETTER
PLEASE WRITE ME ONE TOO LOVE

<div align="center">M.</div>

Western Union night letter.

*Perhaps the most extraordinary portrait of Florence by her friend Margrethe
Mather (fig. 4.2) shows her in a contemplative mood, immersed in thought.
The light rests on her right cheek and behind her, while most of her face
remains dark. Mather presents her against a background of bare walls, pushed
into a corner—as Florence indeed was at this point in her life—dwarfed by
the ominous shadow she projects: a photograph of a darkening, darkened life.*

*The message was lost on Max, who, in the letter that follows, is
concerned mostly with himself. Since they were no longer together in real life,
he waxes lyrical about a Mather photograph that shows them together (how
firm he looks in that one! and how gentle Florence seems!) and about a series
of portraits of him alone taken on Redondo Beach. Signed by both Edward
Weston (Mather's collaborator and former lover) and Mather, they were,
according to Max's later account, Mather's work alone. She had, he recalled,*

driven him out there to take "some Westonlike pictures in which I was
supposed to blend with the infinity . . . of that mysterious landscape."[51]

Praising his own looks, if in jocular fashion ("my two best features—my
nose and my raincoat"), rejecting the "myth" that he had ever been jealous of
Charlie, and telling Florence that she should learn to love without wanting
to own him, Max was eager to beat her at what he saw as her own game,
asserting his independence from her. Little did he expect that Florence would
go on to sever her ties with him completely and send that self-congratulatory,
needy letter right back to him, unopened.

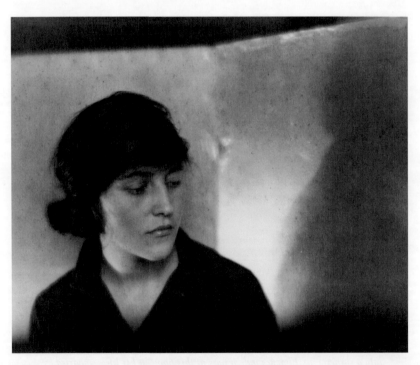

Figure 4.2. Florence Deshon, 1921. Photograph by Margrethe Mather.
Eastman mss. II. Courtesy, Lilly Library.

Love and Loss in Hollywood

Max to Florence, 1743 Cherokee Avenue, Hollywood, California, July 19, 1921

Dearest, the proofs have come, and I am so in love with that picture of you and me that I feel I don't need to do anything else—just hand that to the world and say "Here—I have lived."

Ah if you were so gentle and I were as firm as we look there, what happy friends we would be!

I hope you can get Margarethe to send me a print before too long. I need to have it hanging in my house.

I do like the profile picture of me too. At first I thought I was looking too far the other way—too much white of the eye for comfort—but then I got to admiring my nose, and I didn't care. It is fine modelling. Sallie likes it, and nobody else has seen it yet. She was quite rapturous about the picture of us.

It is such a beautiful beautiful picture of you.

I agree entirely with the choice Margarethe made. That and the one standing against the infinite dune are the ones.

Perfect pictures of my two best features—my nose and my raincoat.

How I wish I could have gone down on the beach and had some pictures with waves in them and no clothes.

I have sent you the last Liberator and put you down on the subscription list.

Yes, dearest, your friends all ask about you. They all asked "When is she coming?" And when they got a rather non-stimulating answer to that they became silent. I have found out the reason for that: Claude tells me that everybody thinks I almost died last fall because you went around with Charlie. The myth they have made up about us involves my going out there, I suppose, and rescuing you and forgiving you and bringing you home.

People can't imagine you not having everything you want. And they are right, if you knew how to want things and not just want to *have* them!

Dearest, I was so glad when your little letter came telling me you missed me, and that you had no one to go with you to see the alligators and lions. I had saved the big fat envelope that came the night before for the voluptuous pleasure of opening it and having you talk to me when I first woke up in the morning. It turned out to be nothing but old letters from other people bunched together. So I rose from quite a depth of disappointment to the joy of finding your little sweet note in my box.

I'm afraid I won't hear from you for quite a long time now, because I've been so busy with the Liberator, and foolishly kept putting off writing to you until I could write a long letter.

I shall get all kinds of opinions on the title of my book. I can remember a good many people saying it is good, and your question is the first hint of doubt I've heard. You liked it originally at least much better than "The Sense of Humor", I remember.

It is supposed to be a little bit droll—or at least said with a smile—that rather illegitimate combination of "What" and "Why". You couldn't really say "Why is Humor?" And for that reason I've sometimes had doubts of it for the book, although I thought it was about perfect for my lecture. I wish you would ask Charlie what he thinks of it.

I took your word about sending any more money, because I couldn't without borrowing again. (That cheque Lucian Carey[52] sent me to Hollywood was no good.) But you know it was a kind of passionate pleasure to steal it from myself for you.

I agree with every word you say about Mark Twain, and about satire. I wish you would copy the poetic humor on p. 213 for me. I haven't any copy of the book.

(Don't do it if it's too long—I've left the reference, and will look it up some day.)

did you think the example from Shakespeare—the long one about Falstaff—was all right?[53] Was it funny enough?

did you mean to desire me not to try being just a poet for a while? I want to try it. I thought you were the one person in the world who would sustain me in it. If you don't really think I am a poet, why, never mind—I am kind of reconciled these days to being whatever I am.

But you must remember that just as this book has deepened and enriched itself, and gained surprise and individuality, because I have dwelt in it and devoted myself to it—so my poetry might grow and become something we can neither of us imagine, if I gave all myself to it.

I never have done that for a week—not since I wrote Child of the Amazons, and I was a baby then.[54]

Yes, you are right about Ruth. And I've been going to tell you that I was wrong and quite unjust about Sallie. I don't like her, and that makes it hard for me to appreciate it, but there is something really very strong and fine about this revolt of hers. She says she has finished the job of rearing the kids, and now she faces the prospect of being a mere insignificant appendage of Mike's personality, and that is what he really—at least unconsciously—would like, and she is not going to do it. She is not even

going to live with him next winter—that is, she will live in her own studio, and has served notice to him that she will have her own secrets, her own affairs—love-affairs if she chooses—and she wants him to do the same thing. It is the only way she can make her own work and her own life stand up beside his. Of course it doesn't mean separation or departure to her. She says she hasn't ceased to love him at all. But she intends to live, and he—while he really endorses the idea of her having any love affairs that she wants to—has got so bound up to the idea of her presence or a part of him that he is *very* sad and doesn't care anything about his art. So he is the one that will go to the psycho-analyst for comfort!

There is something admirably daring in Sallie. It was always in her art. And here it is now in her life.

No, Jane Burr lives all alone in the house up above me—utterly alone. She is getting to be almost a good-humored misanthrope. There is no fun. But Eugen is back now, and he and Annie and I are now living up here. He goes in every day.

Did you know Jan married Charlotte Ives, an actress.[55]

I met her yesterday at their place in Port Washington. She seems very simple and nice. She knows Blythe Daly very well apparently.[56]

Yes Sallie and Mike & Billy & Bartlett and Michael Gold (Irwin Granich)[57] live in the big house. The studio is rented to a rich spinster who put in electricity and never comes there.

Hugo Gellert and Livia live in a house down at the end of the lane—below Margaret's.[58]

Thank you dear, for reading my chapters. I've fixed the sentence you spoke of, and now I feel it is all done.

I'm almost done with Part II also. The long chapter about Schopenhauer—you remember—I cut down almost one-half. And now I am cutting my own chapter—the last one. Then a few little "odd jobs", and it goes to the publisher. Yes—he says he can publish it in two months after I give him the copy.

I wish you would say something about the copies of the Liberator when they come. I am trying to take all my work very seriously and I need to be noticed!

Please be sure to tell me about the play—what is it, and your part in it? And do you enjoy being on the stage?

Write to me dearest. I *love* your letters.

Max.

I feel that this is really too long! Divide it into sections—and forgive me!

Sent in Liberator *envelope. The date was added in pencil by Max, who notes on the envelope: "Sent back unopened July 25, 1921" and "Opened July 2nd—1937." He also saved the envelope, postmarked July 28, in which Florence returned the letter; the post office demanded two cents in due postage. Max wrote on Florence's envelope: "returning my letter."*

Florence to Max, July 20, 1921

I am not going to write to [you] anymore. You know for a long time that has been the deepest desire of my being. I am sorry but I will not read any letters from you in case you should write to me.

Your neurotic selfishness has wiped any memory of you from my mind. It is [as] though I had never known you.

Written in black ink on a sheet of thick paper, with the rest of the sheet torn off.

Meanwhile, Charlie's career had continued to hum along. He finished work on The Idle Class *on June 25, 1921. Then, in August, completely worn out and in the midst of shooting a new work called* Pay Day, *he decided to return to Europe, which he had left nine years before. For six weeks, from September 4 to October 18, he traveled through England, France, and Germany. For Charlie, it was both an exhilarating demonstration of the world-class celebrity he had become in a few short years and proof that he would never be able to avoid the public glare.*

Accompanied by Carlyle Robinson and the indispensable Tom Harrington, Charlie left the Los Angeles Railway Depot on August 24, 1921.[59] He and his companions stopped in Chicago, where he judged a scenario competition and met Carl Sandburg. He then took the 20th Century Limited east from Chicago to New York, detraining in Buffalo on August 25, where he was seen with two (or three) companions, "one of whom it is said he is engaged to."[60] A possible candidate for the latter would have been May Collins, but Collins had just signed a contract with Metro, and it had been widely reported in the gossip columns just several weeks before that Charlie was not engaged to her and never had been.[61] The "fiancée" also could have been Claire Windsor, whose name was also often linked to

Charlie's at this time, but Charlie was supposedly angry at her after she had faked her kidnapping for publicity purposes. And it is at least within the realm of possibility that the woman was Florence. We know that—despite Florence's insistence, shared with Max and no doubt with Charlie, too, that she did not want to marry Charlie (Florence to Max, October 10, 1920)—rumors of an engagement had circulated in and beyond Hollywood, too.[62] However, if one reason Charlie went on his trip was to get away from his multiple entanglements, this seems unlikely, too.

Charlie arrived in New York City on Monday, August 29, 1921.[63] If he wanted to be incognito, he certainly did not act like it. He stayed in the Ritz Carlton, attended the New York premiere of The Three Musketeers with Douglas Fairbanks and Mary Pickford, where he was almost mobbed, and in general got a huge amount of publicity during his stay in the city.

Perhaps because Florence's absence from the scene made such things easier, Charlie and Max resumed their friendship. Charlie writes about these days in some detail in his short book My Trip Abroad. Note, however, the studied detachment he displays when writing about Max, as if he wanted to put the intensity of their past attachment behind him. Meeting Max for lunch, likely on September 1, he called him a "charming and sympathetic fellow who thinks," agreeable company but not much more: "We get together, argue a bit, and then agree to disagree and let it go at that and remain friends."[64] One would assume that Charlie was talking about politics, but given the elephant in the room, Florence must have hovered in the background here, too.

On the same evening, Charlie attended a party at Max's house in Croton throwing himself into a new game of charades until "Charlie Chaplin seemed very far away."[65] As Boardman Robinson, Max's neighbor, recalled, the absolute highlight of these performances was Charlie impersonating a Ford car: "His shy amateurishness made his stuff very charming; he treated us as though we were experts and he a novice." As Boardman also realized, this was mere show. Charlie captivated them all with his energy; there were no limits to his inventiveness. Boardman himself joined him in an act that required, in the words of Boardman's biographer, "the best of Charlie's panto-mimicry." Their charade was a dramatic imitation of a brand of Little Liver Pills known for the motto: "We Work While You Sleep." Charlie played the part of the liver in distress.[66]

These must have been crowded days for Charlie. On September 2, Charlie threw his own party at the Elysée Café.[67] Max was present: "Among the guests were Max Eastman, Harrison Rhodes, Edward Knoblock, Mme. Maeterlinck, Alexander Woolcott [sic], Douglas Fairbanks and Mary, Heywood Broun, Rita Weiman, and Neysa McMein, a most charming

girl for whom I am posing."[68] *Oddly, Charlie professed to be worried about inviting Max:* "*I wondered how Max Eastman would mix with the others, but I was soon put at my ease. Because Max is clever and just as desirous of having a good time as anyone, in spite of intellectual differences. That night he seemed the necessary ingredient to make the party.*"[69]

Again, the party centered on charades. Perhaps the high point was Chaplin and Mme. Maeterlinck[70] doing a burlesque of the dying scene from Camille.[71] *In this version, Chaplin also got Marguerite's dread disease (whether it was consumption or syphilis) and immediately succumbed to it, something of the same plot device that Chaplin had used in his* Burlesque on Carmen *in 1915. The party later adjourned to Alexander Woollcott's house where it continued until five o'clock in the morning.*

The very next day, Charlie was scheduled to leave for Europe. He woke up about noon, totally exhausted, and had to deal with a variety of legal problems before he was able to board the SS Olympic. *On September 3, he sailed out of the country and, for all purposes, out of Florence's life.*

Charlie's numerous dalliances might seem relevant as evidence of his Don Juanism. But there is one relationship from the time after his return from Europe that deserves special mention, because it establishes an additional, if indirect, relationship between Charlie and Max's community in Croton. The sculptor Clare Consuelo Frewen Sheridan (1885–1970) was the niece of Winston Churchill and came from an aristocratic background. Despite this, or perhaps because of it, she became a free thinker. After her husband's death in World War I, she had a series of affairs, traveled widely, and wrote and published a series of diaries about her trips. In the summer of 1920, she traveled to Soviet Russia, became a convert to the cause ("I love my darling Bolsheviks"), and is reputed to have had affairs with several of their leaders. In 1921, she came to the United States, accompanied by her son, Dick, met many prominent people, and lectured, mostly on Russia.

Sheridan had visited the Mount Airy folks in May 1921.[72] Given her pro-Soviet proclivities, it was probably inevitable that she would be drawn to the community there. She describes meeting Crystal Eastman, Claude McKay, Boardman Robinson, and others in Max's circle, but even though she went to Croton to stay with Crystal and her husband, she evidently never crossed paths with Max himself since he was in Hollywood with Florence at that time.

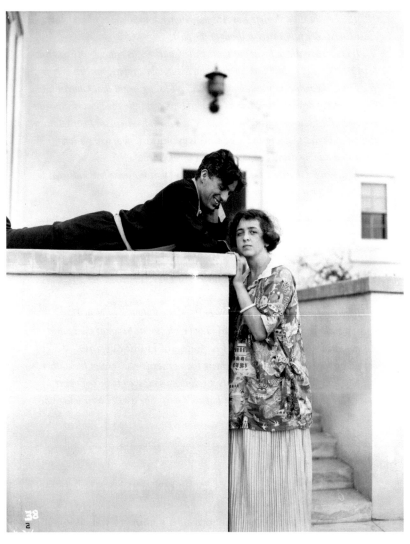

Figure 4.3. Charlie Chaplin and Clare Sheridan. © Roy Export SAS.

Charlie encountered Sheridan at the end of October, on the day he returned to Los Angeles, at a luncheon given by Sam Goldwyn. While Clare was sculpting a bust of him, they promptly embarked on an intense if short-lived love affair (fig. 4.3). Clare describes it in My American Diary, *published in 1922, and Charlie also mentions Clare in his autobiography.[73] Their relationship seems to have lasted from October 31, 1921, to around November*

12, 1921—the date she left Los Angeles. Florence was already back on the East Coast, her film career a thing of the past.

It is worthwhile to point out that while Charlie was ready to discuss his brief relationship with Clare Sheridan in his autobiography, written over forty years later, he made no mention of Florence. The argument that Charlie had done so out of deference to Max or to protect his reputation is moot: in the two versions of his essay about Charlie, Max had already discussed their relationship, and he did so again in Love and Revolution, *now using Florence's name and adding details about Charlie's involvement.*

In the end, Charlie did confirm, in a way, that Florence had mattered to him. More about that in the Coda to this volume.

We cannot be exactly sure when in the fall of 1921, Florence, her dreams

of Hollywood stardom permanently shattered, moved back to New York. After staying for a while with Marie Howe, she took a room at the Hotel Algonquin. In November, Max's The Sense of Humor *appeared, the book for which Florence had done more than anybody else, except the author himself. The finished text was truly a collaboration, the product of many hours of listening and reading on Florence's part. She was ecstatic when she found out.*

Florence to Max, November 21, 1921

Nothing ever made me so deeply happy as my name in your book.
Florence.

Written in ink on a speckled blue notecard. Accompanied by an envelope that looks a bit waterlogged and simply says "Max" on it. Dated in pencil by an unknown hand.

Now that Florence and Max were in the same city again, they approached each other again, gingerly, wary of rekindling what they both knew had long been extinguished inside them. In Love and Revolution, *Max recalled an intense*

afternoon spent at the Algonquin, where they revisited what was left of their friendship. As revealed in a pair of letters they exchanged after their conversation, Max regretted his earlier failure to commit to Florence, while Florence in turn promised to live more "tenderly." Yet in fact nothing would change. Max remembers Florence as being mostly angry during her final weeks. While they did not become lovers again, they continued to meet, with dubious results. Once Max, during one of Florence's fits of anger, by his own admission, spanked her—"in jest," as he hastened to add. They laughed about it, he claimed. But the episode leaves a foul taste in the reader's mouth, as it did, no doubt, in Max's, whose prose, in these uncharacteristically sloppy pages of his memoir, displays a sheepishness absent elsewhere. At a loss for the mot juste, he unspools a string of empty phrases meant to cover up the fact that, in those last weeks, he did nothing to help her: "It made me feel sure that"; "I am afraid I refrained"; "I was in no position"; "It was fair, I told myself"; "It required some effort."[74]

Max to Florence, 120 West 11th Street, New York City, December 6, 1921

Florence dear, it is true that my vagueness is what has angered you, and aroused in you that other personality, this Black Panther, that hates me and is disloyal.

I am not vague now, and yet in your presence I am possessed and inarticulate. At least I feel so, and I want to tell you—even if it seems a foolish repetition—the clear truth of my feelings.

When your letter came, saying you had erased me from your heart and memory, I turned from you completely. Nothing could ever make me turn back or involve my life intimately with yours again.

The fact that I accomplished this by making of you in memory a kind of god of my life, does not alter the absoluteness of it. You were the god in my life. If it is sentimental, then you must understand that sentimentality plays the same role for me that anger did for you. It has enabled me to escape from the pain of our relation without stifling the very action of my heart.

I can be one of your friends if you want me, because my admiration and enjoyment of you is indestructible and independent of other emotions. I always have more fun in any company where you are, for the simple reason that the people are always lovelier—more alive and more fine and elevated. Apart entirely from your sex and our memories, I love to play with you. I love to talk with you about everything.

And so I hope you will be able to make me a friend, as you said you could. I will try to be a generous and simple one, but I will not invite you to my house in Croton anymore unless someone else is there, because it is too much of a strain upon the habits of feeling by which I have become happy again.

—————

I seem to understand so clearly now how the same imperial force of beauty and free-will that made me love you with complete rapture, made impossible the long mutual life that may come when such rapture subsides. In that mutual life—if it should ever come to me (as I trust it will not)—*I* would be the imperial one!

I am bitterly sorry that I did not understand—that I could not be definite, so that you need never have hated me in any part of your spirit.

<div style="text-align:center">Max.</div>

In Liberator *envelope, addressed in pencil, perhaps hand delivered.*

Florence to Max, New York, undated

My pride in the image you have of me in your heart is still high, and I was hurt when you suggested that my radiant freedom and your belief in it was lost to you.

If I falter and strive to live a little more tenderly, and if for the first time I stop in doubt and bewilderment, surely it is better than hitting my head blindly against the wall which hurts so much.

The things that have made me weep before you are the same sad things that have made you weep alone in your room, and I am grateful for any change in my feelings that will release me from being cruel and hard. that was the pain I couldn't stand. I must live with Florence and I haven't liked her for a long time.

The whole tragedy of us is that we cannot laugh together. If you could laugh at the little mule in me instead of expecting it to have horse sense I know I could laugh at you, and we could be happy friends.

<div style="text-align:center">Florence</div>

On Hotel Algonquin letterhead. Erroneous date "1920?" added in pencil.

Florence had not yet given up looking for work. There is also evidence that she continued her efforts to establish herself as a writer. While her article "The Dictatorship of Mediocrity" or "The Way Out" has never been found (and was perhaps lost by Vanity Fair, *as she surmised; see Florence to Max, June 28, 1921), she did write and publish "A Great Art," a satire on the moving picture industry that appeared in* Moving Picture World *in February 1922, the month she died.*[75] *The exact date when she wrote the story is unknown. Even if she had received some help with her writing, no doubt the bitterness toward Hollywood was her own:*

Mr. E. D. Ess was feeling very pleased with the world as he sat in his office of the Enormous Picture Co. He put his feet on his desk and lit a big black cigar with a glittering band on it. That evening all the papers would carry a notice of his latest exploit. He had spent five hundred thousand dollars in exactly three minutes, and he knew that was a record—in fact the record up to date. *He was indeed pleased with himself, otherwise he would not have received the mysterious stranger who pushed his way unannounced into his private sanctum.*

"What do you want?" he growled. Don't misunderstand; he didn't feel angry. But after you have made a million dollars, you always growl. That is the language of the very quickly rich and Mr. E. D. Ess belonged to that class. It was after all quite a good-natured growl.

"I want to see you, and nobody else but you—that's why I fought my way thru those fifteen barred doors," said the stranger, and indeed he looked as tho he had been in a fight. His collar was torn off, his coat badly mussed, and his hair a bit pulled—which will lead my reader to guess he had tussled with some of the dear unfair sex, but such was not the case. It was just his own sex that had so unkindly treated him, altho he looked like such a nice fellow behind his big horn-rimmed glasses.

"I've written a scenario; it's my first; but I want to learn to write for the screen, and in all your articles I notice you clamor for original stories, so I thought I would bring one straight to you and we could talk it over." He said this very quickly. Ordinarily a trap door would have opened beneath our audacious friend, and he would have disappeared below, never to be heard from again. But you remember Mr. E. D. Ess was in a very pleasant mood, and really he liked the young fellow's nerve, and the evidences of his athletic ability.

"Hand it here, young fellow, I'll give it the once over," he said. A very large manuscript was promptly laid before him.

"I'd like you to begin with the first scene," said the young man, and he hurriedly turned over the pages to scene one.

Mr. E. D. Ess read for exactly thirty seconds. Then he shook his head.

"Nope. Wont do."

"Really? How can you tell so quickly?"

"As a busy producer, I have the knack of making quick judgments. Just to show you, we'll take the very first scene. Girl refuses to go to church with parents. Father tries to compel her. In the end he strikes her for her disobedience. This is the last straw. She is twenty-one years old and wants to live her own life, so she quietly packs up that night when her parents are asleep and leaves for the city.

"That's terrible! Terrible! No action, no suspense, nothing! And I'll tell you another thing. See that map over there?" The young man turned and saw a map of the United States in two colors, pink and white, mostly pink. "See those pink states, well, in every one of those places, if a girl refuses to go to church, it's out. Understand? They just cut it out. It's against their Board of Censorship."

The young man looked thoughtful. "Really now. Well, I'm sorry," he said. "I just wanted to show a picture of a modern young woman determined to do as she pleases, and I wanted to get her away from her parents and transfer the action to the city."

"Well, I'll tell you, young fellow, that's a darn poor way to get your girl to the city—just have her go upstairs and pack her bag! Say, these are moving pictures—moving! Action! You've got to have pictures moving!" He sat back quite pleased with the clear way he had presented his point.

"I just wanted to get her away from home," said the young man weakly. "It really wasn't very important. Read a little further, perhaps you'll like it better."

"No, I don't have to. But I'll tell you what I'll do," Mr. E. D. Ess growled very softly, "I'll help you. You're an intelligent young man, and I'll tell you very quickly how to get that girl back to the city."

Our young friend looked delighted. "Really, you are too kind," he said, "That's just what I wanted, just a little information."

"Well, you'll get it. My time is worth $125,000 a minute." He couldn't help saying that, altho it almost had a disastrous effect. His listener turned very pale and nearly fainted, but with a great effort he controlled his feelings, and braced himself for the ordeal of receiving a million dollars worth of information.

"Now we'll have the young girl go properly to church, because if she's the heroine, she's got to be good, good all the way thru. Why, if she defied her father like that in the very first reel, how could you ever get the audience to believe in her again? They'd suspect her of being the vamp, and that would queer her from the start.

"She goes to church, and her sweetheart is going to call for her afterwards and walk home with her. Now this is what happens. An automobile drives up, a young man gets out and walks towards her; he is the villain, but she is not supposed to know it."

Our young friend interrupted: "You mean it's so dark that she does not recognize him?"

"No!" shouted Mr. E. D. Ess. "Maybe she recognizes him, that doesn't matter, but he has his back to the audience, and they dont recognize him. That's the point." He glared a little. He didn't like being interrupted when he was in the throes of creation, so he bit his cigar very hard and went on.

"She gets into the car with him, unsuspecting, and she drives away. They go along for a little way. Suddenly he slows down in a dark spot and tries to kiss her. She recognizes him, is very frightened, and tries to fight him. He starts the car ahead full speed, she still struggling. Suddenly they start over the bridge that leads to the city. She knows she is miles from home. There has been a car strike and the men have torn up the tracks, and that evening they are going to dynamite the bridge. The car just starts across when the explosion takes place. They are both thrown in the water, she still struggling with him. She is almost exhausted, when a boat comes in sight. It is the beautiful new yacht of Mr. Percy Asterbilt, returning from Europe. She cries for help, a rope is thrown, and in a fainting condition she is landed to safety.

"When she comes to, she is in the captain's cabin. She looks around in a dazed condition, then she lifts the window and sees that the boat is approaching the city. Just then the door bursts open and the owner enters." He stopped, a little breathless, he had been talking so rapidly. "Good stuff—hey? Action, lots of action! Fine chance for good night shots, and some peachy close-ups. Swell clothes, too."

Very slowly and wearily our young friend nodded his head. "Yes, I see," he said, "Moving pictures—a great art. I have much to learn."

He rose sadly and held out his hand for his manuscript. "You have been very kind," he said. "I'll never forget this." Mr. E.D. Ess closed the manuscript, and for the first time he glanced at the title page. What he saw there seemed to send him into convulsions. He turned red and began ringing all the bells he could lay his hands on. Meanwhile, in a strangling voice he called, "Dont move!"

People came rushing from all sides, and the room was half full by the time his two partners entered. He then rose proudly to his feet. "Gentlemen," he said, "I have the honor to introduce to you Sir Gilbert Worthing, the great English novelist and playwright."

"Stop!" he commanded and held up his hand, as they all started to rush forward. "He has brought us an original manuscript."

He said this very softly—almost in a reverent tone. They all glanced lovingly now at our now bewildered friend, while he added, "And we are going to give him one hundred thousand in cold cash! Gentlemen, what do you say?"

His two partners stepped up and examined Sir Worthing in that same loving way. It seemed almost as if they were going to stroke his cheek, and he looked a little frightened. "Let's give him a hundred and fifty thousand," purred the two partners. They mistook his silence for a refusal. Still he was speechless. Then Mr. E. D. Ess boomed out, "Two hundred thousand is the limit. What do you say, Sir Gilbert?"

Slowly, the great playwright looked from one to the other of the partners. "You want to buy my story for two hundred thousand?" he said. "Really, now, I thought you didn't like it."

With a wave of his hand, Mr. E. D. Ess dismissed the past. "What do you say?"

There was a slight pause. The Enormous Picture Company wondered if Sir Worthing was going to get more money out of them. His answer came very timidly. "Why, yes," he murmured; "charmed, charmed." And he smiled.

It was as tho his answer had touched a magic spring. Instantly a camera sprang up before his face. The partners surrounded him, a flashlight flared; he realized that he had been photographed. A young man then dashed up and asked him a few impertinent questions, and then flew, without paying any attention to the answers, and he knew that he would be misquoted in all the newspapers. Suddenly the room cleared and he and Mr. E. D. Ess were alone with the check. He took the check and looked at it. It faded out like a movie, and he saw jewels and beautifully dressed men and women, and yachts, and mansions, and strange countries. Somewhere in him a little voice lifted thanks for his talents which were so valuable, and could bring him such rewards. He came back to the check again, and remembered he had to give up his manuscript in return. Very graciously he handed it over to Mr. E. D. Ess.

"Oh, we wont need all that, Sir Gilbert. You can have the rest." Very carefully he tore off the front page:

"THE REBELLION OF RACHEL YOUNG
BY
SIR GILBERT WORTHING"

The rest of the manuscript he handed back to our bewildered friend. The vision of the yacht and mansions returned, and he put his fingers lovingly around the check resting in his pocket. "Have it your own way," he said pleasantly.

Mr. E. D. Ess rang another bell, and a little girl came briskly into the office.

"Jenny," he growled. "Here you are. Wrap a story around that title. You know the kind I want."

She took the title and glanced at it. "That'll be easy: I'll have it tomorrow at four," she said, and whisked away.

Readjusting his moustache and his collar, Sir Worthing sauntered out of the fifteen doors, which were now, one by one, held open for him. "A Great Art. A Great Art," he mumbled to himself all the way down the street. "A Great Art," he said to the hat boy when he arrived at his club. And the hat boy, who was used to the ways of genius, simply smiled and said, "Yes, sir; a Great Art."

Granted that, as satire, this is not in a league with Nathaniel West, S. J. Perelman, Lillian Ross, and many others who have targeted Hollywood, but it is still significant. Obviously, Florence had learned a thing or two about script writing during the brief period she worked for Mabel Normand. And clearly, she was no novice at telling a story. While some of the details are a little strange—why, for example, would Sir Gilbert, if he is really such a famous writer, be so shocked when Mr. E. D. Ess offers to pay him for his work? Yet the dialogue rings mostly true, and the setting (note the fifteen doors

Sir Gilbert had to walk through before meeting the great director) has the appearance of authenticity. One cannot help but wonder if "Rachel Young," the resilient heroine of Sir Gilbert's scenario, a young woman "determined to do as she pleases," wasn't modeled to some degree on Florence herself. And in Mr. E. D. Ess's remark that a rebellious woman would be considered "queer . . . from the start" one does hear a faint echo of the antagonisms Florence experienced in Hollywood.

Florence's "A Great Art" is a story about a story or, rather, about a failed story, a scenario that didn't pan out, because it did not meet the expectations of the industry. In a way, Florence was, at the end of her brief life, offering her own more complex form of art, tinged with sarcasm and shaped by her superior intelligence, as a kind of antidote to the inane plots preferred by Hollywood, many of which she had to suffer through in the films in which she had been cast.

However, as Florence herself had told Max just a few months ago, "the sourest flavor in literature is satire" (June 21, 1921). Surely it is no coincidence that the most stinging barbs in "A Great Art" were directed at the man who, for Florence, embodied the industry like no one else, the man who had destroyed her career. Although Sam Goldwyn did not smoke, the approach of E. D. Ess to the film industry is a spoof of Goldwyn's "Eminent Authors" scheme and his hunger for titles by literary luminaries, which he bought and then turned over to studio hacks so that they could distill film scenarios from them. In 1919, the year of the economic slump, aside from buying theaters and expanding his operations to the West Coast, Goldwyn was indeed spending a fortune on such famous writers.

If Florence's firing from the Goldwyn studios was part of a purge initiated by Godsol, the same purge caught up with Goldwyn himself not too much later. On October 22, 1920, the board of directors of his own company fired him, partly because of his profligate ways with the shareholders' money. On March 22, 1921, he severed all connections with the company that bore his own name.

Coda (1922)

On a Friday evening, February 3, 1922, Minnie Morris, a neighbor, found Florence lying on her bed with the gas turned on. That made no sense, since her third-floor apartment at Rhinelander Gardens, 120 West 11th Street, subleased from her friends Doris Stevens and Dudley Malone, had recently been electrified. Even more strangely, the window was wide open. Florence had last been seen the night before, returning to her apartment at around midnight.[1]

Max was at the theater with Neysa McMein when he learned what had happened. He rushed to St. Vincent's Hospital, where he gave a pint of his blood. In a bizarre parody of their life together, Max lay next to Florence's lifeless body on a stretcher. At 12:30 p.m. on Saturday afternoon, Florence died. The assistant medical examiner of the borough of Manhattan did not mention suicide, ruling instead that "illuminant gas poisoning (accidental)" had been the cause of death.[2] One possibility suggested in the papers was that Florence, who was known to have used Veronal, might have turned the gas on when she was already half asleep.[3] But questions persisted, especially after it became known that a quarrel had taken place recently between her and a visitor, which was heard all over the house. And why were the police informed only twelve hours after she had been transported to the hospital?[4] Florence's death had become national news.

Confronted by a Times reporter, Max categorically denied that there had been a rift between him and Florence ("we had an engagement for the theatre on Saturday") and angrily asked that he be left in peace.[5] One newspaper luridly described him as "weak, partly from the shock of the death, and partly from the loss of blood." That same paper also managed to draw Charlie into the whole scandal, holding him responsible for the "coldness" that had existed between Max and Florence. Several of these accounts mentioned rumors that Charlie had proposed to Florence or even that they had been engaged.[6]

Close friends like Claude McKay did not doubt that she had taken her own life, and others were at least convinced that, however she had died, some of the blame rested with Max. At least one newspaper mentioned Max's decision to travel to Russia (which he in fact would do two months later) as a precipitating factor in Florence's decision to take her own life.[7] But in the end, only he knew what, if anything, had taken place between them. In his autobiography, Max mentions having seen her briefly earlier that day, as he

came out of the subway on 42nd Street. She looked more radiantly beautiful than ever, Max wrote, but he did not ask her where she was headed, because he was afraid she might want to know where he was going. (He was, in fact, picking up a specially bound copy of The Sense of Humor for her, as a surprise.)[8]

Florence's mother, Caroline, hired Frank Campbell's Funeral Church on Broadway to take care of all the arrangements. Campbell's company had made a specialty of the funerals of actors, acquiring a reputation that continues to this day. (The celebrities they have buried range from Rudolph Valentino to Lauren Bacall.) On Monday morning, February 6, they organized a service, at which, according to one newspaper account, Florence's brother, Walter Danks (identified as Walter "Deshon"), made an appearance. Walter was working for the railroads in Bergen, New Jersey.[9] Campbell's was decidedly not his world, and it seems he lost it a bit when talking to the reporter. Scoffing at the suicide theory, he brought up Charlie again, who "had once asked to Miss Deshon to marry her," and mentioned a gold cigarette case, apparently a gift from Charlie to Florence, which "had not been found among her things." He also asserted that Florence had had an appointment to meet Max for lunch the day before she died. Was he insinuating foul play, with Max being involved, or, at the very least, that a jealous Max had pilfered that case?[10]

Florence was buried later that afternoon in Mount Zion Cemetery in Maspeth, Queens, the only tangible acknowledgment we have of her Jewish ancestry. Max, who was nearly mad with grief, did not see her again. Crystal had to physically prevent him from going to Campbell's parlor to see Florence's body. She also persuaded him not to attend the funeral. "I lay still in my room as though paralyzed until it was over."[11] He did not have to wait long. In fact, the speed with which the funeral took place—Florence had died during the Shabbat, on a Saturday afternoon, and was buried the following Monday—also suggests at least an attempt to adhere to Jewish custom, the tradition in which her mother had been raised.

Florence's final resting place was in the section reserved for the Chevra Kadisha (or burial society) Independent Order Free Sons of Judah. According to her burial card,[12] she was interred in grave 23 on Path 10L, Road 3, of Mount Zion. No care for her grave was arranged, and no map of the section has survived. The inscriptions on the small markers, surrounded by overgrown grass and wildflowers, have long faded, revealing only occasionally, as if to tantalize the visitor, a D or an O or an F. These memorials no longer remember. Florence is lost, even though we know she is still here, somewhere under one of these small, withered rocks (fig. 5.1).

Figure 5.1. Mount Zion Cemetery, Free Sons of Judah, Path 10L, Road 3.
Photograph by Madeleine Thompson.

Two additional letters in the Deshon manuscripts shed more light on both Florence's life and her death. The first is from a nurse who had once taken care of Florence while she was suffering from the effects of her abortive pregnancy and became deeply distraught when she found out about her death. After Florence had left Los Angeles in August 1920 to seek help from Max, nurse Marie Alamo Thomas from Grand Junction, Colorado, who had, according to the envelope, continued to live in Florence's apartment, wrote a poem to celebrate her, "To Florence Deshon," which Max must have found among Florence's papers. The little work, deeply felt rather than talented, leaves no doubt that Thomas had, in a rather unprofessional way, fallen head over heels in love with Florence. Interestingly, she adopts some of the same images Max used to describe Florence, even paying tribute to her "gypsy-like grace." Likely Florence had shared Max's Colors of Life *with her. "Beautiful eyes are yours, dear. / Eyes dark brown as so sincere. / Sometimes a flame in their depths is burning— / Again they are filled with laughter or yearning."[13] Now back in Colorado, Thomas had to come to terms with the fact that all that beauty and laughter was gone. Capitalizing her nouns, sprinkling her prose with underlinings and dashes, she gave free rein to her*

Love and Loss in Hollywood

grief. Note her reference to Florence loving Max with all "the love a woman could give a man," a love surpassed by that other kind of love of which Marie Thomas wanted her letter to serve as evidence, the love only a woman can give another woman.[14]

Marie Alamo Thomas to Max, February 6, 1922

Dear Mr. Eastman:

I just read of the terrible news of my beautiful Florence Deshon[']s death—I am heart broken! It seems too tragic to think of all her beauty— gone—and yet over and thru and above all my grief comes the vision of her beautiful soul—*free*—at last! She loved Freedom more than any woman I ever knew—to me she was the very Symbol of Freedom—and now she is Free—from all the shackles of Society and Convention—but I *can* not think of never seeing her again!

I do not know if you ever heard her speak of me or not—I am the nurse who took care of her in Hollywood in July 1920 when she lived in the flat at 6220 De Longpre. Then after she returned from New York I lived with her for three months and we were *such* friends and I loved her so.

I want you to do something for me—*please* send me a picture of her— she has promised me one so many times but never sent it and I want one oh! *so* much—*please* get one for me and send it and I will ever be *so* grateful to you.

She used to speak of you *so* often to me—and she loved you dearly— Max Eastman—loved you with all the love a woman could give a man and I want you *always* to remember that—and her!

I read in the paper how you gave your blood for the transfusion to save her life—I'm glad you did that and I know you are sorrowing over her death.

I would appreciate it so much if you would write and tell me about it and if she suffered much—tell me *all* if you can.

I shall not forget her ever—she shall always live in my heart in a hundred beautiful memories—but the grief seems greater than I can bear—her tragic passing!

I am *so* sorry for you—I know you must have loved her—and she loved you *so*!

Please write and tell me all about her and send me *one* picture—

<div style="text-align:right">

Most sincerely
Marie Alamo Thomas.
252 Zeller Ave.
Grand Junction, Colorado

</div>

No envelope present.

The second letter was from Marie Howe, who wrote from the Clifton Springs sanitarium in Ontario County, New York, home of the Clifton Springs Water Cure, where she had gone to seek relief from her chronic liver and gall problems.[15] *She had been one of Florence's closest friends in those final weeks. But her friendship with Max predated Florence's arrival on the scene, and the letter she sent to the grieving Max reflects her divided loyalties. When Max reprinted that letter in* LR, *280–81, he deleted an entire passage in which Howe explained that Florence had wanted to go back to him and that that had turned out to be impossible since he, too, had changed. (The passage appears in italics in the letter below, as does the ending of the letter, which Max also omitted.)*

Marie Howe to Max, February 6, 1922

Dear Max,

I wish I could talk to you. I want to tell you one thing—The cause of Florence's mental despair was her sense of failure in her work.

Don't reproach yourself too much—it wasn't you. If she had found a job she would have been all right again. The constant rebuffs and disappointments wounded her spirit—All this had gone on for so long, for two years or more. Every time she hoped for a position she was stabbed again in the same spot, so that the wound could never heal. It was always open and bleeding. And it was necessary to her pride to conceal this suffering from her friends—from you most of all.

She was with me a great deal these last few weeks—She talked to me hours at a time and I know positively that what I say is true. She needed

a job. I mean she needed it psycologically [*sic*]. Nothing else could have saved her.

Of course her state of mind was complicated by the sort of impasse that existed between you two. But to say that it was complicated, is a very different thing from saying that it was caused by this impasse. The cause was her sense of failure in what she had started out to do.

She went to Hollywood in the first place so filled with the sense of power and success that she abandoned you without a pang of regret. She then showed the dominant impulse of her life, the desire for personal success. I began then to be frightened for her, because she soared so high that I knew how far she had to fall. When I called her joyous excitement the arrogance of youth and beauty, she laughed at me because she was so sure, so terribly sure, of fame and wealth and success.

Then after a short time there followed continued repeated failure.

The man who sent her to Hollywood fed her ego with flattery and false hopes. The day she signed her contract was the beginning of the end. That man—or, if you like, the movies, did her an irreparable injury from which she never recovered.

She chose then between what was to her a perfect love and what she called her career. I go back to this because this choice determined everything and explains everything. It explains her. It explains her last act of despair. She wanted to make good, she wanted to justify that choice and she could not bear the consequences—

All last winter I saw her meet one blow after another. She struggled on manfully. She tried to bolster her self confidence by brave talk. She tried to hide her hurt by silence. She would rather have died than confide all this to you. She had such enormous pride toward you. *She really wanted to go back to the place where she had made that mistaken choice. But life had gone on. You had changed as a result of her departure—she had changed. To go back was impossible.*

All these last weeks in New York her state of mind was getting worse, no work, no hope of work, nothing but discouragement. She decided to leave the movies and go on the stage—again she met disappointment. Perhaps she did not tell you how many people she interviewed, how many times she tried. Then she decided to become a writer—This she talked to you about. She wrote a few things and came to realize that she lacked training and experience. She did not really have confidence that she could ever write. Her first success had been so swift and effortless that she could not face long years of slow preparation for a different work. And she wanted something important and exciting. She did not care for a dull obscure job in the business world.

Finally she faced herself—a girl with youth and beauty and no trained ability for the important position in the world that her soul craved. She saw no future. Instead of the glittering success she had expected there was nothing but blackness.

I am so afraid that you are living through a nightmare of remorse and self-reproach, feeling that you hurt or failed her and that somehow it must be your fault.

Please try to take some comfort out of my assurance that it is not so. Perhaps she talked more freely to me than to anyone. You must believe what I tell you. She struggled to deceive everybody and you more than anyone, and all the time she was falling down down down until she struck bottom.

No love affair could ever kill our beautiful proud Florence—You know and I know that she could always rise above her emotions. They never conquered her, she conquered them—But with pride lost, she could not face the world.

I do not know whether you are going abroad or whether you have already gone, and as I fear this might be opened at the Liberator office, I think it safer to send it in care of Crystal. I do not know your address.

Anyhow, dear Max, if I have not said a word to comfort you, I send you all the sympathy I am capable of feeling.

Affectionately yours,
Marie Howe.

Febru[a]ry sixth
Clifton Sanitarium
Clifton Springs
N.Y.

No envelope present; hand delivered by Crystal Eastman.

Howe's letter is remarkable for her determination to lay the blame for what happened mostly on Florence: torn between career and love (the love of Max, that is), Florence had chosen her career. Spoiled by success that came to her too early and too easily, holding herself to impossibly high standards, she was not prepared for setbacks. No doubt Max was ready for such a spin on recent events. The one passage that attributed a modicum of responsibility to him he did not transcribe.

Yet, in her desire to exonerate Max, Howe might have exaggerated the degree to which Florence suffered disappointments no matter what activity she pursued. As we have seen, Florence continued to receive good reviews even after she returned to the stage. The tragic ending of Florence's life was due to a variety of factors: certainly Max's egotism that militated against the kind of mutually sustaining relationship she envisioned; her ambitiousness, as explained by Theodore Dreiser; and her own inner demons, the curse of all extraordinarily gifted people, what Max called the "Black Panther" that lived inside Florence. Definitely, the changes in the industry also contributed to Florence's problems: the shift to the studio system, for which she, an actress who had come to Hollywood from the older Vitagraph model of making movies, wasn't prepared, as well as the recession of 1920, in the wake of which some of Florence's colleagues lost their jobs, too.

Ridiculing the East Coast bias that holds Hollywood responsible for failed careers, John Gregory Dunne once said that "the writers who fell apart in Hollywood"—he was referring specifically to screenwriters—"would have fallen apart in Zabar's."[16] It is indeed possible that Florence's personal problems would have undone her even had she stayed in New York, that her Hollywood debacle wasn't the decisive factor in her demise. Yet this is ultimately not a satisfactory explanation as to why a woman with a strong work ethic and undisputed charisma, an actress who had proved all over again, in scores of films and on the stage, that she was equipped with superior talent, should have died so senselessly. One thing is certain: the men whom Florence had taken to task for doing "nothing but brag about their power and what they have done for girls, and what they could do for me" (to Max, January 9, 1920) had indeed done nothing to save her. Nor had, as he well knew, Max.

After Florence's burial, Max entered her apartment and retrieved their correspondence as well as the books he had lent or given her. If Florence had refused to be owned by him, if she had rejected his attempts to influence her makeup, her hairstyle, her work, her reading, he was now in control at least of what she had left behind—piles of letters, a few poems, and her treasured volumes of Keats and Milton. For the rest of his life, through two more marriages and an increasing drift to the political Right that finally landed him a job writing for Reader's Digest, *a prospect that would have appalled her, Max kept revisiting his relationship with Florence, compulsively rereading and annotating their correspondence, and then finally writing about her, too. He was convinced that Florence had, in killing herself, also killed a part of him: "My life is buried in the earth with you," he wailed in a poem written after her death.[17]*

Among the papers he retrieved from her apartment, he also would have found a disturbing poem in which Florence metaphorically killed him: "I once said I would not stand / by and watch my love dying / I did not think / that with burning tongue / and brain seething with hate / I would kill him / I did not think / that I would press my heel / upon his throat."[18] *Florence's fantasy continued with her bending over and picking up a stone and putting it inside herself to "carry it for a heart." In the end, though, it was Max who survived the death of their love.*

Charlie, who stayed in touch with Max even when both were old men, never publicly mentioned Florence. But Limelight *(1952), Charlie's last great and most personal film, begins with a scene that Max would have watched with a shock of recognition: we see the young dancer Terry Ambrose, played by Clare Bloom, sprawled unconscious on her bed, clutching a pill bottle, while the gas is streaming out of the stove. Yet this time, Charlie, who plays the role of the alcoholic clown Calvero, gets the chance he wasn't given, or didn't avail himself of, in life. Arriving just in the nick of time, he pulls the woman out of the room, thus rescuing her and, in a way, himself.*[19] *At the end of the film, the old clown dies. While his time has come to an end, his young friend's career has just begun. "The heart and the mind . . . what an enigma."*

NOTES

Introduction

1. Max Eastman, *Venture* (New York: Albert and Charles Boni, 1927), 57.

2. As listed in her passport application, February 28, 1919, National Archives and Records Administration (NARA), Washington, DC, roll *713*, vol. roll 713, vol. roll 0713—Certificates: 66500-66749, 27 Feb 1919-28 Feb 1919. See also the entry for Florence in the *Motion Picture Studio Directory and Trade Annual* (New York: Motion Picture News, 1921), 218. The 1919 edition of the *Directory* (p. 101) describes her interests as dance and outdoor sports.

3. Florence to Max, September 19, 1919.

4. Florence to Max, November 7, 1917; Florence to Max, January 7, 1920.

5. Florence to Max, July 13, 1919; Florence to Max, January 15, 1920.

6. The poet and suffragist Sara Bard Field, upon meeting Florence in 1917, nastily claimed that Florence looked "a bit shop-worn," the result of having had too many lovers in the Village (to C. E. S. Wood, October 6, 1917, Field/Woods Collection, Huntington Library, quoted in Christine Stansell, *American Moderns: Bohemian New York and the Creation of a New Century* [New York: Metropolitan, 2000], 299).

7. See M. Eastman, *The Sense of Humor* (New York: Scribner's, 1922), 6, 4.

8. From Max's account in *LR*, 8–11. John Fox Jr. (1862–1919) was quite the celebrity at the time: *The Trail of the Lonesome* Pine (1908) was among the *New York Times* top ten bestselling novels in 1903, 1904, 1908, and 1909; when Florence was dating him, it had already been adapted for Broadway and film (including a version by Cecil B. DeMille). Some of Fox's letters to Florence are in the Deshon mss., Lilly Library, Bloomington, Indiana.

9. Rumors of Florence's radicalism precede her relationship with Max. According to an apocryphal story, she once stayed in her seat during a movie premiere when the national anthem was played, claiming that she was a citizen of the world rather than of a specific country. The only reliable source for this much-repeated story is *LR*, 7–8. See Beth Gates Warren, *Artful Lives: Edward Weston, Margrethe Mather, and the Bohemians of Los Angeles* (Los Angeles: Paul J. Getty Museum, 2011), 155. Once she had begun dating Max, it was clear to the authorities that she shared his views.

10. Max to Florence, December 29, 1919; Max to Florence, March 4, 1919.

11. "6 Anti-Wilson Suffragists Are Arrested Here," *New-York Tribune*, March 5, 1919, 1, 4.

12. Max to Florence, August 11, 1919. Subsequent references to letters in this collection will be given by date.

13. David Thomson, *Sleeping with Strangers: How the Movies Shaped Desire* (New York: Knopf, 2019), 13–14.

14. For more on this subject, see chap. 9 ("Triangles") in Ethel Spector Person, *Dreams of Love and Fateful Encounters: The Power of Romantic Passion* (1988; Reprint, Washington, DC: American Psychiatric Publishing, 2007).

15. Shakespeare, *The Two Gentlemen of Verona*, II.iv, 192–95, in Shakespeare, *The Complete Works*, ed. Peter Alexander (London: Collins, 1951), 36; René Girard, *A Theatre of Envy: William Shakespeare* (New York: Oxford University Press, 1991), 4, 8–20.

16. See Max to Florence, January 17, 1920; Max to Florence, February 5, 1920.

17. A gift from Max's widow Yvette, Max's notebook, titled "C. Chaplin Florence," is now in the possession of Heather Kiernan and is quoted here with her kind permission. All quotations in this paragraph are from this manuscript.

18. Florence to Max, June 8, 1921.

19. See Max's "Actor of One Role: A Character Study of Charlie Chaplin," in *Heroes I Have Known: Twelve Who Lived Great Lives* (New York: Simon and Schuster, 1942), 155–200, esp. 165, 161. The later version of the essay, "Charlie Chaplin: Memories and Reflections," in *Great Companions: Critical Memoirs of Some Famous Friends* (New York: Farrar, Straus and Cudahy, 1959), 207–47, retains those references (216, 217).

20. See Christoph Irmscher, *Max Eastman: A Life* (New Haven: Yale University Press, 2017), 145–46.

21. See M. Eastman, "Charlie Chaplin: Memories and Reflections," 207–8.

22. *LR*, 206–8; Max to Florence, October 19, 1920.

23. Florence to Max, February 14, 1917.

24. *LR*, 34–35.

25. *LR*, 35.

26. *Who May Safely Advocate Force and Violence?* (New York: American Civil Liberties Union, November 1922).

27. See Michael McGerr, *A Fierce Discontent: The Rise and Fall of the Progressive Movement in America, 1870–1920* (2003; Reprint, New York: Oxford University Press, 2005), 304–6.

28. See Florence to Max, July 22, 1919, revealing some of her own racial bias: "Weren't you shocked at the race riots? Down in Washington Doris and Sally and I were playing with the (Weegee?) board and it said that when the blacks came back, they would burn the senate we were all surprised and I believe a little scared." Max's response was free of such concerns: "Yes, the race riots are terrible, and more is coming. . . . I can see absolutely no end of the race-riots except either the slaughter of hundreds of thousands of negroes, or a success on their part in compelling the respect of the whites by force and organization" (Max to Florence, July 29, 1919).

29. John Jay Chapman, "Coatesville" (1912), *The Selected Writings of John Jay Chapman*, ed. Jacques Barzun (New York: Farrar, Straus and Cudahy, 1957), 256. On the Red Summer, see, for example, Cameron McWhirter's narrative history in *Red Summer: The Summer of 1919 and the Awakening of Black America* (New York: Holt, 2011); as well as, putting events in a larger context, Philip Dray, *At the Hand of Persons Unknown: The Lynching of Black America* (New York: Modern Library, 2002).

30. The account given here follows Douglas Gomery's *The Hollywood Studio System: A History* (London: British Film Institute, 2005); as well as Steven J. Ross, *Working-Class Hollywood: Silent Film and the Shaping of Class in America* (Princeton, NJ: Princeton University Press, 1998), 118–23.

31. Lewis Jacobs, *The Rise of the American Film: A Critical History, with an Essay "Experimental Cinema in America, 1921–1947"* (1939; Reprint, New York: Teachers College Press, Columbia University, 1968), 295.

32. Florence to Max, January 9, 1920.

33. See, for example, Daniel Okrent, *Last Call: The Rise and Fall of Prohibition* (New York: Scribner, 2010), esp. 100–3.

34. Irmscher, *Eastman*, 117.

35. Jerome Edwards, "Mary Pickford's Divorce," *Nevada Historical Society Quarterly* 19, no. 3 (Fall 1976): 185–91.

36. Dave Kehr, "Restoring Fatty Arbuckle's Tarnished Reputation at MoMa," *New York Times*, April 16, 2006.

37. Jacobs, *Rise of the American Film*, 291.

38. Gomery, *Hollywood Studio System*, 64–68.

39. For more on this, see Charles J. Maland, *Chaplin and American Culture* (Princeton, NJ: Princeton University Press, 1989), 56–59.

40. M. Eastman, "Actor of One Role," 155.

41. David Robinson, *Chaplin: His Life and Art* (New York: McGraw-Hill, 1985), 223.

42. Robinson, *Chaplin*, 256; Maland, *Chaplin and American Culture*, 47.

43. Max to Florence, March 4, 1919; *LR*, 147. In *LR*, 146, Max places the first meeting with Charlie at the Los Angeles Opera House, but the contemporary account in the *Los Angeles Times* is likely more trustworthy than Max's reminiscences written some forty years after the fact ("Call for Police at Eastman's Meeting," *Los Angeles Times*, February 27, 1919, 13).

44. "Charlie Chaplin Denies Backing Eastman's Bolshevist Monthly," *Variety* 56, no. 12 (November 14, 1919): 65; [Cal York], "Plays and Players," *Photoplay* 17, no. 3 (February 1920): Advertising Section, 111.

45. Buster Keaton, emphasizing that his creation was a "working man," called Charlie's Tramp a "bum with a bum's philosophy"; see Richard Carr, *Charlie Chaplin: A Political Biography from Victorian Britain to Modern America* (London: Routledge, 2017), 67.

46. See Maland, *Chaplin and American Culture*, 37–39.

47. Ross, *Working-Class Hollywood*, 81.

48. Max Eastman Papers, New York Public Library (hereafter NYPL), T MSS 1994 008, box 1, folder 2.

49. Robinson, *Chaplin*, 275.

50. See *LR*, 208.

51. M. Eastman, *Heroes I Have Known*, 167.

52. Communication from Philip Danks, June 6, 2015. For more on Florence's family, see also Irmscher, *Eastman*, 121–22.

53. *LR*, 10.

54. Communication from Philip Danks, June 6, 2015.

55. Communication from Philip Danks, June 6, 2015.

56. *LR*, 64.

57. U.S. City Directories, 1822–1995, accessed through Ancestry.com.

58. "Additional Notes of the Players," *Motion Picture News* 20, no. 11 (September 6, 1919): 2032.

59. *LR*, 65.

60. "Ernestine," a portrait of woman called "Ernestine de Jongh" ("de Jongh" does echo "Deshon"), is part of Dreiser's *A Gallery of Women*, published in 1929, which consists of a series of portraits of "New Women," to use the then-current term for women defying the social norm. Ernestine first appeared under the title "Portrait of a Woman" in *The Bookman* in 1927 and later in Dreiser's *A Gallery of Women*, 2 vols. (New York: Horace Liveright, 1929), 2:529–64.

61. Dreiser, *Gallery*, 530–31.

62. Theodore Dreiser to Florence, October 29, 1920 (included in this volume).

63. *LR*, 64–65. A good example is David E. Bloch, "Stage Models to Make Illustrations Life-Like," *Printers Ink: A Journal for Advertising* 84, no. 1 (January 1914): 17, which featured Florence with some new barrister bookshelves. The article also contains references to Florence's stage and film performances.

64. "Tells about the People of the Screen," *New York Dramatic Mirror*, April 27, 1918, 594.

65. Mildred Morris, "Greenwich Village as It Ain't," *Photoplay* 15, no. 1 (December 1918): 30–32. Construction of the L train, connecting Manhattan and north Brooklyn, had begun in 1916.

66. Gordon Brooke, "The Lady of the Square Room," *Picture-Play Magazine*, 12, no. 2 (April 1920): 156–57.

67. Warren, *Artful Lives*, 164. Florence's letter to Max of January 9, 1920, does in fact mention that de Meyer photographed Florence. Warren cites a nude photograph of Florence, allegedly by Genthe, that was sold at auction in 1977; see Sotheby's, New York, 19th and 20th Century Photographs sale cat., October 4, 1977, lot 324.

68. Rida Johnson Young, *The Girl and the Pennant: A Base-Ball Comedy* (New York: Samuel French, 1917). For more on the play, see https://baseballhall.org/discover/going-deep /christy-mathewson-helene-britton-and-theater.

69. "New Plays for the Coming Week," *The Evening World* (New York), October 10, 1914, 5.

70. Frank Craven (1875–1945), mentioned several times in the Deshon-Eastman correspondence, already had a reputation as an author and leading actor. Later, he became a famous character actor, best known as the Stage Manager in Thornton Wilder's *Our Town*.

71. Florence's height and weight are confirmed by her entry in the *Motion Picture Studio Directory and Trade Annual*, 1921, 218. On Pickford's size, see Peggy Dymond Leavey, *Mary Pickford: Canada's Silent Siren, America's Sweetheart* (Toronto: Dundurn, 2011), 54.

72. Roi Cooper Megrue, *Seven Chances: A Comedy in Three Acts* (New York: Samuel French, 1916), 67–68.

73. Bloch, "Stage Models to Make Illustrations Life-Like."

74. *American Film Institute Catalog: Feature Films, 1911–1920* (Berkeley: University of California Press, 1988), 59–60.

75. "Frohman Produces 'Jaffery,'" *Motography* 15, no. 26 (June 24, 1916): 1426.

76. "'Million Dollar' Film Completed," *Motography* 15, no. 19 (May 6, 1916): 1035. Florence's return from Kingston, Jamaica, is documented. Traveling on the *Carrillo*, she arrived in the port of New York on March 2, 1916. Passenger and Crew Lists of Vessels Arriving at New York, New York, 1897–1957, Microfilm Publication T715, 8892 rolls, NAI: 300346, Records of the Immigration and Naturalization Service, National Archives, Washington, DC.

77. "Annette Kellerman is a Mermaid Again," *The Janesville (Wisconsin) Daily Gazette*, January 22, 1916.

78. "Frohman Produces 'Jaffery'"; *American Film Institute Catalog*, 792.

79. Julian Johnson, "The Shadow Stage," *Photoplay* 10, no. 6 (November 1916): 79–80. Johnson was no hack. Educated at University of Southern California, he was made the drama critic for the *Los Angeles Times* in 1907 and then became editor of *Photoplay* in 1915. A prominent screenwriter thereafter, he wrote the titles for many of the most famous films of the 1920s. See Anthony Slide, *Inside the Hollywood Fan Magazine: A History of Star Makers, Fabricators, and Gossip Mongers* (Jackson: University of Mississippi Press, 2010), 52.

80. Guy Price, "Jaffery, New Photo Play, Is Rare Gem of Cinema Art," *Los Angeles Herald*, August 24, 1916.

81. Jesse Lasky, letter to C. B. DeMille, October 30, 1916, cited in Paolo Cherchi Usai and Lorenzo Codelli, *L'Eredità DeMille*, *Le Giornale del Cinema Muto* (Pordenone: Edizione Biblioteca dell' Immagine, 1991), 432. The criticism perhaps explains Florence's discomfort when she saw *Jaffery* a year later in the company of some producers (Florence to Max, August 21, 1917).

82. C. Aubrey Smith to Florence, July 13, 1916; Max Eastman Papers, NYPL, Billy Rose Collection, T-MSS 1994-008, folder 4.

83. *LR*, 65–66.

84. Florence to Max, August 17, 1919.

85. "Screen Gossip, by the Screen Colonist," *Picture-Play Magazine* 12, no. 1 (March 1920): 100.

86. See LR, 206.

87. Florence to Max, December 26, 1919.

88. "Stars and Their Hobbies," *Picture-Play Magazine* 12, no. 4 (June 1920): 90.

89. For a possible script by Florence, see "Brother Going Away to School," Eastman Mss. II, Lilly Library.

90. Max to Florence, December 6, 1921. One of her favorite books was Burton's *Anatomy of Melancholy*; see Florence to Max, July 10, 1919.

91. Florence to Max, January 9, 1920.

92. Florence to Max, July 11, 1920.

93. Claude McKay to Max, undated [likely 1935], McKay mss., Lilly Library.

94. See Irmscher, *Eastman*, 160–61; "Young Woman Is Found Dying in Gas Filled Room," *Mansfield (Ohio) News*, February 5, 1922. The prize for lurid reporting goes to the *Dayton Daily News* for an article with the (front-page) megaheadline "Film World Stirred by Fate of Deshon: Screen Star. Actress, Once Reported Engaged to Charlie Chaplin, Found Unconscious in Bed," February 5, 1922.

95. Joseph Freeman, *An American Testament: A Narrative of Rebels and Romantics* (London: Gollancz, 1938), 250. On Max's fraught relationship with Freeman, see Irmscher, *Eastman*, 238–39.

96. Quoted in *LR*, 207.

1. "Words to Keep Us Warm" (1917)

1. Having told Florence earlier that he would always be her friend ("as long as you live you will never have a better one"), Fox kept sending her letters even after her attention had already shifted to Max, announcing that he was worried about her, that she should take

care of herself and avoid any and all temptations: "I am proud of you and hope to be prouder still" (John Fox Jr. to Florence Deshon, December 3, 1916; December 31, 1916; February 17, 1917, Deshon mss., Lilly Library).

2. February 12 is Abraham Lincoln's birthday, observed as a state holiday in Connecticut, Illinois, Indiana, Ohio, Missouri, and New York.

3. Angered by President Wilson's lackluster support for the suffrage amendment, various organizations, among them the Women's Peace Party (whose first president was Jane Addams and which in 1919 became the US section of the Women's International League for Peace and Freedom), picketed outside of the White House for many months, protesting the disenfranchisement of women and often burning copies of the president's speeches. Another group that was active in the demonstration was the National Woman's Party (NWP) and their future leader, Alice Paul (1885–1977). Warned by the police that they would be arrested if they returned, they did so anyway, with many of the protesters ending up in workhouses, and became celebrated in the history of the suffrage movement. Florence later became active in the NWP, if she wasn't already.

4. Beverly West (1898–1982). Her performance as Irene Trevor in *Seven Chances* was praised by *The Nation* as "standing out above the rest" (S. W., "Seven Chances," *The Nation*, August 17, 1916, 160–61). Spending her life in the shadow of her more famous sister, with whom she appeared in a vaudeville act called "Mae West and Sister" or "Mae West and Beverly" and whom she followed to Hollywood, she adopted the name "Beverly Osborne" but was never able to build on her early success on the stage (John Tuska, *The Complete Films of Mae West* [1973; Reprint, New York: Citadel, 1992], 24, 40).

5. Likely a reference to Max's wife, Ida Rauh, and their young son, Daniel, who continued to live in the old Waverly Place apartment.

6. Arturo Giovannitti (1884–1959), activist, union leader, poet, and contributing editor to *The Liberator*. Arrested in 1912 for inciting a riot, he was acquitted after delivering a speech in which he eloquently offered his support for anyone's right to strike.

7. For Max's Detroit speech, given on April 1, 1917, see Eastman mss. II, Lilly Library, box 9, folder "Stopping a World War."

8. A reference to the third installment of William C. Brownell's "Standards," *Scribner's Magazine*, May 1917, 619–26, which praises Max's *Enjoyment of Poetry* (1913) as a "delightful and able book" and comments: "It would be hard to find elsewhere so many penetrating observations on the art of poetry" (624).

9. The Jewish comedy *Potash and Perlmutter* (1913), by Montague Glass and Charles Klein, ran on Broadway for an astonishing 441 performances. Goldwyn went on to produce a highly successful series of films from the play.

10. Harry (Herman) Lorber, Greenwich Village doctor and Max's physician. Florence is not mentioned in Adam Barnett's biography of Lorber (*Dr. Harry: The Story of Doctor Herman Lorber* [New York: Crowell, 1958]). Lorber, who was famous for his receptivity to the quirks of Village artists, treated Max's Croton neighbor Louise Bryant for a similar problem, officially diagnosed as an "infection of the uterus" (Eric Homberger, *John Reed* [Manchester: Manchester University Press, 1990], 118–19).

11. *LR*, 57–58.

12. Art Young (1866–1943), cartoonist for *The Masses*, lived on Chestnut Ridge Road in Bethel, Connecticut, from 1904 to 1942.

13. IWW, short for Industrial Workers of the World, or "Wobblies," supporters of industrial unionism (the "One Big Union" approach). The Wobblies, outspoken critics of the AFL

(American Federation of Labor), were subjected to unprecedented government prosecution. Sydney See left no traces either in history or on Ancestry.com.

14. The Delaware, Lackawanna & Western Railroad (also known as the DL&W, or Lackawanna Railroad) connected Hoboken, New Jersey, with Buffalo, New York, a distance of about four hundred miles.

15. Journalist, poet, adventurer, and revolutionist John "Jack" Silas Reed (1887–1920). The *Times* cites Eastman's Chicago speech ("We are not yet so excited over German atrocities that we can't see the atrocities of our own people") on August 20, 1917 ("5,000 at Pacifist Rally: 'American Kaisers' Denounced by Eastman and Others at Chicago," *New York Times*, August 20, 1917).

16. See figures i.5 to i.10.

17. Edwin Arden (1864–1918) was an American actor, theater manager, and playwright, who ended up with his own stock company in DC.

18. *The Deluge*, directed by Arthur Hopkins and originally written by the Swedish writer Henning Berger, opened at the Hudson Theatre, New York, on August 20, 1917.

19. Note Max's tendency to represent himself as "child." (The fantasy also extends to Deshon, his "miracle child"; see Max to Florence, January 15, 1920; January 3, 1921.)

20. The Amsterdam-born Eugen Boissevain (1880–1949), officially a businessman and importer of coffee from Java but in reality a bon vivant and great supporter of his artistic friends in the Village, was married to the suffragist Inez Milholland (1886–1916), for whose sake he had emigrated to New York. In 1923, he married the poet Edna St. Vincent Millay (1892–1950).

21. Lella Fay Secor (1887–1966), who had a "smile like a Correggio madonna," was in charge of arranging Eastman's 1917 lecture tour on behalf of the People's Council (*LR*, 49). After marrying the economist Philip Sargant Florence, she moved to England, where she became a prominent birth control activist.

22. This was probably Florence's contract to appear in *The Judgment House*. Directed by J. Stuart Blackton, *The Judgment House* was originally supposed to be a Vitagraph film, but Blackton left Vitagraph and the film was released by Paramount. There was publicity about the making of the film, and the *Moving Picture World* lists Florence as a cast member in September 1917: "Violet Heming in Blackton Picture," *Moving Picture World* 33, no. 13 (September 29, 1917): 1993; "First Blackton Paramount," *Motography* 13, no. 13 (September 29, 1917): 654.

23. Ralph Waldo Trine (1866–1958), self-declared mystic and leader of the New Thought Movement, which was devoted, in William James's pithy summary, to "mind cure" by way of an eclectic mix of transcendentalist ideas, spiritual self-improvement, and Christianity. In the 1890s, Trine purchased land in Croton and founded a religious colony. Part of his property included Trine's Lane (now Glengary Road), up the road from Max's property. By the time Max arrived in Croton, most of the New Thoughters had left, though Trine's Lane remained. Information provided by Marc Cheshire, village historian of Croton, who helped us decipher the passage. See also Jane Northshield, "Mt. Airy Road," *History of Croton-on-Hudson*, ed. Jane Northshield (Croton, NY: Croton-on-Hudson Historical Society, 1976), 147–57, 149.

24. Max's yellow clapboard house at 70 Mt. Airy Road in Croton-on-Hudson, a former cider mill and still extant today (if modified and enlarged). At the time, it had four small rooms, a roofless porch, and a barn, which Max used as a study. According to Max, it was "the second oldest [house] in Croton" (*LR*, 5).

25. "Mike" was the nickname Sarah Senter Whitney used for her husband Boardman Michael Robinson (1876–1952), the Nova Scotia–born artist and prolific illustrator for *The Masses* and a contributing editor to *The Liberator*. Boardman and Sarah (Sally, often spelled "Sallie" by Max) were Max's next-door neighbors in Croton. See Albert Christ-Janer (with chapters by Arnold Blanch and Adolph Dehn), *Boardman Robinson* (Chicago: University of Chicago Press, 1946), 10.

26. Ruth Pickering (1893–1984), Eastman's childhood friend and perennial love interest. A journalist and activist for women's suffrage, she married Amos Pinchot in 1919.

27. See Max's poem "To an Actress" from his second volume of poetry, *Colors of Life: Poems and Songs and Sonnets* (New York: Knopf, 1918): "You walk as vivid as a sunny storm / Across the drinking meadows, through the eyes / Of stricken men" (65).

28. "Fargo Hoots Eastman and Stops Meeting: Civilians, Home Guard and Military Show Hostility to Pacifist," *Bismarck (North Dakota) Tribune*, August 29, 1917, 1, 5.

29. The Nonpartisan League (NPL) of North Dakota, founded in 1915, united progressives, reformers, and radicals behind a platform that called for progressive reforms, ranging from improved state services and full suffrage for women to state ownership of banks, mills and elevators, and insurances. The league was led by A. C. Townley, a man after Max's heart, celebrated for driving around North Dakota in a Ford Model T encouraging farmers to join his movement. The NPL used the primary election to take control of the Republican Party in 1916 and dominated all state government until after the war. The antiwar leanings of its leaders led to a backlash, and by 1921 the NPL's influence on politics in North Dakota had ceased.

30. Likely a hat Florence had bought for Max.

31. William Langer (1886–1959), also known as "Wild Bill," a member of the Nonpartisan League, who later served two terms as governor of North Dakota and represented the state in the US Senate from 1941 to 1959.

32. Gordon Brooke, "The Lady of the Square Room," *Picture-Play Magazine* 12, no. 2 (April 1920): 156–57.

33. "'The Barrier' to Be $1.00 Attraction," *Motion Picture News* 15, no. 9 (March 3, 1917): 1369.

34. "'The Auction Block' by Rex Beach," *Moving Picture World*, September 1, 1917, 1404.

35. "Blackton Completes His Second Parker Story," *Motion Picture News* 16, no. 15 (October 13, 1917): 2532.

36. Vincent Pepe was "the rotund, glinty-eyed Italian real estate agent for all Greenwich Village" (*LR*, 123). He had likely brokered Max's move to the house on Washington Place that he shared with Crystal, Eugen Boissevain, and Florence (when she wasn't living with her mother or in Croton). Florence's correspondence includes a small pencil sketch of the apartment's blueprint that also, touchingly, included a room for his son, Dan.

37. Frank Harris (1855–1931), the Irish-born writer and author of the controversially explicit *My Life and Loves* (1922–1927), was in charge of the US edition of *Pearson's Magazine*, a popular monthly publication that published short fiction alongside socialist-leaning opinion pieces. On Max's involvement with Harris and their falling-out, see *LR*, 156.

38. Florence deleted an entire sentence here.

39. Wildly popular stage adaptation of Booth Tarkington's best-selling humorous novel *Seventeen*, about the trials and tribulations of adolescent love. *Seventeen* premiered at the Chicago Playhouse on October 1, 1917.

40. The letter "about Toledo" appears to be lost. From the context, it appears that Max had discouraged Florence from joining him and was hoping that she would disagree with him.

41. Morris Hillquit (1869–1933) was a founder of the Socialist Party of America and a prominent labor lawyer in New York City's Lower East Side. He would defend Eastman during the second *The Masses* trial, successfully keeping him out of prison. Max refers to the fact that on November 6, the Socialist Hillquit, running for mayor, had shocked the New York establishment by garnering an unprecedented 22 percent of the vote.

42. The first of her scripts for Vitagraph. A likely candidate is *The Other Man*, released on February 4, 1918, Florence's first film for Vitagraph. *The Judgment House*, which started out with Vitagraph and was then picked up by Paramount, was completed at least by October 20, 1917, according to the *Moving Picture World* ("Judgment House Set for Nov. 19," *Moving Picture World* 34, no. 3 [October 20, 1917]: 407).

43. On November 6, 1917, New York voters passed woman suffrage in a "sweeping victory" (Brooke Kroeger, *The Suffragents: How Women Used Men to Get the Vote* [Albany: SUNY Press, 2017], 228–29).

44. Rex Beach, *The Auction Block: A Novel of New York Life* (New York: P. F. Collier & Son, 1914).

45. Ross, *Working-Class Hollywood*, 63–69.

46. "Official Cut-Outs by the Chicago Board of Censors," *Exhibitors Herald* 6, no. 1 (December 29, 1917): 31.

47. Dorothy Day, "News of the Movies," *Des Moines Tribune*, December 7, 1917, 2.

48. Richard Abel, *Menus for Movieland: Newspapers and the Emergence of American Film Culture 1913–1916* (Oakland: University of California Press, 2015), 125, 168, 213–16, 217, 228, 243, 274, 344n419.

49. Joseph L. Kelley, "The Auction Block," *Motion Picture News* 16, no. 26 (December 29, 1917): 4590.

50. "Florence Deshon Signs with Vitagraph," *Motion Picture News* 16, no. 26 (December 29, 1917): 4509.

51. Richard Koszarski, *Hollywood on the Hudson: Film and Television in New York from Griffith to Sarnoff* (New Brunswick, NJ: Rutgers University Press, 2008) 108. See the Vitagraph filmography in Anthony Slide and Alan Gevinson, *The Big V: A History of the Vitagraph Company*, rev. ed. (Metuchen, NJ: Scarecrow, 1987) 169–323.

2. "A Lovely Place to Work?" (1918/1919)

1. Doris Stevens, "A Bend in the River (Croton, New York, Neighbors)," dictated at Burke Foundation, July 4, 1961, MC546-1, T-182_02, side 1, Papers of Doris Stevens, Schlesinger Library, Radcliffe College, Harvard University. The writer and women's rights campaigner Doris Stevens (1888–1963) joined Crystal Eastman in forming the Congressional Union for Woman Suffrage in 1913. In 1921, she married the progressive lawyer and former assistant secretary of the navy under Wilson and collector for the Port of New York, Dudley Field Malone (1882–1950). Malone later became Clarence Darrow's co-counsel for the defense of John T. Scopes in the famous "Monkey Trial" (1925). Doris and Dudley were Max's neighbors in Croton, living in a house on the corner of North Highland and Mount Airy Road.

2. "Current Feature Screenplays Passed in Review," *New York Dramatic Mirror*, February 9, 1918, 19.

3. William D. Miller, *Pretty Bubbles in the Air: America in 1919* (Urbana: University of Illinois Press, 1991) 191n195.

4. "Conscription for What?," *The Masses* 9, no. 9 (July 1917): 8.

5. "Notes of the Industry in General," *Motography* 19, no. 14 (April 6, 1918): 686.

6. In the language of the Sedition Act of June 15, 1917, chap. 30, title 1, §3, 40 Stat. 219, amended by Act of May 16, 1918, chap. 75, 40 Stat. 553–54, http://www.vlib.us /amdocs/texts/esp1918.htm.

7. Max Eastman, *Kinds of Love: Poems by Max Eastman* (New York: Scribner's, 1931), 6.

8. "Sixteen Vitagraphs for Release in May," *Motography* 19, no. 18 (May 4, 1918): 845.

9. Larry Langman, *American Film Cycles: The Silent Era* (Westport, CT: Greenwood, 1998), 108.

10. See the Library of Congress's "List of 7200 Lost U.S. Silent Feature Films 1912–1929," http://memory.loc.gov/diglib/ihas/html/silentfilms/silentfilms-home.html.

11. *Max Eastman's Address to the Jury in the Second Masses Trial: In Defense of the Socialist Position and the Right of Free Speech* (New York: The Liberator, 1918) 18, 15. *LR*, 122.

12. The scene is described in *LR*, 81–82.

13. Floyd Dell, *Homecoming: An Autobiography* (New York: Farrar & Rinehart, 1933), 334.

14. Walter Fuller to Crystal Eastman Fuller, undated [August 13, 1919] and undated [August 14, 1919], Crystal Eastman Papers, Schlesinger Library, The Radcliffe Institute; see G. Peter Winnington, *Walter Fuller: The Man Who Had Ideas* ([Mauborget], Switzerland: Letterworth, 2014), 255–56.

15. See her letter to Max, March 9, 1920.

16. Freeman, *An American Testament*, 216–17.

17. See Dell, *Homecoming*, esp. 330–34; as well as Douglas Clayton, *Floyd Dell: Life and Times of an American Rebel* (Chicago: Ivan R. Dee, 1994).

18. Unidentified.

19. The Altadena pacifist and philanthropist Kate Crane, better known as Kate Crane Gartz or "Mrs. Gartz" (1865–1949), the daughter and heiress of Richard Teller Crane of Chicago, founder of Crane Plumbing, was a well-known supporter of progressive causes from labor problems to civil rights. She became one of Florence's most important supporters in Hollywood.

20. Isaac McBride (also known as "Mac"), Max's traveling companion on the "Hands Off Russia" tour; see fig 2.4.

21. National Archives and Records Administration (NARA), Washington, DC, roll *713*, vol. *"Roll 0713 - Certificates: 66500-66749, 27 Feb 1919-28 Feb 1919."*

22. The Covenant of the League of Nations, the first international intergovernmental association with the primary mission of promoting peace, was not signed before June 28, 1919; Florence might be referring to the *proposal*, emphatically endorsed by President Wilson, to create the league that came out of the Paris Peace Conference in January 1919. Thanks to Republican opposition, the United States never joined the League; Max and his radical friends had their own reasons for opposing it. In "All about It: Art Young in Washington," Young called the League "the last stand of Commercial aristocracy" (*The Liberator* 2, no. 10 [October 1919]: 20–23, 23).

23. Did Florence not know that Max had written his dissertation about Plato? See Irmscher, *Eastman*, 79–80.

24. Benjamin B. Hampton (1875–1932), a muckraker and founder of *Hampton's Magazine*, lived in California from 1916 to 1930 and held various positions in Hollywood. He had started his career as a journalist, and his muckraking magazine featured contributions by

Theodore Dreiser, Jack London, suffragist Rheta Childe Dorr, and Rex Beach. *Hampton's Magazine* was evidently successful enough that the targets of his articles managed to put the magazine out of business through a combination of intimidation and the destruction of his lines of credit. He then became an executive in the American Tobacco Company but soon turned his attention to the movie business, both as a new and significant form of communication and as a commercial enterprise. In 1917, he was president of the Rex Beach Film Corporation. In August 1917, Hampton, Rex Beach, and Samuel Goldwyn signed a contract agreeing that all Rex Beach pictures were to be produced and distributed by Goldwyn. *Motography* mentions the forthcoming release of Florence's *The Auction Block*, a Rex Beach film ("Goldwyn Makes New Haul," *Motography* 18, no. 6 [August 11, 1917]: 288). Hampton was also an independent film producer. After 1922, Goldwyn distributed all of Hampton's productions, so one might surmise that Goldwyn and Hampton were fairly closely bound at least by business ties. Florence must have considered Hampton a friend. After he retired from business, he wrote what is still the best account of early American film, *A History of the Movies* (New York: Covici, Friede, 1931). On Hampton, see Rex Beach, *Personal Exposures* (New York: Harper and Brothers, 1940), 185–86.

25. Likely Argus Enterprises in Cleveland, a well-known manufacturing firm producing various types of products for motion picture theaters, such as improved screens. In 1919, Argus ventured into filmmaking, though only two completed productions are documented, *The House without Children* and *Hidden Charms*. See "Foreign Rights Sold on 'House without Children,'" *Moving Picture World* 40, no. 11 (June 14, 1919): 1673; "Argus Enterprises Finishes Second McLaughlin Picture," *Moving Picture World* 21, no. 12 (March 20, 1920): 1952; *American Film Institute Catalog* 402, 430.

26. The phrase "cor gentil" ("the gentle heart"), likely some code shared by Florence and Max, is used by Francesca da Rimini in Dante's *Inferno* V, 100: "Amor, ch'al cor gentil ratto s'apprende" ("Love, which can quickly seize the gentle heart"); *The Divine Comedy of Dante Alighieri: Inferno. A Verse Translation by Allen Mandelbaum* (New York: Bantam, 1982), 44–45.

27. One of a succession of Fords owned and destroyed by Max; see his letters to Florence, July 30, 1919; July? 1919; April 16, 1920. For a memorable description of his first Model T, which made "a noise like Gettysburg" and could go as fast as forty miles an hour, see *LR*, 9. Florence was not blameless in that department either. The *Los Angeles Times* reported that on September 11, 1919, Florence managed to wreck a Ford that she had not even purchased yet during a test drive.

28. Isaac McBride; see note 20.

29. "Call for Police at Eastman's Meeting," *Los Angeles Times*, February 27, 1919, 13. Union leader Eugene Debs (1855–1926), after publicly encouraging resistance to the military draft, was arrested on June 30, 1918, and sentenced to ten years in prison, a ruling that, Max's pleas notwithstanding, would be upheld by the US Supreme Court, the pivotal event that precipitated the May Day Riots of 1919. Tom Mooney (1882–1942), an activist and labor leader, was tried and convicted for his alleged involvement in the Preparedness Day bombing on July 22, 1916, in San Francisco; at the request of President Wilson, his sentence was changed from execution to life imprisonment. Despite evidence of witnesses having been coached at the trial and a worldwide campaign to free him, he was not pardoned until 1939, after having served twenty-two years at San Quentin. Debs, whom Max regarded as "the sweetest strong man in the world," had vigorously denounced Mooney's conviction as a capitalist "frame-up" (Ernest Freeberg, *Democracy's Prisoner: Eugene V. Debs, the Great War, and the Right to Dissent* [Cambridge, MA: Harvard University Press, 2008], 32, 249). The newspaper magnate William Randolph Hearst (1863–1951), no friend of Woodrow Wilson's internationalism, welcomed the Russian

Revolution (Richard Pipes, *A Concise History of the Russian Revolution* [New York: Vintage, 1995], 301).

30. M. Eastman, "Actor of One Role," *Heroes I Have Known*, 156–57. "Bob Wagner" is Rob Wagner (1872–1942), a writer, editor, and painter, and the author of *Film Folk* (1918). Working as an informal secretary, publicist, and political mentor for Chaplin, Wagner was well known for his progressive leanings and antiwar views and had been under near constant surveillance for his allegedly pro-German views.

31. M. Eastman, "Actor of One Role," *Heroes* 157.

32. "Bolshevism Unstinted: Max Eastman Attacks President's Policies at Forum," *Baltimore Sun*, March 14, 1919.

33. Cecil B. DeMille (1881–1959) had not reached the apex of his popularity, although *The Squaw Man* (1914) had made him a well-known figure. He became one of the prominent right-wing figures in Hollywood and most famously waged an extremely vicious campaign to force the Screen Directors Guild to impose a loyalty oath on its members in 1950; see Greg Mitchell, *Tricky Dick and the Pink Lady: Richard Nixon vs Helen Gahagan Douglas; Sexual Politics and the Red Scare, 1950* (New York: Random House, 1998), 131–32. It is ironic that thirty-five years later, when Max had finished his erratic journey to the Right, DeMille sent William Buckley a note of congratulations on the founding of the anticommunist *National Review*, which appeared in its first issue on November 19, 1955, shortly after Buckley had invited Max to join its masthead. See Jack Fowler, "Meryl Streep, Meet Cecil B. DeMille," *National Review*, January 12, 2017, https://www.nationalreview.com/corner/cecil-de-mille-hollywood-conservative-roots/.

34. Ward C. Osborne, *The Ancient Lowly: A History of the Ancient Working People from the Earliest Known Period to the Adoption of Christianity by Constantine* (Chicago: Kerr, 1907).

35. Margaret Lane was the business manager of *The Liberator* and formerly the secretary of the Women's Peace Party.

36. "6 Anti-Wilson Suffragists Are Arrested Here," *New-York Tribune*, March 5, 1919, 1, 4 ("The last banner, borne by Miss Florence Deshon").

37. Max was visiting his old friend from Williams College, Sidney ("Sid") B. Wood (1878–1947), an adventurer who was, at the time, a mining entrepreneur in Smartsville, Yuba County, a historic town in California's gold country; see *LR*, 148, and Sidney Wood's draft card, September 10, 1918, US, World War I Draft Registration Cards, 1917–1918, Yuba County, California, roll # 1544471, accessed through Ancestry.com. Wood was the father of the 1931 Wimbledon singles tennis champion Sidney Wood Jr.

38. On March 10, 1919, the US Supreme Court upheld the ten-year sentence against Eugene Debs, finding that, in the opinion written by Justice Oliver Wendell Holmes Jr., Debs had indeed "obstructed and attempted to obstruct the recruiting and enlistment service of the United States" and that his antiwar speech was subject to prosecution under the 1917 Espionage Act. On April 13, 1919, Debs reported to the West Virginia State Prison in Moundsville. *Debs v. United States*, 249 U.S. 211 (1919).

39. Belasco had objected to the "musicalized production" of *Seven Chances* but relented when Archie Selwyn offered him a share of the profits ("Belasco-Selwyn Jam Settled," *New York Clipper*, May 7, 1919, 7).

40. One of the theaters in Sylvester Poli's megaempire, on Pennsylvania Avenue and 15th Street NW.

41. Alice Paul was one of the leading suffragists and feminists of the period. She was imprisoned for demonstrating in front of the White House after war was declared in April 1917. Both the suffragists and Mooney supporters were out in force at the NWP demonstration

against President Wilson in New York on March 4, 1919. Max seems to have taken of-fense at some comment by Doris about the suffragists having received rougher treatment than the supporters of Tom Mooney. Since we know that Florence was carrying a placard in that demonstration and was nearly arrested herself, one wonders how she felt about Max's put-down of her allies.

42. Much of what follows in the correspondence is overshadowed by Max's concern over his lack of progress on *The Sense of Humor*.

43. Samuel Danks, Florence's father; see the introduction to this volume.

44. Frank Craven had been the lead in the original *Seven Chances*; see the introduction.

45. *Dear Brutus* (1917), a comedy by J. M. Barrie, of *Peter Pan* fame, which ran for 184 perfor-mances at the Empire Theatre in New York before it closed in June 1919.

46. See "Dry Law Denounced: Big Group Cheers," *New York Times*, May 25, 1919.

47. The German answer to the Peace Treaty of Versailles, which (in the form of a long list of complaints!) had actually come on May 15, 1919.

48. A possible candidate is *The Cambric Mask*, a Vitagraph film directed by Tom Terriss and released on April 7, 1919.

49. Under the title *The Jest*, the Italian author Sem Benelli's play *La cena delle beffe* (*The Supper of the Jests*), starring Lionel and John Barrymore, was a great 1919 New York theater success.

50. Θυμός in fact means "spiritedness" or the desire for praise rather than praise itself.

51. Possibly Arturo Giovannitti's letter to the editor, "A Lance for Max Eastman," published not in the *New Republic* but in *The Dial*, no. 66 (February 8, 1919), 146. In his letter, Giovannitti, referring to Max's poem "At the Aquarium," called Max "the foremost poetical ichthyologist in America." He was responding to the poet Louis Untermeyer's unfavorable review of Max's *Colors of Life* ("Whitman, Poe, and Max Eastman," *The Dial*, no. 65 [December 28, 1918], 611–12), in which Untermeyer (1885–1977), a contribut-ing editor to *The Liberator*, had expressed the opinion that the best thing that could be said about Max's poetry was that it served as an excellent introduction to Max's preface (which Untermeyer liked).

52. George Andreytchine (1894–1947/48), a Bulgarian immigrant, a "human torch" (*LR*, 430) with a penchant for getting himself in trouble. After his friends had bonded him out of jail, where his activism had landed him, George escaped first to Croton and then to Russia. In 1915, Chaplin met George in New York and took to him as well. See Chaplin, *My Trip Abroad* (New York: Harper & Brothers, 1922), 15–17. Liberty bonds or loans were war bonds launched by the government to finance the US war effort. Bonds released in April 1919 were also known as "Victory Bonds."

53. The Left Wing section of the Socialist Party of Greater New York held its first general meeting on April 20, 1919, and established the *New York Communist* and the Yiddish-lan-guage *Kampf* as their official mouthpieces.

54. The letter seems to have been destroyed.

55. On May 26, the *Times* reported that anti-Bolshevik forces were making progress against Lenin; that their leader Kolchak had refused Lenin's offer of a truce; and that Britain appeared all set to recognize the Kolchak government, all depressing news for those who, like Florence, had hoped that Lenin's example would reinvigorate the Left in the United States, too.

56. Brander Mathews, "Comparing Lincoln and Shakespeare as Men of Letters," *New York Times*, May 25, 1919. The "very funny review" was the unsigned "The Peep-Hole of the

Unconscious," in the same section, a takedown of Albert Mordell's Freud-inspired *The Erotic Motive in Literature*.

57. "'Pressure' for Suffrage: Three Interlocking Systems of Political Machinery Used by Women in Converting Members of Congress," *New York Times*, May 25, 1919.

58. Doris had two younger brothers, Harry E. Stevens (ca. 1892–1943) and Ralph G. Stevens (1895–1968).

59. Jack Reed and Louise Bryant. Reed—in the words of Louis Untermeyer, a cross of Don Giovanni, Don Quixote, and Jack London—was best known for his eyewitness account of the Bolshevik revolution, *Ten Days that Shook the World* (1919); see Daniel Aaron, *Writers on the Left* (1961; Reprint, New York: Oxford University Press, 1971), 37–41. He wrote for *The Masses* and *The Liberator* but withdrew his name from the latter's editorial page over Max's soft attitude to what he saw as Woodrow Wilson's warmongering. Reed married Louise Bryant (1885–1936) in 1916. Bryant, famous for her recklessness, was introduced to Reed in Portland, Oregon, when she was still married to the wealthy dentist Paul Trullinger. She followed him to New York and eventually to Croton, where, in the fall of 1916, they purchased the house once rented by Reed's former lover, Mabel Dodge (later Luhan). See Robert A. Rosenstone, *Romantic Revolutionary: A Biography of John Reed* (1975; Reprint, New York: Vintage, 1981), 203, 204, 255. Bryant's affairs (among them a protracted one with Eugene O'Neill) were the subject of much scandalized gossip among the Villagers.

60. Irmscher, *Eastman*, 129–30, 161.

61. John Livingston Lowes's *Convention and Revolt in Poetry* (1919) contains a chapter titled "Rhythm, Metre, and Vers Libre."

62. Hutchins ("Hutch") Hapgood (1869–1944), anarchist and drama critic for the *New York Evening Post*. His account of his open marriage, *Story of a Lover*, was published anonymously by Boni & Liveright in 1919. Christine Stansell offers useful context for the interest in sexual experimentation shared by Hapgood and Max (though she incorrectly claims that Hapgood had released the account "under his own name" [Stansell, *American Moderns*, 304]).

63. Popular historical romance about Lincoln's controversial first love, by Arkansas writer "Bernie" (Julia Burnelle Smade) Babcock, published in 1919 by J. B. Lippincott Co.

64. "The Revenge of Hamish" (1878), poem by Sidney Lanier (1842–1881). Lanier was Max's favorite poet when he was in college; see Irmscher, *Eastman*, 34.

65. Likely a reference to the Pedersen case. Malone was defending Captain Pedersen and his son, of the bark *Puako*, against the charge of murdering one of their sailors. The murder trial ended in acquittal, though they were later found guilty of assault charges. "Hear 'Old Salts' on Sea Tragedy," *New York Times*, June 8, 1919.

66. The Nineteenth Amendment, which prohibits the states and the federal government from denying the right to vote to citizens of the United States on the basis of sex, was Doris Stevens's passion. It had passed the house on May 21, 1919, and was finally before the Senate on June 4, the day before Florence's letter, where it was approved with fifty-six nays and twenty-five ayes. From 1917 to 1919, Stevens had taken part in the Silent Sentinels vigils in front of Woodrow Wilson's White House to urge him to support the amendment.

67. No longer extant.

68. Max Eastman Papers, NYPL, T-MSS 1994-008.

69. On Goldwyn's Eminent Authors project, see A. Scott Berg, *Goldwyn: A Biography* (New York: Knopf, 1989), 91–92, 95, 96; Carol Eastman, *The Search for Samuel Goldwyn* (New

York: Morrow, 1975), 50–57; Arthur Marx, *Goldwyn: A Biography of the Man behind the Myth* (New York: Norton, 1976), 98–99, 100–101, 161.

70. Beach, *Personal Exposures*, 186–87.

71. Robinson, *Chaplin*, 245.

72. *Los Angeles City Directory, Including San Pedro, Wilmington, Palms, Van Nuys, and Owensmouth* (Los Angeles: The Los Angeles Directory Company, 1921), 900.

73. See also Florence to Max, August 6, 1919.

74. Robert Burton, *The Anatomy of Melancholy*, ed. Floyd Dell and Paul Jordan-Smith (New York: Farrar & Rinehart, 1927), viii.

75. A chemise.

76. The reference is presumably to Marguerite (not "Florence") Wilkinson's anthology, *New Voices: An Introduction to Contemporary Poetry* (New York: Macmillan, 1919), in which she extensively quotes from Eastman's "admirable book" and endorses especially his opinion that "children are poets" and "love poetry the way poets love it" (380).

77. Sara Teasdale (1884–1933) had won the 1918 Pulitzer Prize for her poetry collection *Love Songs*.

78. In "The New International," *The Liberator* 2, no. 7 (July 1919): 28–35, Max condemns the lackluster response of other countries to the successes of the Russian Revolution: "They are fighting and starving and pouring out the blood of their lives for Socialism, calling to us, their comrades, for world-wide solidarity in the case, and what are we doing . . .?"

79. Peggy Hoyt, Inc., a millinery shop, was located on 16 East 55th Street. After World War I, Peggy Hoyt became one of the foremost American designers of gowns and millinery. Hoyt's designs, known for their abundant use of rhinestones, were meant for a small and exclusive clientele.

80. Robinson, *Chaplin*, 252.

81. A possible candidate would be the actor Jack Sherrill (1898–1972), who had played juvenile roles in such films as *The Witching Hour* (1916). Perhaps more likely is the producer William L. Sherrill (1866–1940), who had good reason to remember and like Deshon. He served as president of the Frohman Amusement Company, which had made *Jaffery*.

82. Twain's *Personal Recollections of Joan of Arc* was published in book form in 1896.

83. As it turned out, Young's humor magazine *Good Morning* was only on hiatus; it survived until 1922.

84. Max was fond of comparing Florence to a gypsy; however, in that he was far from original. See the trivia quiz, "Secrets of the Movies Revealed," in *Aberdeen Daily American*, June 4, 1920: "Q—Of what nationality is Florence Deshon? A—Perhaps you have already suspected that there is something of the gypsy in Florence's dark-eyed beauty. Her mother was a Hungarian gypsy and her father an Englishman."

85. Was Max trying to use a German word (*Klappbett*—for a foldable bed)?

86. Marx, *Goldwyn*, 85–88.

87. Thanks to the Academy Film Archives' public access coordinator, Cassie Blake, and Nitrate Curator, Melissa Levesque, for giving us access to *The Loves of Letty*.

88. Maurice Sterne (1878–1957), sculptor and Mabel Dodge Luhan's husband from 1916 to 1923. Elizabeth "Betty" Hare, formerly Elizabeth Goodwin, was Max's generous Croton neighbor; Max details his "conspiracies" against her bank account in *EL*, 457–58.

89. Presumably "Annie" Crocket, Max's cook (*LR*, 254).

90. Géza Válfi. See Max to Florence, July 29, 1919.

91. Robert Minor's cartoons for *The Masses* were a major piece of evidence at *The Masses* trial. He was also a contributing editor to *The Liberator*. A stay in Soviet Russia converted him to the cause of communism. In 1919, Minor (1884–1952) was held in prison for a month after being accused of acting as an agent for the German Spartacus League in his dealings with American troops in Germany. He was released from military custody in Germany on July 8 after the intervention of a senator from Texas, who had been prompted by Minor's father, a federal judge. The article in the *Times* quoted Max as having said that Minor's views on Russia and class warfare were "a bit too strong" even for him (Edwin L. James, "Minor Was Warned by Max Eastman: Advised to Come Home and Get Proper Slant on Domestic Conditions," *New York Times*, July 12, 1919). Max later took advantage of his friendship with Minor and engaged in a torrid affair with Minor's lover Vera Zaliasnik (Irmscher, *Eastman*, 136).

92. Santa Catalina Island, one of California's Channel Islands, southwest of Los Angeles.

93. Burton cites Antonio Zara's *Anatomy of Wit* (1614) as one of the precedents for his book; see his introduction, "Democritus to the Reader," in Burton, *Anatomy of Melancholy*, 16.

94. The Legislative Committee to Investigate Seditious Activities, popularly known as the Lusk Committee, was formed in 1919 by the New York State Legislature to investigate individuals and organizations in New York State suspected of sedition. Max described the activities of the Lusk Committee as "shadowing all our conspicuously intelligent citizens, holding them up on the street, searching them, breaking into their houses, cracking their safes to see if they have any concealed opinions" ("S-s-s-s-h!," *The Liberator* 2, no. 10 [September 1919]: 24).

95. B. Marie Dell, who was from California, although "Marie" in Florence's letters may also refer to Marie Jennie (Jenney) Howe (1870–1934), the founder of the Greenwich Village Heterodoxy Club, a group of "unorthodox" women that met every other Saturday and was devoted to the idea of "individual psychic freedom." Crystal Eastman, Elizabeth Gurley Flynn, Susan Glaspell, Rose Pastor Stokes, and Doris Stevens were among the members. Howe, a biographer of George Sand, was a former Unitarian minister. In 1919, she was arrested and interrogated about her radical views.

96. Part of an ongoing joke between Florence and Max; see also Florence to Max, October 11, 1920.

97. Oswald Garrison Villard (1872–1949), grandson of the abolitionist William Lloyd Garrison, founder of the American Anti-Imperialist League and owner of *The Nation*. On Villard's instrumental role in the creation of the Men's League for Woman Suffrage, see Brooke Kroeger, *The Suffragents*, 11–21.

98. Alexander Kolchak (1874–1920), leader of counterrevolutionary forces against the Bolsheviks.

99. Parentheses appear in the original. The Ouija, also known as a spirit board or talking board.

100. See "Louis Sherwin Writes Play for Goldwyn," *Motion Picture World* 20, no. 8 (August 16, 1919): 1445. Today, Sherwin is chiefly remembered as the author of the great quip: "[In *Hollywood*] they know only one word of more than one syllable . . ., and that is 'fill-um'" (H. L. Mencken, *A New Dictionary of Quotations on Historical Principles from Ancient and Modern Sources* [New York: Knopf, 1942], 541).

101. Winnington, *Fuller*, 268.

102. Florence's writing trails off the page here.

103. A reference to a variety of strikes or threats of strikes, on the docks, among transport workers, bakers and tenants, and eventually the police, which led some commentators

to claim that the Bolshevik Revolution had arrived in England. See the British suffragist Sylvia Pankhurst's "The British Workers and Soviet Russia," *Revolutionary Age*, August 9, 1919, https://www.marxists.org/archive/pankhurst-sylvia/1919/british-workers.htm.

104. See Max to Florence, July 17, 1919.

105. On their shared fascination with "the handsome Indian," see Max to Florence, July 20, 1910, and figures 3.15 and 3.16.

106. Florence refers to the disclosure of a secret State Department message regarding support for anti-Bolshevik coalitions in Russia that was printed in Villard's *The Nation*. A previous message was read publicly on June 20 in Madison Square Gardens—by Max! See "Shows New Theft of State Message," *New York Times*, July 19, 1919.

107. The *Los Angeles Record* (1895–1933), founded by newspaper magnate Edward W. Scripps (1854–1926). *The Call* was a New York socialist paper from 1908 to 1923. Deprived of second-class mailing privileges because of its opposition to the war, it was only available at newsstands and through door-to-door sales.

108. Florence would have been satisfied to see that, even without her as a member of the cast, a movie version of *The Perch of the Devil*, based on the 1914 book by Gertrude Atherton (1857–1948), did not come to happen until much later. Directed by King Baggot, it was released in 1927. Atherton was one of Goldwyn's Eminent Authors.

109. Francis Patrick Walsh (1864–1939), Kansas City lawyer and advocate of progressive causes, cochairman of the National War Labor Board.

110. The actor Holbrook Blinn (1872–1928), who played the lead in the first movie adaptation of Frank Norris's novel *McTeague*. Eugene Walter (1874–1941) was a prolific author of "social melodramas." In 1919, the Selwyn Theatre in New York staged his play *The Challenge*.

111. A moderately progressive political organization for social reform, the so-called Forty-Eighters unsuccessfully attempted to form a progressive but pro-capitalist third party. *The Committee of Forty-Eight: For a Conference of Americans Who are Equally Opposed to Reaction and Violent Revolution; Its Purposes—and the Reasons for It* (New York: Committee of Forty-Eight, n.d. [1919]).

112. Unidentified.

113. See "Samuel Lumiere," Broadway Photographs. https://broadway.cas.sc.edu/content/samuel-lumiere.

114. Joe (Joseph Ely) O'Carroll was an Irish-born labor organizer and activist with a reputation for aggressiveness, who for several months was involved with Max's friend Margrethe Mather.

115. First mention of photographer Margrethe Mather, whose name is subsequently often misspelled, even by her friend Max.

116. The Chicago Race Riots began on July 27, 1919, and their effects rippled throughout the country (see the introduction).

117. See Max's "Advertising Democracy," *The Masses* 9, no. 8 (June 1917): 5.

118. Joyce Milton, *Tramp: The Life of Charlie Chaplin* (New York: Da Capo, 1998) 178.

119. See Jamie Bisher, *The Intelligence War in Latin America, 1914–1922* (Jefferson, NC: McFarland, 2016), 322.

120. Likely John Larkin, a wealthy New York attorney and part-time resident of Croton, who lived on Prickly Pear Hill, northwest of Max's house. Marie Jenney Howe, founder of the Heterodoxy Club; see note 95.

121. A possible candidate is Theodor Lipps, *Komik und Humor: Eine psychologoisch-ästhetische Unter-suchung* (Hamburg: Leopold Voss, 1898), frequently cited in *The Sense of Humor*, especially in chapter 6, where Max rejects Lipps's "mechanical" theory of laughter. As philosophical treatises go, Lipps's book is neither ponderous nor particularly long (254 pages), but it might have strained Max's command of German.

122. The Tumble Inn, a roadhouse and speakeasy, since demolished, on the Albany Post Road in Croton. Charlie Chaplin took a room at the inn when he came to Croton in the summer of 1920 to be near Florence.

123. On July 27, 1919, Bulgarian communists staged a massive demonstration in Sofia, a prelude to their success in the August elections.

124. Béla Kun, or Kohn (1886–1938), leader of the Hungarian Revolution in 1919.

125. Carl Haessler (1888–1972), a political activist and journalist from Wisconsin. A conscientious objector, he refused to put on the uniform when drafted and served his sentence at Fort Leavenworth as well as Alcatraz.

126. Samuel Untermyer, civic leader and famed trial lawyer (1858–1940).

127. The Rand School of Social Science, a workers' education institute in New York, founded by the Socialist Party of America. For the court case mentioned here, see "Court Dismisses Rand School Case; Justice McAvoy Refuses Postponement Asked for by the Attorney General," *New York Times*, July 31, 1919.

128. The Jamaican American poet Claude McKay (1889–1948), one of Max's closest friends, served as coexecutive editor of *The Liberator* until 1922.

129. First mention of Charlie Chaplin in the correspondence.

130. Rob Wagner's second wife, Florence Welch (1883–1971), a journalist from Kansas, later the business manager of Wagner's magazine *Script*.

131. The Samuel Lumiere portraits mentioned in Max's letter to Florence, July 29, 1919.

132. Naomi Childers (1892–1964) had played the modern equivalent of Joan of Arc, a character named Jane Strong, in a 1917 Vitagraph production, the war-propaganda movie *Womanhood, the Glory of the Nation*, directed by J. Stuart Blackton and William P. S. Earle.

133. The Painted Desert in Arizona. The wish to visit the Painted Desert goes back to Max's college days. During their trip west in 1902, Max and his buddy Sidney ("Sid") Wood (see note 37) made it as far as Flagstaff, Arizona. While Sid followed a group of Native Americans into the Painted Desert, where he lived for two years, the less courageous Max returned home (*EL*, 175).

134. George Andreytchine to Florence, August 1, 1916, Deshon mss., Lilly Library.

135. See Florence to Max, July 26, 1919 (figs. 2.5 and 2.6 in this book).

136. On June 28, *Cambridge Magazine*, no. 8 (1918–1919), celebrated Max as "the most distinguished poet of modern America" ("Literary Digest," 815). The year before, they had reprinted large portions of his preface to *Colors of Life* ("Modern American Poetry," *Cambridge Magazine* [November 2, 1918]: 89–90).

137. On Linn A. E. Gale and his review of Max's poetry in *Gale's Magazine*, see the comment after Max to Florence, July 29, 1919.

138. The cover featured a portrait of a girl against a beige background, drawn by Maurice Sterne.

139. The August 1919 issue of *The Liberator* contained Crystal Eastman's "In Communist Hungary" (5–10) and Arthur Ransome's "Conversations with Lenin" (31–35), from which Florence offers a verbatim quotation in the letter. Max's "To Lenin" was written in 1918 and published in Eastman's *Kinds of Love*, 11. Arthur Ransome (1884–1967) was

an English writer and journalist with personal connections to Lenin and Trotsky (he also provided information to MI6).

140. The August 1919 *Liberator* also featured Claude McKay's "Negro Poems" (46).

141. Business manager of *The Liberator*; see note 35.

142. Paul Jordan-Smith (1885–1971) cowrote the feminist manifesto *The Soul of Woman* (1916) with his wife Sarah Hathaway Bixby Smith. He is now mostly remembered for posing as the artist "Pavel Jerdanowitch" and submitting hoax paintings—one was originally called *Yes, We Have No Bananas* and was created from swirling tubes of running paint—to modern art exhibitions. He called his new movement "Disumbrationism" (because he didn't know how to paint shadows). Art critics were fooled by the masquerade. With Floyd Dell, he went on to edit Burton's *Anatomy of Melancholy* for Farrar & Rinehart. Florence, carrying Burton with her to Hollywood, might have facilitated the collaboration with Dell, whom Jordan-Smith had met when a student in Chicago (Warren, *Artful Lives*, 115).

143. The Chinese "May Fourth Movement," which might have been the source of Florence's interest in a trip to China, peaked with a protest involving thousands of students in Beijing's Tiananmen Square on May 4, 1919. Two years later, the Communist Party of China was formed.

144. Charles Whitman, ex-governor of New York, and lobbyist Richard Henry Burke had approached the state senator George F. Thompson (Niagara) promising a slush fund of $500,000, a law practice worth $50,000, and "moral support" in his quest for the Republican nomination for governor if he backed a bill that would allow the public service commission to increase fares, despite existing contrary provisions ("Thompson Sticks to Bribery Story," *New York Times*, May 16, 1919). Frederic ("Fred") C. Howe (1867–1940), another Croton resident and Marie Howe's husband, was a progressive reformer and commissioner of immigration for the Port of New York from 1914 to 1919.

145. For Untermyer, see note 126. George Bellows (1882–1925), realist painter of urban scenes and political cartoonist for *The Masses*. His support for American entry into World War I made Bellows a bit of a pariah among the Croton radicals.

146. Justus Ebert (1869–1946), author of *Trial for a New Society* (1913), a history of the Lawrence textile strike.

147. Percy Bysshe Shelley's ottava rima poem "The Witch of Atlas," published posthumously in 1824.

148. Written in 1820, "Letter to Maria Gisborne" was included in Shelley's posthumous *Poems* (1824).

149. "To Our American Comrades of the Railroads: From the President of the British Railroad Workers," *The Liberator* 2, no. 9 (September 1919): 8.

150. On the 1919 Actors' Equity Association strike, see Sean P. Holmes, "All the World's a Stage! The Actors' Strike of 1919," *Journal of American History* 91, no. 5 (March 2005): 1291–3171.

151. "The Lesson of the Actors' Strike," *The Liberator* 2, no. 10 (October 1919): 35–40.

152. The actress Ethel Barrymore (1879–1959), a strong supporter of the AEA.

153. Max expressed a similar view of Béla Kun in *The Liberator* 2, no. 9 (September 1919): 8.

154. Here Max draws a line connecting this sheet, filled with only a couple of lines, to the facing sheet (which he then covers completely).

155. Max is responding to Florence's letter of August 4, 1919.

156. A socialist drama at the Selwyn Theater called *The Challenge*, by Eugene Walter (see note 110), starring the popular actors Holbrook Blinn and Alan Dinehart. It ran for

seventy-two performances; the show was still open despite the strike. See the front page of *Variety*, August 13, 1919.

157. Thompson Buchanan (1877–1937), a playwright and screenwriter, would produce the script for the film *Dangerous Days* (1920), in which Florence had a minor role.

158. The "awfully English actor," who cannot be conclusively identified, shows up again in Max's letter to Florence, August 19, 1919.

159. Florence's first reference to Charlie Chaplin.

160. A reference to *The Loves of Letty*.

161. See "New Corporation," *Camera!* 22, no. 15 (July 27, 1919): 4.

162. The movie version of Rex Beach's 1909 novel *The Silver Horde*, released in 1920.

163. A prominent example of Hollywood's interest in Christian Science was *Jewel* (1915), directed by Phillips Smalley.

164. John Keats, Letter to Fanny Keats, April 17, 1819. Four volumes of, or related to, Keats that were formerly owned by Deshon subsequently found their way into Max's library: *Letters*, vols. 1 and 2, ed. H. Buxton Forman (Glasgow: Gowan & Gray, 1901); Sidney Colvin, *John Keats* (New York: Scribner's, 1917); and Francis T. Palgrave, ed., *The Poetical Works of John Keats* (1884/1885; Reprint, New York: Macmillan, 1910). All but the Palgrave edition bear the initials or names of both Florence ("F.D.") and Max; the books are now at the Lilly Library, Bloomington, Indiana. Colvin's volume once belonged to Max's childhood friend Ruth Pickering; it is possible that Florence had taken that volume with her to Hollywood.

165. T. Hayes Hunter (1884–1944), director of *The Cup of Fury* (as well as a long list of other melodramas and thrillers), now best known for *The Ghoul* (with Boris Karloff, 1933). Hunter was hired by Goldwyn in July 1919. *The Cup of Fury* was his first assignment.

166. The mathematician and scientist Émilie, Marquise du Châtelet (1706–1749), Voltaire's partner from 1733 to 1749.

167. John Keats to George and Georgiana Keats, March 12, 1819: "to know in what position Shakespeare sat when he began 'To be or not to be'" (Newton is not mentioned); John Keats, *Selected Letters*, ed. Robert Gittings and Jon Mee (Oxford: Oxford University Press, 2002), 2008.

168. Frank Bacon (1864–1922), actor and playwright, creator of the character Lightnin' Bill Jones. Max re-created Bacon's speech in his "The Lesson of the Actors' Strike."

169. The stage and movie actress Marie Dressler (1868–1934) became the first president of the Chorus Equity Association, founded during the 1919 strike.

170. Max's somewhat erratic punctuation in the re-creation of Bacon's speech has been slightly corrected for the sake of better readability. The speech also appears in Max's "The Lesson of the Actors' Strike."

171. The victim in the Pedersen case had been an IWW "soap box orator," according to the *New York Times* coverage (see note 65).

172. The Indiana-born artist Frank Walts (1877–1941) contributed covers to *The Masses*, *The Crisis*, *The Liberator*, and *New Masses*. For Art Young's perspective on the strike, see "The Terror on Broadway," *The Liberator* 2, no. 10 (October 1919): 34–35.

173. Play by Eugene Walter; see note 110.

174. Florence mentioned wanting to buy a car several times in her correspondence. It was around that time that she crashed a Ford when taking it for a road test; see note 27.

175. Florence is probably referring to Abe Scholtz (1877–1941), a Russian Jew, who was the head cinematographer for *The Cup of Fury*. Judging from the surviving stills at the Museum of Modern Art, Scholtz was an expert in lighting effects.

176. Likely the initials for writer and feminist advocate Sarah Hathaway Bigsby Smith (1871–1935), wife of Paul Jordan-Smith.

177. Mark Twain's *The Mysterious Stranger*; see p. 154.

178. The Actors' Fidelity League (AFL) was formed in opposition to the AEA and its allegedly too radical demands. The AEA referred to the AFL dismissively as "Fido"; its membership never reached the same level as the AEA's.

179. The targets of Max's scorn are established stage actors of the era: Julia Arthur (1868–1950), Janet Beecher (1884–1955), William Collier Sr. (1864–1944), Alan Dinehart (1889–1944), Howard Kyle (1861–1950), Lenore Ulric (1892–1970), David Warfield (1866–1951), and Marjorie Wood (1882–1955). George M. Cohan (1878–1942) was known as the "Yankee Doodle" of the American stage and as the author and performer of the patriotic World War I song "Over There!" Louis Mann (1865–1931), married to the actress and playwright Clara Lipman, was a theater comedian who occasionally ventured into film as well. "Mrs. Fiske" was Minnie Maddern Fiske (1865–1932), a stage actress known for her performances of Ibsen and resistance to the Theatrical Syndicate. "Blynn" is Holbrook Blinn; see note 110.

180. Harry Mountford (1871–1950), a British music hall performer, had assumed leadership of the union of vaudeville artists, known as the White Rats.

181. The painter and sculptor Andrew Dasburg (1887–1979), who was born in Paris and competed for Bryant's affections with Reed. Later, he also lived with Max's ex-wife Ida Rauh. See Virginia Gardner, *"Friend and Lover": The Life of Louise Bryant* (New York: Horizon, 1982), 237.

182. The 1919 Emergency National Convention of the Socialist Party of America, held in Chicago from August 30 to September 5, 1919. The effort by the "regular" attendees to suppress the party's Left Wing led to the three-way split, with the Communist Labor Party formed at the meeting and the Communist Party of America established on September 1, also in Chicago. See Max's comprehensive account, illustrated by Art Young, "The Chicago Conventions," *The Liberator* 2, no. 10 (October 1919): 5–19.

183. The social realist painter William Gropper (1897–1977) worked as an illustrator for *The Masses*, *The Liberator*, and *New Masses*. See "Heraldgrams," *Exhibitor's Herald and Motography* 9, no. 10 (August 30, 1919): 40: "WILLIAM GROPPER, prominent among the younger set of artists, will make impressionistic sketches of Goldwyn stars for the use of newspapers and magazines around the country."

184. Unfortunately, *Deliverance* (1919) was not commercially successful. The steel magnate Charles Schwab had put up $250,000 to finance the enterprise. See Joseph P. Lash, "Helen Keller, Movie Star," *American Heritage* 31, no. 3 (April/May 1980), https://www.americanheritage.com/helen-keller-movie-star. Helen Keller appeared on *The Liberator*'s masthead as a contributing editor.

185. A "one-lunger" is a one-cylinder engine. The implication is that the scabs are weak, half-hearted people.

186. See figure i.1 in this book. The photographer's name was Marjorie Jones, a Chicago photographer, who was briefly Floyd Dell's lover after his arrival in the Village. They separated in 1916 (Ross Wetzsteon, *Republic of Dreams: Greenwich Village, the American Bohemia of 1910–1960* [New York: Simon and Schuster, 2002], 255).

187. For more on Allan Dwan, see Kevin Brownlow, *The Parade's Gone By* . . . (Berkeley: University of California Press, 1996), 95–104.

188. Chase Herendeen had married the director Dudley B. Murphy (1897–1968) on August 27, 1919. In 1921, she was featured in Murphy's short film *The Soul of the Cypress* as a wood nymph frolicking on the seaside cliffs of Point Lobos. Murphy's experimental dance film was set to Debussy's *Prélude à l'après-midi d'un faune*.

189. George Andreytchine, see note 52.

190. Terry Ramsaye, *A Million and One Nights: A History of the Motion Picture through 1925* (1926; Reprint, New York: Touchstone, 1986), 806–7.

191. Most film historians are unsympathetic to Godsol. For a slightly more favorable view, see Kevin Lewis and Arnold Lewis, "Include Me Out: Samuel Goldwyn and Joe Godsol," *Film History* 2, no. 2 (June–July 1988): 133–53.

192. Margaret Lane; see note 35.

193. S. A. Connell, "Re:—MRS. KATE GARTZ, UPTON SINCLAIR, MAX EASTMAN et al.—Radical Activities," December 8, 1919, FBI Case Files Various (#374663), folder 3, p. 7, records concerning German enemy aliens, German sympathizers, and other individuals suspected of disloyalty, mainly during World War I ("Old German Files"), 1915–20 (595 rolls); and records transferred from the Department of Justice ("Bureau Section Files"), 1920–21 (81 rolls); Record Group 65, National Archives, College Park, Maryland.

194. Curiously, a Freedom of Information Act (FOIA) request for Max Eastman (FOIA case RD 42256) revealed little useful information, while a similar request to the FBI for records on Florence produced nothing at all (FOIA request no. 1413442-000, FBI to Christoph Irmscher, August 23, 2018).

195. *LR*, 172. Joyce Milton suggests that Florence met Chaplin at a dinner at the Wagners, probably in September 1919. Milton, *Tramp*, 164.

196. M. Eastman, "Actor of One Role," *Heroes*, 165–66.

197. Carrie Nation (1846–1911), radical American temperance activist, known for taking a hatchet to taverns.

198. M. Eastman, "Actor of One Role," *Heroes*, 166–68.

199. Chaplin, *My Trip Abroad*, 15. In *Heroes*, Max cites this passage from the French edition of Charlie's book, *Mes Voyages* (168).

200. From Rosalinde Fuller's autobiography, quoted in Winnington, *Walter Fuller*, 306–7.

201. See M. Eastman, "Actor of One Role," *Heroes*, 181.

202. Irmscher, *Eastman*, 146–47, 384–85.

203. Sidney Wood, Max's college friend (see note 37). Joe was Joe O'Carroll (see note 114).

204. Max's review of Floyd Dell's treatise on education, *Were You Ever a Child?*, appeared under the title "Education Made Happy," in *The Liberator* 3, no. 2 (February 1920): 4. Max lavished ironic yet heartfelt praise on his largely self-taught friend ("there is hardly a better educated man in the United States"). Wang Wei (699–759) was a famous Chinese poet during the Tang dynasty. Max's reworkings of Moon Quan's translations of Wang Wei were published, in considerably revised form, in *Kinds of Love*, 61–62. On Moon Quan, or Kwan ("a young delicate-featured Chinese poet I knew in Los Angeles"), see the note accompanying the two translations in Max's *Poems of Five Decades* (New York: Harper & Brothers, 1954), 34. Moon Kwan was the subject of several photographs by Mather; see Warren, *Artful Lives*, 145–46; Beth Gates Warren, *Margrethe Mather and Edward Weston: A Passionate Collaboration* (Santa Barbara, CA: Santa Barbara Museum of Art, 2001), 21–23.

205. According to Max's own later note in the margin, this was "Joe O'Carroll."

206. Perhaps a parody of a phrase Charlie would often use; see Warren, *Artful Lives*, 175.

207. Vera Zaliasnik, see note 91.

208. The artist and poet Lydia Gibson (1891–1964) had worked as an illustrator for *The Masses*, where Max had also published thirty of her poems. In 1915, Gibson married the industrial engineer Harold Mestre, with whom she moved to San Francisco, a fact usually omitted from her biography (New Jersey, Marriage Index, 1901–2016, accessed through Ancestry.com). After relocating to New York, she worked with Bob Minor in the *Liberator* office; he became her second husband.

209. Genevieve Taggard (1894–1948)—poet, socialist, and, later, a professor at Sarah Lawrence College—edited an anthology of the verse from *The Liberator* called *May Days*; her alleged misrepresentation, in the introduction to her anthology, of Max's testimony at the *Masses* trials became the cause of a massive falling out between Max and her (see Irmscher, *Eastman*, 384n85).

210. "The Lonely Bather," in Max's *Colors of Life*, 45, a poem rich with suggestive allusions ("Your flesh of passion pale and amber-kissed / With years of heat that through your veins have run.").

211. Charles Erskine Scott Wood (1852–1944), was a Portland, Oregon, civic leader, artist, and attorney, credited with recording Chief Joseph's famous surrender speech. His long poem *The Poet in the Desert*, called "strong meat" by the *New York Times*, was published in 1918 by W. Baltes and Company in Portland.

212. A kakemono is a Japanese scroll painting.

213. Hugo Gellert, born Hugó Grünbaum (1892–1985), Hungarian American illustrator, muralist, and cartoonist, contributor to *The Masses* and a contributing editor of *The Liberator*. Livia Cinquegrana (1894–1988) was an Italian, Australian-born fauvist painter (and recent immigrant to the United States). Hugo and Livia were married in June 1921 (New York, Marriage License Indexes, 1907–2018, accessed through Ancestry.com).

214. The Kinema, on 642 South Grand Avenue in Los Angeles (later renamed The Criterion), had opened on December 15, 1917, with Cecil B. DeMille's *The Woman God Forgot*. The California Theater at 810 South Main Street was leased by Goldwyn and became known as the "Home of Goldwyn Pictures."

215. The *20th Century Limited* was an express passenger train on the New York Central Railroad, traveling between Grand Central Terminal in New York City and LaSalle Street Station in Chicago.

216. A reference to *A Day's Pleasure*, released December 15, 1919. Both *Sunnyside* and *A Day's Pleasure* (Charlie's 1919 releases) were critical failures.

217. Elmer Ellsworth, originally from Salt Lake City, known for his sarcasm, introduced Mather to photography and worked for Charlie (until their falling out over a large sum of money Ellsworth had kept for him). See Jessica Buxton, "With Writer, Elmer Ellsworth, c. 1921," *Discovering Chaplin* (blog), February 11, 2013, https://discoveringchaplin.blogspot.com/2013/02/with-writer-elmer-ellsworth-c-1921.html.

218. Charles Cullum Parker's store at 220 South Broadway relocated in 1921 to the new Pacific Finance Building at 520 West Sixth Street in Los Angeles.

219. For "I" read "he."

220. Unidentified.

221. Reginald ("Reggie") Pole (1887[?]–?), an English-born, Cambridge-educated actor and acting teacher who went on to develop a serious crush on Florence; see Florence to Max, January 15, 1920.

222. Robinson, *Chaplin*, 522–28.

223. As Richard Carr calculates, Charlie's weekly wage had increased 137-fold in four years in the United States, from $150 a week at Keystone in 1913 to $20,000 with the First National Film Corporation in 1917. While Charlie, in 1917, thus raked in about $1 million a year (roughly $20 million a year in today's money), President Wilson's annual salary was $75,000 (roughly $1.5 million in today's money). See Carr, *Chaplin*, 86. Thanks also to Charles Maland for related information. The figures account for an inflation rate of close to 19 percent (https://www.usinflationcalculator.com/).

224. Dan Lane, Margaret Lane's husband (Winnington, *Fuller*, 23–54).

225. Florence refers to the holiday telegram from her Croton friends ("my friends on the hill"), which was sent December 25.

226. Charlie seems to have cut that scene. The only existing version is the one Charlie produced in 1963 by adding musical accompaniment (to extend the copyright terms). Communication from Charles Maland, August 22, 2012, and Nicola Mazzanti, Conservator Cinémathèque Royale de Belgique, September 17, 2012. The production records for *A Day's Pleasure* at the Chaplin Archives also make no mention of shooting Florence's scene.

227. Frayne Williams (1884–1962), a Welshman by birth and versatile actor, friends with Chaplin and Mather.

228. Ramiel McGehee (1882–1943), born Clarence McGehee and renamed Ramiel ("the universal mind") by a Persian friend, was a dancer and writer deeply versed in Eastern cultures. He was involved in a brief relationship with the photographer Edward Weston.

229. Likely Walter Danks, Florence's brother, proof that they were still in touch. The 1920 census shows Walter working as a clerk for the railroad in Bergen, New Jersey (Fourteenth Census of the United States, 1920, NARA microfilm publication T625, 2076 rolls, roll T625_1019, p. 15A, Enumeration District 99, Records of the Bureau of the Census, Record Group 29, National Archives, Washington, DC, accessed through Ancestry.com).

230. See Max's editorial "Contributions" in *The Liberator* 3, no. 2 (February 1920): 7.

231. Presumably a derogatory reference to B. Marie Dell. Floyd's first novel was titled *Moon-Calf* (1920).

232. Margaret and Dan Lane (see note 224).

233. Jan Maurits Boissevain (1883–1964), Eugen Boissevain's brother.

3. "Talking Together in the Ford" (1920)

1. The December 1919 issue of *The Liberator* contained a long article by Floyd Dell, "Pittsburgh or Petrograd?," about the Pittsburgh Steel strike, organized by a weakened American Federation of Labor ("With the most brazen and cynical candor, the United States government has placed itself on the side of capitalism. . . . The workers can only make one reply: organization on a grander scale," 10); a report on the Glasgow Congress of the British Trade Unions by Crystal's husband Walter Fuller ("Leftward Ho!," 11–14); a clutch of book reviews, all of them by Floyd Dell; and a brilliant response by Max to Romain Rolland's "Declaration of Intellectual Independence" ("Morally it is distasteful to me to treat of myself, and to see you and those associated with you, treating of yourselves as 'intellectuals,' and conceive yourselves as thus forming a separate class"; "A Letter to Romain Rolland," 24). It is possible that in his letter Max was objecting to Floyd's oversized presence in the issue, which was arguably a product of Max's prolonged absence (there was no November issue for 1919), and that he also resented the somewhat lackluster tone of Floyd's Pittsburgh article.

2. Waldo Frank, *Our America* (New York: Boni and Liveright, 1919); F. H. (Francis Hackett), "Mr. Frank's America," *New Republic*, December 24, 1919, 122–23. Frank (1889–1967) was a radical novelist and pacifist, associate editor of *Seven Arts*, known for his intense interest in the Hispanic world.

3. The oldest and most fashionable hotel on lower Fifth Avenue, at the northeast corner of 8th Street (demolished in 1954).

4. McWhirter, *Red Summer*, 239–41; McGerr, *A Fierce Discontent*, 206.

5. Likely a reference to the Palmer raids; see Florence to Max, January 7, 1920.

6. Charles Ray (1891–1943), a silent movie star known for his success in juvenile roles and playing country bumpkins.

7. Reginald Pole's production of *Othello* at the Los Angeles Trinity Auditorium, February 20 and 21, 1920.

8. On Hughes's anticommunist efforts, see Larry Ceplair and Steven Englund, *The Inquisition in Hollywood: Politics in the Film Community* (New York: Anchor Press / Doubleday, 1980), esp. 37–38.

9. "When Is a Revolution Not a Revolution: Reflections on the Seattle General Strike by a Woman Who Was There," *The Liberator* 14 (April 1919): 23–25.

10. "The Cup of Fury: Synopsis," (c) L14707, February 5, 1920. Copyright synopsis, 10 pp. (microfilm of original copyright deposit), Library of Congress, Motion Picture, Broadcasting and Recorded Sound Division.

11. Rupert Hughes, *The Cup of Fury: A Novel of Cities and Shipyards* (New York: Harper Brothers, 1919), 15.

12. The British actress Clarissa Selwynne (1886–1948), who seems to have specialized in playing matrons and dowagers at Goldwyn Studios and elsewhere, playing in over one hundred films. She also costarred with Florence in *Dangerous Days* (1920).

13. Rockliffe Fellowes (1883–1950), a Canadian actor best known for playing the role of the gangster Joe Helton in the Marx Brothers' *Monkey Business* (1931).

14. Apparently, the French revolutionaries could not speak French.

15. Hughes, *Cup of Fury*, 67–68.

16. Hughes, *Cup of Fury*, 68.

17. "Industry Leaders Pledge Support to Lane's Americanization Plan," *Moving Picture World* (January 24, 1920): 583. See Ross, *Working-Class Hollywood*, 129–30.

18. S. N. B., "Rupert Hughes and Karl Marx," *New Republic* (July 19, 1919): 335–36; "War as Rupert Hughes Sees It," *New York Times*, May 18, 1919.

19. James O. Kemm, *Rupert Hughes: A Hollywood Legend* (Beverly Hills, CA: Pomegranate, 1997), 90, 98, citing Frederick Palmer and Eric Howard, *Photoplay Plot Encyclopedia* (Los Angeles: Palmer Photoplay, 1920), 78.

20. [Cal York], "Plays and Players," see introduction, note 44.

21. On de Meyer, see the "Interlude" in this book.

22. Boris Anisfeld (1878–1973) had arrived in New York in 1918. The same year, a major exhibition of his art opened in Brooklyn and traveled the country.

23. Frayne Williams, see chapter 2, note 227.

24. Edna Purviance (1895–1958), Charlie's muse and the leading lady in many of his films. See figures 3.3. and 3.4.

25. "G" is, of course, Samuel Goldwyn.

26. The unidentified Chinese professor was praising the Empress Dowager Cixi (1835–1908). On Moon Kwan ("Moon-huan"), see Max to Florence, December 21, 1919.

27. Edward Weston, "Ramiel McGehee in Japanese Noh Dance, 1918," in Merle Armitage, *Dance Memoranda*, ed. Edwin Corle (New York: Duell, Sloan & Pearce, 1946), n.p. (section on "Portraits and Persons").

28. Possibly Charlie's Japanese driver, Toraichi Kono (1885–1971).

29. "Othello Benefit for Children's Hospital," *Los Angeles Times*, February 19, 1920, sec. 2, 12.

30. Warren, *Mather and Weston*, plate 33.

31. Marquis Busby, "'Idiot' Is Intensely Powerful," *Los Angeles Times*, January 26, 1928, A11.

32. "Grock" (1880–1959), born Charles Adrien Wettach, a world-famous clown, was in fact Swiss.

33. Thompson Buchanan's *Civilian Clothes* ran at the Morosco Theatre from September 12, 1919, to January 1, 1920.

34. "Clarissa" is Clarissa Selwynne; see note 12. "Betty" is Betty Compson (1897–1974), who went on to head her own production company and became one of the most prominent stars of the silent screen.

35. An inside joke. Max misspells Toraichi Kono's name (see note 28). Kono appeared in Charlie's 1916 short *The Rink*, to which this line alludes.

36. Max's former apartment at 126 Washington Square, New York.

37. Allen Norton (1888–1945[?]), poet and, with his wife Louise Norton, editor of the little magazine *The Rogue* (1915–1916). Louise and Allen separated in 1917.

38. Crystal's outspokenness and activism had indeed limited her career choices. She died on July 8, 1929, aged only forty-eight, after a series of professional setbacks and disappointments (Irmscher, *Eastman*, 219).

39. Frances Crane Lillie (1869–1958), married to the zoologist Frank R. Lillie. The black sheep of the family, she joined the picket lines during the International Ladies' Garment Workers Union strike of 1915 and managed to get herself arrested.

40. See, for example, Wolfram Tichy, *Chaplin* (Hamburg: Rowohlt, 1974), 70.

41. Constance Brown Kuriyama, "Chaplin's Impure Comedy: The Art of Survival," *Film Quarterly* 45, no. 3 (Spring 1992): 26–38, 31.

42. M. Eastman, *Sense of Humor*, 46.

43. J. M. Barrie (1860–1937), author of the immensely popular play *Peter Pan; or, the Boy Who Wouldn't Grow Up* (1904). Barrie never wrote that play for Charlie, but at a dinner in Charlie's honor during his 1921 trip abroad, he expressed the wish that Charlie play Peter Pan. (He also criticized the heaven sequence in *The Kid* as "entirely unnecessary," Robinson, *Chaplin*, 285.)

44. On Mather's affair with "Wild" Joe O'Carroll and her portrait of him, see Warren, *Artful Lives*, 144–45.

45. Inserted later at the top of the sheet.

46. Two potential candidates for those are *Florence Deshon with Rose* and *Florence Deshon*, both taken in 1919. Warren, *Margarethe Mather*, plates 20 and 21.

47. Metropolitan Museum of Art, Elisha Whittelsey Collection, accession no. 1975.502.

48. Ariella Budick, "The 'Debussy of the Camera': Adolph de Meyer's Photographs at the Met," *Financial Times*, January 5, 2018.

49. See Adolph de Meyer, *A Singular Elegance: The Photographs of Baron Adolph de Meyer* (San Francisco: Chronicle / International Center for Photography, 1994), fig. 16.

50. See Anne Ehrenkranz, "A Singular Elegance," in de Meyer, *A Singular Elegance*, 13–49.

51. See Beth Saunders, "More than a Honeymoon: The Influence of Japan on Adolf de Meyer's Photographs," *Now at the Met* (blog), April 3, 2018, https://www.metmuseum .org/blogs/now-at-the-met/2018/adolf-de-meyer-honeymoon-japan.

52. A likely lapse on Florence's part. Instead of "if," read "in."

53. Originally spelled "A. W." but then corrected by Florence. William Andrews Clark (1877–1934), son of the copper baron and US senator W. A. Clark Sr., was the founder and principal benefactor of the Los Angeles Philharmonic. UCLA's William Andrews Clark Memorial Library houses his extensive collection of rare books and manuscripts.

54. The Theatre Guild's production of Tolstoy's *The Power of Darkness* opened on January 19, 1920, at the Garrick, with Ida Rauh playing the part of Anisiya (a character who kills her own husband, a detail she would have appreciated). *Theatre Magazine*, in its March 1919 issue, called the play "not cheerful entertainment" (184). One wonders if a similar thought had crossed Florence's mind as she pointed out Ida's suitability for acting in a Tolstoy play.

55. The lifelong pacifist Roman Rolland (1866–1944), who had won the 1915 Nobel Prize in Literature, had sent a letter of support to *The Masses*, praising the editors for the "good fight you are putting up." After the war, Max attacked him for his "idealism" (*LR*, 19, 175–76); see also note 1.

56. Paul Jordan-Smith, see chapter 2, note 142.

57. Max is misquoting a line from his own poem "Leif Ericson" (1913): "And sweet is the world to the dreamer and doer of dreams" (M. Eastman, *Child of the Amazons and Other Poems* [New York: Mitchell Kennerley, 1913], 69).

58. The phrase "short wrinkles of grief" later occurs in Max's *The Sense of Humor*: "it seems strange that tears and moanings and the piteous short wrinkles of grief in the forehead should be accepted by philosophers as justified through their expressive value, while laughter . . . should always have to be explained away" (9). It is possible that Max had, in conversation, tried out the phrase as a description of Charlie's acting and thus provoked his ire.

59. Reading conjectural; Max's handwriting is difficult here. The pictures are unidentified.

60. Florence Rauh (1880–1977), Ida's sister and a well-known feminist socialist and supporter of revolutionary arts in the Village.

61. Daniel Eastman (1912–1969), Max's son, who later worked as a psychologist and writer. Abandoned by his father when he was only four, he never quite overcame his resentment and only incompletely reconciled with him later. Daniel died within a half year after Max did, according to family tradition by his own hand (Irmscher, *Eastman*, 118–20, 362–63).

62. Jeffrey Fuller (1917–1970), Crystal Eastman's son.

63. Gabriel-Maximilien Lieuvielle, better known under his stage name "Max Linder," was a successful French comedian known as "Max" (for his impersonation of a well-dressed, somewhat befuddled character who inevitably runs into trouble because of his fondness for beautiful women). Max Linder's works include such hilarious shorts as *Max prend un bain* (1908) and *Max Wants a Divorce* (1917). Linder's attempt to export "Max" to the United States was not entirely successful with audiences, and he and his wife committed suicide in 1925.

64. Mary Wilshire, wife of the socialist millionaire Gaylord Wilshire, who had studied with C. G. Jung. On Herendeen and her husband Dudley Murphy, see chapter 2, note 188.

65. Likely the murder of Ream Constance Hoxie, seventeen years old, beaten to death in her own bedroom on West 89th Street in New York. The intruder played ragtime tunes on the phonograph as he killed her. The lurid case, which, for obvious reasons, captured the imagination of the Jazz Age set, remained unsolved. Florence would have read about it in the *Los Angeles Herald*, February 3, 1920: "Jazz Murderer of Beauty Is Hunted."

66. Max, a formalist poet himself and not a fan of Algernon Charles Swinburne, as documented in his essay "The History of English Poetry," added to the revised edition of *Enjoyment of Poetry*: "Swinburne . . . poured out a liquid stream of language like tide running out through a channel, a liquid in which not knowledge only disappears, but frequently the meaning too" (*Enjoyment of Poetry with Anthology for "Enjoyment of Poetry,"* [1939; Reprint, New York: Scribner's, 1987], 184–85).

67. Reported by Doris Stevens in "A Bend in the River" (1961), see chapter 2, note 1.

68. Elmer Leopold Reizenstein (1892–1967) had indeed changed his name to Elmer Rice. *For the Defense* ran at the Playhouse Theatre from mid-December 1919 to February 1920. A murder mystery, it featured an evil, lecherous Hindu doctor whose bad luck it was to covet the DA's fiancée. The play gave Rice a chance to showcase one of his signature achievements, the flashback technique. See "'For the Defense' Is Tense," *New York Times*, December 20, 1919. Rice's "A Diadem of Snow" was published in *The Liberator* 1, no. 2 (April 1918): 26–33.

69. Margaret Lane, business manager of *The Liberator* (chapter 2, note 35).

70. Florence is quoting from one of Max's poems about her: "And you would lie in life as in her bed / The mistress of a pale king, indolent, / Though hot her limbs and strong her languishment, / And her deep spirit is unvisited" ("Those You Dined With," in M. Eastman, *Colors of Life*, 75).

71. Unidentified. None of the directors working regularly for Goldwyn at the time was Dutch. Victor Schertzinger was of Pennsylvania Dutch descent, but his wife, Julia Nicklin, was not British. Another new director who was being considered by Goldwyn but never hired was Rupert Julian. However, both he and his wife were from New Zealand. "Three Goldwyn Directors: Julian, Hunter and Wallace Worley Added for Increased Studio Activity," *Motion Picture News* 20, no. 8 (August 16, 1919): 1446.

72. The legendary violinist Jascha Heifetz had come to the United States in 1917, at age sixteen; in 1928, he would marry Florence Vidor, the ex-wife of the movie director King Vidor.

73. "Duponts [*sic*] Enter Picture Business in Association with Goldwyn Co," *Exhibitor's Herald* 9, no. 25 (December 13, 1919): 41.

74. "The Metro-Loew Merger," *Moving Picture World* 43, no. 3 (January 17, 1920): 331.

75. Benjamin B. Hampton, *History of the American Film Industry from Its Beginnings to 1931* (previously titled *A History of the Movies*) (1931; Reprint, New York: Dover, 1970), 248.

76. Gomery, *Hollywood Studio System*, esp. 4–5.

77. Hampton, *History*, 248–51.

78. Robinson, *Chaplin*, 268–69.

79. Theodore Dreiser, *Gallery of Women*, 2:559–60.

80. Dreiser, *Gallery*, 2:550–51.

81. Clifford Robertson, Goldwyn's studio manager. He went to MGM after Goldwyn resigned from his own company and it merged with Metro in 1926; "Clifford Robertson,

Casting Director for M-G-M," *Motion Picture News* 33, no. 13 (March 27, 1926): 1372; Anthony Slide, *Hollywood Unknowns: A History of Extras, Bit Players, and Stand-ins* (Jackson: University of Mississippi Press, 2012), 28.

82. On the Omaha lynching, which was witnessed by young Henry Fonda, see McWhirter, *Red Summer*, 194–200, as well as Max's "Examples of 'Americanism,'" *The Liberator* 23 (February 1920): 13–16, esp. 15.

83. On Parker's bookstore, see chapter 2, note 218.

84. Goldsworthy Lowes Dickinson (1862–1932), a British philosopher and friend of E. M. Forster, wrote *The Greek View of Life* (1896). The "Chinese book" is possibly Dickinson's collection *Letters from John Chinaman and Other Essays* (1901).

85. The actress Dagmar Godowsky (1897–1975), daughter of the composer Leopold Godowsky, counted superstar violinist Jascha Heifetz among her lovers. Apparently, Max had trouble with Florence's handwriting; when reading her letter, he transliterated the name "Dagmar" in pencil.

86. Samuel Chotzinoff (1889–1964), Heifetz's accompanist since 1919. Known as "Shoots," he was also Heifetz's brother-in-law.

87. The correspondence between President Woodrow Wilson and Secretary of State Robert Lansing that led to Lansing's resignation (for complex reasons, one being Lansing's alleged assumption of semipresidential power during Wilson's illness) was printed in the *New York Times*, February 14, 1920: "Text of Wilson and Lansing Letters Which Ended in Resignation."

88. See Max's "Examples of 'Americanism,'" note 82. For the earlier essay Florence was remembering, see Max Eastman, "The Religion of Patriotism," *The Masses* 9, no. 9 (July 1917): 8–12.

89. Abraham Lehr (1880–1952), vice president of the Goldwyn Pictures Corporation.

90. Barbara Castleton (1894–1978) appeared with Florence in *Dangerous Days*. For Naomi, Betty, and Clarissa, see, for example, Florence to Max, August 1, 1919. The fact that not only Florence but also the other actresses were terminated does suggest that the breaking of her contract was at least in part motivated by economy.

91. Doris Stevens's *Jailed for Freedom*, an account of the imprisonment of members of the National Woman's Party (or NWP) was published later that year by Boni and Liveright.

92. See Captain Sheffield's handbook *Swimming in All Its Branches* (Los Angeles: Phillips, 1924).

93. "What the Picture Did for Me," *Exhibitors Herald* 13, no. 15 (October 8, 1921): 79; "What the Big Houses Say," *Motion Picture News* 23, no. 2 (January 1, 1921): 359. The comments in these trade journals give the impression that the film was adequately made but had no real box office appeal. Grace Kingsley, in the *Los Angeles Times*, observed that the unpromising material, that is, the mediocre book by F. Hopkinson Smith, made no "high demands upon [Tourneur's] genius." Grace Kingsley, "Flashes," *Los Angeles Times*, October 19, 1920, 30.

94. The "not" is likely a lapse on Florence's part.

95. A reference to Stirling Bowen's "Further Commentary on 'Colors of Life,'" *Detroit Sunday News*, February 1, 1920, 10. No wonder that Max was pleased with the review: Max had written "one of the greatest books of verse in the country," wrote Bowen, adding that the poems suggested "the crystalline yet limpid translucence of water." A poet and newspaperman in Detroit, Bowen (1895–1955) published a number of poems in magazines (more than a dozen of them in *The Liberator*), as well as *Wishbone* (1930), a collection of stories.

96. The flamboyant actress Alla Nazimova (1879–1945), originally from Yalta, known simply as "Nazimova," scandalized Hollywood by her liaisons with women. Taking aspiring young actresses under her wing, she helped launch their careers. (One of them was Anna May Wong.) Allegedly, Nazimova used the term "sewing circles" for the informal groups of bisexual or lesbian actresses who found a safe haven in each other's company in Hollywood. See Axel Madsen, *The Sewing Circle: Sappho's Leading Ladies* (1995; Reprint, New York: Kensington, 2002), 18.

97. Brooke, "The Lady of the Square Room" (see chapter 1, note 32).

98. Herman Lorber, Eastman's Greenwich Village doctor. See chapter 1, note 10.

99. Perhaps a reference to Paul Thompson's portrait of Max in "The Country of Some Interesting People," *Countryside*, December 1916, 273; see Irmscher, *Eastman*, 110–11.

100. Charlie's brother Syd's aerodrome on Crescent and Wilshire Boulevards in Los Angeles offered, according to a contemporary ad, "a fleet of newest Curtis one and two-passenger aeroplanes, large shops with complete equipment and hangars for our own ships as well as those belonging to business firms and individuals" ("Aviation History of the Miracle Mile," https//miraclemilela.com/aviation-history-of-the-miracle-mile/). The Goldwyn Studios had also started a Goldwyn Aero Club with a hangar and a field right on the lot, to which Syd Chaplin was to deliver a new JN40 airplane. See *The Studio Skeleton*, November 21, 1919, 2.

101. *Deep Waters*, released October 1920

102. In February 1920, *Current Opinion* reprinted Max's "Rainy Song" with the addition that it was "altogether delightful" (M. Eastman, "Rainy Song," *Current Opinion* 68, no. 2 [February 1920]: 246).

103. Added at the top of the letter.

104. See Max's poem "Those You Dined With," from *Colors of Life*, which contains the lines (referring to Florence, of course): "But I would see you like a gypsy, free / As windy morning in the sunny air" (75).

105. Wetzsteon, *Republic of Dreams*, 65.

106. Lisa Duncan to Max, June 1, 1962, Eastman mss., Lilly Library. Max's "To Lisa in Summer" was published in M. Eastman, *Kinds of Love*, 35.

107. For more on Lisa Duncan, with quotations from her letters at the Lilly Library, see Christoph Irmscher, "An Isadorable Unbound," *Raritan* 39, no. 2 (Fall 2019): 11–35.

108. Likely a reference to Ida Rauh.

109. See Florence to Max, March 16, 1920.

110. Elsie Ferguson (1885–1961), American stage and film actress, called "the Aristocrat of the Silent Screen," who had been starring in films by Tourneur (*The Witness for the Defense*, 1919) and made a reported $1,000 a day when under contract with Paramount.

111. Amelita Galli-Curci (1882–1963), famous Italian coloratura soprano, at the time a member of the Chicago Opera Company.

112. *The Gold-Diggers*, a sensationalized portrayal of the lives of chorus girls, opened September 30, 1919, and ran—for 228 performances—through June 20, 1920, at the Lyceum Theatre in New York. Written by Avery Hopgood, the play added the phrase "gold-digger" to the English vocabulary. Produced by David Belasco, the show featured one of his stars, Ina Claire (1893–1985). McBride's was theater ticket agency in Times Square, with offices in various locations in New York City hotels.

113. Presumably Jacob W. Greenberg, who would later publish Max's *Trotsky: Portrait of a Youth* (1925).

114. One of the anarchist Emma Goldman's favorite plays ("Never before has anyone given such a true, realistic picture of the social depths as Maxim Gorki"), *A Night-Lodging* was put on by Arthur Hopkins at the Lyceum Theatre, in a new translation by Fania Midell, and generated an instant controversy (Emma Goldman, *The Social Significance of the Modern Drama* [Boston: Badger, 1914], 294). *Beyond the Horizon*, O'Neill's first full-length play (which would earn him the 1920 Pulitzer Prize for Drama) had opened at the Morosco Theatre on February 2, 1920.

115. Probably the Capitol Theatre in New York, a movie palace with 5,230 seats at 1645 Broadway. Theda Bara (1885–1955), sex symbol of the silent movie era, was one of Fox's biggest stars. (Her final film for the studio was *The Lure of Ambition* [1919].)

116. The dancer and actress Rosa Rolanda or Rose Rolando (1895–1970), born Rosemonde Cowan Ruelas, later became known as a photographer and a surrealist, semiabstract painter. In 1930, Rosa married the Mexican painter Miguel Covarrubias.

117. Billie Burke (1884–1970), film and stage actress famous for her beauty. She would later play Glinda the Good Witch of the North in *The Wizard of Oz* (1939).

118. Max likely had intended to write "you."

119. John Fox Jr., Florence's former lover (see chapter 1, note 8).

120. Unidentified.

121. Iconic New York department store. Its flagship store at 424 Fifth Avenue opened in 1914 and was closed in 2018.

122. Florence to Max, April 26, 1920. Max was reading and quoting Florence's letters as if they were scripture.

123. Yet it appears that Max later shared the letter with Florence; see Florence to Max, July 8, 1920.

124. The labor leader Eugene Debs was serving his ten-year sentence (commuted in 1921) at the Atlanta Federal Penitentiary.

125. In May, Goldwyn bought a large interest in the Capitol (see note 115), and many important Goldwyn features opened there. Max might have been interested because he hoped to see some of Florence's films at this flagship theater. "Goldwyn Picture Company Buys into the Capitol," *New York Herald*, May 16, 1920, 14.

126. A reference to Alcatraz. Political prisoners kept there at the time included Jackson Leonard, a member of the IWW, and the anarchist and conscientious objector Philip Grosser.

127. On Waldo Frank, see Max to Florence, January 4, 1920.

128. Grace Kingsley, "Flashes," *Los Angeles Times*, June 9, 1920, 32.

129. George Parker, Max's psychoanalyst, who also became Florence's doctor in the final months of her life (*LR*, 277, 279).

130. Florence was keeping a scrapbook, now lost (see Florence to Max, January 11, 1920). In *Enjoyment of Poetry*, Max praises Sappho because "her very looking upon a thing was poetry" and quotes her poem "To Evening": "Evening, you bring all things that the bright morning scattered wide, / You bring the sheep, you bring the goat, you bring the child to his mother" (83).

131. Grace Kingsley, "Flashes," *Los Angeles Times*, July 9, 1920, 30.

132. *Wid's Daily*, July 10, 1920, 4.

133. See Max to Florence, May 11, 1920.

134. See Max to Florence, February 2, 1920. Obviously, Florence had made a careful study of Max's letters.

135. See Max to Florence, June 30, 1920.

136. Peter Ackroyd, *Charlie Chaplin: A Brief Life* (New York: Talese, 2014), 171–72. For more on Charlie's anxieties, especially the claim that he knew about his mother's illness, see the account by Stephen Weissman, who examined Hannah Chaplin's medical records, in *Chaplin: A Life* (New York: Arcade, 2008), 15–18.

137. Max had originally written "complete revenge."

138. An openly lesbian member of the Heterodoxy Club, Jacobi was a prison guard in a Framingham, Massachusetts, women's prison when she was arrested as a suffrage picketer; see Susan Gonda, "Suffrage Movement," *Lesbian Histories and Cultures: An Encyclopedia*, ed. Bonnie Zimmerman (New York: Garland, 2000), 742.

139. John Mosher (1892–1942), a playwright and member of the Village theater community, later known for the short stories he contributed to the *New Yorker*.

140. The inn in Croton-on-Hudson owned by Max's friend Jane Burr; see Max to Florence, June 18, 1921, and chapter 4, note 30.

141. Walter Fuller and Crystal had maintained separate quarters since the beginning of the year, an arrangement she praised in a piece published in *Cosmopolitan* in 1923, "Marriage under Two Roofs" (Crystal Eastman, *Crystal Eastman on Women and Revolution*, ed. Blanche Wiesen Cook [New York: Oxford University Press, 1978], 76–83). In the piece, Walter appears as "John," whose absence is described as "a refreshment, a chance to be yourself for a while, in a rich, free sense" (80).

142. Margaret Lane and her husband Dan (see chapter 2, note 224).

143. Grace Kingsley, "Flashes," *Los Angeles Times*, July 27, 1920, 30.

144. Likely the bookseller Charles Cullum Parker and not Max's Dr. Parker (who would have shared his concerns with Max); see chapter 2, note 218, and in this chapter, note 129.

145. Likely Marie Alamo Thomas; see Coda, note 14.

146. That is, seeking to seize it as her property by legal means. California recognized the legal doctrine of joint ownership of community property by husband and wife. Thus, since Mildred was married to Charlie while he was making *The Kid*, half of the proceeds of the film would have belonged to her (Robinson, *Chaplin*, 262).

147. See Florence to Max, August 9, 1920.

148. Robinson, *Chaplin*, 262–63. See also "Chaplin Visits in Salt Lake," *Ogden [Utah] Standard Examiner*, August 9, 1920, 3.

149. Thanks to John McVey, Montserrat College of Art, Beverly, Massachusetts, for helping to untangle the complicated story of Crystal's duplicate telegram.

150. Milton, *Tramp*, 178; Kenneth S. Lynn, *Charlie Chaplin and His Times* (New York: Simon and Schuster, 1997), 236.

151. *Wid's Daily* 13, no. 62 (September 1, 1920): 1.

152. Max's *Colors of Life* (1918).

153. Giles Cain, "Two Sides of the Footlights," *The Independent* 44, no. 9 (October 9, 1920): 2.

154. "Screen Gossip: The Latest Line-Up," *Picture-Play Magazine* 13, no. 2 (October 1920): 90.

155. Mary Austin's novel *No. 26 Jayne Street* (Boston: Houghton Mifflin, 1920), offers an ironic look at the sexual politics of New York bohemians, especially in terms of how their personal behavior contradicts their stated convictions. The radical editor Adam Frear ("a bright, outstanding peak in the American scene," equipped with "fine workless hands," and officially a proponent of free love) sends his lover Rose packing so that he can stay with the novel's protagonist, Neith Schuyler (who nevertheless rejects him). Frear is

generally assumed to be based on the muckraker Lincoln Steffens (1866–1936), but his complicated love arrangements explain why some readers would have thought of Max.

156. A donor to *The Masses* and *The Liberator*, E. W. Scripps (chapter 2, note 107) had warned Mrs. Gartz early on that he believed Max was not sufficiently "robust physically" for his editing work: "His nervous system is such that it should not and cannot safely be submitted to the strains inevitably attendant on such a business" (quoted in Irmscher, *Eastman*, 96).

157. *The Twins of Suffering Creek* (Fox, 1920); see Florence to Max, May 20, 1920.

158. Presumably an employee of Peggy Hoyt's millinery establishment, which Max would have visited to pick hats for Florence.

159. Likely other employees of Hoyt's.

160. Herbert Croly (1869–1930), leading progressive thinker and cofounder of *The New Republic*.

161. The (Mark) Strand Theatre, demolished in 1987, was a movie palace at 1579 Broadway. "Tourneur's picture" is *Deep Waters*, which was released on October 10, 1920.

162. C. O. Bigelow Apothecary, founded in 1838, is still in the West Village location where Clarence Otis Bigelow moved it in 1902, 414 Avenue of the Americas.

163. Likely the cook working for Dudley Malone and Doris Stevens.

164. "Cruel Words, Mr. Dreiser!" *Los Angeles Sunday Times*, September 17, 1922, pt. 3, 13, 15.

165. For more on Mather's photographs of Florence, see Irmscher, *Eastman*, 155–58.

166. Unidentified.

167. Dell's *Moon-Calf* (1920), which became a best seller; by early 1922, it had been reprinted eleven times.

168. See figure 3.17 in this book.

169. Robinson, *Chaplin*, 263.

170. Theodore Dreiser, *Theodore Dreiser: American Diaries 1902–1926*, ed. Thomas P. Riggio and James L. W. West III (Philadelphia: University of Pennsylvania Press, 1983), 349–50.

171. Dreiser, *Diaries*, 544–45.

172. Dreiser, *Diaries*, 562–63. See Marx, *Goldwyn*, 69–70; Berg, *Goldwyn*, 51, 122.

173. Doris Stevens to Florence, January 13, 1921, Eastman mss. II.

4. "I Object to the Slander of the Ladies" (1921)

1. M. Eastman, *Sense of Humor*, 76–7.

2. Florence's "Forget forever those wild autumn days"; see Florence to Max, December 26, 1920.

3. An oblique comment on Florence's newly shortened hair: the biblical Samson (Judges 13–16) lost his strength when his hair was shorn while he was sleeping; note how Florence masculinizes her role in their relationship.

4. Crystal's last contribution, "Alice Paul's Convention," appeared in the April issue of *The Liberator*. See Winnington, *Walter Fuller*, 306–8.

5. *LR*, 243–45.

6. Perhaps Florence's landlady.

7. Robert Edeson (1868–1931) had starred in Cecil DeMille's *The Call of the North* (1914). His wife, Mary Newcomb, helped Florence get cast in productions of the Wilkes Stock Company; see Florence to Max, July 1, 1921, and July 2, 1921.

8. Claire Windsor (1892–1972), born Clara Viola ("Ola") Cronk, was an aspiring actress who had just signed a contract with film director Lois Weber. May Collins's suspicions were justified: on July 12, Windsor "disappeared" before a planned rendezvous with Charlie, who joined the search for her and offered a reward of $1,000 for her safe return. It turned out that her abduction was a publicity stunt (arranged by Weber, in some accounts) intended to attract Charlie's interest (and to embarrass him as well). Although Charlie's feelings for her cooled as a result, Windsor's movie career was launched (Robinson, *Chaplin*, 294; Milton, *Chaplin*, 184–85).

9. "With" added in red pencil, likely by Max.

10. See Max to Florence, June 20, 1921; Florence to Max, June 28, 1921.

11. For details about May Collins, see Milton, *Tramp*, 184–86; [Cal York], "Plays and Players," *Photoplay* 20, no. 2 (July 1921): Advertising Section, 74.

12. On April 3, 1921, Albert Einstein had arrived in New York for his first visit to the United States, which he jokingly called "Dollaria." His visit was accompanied by a veritable media frenzy. It is possible that the visit had inspired Max and that, as a trained philosopher, he was trying to make his way through Einstein's *Relativity: The Special and the General Theory*, published by Henry Holt in 1920. One suspects that *Relativity* would have been eminently unsuitable reading for a train ride.

13. "Piquots" are ornamental loops as in lace; here used figuratively.

14. Margrethe Mather and, presumably, Marie Howe, who was visiting with her husband (see chapter 2, notes 95, 144; Florence to Max, June 17, 1921).

15. Margrethe Mather's photograph of Florence and Max, in *LR*, pictorial insert III, reproduced as the cover of this volume.

16. "Dora" was likely Max's nickname for Florence in her less agreeable moods.

17. Edward F. Mylius, bookkeeper and advertising manager of *The Liberator*. For a public controversy later that year, regarding money Mylius had "borrowed" from the magazine, see "Max Eastman Replies to E. F. Mylius Letter," *New York Times*, December 3, 1921; and *LR*, 262–64. The Belgian-born Mylius had an interesting history, which included being jailed in 1911 for publishing a report that King George V of the United Kingdom was a bigamist.

18. Proverbs 6:6–8: "Go to the ant, thou sluggard."

19. Dorothy Kenyon (1888–1972) was a New York lawyer, judge, and feminist. Her lover Wolcott H. Pitkin, whom she nicknamed "Patsy," was one of the ACLU's first lawyers. See Leigh Ann Wheeler, *How Sex Became a Civil Liberty* (New York: Oxford University Press, 2013), 32–33, 232n55. The "noisy" children are perhaps the Robinsons' two sons.

20. A reminder that Croton, despite or because of its distance from New York City, was a happening place, where many nighttime delights were available to the discerning resident. The Nikko Inn, a famed Japanese restaurant, teahouse, and speakeasy, was located in Harmon just outside of Croton, perched dramatically on a cliff overlooking the Croton River: "on wooded Croton's brink / The situation picturesque; / The food is fine we think" (according to a contemporary promotional postcard). See Marc Cheshire, "If You Follow the Road to Harmon, You Surely Can't Go Wrong," *Croton: History and Mysteries* (blog), August 19, 2015, https://crotonhistory.org/2015/08/19/if-you-follow-the-road -to-harmon-you-surely-cant-go-wrong/. This blog is maintained by Mr. Cheshire, Croton's village historian, to whom we owe the reference.

21. Jack's Restaurant was located at 763 Sixth Avenue, New York.

22. *Irene*, with music by Harry Tierney, at the time the longest running Broadway musical.

23. Milton, *Tramp*, 112.

24. See American Automobiles and American Automobile Manufacturers, "The Buick Automobile 1920–1929 & The Buick Motor Car Co.," American Automobiles, https://www.american-automobiles.com/Buick-1920-1929.html.

25. "M." refers to May Collins.

26. Although Max had been keeping notes about Chaplin (see introduction, note 17), it took Max two decades to write "Actor of One Role: A Character Study of Charlie Chaplin," in *Heroes I Have Known*, 155–200.

27. Reprinting the letter in *LR*, 244, Max replaced "Dora" (see note 16) with "Black Panther," his metaphor for Florence's darker side.

28. Max's older brother, Anstice "Peter" Eastman, a physician (1877–1937). Florence, the car connoisseur, would have appreciated the mention of the Paige car, a six-cylinder luxury vehicle renowned for its beauty.

29. Jack Reed had succumbed to typhoid fever in Moscow on October 17, 1920. His body was buried in the Kremlin Wall Necropolis.

30. Jane Burr, born in Texas as Rosalind Mae Guggenheim (1882–1958), was married to Horatio Gates Winslow, the first copy editor of *The Masses*. A poet, journalist, and actress, she bought the Post Road Inn (right across the street from the Holy Name of Mary Church) in Croton-on-Hudson and renamed it The Drowsy Saint.

31. George Andreytchine see chapter 2, note 52.

32. See Florence to Max, June 8, 1921.

33. Fifty words was the standard unit for a "day letter" telegram; see Rupert P. Sorelle and John Robert Gregg, *Secretarial Studies* (Chicago: Clegg, 1922), 180.

34. The artist William Gropper; see Florence to Max, September 4, 1919.

35. Sarah Senter Whitney was studying with Rodin in Paris when she met Boardman. Although she attempted to return to sculpture and even took a studio in New York City, there is no record of her exhibiting after 1903 (Christ-Janer, *Robinson*, 31).

36. As a money order.

37. Margrethe Mather.

38. The anecdote involving the Irishman does not appear in the finished version of Max's *The Sense of Humor*. Brooks's examples of poetic humor include the moment from *A Tramp Abroad*, where Twain finds himself sitting behind and admiring a beautiful girl at the opera in Mannheim, wishing for hours that she would speak, only to hear her say, finally: "Auntie, I just *know* I got five hundred fleas on me!" (Van Wyck Brooks, *The Ordeal of Mark Twain* [New York: E. P. Dutton, 1920], 213).

39. First published in 1913, Max's *Enjoyment of Poetry*, one of his most enduringly successful titles, was reissued by Scribner's in 1921, with a new chapter titled "Ideals of Poetry."

40. In the lengthy chapter 11 of *The Sense of Humor* ("Good and Bad Jokes," 86–120), Max offers eight "laws" for "serious joke-makers," ranging from "Law Number One" (*"There must be a real engagement of the interest of the person who is expected to laugh,"* 88) to "Law Number Eight" (*"The interest disappointed must not be too strong in proportion to the interest satisfied,"* 116).

41. Mary Newcomb; see note 7.

42. Guy Price, "Facts and Fables of the Foyer," *Los Angeles Herald*, March 24, 1921, B4; Grace Kingsley, "Flashes," *Los Angeles Times*, March 23, 1921, sec. 3, 4.

43. "Stage," *Los Angeles Herald*, July 16, 1921, B4.

44. Bess Meredyth (1890–1969). The lead in the comedy series *Bess the Detectress* (1914), she was best known as a screenwriter, collaborating with her husband, Wilfred Lucas (perhaps referenced here as well), on numerous productions, beginning with *A Sailor's Heart* (1913).

45. The first major one-man exhibit of Alfred Stieglitz's photographs in more than a decade opened on February 7, 1921 at Mitchell Kennerley's Anderson Galleries in New York.

46. David Menefee, *The First Female Stars: Women of the Silent Era* (Westport, CT: Greenwood, 2014), 116.

47. The "news" was Florence's return to the stage.

48. A popular actors' colony in Queens, New York.

49. The match between Jack Dempsey and Georges Carpentier was held at Boyle's Thirty Acres in Jersey City on Saturday, July 2, 1921. Drawing a crowd of over 80,000 spectators, it was one of the major sporting events of the year and the first fight to be broadcast.

50. Derogatory term for a person of Irish descent.

51. *LR*, 172. For a reading of one of these photographs, see Irmscher, *Eastman*, 156–57.

52. Lucian Cary (1885–1971), novelist and editor, since 1916 contributor to *Collier's* and the *Saturday Evening Post*.

53. In the published version of *The Sense of Humor*, Falstaff serves a negative example of forced jokes, a problem Max thinks is endemic to Shakespeare: "Even when they are good jokes, he usually contrives to destroy the current of life in them by turning them upside down" (102).

54. Max's first collection of poems, published in 1913.

55. Charlotte Ives (1891–1976), who had several Broadway credits too, starred in films like *The Warfare of the Flesh* (1917) and, alongside Enrico Caruso, *Prince Cosimo* (1919). Her marriage to Jan Boissevain was covered by the *New York Times*, May 13, 1921.

56. Blyth Daly or Blythe Daley (1901–1965), a Broadway and film actress, mostly remembered for her open bisexuality. One of the "Four Riders of the Algonquin" (after the Hotel Algonquin in New York), along with Tallulah Bankhead, Estelle Winwood, and Eva Le Gallienne.

57. The radical writer Michael Gold (1894–1967), born Itzok Isaac Granich, began publishing first under yet another pen name, Irwin Granich. "Billy & Bartlett" are the Robinsons' children, John Whitney Robinson (nicknamed "Billy," born 1906) and Bartlett Whitney Robinson (1912–1985); the latter became a successful actor, known chiefly for being the radio voice of Perry Mason.

58. On Hugo Gellert and Livia Cinquegrana, see chapter 2, note 213.

59. Robinson, *Chaplin*, 273, citing Chaplin, *My Trip Abroad*; Edwin Schallert, "Chaplin to Europe," *Los Angeles Times*, August 25, 1921, 32.

60. "Having Delightful Time," *Buffalo Enquirer*, August 25, 1921, 8; "Cane and Derby Pays Brief Call," *Buffalo Courier*, August 25, 1921, 12.

61. See, for example, "Secrets of the Movies," *Brooklyn Daily Eagle*, August 18, 1921, 17 ("Latest studio rumors are that May Collins is not engaged to Chaplin and never was, that they were merely good friends"); "Pretty May Collins Not Even Engaged," *Daily News*, August 8, 1921, 6.

62. See the Coda to this book.

63. "Chaplin Here, Gotham Film Capital Now," *Daily News*, August 29, 1921, 3; "Douglas and Mary Mobbed by Friends," *New York Herald*, August 29, 1921, 16.

64. Chaplin, *My Trip Abroad*, 14.

65. Chaplin, *My Trip Abroad*, 15.

66. In *My Trip Abroad*, Charlie merely mentions that the party took place at "Max's house," but other accounts seem to confirm that he had in fact gone out to Croton. See Christ-Janer, *Robinson*, 32. Christ-Janer's account is based on interviews with Robinson himself. Carter's Little Liver Pills, a popular patent medicine, was a laxative and had in fact no medicinal effect whatsoever on a person's liver. Claude McKay also remembers Charlie showing up in Croton and performing "marvels of comedian tricks" and then paying another unexpected visit to Max—when exactly is unclear—in the company of the illustrator Neysa McMein (1888–1949), whom Charlie had apparently added to his collection of mistresses (Claude McKay, *A Long Way from Home*, ed. Gene Andrew Jarrett [1937; Reprint, New York: Rutgers University Press, 2007], 195).

67. For an additional and more detailed description of Charlie's party, see "The Gossip Shop," *The Bookman* 54, no. 3 (November 1921): 279–80.

68. Chaplin, *My Trip Abroad*, 18–20. Charlie had assembled the crème de la crème of New York bohemia: Harrison Rhodes was the editor of *The Chap-Book*; drama critics Heywood Broun and Alexander Woollcott were members of the famous Algonquin Round Table, as was Neysa McMein. "The men I adore most are Herbert Hoover, and Charles Chaplin," she announced, "and I am enamored of Max Eastman" ("Neysa M'Mein Recalls Her Art Struggles Here," *Chicago Tribune*, September 17, 1921, 17). Rita Weiman (1885–1945) was a playwright and screenwriter. In 1920, her story "Curtain" was made into a Katherine McDonald film featuring, among others, Florence, so no doubt she and Charlie had things to talk about.

69. Surely by this time, Charlie must have known that Max was not going to come over to his guests like a bomb-throwing anarchist and that Max, capable of extracting large sums of money from rich dowagers for his magazines, could exert an impressive charm when he wanted to.

70. The Belgian writer Maurice Maeterlinck's lover, the soprano Georgette LeBlanc (1869–1941).

71. Alexandre Dumas fils's *La Dame aux Camélias* (1848), known as *Camille* to most English speakers, had inspired many adaptations, from Verdi's *La Traviata* to silent movies. Nazimova's *Camille*, starring her as Marguerite and Rudolph Valentino as her lover, was due to be released later that same month.

72. Irmscher, *Eastman*, 110.

73. Clare Sheridan, *My American Diary* (1922; Reprint, N.p.: Big Byte Books, 2014), 199–210; Chaplin, *My Autobiography* (1964; Reprint, Brooklyn, NY: Melville House, 2012), 285–86.

74. *LR*, 277.

75. Florence Deshon, "A Great Art," *Motion Picture Magazine* 23, no. 1 (February 1922): 39–40, 100. Florence's story was accompanied by humorous illustrations and an editor's note that must have pleased her immensely if she still saw it: "We are glad to offer the article below which is from the pen of Florence Deshon, whom most of us know thru her screen portrayals. In this satire, Miss Deshon proves her ability as a writer as well as an actress."

Coda (1922)

1. "Actress Dies of Gas Poison," *New York Times*, February 5, 1922.

2. See certificate no. 3448, Department of Health of the City of New York. Written in a typical doctor's scribble, the time of death on the certificate is difficult to decipher. According to the *Times*, Florence's death did occur in the afternoon on February 4

("Actress Dies of Gas Poison"), which would be consistent with our reading of the official certificate.

3. "Young Woman Is Found Dying in Gas Filled Room," *Mansfield (Ohio) News*, February 5, 1922; "New Shock to Filmland: Murder Hints in Poisoning of Florence Deshon, Actress," *Kansas City Star*, February 5, 1922.

4. "Movie Actress Dies from the Effects of Gas," *Creston (Iowa) Advertiser-Gazette and Plain Dealer*, February 6, 1922.

5. "Eastman Denies Rift with Miss Deshon," *New York Times*, February 6, 1922. Max's autobiography mentions an engagement with "some friends," but not with Florence (*LR*, 278).

6. "Actress Dead, Hint Chaplin Love Tragedy," *Manitowoc (Iowa) Herald News*, February 6, 1922. See also "Max Eastman Denies Actress Killed Self Because of Quarrel," *New York Daily News*, February 6, 1922 ("During her year at Hollywood, [Florence's] engagement to Charlie Chaplin was both reported and denied").

7. "New York Letter," *Philadelphia Inquirer*, February 6, 1922.

8. *LR*, 277–78.

9. Fourteenth Census of the United States, 1920, NARA microfilm publication T625, 2076 rolls, Records of the Bureau of the Census, record group 29, National Archives, Washington, DC. Accessed through Ancestry.com.

10. "Bury Florence Deshon; Brother Scouts [*sic*] Suicide," *Evening World*, February 6, 1922. The nonsensical headline might be the result of a typo ("scouts" for "scoffs"?).

11. *LR*, 279.

12. Correspondence with Karen Grego, Mount Zion Cemetery, Queens, New York, September 2014.

13. Marie Alamo Thomas to Florence, September 7, 1920, Eastman mss. II, Lilly Library.

14. It didn't take Marie Alamo Thomas long to console herself. According to Colorado marriage records, she married John Harris Boden on January 24, 1924 (Mesa County Marriage Records, Mesa County Clerk and Recorder, Grand Junction, Colorado, accessed through Ancestry.com). Involved in child welfare efforts and health education in Colorado, Thomas eventually embarked on a career in public health work in California, which included an appointment as the first female milk inspector in the West and supervisor of sanitation for the city of Santa Cruz. She died in 1957, aged 63 (https://www.findagrave.com/memorial/87089077).

15. Kenneth E. Miller, *From Progressive to New Dealer: Frederic C. Howe and American Liberalism* (University Park: Penn State Press, 2010) 98.

16. "Pauline" (1973), in John Gregory Dunne, *Regards: The Selected Nonfiction of John Gregory Dunne* (New York: Thunder's Mouth, 2006), 251–58, 254.

17. "To One Who Died," Eastman mss., Lilly Library, quoted in Irmscher, *Eastman*, 162.

18. Florence Deshon, "I once said . . .," pencil draft in Deshon mss. Lilly Library.

19. Milton, *Chaplin*, 205–6.

Glossary of Names

A list of frequently mentioned names in the correspondence, ordered by first names. Well-known contemporary figures, such as a Goldwyn, are not included. The index will guide the readers to passages in the introduction or relevant notes that offer more information.

Amos Amos Pinchot, lawyer and leftist reformer; married to Max's friend Ruth Pickering

Arthur or **Arturo** Arturo Giovannitti, activist and poet

Betty Elisabeth "Betty" Hare, Croton-on-Hudson resident

Caroline Flora or Caroline Spitzer (Danks), Florence's mother

Claude Claude McKay, Jamaican American poet

Crystal Crystal Eastman, Max's sister; lawyer and activist

Doris Doris Stevens, feminist; married to Dudley Field Malone

Dudley Dudley Field Malone, lawyer

Eugen or Eugene Eugen Jan Boissevain, Dutch businessman; married to suffragist and public speaker Inez Milholland (and, later, poet Edna St. Vincent Millay)

George George Andreytchine, Bulgarian revolutionary and IWW activist

Ida Ida Rauh, lawyer, activist, sculptor, actress; Max's first wife

Jack John "Jack" Reed, journalist

Jan Jan Boissevain, Eugen Boissevain's brother

John John Fox Jr., author; Florence's lover when she met Max

Louise Louise Bryant, writer; Jack Reed's wife

Kate Kate Crane Gartz, Pasadena millionaire and sponsor of leftist causes

Marie feminist organizer and writer Marie Jenney Howe; or (in connection with Floyd Dell), B. Marie Dell, Floyd's wife

Mike Boardman Robinson, artist and cartoonist for *The Masses*; Croton-on-Hudson resident

Ruth Ruth Pickering Pinchot, writer and activist; Max's childhood friend and love interest; married to Amos Pinchot

Sallie or **Sally** Sarah Senter Whitney, sculptor; "Mike" (Boardman) Robinson's wife

Sidney or **Sid** Sidney Wood, Max's Williams College friend; adventurer and mining entrepreneur

Walter Walter Fuller, British journalist; Crystal Eastman's second husband

The following chronology compiles milestones in the intersecting lives of Florence Deshon (FD), Max Eastman (ME), and Charlie Chaplin (CC) and does not, of course, aspire to completeness. The editors hope these basic dates will help readers orient themselves amid the often cascading events narrated in the correspondence. For a listing of the details of Florence's most important films, see the filmography provided by the American Film Institute (https://catalog.afi.com/Catalog/PersonDetails/51572).

1883	January 4: ME born in Canandaigua, Ontario County, New York.
1889	April 16: CC born Charles Spencer Chaplin in London's East End.
1893	July 19: FD born Florence Danks in Tacoma, Washington.
1905	ME graduates from Williams College.
1907–1911	ME completes course work for PhD at Columbia University. Introduced to Marxism by first wife, activist lawyer Ida Rauh.
1911–1913	CC arrives in the United States with Karno Company tours.
1912	September 6: birth of ME's only child, Daniel Eastman.
1913	ME becomes editor of the important radical periodical *The Masses*.
1913	ME publishes *Enjoyment of Poetry*.
1914	CC begins working for Keystone.
	February: CC's Tramp character introduced in *Kid Auto Races at Venice* (Keystone).
	December: CC joins Essanay Studios.
1915	FD reputedly appears in Pathé Exchange six-reeler *The Beloved Vagabond* (music by Darius Milhaud).
	ME acquires house in Croton-on-Hudson, New York, later known as the "Soviet-on-the-Hudson" (John Reed).
	"Chaplinitis" (*Motion Picture Magazine*, May 1915) grips United States.
1916	Signing contract with Mutual, CC opens own studio in Los Angeles.
	ME's *Journalism versus Art* advocates the "expression of intense feeling" over "the intense expression of feeling."
	FD stars in Roi Cooper Megrue's comedy *Seven Chances* (opening August 8 at George M. Cohan Theater in New York) and in movie *Jaffery* (Frohman Amusement Corp., July).
	December 15: ME meets FD at ball for *The Masses* and falls in love with her.

1917	June: CC signs "Million-a-Year" contract with First National; builds studio on Sunset Boulevard in Hollywood.
	December: FD stars as Lilas Lynn in *The Auction Block* (Rex Beach Film Corp.).
1918	April: CC releases *A Dog's Life* (First National).
	May: FD portrays Beatrice Walton in *The Golden Goal* (Vitagraph). After two unsuccessful trials for treason (April and September), *The Masses* shut down by government through wartime mailing regulations.
	April: ME launches *The Liberator*, with his sister and fellow radical, Crystal Eastman.
	CC embarks on Liberty Bond campaign.
	October: publication of ME's *Colors of Life* (poetry), dedicated to FD.
1919	United Artists launched by CC, Douglas Fairbanks, Mary Pickford, and others.
	February: CC meets ME in Los Angeles during the latter's "Hands Off Russia" tour.
	July 7: CC's first child, Norman Spencer, born; lives only three days.
	July 9: FD boards train for Hollywood.
	September: during visit to Hollywood, ME introduces FD to CC.
	December: FD plays Marion Allardyce in *The Loves of Letty* (Goldwyn).
	In early December, ME returns to New York City via San Francisco.
1920	FD portrays Polly Widdicombe in *The Cup of Fury* (Goldwyn's Eminent Authors, January); Marion Hayden (a minor part) in *Dangerous Days* (Goldwyn's Eminent Authors, March); Daisy in *Dollars and Sense* (Goldwyn, June); Jess Jones in the western *The Twins of Suffering Creek* (Fox, June); Kate Leroy in Maurice Tourneur's *Deep Waters* (Tourneur, October); and Lila Grant in *Curtain* (First National, October).
	February 17: Goldwyn Studios breaks its contract with FD.
	March: impressed by the "Isadorables," ME begins affair with dancer Lisa Duncan.
	December: CC completes *The Kid*, interrupted by work on *A Day's Pleasure* (First National), which originally also includes scene with FD (later cut).
	July: FD likely follows CC to Utah and then joins ME in New York, arriving July 20 to recover from her abortive pregnancy with CC's child. CC follows FD and ventures out to Croton.
	October: FD returns to Hollywood.
1921	January: CC's *The Kid* released (First National).
	February: ME makes second visit to Hollywood.
	May: ME departs, after two months with FD, for New York City.
	FD resumes stage acting, relocates in the fall to New York City.
	September 4 to October 18: CC travels to New York City, meets ME but not FD, then leaves for Europe.
	November: ME's *The Sense of Humor* published. Dedicated to Florence Deshon, the book extols laughter as the "chief thing" that holds society together.

	December: release of *The Roof Tree* (Fox), FD's last film.
1922	FD's story "A Great Art" published in February issue of *Moving Picture World*.
	February 3: FD found unconscious in Rhinelander Gardens apartment, dies from "gas asphyxiation" the next day.
	ME divorces Ida Rauh and travels to the Soviet Union, where he meets Trotsky and becomes critical of Stalin.
	CC publishes *My Trip Abroad*.
1924	November 26: CC marries sixteen-year-old Lillita McMurray ("Lita Grey"); they divorce in 1927.
	June 3: ME marries Eliena Krylenko, with whom he remains—in an unconventional, open relationship—for the next thirty-four years.
1925	June: CC releases *The Gold Rush* (United Artists).
1928	July 8: death of Crystal Eastman Fuller.
1931	January: CC releases *City Lights* (United Artists).
1936	February: CC releases *Modern Times* (United Artists).
	CC marries Paulette Goddard (they divorce in 1942).
1937	March: ME's anti-Stalinist documentary, *Tsar to Lenin*, coproduced with Herman Axelbank, premieres in New York.
1942	ME's appointment as "roving editor" for *Reader's Digest* completes what many see as ME's betrayal of the Left and turn to conservatism.
1943	June 16: CC marries eighteen-year-old Oona O'Neill, Eugene O'Neill's daughter.
1944–1945	CC indicted on the Mann Act for his relationship with Joan Barry. Wins acquittal. Paternity suit brought by Barry (and retried in 1945) ends with guilty verdict despite evidence of blood tests.
1948	ME's *Enjoyment of Living*, the first volume of his autobiography, appears, to the acclaim even of former radical friends. (Floyd Dell calls it "the top star on the Christmas tree.")
1950	CC sells share in United Artists.
1952	September 18: CC leaves the United States.
	October: CC releases *Limelight* (Celebrated Productions, distributed by United Artists).
1956	October 9: Eliena Krylenko Eastman dies of cancer on Martha's Vineyard.
1958	March 23: ME marries Yvette Szekely (1912–2014).
1964	Publication of CC's *My Autobiography* and *Love and Revolution: My Journey through an Epoch*.
1969	March 25: ME dies in Bridgetown, Barbados, of a brain hemorrhage; son Daniel survives him by only six months.
1972	CC's reconciliation trip to the United States, collects special Academy Award.
1977	December 25: CC dies at his estate in Corsier-sur-Vevey, Switzerland.

Selected Bibliography

Aaron, Daniel. *Writers on the Left*. 1961. Reprint, New York: Oxford University Press, 1977.

Ackroyd, Peter. *Charlie Chaplin: A Brief Life*. New York: Tales, 2014.

American Film Institute Catalog: Feature Films, 1911–1920. Berkeley: University of California Press, 1988.

Barnett, Adam. *Dr. Harry: The Story of Doctor Herman Lorber*. New York: Crowell, 1958.

Beach, Rex. *Personal Exposures*. New York: Harper and Brothers, 1940.

Berg, A. Scott. *Goldwyn: A Biography*. New York: Knopf, 1989.

Brownlow, Kevin. *The Parade's Gone By . . .* Berkeley: University of California Press, 1996.

Buxton, Jessica. *Discovering Chaplin* (blog). https://discoveringchaplin.blogspot.com/.

Carr, Richard. *Charlie Chaplin: A Political Biography from Victorian Britain to Modern America*. London: Routledge, 2017.

Ceplair, Larry, and Steven Englund. *The Inquisition in Hollywood: Politics in the Film Community, 1930–1960*. New York: Anchor/Doubleday, 1980.

Chaplin, Charlie. *My Autobiography*. Brooklyn: Melville House, 2012.

———. *My Trip Abroad*. New York: Harper & Brothers, 1922.

Christ-Janer, Albert (with chapters by Arnold Blanch and Adolf Dehn). *Boardman Robinson*. Chicago: University of Chicago Press, 1946.

Dell, Floyd. *Homecoming: An Autobiography*. New York: Farrar & Rinehart, 1933.

De Meyer, Adolph. *A Singular Elegance: The Photographs of Baron Adolph de Meyer*. San Francisco: Chronicle Books / International Center for Photography, 1994.

Diggins, John P. *Up from Communism: Conservative Odysseys in American Intellectual History*. 1975. Reprint, New York: Harper Torchbooks, 1977.

Dreiser, Theodore. *American Diaries 1902–1926*. Edited by Thomas P. Riggio and James L. W. West III. Philadelphia: University of Pennsylvania Press, 1983.

———. *A Gallery of Women*. 2 vols. New York: Horace Liveright, 1929.

Eastman, Carol. *The Search for Samuel Goldwyn*. New York: Morrow, 1975.

Eastman, Crystal. *Crystal Eastman on Women and Revolution*. Edited by Blanche Wiesen Cook. New York: Oxford University Press, 1978.

Eastman, Max. *Child of the Amazons and Other Poems*. New York: Mitchell Kennerley, 1913.

———. *Colors of Life: Poems and Songs and Sonnets*. New York: Knopf, 1918.

———. *Enjoyment of Living*. New York: Harper and Brothers, 1948.

——. *Enjoyment of Poetry*. New York: Scribner's, 1913. Rev. eds., 1921, 1926. Expanded edition (with *Other Essays in Aesthetics*), 1939. One-volume edition (with *Anthology for "Enjoyment of Poetry"*), 1951.

——. *Great Companions: Critical Memoirs of Some Famous Friends*. New York: Farrar, Straus, and Cudahy, 1959.

——. *Heroes I Have Known: Twelve Who Lived Great Lives*. New York: Simon and Schuster, 1942.

——. *Kinds of Love: Poems by Max Eastman*. New York: Scribner's, 1931.

——. *Love and Revolution: My Journey through an Epoch*. New York: Random House, 1964.

——. *The Sense of Humor*. New York: Scribner's, 1922.

——. *Venture*. New York: Albert and Charles Boni, 1927.

Gardner, Virginia. *"Friend and Lover": The Life of Louise Bryant*. New York: Horizon, 1982.

Girard, René. *A Theatre of Envy: William Shakespeare*. New York: Oxford University Press, 1991.

Gomery, Douglas. *The Hollywood Studio System: A History*. London: British Film Institute, 2005.

Hampton, Benjamin B. *History of the American Film Industry from Its Beginnings to 1931*. New York: Dover, 1970. First published in 1931 as *A History of the Movies* by Covici, Friede (New York).

Holmes, Sean P. "All the World's a Stage! The Actors' Strike of 1919." *Journal of American History* 91, no. 5 (March 2005): 1291–1317.

Homberger, Eric. *John Reed*. Manchester: Manchester University Press, 1990.

Irmscher, Christoph. "An Isadorable Unbound." *Raritan* 39, no. 5 (Fall 2019): 11–35.

——. *Max Eastman: A Life*. New Haven: Yale University Press, 2017.

Jacobs, Lewis. *The Rise of the American Film: A Critical History, with an Essay "Experimental Cinema in America, 1921–1947."* 1939. Reprint, New York: Teachers College Press, Columbia University, 1968.

Koszarski, Richard. *Hollywood on the Hudson, Film and Television in New York from Griffith to Sarnoff*. New Brunswick, NJ: Rutgers University Press, 2008.

Kroeger, Brooke. *The Suffragents: How Women Used Men to Get the Vote*. Albany: SUNY Press, 2017.

Kuriyama, Constance Brown. "Chaplin's Impure Comedy: The Art of Survival." *Film Quarterly* 45, no. 3 (Spring 1992): 26–38.

Lewis, Kevin, and Arnold Lewis. "Include Me Out: Samuel Goldwyn and Joe Godsol." *Film History* 2, no. 2 (June–July 1988): 133–53.

Lynn, Kenneth S. *Charlie Chaplin and His Times*. New York: Simon and Schuster, 1997.

Madsen, Axel. *The Sewing Circle: Sappho's Leading Ladies*. New York: Kensington, 2002.

Maland, Charles J. *Chaplin and American Culture: The Evolution of a Star Image*. Princeton, NJ: Princeton University Press, 1989.

Marx, Arthur. *Goldwyn: A Biography of the Man behind the Myth*. New York: Norton, 1976.

McGerr, Michael. *A Fierce Discontent: The Rise and Fall of the Progressive Movement in America, 1870–1920*. 2003. Reprint, New York: Oxford University Press, 2005.

Menefee, David. *The First Female Stars: Women of the Silent Era*. Westport, CT: Greenwood, 2014.

Milton, Joyce. *Tramp: The Life of Charlie Chaplin*. New York: Da Capo, 1998.

Northshield, Jane, ed. *History of Croton-on-Hudson*. Croton, NY: Croton-on-Hudson Historical Society, 1976.

Ramsaye, Terry. *A Million and One Nights: A History of the Motion Picture through 1925*. 1926. Reprint, New York: Touchstone, 1986.

Robinson, David. *Chaplin: His Life and Art*. New York: McGraw-Hill, 1985.

Rosenstone, Robert A. *Romantic Revolutionary: A Biography of John Reed*. 1975. Reprint, New York: Vintage, 1981.

Ross, Steven J. *Working-Class Hollywood: Silent Film and the Shaping of Class in America*. Princeton, NJ: Princeton University Press, 1998.

Sheridan, Clare. *My American Diary*. 1922. Reprint, N.p.: Big Byte Books, 2014.

Slide, Anthony. *Hollywood Unknowns: A History of Extras, Bit Players and Stand-ins*. Jackson: University of Mississippi Press, 2012.

Slide, Anthony, and Alan Gevinson. *The Big V: A History of the Vitagraph Company*. Rev. ed. Metuchen, NJ: Scarecrow, 1987.

Stansell, Christine. *American Moderns: Bohemian New York and the Creation of a New Century*. New York: Metropolitan, 2000.

Stevens, Doris. *Jailed for Freedom*. New York: Boni and Liveright, 1920.

Thomson, David. *Sleeping with Strangers: How the Movies Shaped Desire*. New York: Knopf, 2019.

Tichy, Wolfram. *Chaplin*. Hamburg: Rowohlt, 1974.

Warren, Beth Gates. *Artful Lives: Edward Weston, Margrethe Mather, and the Bohemians of Los Angeles*. Los Angeles: Paul J. Getty Museum, 2011.

———. *Margrethe Mather and Edward Weston: A Passionate Collaboration*. Santa Barbara, CA: Santa Barbara Museum of Art, 2001.

Weissman, Stephen. *Chaplin: A Life*. New York: Arcade, 2008.

Wetzsteon, Ross. *Republic of Dreams: Greenwich Village, the American Bohemia of 1910–1960*. New York: Simon and Schuster, 2002.

Winnington, G. Peter. *Walter Fuller: The Man Who Had Ideas*. [Mauborget], Switzerland: Letterworth, 2014.

Page numbers in *italics* refer to illustrations.

Harris, 319, 332; earnings of, 209, 417–18n223; fear of venereal disease, 311; Florence's contract with Goldwyn and, 118; insecurity of, 255, 256, 266; *The Liberator* magazine and, 225; Liberty Bond drive and, 16, 81; as "man-child," 33; modesty of, 94; *My Autobiography* (1964), 18, 377, 378; *My Trip Abroad* (1922), 200, 375, 431n66; in New York, 375; photographed by de Meyer, 244; power in Hollywood, 19; publicity photo (1919), 16–17, *17*; secret film editing in Hotel Utah, 316–17; as star, 117; Tramp creation of, 6, 14–15, 16, 200, 240, 397n45; United Artists ("Charlie's Company"), 118, 193, 194, 260, 261; as world-class celebrity, 374. *See also* Deshon–Chaplin relationship; Eastman–Chaplin friendship

Chaplin, Charlie, erotic affairs of: Collins (May), 344, 348, 350, *351*, 357, 374; paternity suit by Barry (1944), 209; Sheridan (Clare), 377–78, *377*

Chaplin, Charlie, films of: *The Bond* (1918), 16; *A Day's Pleasure* (1919), 15, 33, 210, 238, 252, 417n216, 418n226; *A Dog's Life* (1918), 15, 240; *The Great Dictator* (1940), 200; *His Prehistoric Past* [*Hula Hula Dance*, 1916] (1914), 336; *The Idle Class* (1921), 374; *Limelight* (1952), 394; *Pay Day* (1922), 374; *The Pilgrim* (1923), 19, 199; *Shoulder Arms* (1918), 15, 16; *Sunnyside* (1919), 15, 417n216. See also *Kid, The*

Chaplin, Mildred Harris (first wife of Chaplin), 15–16, 118, 197, 238; divorce from Charlie, 319, 332; Dreiser's account of, 333; proceeds from *The Kid* and, 314, 315, 426n146

Chaplin, Norman Spencer (son of Charlie), 16, 238

Chaplin, Oona, 6

Chaplin, Syd (brother of Charlie), 424n100

Chaplin: His Life and Art (Robinson, 1985), 6

Chapman, John Jay, 12

Characters and Commentaries (Strachey, 1933), 171

Chicago Board of Censors, 74, 77, 78

Childers, Naomi, 153, 259, 267, 412n132

Child of the Amazons (Eastman), 372

China, Florence's interest in trip to, 160, 413n143

Chorus Equity Association, 414n169

Chotzinoff, Samuel, 423n86

Christians, Rudolph, 269

Christian Science, 169, 350, 414n163

Cinquegrana, Livia, 206–7, 373, 417n213

Civilian Clothes (Buchanan play), 234, 420n33

Civil Liberties Bureau (CLB), 11

Cixi, Empress Dowager of China, 231, 420n26

Claire, Ina, 290

Clark, William Andrews, 250, 421n53

Coca-Cola, modeling gig offered to Florence, 105

Cohan, George M., 179, 187, 415n179

Collier, William, Sr., 179, 415n179

Collins, May, 344, 348, 349, 350, 357, 428n8, 428n11, 430n61; with Charlie and Goldwyn, *351*; Metro contract of, 374

Colors of Life (Eastman, 1918), 112, 388, 402n27, 407n51, 412n136, 423n95; dedication to Florence, 80, 333; Gale's review of, 146

communism: in Bulgaria, 148, 412n123; in China, 413n143; in Croton-on-Hudson, 32, 86; Hollywood screenwriters and, 220; in Hungary, 164, 412n124; splits out of Socialist Party of America, 415n182. *See also* Bolsheviks; Russian Revolution

Communist Manifesto (Marx and Engels), 96

Compson, Betty, 235, 259, 267, 420n34

Comstock Act, 13

Congressional Union for Woman Suffrage, 403n1

Convention and Revolt in Poetry (Lowes), 109, 112, 408n61

"Conversations with Lenin" (Ransome), 158, 412n139

Coogan, Jackie, 124, 238

Cooper, Lenetta M., 99

Cox, James M., 309

Craven, Frank, 22, 23, *23*, 102, 398n70, 407n44

Crawford, Joan, 127, 203

Creel, George, 220

Critique of Pure Reason (Kant), 3, 212

Crocket, Anna ("Annie"), 131, 294, 312, 409n89

Croly, Herbert, 324, 325, 427n160

Croton-on-Hudson, New York, 7, 8, 46, 61, 312; Charlie at Max's house, 375, 431n66; Christmas party (1919) in, 212; communist enclave of, 32, 86; Drowsy Saint inn, 312, 429n30; friends of Max and Florence in, 80, 85–88, 166, 402n25,

Hughes, Howard, 220
Hughes, Rupert, 32, 117, 168, 220, 221, 223–24, 353
Hula Hula Dance (Chaplin, 1916), 336
Hungary, communist revolution in, 164, 412n124
Hunter, T. Hayes, 32, 220, 414n165

Idiot, The (Dostoyevsky), 232
Idle Class, The (Chaplin, 1921), 374
Ince, Thomas H., 227
"In Communist Hungary" (Crystal Eastman), 158, 412n139
Industrial Workers of the World ("Wobblies"). *See* IWW
International Film Services, 25
Intolerance (Griffith, 1916), 15, 367
Irving, George, 31
Isadorables, 4, 215, 281, 284
Ives, Charlotte, 373, 430n55
IWW (Industrial Workers of the World; "Wobblies"), 10, 50, 87, 92–3, 153, 161, 223, 400n13; imprisoned members of, 425n126; Pedersen murder trial and, 172, 414n171; Seattle General Strike and, 220

Jacobi, Paula, 312, 426n138
Jacobi, Victor, 318
Jacobs, Lewis, 12
Jaffery (Frohman, 1916), 25, 31–32, 33, 69, 78, 136, 399n81, 409n81; Florence in stills from, *26–30*; Florence's later dislike of, 54, 399n81; Max's view of, 61; reviews of, 28, 31; stills viewed by Goldwyn, 53
James, William, 401n23
Jenkins, Frank Lynn, 21
Jest, The (Benelli play, 1919), 107, 407n49
Jewel (Universal, 1915), 414n163
Joan of Arc, 124, 126, 141, 412n132
Johnson, James Weldon, 11
Johnson, Julian, 28, 399n79
Jones, Marjorie, 16–17, 415n186; photographs by, *9*, 16–17
Jordan-Smith, Paul, 159, 208, 251, 254, 413n142, 415n176
Joyce, Alice, 79
Judgment House, The (Paramount, 1917), 69, 401n22, 403n42

Kant, Immanuel, 162, 212
Karloff, Boris, 414n165
Keaton, Buster, 23, 364, 397n45

Keats, John, 120, 167, 169, 170, 176, 393, 414n164, 414n167
Keller, Helen, 184, 415n184
Kellerman, Annette, 25
Kelley, Joseph L., 78
Kelly, Anthony Paul, 220
Kennedy, Madge, 202, 203
Kenyon, Dorothy, 352, 428n19
Kid, The (Chaplin, 1921), 14, 19, 124, 199, 208, 238–39; Barrie's criticism of, 420n43; Charlie's earnings from, 261; death of Charlie's son and, 16, 238; dream sequence, 338, 420n43; Florence's excitement about, 239; proceeds attached by Mildred, 314, 315, 426n146; reviews of, 239; stills from, 18, 240, *241*
Kiernan, Heather, 396n17
Kinds of Love (Eastman, 1931), 416n204
Kinemacolor, 24
Kinema Theater (Los Angeles), 207, 417n214
Kingsley, Grace, 18, 305–6, 309, 313, 423n93
Klein, Charles, 400n9
Knight, Dorothy, 330
Knight, Percival ("Percy"), 100, 102, 110, 318
Knoblock, Edward, 22, 375
Knopf, Alfred A., Sr., 80
Kolchak, Alexander, 134, 407n55, 410n98
Komik und Humor (Lipps, 1898), 147, 412n121
Kono, Toraichi, 232, 235, 420n28, 420n35
Kreisler, Fritz, 318
Ku Klux Klan, 11
Kun, Béla, 148, 155, 164, 412n124, 413n153
Kwan (Quan), Moon, 204–5, 231, 416n204, 420n26
Kyle, Howard, 179, 415n179

Lane, Dan, 210, 313, 418n224
Lane, Franklin K., 224–25
Lane, Margaret, 97, 159, 195, 212, 258, 313, 373, 406n35
Langer, William ("Wild Bill"), of North Dakota, 68, 402n31
Langtry, Albert P., 11
Lanier, Sidney, 109, 115, 408n64
Lansing, Robert, 266, 423n87
Larkin, John, 147, 411n120
Lasky, Jesse, 31, 193, 327, 399n81
Lawrence, Florence (the "Biograph Girl"), 117
League for the Suppression of Vice, 13
League of Nations, 90, 404n22
Leave It to Beaver (TV series, 1957–1963), 203

with Bryant, 179, 415n181; death of, 358, 429n29; as eyewitness to Bolshevik Revolution, 408n59; on trial for opposing US war effort (1918), 81; withdraws from *Liberator* 408n59

Reeves, Alfred ("Alf"), 315

Reisner, Charles, 240, *241*

Reitell, Charles, 200

Rempfer, William C., 53, 57

Remsen, Ida Mallory, 364

Retzlaff, F. H., 58

"Revenge of Hamish, The" (Lanier, 1878), 115, 408n64

Rex Beach Film Company, 69, 74, 404n24

Rhodes, Harrison, 375, 431n68

Rice, Elmer (Elmer Reizenstein), 257–58, 266, 422n68

Richardson, Helen Patges, 327

Rickman, Helen, 208

Rinehart, Mary Roberts, 117

Robertson, Clifford, 259, 262, 267, 269, 270–71, 274, 422n81

Robinson, Bartlett Whitney, 373, 430n57

Robinson, Boardman ("Mike"), 60, 111, 134, 162, 324, 360, 376, 402n25; car of, 312; on Charlie's charades, 375; marriage to Sally, 166, 372–73, 429n35

Robinson, Carlyle, 19, 374

Robinson, David, 6

Robinson, John Whitney ("Billy"), 373, 430n57

Rogers, Merrill, 81

Rolando, Rose, 290, 425n116

Rolland, Romain, 251, 254, 418n1, 421n55

Roof Tree, The (Fox, 1921), 33, 301

Roosevelt, Franklin Delano (FDR), 309

Ross, Lillian, 384

Ross, Steven, 75

Rosslyn Hotel (Los Angeles), 95–96

Ruling Passion, The (Fox, 1916), 25

Russell, William, 301

Russia, Soviet, 136, 207–8, 358, 376, 410n91; Max's travel to, 1, 386

Russian Revolution, 80, 152, 207–8, 376, 386, 405n29, 409n78; civil war and, 69, 110, 134, 407n55, 410n98, 411n106; Florence's script set in revolutionary Russia, 270; Red Terror, 132, 138, 152. *See also* Bolsheviks; communism

Ryckman, J. H., 91

St. Vincent Millay, Edna, 401n20

Sandburg, Carl, 374

Sappho, 307, 425n130

Scardon, Paul, 80, 82, 258

Schenck, Joseph M., 366

Schertzinger, Victor, 422n71

Scholtz, Abe, 415n175

Schopenhauer, Arthur, 162, 373

Schwab, Charles, 184, 415n184

Scopes, John T., 403n1

Scopes "Monkey Trial" (1925), 403n1

Scribner's (publisher), 274, 278, 353, 366

Scribner's Magazine, 46, 400n8

Scripps, Edward W., 320, 330, 411n107, 426n156

Seattle General Strike (1919), 220, 221

Second International Congress of Women (Zurich, 1919), 136

Secor, Lella Fay, 56, 401n21

Sedition Act (1918), 10, 80, 404n6

Selwyn, Archibald, 53, 100, 116–17, 118, 140, 406n39, 411n110

Selwyn, Edgar, 53, 54, 100, 116–17, 118, 140, 411n110

Selwynne, Clarissa, 222, *223*, 235, 259, 267, 419n12

Selwyn Theatre (New York), 140, 411n110, 413n156

Selznick, David O., 260

Sense of Humor, The (Eastman, 1921), 3, 7, 17, 105, 172, 198, 199, 211, 239, 331, 338, 387, 407n42, 412n121, 421n58, 429n38; dedication to Florence, 338; Florence as listener and critic during writing of, 344, 346, 354–55, 361, 378; "laws" for jokes, 363, 429n40; on Shakespeare's jokes, 372, 430n53; title of, 361, 372

Seven Chances (Belasco play), 22–24, *23*, 40, 44, *45*, 100, 118, 400n4, 406n39, 407n44. See also *Among the Girls* (musical)

Seventeen (Tarkington novel and play), 73, 402n39

Severance, Caroline Seymour, 335

Sex (Pathé Exchange, 1920), 227

Shakespeare, William, 4, 75, 110, 170, 209, 232, 372, 414n167, 430n53

Sheffield, Captain Tom, 269, *270*, 423n92

Shelley, Percy Bysshe, 162, 167, 176, 413n147, 413n148

Sheridan, Clare Consuelo Frewen, 376–78, *377*

404n22; public opinion against, 61; US entry into, 45; violent reaction to antiwar views in Fargo, 64–68

York, Cal, 350
Young, Art, 49, 81, 125, 172, 253, 358, 400n12, 404n22, 409n83, 414n172, 415n182

Young, James, 301
Youngren, Emma Caroline. *See* Mather, Margrethe

Zaliasnik, Vera, 200, 410n91
Zara, Antonio, 132, 410n93
Ziegfeld, Florenz Jr., 78
Zukor, Adolph, 12, 14, 193–94

Cooper Graham, retired film curator at the Library of Congress, is widely known for his work on Leni Riefenstahl and D. W. Griffith. His most recent book, cowritten with James W. Castellan and Ron van Dopperen, is *American Cinematographers in the Great War, 1914–1918.*

Christoph Irmscher is Provost Professor of English and Director of the Wells Scholars Program at Indiana University Bloomington. A regular contributor to the *Wall Street Journal,* he is the author of numerous books, including, most recently, *Max Eastman: A Life* and *Stephen Spender: Poems Written Abroad.*